UPGRADE TO HEAVEN

Edited by

Marina Bauernfeind & David Löwe

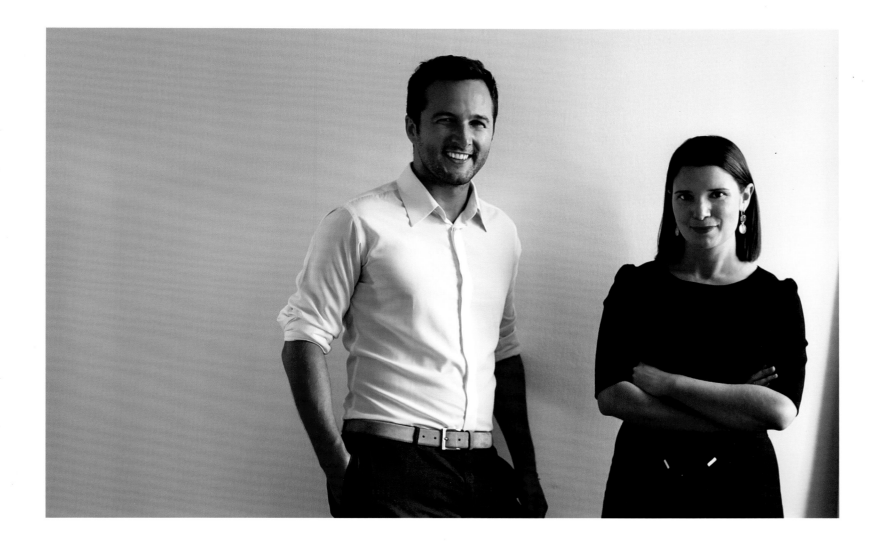

We have an upgrade for you!

Wer weiß, wie fantastisch sich ein Upgrade anfühlt, wird dieses Buch lieben! UPGRADE TO HEAVEN ist ein Lifestyle Coffee Table Book, das Ihnen bei einer weltweiten Auswahl außergewöhnlicher und luxuriöser Hotels kostenfreie Upgrades ermöglicht. Die UPGRADE TO HEAVEN-Karte macht Sie in den teilnehmenden Häusern zu einem ganz besonderen Gast und bringt Sie in den Genuss der begehrten "Upgrade Experience".

Hinter UPGRADE TO HEAVEN steckt die Agentur BAUERNFEIND + LÖWE. Smarte Ideen sind unser Markenzeichen. Nach gemeinsamen Jahren bei Hubert Burda Media gründeten wir im Jahr 2013 unsere Agentur und sind seitdem im Herzen von München zuhause. Wir stehen für Creative Marketing, Design, Live-Kommunikation und Public Relations und realisieren seit Jahren erfolgreich Kooperationen zwischen Medien und Wirtschaft. David Löwe ist zudem Editor-in-Chief von Hotels in Heaven®, Online-Magazin und Community für Luxushotels.

UPGRADE TO HEAVEN ist eine perfekte Verbindung aus der Expertise unserer Agentur im Bereich Cooperative Marketing und unserer Leidenschaft für Design, Architektur und Kunst. Unterstützt von einem großartigen Team entstand ein einzigartiges Buch mit 50 der schönsten Hotels dieser Welt – ein Must-Have für alle, die gerne reisen und vom Upgrade-Feeling niemals genug bekommen können.

Viel Vergnügen mit Ihren Upgrades!

Marina Bauernfeind & David Löwe

Anyone who knows how great an upgrade feels will love this book! UPGRADE TO HEAVEN is a lifestyle coffee table book with a selection of unusual, luxurious hotels worldwide and a built-in upgrade bonus. The UPGRADE TO HEAVEN card makes our readers very special guests at the participating hotels and ensures them the coveted "Upgrade Experience".

UPGRADE TO HEAVEN is the brainchild of the BAUERNFEIND + LÖWE agency. Smart ideas are our trademark. After working together for several years at Hubert Burda Media, we founded our agency in 2013 and have been at home in the heart of Munich ever since. We are synonymous with creative marketing, design, live communication and public relations. Crafting successful partnerships between media and business has been our speciality for years now. David Löwe is also Editor-in-Chief of the leading social hotel guide Hotels in Heaven®.

UPGRADE TO HEAVEN is the perfect symbiosis of our agency's expertise for cooperative marketing and our passion for design, architecture and art. With the help of an outstanding team, we created a unique book featuring 50 of the world's most beautiful hotels – a must-have for savvy travellers who can't get enough of that upgrade feeling.

Enjoy your upgrades!

Marina Bauernfeind & David Löwe

A special thank you to

our UPGRADE TO HEAVEN team Sabine Seidl, Tanja Maria Thurner, Julia Hallhuber, Emily Wilson, Käthe Schulz, Luisa Fürstenberg, Antonia Kirchberg, Vanessa Tschapke and Anne-Katrin Ahrens, our business partners Regina Denk from teNeues, Benedikt Böckenförde and Kerstin Schiefelbein from Hotels in Heaven®, and our beloved families Natascha, Lana-Sophie and Kornelia Löwe, and Axel Nething.

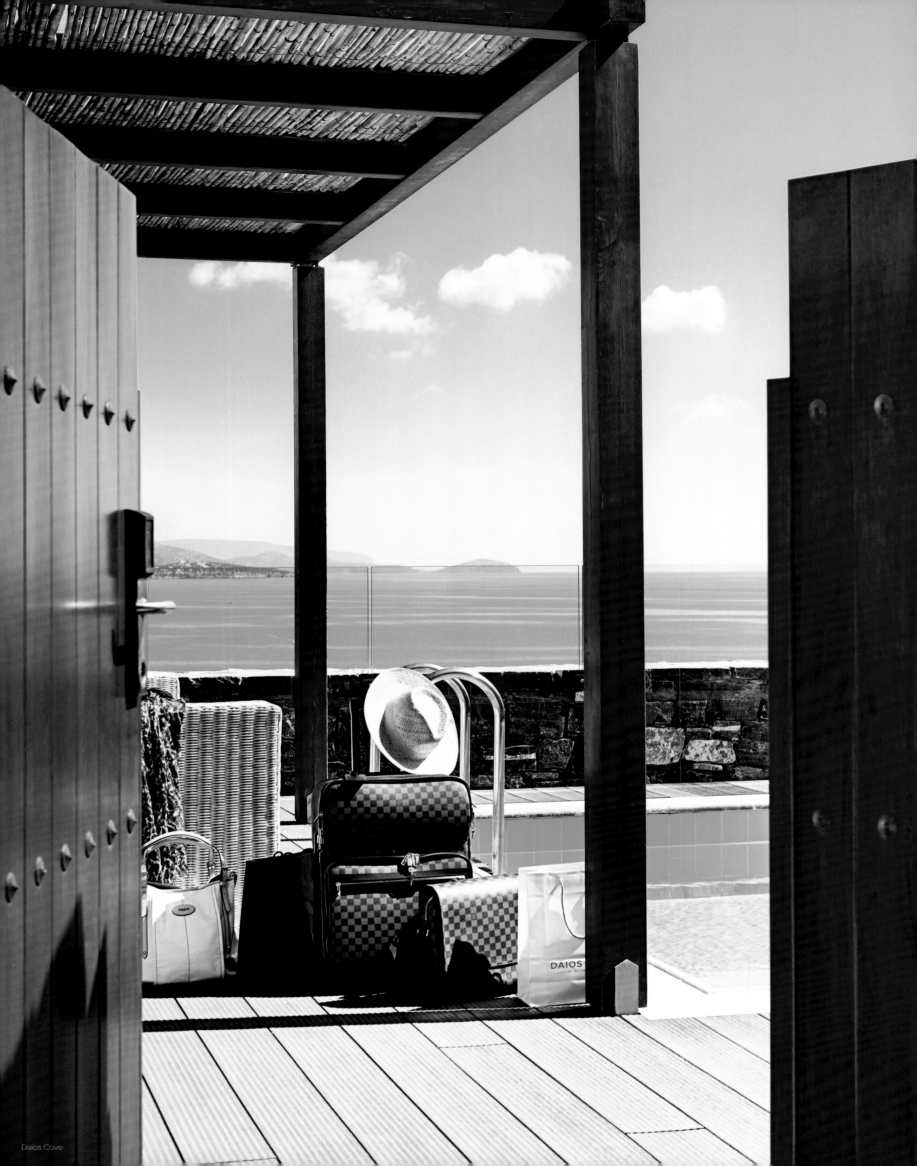

Daios Cove

How it works

Willkommen bei UPGRADE TO HEAVEN. Jedes auf den folgenden Seiten abgebildete Hotel gewährt Ihnen als UPGRADE TO HEAVEN-Teilnehmer einmalig auf Ihre Buchung ein kostenfreies Upgrade mindestens in die nächsthöhere Zimmerkategorie. Ihr Aufenthalt soll Dank der Upgrade Experience etwas ganz Besonderes werden. Ist das Upgrade aufgrund von Auslastung nicht verfügbar, so dürfen Sie sich über eine adäquate Ersatzleistung wie Spa Treatments, Einladungen zu Dinner oder Lunch oder ähnlichem vom Hotel freuen. Mit den folgenden drei Schritten kommen Sie in den Genuss Ihrer Upgrades.

Welcome to UPGRADE TO HEAVEN. Every hotel featured on the following pages guarantees to grant you, as the owner of this book, a single free upgrade for your booking to at least the next-highest room category. Your stay will be something very special with an unforgettable Upgrade Experience. If the upgrade is unavailable due to the hotel being fully booked, you can look forward to receiving appropriate substitute services from the hotel, such as spa treatments, dinner or lunch invitations or similar. By following these three steps you can get your upgrade.

1 UPGRADE TO HEAVEN CARD

Auf der letzten Seite des Buches finden Sie Ihre persönliche UPGRADE TO HEAVEN-Karte. Bitte ergänzen Sie auf der Rückseite Ihre persönlichen Daten. Diese Karte dient der Identifikation und darf bei Ihren Reisen nicht fehlen.

1 UPGRADE TO HEAVEN CARD

On the last page of this book, you will find your personal UPGRADE TO HEAVEN membership card. Please fill out your details on the reverse side of this card. You are required to present this card on your journeys.

2 WWW.UPGRADETOHEAVEN.COM

Auf der Website von UPGRADE TO HEAVEN finden Sie im Mitgliederbereich alle Details wie Sie in den Genuss Ihres Upgrades kommen. Bitte gehen Sie dazu online auf www.upgradetoheaven.com und registrieren Sie sich bei Ihrem ersten Besuch. Hierfür benötigen Sie die individuelle Seriennummer auf der Rückseite Ihrer UPGRADE TO HEAVEN-Karte.

2 WWW.UPGRADETOHEAVEN.COM

In the membership area on the UPGRADE TO HEAVEN website you will find details on how to obtain your upgrades. Please go online at www.upgradetoheaven.com and register your membership card on your first visit. To do this, you will need the serial number stated on the back of your membership card.

3 BOOKING

Sie können sich jederzeit mit Ihren persönlichen Zugangsdaten auf der UPGRADE TO HEAVEN Internetseite anmelden und finden dort – stets aktuell – alle Informationen zur Buchung mit dem UPGRADE TO HEAVEN-Vorteil. Bitte zeigen Sie beim Check-in im Hotel Ihre UPGRADE TO HEAVEN-Karte zusammen mit Ihrem Ausweis vor.

3 BOOKING

Log in any time with your personal registration details at www.upgradetoheaven.com to find the direct booking link for the hotel and all other information about your booking and upgrade – which is always up to date. When you check in at your hotel, please confirm your identity by showing your UPGRADE TO HEAVEN membership card and proof of ID.

Enjoy!

GOOD TO KNOW
- Der Erwerb des Buches berechtigt zur Teilnahme bei UPGRADE TO HEAVEN mit kostenlosen Upgrades. Gültig bis 31.12.2018
- Erforderlich ist dafür die Registrierung über www.upgradetoheaven.com
- Unser Kundenservice ist Ihnen per E-Mail an service@upgradetoheaven.com jederzeit gerne behilflich. Weitere Kontaktinformationen finden Sie unter www.upgradetoheaven.com.
- Bitte beachten Sie, dass das Upgrade nur dann gewährt werden kann, wenn die Buchung durch die online vorgegebenen Buchungsabläufe getätigt wird.
- Die Teilnahmebedingungen finden sie unter www.upgradetoheaven.com/teilnahmebedingungen

GOOD TO KNOW
- The purchase of the book allows the participation in UPGRADE TO HEAVEN with complimentary upgrades for 50 of the most stunning hotels in the world. Valid until 31.12.2018
- The registration on www.upgradetoheaven.com is required.
- Our service team is available at any time via service@upgradetoheaven.com. To find additional contact information, go to www.upgradetoheaven.com.
- Please note that an upgrade can only be granted if the booking is made via the link given.
- Terms and conditions can be found at www.upgradetoheaven.com/termsandconditions

Content

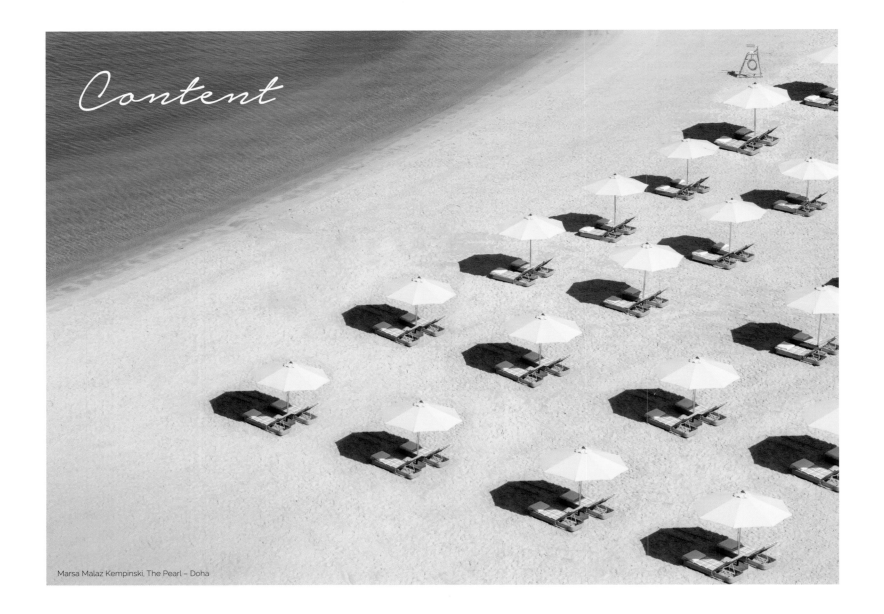

Marsa Malaz Kempinski, The Pearl – Doha

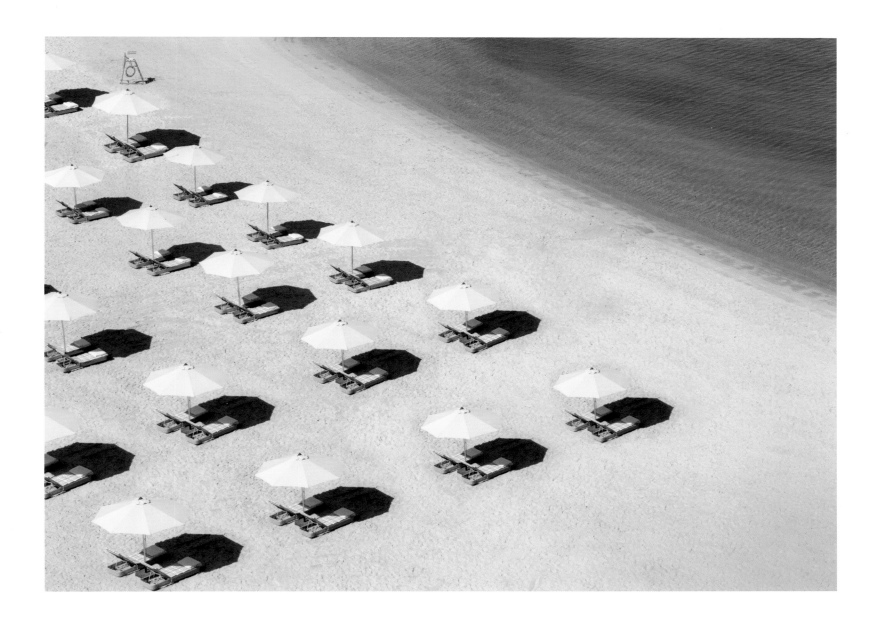

HOTEL	DESTINATION	CONTINENT	PAGE
The Charles Hotel, a Rocco Forte Hotel	Munich, Germany	Europe	156–160
Campo Bahia	Santo André, Brazil	South America	162–167
Hotel Bachmair Weissach	Tegernsee, Germany	Europe	168–173
The Residence Mauritius	Belle Mare, Mauritius	Africa	174–179
Bio- und Wellnessresort Stanglwirt	Going, Austria	Europe	180–185
Lux* Le Morne	Le Morne, Mauritius	Africa	186–189
The Residence Maldives	Gaafu Alifu Atoll, Maldives	Asia	190–195
Boutique Hotel Heidelberg Suites	Heidelberg, Germany	Europe	196–201
Como Point Yamu	Phuket, Thailand	Asia	202–207
Macdonald Monchique Resort & Spa	Algarve, Portugal	Europe	208–211
Carlton Hotel	St Moritz, Switzerland	Europe	212–215
Lux* Belle Mare	Belle Mare, Mauritius	Africa	216–221
Hotel Amigo, a Rocco Forte hotel	Brussels, Belgium	Europe	222–225
Hillside Beach Club	Aegean, Turkey	Asia	226–231
Badrutt's Palace Hotel	St Moritz, Switzerland	Europe	232–235
Let's Sea Hua Hin Al Fresco Resort	Hua Hin, Thailand	Asia	236–239
Private Hideaway Jagdgut Wachtelhof	Maria Alm Hinterthal, Austria	Europe	240–243
Coco Bodu Hithi	North Malé Atoll, Maldives	Asia	244–247
Hotel Sans Souci Wien	Vienna, Austria	Europe	248–253
The Residence Zanzibar	Zanzibar, Tanzania	Africa	254–259
Adler Mountain Lodge	Alpe di Siusi, South Tyrol, Italy	Europe	260–265
Aenaon Villas	Santorini, Greece	Europe	268–271
Rocco Forte Hotel Astoria	St Petersburg, Russia	Europe	272–275
Wiesergut	Hinterglemm, Austria	Europe	276–281
Como Cocoa Island	South Malé Atoll, Maldives	Asia	282–285

TRAVEL IN STYLE WITH

UPGRADE TO HEAVEN.

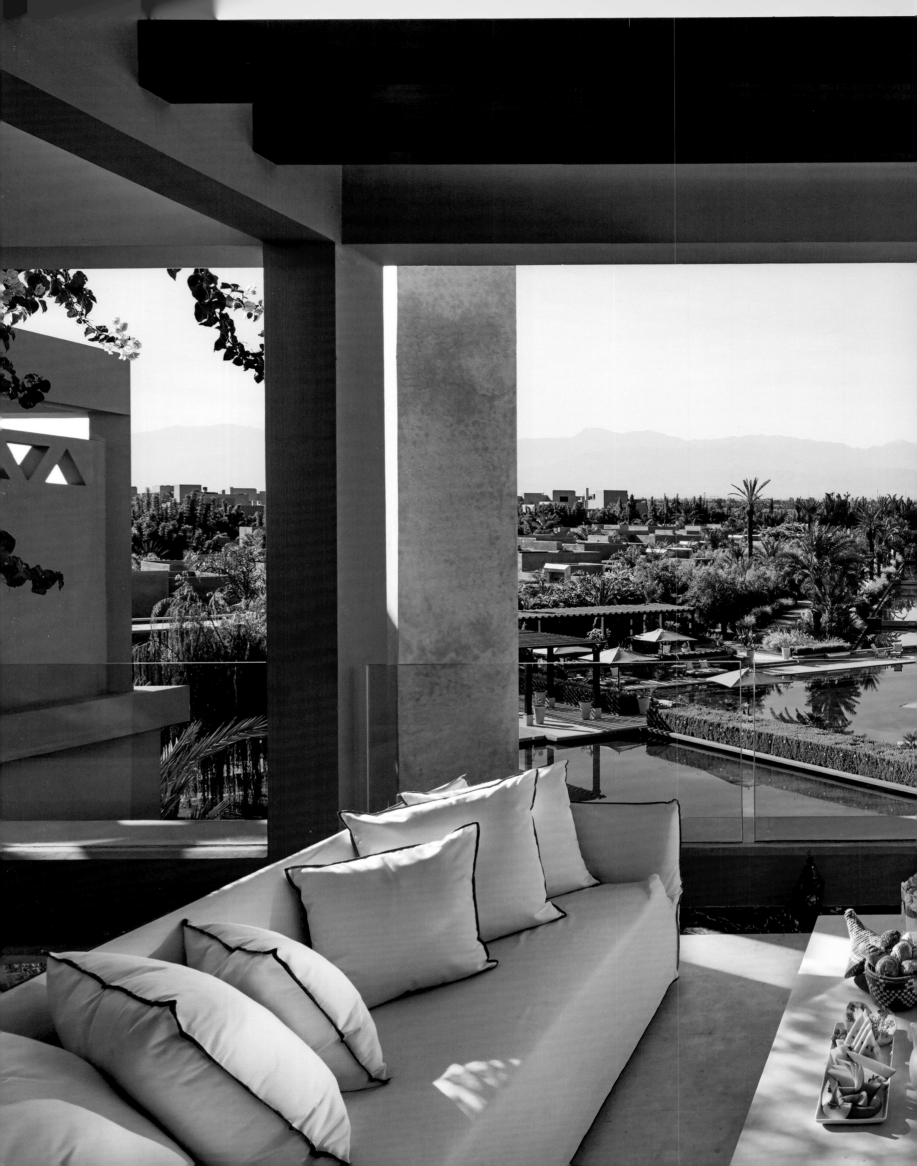

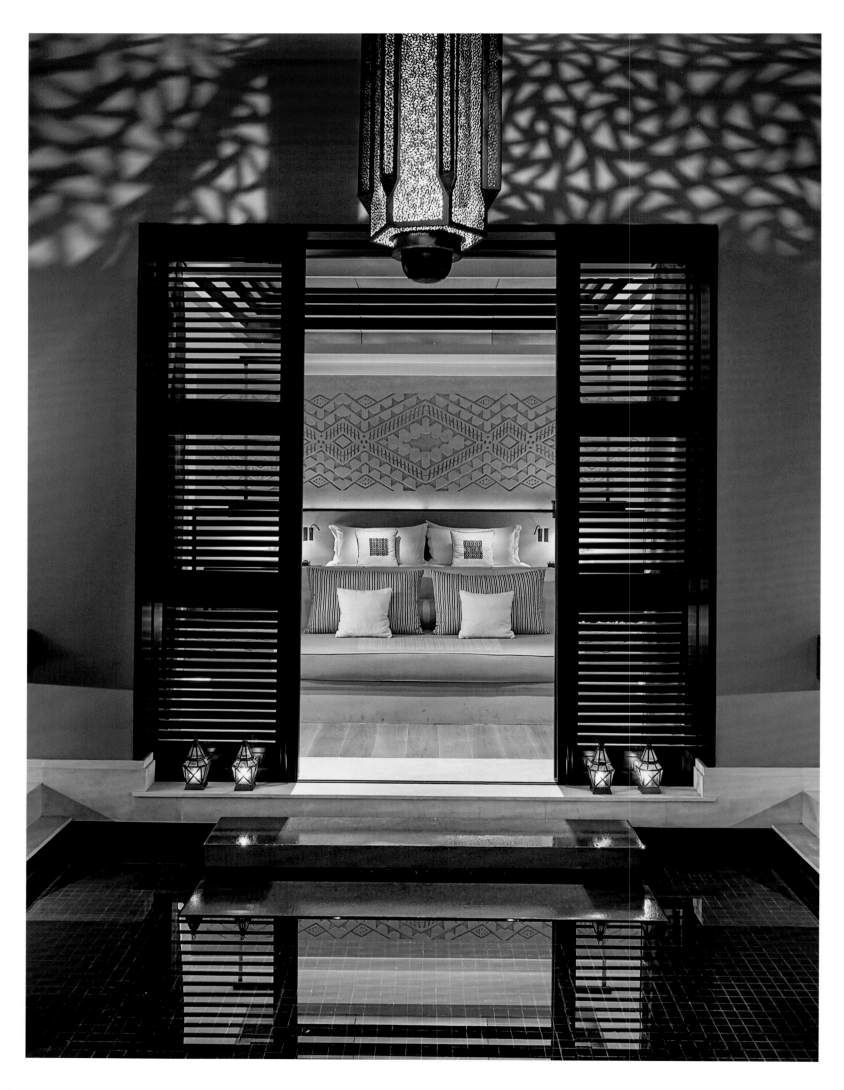

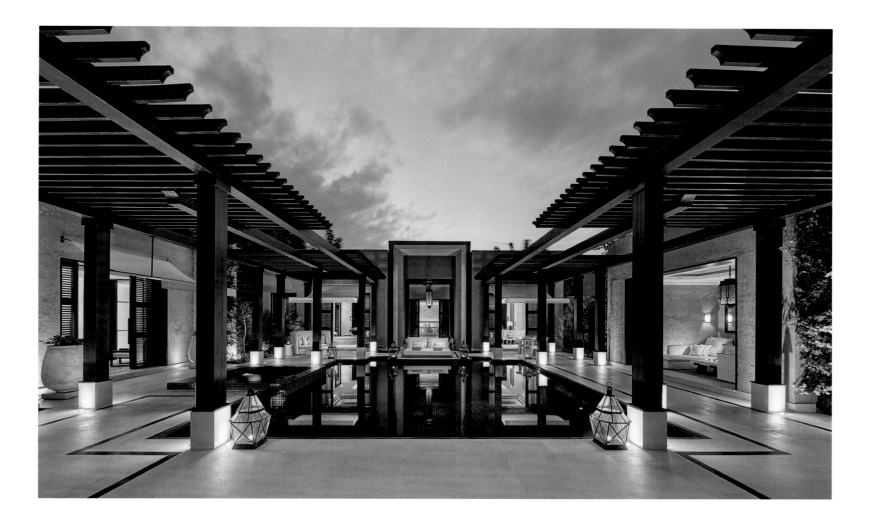

LOCATION

Das Sehnsuchtsziel Marrakesch liegt im Südwesten Marokkos in einer Ebene und blickt auf den Hohen Atlas. Hinter der Stadtmauer Marrakeschs beginnt die Sahara-Wüste. Die Altstadt, Medina genannt, gehört ebenso wie die Agdal- und Menara-Gärten zum UNESCO-Weltkulturerbe. Die berühmten Souks, in denen unter anderem Gewürze, Lederwaren und Laternen gehandelt werden, und der tosende Marktplatz Djemaa el Fna ziehen Besucher magisch an. Die verwinkelten Gassen der Medina sowie Marrakeschs Paläste und Gärten entdeckt man am besten zu Fuß. In der Neustadt befindet sich Yves Saint Laurents bezaubernder Jardin Majorelle – ein faszinierender Ort mit wunderbarer Pflanzenvielfalt und kobaltblauer Architektur.

HOTEL

Das Schmuckstück der Luxushotelkette Mandarin Oriental eröffnete 2015 in Marrakesch: Ein Resort inmitten eines 20 Hektar großen Landschaftsgartens mit 100.000 Rosen, Olivenhainen und Bougainvilleen. Nur wenige Minuten von der Medina entfernt bietet es traumhaften Ausblick auf das Atlasgebirge. Die 54 Villen und neun Suiten sind im traditionellen Berberstil mit maurischen Einflüssen gestaltet. Jede Villa verfügt über einen kleinen Garten mit Swimmingpool, Whirlpool und Terrasse, die zum Sonnenbaden oder Essen im Freien einlädt. Einen atemberaubenden Ausblick auf die Gärten und den Atlas gewähren die Suiten mit eigener Dachterrasse mit Pool. Die marokkanische Starköchin Meryem Cherkaoui serviert im Restaurant "Mes'Lalla" zeitgenössische Interpretationen traditioneller Landesküche. Im "Pool Garden" stehen mediterrane Gerichte mit knackigem Gemüse aus dem Hotelgarten auf der Karte. Frühstück sowie ganztägig marokkanische und internationale Gerichte werden im "Salon Berbère" serviert. Ein Partyhotspot mit innovativen Cocktails und kantonesischen Speisen ist das "Ling Ling by Hakkasan", das im Sommer 2016 eröffnete. Zum Entspannen lädt das 1.800 qm große Spa ein. Die Wellnessoase verfügt über sechs Behandlungsräume sowie einen Thai-Massage-Raum und zwei luxuriöse Hamams. Das Mandarin Oriental Marrakech lockt außerdem als ultimative Golf-Destination: Vom Hotel aus hat man direkten Zugang zu den Golfclubs The Royal Golf und Al Maaden. Der Amelkis Golfplatz ist nur wenige Fahrminuten entfernt.

LOCATION

The dream destination Marrakech is in Morocco's south-west and overlooks the Atlas Mountains. The Saharan desert starts behind Morocco's city wall. The old city, known as the Medina, is on the UNESCO's World Heritage list, as are the gardens of Agdal and Menara. The famous suqs, where spices, leather goods and lanterns are traded, and the vibrant market Djemaa el Fna magically attract visitors. The Medina's crooked streets and Marrakech's palace and gardens are best discovered on foot. Yves Saint Laurent's charming Jardin Majorelle – a fascinating destination with a wonderful variety of plants – is located in the new town.

HOTEL

The luxury hotel chain Mandarin Oriental established this jewel in 2015 in Marrakech: a resort in a 20-hectare landscaped garden with 100,000 roses, olive groves and bougainvillea. It offers a picturesque view of the Atlas Mountains only a few minutes away from the Medina. The 54 villas and 9 suites are designed in the traditional Berber style with Moorish influences. Each villa includes a small garden with pool, whirlpool and terrace, which are perfect for sunbathing or outdoor dining. A breath-taking view of the gardens and the Atlas can be enjoyed from the suites with private rooftop and pool. The Moroccan star chef Meryem Cherkaoui serves contemporary renditions of the country's traditional cuisine in the "Mes'Lalla". The "Pool Garden" serves Mediterranean dishes with crisp vegetables from the hotel's garden. Breakfast and all-day Moroccan and international dishes are offered in "Salon Berbère". The "Ling Ling by Hakkasan" is a party hotspot with innovative cocktails and Cantonese dishes, which opened in summer 2016. The 1,800 sqm spa invites guests to enjoy pure relaxation. The wellness oasis includes six treatment rooms as well as a Thai massage room and two luxurious hammams. The Mandarin Oriental Marrakech is also attractive as the ultimate golfing destination: there is direct access to the golf clubs The Royal Golf and Al Maaden, and the Amelkis golf course is only a few minutes away.

Get your Upgrade

www.upgradetoheaven.com/mandarin-oriental-marrakech

MANDARIN ORIENTAL MARRAKECH . Route du Golf Royal, Marrakech 40000, Morocco . www.mandarinoriental.de/marrakech

A MOROCCAN VILLA OASIS WITH ASIAN TOUCH

Eine marokkanische Villen-Oase
mit asiatischem Touch

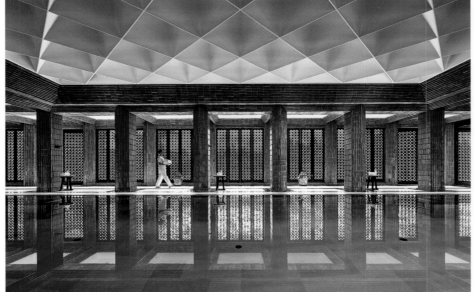

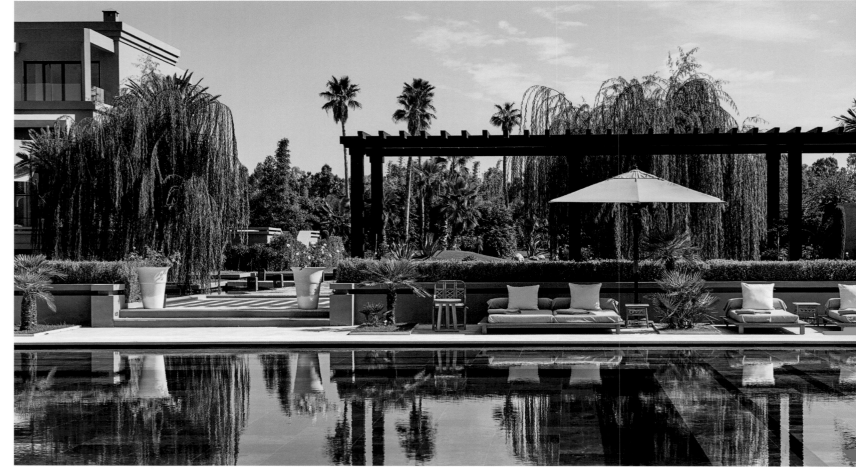

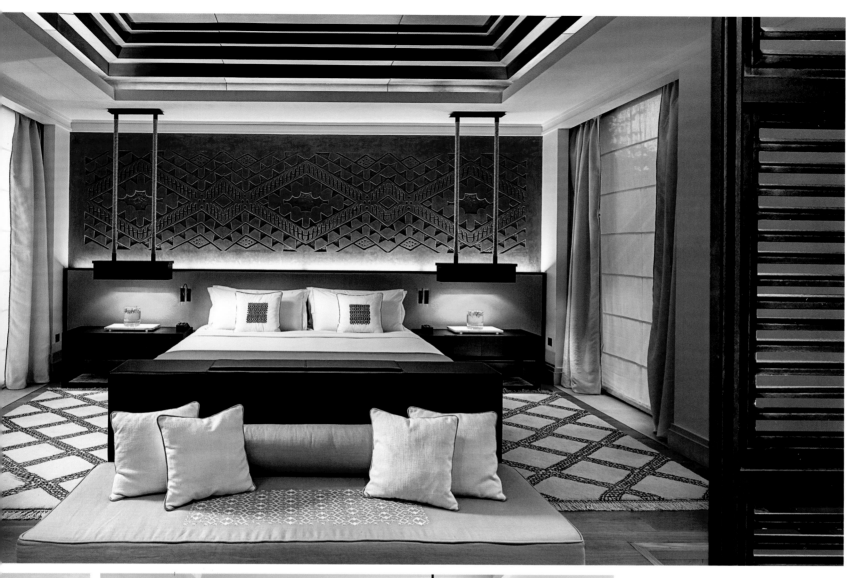

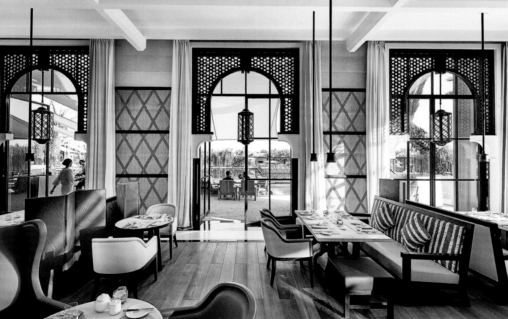

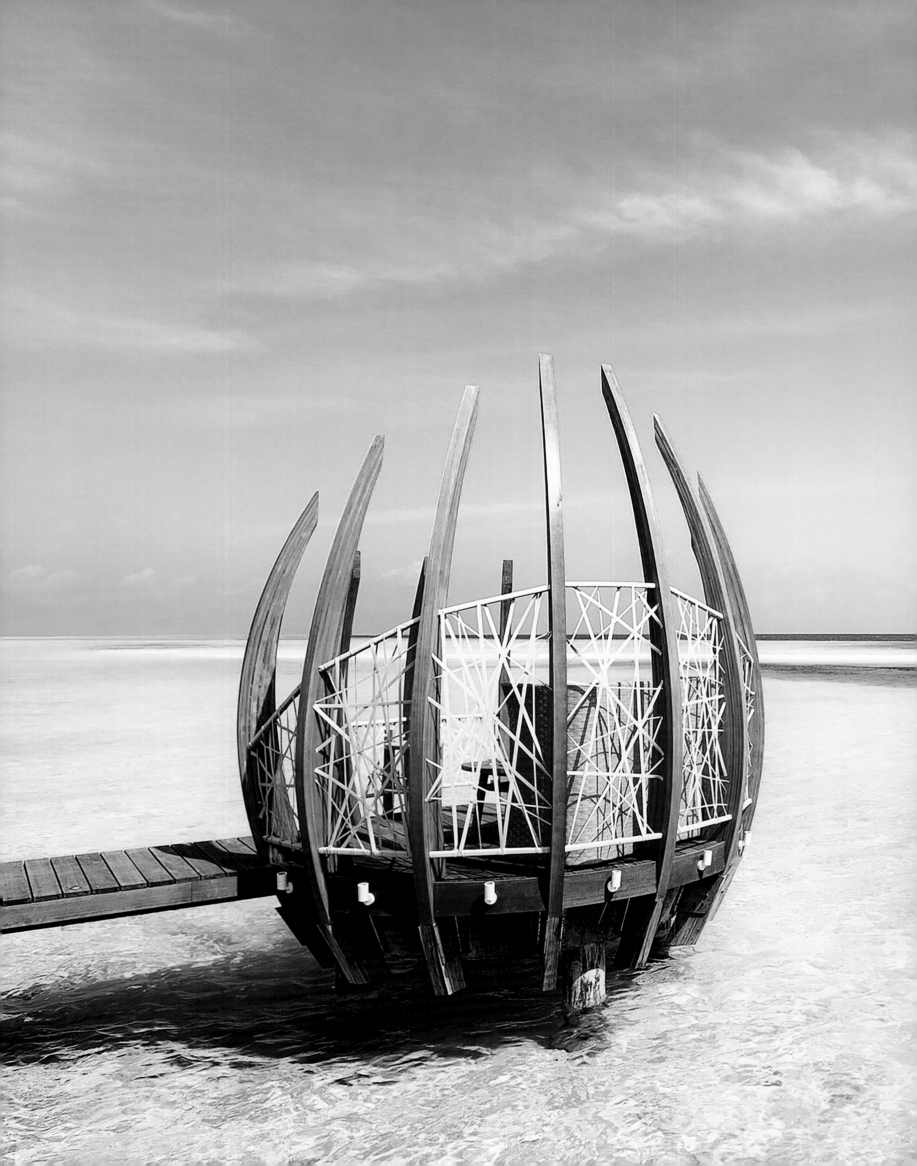

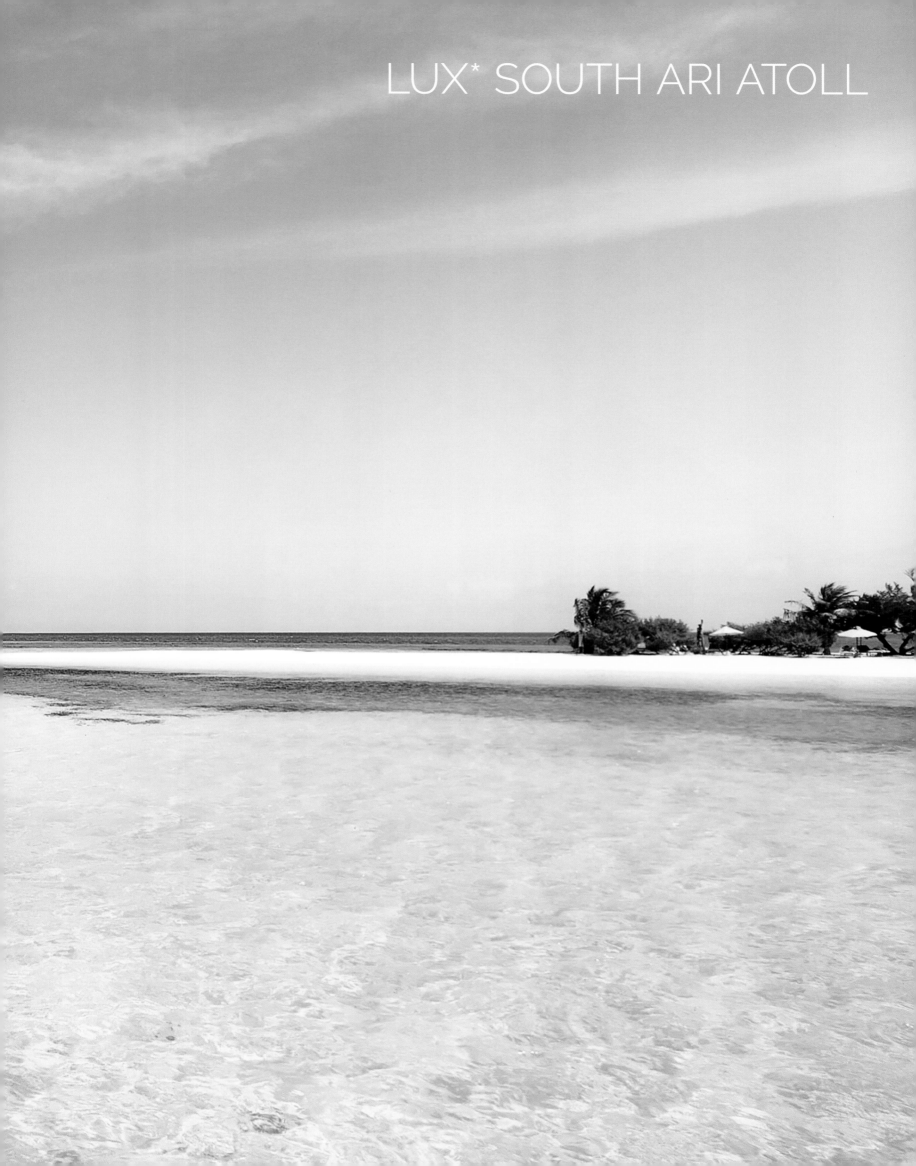

LUX* SOUTH ARI ATOLL

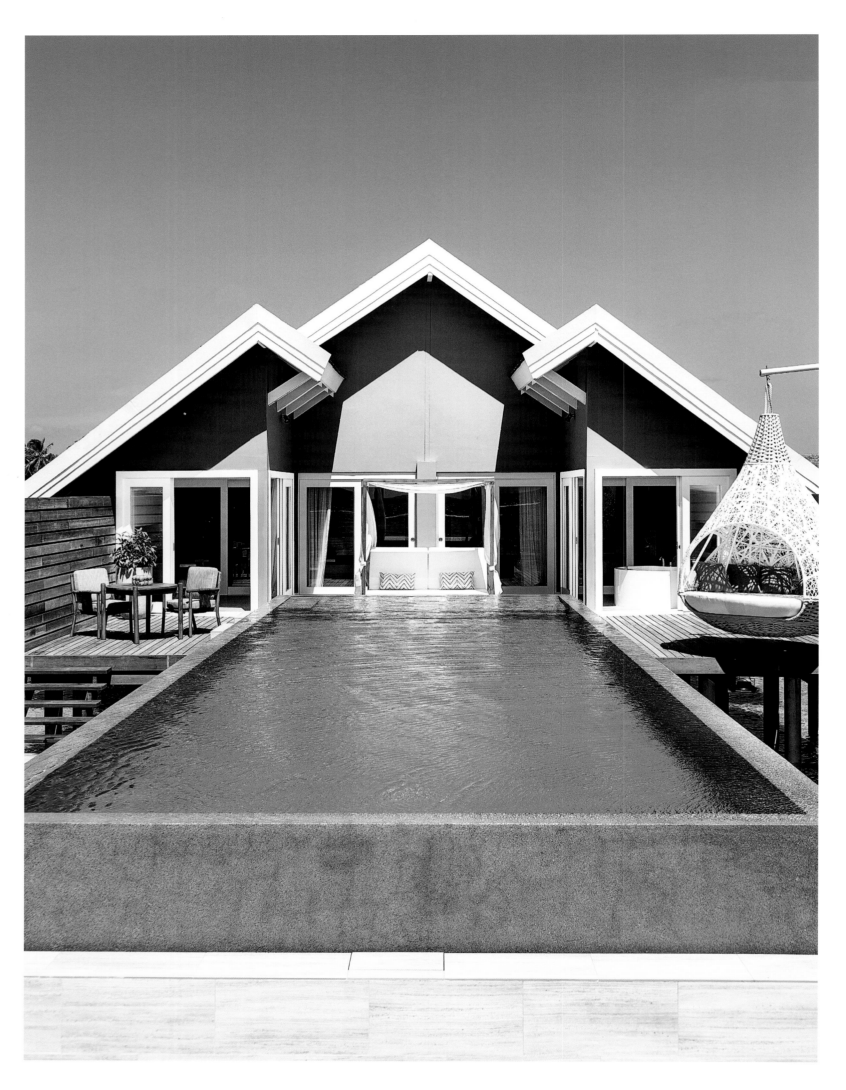

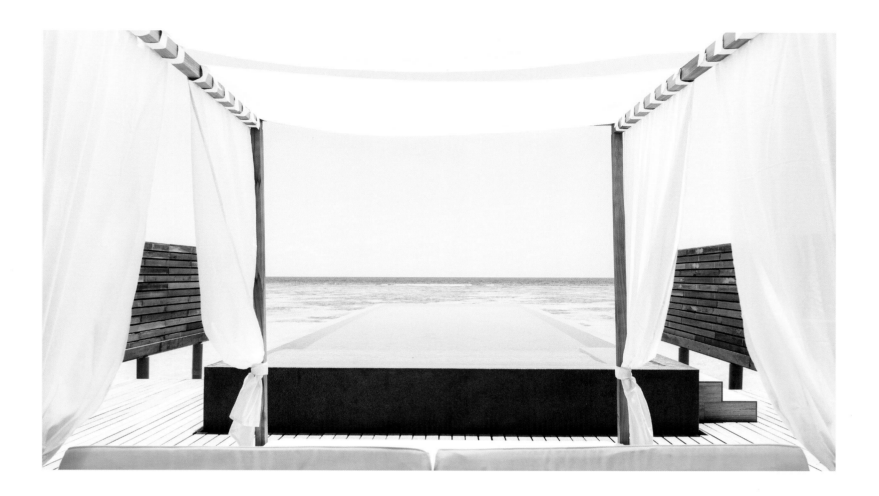

LOCATION

Nach einer Komplett-Renovierung eröffnete im September 2016 Lux* South Ari Atoll neu. Das Luxus-Resort liegt auf der großzügigsten und schönsten Insel der Malediven im Süden des Ari-Atolls. Der internationale Flughafen in der Hauptstadt Malé ist ca. 100 Kilometer entfernt und per Inlandsflug und Bootstransfer in etwa 45 Minuten zu erreichen. Das Resort ist drei Kilometer lang und von weißen Sandstränden umgeben. Kristallklares Lagunenwasser lädt zu Ausflügen auf einem der traditionellen Dhonis oder eines Luxus-Segelkatamarans ein. Begleitet von einem Meeresbiologen können die Gäste ein Bad mit dem größten Hai und zugleich größten Fisch, dem für Menschen ungefährlichen Walhai nehmen. Ein weiteres aufregendes Erlebnis für Groß und Klein sind die Fütterungen der Rochen. Täglich statten sie dem Luxus-Resort ihren Besuch ab und kommen den Gästen dabei ganz nahe.

HOTEL

Die 193 Pavillons und Villen thronen auf Stelzen in dem türkisfarbenen Wasser des Indischen Ozeans. Das renommierte Designstudio P49 Deesign hat sich bei der Renovierung von den sanften Meeresfarben und den organischen Formen inspirieren lassen. Die Grünanlage, eine üppige Pracht aus Bäumen und Pflanzen, gestaltete der preisgekrönte Landschaftsarchitekt Stephen Woodhams. Die Ostseite des Atolls mit 46 „Romantic Pool Villas" ist allein den Erwachsenen vorbehalten. Ein Großteil der Villen verfügt über einen eigenen Pool. Auf kulinarische Vielfalt wird viel Wert gelegt. Insgesamt sieben Restaurants verwöhnen die Gäste mit Gaumenfreuden aus aller Welt. Das wunderschöne Zen-inspirierte Lux* Me Spa liegt direkt an und über dem Meer. Neben einer Reihe von Aktivitäten wie Yoga, Meditation oder Qi Gong, die unter Leitung der Wellness Concierges stattfinden, hat man die Möglichkeit zur völligen Entspannung bei verschiedenen Massagen und Anwendungen. Auch das traditionelle chinesische Teehaus lädt ein, die Seele baumeln zu lassen. Regelmäßig stattfindende Workshops unter Leitung bekannter Experten werden das Urlaubserlebnis einzigartig machen. Ob ein Malworkshop mit der Künstlerin Corinne Dalle Ore, ein Fotokurs mit dem bekannten Reisefotografen Michael Freeman oder die Kunst des Meditierens unter Anleitung von Bhavnath Gansman lernen, Gäste des Lux* South Ari Atoll erleben einen Urlaub der Extraklasse.

LOCATION

Following a complete renovation, Lux* South Ari Atoll reopened in September 2016. The luxury resort is located on the largest and most beautiful island of the Maldives in the south of the Ari Atoll. The international airport in the capital Malé is approximately 100 kilometres away and can be reached in around 45 minutes by a domestic flight and boat transfer. Surrounded by white sandy beaches, the resort is three kilometres long. To make the most of the crystalline lagoon water you can take a trip on a traditional dhoni or a luxury catamaran. Accompanied by a marine biologist, guests can also go swimming with a shark, which also happens to be the world's largest fish: the whale shark, which poses no risk to humans. Another exciting experience for young and old alike is feeding the manta rays which visit the luxury resort every day and come very close to the guests.

HOTEL

The 193 pavilions and villas are enthroned on stilts in the turquoise water of the Indian Ocean. For the refurbishment, renowned design studio P49 Deesign drew inspiration from the gentle ocean colours and organic shapes. The landscaped gardens featuring an abundant array of trees and plants were designed by award-winning landscape architect Stephen Woodhams. The eastern side of the atoll with 46 romantic pool villas is reserved for adults only. Most of the villas have their own pool. Culinary variety is the utmost priority here. A total of seven restaurants offer the guests a first-class dining experience with delicacies from all over the world. The treatment rooms of the wonderful zen-inspired Lux* Me Spa are partially suspended over the water. As well as a range of activities including yoga, meditation and qigong, all of which are led by the wellness concierges, it is also possible to enjoy head-to-toe relaxation with various massages and treatments. The traditional Chinese teahouse is another wonderful place to relax the mind, body and soul. Regular workshops led by renowned experts make every holiday here unique. Whether a painting session with the artist Corinne Dalle Ore, a photography course with well-known travel photographer Michael Freeman, or learning the art of meditation guided by Bhavnath Gansman, guests at the Lux* South Ari Atoll will enjoy a holiday that is second to none.

Get your Upgrade

www.upgradetoheaven.com/lux-south-ari-atoll

LUX* SOUTH ARI ATOLL . South Atoll, Dhidhoofinolhu, Maldives . www.luxresorts.com/luxsouthariatoll

"WE WANT TO HELP OUR GUESTS CELEBRATE LIFE BY MAKING EACH MOMENT MATTER"

"Wir wollen, dass unsere Gäste das Leben feiern, indem jeder Augenblick zählt"

– Paul Jones,
CEO Lux* Resorts & Hotels

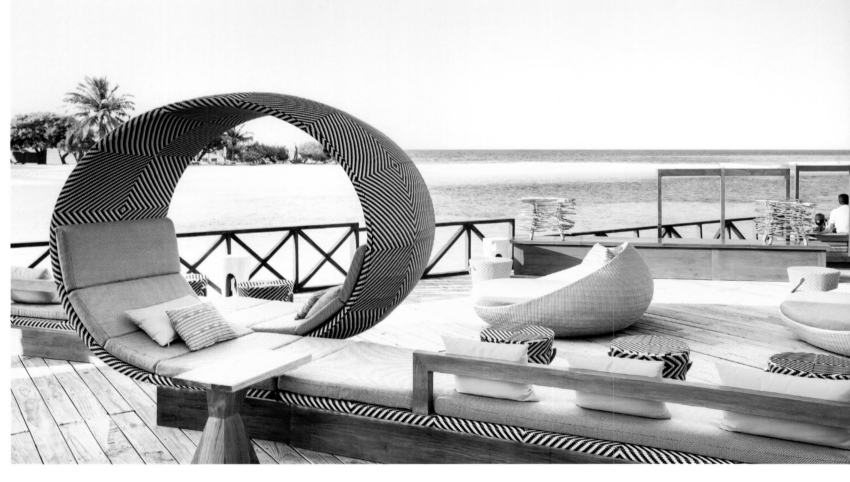

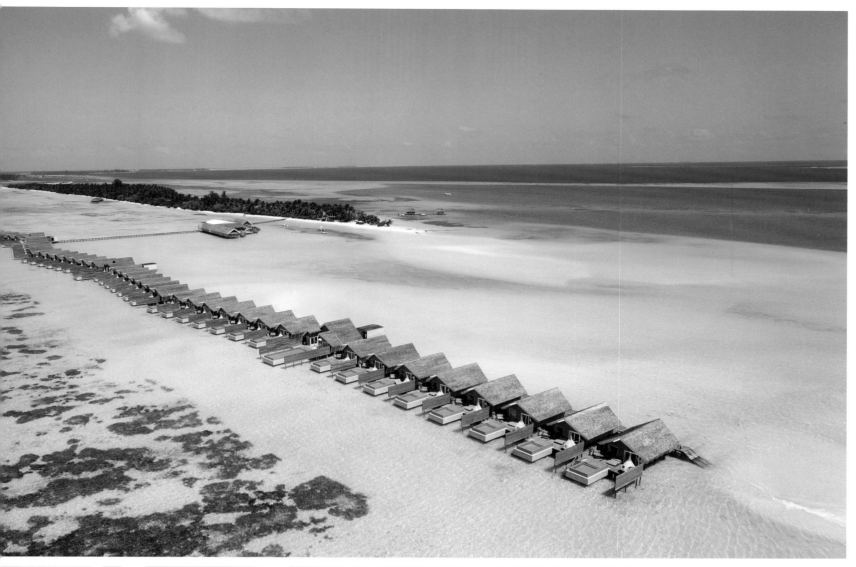

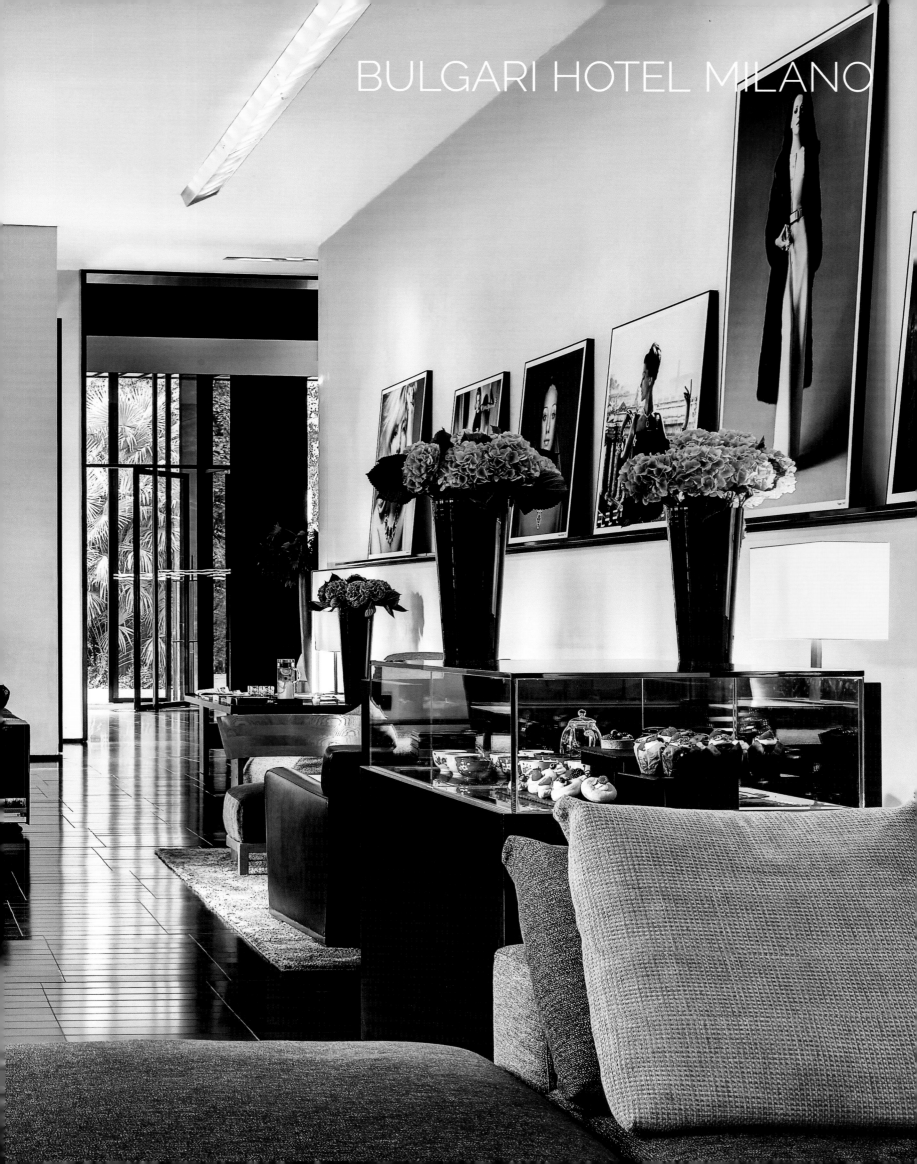

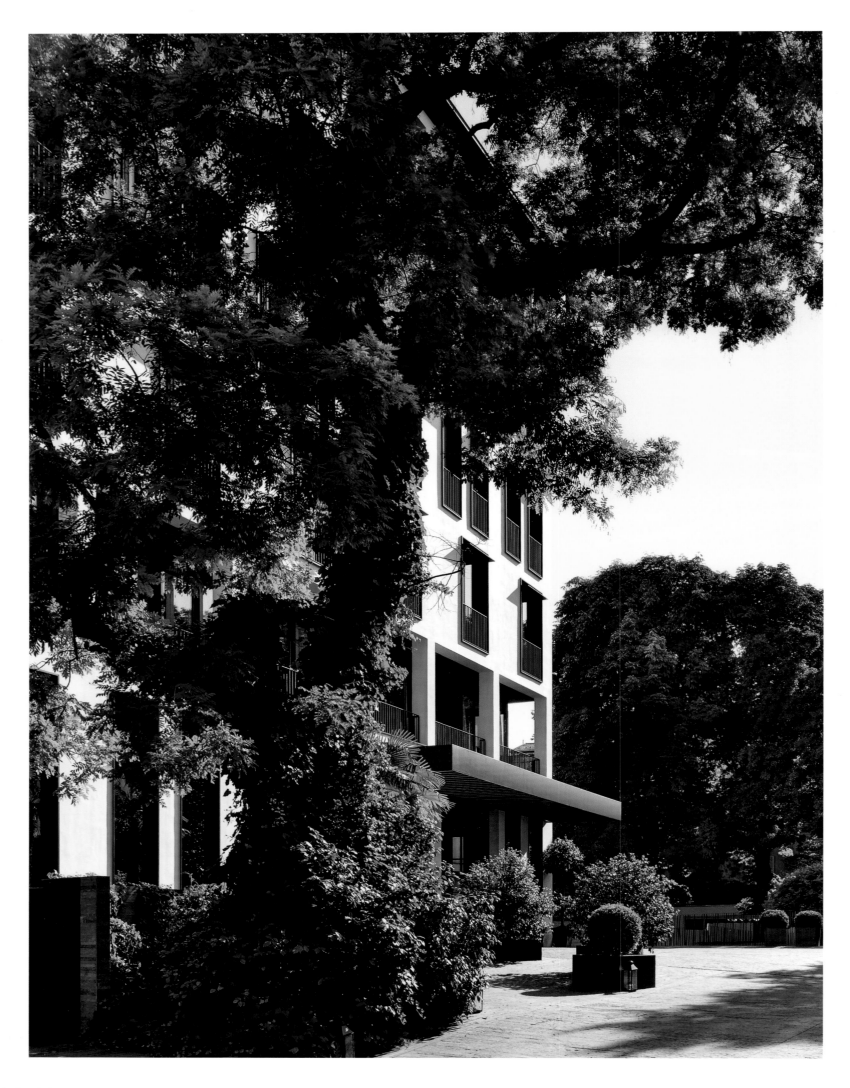

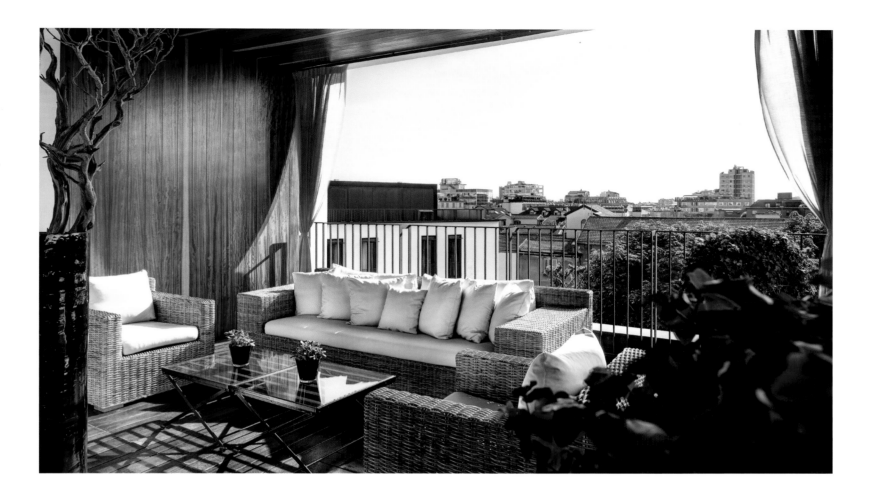

LOCATION

Das Bulgari Hotel Milano liegt im wunderschönen Brera, einem der repräsentativsten Stadtviertel Mailands mit reicher Kulturgeschichte und luxuriösen Einkaufsmöglichkeiten. Das Hotel befindet sich inmitten eines hellen 4.000 qm großen privaten Gartens neben den Botanischen Gärten. Die Eröffnung des Bulgari Hotel Milano in 2004 markierte den Eintritt der Bulgari Group, einem der größten Akteure der Luxusindustrie, ins Hotelgeschäft. Heute ist das renommierte Bulgari Hotel Milano eines der führenden Luxushotels in Mailand.

HOTEL

Das Hotel hebt sich durch drei Schlüsselelemente ab: die einzigartige Lage, das zeitgenössische Design und die Vielzahl an Services, die allesamt mit dem gleichen Qualitätsanspruch gestaltet wurden, der Kreationen von Bulgari schon immer auszeichnete. Das Hotel verfügt über 58 exklusive Zimmer und Suiten, die meisten mit Blick in den Garten. Im Obergeschoss des Hotels befindet sich die Bulgari Suite – eine Oase der Ruhe. Im Herzen des Bulgari Hotel Milano sorgen schwere, massive Materialien wie schwarzer Marmor aus Zimbabwe und Bronze für ein feinsinniges Gleichgewicht zwischen dem strengen Raumdesign und dem reichhaltigen Interior. Jedes Detail wurde mit größter Sorgfalt designt. Damit aus dem Restaurant, der Bar mit Terrasse und Lounge im Garten, dem privaten Esszimmer, der Zigarren-Lounge und dem Spa lokale gesellschaftliche Treffpunkte werden, wurden bei der Planung auch die Bewohner Mailands bedacht. Das Bulgari Hotel Restaurant serviert klassische Gerichte mit zeitgenössischem Twist, inspiriert von italienischer Tradition und basierend auf kräftigen Aromen. Als urbaner Schutzraum für Körper und Geist wurde das Spa des Bulgari Hotel Milano konzipiert. Es verfügt über eine private Pärchen-Suite, ein Marmor-Dampfbad, eine schwedische Sauna und einen Outdoor-Whirlpool. Die Gäste können zwischen drei hochwertigen Produktlinien für ihre Treatments wählen: La Mer, Amala und Sothy's Gentlemen's Studio. Dank des besonders aufmerksamen 24-Stunden-Service ist ein Aufenthalt im Bulgari Hotel Milano unvergesslich. Gerne kümmert sich das Hotel um Besuche und Ausflüge zu Italiens exklusivsten Destinationen, ob mit dem Privatflugzeug, in einer Limousine oder per Yacht. Als weitere Services stehen den Gästen persönliche Einkäufer, Personal Trainer, ein luxuriöser Autoverleih, In-Room Check-in und Hilfe beim Ein- und Auspacken des Gepäcks zur Verfügung.

LOCATION

Located in beautiful Brera, one of Milan's most prestigious districts, rich in cultural heritage and close to luxury shopping experiences, the Bulgari Hotel Milano is set in the heart of a bright 4,000 sqm private garden adjoining the Botanical Gardens. The opening of the Bulgari Hotel Milano in 2004 marked the entry of the Bulgari Group, one of the major players in the luxury business, into the world of hospitality. The Bulgari Hotel Milano has now established itself as one of Milan's leading luxury hotels.

HOTEL

The three key elements that distinguish the hotel are its unique location, contemporary design, and variety of services, all of which have been crafted with the same attention to detail that has always distinguished Bulgari creations. The hotel has just 58 exclusive rooms and suites, most with garden views. Located on the hotel's top floor, the Bulgari suite is a quiet haven. At the heart of the Bulgari Hotel Milano is a delicate balance between the rigorous design and rich ambience, achieved through solid materials such as black marble from Zimbabwe and bronze elements. Every single detail has been carefully designed. The restaurant, bar with terrace and lounge in the garden, private dining room, cigar room and spa have also been planned with the Milanese people in mind and have become a social destination for the locals. Italian tradition, based on strong flavours and the consistency of the dishes, inspires the Bulgari Hotel Restaurant to add a contemporary twist to classical dishes. The spa at the Bulgari Hotel has been conceived as an urban retreat for the mind and soul, featuring a private suite for couples, a marble steam room, Swedish sauna and outdoor Jacuzzi. There are three exclusive product lines: La Mer, Amala and the Sothys' Gentlemen's Studio. Guests at the Bulgari Hotel Milano enjoy an unforgettable stay thanks to highly attentive service 24 hours a day. It organises various private visits and excursions to Italy's most exclusive destinations by private plane, limousine or yacht. Other services include personal shopper, personal trainer, luxury car rental, in-room check-in and assistance with packing and unpacking.

Get your Upgrade

www.upgradetoheaven.com/bulgari-milano

BULGARI HOTEL MILANO . Via Privata Fratelli Gabba 7b, 20121 Milan, Italy . www.bulgarihotels.com

THE BULGARI HOTEL'S PRIVATE GARDEN IS AN OASIS OF CALM AMID MILAN'S HUSTLE AND BUSTLE

Der private Garten des Bulgari Hotels
ist eine ruhige Oase inmitten
des belebten Mailand

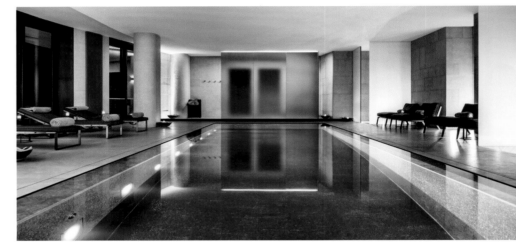

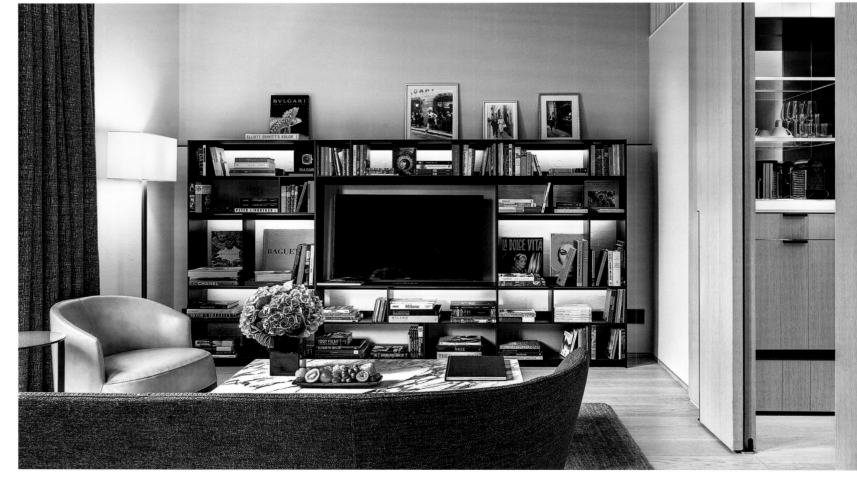

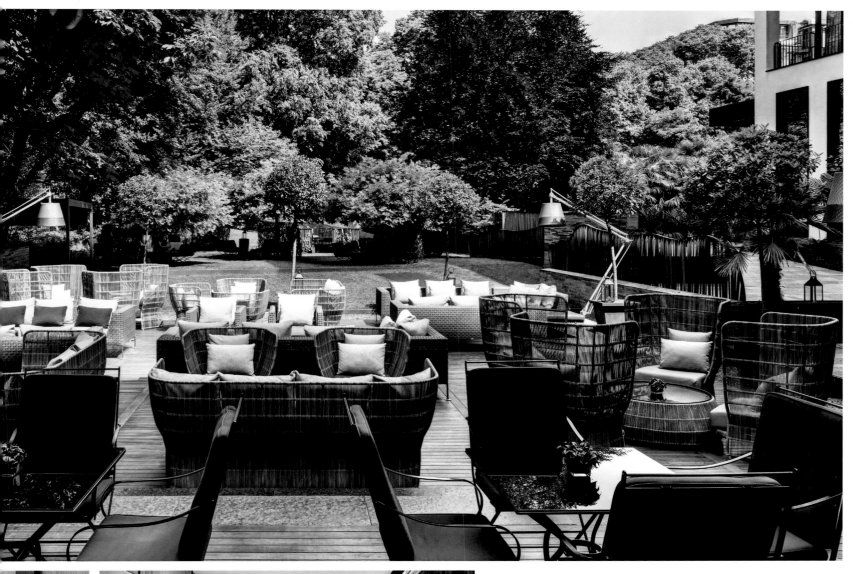

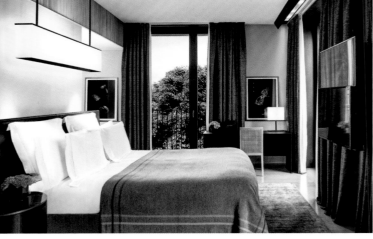

The project to redevelop the garden of the Bulgari Hotel provided an opportunity to rediscover one of the few historical gardens in Milan. The aim was to evoke the many different gardens of historical villas that have strongly contributed to the character of the local landscape. The journey through the garden ends at the private Dom Pérignon Bar, which is surrounded by tall red beech hedging.

Mit der Sanierung des Gartens des Bulgari Hotels bot sich die Möglichkeit, einen der wenigen historischen Gärten Mailands wieder aufleben zu lassen. Die vielen historischen Villengärten, welche die lokale Landschaft so geprägt haben, sollten auf zeitgenössische Art und Weise eingebunden werden. Die Reise durch die Gärten endet an der privaten Dom Pérignon-Bar, die von einer hohen, roten Buchenhecke umgeben ist.

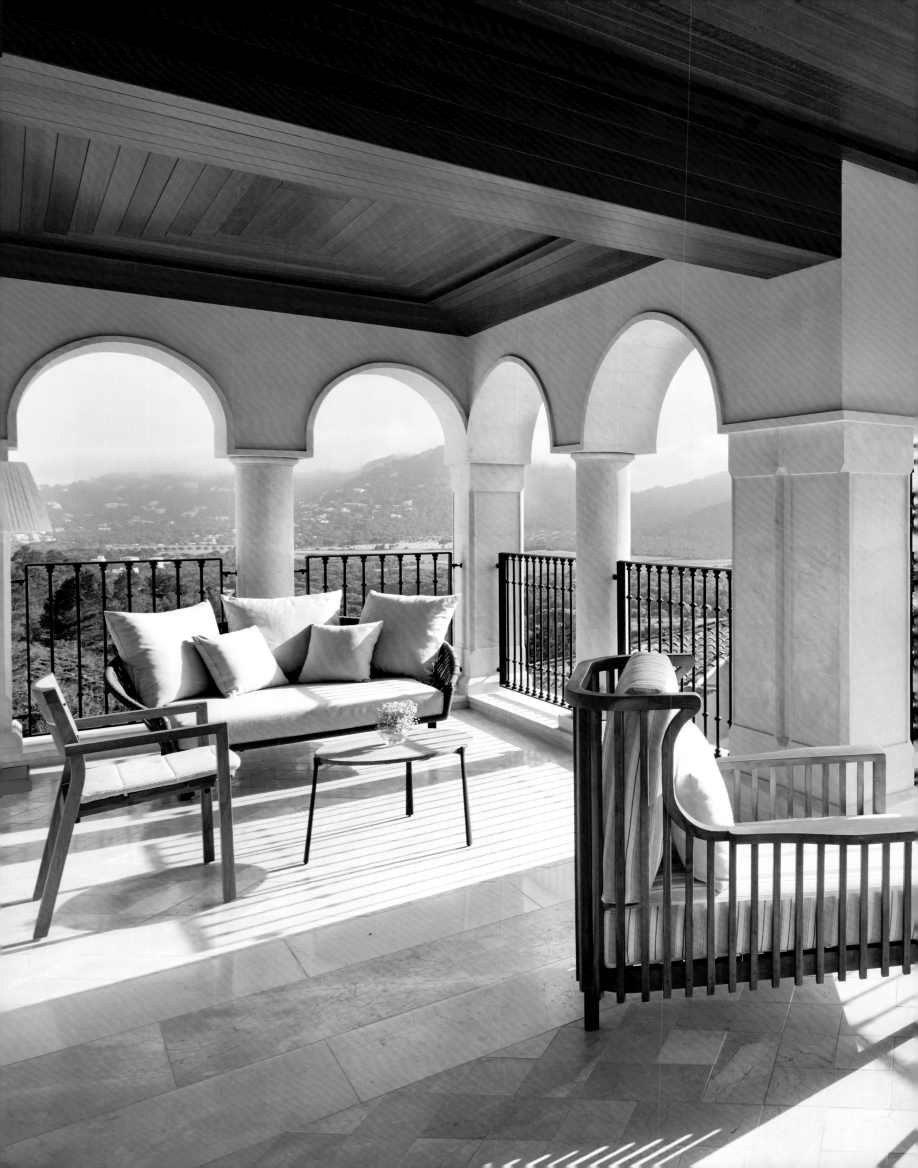

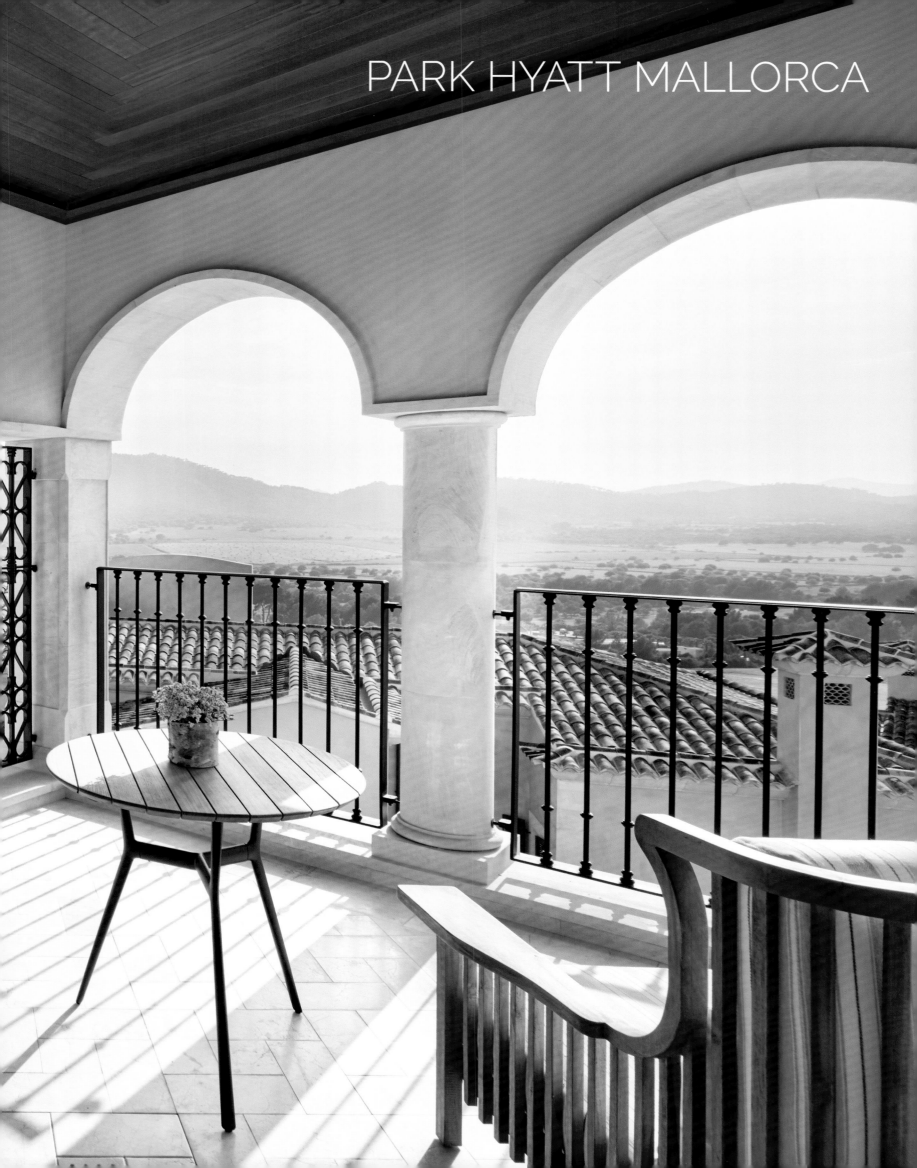

AN INTIMATE HAVEN WITHIN A VIBRANT AND CHARMING ISLAND

Eine Oase der Ruhe auf der pulsierenden und bezaubernden Insel

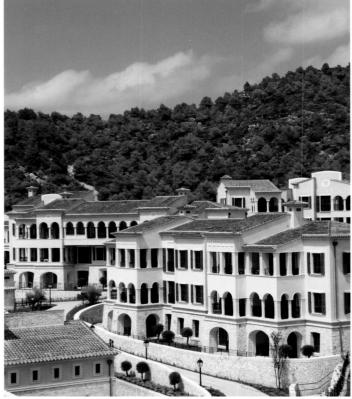

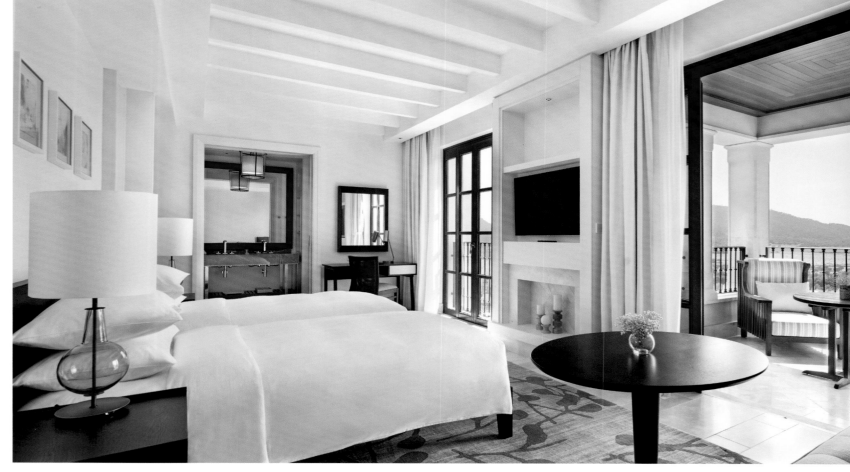

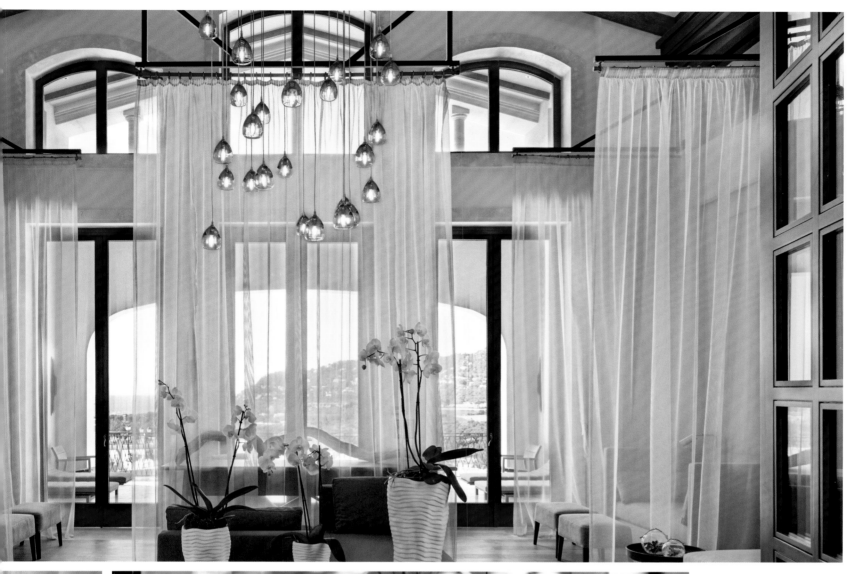

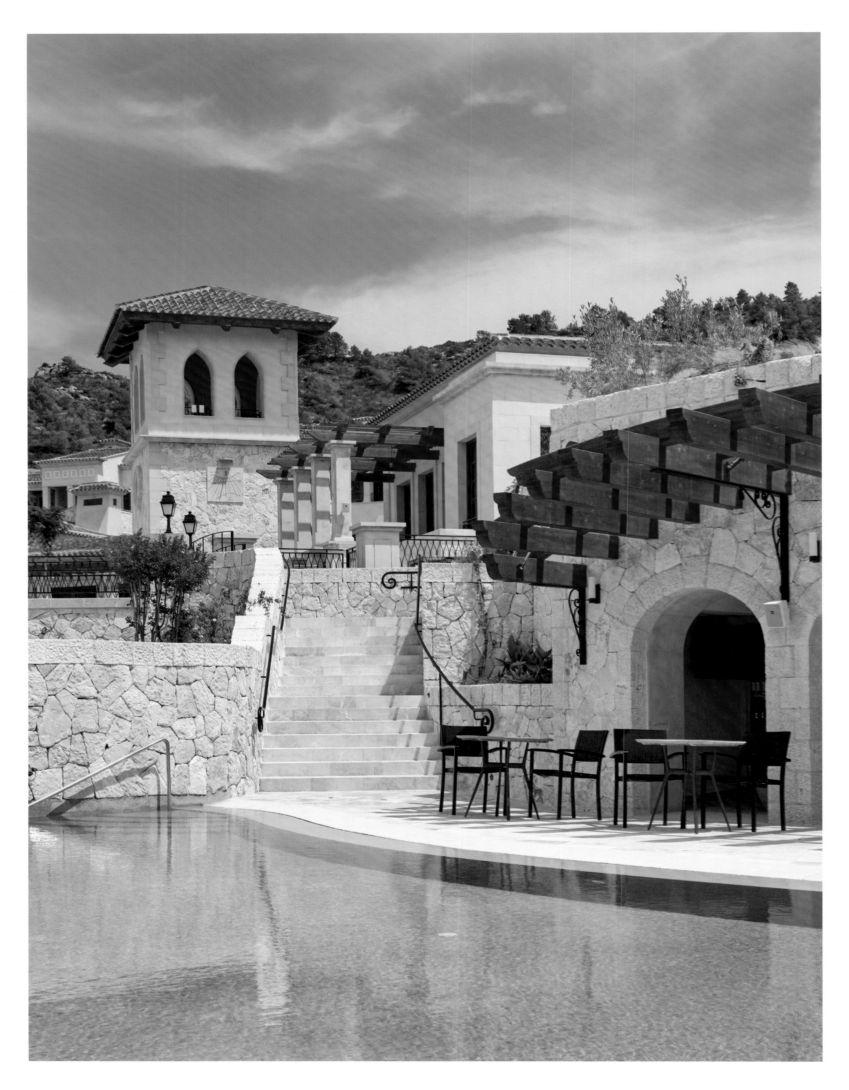

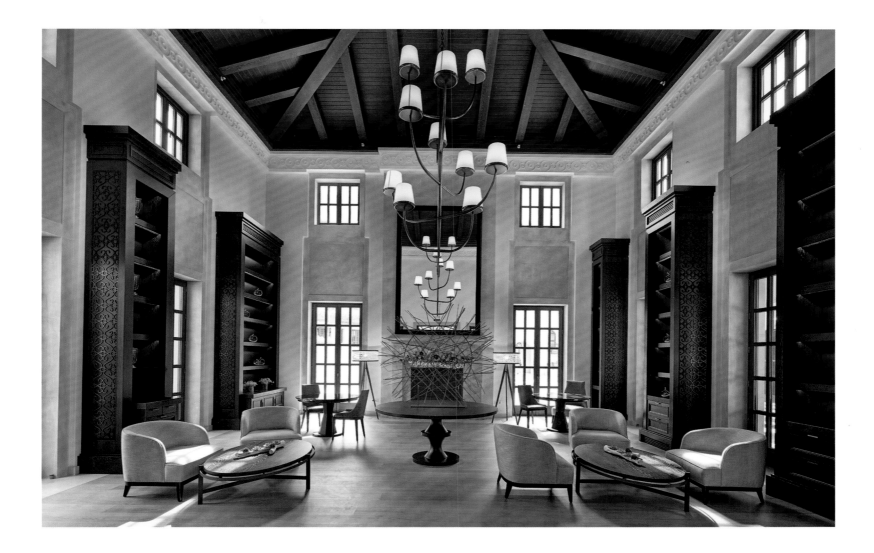

LOCATION

Etwa eine Stunde von der Hauptstadt Palma entfernt, schmiegt sich, im idyllischen Tal von Canyamel mit Blick auf das Mittelmeer, das erste Park Hyatt Resort Europas an die Berge. Das Luxushotel ist das Herzstück des Immobilienprojektes Cap Vermell an der ruhigen Nordostküste der Insel Mallorca. Hotelgäste profitieren von einem kostenlosen Shuttle zum benachbarten Strand von Canyamel oder besuchen Schlösser und Burgen, prähistorische Ruinen, Wehrtürme, traditionelle Wochenmärkte und Kunstmuseen in der nahen Umgebung. Das Hotel befindet sich zudem in der Nähe des Naturparks von Llevant und ist weniger als 15 Minuten von idyllischen Sandstränden wie Cala Agulla oder Cala Torta entfernt. Unmittelbar neben dem Resort befindet sich ein 18-Loch-Golfplatz, so wie drei weitere Golfplätze im Umkreis von 15 Minuten Fahrzeit. Outdoorsportler und Naturliebhaber können den Nordosten Mallorcas per Wanderung, Pferdetrekking oder Radsport entdecken.

HOTEL

Die weitläufige Anlage des Park Hyatt Mallorca, im Stil eines traditionell mallorquinischen Bergdorfes erbaut, verfügt über 142 luxuriöse Zimmer und Suiten (jeweils mit Balkon oder Terrasse), vier Restaurants und eine Pool-Bar, ein Spa, zahlreiche Freizeiteinrichtungen und moderne Veranstaltungsräume. Regionale Akzente versprühen mallorquinisches Flair und unterstreichen das geschmackvolle, moderne Design. In den Restaurants genießen Hotelgäste spanische und internationale Spezialitäten, rustikale Tapas oder asiatische Küche von ausgewählten Gastköchen. Einen Großteil der Zutaten bezieht das Luxushotel von lokalen Produzenten. Das Spa bietet eigens für das Hotel kreierte Wellness-Behandlungen mit mallorquinischen Produkten wie Mineralien, Kräuter, Früchte und Salze.

LOCATION

Approximately an hour away from the capital city Palma, in the idyllic valley of Canyamel, the first Park Hyatt Resort in Europe hugs the cliffs of the coastline. The luxury hotel is the heart and soul of the real estate project Cap Vermell on the quiet northern coast of the island of Mallorca. Hotel guests benefit from a complimentary shuttle to nearby Canyamel beach or visit castles, prehistoric ruins, defence towers, traditional markets and art museums in the surrounding area. Furthermore the hotel is situated next to the natural reserve of Llevant and less than 15 minutes away from idyllic sandy beaches like Cala Agulla or Cala Torta. An 18-hole golf course and three additional courses are only 15 minutes away. Outdoor and nature lovers will enjoy exploring the north-east coast of Mallorca for hiking, horse riding or cycling.

HOTEL

The spacious enclosure of the Park Hyatt Mallorca, which was built in the style of a traditional Mallorcan mountain village, has 142 luxurious rooms and suites (each with a balcony or terrace), four restaurants, a pool bar, a spa and numerous leisure facilities as well as modern event premises. Regional accents spread a Mallorcan flair and underline the tasteful and modern design. In the restaurants guests can savour Spanish and international specialities, rustic tapas or the Asian cuisine of selected guest chefs. The luxury hotel obtains the majority of ingredients from local producers. Wellness treatments with Mallorcan products including minerals, herbs, fruits and salts were specifically created for the hotel and can be enjoyed at the spa.

Get your Upgrade

www.upgradetoheaven.com/park-hyatt-mallorca

PARK HYATT MALLORCA . Urbanización Atalaya de Canyamel, Vial A, 12, 07589 Canyamel, Spain . www.mallorca.park.hyatt.com

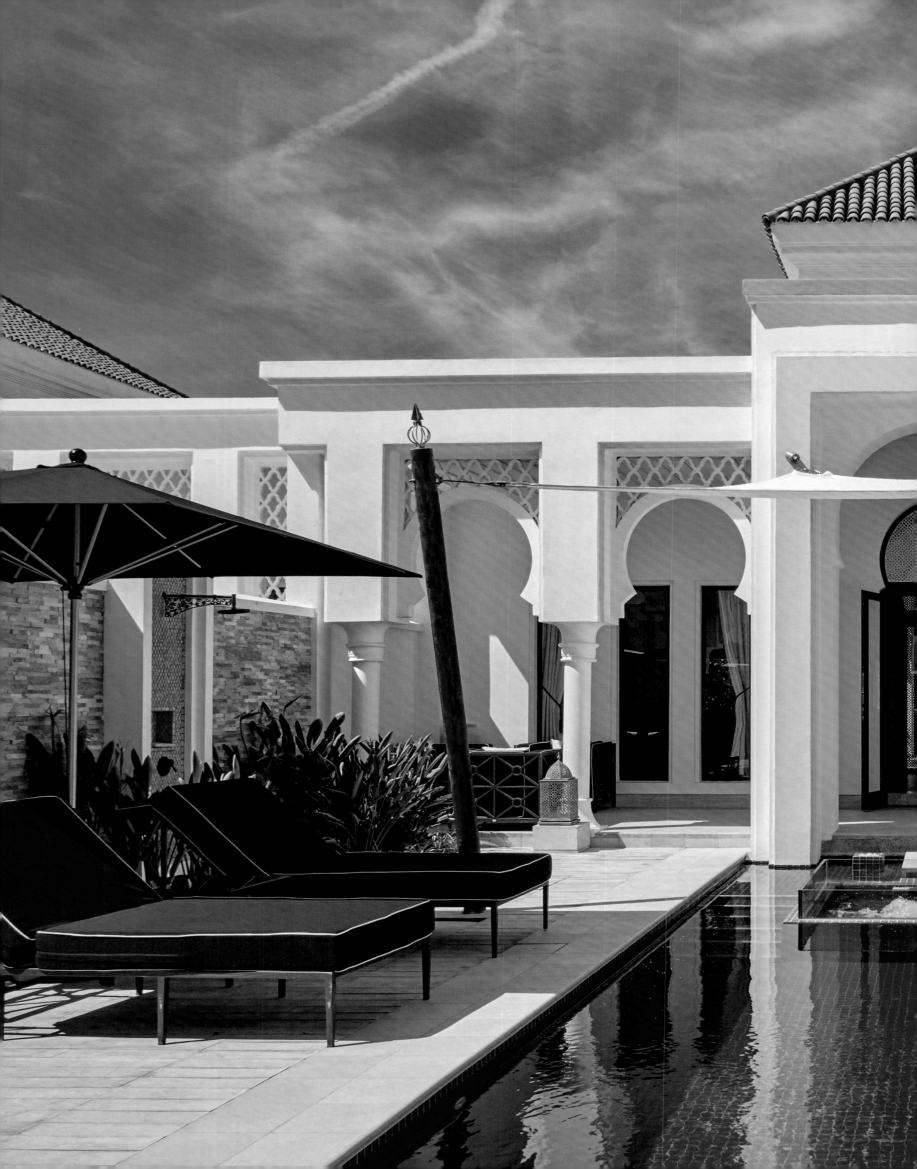

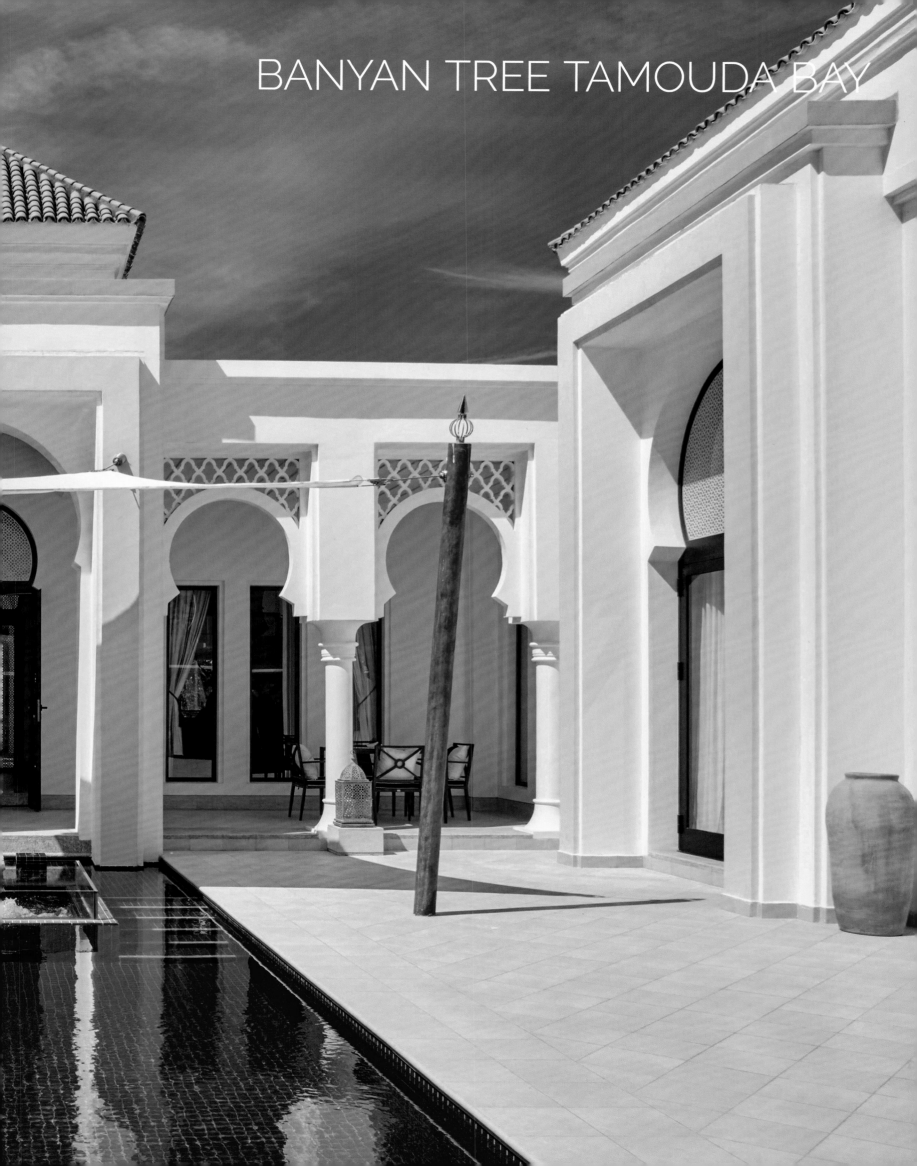

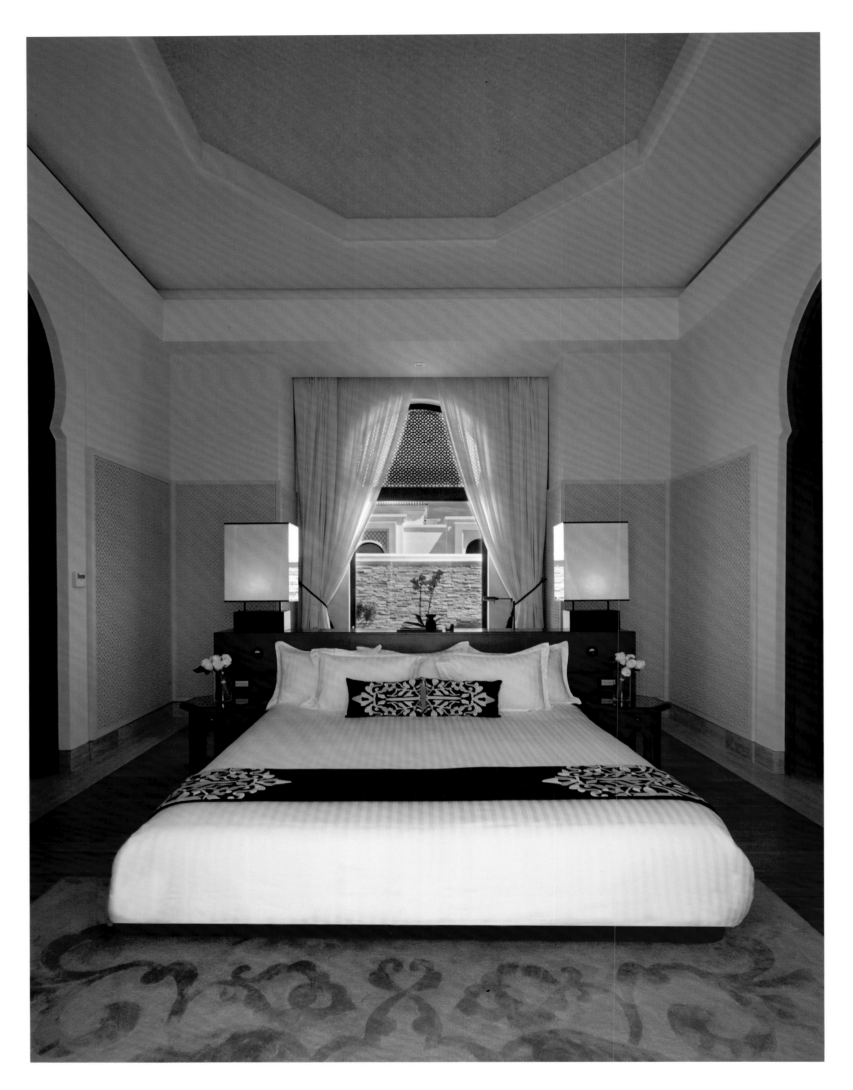

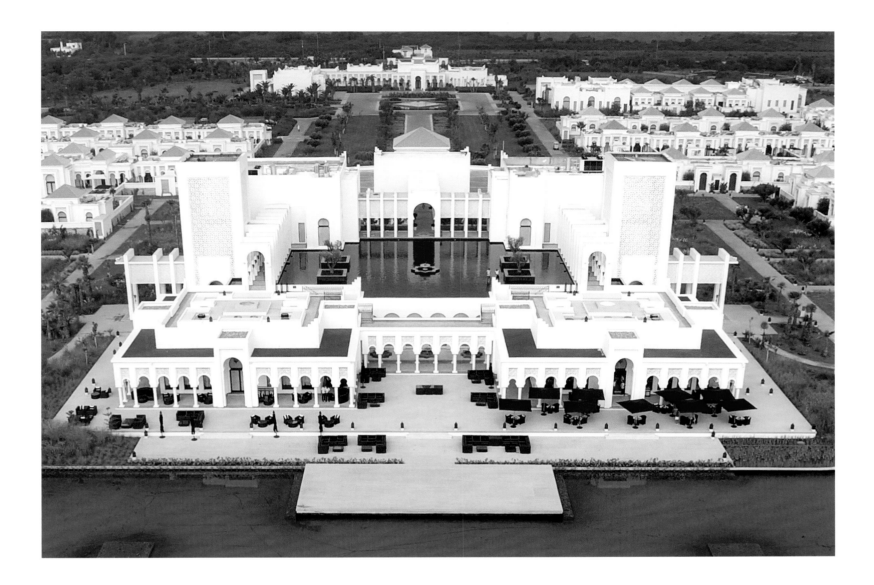

LOCATION

Tamouda Bay liegt im Norden Marokkos zwischen schroffen Küstenfelsen und glitzerndem Mittelmeer. Die Gegend lockt Besucher mit ihrer außergewöhnlichen Landschaft – der unberührte Sandstrand von Tamouda Bay ist der längste im Norden des Landes – und ihrem kulturellen Reichtum. Die Städte Tetouan, Chefchaouen, Ceuta und Marbella befinden sich nur einige Kilometer entfernt. Die Medina Tétouans gehört zum UNESCO-Weltkulturerbe und das lebhafte Tanger, "Tor zu Afrika" genannt, ist dank seiner Lage zwischen Europa und Afrika eine Stadt der Begegnungen. Der Norden Marokkos bietet Gästen unvergleichliche Naturerlebnisse wie eine Delfin-Safari in der Straße von Gibraltar oder ein Bad im kalten Wasser der Akchour Wasserfälle, gefolgt von einem traditionellen, über Feuer gekochtem marokkanischen Essen.

HOTEL

Das Banyan Tree Tamouda Bay ist die jüngste Eröffnung der Banyan Tree Hotels & Resorts Gruppe. Das erste Villen-Resort Marokkos verbindet marokkanische und mediterrane Kultur auf einzigartige Art und Weise. Die 92 luxuriösen Villen des Banyan Tree Tamouda Bay sind zwischen 200 und 400 qm groß, liegen Richtung Mittelmeer und verfügen über einen eigenen Pool. In der Architektur des Resorts spiegelt sich das andalusisch-maurische und marokkanische Vermächtnis der Region wider: sachlich-moderne Gebäude überraschen in ihrem Innern mit opulentem Dekor. Das Fine Dining Thai-Restaurant "Saffron" empfängt seine Gäste zum Dinner und bietet exquisite, innovative Thai-Küche mit traditionellen Zutaten. Show Cooking lokaler Tajine-Gerichte steht auf dem Plan des "Tingitana". Absolutes Highlight im Banyan Tree Tamouda Bay ist Destination Dining – vom entspannten Dinner am Strand oder einem Festmahl im marokkanischen Zelt bis hin zum opulenten In-Villa-Barbecue.

LOCATION

Tamouda Bay in northern Morocco is situated between rugged coastal rocks and the glistening Mediterranean. The area attracts visitors with its extraordinary landscape – the unspoiled sandy beach in Tamouda Bay is the longest in the north of the country – and rich cultural diversity. The cities of Tétouan, Chefchaouen, Ceuta and Marbella are just a few kilometres away. The Medina of Tétouan is on the UNESCO World Heritage List and the vibrant city of Tangier, known as the "Gateway to Africa", is a place of encounters thanks to its location between Europe and Africa. Northern Morocco also offers guests incomparable nature experiences, such as a dolphin safari in the Strait of Gibraltar or a bath in the cold waters of the Cascades d'Akchour, followed by a traditional Moroccan meal cooked over an open fire.

HOTEL

The Banyan Tree Tamouda Bay is the latest opening by the Banyan Tree Hotels & Resorts Group. Morocco's first villa resort fuses Moroccan and Mediterranean culture in a unique way. The 92 luxurious villas at the Banyan Tree Tamouda Bay are between 200 and 400 sqm in size, overlook the Mediterranean Sea and have their own pool. The Andalusian, Moorish and Moroccan legacy of the region is reflected in the resort's architecture: functional and modern buildings feature surprisingly opulent interior design. The "Saffron" fine dining Thai restaurant welcomes guests for dinner and serves exquisite, innovative Thai cuisine with traditional ingredients. Show cooking featuring local tajine dishes is the order of the day at "Tingitana". The absolute highlight at the Banyan Tree Tamouda Bay is destination dining – from a relaxed dinner on the beach or a feast in a Moroccan tent to a lavish in-villa barbecue.

Get your Upgrade

www.upgradetoheaven.com/banyan-tree-tamouda-bay

BANYAN TREE TAMOUDA BAY . Route Nationale 13, Oued Negro, 93100 Fnideq, Morocco . www.banyantree.com

CAPTIVATING MOROCCAN CHARM AND A REFRESHING MEDITERRANEAN SPIRIT

Betörender marokkanischer Charme und erfrischender mediterraner Geist

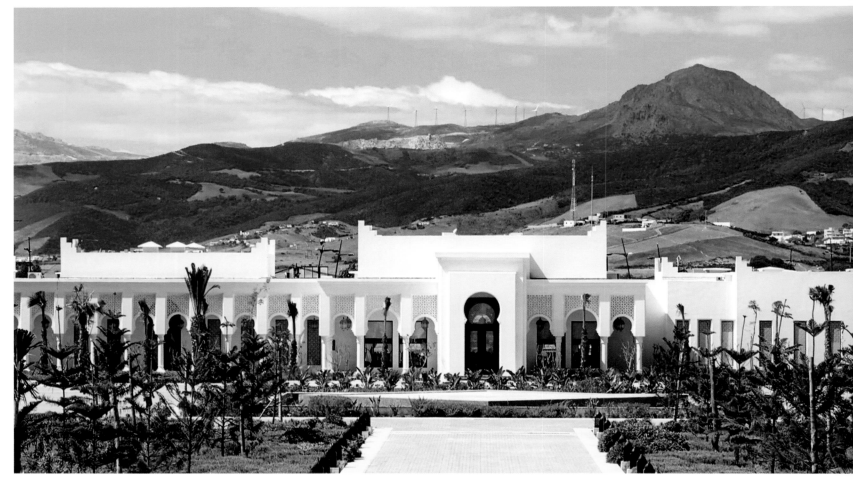

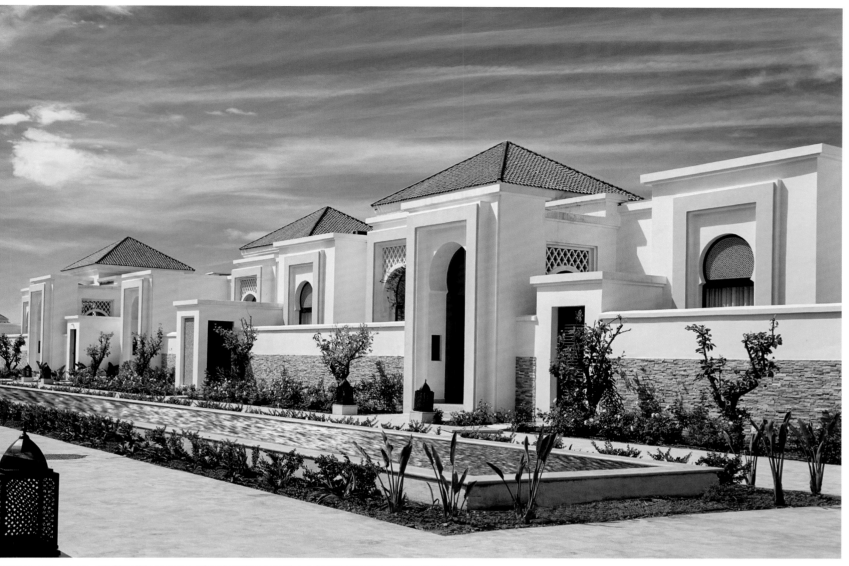

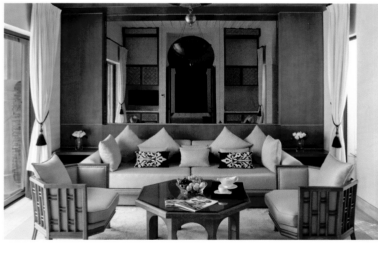

The award-winning spa at the Banyan Tree Tamouda Bay features a hammam, a vitality pool, a number of treatment rooms, a yoga pavilion and a spa gallery, among other things. Guests can also relax by the resort's central pool. A modern fitness area is available for sports training. The Banyan Tree Tamouda Bay offers active guests adrenaline kicks in the form of windsurfing, kayaking or hiking in the Rif Mountains. All of these elements make the new Banyan Tree luxury resort in northern Morocco a heavenly travel destination.

Das preisgekrönte Spa des Banyan Tree Tamouda Bay verfügt unter anderem über ein Hamam, einen Vitalitypool, eine Vielzahl von Behandlungsräumen, einen Yoga-Pavillon und eine Spa-Galerie. Entspannen können Gäste auch am zentralen Pool des Resorts, für sportliches Training steht ein moderner Fitnessbereich zur Verfügung. Aktiven Gästen bietet das Banyan Tree Tamouda Bay Adrenalinkicks beim Windsurfen, Kajakfahren oder Wandern im Rif-Gebirge. Alles zusammen macht das neue Luxusresort von Banyan Tree in Marokkos Norden zu einem himmlischen Reiseziel.

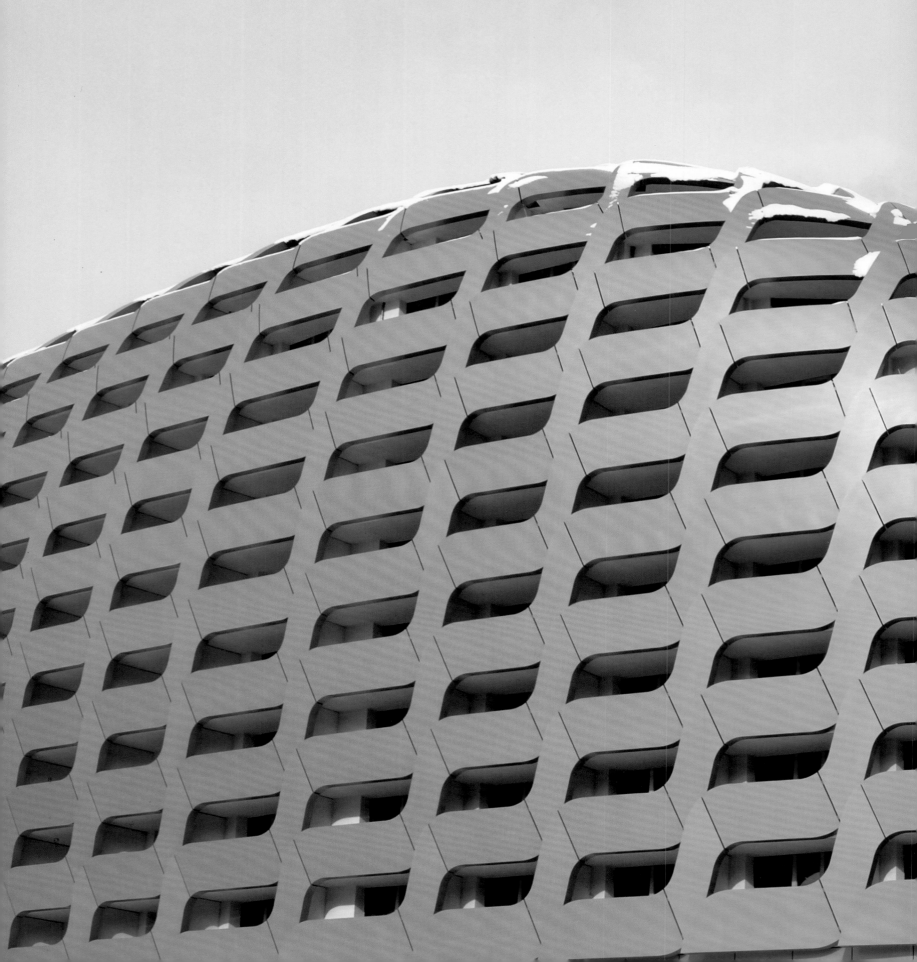

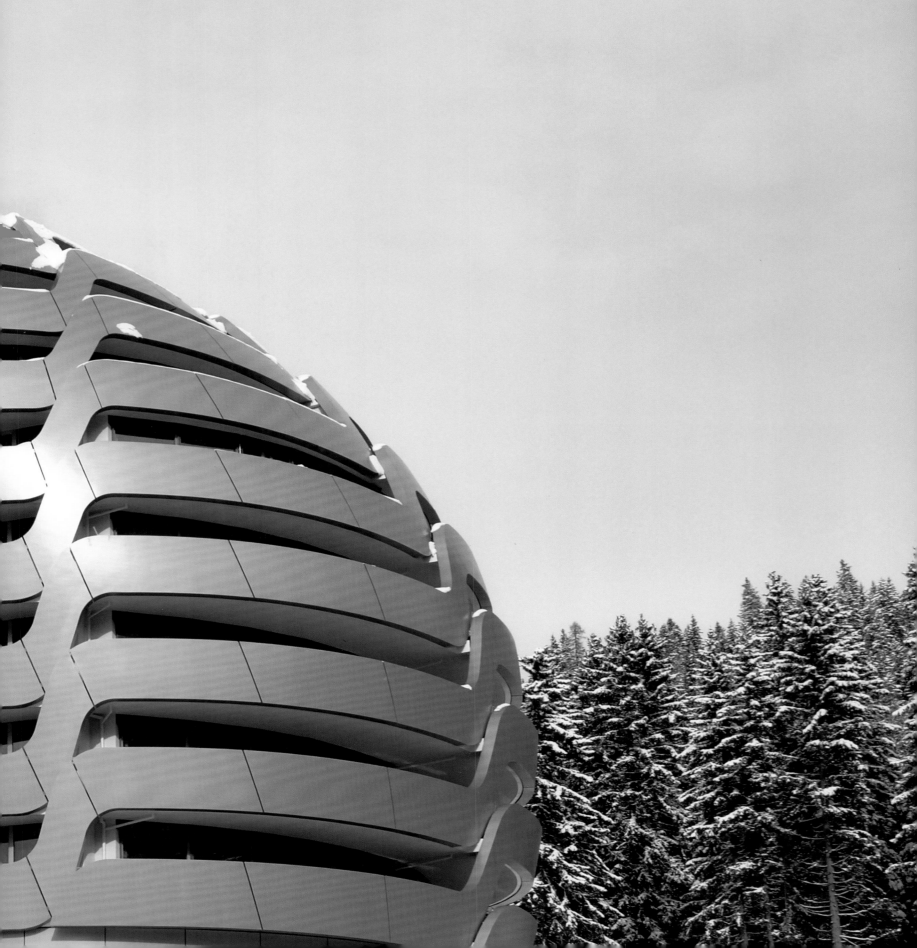

ENJOY
ALPINE GOLDEN
MOMENTS

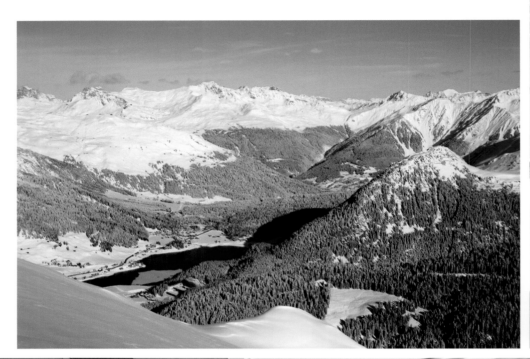

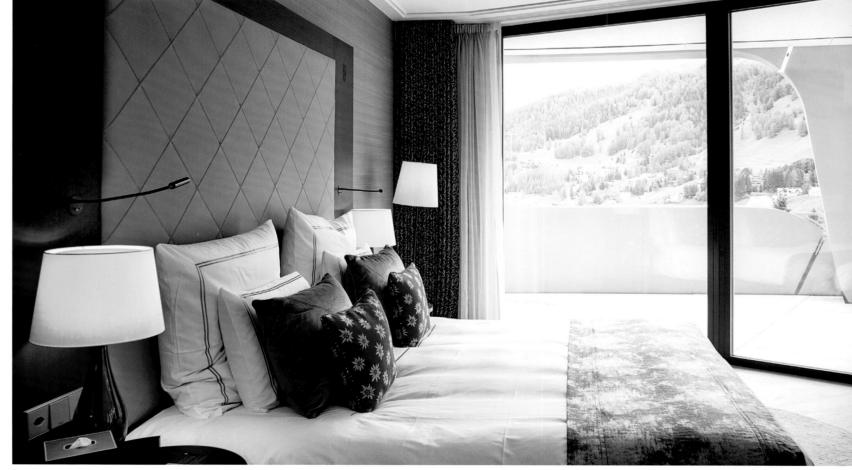

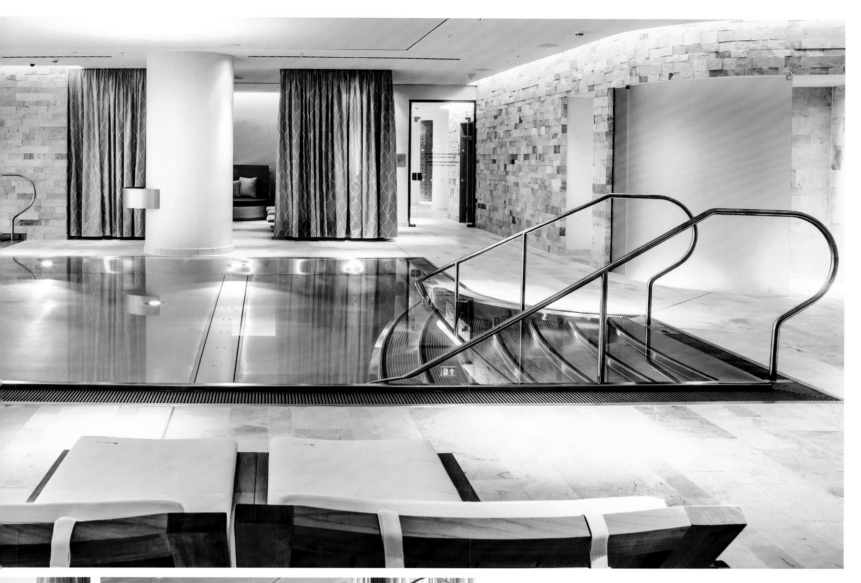

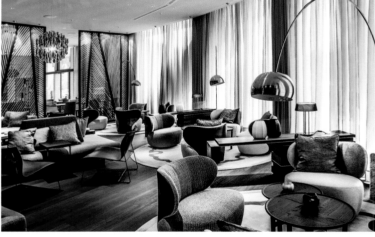

With spectacular architecture and panoramic views, the ultra-modern luxury hotel InterContinental Davos is situated in a peaceful and secluded location at the foot of the Seehorn mountain against a backdrop of breathtaking nature and fresh Alpine air. Enveloped in a gold-coloured metal cocoon, the InterContinental Davos stands out in magnificent style, which is why it has become the town's new landmark. Inspired by the hotel's façade and surroundings, the slogan "Alpine Golden Moments" represents the promise of InterContinental Davos to its guests. This is expressed in the highly attentive, personalised service provided in all areas of the hotel.

Mit spektakulärer Architektur und grandioser Panorama-Aussicht liegt das ultramoderne Luxushotel InterContinental Davos ruhig und abgeschieden am Fuße des Seehorns in eindrücklicher Natur und gesunder Bergluft. Mit seiner goldenen Metallhülle zieht es die Aufmerksamkeit unweigerlich auf sich, weshalb das InterContinental das neue Wahrzeichen von Davos wurde. "Alpine Golden Moments" lautet das, von Fassade und Umgebung inspirierte, Versprechen des InterContinental Davos an seine Gäste. Dafür steht auch der höchst aufmerksame, individuelle Service in allen Bereichen des Hauses.

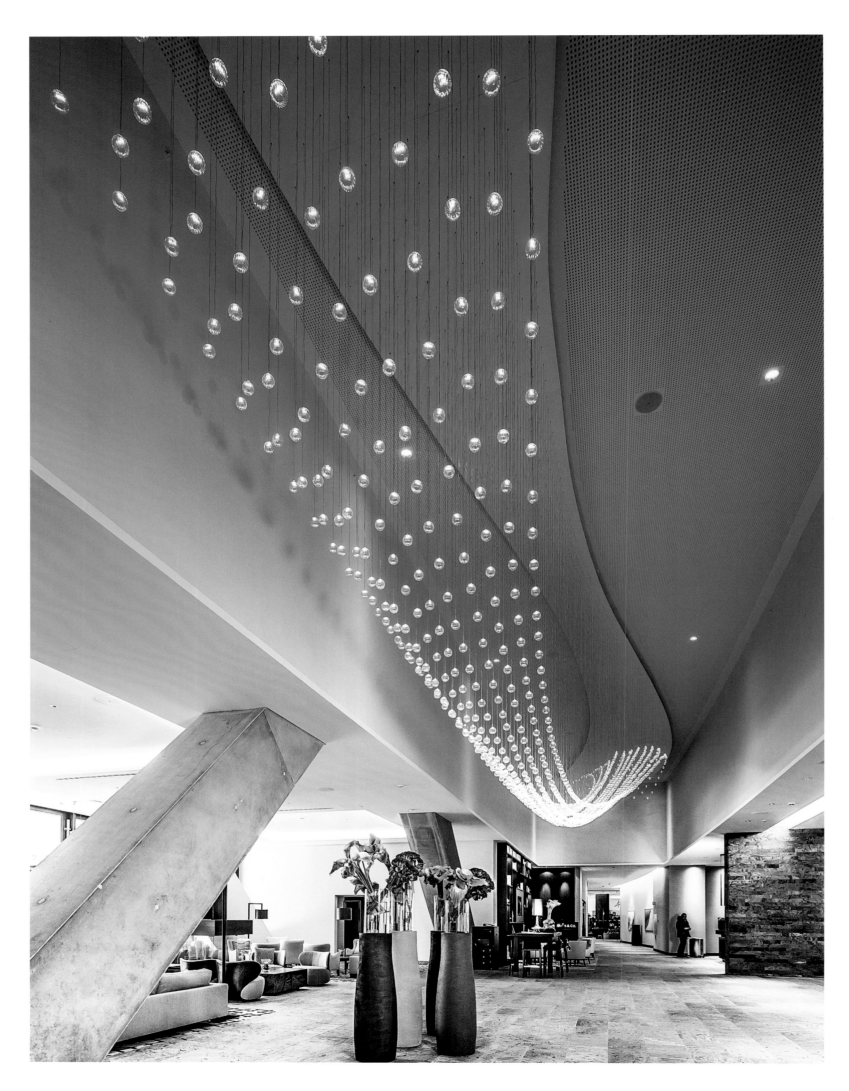

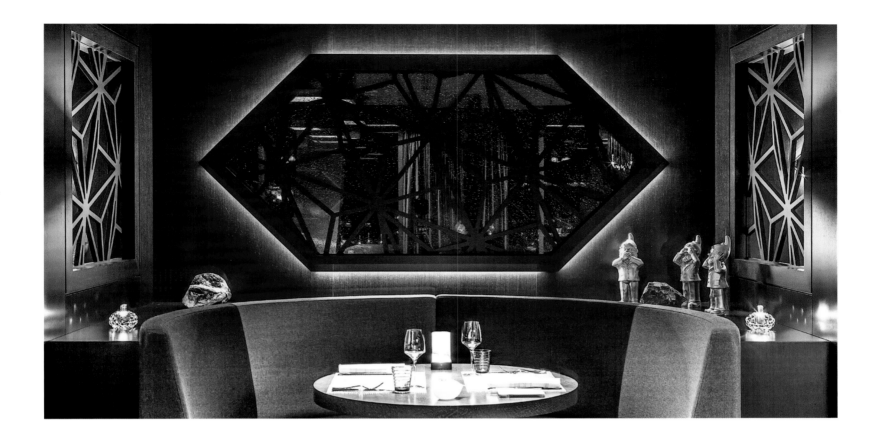

LOCATION

Eine wunderbare, etwa eineinhalb Stunden lange Fahrt von Zürich entfernt, liegt Davos auf 1.560 Meter Höhe inmitten der Bündner Bergwelt. Die höchstgelegene Stadt Europas genießt dank ihrer Lage ein einzigartiges Hochgebirgsklima, ein Paradies für Allergiker und Asthmatiker. Davos punktet mit faszinierender Bergwelt und wegweisender Architektur, zu der das InterContinental Davos ebenso wie das Kirchner Museum zählen. Sportlich aktiven Gästen bietet sich sommers wie winters ein reichhaltiges Freizeitangebot – unzählige Kilometer für Wanderer, Mountainbiker oder Skifahrer, Wassersport auf den umliegenden Seen, ein 18-Loch-Golfplatz und vieles mehr. Jedes Jahr Ende Januar wird die beschauliche Alpenstadt zum Mittelpunkt des Weltgeschehens, wenn die wichtigsten Größen aus Wirtschaft, Politik, Wissenschaft und Gesellschaft sich anlässlich des World Economic Forum treffen. Davos liegt auf den Strecken von Glacier und Bernina Express und wer die Alpen per Zug bereisen möchte, sollte nicht verpassen, einen Tag in der schönen Umgebung zu verweilen.

HOTEL

Die 216 Zimmer und Suiten des InterContinental Davos sind großzügig gestaltet und mit hochwertigen Materialien ausgestattet, die Bezug auf die alpine Umgebung nehmen. Sämtliche Zimmer verfügen über einen Balkon oder eine Terrasse mit spektakulärer Aussicht auf das Davoser Bergpanorama. Das Alpine Spa bietet auf 1.200 qm sowohl gemeinsame als auch getrennte Bereiche für Damen und Herren, einen In- und Outdoor-Pool, Saunen sowie Dampfbäder. Des Weiteren gibt es einen 24/7 Fitness- und Yogaraum sowie insgesamt 14 Behandlungsräume und zwei Spa Suiten für privaten Spa-Genuss zu zweit. In seinen speziellen Treatments vereint es die Heilkräfte der Davoser Natur mit dem Ziel ganzheitlichen Wohlbefindens. Im Zentrum stehen Schweizer Bergkräuter, wie beispielsweise beim Heu-Wickel. In den Restaurants und Bars des InterContinental Davos erleben Gäste inspirierende und führende Gastronomie, allen voran das "Studio Grigio" im 10. Stock mit seinem außergewöhnlichen Design und einer Dachterrasse mit atemberaubender Aussicht. Das "Capricorn" serviert alpine Schätze und Köstlichkeiten: Im Sommer wird ein Alpine BBQ angeboten, im Winter sind es regionale Spezialitäten, wie zum Beispiel Heusuppe, die frisch interpretiert werden. Im "Al Pino" setzt man auf einfache, italienische Küche für die ganze Familie. Die "Nuts & Co."-Lounge-Bar ist das Wohnzimmer des Hauses und verfügt über eine Sonnenterrasse mit phänomenaler Aussicht. Viele Alpine Golden Moments machen einen Aufenthalt im InterContinental Davos zu einem unvergesslichen Erlebnis.

LOCATION

Davos is a wonderful 90-minute drive from Zurich and located in the heart of the Grison Mountains at an elevation of 1,560 metres, making it the highest-altitude town in Europe. Thanks to its location, it enjoys an extraordinarily healthy climate, making it a paradise for people suffering from allergies and asthma. Davos boasts fascinating mountain landscapes and groundbreaking architecture, including the InterContinental Davos and the Kirchner Museum. The town offers active guests an incredible choice of options both in summer and winter – such as countless miles to be covered by hikers, mountain bikers and skiers, water sports on the surrounding lakes, an 18-hole golf course and lots more. Every year at the end of January, the idyllic Alpine destination plays host to world affairs when the most important political and business leaders come together at the World Economic Forum. The Glacier and Bernina Express railway routes pass through Davos and if you wish to travel the Alps by train, you should also plan to spend a day in these beautiful surroundings.

HOTEL

The InterContinental Davos has 216 spacious, luxurious rooms and suites, which are all fitted out to the highest standard referring to the Alpine surroundings. Most of the rooms are equipped with a balcony or terrace offering a spectacular view of the panoramic mountain range of Davos. Covering an area of 1,200 sqm, the InterContinental's Alpine Spa offers both communal and separate areas for ladies and men, indoor and outdoor pools, saunas and steam baths, a 24/7 gym and yoga room and a total of 14 treatment rooms and two private spa suites for couples. For its special treatments it unites the healing powers of Davos's natural surroundings with the goal of holistic well-being. The focus is on Swiss mountain herbs, such as those used in the herb-infused hay wrap. In the restaurants and bars of the InterContinental Davos guests can look forward to inspiring, top-class gastronomy, most notably at "Studio Grigio" on the 10th floor, with its remarkable design and rooftop terrace with stunning views that will take your breath away. The "Capricorn" restaurant serves unique Alpine cuisine, lovingly referred to as "Alpine treasures": in summer an Alpine BBQ is offered and in winter the menu includes reinterpretations of classical Alpine specialities like hay soup. The focus at "Al Pino" is on simple, Italian cuisine for the whole family. The "Nuts & Co." lounge bar serves as the hotel's living room and boasts a sun-drenched terrace with phenomenal vistas. A multitude of Alpine Golden Moments make every stay at the InterContinental Davos an experience you won't forget in a hurry.

Get your Upgrade

www.upgradetoheaven.com/intercontinental-davos

INTERCONTINENTAL DAVOS . Baslerstrasse 9, 7260 Davos Dorf, Switzerland . www.davos.intercontinental.com

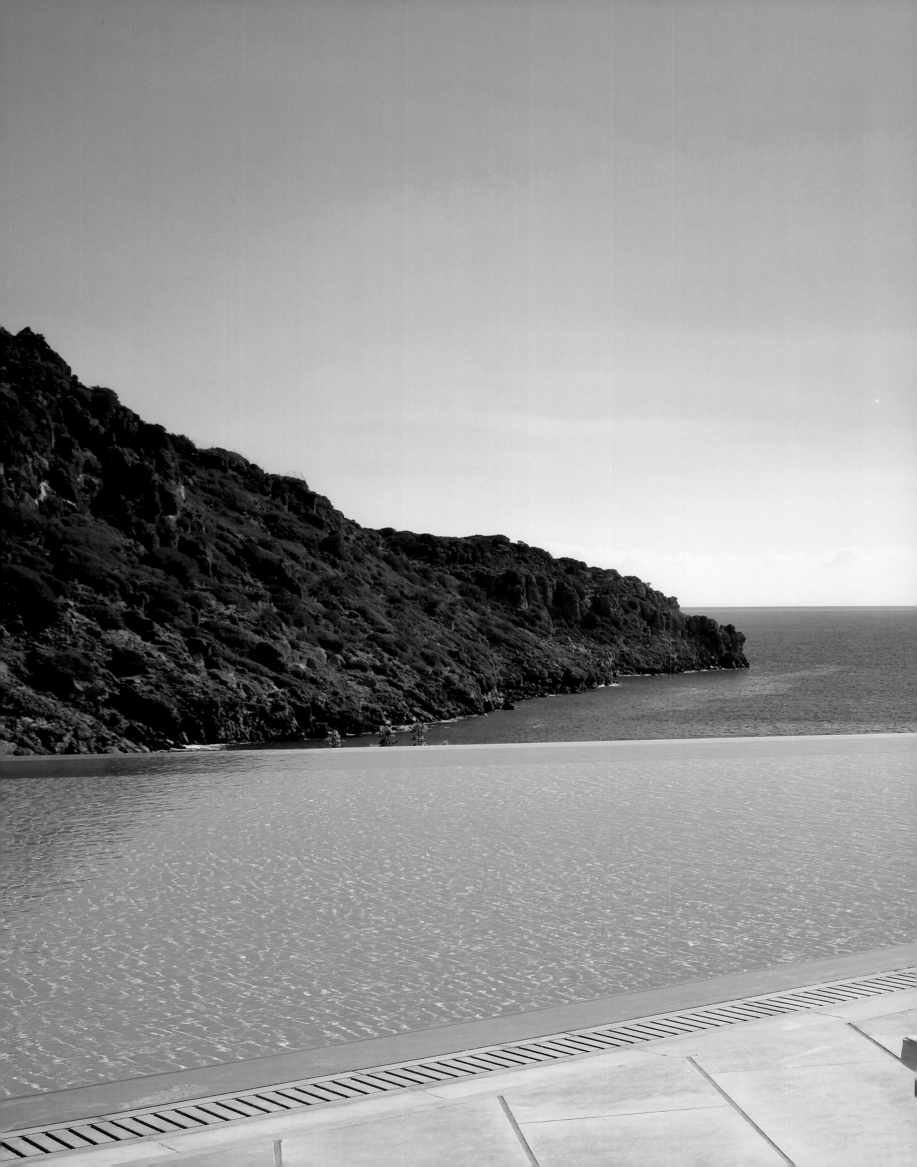

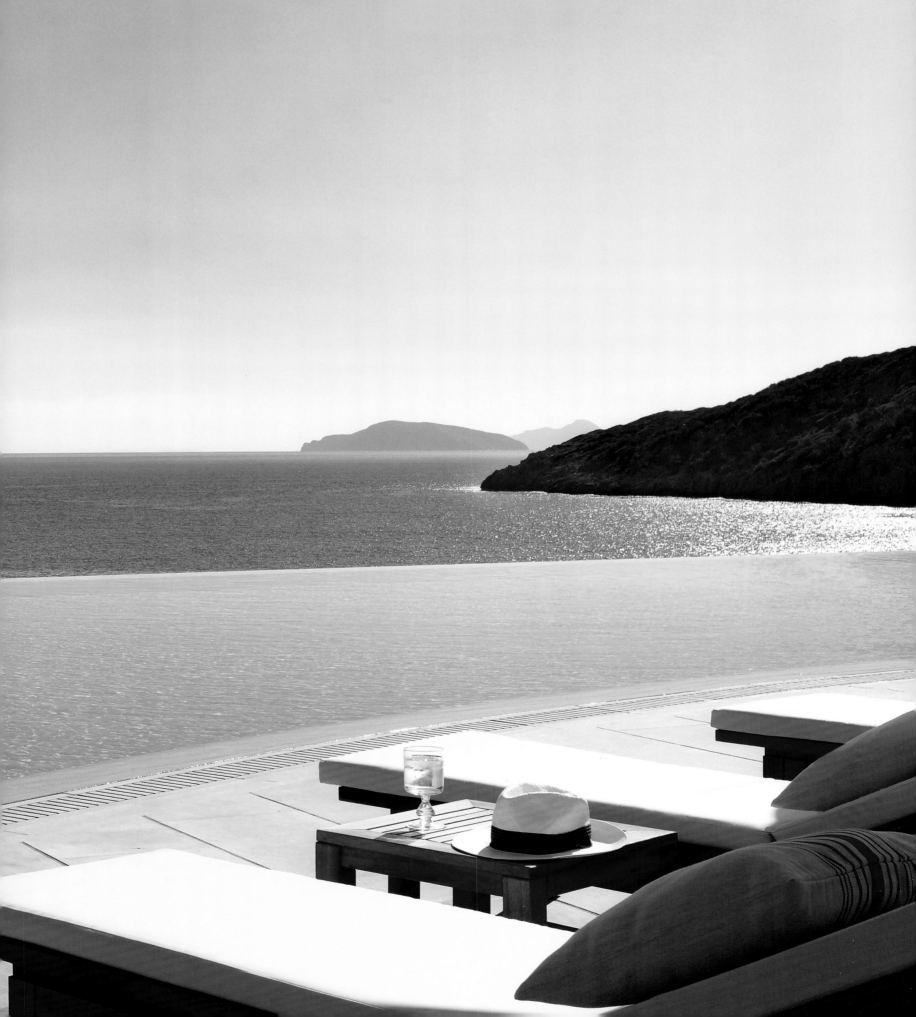

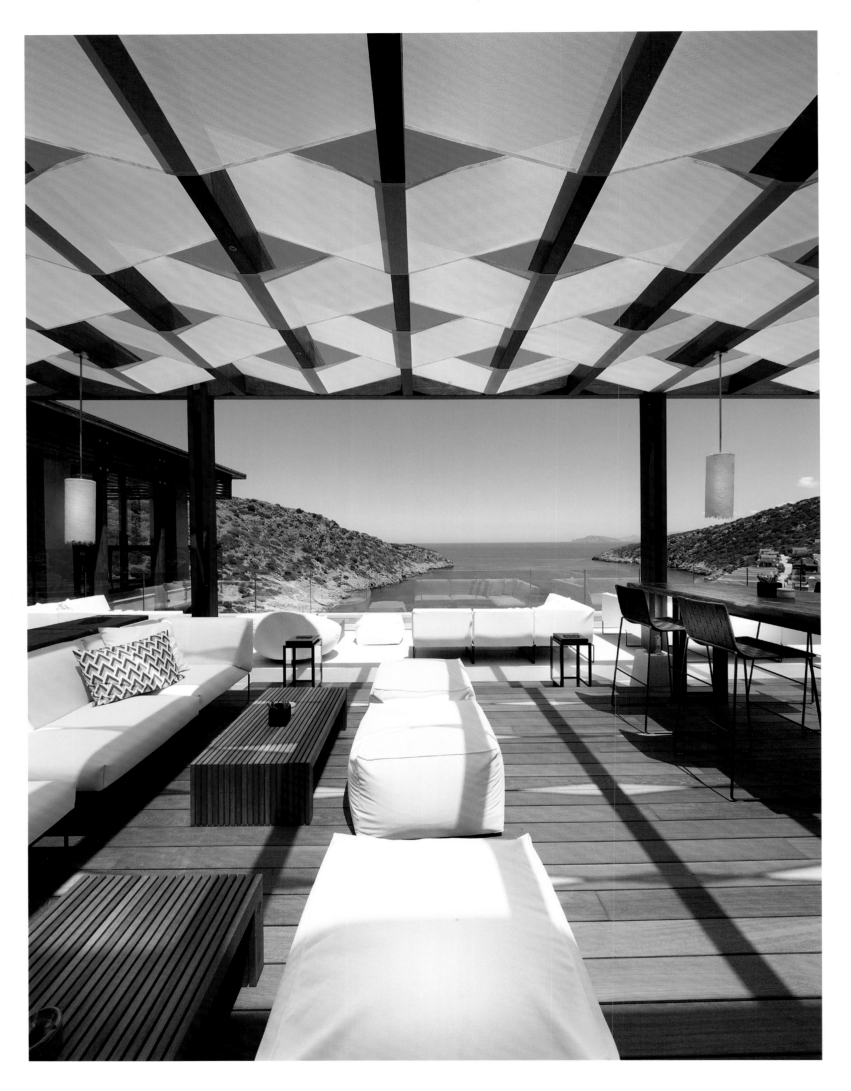

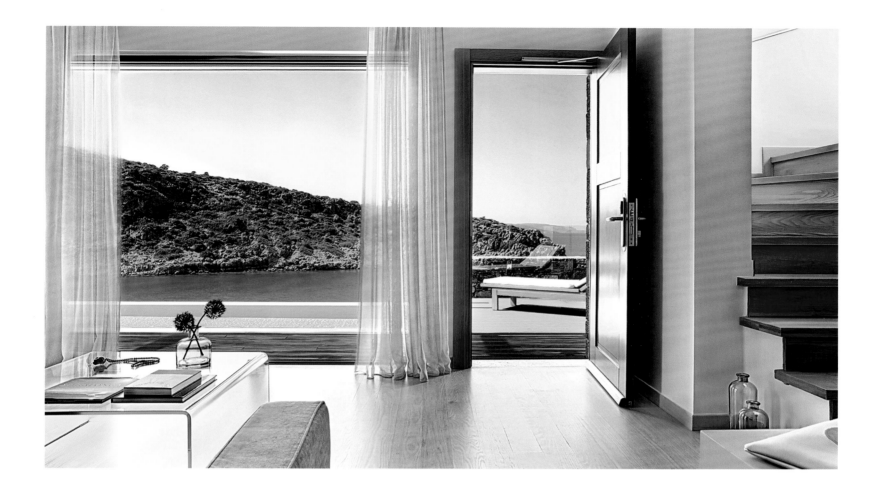

LOCATION

Kreta ist die größte aller griechischen Inseln und verzaubert mit außergewöhnlicher Landschaft, jahrtausendealter Geschichte und türkisem Meer. Das 5-Sterne-Resort Daios Cove liegt im Nordosten der Insel Kreta, am schönen Vathi Strand bei Agios Nikolaos, in der romantischen Bucht Daios Cove. Die terrassenförmige Bauweise der Anlage ermöglicht von fast jedem Zimmer einen direkten Meerblick. Zum privaten Sandstrand gelangt der Gast mit der Seilbahn des Resorts, die auch die Zimmer mit den öffentlichen Bereichen der Anlage verbindet. Mit Schnorcheln, Tauchen, Wasserski, Jet-Ski, Segeln, Katamaranfahren, Tennis, Kochstunden und Weinverkostungen bieten sich unzählige Freizeitmöglichkeiten. Das Daios Cove Luxury Resort & Villas ist mit seiner privaten Bucht der ideale Ort für Entspannung und gesunde Küche, in der das bekannte kretische Olivenöl einen festen Platz hat.

HOTEL

Die meisten der 285 Zimmer, Suiten und Villen des Daios Cove verfügen über einen privaten beheizten Pool mit Meerwasser. Zeitgenössisches Design, helle Farben und Naturmaterialien geben den Unterkünften ein mediterranes Flair. Eine Besonderheit sind die Wellness-Villen für Spa-Fans mit Laufband, Badewanne und privater Sauna. Familien finden in den Villen mit mehreren Schlafzimmern und entsprechender Ausstattung alles, was sie für einen perfekten Urlaub benötigen. Für Veranstaltungen jeglicher Art stehen im Daios Cove ein Businesscenter mit modernster Technik, elf Konferenz- und Banketträume sowie zwei Ballsäle zur Verfügung. Pure Entspannung bietet das 2.500 qm große Daios Cove Spa by Anne Sémonin: Acht großzügig gestaltete Behandlungsräume sowie ein Nassbereich mit finnischer Sauna, Softsauna, Mediterraneo, Erlebnisdusche und Indoorpool mit Meerblick und zudem zwei exklusive Spa Suiten. Das Spa Angebot reicht von Massagen über Körperpeelings und Gesichtsbehandlungen bis hin zu Maniküre und Pediküre. Yoga- und Pilateskurse können ebenso gebucht werden wie ein Personal Trainer. Insgesamt vier Restaurants und drei Bars bieten vielfältige Gaumenfreuden von modern kretisch über mediterrane Küche bis hin zu internationalen Themenbuffets. Das familiengeführte Daios Cove Luxury Resort & Villas empfängt seine Gäste von April bis Oktober (exakte Öffnungsdaten finden sich auf der Hotel-Website).

LOCATION

Crete is the largest Greek island and charms with its unique landscape, a history going back thousands of years and the turquoise sea. The five-star resort Daios Cove is located north-east of the island Crete, by the beautiful Vathi beach at Agios Nikolaos, in the romantic Daios Cove. The terraced construction of the hotel allows direct ocean views from almost every room. Guests may take the resort's cable-way to the private beach, which also connects rooms with the resort's public areas. Countless leisure activities are on offer with snorkelling, diving, waterskiing, jet-skiing, sailing, catamaran sailing, tennis, cooking lessons and wine tastings. The Daios Cove Luxury Resort & Villas with its private bay is the ideal location for relaxation and a healthy cuisine, in which the famous Cretan olive oil is never left out.

HOTEL

Most of the 285 rooms, suites and villas of Daios Cove have a private heated pool with ocean water. Contemporary design, light colours and natural materials give the accomodations a Mediterranean flair. The wellness villas for spa fans with a treadmill, bathtub and private sauna are a special feature. Families can find everything they need for a perfect vacation in their villas with multiple bedrooms and corresponding equipment. For events of all kinds there is a business centre with modern technology, eleven conference and banquet rooms, and two ballrooms provided. The 2,500 sqm Daios Cove Spa by Anne Sémonin offers pure relaxation: eight generous treatment rooms, as well as a wet area with Finnish sauna, soft sauna, Mediterraneo, adventure shower and indoor pool with ocean view and moreover two exclusive spa suites. The spa offer varies from massages to body peelings and face treatments, as well as manicures and pedicures. Yoga and Pilates courses can be booked, as well as a personal trainer. Overall there are four restaurants and three bars, which offer a variety of culinary delights from modern Cretan all the way to Mediterranean cuisine as well as international-themed buffets. The family-run Daios Cove Luxury Resort & Villas welcomes their guests from April until October (exact opening dates can be found on the hotel website).

Get your Upgrade

www.upgradetoheaven.com/daios-cove

DAIOS COVE CRETE . Vathi, 72100 Agios Nikolaos, Crete, Greece . www.daioscove.com

TRULY DIVINE, CRETE'S MOST ROMANTIC DESTINATION

Wahrhaft göttlich, Kretas
romantischster Ort

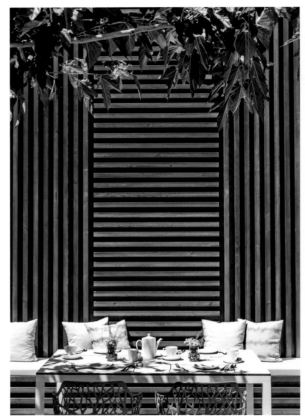

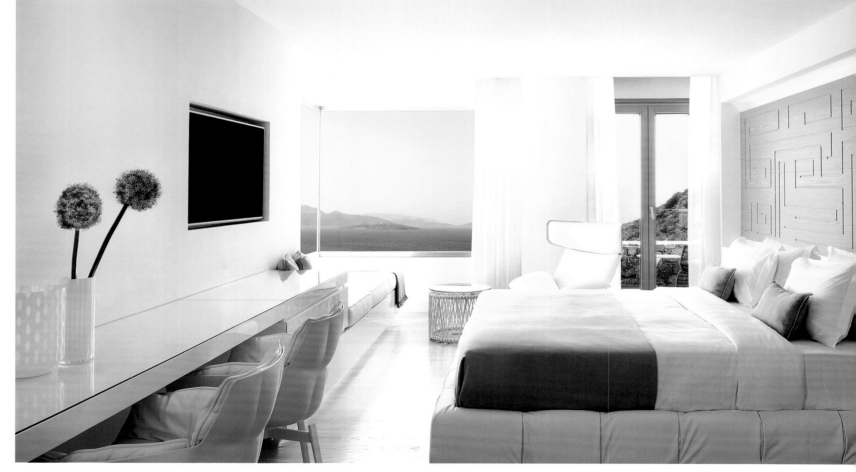

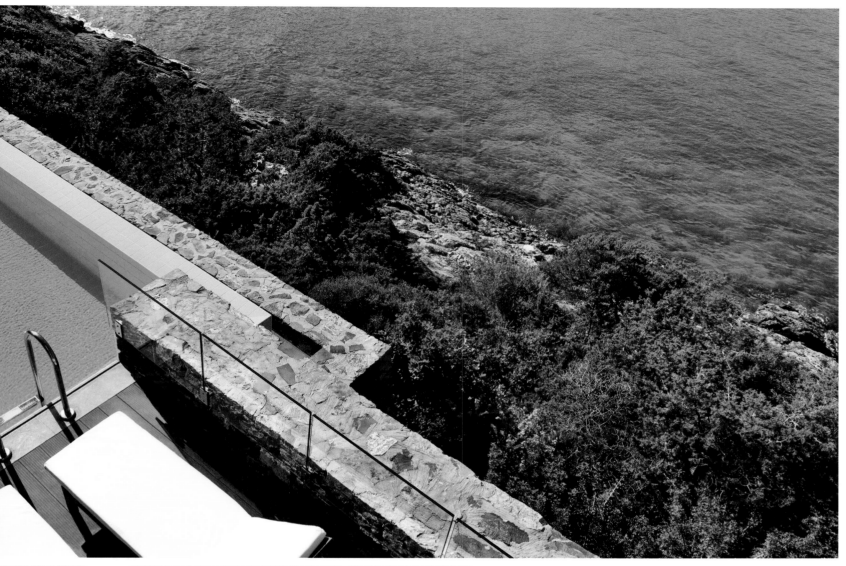

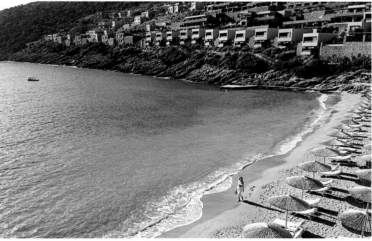

The resort offers a total of 14 room categories: starting with the deluxe room (42 sqm) and the suites (65 to 107 sqm) to the villas (95 to 130 sqm). Starting from summer 2016 Daios Cove will additionally offer Crete's largest luxury villa "The Mansion". The exclusive, contemporary high-end villa made of natural stone, marble and glass offers a living space of over 600 sqm with high-quality designer furniture, as well as a private on-site spa area. The over 300-sqm-large outside area provides an ocean water infinity pool and panoramic view overlooking Daios Cove's private bay. Guests at a villa enjoy the special pleasure of the "Residents' Club" concept, which includes the following services: all-inclusive dining in all of the six restaurants, as well as drinks at the bars, 24-hour room service, personal concierge and unlimited ice cream enjoyment for children at the beach and pool bar.

Das Resort verfügt über insgesamt 14 Zimmerkategorien: Vom Deluxe Zimmer (42 qm) über Suiten (65 bis 107 qm) bis hin zu Villen (95 bis 130 qm). Ab Sommer 2016 bietet das Daios Cove zusätzlich die größte Luxus-Villa Kretas - "The Mansion". Die exklusive, zeitgenössische High-End Villa aus Naturstein, Marmor und Glas mit über 600 qm Wohnfläche ist mit den hochwertigsten Designermöbeln sowie einem eigenen Spa-Bereich ausgestattet. Ihr über 300 qm großer Außenbereich bietet einen Meerwasser-Infinity-Pool und Panoramablick über die Privatbucht von Daios Cove. Gäste einer Villa kommen in den besonderen Genuss des "Residents' Club"-Konzepts, das u.a. folgenden Service umfasst: Kostenfreies Speisen in den sechs Restaurants sowie Drinks an den Bars, 24-Stunden-Zimmerservice, persönlicher Concierge-Service und für Kinder grenzenloses Eisvergnügen an Beach- und Pool-Bar.

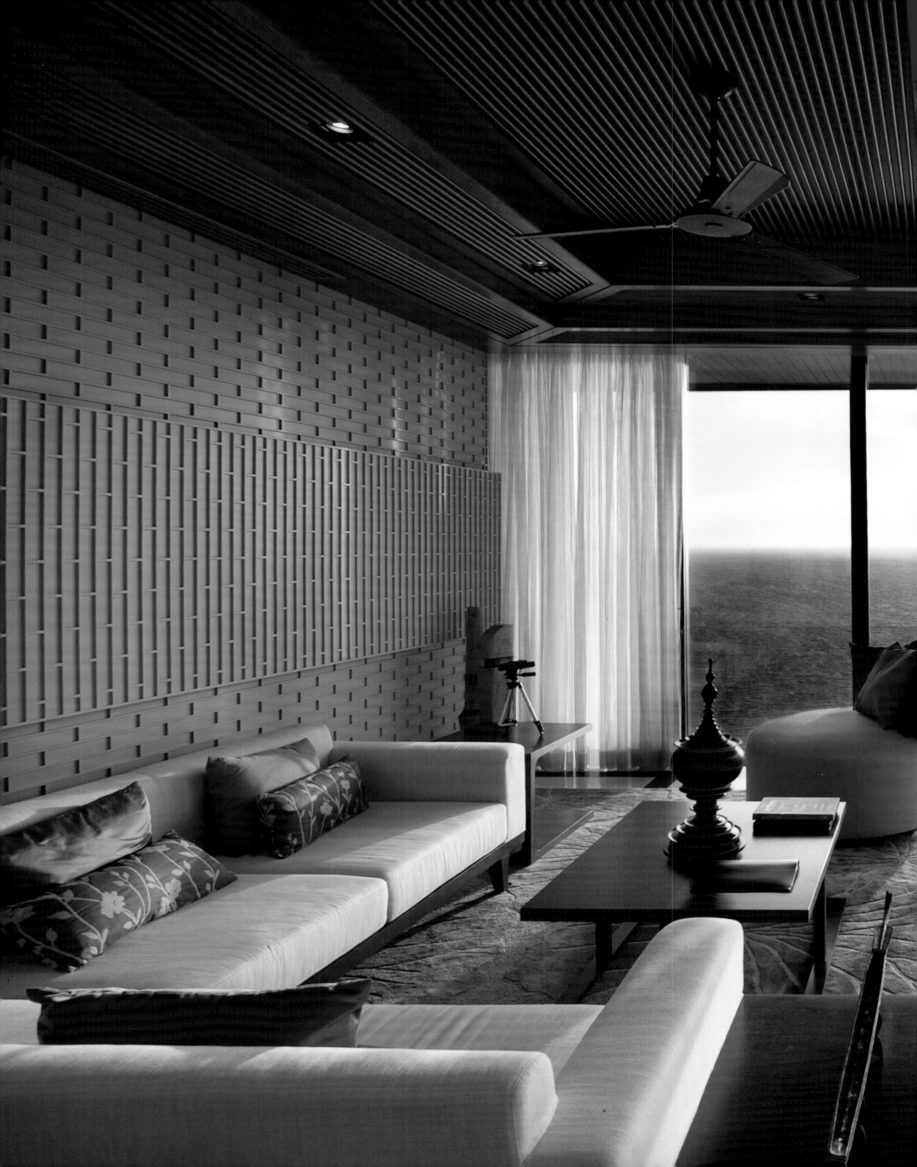

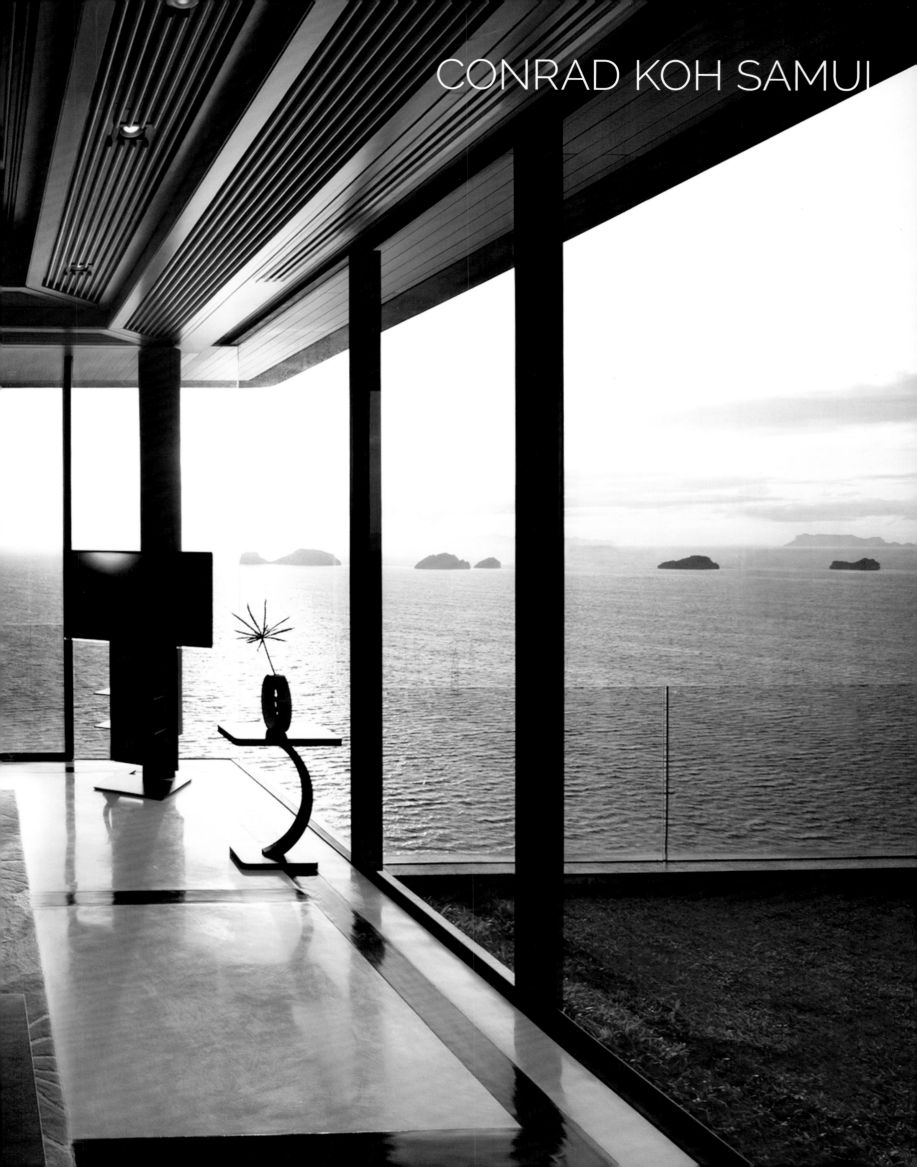

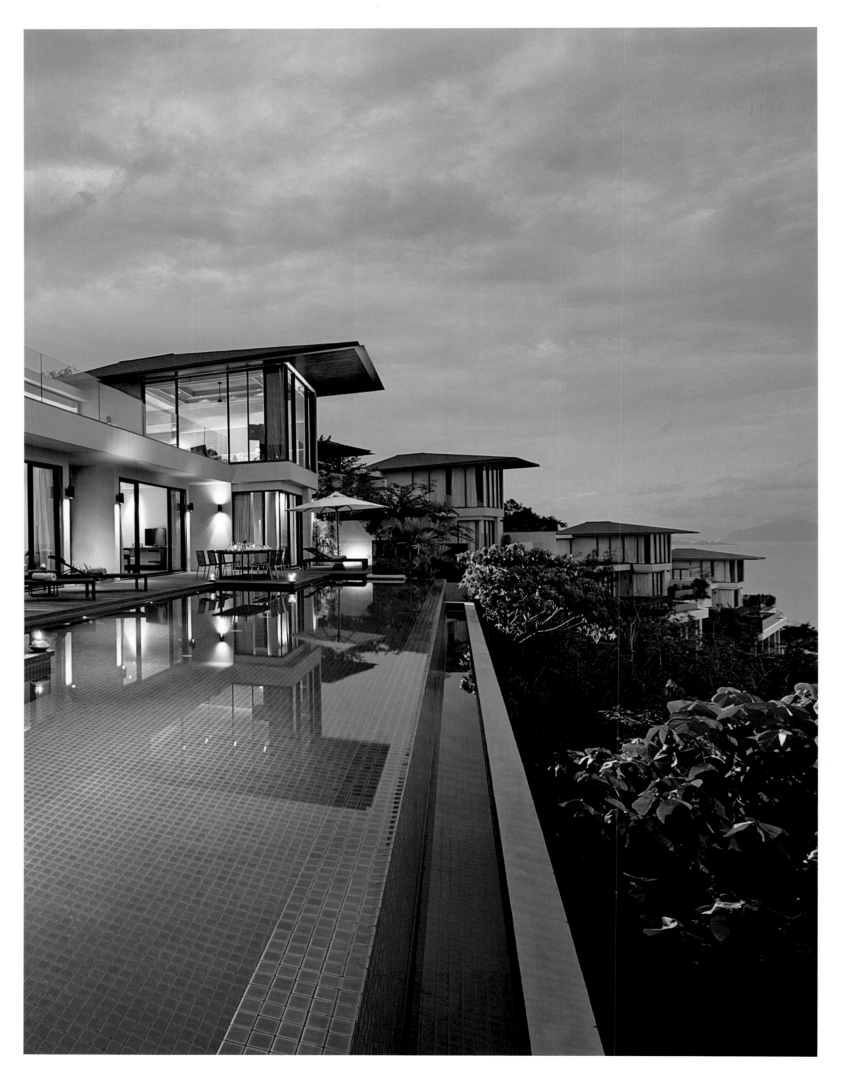

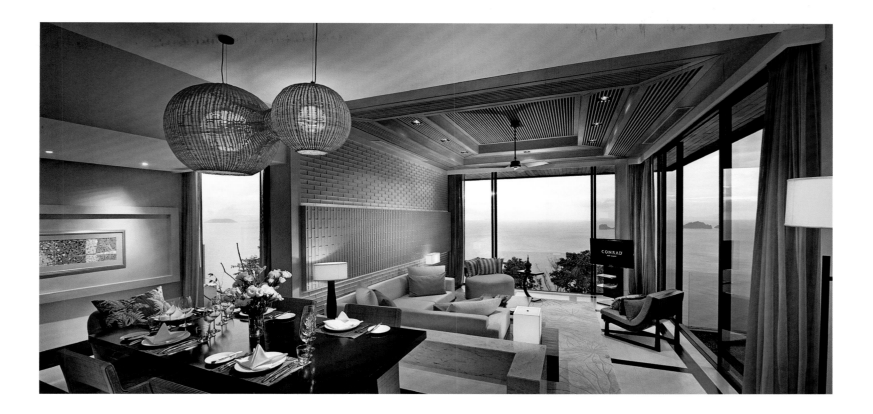

LOCATION

Koh Samui ist eine tropische Bilderbuchinsel im Golf von Thailand mit glasklarem Wasser, feinen Sandstränden und sattgrüner Vegetation. Das luxuriöse Poolvillen-Resort Conrad Koh Samui besticht durch seine landschaftlich einzigartige Lage an einer wild zerklüfteten Steilküste an der Südwestspitze der thailändischen Insel. Traumhafte Sonnenuntergänge, die azurblauen Riffe des Aow Thai Beach sowie der große Resortgarten bilden die natürliche Kulisse für das Conrad Koh Samui. Der Südwesten von Koh Samui ist nur dünn besiedelt und bietet Ruhe und Privatsphäre fernab der touristischen Gebiete im Norden der Insel, die jedoch täglich per Shuttle bedient werden. Die weißen Traumstrände der Nachbarinsel Koh Matsum erreichen Gäste in nur wenigen Minuten dreimal täglich mit dem hauseigenen Speedboot.

HOTEL

Die 81 Pool-Villen und Residenzen des Conrad Koh Samui mit einem, zwei oder drei Schlafzimmern sind von der großzügigen thailändischen Wohnkultur inspiriert. Jede einzelne Villa verfügt über luxuriöse Wohnräume im zeitgenössischen thailändischen Stil und privatem Infinity-Pool, manche davon mit eigenem Garten. Je nach Kategorie gehören modernste Unterhaltungselektronik, Oversize-Badewannen, Regenduschen und Gourmet-Minibar zur Ausstattung. Die Lage am Hang sorgt für garantiert private Abgeschiedenheit und Meeresrauschen in den untersten Villen am Wasser. Im vielfach ausgezeichneten Spa des Conrad Koh Samui werden internationale Methoden mit Thai-Spa-Techniken und erstklassiger Ausstattung kombiniert. Besonders beliebt sind die traditionellen Thai-Massagen, die Stress und Jetlag aller Art wegzaubern. Sportbegeisterte trainieren im Outdoor-Infinity-Pool oder im Fitnesscenter des Resorts. Aqua Aerobics, Yoga, Tai-Chi und Thai-Boxing-Unterricht wird ebenfalls angeboten. Abenteuerlich wird es beim Elefanten-Trekking oder beim Tauchgang an den besten Tauchspots Thailands. In den Restaurants und Bars des Conrad Koh Samui werden die Gäste mit höchster Qualität und bestem Service in außergewöhnlichem Ambiente verwöhnt. Das "Zest" begeistert mit einem einmaligen Food-Library-Konzept. Gourmets werden die Thai Fusion Cuisine der exklusiven Fine-Dining-Location "Jahn Restaurant" schätzen und Weinliebhaber den Weinkeller des Hauses, "The Cellar". Ein privates Dinner in der eigenen Villa bietet das Conrad Koh Samui ebenso an wie "Destination Dining" zu besonderen Anlässen an außergewöhnlichen Orten. Malerische Sonnenuntergänge und ein Hotel, das keine Wünsche offen lässt, machen das Conrad Koh Samui zur perfekten Location für einen romantischen Honeymoon. Das Luxusresort wurde bei den World Luxury Hotel Awards zum "Global Winner of Luxury Hideaway Resort 2014" gewählt und zeitgleich beim TripAdvisor Travellers' Choice Award als eines der "Top 25 Luxury Hotels in Thailand" sowie eines der "Top 25 Hotels in Thailand" ausgezeichnet.

LOCATION

Koh Samui is a picturesque island in the Gulf of Thailand with crystal-clear water, fine sandy beaches and vibrant green vegetation. The luxurious pool villa resort Conrad Koh Samui is outstanding because of its amazing location by a jagged steep cliff at the south-west tip of the Thai island. Breathtaking sunsets, azure reefs of Aow Thai Beach and the resort's large garden form a natural backdrop for the Conrad Koh Samui. The south-west of Koh Samui is only sparsely populated and offers calm and privacy far away from the touristic areas in the north of the island, which can still be reached daily by shuttle. The white dream beaches of the neighbouring island Koh Matsum can be visited by the hotel's own speedboat three times a day.

HOTEL

The 81 pool villas and residences of Conrad Koh Samui with one, two or three bedrooms are inspired by the generous Thai housing culture. Every villa offers luxurious living spaces in contemporary Thai style and an infinity pool, some of them even a private garden. Depending on the category, they are equipped with modern entertainment technology, oversize bathtubs, rain showers and gourmet minibar. Its location on a slope ensures private seclusion and the sound of the sea in the bottom villas by the water. The award-winning Conrad Koh Samui's spa uses international methods with Thai spa techniques combined with first-class equipment. Exceedingly popular are the traditional Thai massages, which release stress and jet-lag of all kind. Sports enthusiasts can work out in the outdoor infinity pool or in the resort's gym. Aqua aerobics, yoga, tai chi and Thai boxing are offered as well. Elephant trekking and dives to Thailand's best dive spots turn the experience into an adventure. At Conrad Koh Samui's restaurants and bars, guests are spoilt with the highest quality and best service in extra-ordinary ambience. The "Zest" captivates with a unique food library concept. Gourmets will treasure the Thai Fusion cuisine at the exclusive fine dining destination "Jahn Restaurant" and wine lovers will appreciate the hotel's wine cellar "The Cellar". Conrad Koh Samui offers private dining in their own villas, as well as "destination dining" for special occasions at outstanding locations. Breathtaking sunsets and a hotel that leaves nothing to be desired make Conrad Koh Samui the perfect place for a romantic honeymoon. The luxury resort was awarded as the "Global Winner of Luxury Hideaway Resort 2014" at the World Luxury Hotel Awards as well as at the Tripadvisor Travellers' Choice Award as one of the "Top 25 Luxury Hotels in Thailand" and "Top 25 Hotels in Thailand".

Get your Upgrade

www.upgradetoheaven.com/conrad-koh-samui

CONRAD KOH SAMUI . 49/8-9 Moo 4, Hillcrest Road, Taling-Ngam, Koh Samui, 84140, Thailand . www.conradkohsamui.com

INCREDIBLE SUNSETS AND BREATHTAKING OCEAN VIEWS IN THE SOUTH-WEST OF KOH SAMUI

Unglaubliche Sonnenuntergänge und atemberaubender Meerblick in Koh Samuis Südwesten

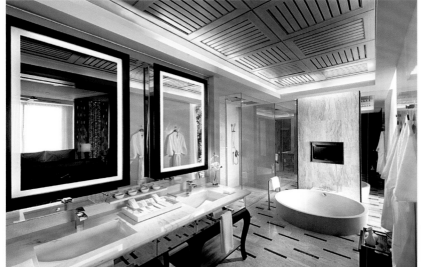

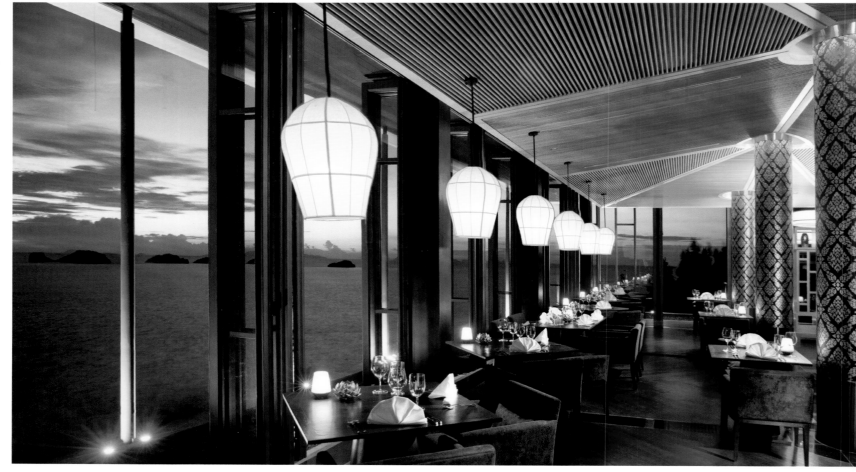

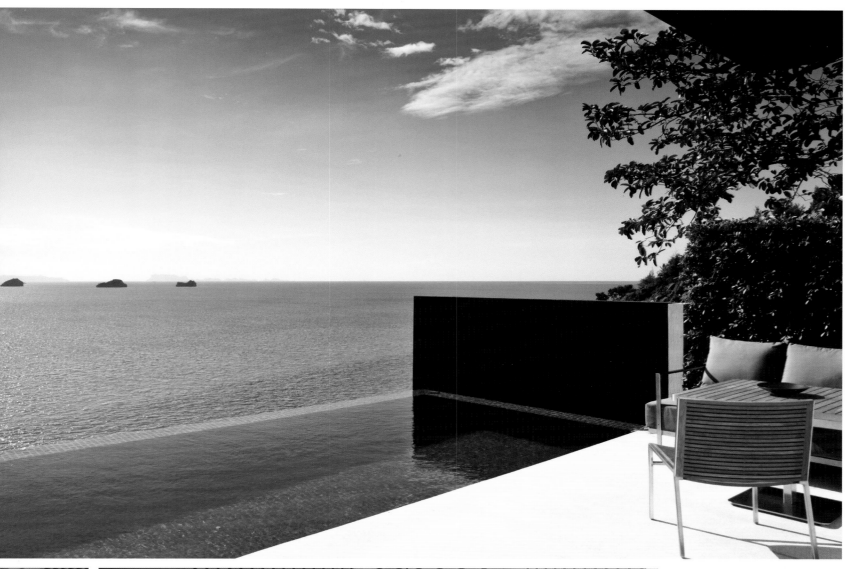

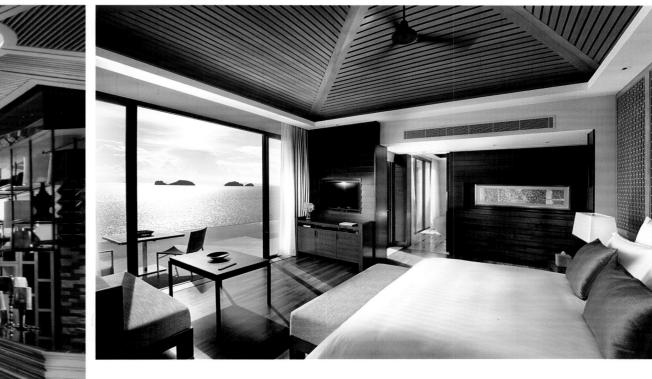

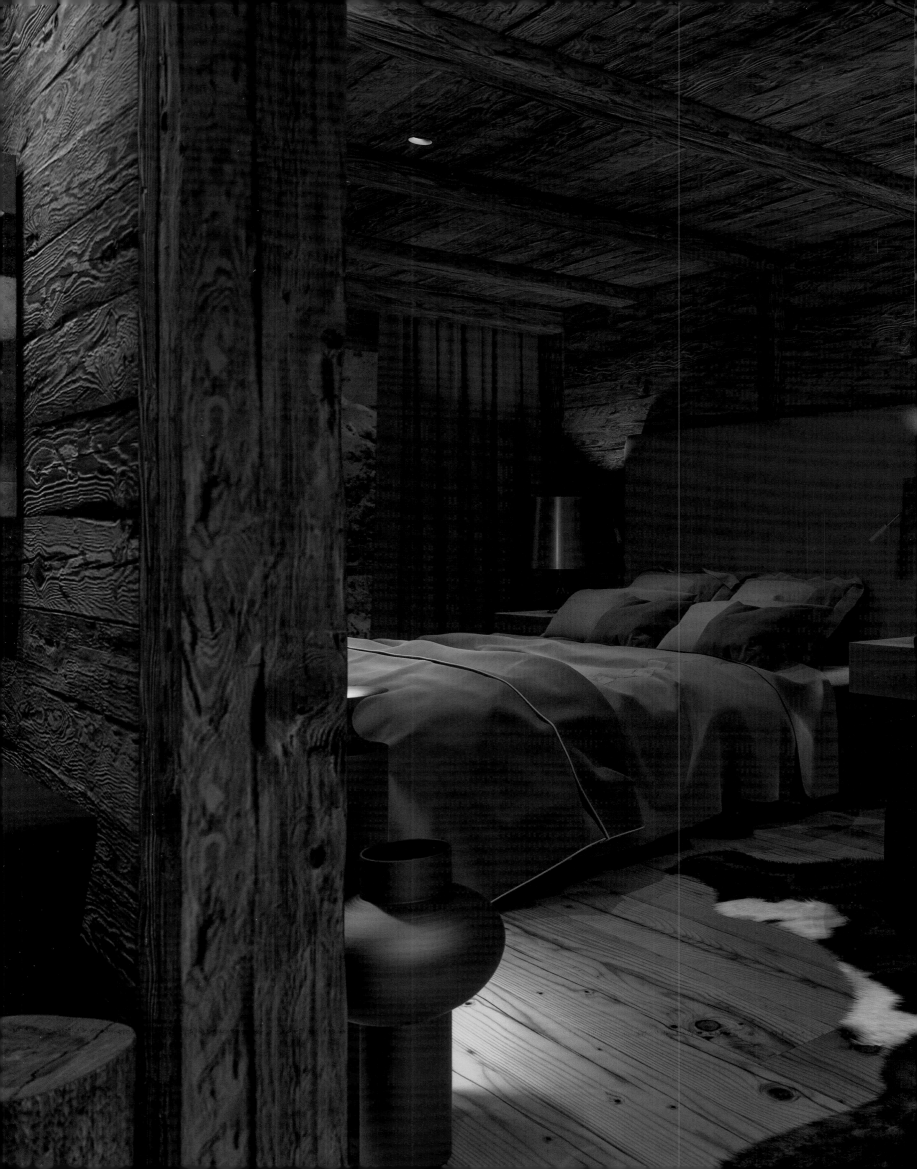

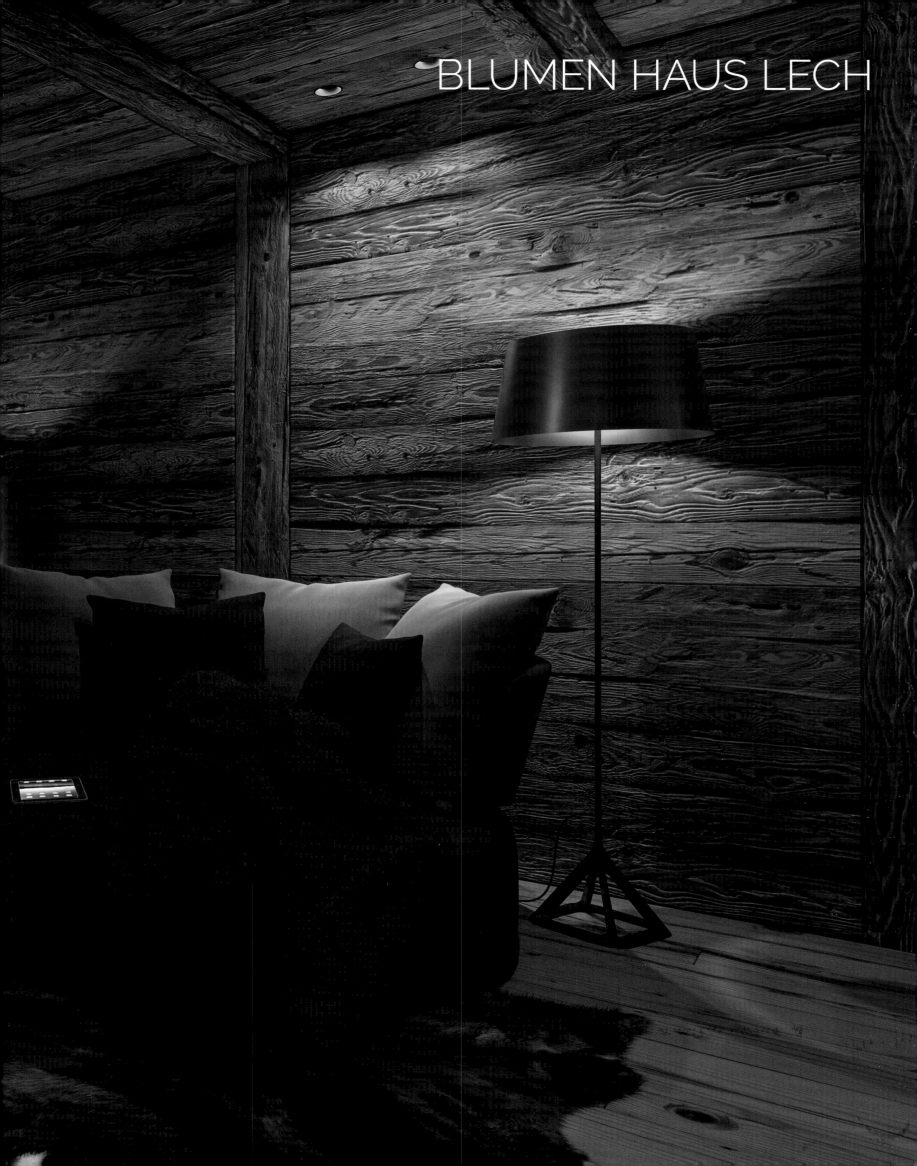

BLUMEN HAUS LECH

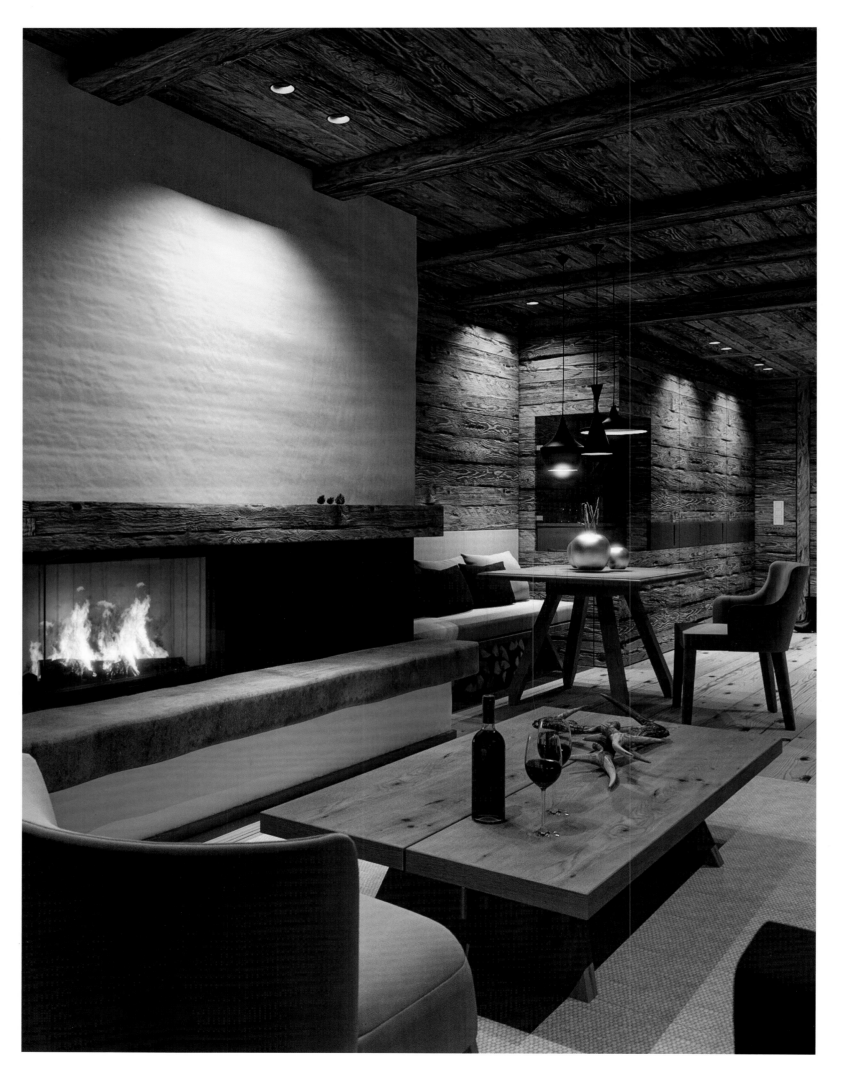

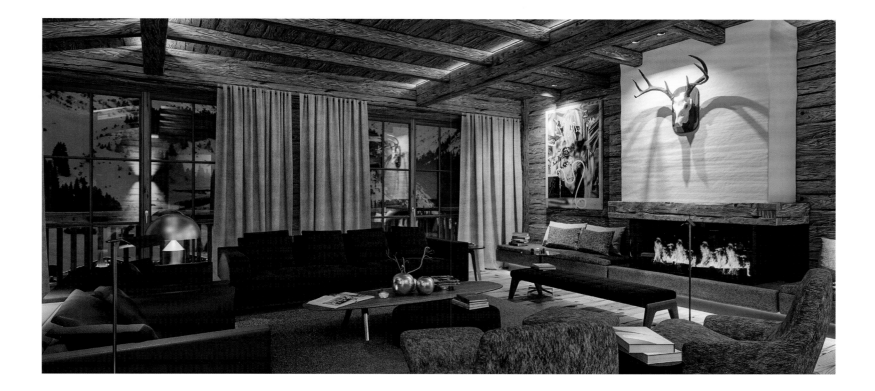

LOCATION

Lech am Arlberg gilt als die Wiege des alpinen Wintersports. Ab dem 1. Dezember 2016 bereichert das Luxusrefugium Blumen Haus Lech die Region. In unmittelbarer Nachbarschaft befinden sich Zürs, St. Christoph und St. Anton. Skifahrer und Wintersportler freuen sich über 350 Pistenkilometer und 200 Kilometer für Tiefschneeabfahrten. Ein zum Start der Wintersaison 2016/17 eröffnender Skilift wird nicht nur Lech und St. Anton miteinander verbinden, sondern die Arlberg Region zum größten zusammenhängenden Skigebiet Österreichs machen. Im Sommer ist die Region eine hervorragende Destination für Wanderer, Aktivurlauber und Freunde kultureller Veranstaltungen wie der jährlich stattfindenden Arlberg Classic Car Rally oder dem Lech Classic Festival.

HOTEL

Als Vorbild für das Design des Blumen Haus Lech diente die für die Region typische Architektur. Durch traditionelle Elemente wie ein Kupferdach, antikes Tiroler Holz und eine Steinfassade, integriert sich das Hotel optisch harmonisch in das Gesamtbild des Dorfes. In den neun spektakulären Suiten des 5-Sterne-Hauses erleben Gäste puren Luxus im alpinen Stil. Aufgeteilt sind die Suiten in einen großzügigen Wohn- und Schlafbereich und variieren zwischen 47 und 67 qm. Von den dazugehörigen Terrassen und Balkonen eröffnet sich ein grandioses Bergpanorama. Innen überzeugen die Suiten mit technischem Luxus als Standardausstattung wie Loewe Fernsehern mit Netflix-Zugang, Revox Soundsystemen und in die Wände integrierte iPads zur Bedienung der Klimaanlage und des Lichts. Um auch beim Mobiliar dem exklusiven Anspruch von Blumen Haus Lech gerecht zu werden, wurden Stücke der italienischen Manufaktur Minotti als frischer Kontrast zum rustikalen Ambiente gewählt. Drei der neun Suiten lassen sich ganz einfach zu Familiensuiten verwandeln. Ein besonderes Highlight des Blumen Haus Lech ist das Master Appartement, in dem Gäste besonders gehoben residieren. Es erstreckt sich auf 423 qm über zwei Stockwerke und ist direkt von der Garage aus mit einem privaten Lift zu erreichen. Das Master Schlafzimmer mit offenem Badezimmer ist atemberaubend. Drei weitere Schlafzimmer sowie eine moderne Küche, ein gemütliches Esszimmer, ein Heimkino sowie Billardtisch, eine kleine Bar und ein Büro machen die Räumlichkeit zum Männertraum in den Alpen. Der eigene Jacuzzi sorgt für perfekte Entspannung. Das Master Appartement ist ideal für Urlauber, die absolute Privatsphäre in Kombination mit erstklassigem Hotelservice genießen möchten. Ein 24-Stunden-Butlerservice lässt keine Wünsche offen und rundet das Luxus-Erlebnis ab. Für Liebhaber zeitgenössischer Kunst bietet das Blumen Haus saisonal wechselnde Werke internationaler Künstler, die gemeinsam mit den Wiener Experten der Contemporary Art Advisors ausgewählt werden. Auf Wunsch ist das Blumen Haus Lech auch komplett exklusiv mietbar.

LOCATION

Lech am Arlberg is knwon as the cradle of Alpine winter sports. The luxury retreat Blumen Haus Lech will enrich the region from the 1st of December 2016. Zürs, St Christoph and St Anton are located nearby. Skiers and winter sports enthusiasts can get excited about 350 kilometres of ski runs and 200 kilometres of deep-snow slopes. A new ski lift, that will be opened at the beginning of winter season 2016/17, will not only connect Lech and St Anton, but also it will make the Arlberg region Austria's largest combined ski area. In summer the destination is perfect for hikers, active vacationers and fans of cultural events. They find for example the annual Arlberg Classic Car Rally or the Lech Classic Festival.

HOTEL

The design of Blumen Haus Lech was influenced by The region's typical architecture. Through traditional construction elements, such as copper roofs, antique Tyrolean wood and its stone facade, the hotel is able to integrate itself visually into the village's overall appearance. In the nine spectacular suites of the five-star hotel, guests can experience pure luxury in the Alpine style. The suites are separated into spacious living and sleeping areas and vary between 47 and 67 sqm. A breathtaking mountain panorama stretches in front of the terraces and balconies. The suites are standardly fitted with luxury technology, such as Loewe televisions with Netflix access, Revox sound system, and wall-integrated iPads to navigate air conditioning and lights. The Italian label Minotti was chosen to provide the hotel's furniture with a fresh contrast to meet Blumen Haus Lech's exclusive standards and rustic ambience. Three of the nine suites can easily be transformed to family suites. A special highlight of Blumen Haus Lech is the Master Apartment, where guests can reside majestically. It stretches over 423 sqm with two levels and is accessible through the garage via a private lift. The master bedroom with open bathroom is breathtaking. Three additional bedrooms, as well as a modern kitchen, a comfortable dining room, a home cinema, a pool table, a small bar and an office turn the space into a dream retreat in the Alps. The private Jacuzzi guarantees a perfect relaxation. The Master Apartment is ideal for vacationers seeking absolute privacy in combination with first-class hotel service. A 24-hour butler service leaves nothing to be desired and rounds off the luxury experience. For lovers of contemporary art, the Blumen Haus offers works by international artists, which are seasonaly changed and chosen in cooperation with Viennese experts from Contemporary Art Advisors. In addition, Blumen Haus Lech can also be rented exclusively.

Get your Upgrade

www.upgradetoheaven.com/blumen-haus-lech

BLUMEN HAUS LECH . Stubenbach 273, 6764 Lech am Arlberg, Austria . www.blumenhauslech.com

EINE NEUE DIMENSION VON LUXUS AM ARLBERG

A new dimension of luxury
at the Arlberg

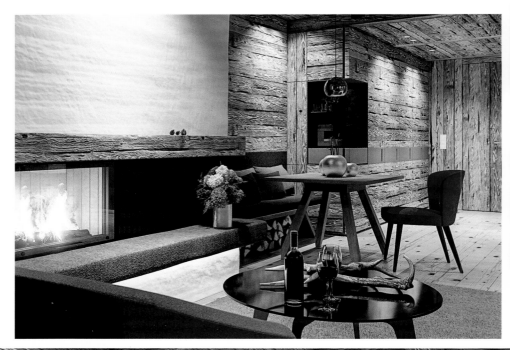

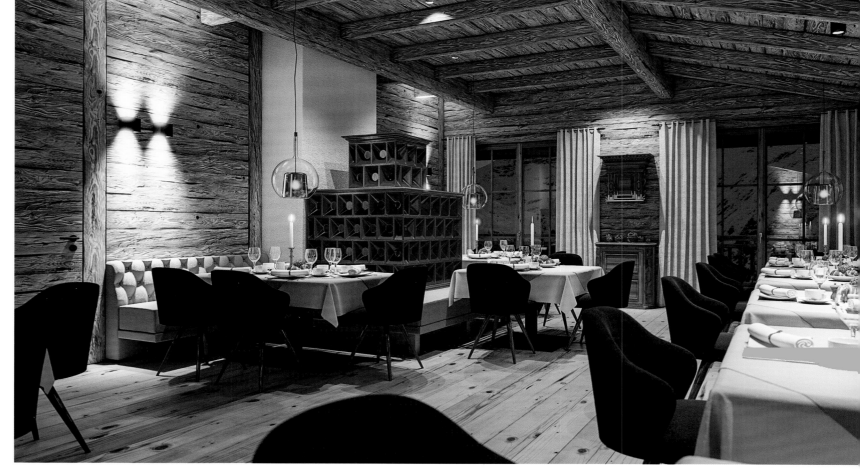

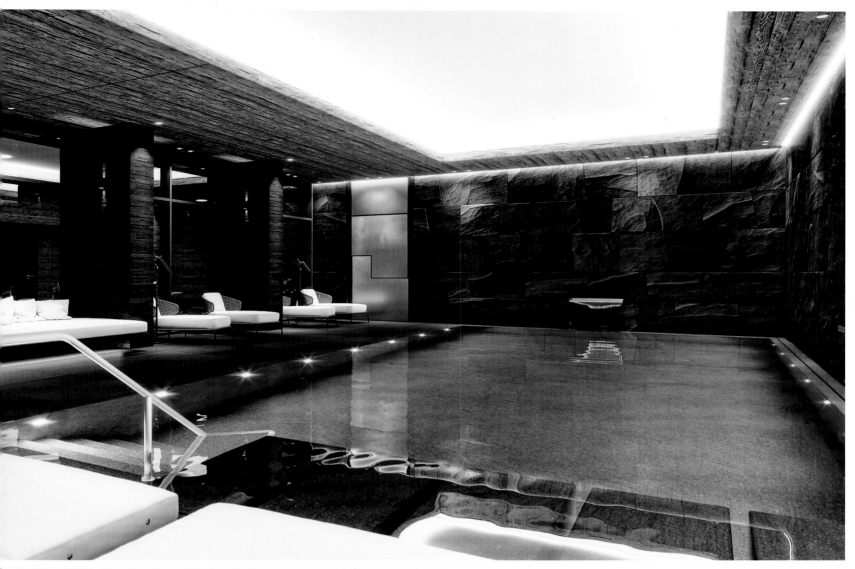

With its restaurant "Marmotta by Steven Ellis" and the Austrian chef Barbara Mairhofer, Blumen Haus Lech is on a culinary world-class level. She trained under the British star cook Gordon Ramsay and his sous-chef Steven Ellis, who established Marmotta's concept, which serves youthful, modern, fresh cuisine based on local, organically grown produce. In the hotel's own wine cellar, which is connected to the "Living Room" garage, gourmets can enjoy wine tastings, private dinners and small events. In the wellness and spa area of Blumen Haus Lech, there is a 415 sqm beauty and hair salon, a spa suite, an excellently equipped gym and an indoor pool with counter-current flow and whirlpools, two saunas, a steam bath and an infrared cabin. The unique high-pressure oxygen cabin is especially meant to prepare professional athletes for heights of up to 5,600 metres. The Blumen Haus Lech is a new dimension of luxury on the Arlberg in every way.

Mit dem Restaurant Marmotta by Steven Ellis und der österreichischen Küchenchefin Barbara Mairhofer bewegt sich Blumen Haus Lech auch kulinarisch auf Weltklasse-Niveau. Mairhofer lernte beim britischen Star-Koch Gordon Ramsay und dessen Sous-Chef Steven Ellis, der das Konzept für das Restaurant Marmotta entwickelte, in dem eine junge, moderne und frische Küche auf Basis lokaler Bio-Produkte serviert wird. Im hauseigenen Weinkeller, der sich an die "Living Room" Garage anschließt, können Feinschmecker neben Weindegustationen private Dinner und kleine Events genießen. Im Wellness- und Spabereich von Blumen Haus Lech erwartet die Gäste auf 415 qm ein Beauty- und Friseursalon, eine Spa Suite, ein erstklassig ausgestatteter Fitnessraum sowie ein Indoorpool mit Gegenströmung und Whirlpools, zwei Saunas ein Dampfbad und eine Infrarotkabine. Einzigartig ist die Hochdruck-Sauerstoff-Kammer, die insbesondere Hochleistungssportler auf eine Höhe von bis zu 5,600 Metern vorbereiten soll. Das Blumen Haus Lech ist in jeder Hinsicht eine neue Dimension von Luxus am Arlberg.

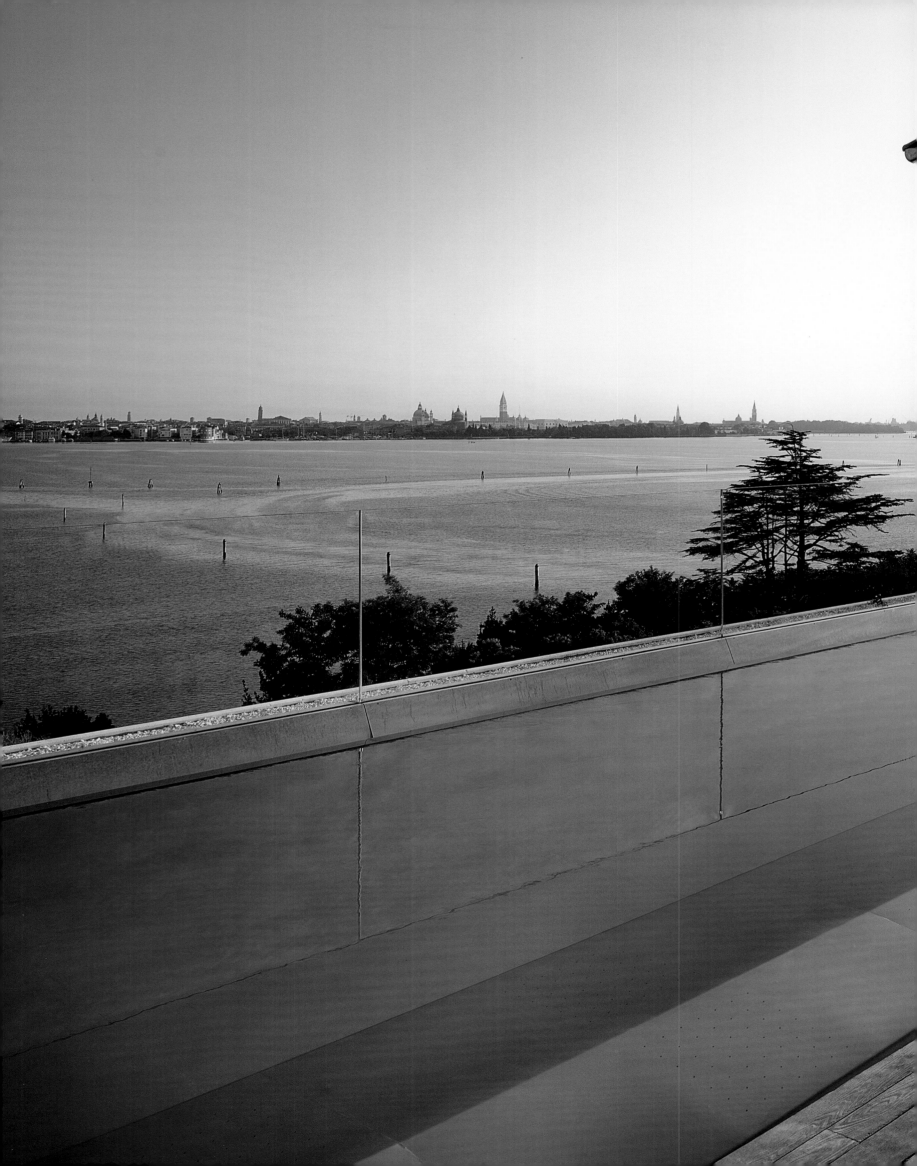

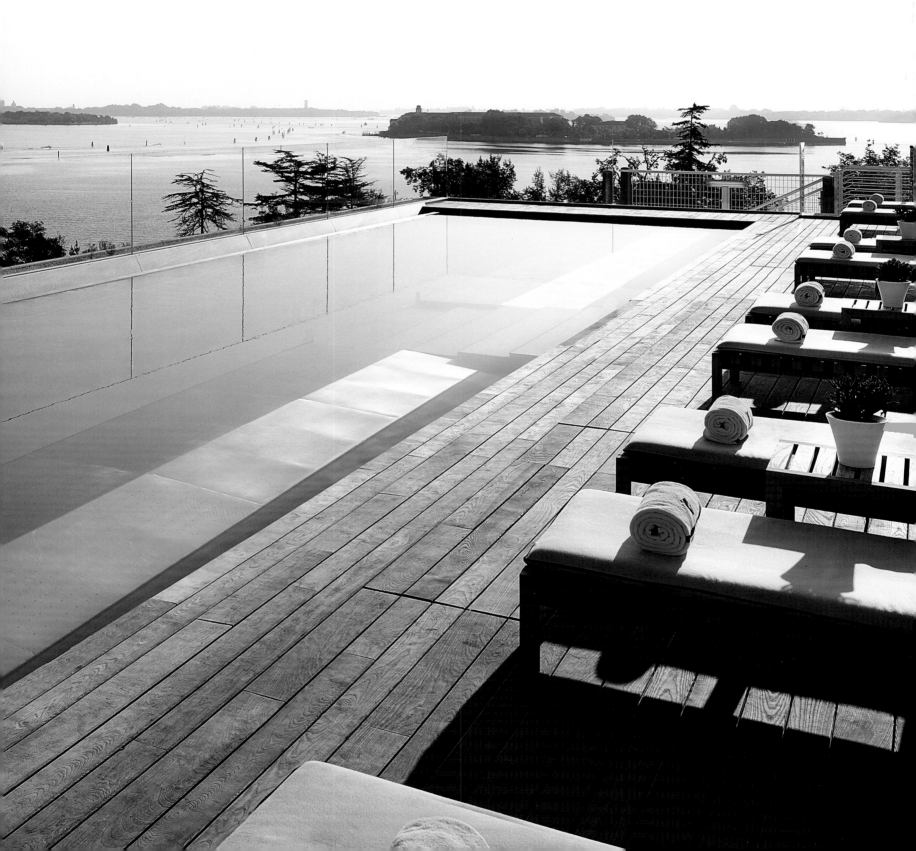

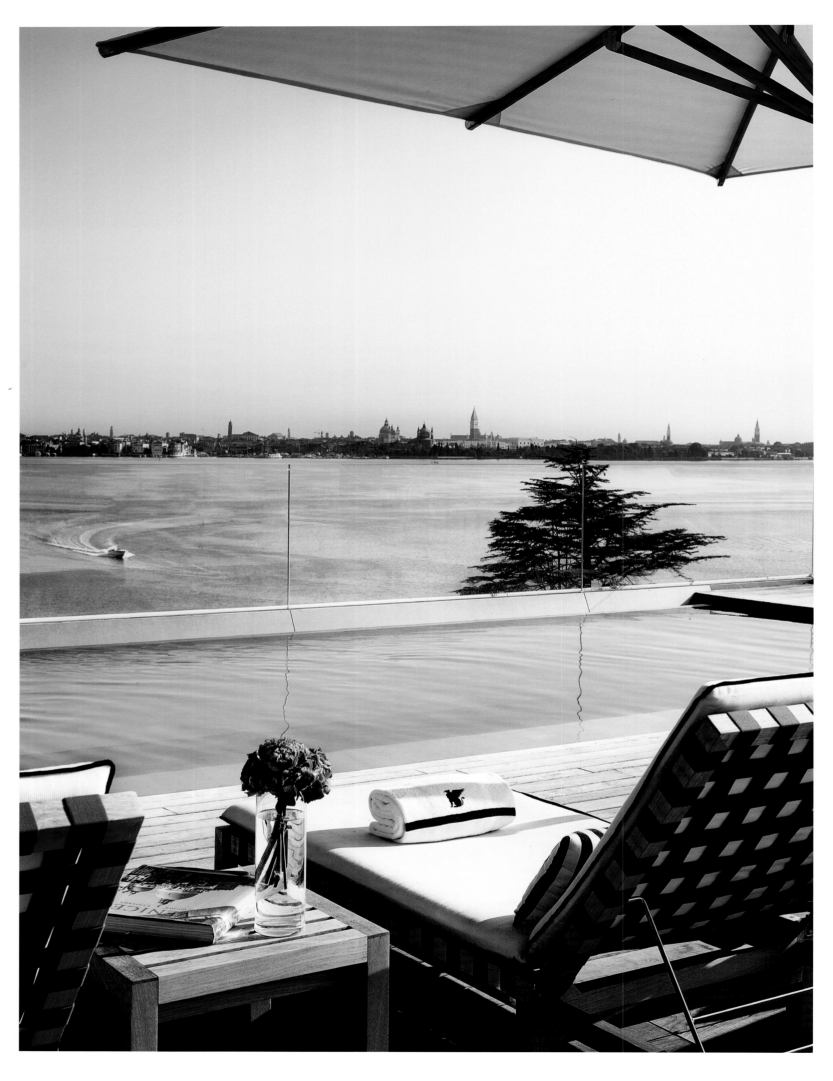

LOCATION

Auf einer privaten Insel in Venedig gelegen, nur einige Minuten vom Markusplatz entfernt, liegt das JW Marriott Venice Resort & Spa. Weitläufige Grünflächen, eine stilvolle Restaurierung durch Stararchitekt Matteo Thun, aufmerksamer Service und einzigartige Wellness- und Kulinarik-Angebote prägen die Atmosphäre auf der Isola delle Rose. Die Gäste können von dort aus bequem die Sehenswürdigkeiten Venedigs und des Umlands, wie beispielsweise Glaskunsthandwerk auf Murano, erkunden und gleichzeitig den Luxus eines großzügigen Resorts genießen. Ein kostenloser Boots-Shuttle verkehrt regelmäßig von 8.30 Uhr bis Mitternacht zwischen Resort und Markusplatz.

HOTEL

Privat und exklusiv gelegen garantiert das luxuriöse 4-stöckige Hotel absolute Ruhe, nur wenige Meter von der Lagune von Venedig entfernt. Der spektakuläre Rooftop-Pool des Resorts bietet einen 360-Grad-Panoramaausblick auf Venedig und die Lagune. Das JW Marriott Venice Resort & Spa verfügt über fünf verschiedene Unterkunftsmöglichkeiten – das JW, La Residenza, das Uliveto inmitten eines jahrhundertealten Olivenhains, La Maisonette und die freistehende, private Villa Rose. Gäste im Hauptgebäude des Hotels genießen die unmittelbare Nähe zur Hotellobby, die sich zur gemütlichen "Rose Bar", zur Boutique und dem "Cucina" Restaurant hin öffnet, das seine Gäste zum Frühstück willkommen heißt. Im 4. Stock befindet sich das "Sagra" Restaurant, das zum Mittag- und Abendessen zur Verfügung steht. Das mit einem Michelin Stern ausgezeichnete "Dopolavoro" serviert innovative Gerichte mit außergewöhnlichen Aromen und höchstem Standard. Im Juli 2016 wurde das GOCO Spa Venice im JW Marriott Venice Resort & Spa zum Gewinner des World Luxury Spa Award in der Kategorie „Best Luxury Resort Spa in Italien" gekürt. Das größte Spa Venedigs bietet ein umfangreiches Wellness-angebot, einen Innen- und einen Außenpool mit Blick auf die Lagunenstadt, acht Behandlungsräume, eine Sauna, ein Dampfbad sowie ein Fitnessstudio. Für individuelle Yoga- oder Meditationseinheiten stehen den Gästen private Gärten zur Verfügung. Das JW Marriott Venice Resort & Spa ist jährlich von März bis Oktober geöffnet (exakte Öffnungsdaten finden sich auf der Hotel-Website).

LOCATION

Situated on a private island in Venice, just minutes away from St Mark's Square, is the JW Marriott Venice Resort & Spa. Extensive green spaces, stylish restoration by Archi-star Matteo Thun, attentive service and unique wellness facilities and cuisine set the ambience on the Isola delle Rose. From here, guests can conveniently explore the sights of Venice and the surrounding area, such as the handcrafted glass on the island of Murano, while enjoying the luxury of an opulent resort. A free boat shuttle runs daily from 8:30 am to 12:00 am between the resort and St Mark's Square.

HOTEL

Situated in a private and exclusive location, the luxurious four-storey hotel guarantees absolute tranquility just a few metres from the lagoon of Venice. The resort's spectacular rooftop pool affords a 360-degree panoramic view of Venice and its lagoon. The JW Marriott Venice Resort & Spa has five different accommodation options – The JW, La Residenza, the Uliveto, set amid an olive grove dating back centuries, La Maisonette and the detached, private Villa Rose. Guests in the hotel's main building enjoy being close to the hotel lobby, which opens onto the cosy "Rose Bar", the boutique and the "Cucina" restaurant, which welcomes guests for breakfast. The "Sagra" restaurant on the fourth floor is open for lunch and evening meals. The "Dopolavoro" has been awarded a Michelin star for its high standards and innovative dishes with extraordinary flavours. In July 2016 the GOCO Spa Venice at the JW Marriott Venice Resort & Spa was named the winner of the World Luxury Spa Award in the category "Best Luxury Resort Spa in Italy". Venice's biggest spa features extensive wellness facilities, an indoor and outdoor pool with a view of the city and its lagoon, eight treatment rooms, a sauna, steam room and fitness center. Private gardens are available to guests for individual yoga or meditation sessions. The JW Marriott Venice Resort & Spa is open annually from March until October (precise opening times can be found on the hotel website).

Get your Upgrade

www.upgradetoheaven.com/jw-marriott-venice

JW MARRIOTT VENICE RESORT & SPA . Isola delle Rose, Laguna di San Marco, 30133 Venice, Italy . www.jwvenice.com

NOWHERE ELSE IN VENICE IS IT POSSIBLE TO SWIM IN SUCH LOVELY GREEN SURROUNDINGS

So schön im Grünen schwimmt
man nirgendwo sonst
in Venedig

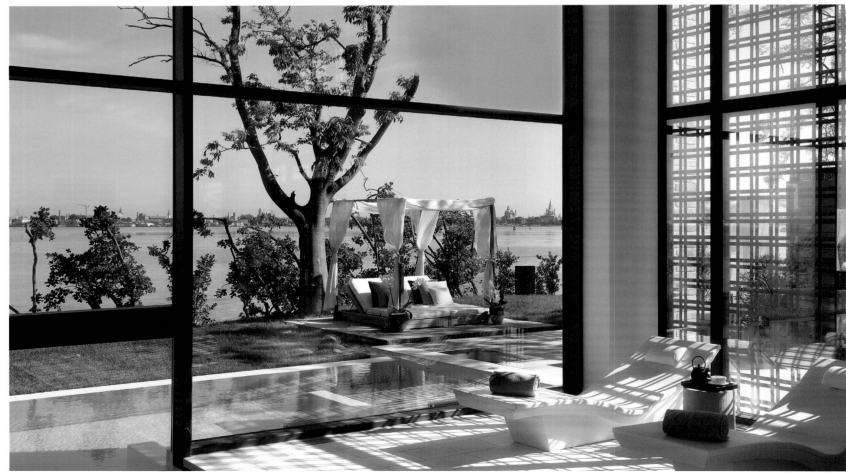

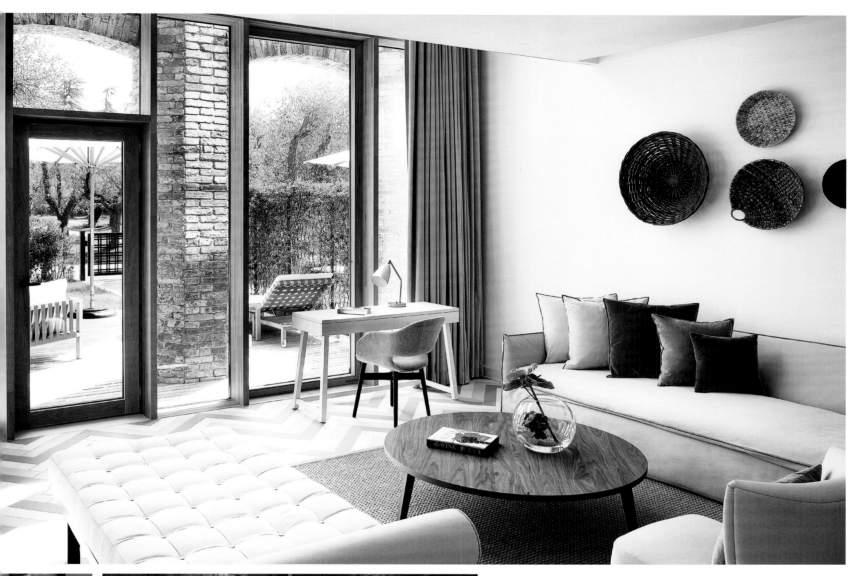

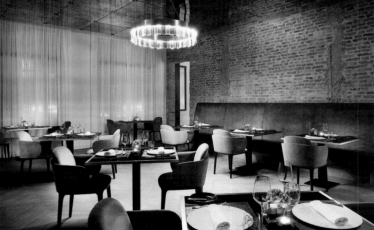

The 266 luxury rooms and suites were designed by star architect Matteo Thun. They are sophisticated and comforable, featuring Mediterranean style and floor-to-ceiling windows that let in plenty of natural daylight and either afford a view of Venice or the resort's lush gardens.

Die 266 edlen Zimmer und Suiten wurden vom Stararchitekten Matteo Thun konzipiert. Sie repräsentieren durchdachten Komfort, mediterranen Stil und bodentiefe Fenster, die viel Tageslicht in die Räumlichkeiten lassen, und bieten entweder einen Blick auf Venedig oder auf die üppigen Gärten des Resorts.

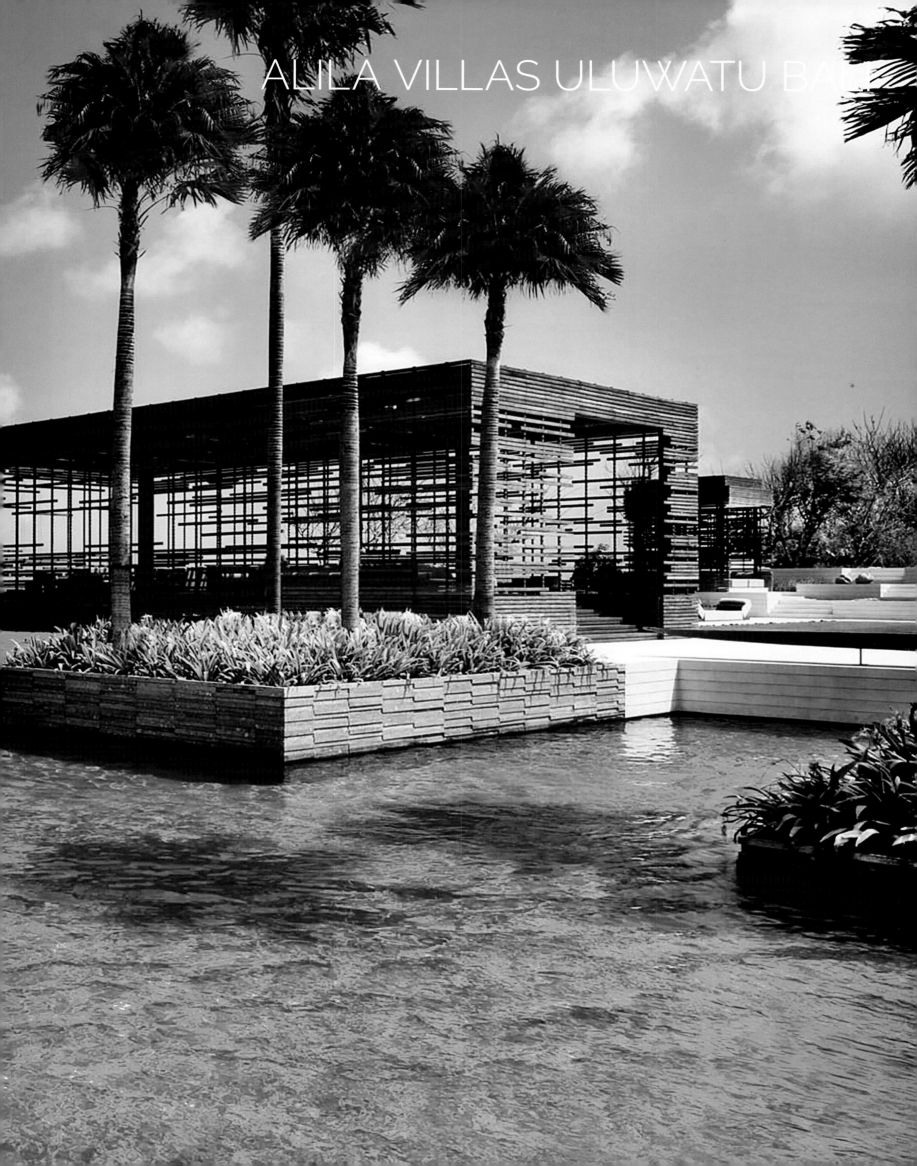

Eine Ansammlung stilvoller, moderner Villen auf einem Felsen mit spektakulärstem Blick.

A collection of chic, contemporary villas set on a cliff top with the most spectacular views.

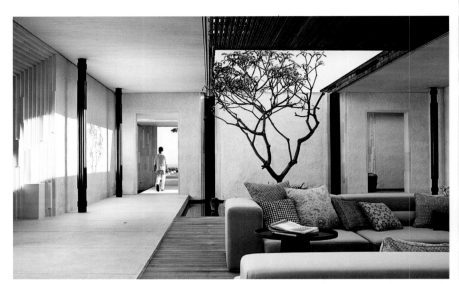

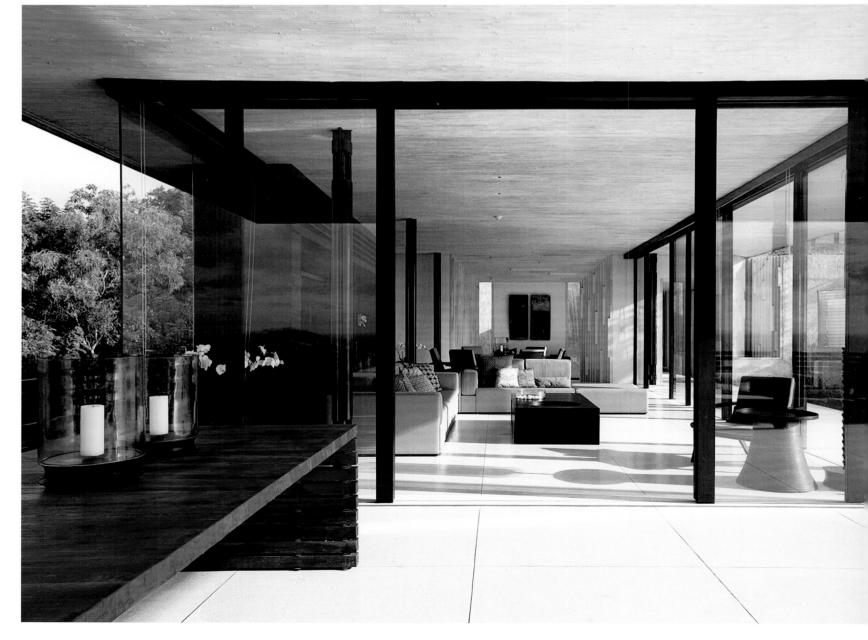

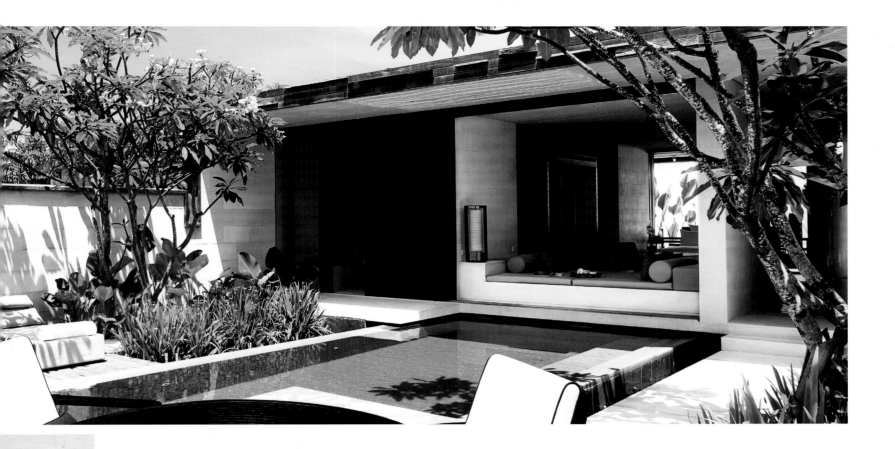

LOCATION

Die Stadt Uluwatu und ihr Tempel, die den Alila Villas Uluwatu ihren Namen geben, befinden sich im Süden Balis, auf der felsigen Halbinsel Bukit. Landschaftlich wechseln sich weiße, feine Sandstrände mit hohen Klippen, guten Surfspots und kleinen Dörfern ab. An einem ganz besonders steil abfallenden Stück im Westen Bukits befindet sich der "Tempel über den Felsen", Pura Luhur Ulu Watu. Die eindrucksvolle Anlage der Alila Villas Uluwatu liegt mit spektakulärem Blick auf den Indischen Ozean auf einem felsigen Hochplateau direkt über dem Wasser. Zum Ngurah International Airport sind es nur etwa 30 Autominuten.

HOTEL

Alilas Philosophie des nachhaltigen Luxus' steckt in jeder einzelnen der 65 Villen mit eigenem Pool und privater Cabana, die alle individuell entworfen und gebaut wurden. Das moderne Interior Design des Luxusresorts wird durch Akzente aus der Natur und der balinesischen Kultur, in Form von Holz, Wasser, Stein und Rattan, ergänzt. Fußwege und Brücken verbinden das Spa, diverse Pools und die großzügigen Aufenthaltsbereiche miteinander. Dank offener Architektur, einer einzigartigen Lavastein-Dachkonstruktion und Bambusdecken weht stets ein angenehme Brise durch die Räume. Mit seinen vielen Lounge-Möglichkeiten und Meerblick bis zum Horizont lädt das Resort zum entspannten Genießen ein, auf Wunsch werden auch gerne Ausflüge organisiert. Die Alila Villas Uluwatu verfügen über zwei Restaurants mit hervorragender Küche. "The Warung" bietet ganzheitliche indonesische und balinesische Küche in lockerer Atmosphäre an der großen Tafel oder ganz privat am eigenen Tisch. Die Küche des "Cire" kombiniert Aromen und Zutaten Ostasiens mit westlicher Zubereitungsart. Die Speisen werden so serviert, dass sie nach asiatischer Tradition auch gemeinsam gegessen werden können. Auch im Spa Alila finden asiatische und westliche Kultur zueinander. Für die Treatments werden verschiedene Therapiemethoden kombiniert und unter anderem Produkte der deutschen Luxuskosmetikmarke Babor verwendet. Neben Spa-Genuss steht den Gästen ein 50 Meter langer Pool entlang der Felsenkante sowie ein 24 Stunden geöffnetes Fitnessstudio zur Verfügung. Wer möchte, der beginnt den Tag mit Morgen-Yoga im architektonischen Symbol der Alila Villas Uluwatu – der Sunset Cabana.

LOCATION

The destination of Uluwatu and its temple, which give the Alila Villas Uluwatu their name, is located in southern Bali on the rocky peninsula of Bukit. In terms of the landscape, white, fine sandy beaches alternate with high cliffs, great surf spots and small villages. Perched vertiginously on a particularly steep cliff in the west of Bukit is the "temple above the rocks", the Pura Luhur Ulu Watu. With jaw-dropping views of the Indian Ocean, the spectacular Alila Villas Uluwatu complex is situated on a rocky panoramic plateau directly above the water. Ngurah International Airport is a mere 30-minute drive away.

HOTEL

Alila's philosophy of sustainable luxury is the idea behind each and every one of the 65 villas with their own pool and private cabana, all of which were individually designed and built. The modern interior design of the luxury resort is complemented by highlights from nature and the Balinese culture, in the form of wood, water, stone and wickerwork. Walkways and bridges connect the spa and pools to the spacious living areas. Thanks to the open-plan architecture with a unique lava rock roof construction and bamboo ceilings, a pleasant sea breeze gently circulates throughout the space. With its many lounge areas and ocean views extending all the way to the horizon, this resort is the perfect place to relax and unwind. Excursions can also be organised upon request. The Alila Villas Uluwatu have two restaurants serving excellent cuisine. The Warung offers wholesome Indonesian and Balinese dishes in a relaxed atmosphere, together with the other diners or at your own private table. And The Cire serves culinary delights that combine East-Asian flavours and ingredients with Western preparation methods. In accordance with Asian tradition, the dishes are served so they can be shared and enjoyed together. A fusion of Asian and Western cultures can also be experienced at the Alila Spa. Various different therapy methods are combined for the treatments, which also use products by German luxury cosmetics brand Babor. As well as indulging their senses at the spa, guests can take advantage of the 50-metre pool along the cliff edge, or the gym, which is open 24 hours a day. You can also choose to begin your day with morning yoga in the Sunset Cabana, the architectural symbol of the Alila Villas Uluwatu.

Get your Upgrade

www.upgradetoheaven.com/alila-villas

ALILA VILLAS ULUWATU BALI . Jl. Belimbing Sari, Banjar Tambiyak, Desa Pecatu, Uluwatu, Kabupaten Badung, Bali 80364, Indonesia
www.alilahotels.com/uluwatu

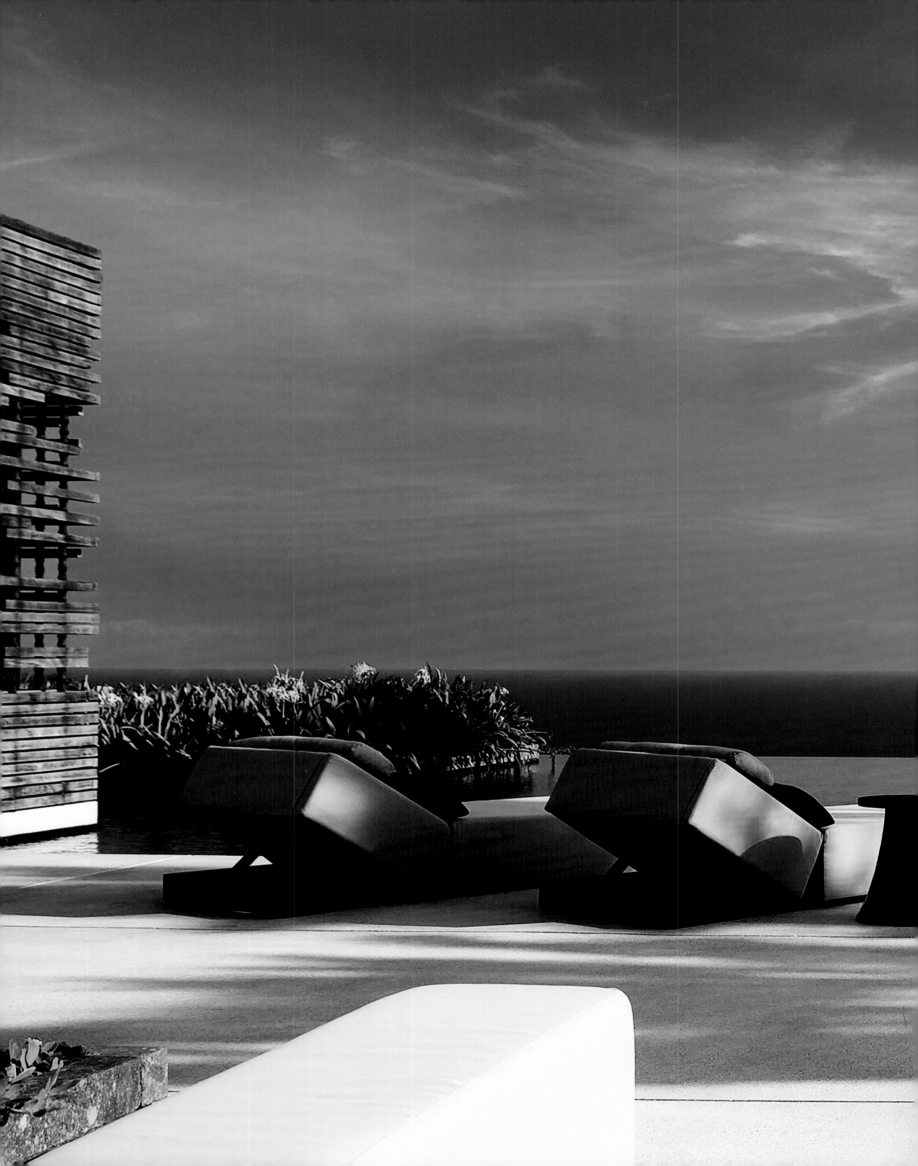

Heavenly
SPA EXPERIENCE

LUXUS HAUTPFLEGE „MADE IN GERMANY"

Luxury skincare
„Made in Germany"

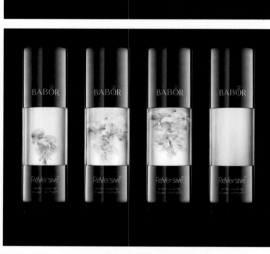

Isabel Bonacker, Dr. Martin Grablowitz

Die hochwirksamen Produkte und Treatments von Babor werden weltweit in den Spas luxuriöser Hotels angeboten.

Babor's highly efficient products and treatments are offered worldwide in the spas of luxury hotels.

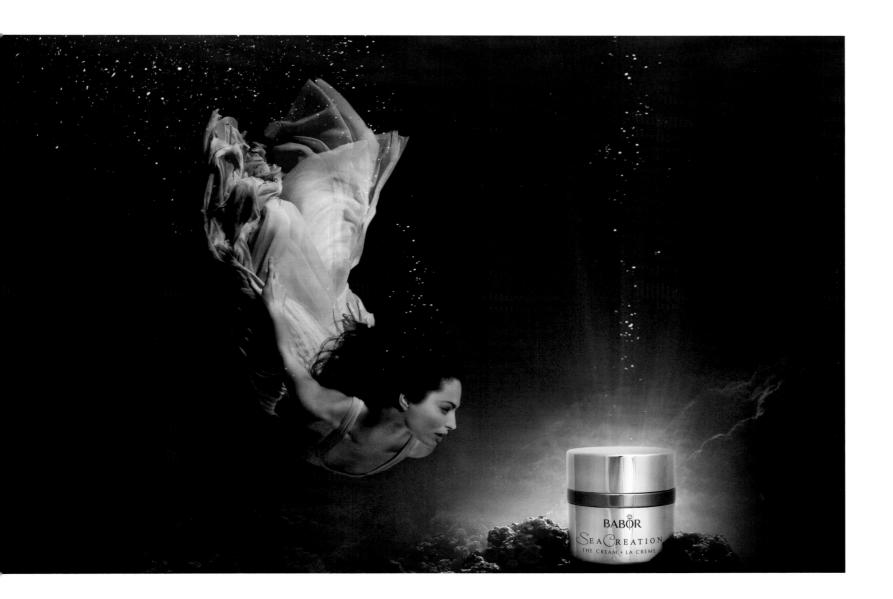

DIE ERFOLGSGESCHICHTE DER MARKE BABOR

Alles begann 1956 mit einer schwarzen Rose, dem Symbol vollkommener Schönheit. Seit mehr als 60 Jahren erforschen und entwickeln Experten am Stammsitz von Babor in Aachen Beautyinnovationen, die unter die Haut gehen – oftmals preisgekrönt. Heute ist Babor Marktführer in Deutschland und die einzige Luxus-Kosmetikmarke, die wirklich „Made in Germany" ist. Bis heute ist Babor in Familienbesitz. An der Spitze des Unternehmens steht die Inhaberfamilie in dritter Generation: Dr. Martin Grablowitz (Vorsitzender des Verwaltungsrates) und Isabel Bonacker (Mitglied des Verwaltungsrates) sind die Enkel von Dr. Leo Vossen, der das Unternehmen aufgebaut hat.

VON DER KUNST PRÄZISER HAUTPFLEGE

Fundierte wissenschaftliche Forschung ist ein Teil der Unternehmens-DNA, denn Haut ist so individuell wie ein Fingerabdruck und braucht daher maßgeschneiderte Pflege. Dabei verzichtet Babor aber auf Tierversuche. Alle Produkte aus dem Hause Babor basieren auf Präzisionsformeln mit innovativsten Wirkstoffen, wie zum Beispiel die Serie Reversive: Sie kann die Zeit für die Haut ein wenig zurückdrehen und verleiht dem Teint einen jugendlichen Glow. Oder Babors Bestseller – die Wirkstoff-Ampullen. Jede filigrane, gläserne Ampulle hütet ein eigenes High-Tech-Geheimnis der Babor Schönheits-Forschung und zwar so hoch konzentriert, dass schon 2 Milliliter für einen sofort sichtbaren Effekt sorgen. Die edlen Tröpfchen können mehr als Cremes. Dank flüssiger High-Tech Vehicle passieren die Wirkstoffe schneller die Hautbarriere und können gezielt in tiefen Hautschichten die Zellaktivität ankurbeln. Babor Ampullen wirken problemorientiert, sie bekämpfen die sichtbaren Zeichen von Stress, Feuchtigkeitsmangel, Fältchen oder Unreinheiten. 19 Millionen dieser kleinen Schönheitswunder schickt der Ampullen-Weltmeister jedes Jahr von Aachen aus auf die Reise rund um die Welt. Babor ist mit seinen Luxusprodukten und innovativen Massagetechniken weltweit in den Spas von 5-Sterne-Hotels vertreten, zum Beispiel beim UPGRADE TO HEAVEN-Partner Alila Villas Uluwatu auf Bali. Gäste genießen bei Babor Treatments eine außergewöhnliche Verbindung aus präzisen Ergebnissen und einem absoluten Verwöhnfaktor. Weitere Luxushotel-Spas mit Babor im Angebot sind: The Langham Sidney, Upperhouse in Göteborg, Al Maha Dubai, Viceroy Anguilla, El Lodge in der Sierra Nevada Spaniens sowie Weissenhaus Grand Village & Spa an der Ostsee und viele mehr.

THE SUCCESS STORY OF THE BABOR BRAND

It all started in 1956 with a black rose, the symbol of perfect beauty. For more than sixty years, experts have researched and developed award-winning beauty innovations, which go beneath the skin at Babor's headquarters in Aachen. Today Babor is the market leader in Germany and the only luxury beauty brand that is truly "Made in Germany". Babor is still family owned today. At the head of the company is the owner family in its 3rd generation: Dr Martin Grablowitz (Head of the Board of Directors) and Isabel Bonacker (Member of the Board of Directors), grandchildren of Dr Leo Vossen, who established the company.

ABOUT THE ART OF PRECISE SKINCARE

Sound scientific research is part of the Babor DNA, and with skin being as individual as a fingerprint, it needs tailor-made care. In all its processes, Babor is firmly against animal testing. All products by Babor are based on a precision formula with innovative substances. Such as the Reversive series which turns back the ageing clock of skin cells and bestows the skin tone with a youthful glow. Also Babor's bestseller is based on a precision formula: the ampoules of concentrated active ingredients. Every delicate, glassy ampoule guards its own high-tech secret of Babor beauty research so highly concentrated that even 2 millilitres show an immediate, visible effect. The precious droplets are more effective than creams. Thanks to its liquid high-tech vehicle the substances pass much faster through the skin barrier and can boost the cell activity in deep skin layers. Babor ampoules work specifically target fighting the visible signs of stress, dehydration, wrinkles and impurities. Every year ampoule-champion Babor sends 19 million of these little beauty wonders on a journey from Aachen around the world. Babor, with its luxury products and innovative massage techniques, is used in the spas of five-star hotels such as the UPGRADE TO HEAVEN partner Alila Villas Uluwatu in Bali. With a Babor treatment guests enjoy the exceptional combination of precise results and an absolute indulgence factor. Further luxury hotel spas where Babor treatments offered are: The Langham Sydney, Upperhouse in Gothenburg, Al Maha Dubai, Viceroy Anguilla, El Lodge in Spain's Sierra Nevada, the Weissenhaus Grand Village & Spa at the Baltic Sea, and a lot more.

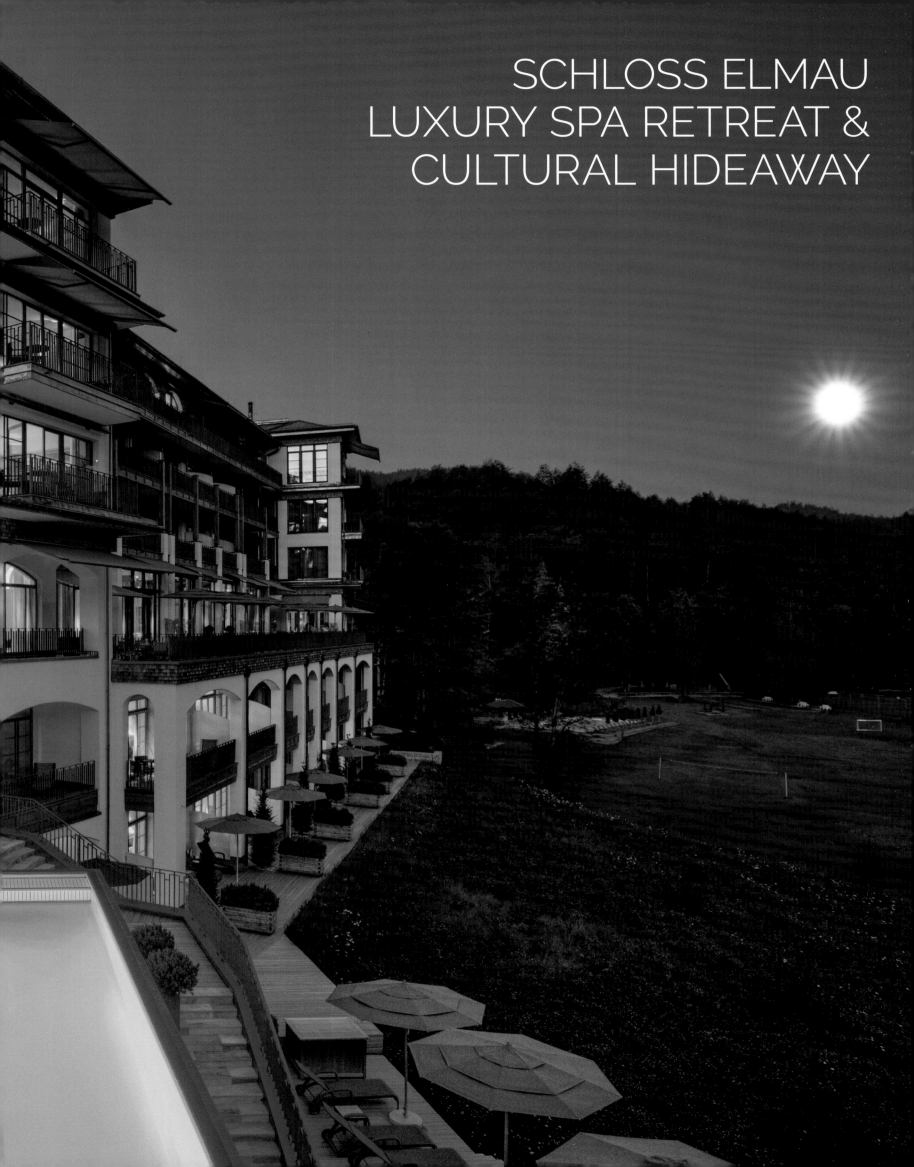

SCHLOSS ELMAU
LUXURY SPA RETREAT &
CULTURAL HIDEAWAY

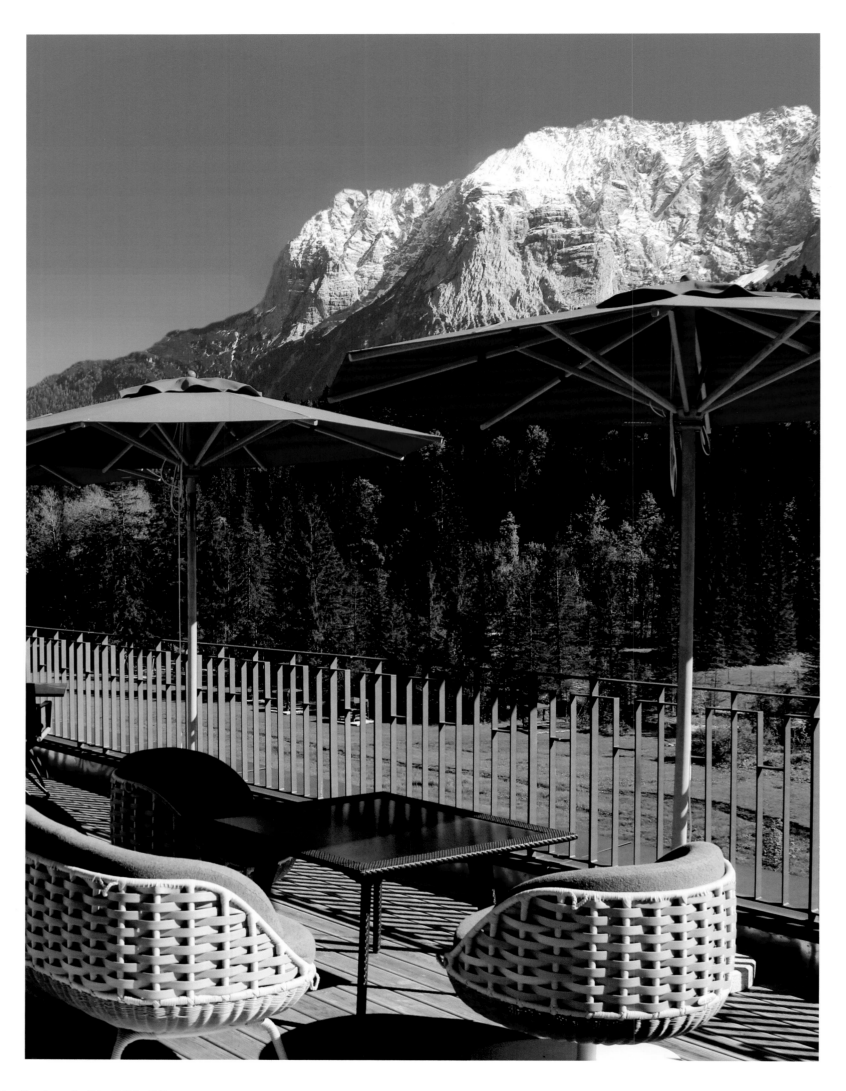

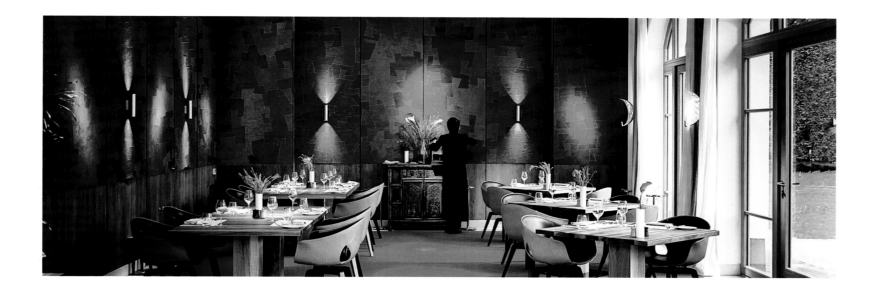

LOCATION

100 Kilometer südlich von München, in einem weiten und geschützten Hochtal der Bayerischen Alpen, nahe der Schlösser von König Ludwig II, befindet sich das luxuriöse 5-Sterne-Hotel Schloss Elmau Luxury Spa Retreat & Cultural Hideaway. Sattgrüne Wiesen, beeindruckende Berge und rauschende Gebirgsbäche bilden die Kulisse für dieses traumhafte Hotel. Über 70 Gipfel lassen sich in der Region rund um Elmau, geführt und ungeführt, erklimmen. Vom Schloss direkt führt ein Wanderweg zum Königshaus Schachen, dem vielleicht spektakulärsten Wanderziel der Alpen auf 1.800 Meter Höhe im Wettersteingebirge. Im Sommer sind die umliegenden Seen, Almen und Orte wunderbare Ziele für Jogger, Nordic Walker und Biker. Die hervorragende Lage von Schloss Elmau ermöglicht darüber hinaus Wildwassersport auf den umliegenden Flüssen, Reiten und Golfen auf hotelnahen Anlagen. Im Winter bieten sich Skifahrern über 200 Pistenkilometer und Langläufern 20 Kilometer Loipen direkt vor der Tür. Für Anfänger und Mutige gibt es zudem Rodelvergnügen am Schlosshang und ab der Schloss Elmau Alm. Gemütlichere Gäste freuen sich über zwei Eisplätze vor dem Schloss, Winterwandern und romantische Pferdekutschenfahrten.

HOTEL

Schloss Elmau Luxury Spa Retreat & Cultural Hideaway das bedeutet: zwei Hotels, ein Resort, fünf getrennte Spas für Familien und Damen sowie exklusive Bereiche für Erwachsene, zwei Gyms, ein Indoor-Pool, vier ganzjährig beheizte Außenpools, ein Yoga Center mit täglichen Yoga-Klassen und speziellen Yoga Retreats, neun Restaurants inklusive Sternegastronomie, vier Lounges und zwei Bars, Edutainment und Abenteuer für Kinder, drei Bibliotheken, eine Buchhandlung sowie ein einzigartiger Konzertsaal. Gäste eines Hotels können alle Angebote des jeweils anderen nutzen, wobei die Hotelanlage exklusiv für Hotelgäste reserviert ist. Schloss Elmau und das 2015 eröffnete Schloss Elmau Retreat bieten insgesamt 162 verschiedene Zimmer und Suiten mit einer traumhaften Alleinlage zwischen Karwendel, Wettersteingebirge und Zugspitze. Die großzügigen Räume vereinen stilistisch anspruchsvolle Architektur und zeitgemäßen Komfort, kunstvoll in Szene gesetzt mit subtilen asiatischen Einflüssen und warmem Licht. Die Suiten im 150 Meter entfernten Schloss Elmau Retreat bieten in spektakulärer Hanglage mit atemberaubender Aussicht auf den Wetterstein ein Maximum an Ruhe und Privatsphäre für Spa-Liebhaber und Ästheten. Asiatische Leichtigkeit und weltoffene Zurückgezogenheit zeigen sich in modernem Interior Design. Im Mittelpunkt des gastronomischen Angebots im Schloss steht das mit einem Michelin Stern sowie 17 Gault-Millau-Punkten ausgezeichnete "Luce d'Oro". Das "Fidelio" verzaubert Gäste mit täglich frisch zubereiteter thailändischer Hochküche. Im "La Salle" wird morgens das Frühstück serviert und abends in einer offenen Küche live gekocht. Im gemütlichen "Kaminstüberl" wählen Gäste zwischen Speisen aus dem "La Salle" und verschiedensten Fondues, ein breites gastronomisches Angebot findet sich im "Wintergarten" mit malerischem Wettersteinblick. Darüber hinaus stehen zahlreiche Bars und Lounges zur Verfügung. Komplettiert wird der Genuss für die Gäste durch ein vielfach prämiertes, herausragendes Spa-Angebot und Kulturprogramm für vier Generationen. Das Schloss Elmau Luxury Spa Retreat & Cultural Hideaway wurde international mit unzähligen Preisen ausgezeichnet und ist Mitglied der Leading Hotels Of The World.

LOCATION

Situated 100 kilometres south of Munich, in a wide and secluded high valley of the Bavarian Alps, close to the ancient castles of King Ludwig II, is the luxury five-star hotel Schloss Elmau Luxury Spa Retreat & Cultural Hideaway. Bright green meadows and roaring mountain streams form the perfect backdrop to this dreamlike hotel. In and around Elmau, there are over 70 summits one can climb, some with and some without a guide. A hiking trail starting directly at the hotel leads the guests to Königshaus Schachen, which is perhaps the most spectacular hiking destination in the Alps, at an altitude of 1,800 metres on the Wetterstein massif. Surrounded by lakes, Alpine meadows and villages hotel Schloss Elmau is a marvellous destination for all summer sports enthusiasts, offering white-water sports on the neighbouring rivers, horse riding and golfing on a nearby golf course. For winter sports fans, there are more than 200 kilometres of ski trails and 20 kilometres of cross-country ski trails directly by the hotel. Furthermore guests can enjoy sledging, an activity for both beginners and the brave, on the slopes and meadows just outside the castle. Guests who prefer the more relaxed variant will enjoy the two ice-skating rinks in front of the hotel, winter hiking or a romantic ride in a horse-drawn sleigh.

HOTEL

Schloss Elmau Luxury Spa Retreat & Cultural Hideaway consists of two hotels, one resort, five separate spas for families and women, as well as exclusive areas for adults, two gyms, one indoor pool, four all-year-round heated outside pools, a yoga centre offering daily yoga classes and special yoga retreats, nine restaurants including award-winning cuisine, four lounges and two bars, edutainment and adventure for children, three libraries, a bookshop and a unique concert hall. Guests of one hotel are welcome to enjoy the amenities of the others as well, bearing in mind that the hotel facilities are exclusively reserved for hotel guests. Schloss Elmau and the Schloss Elmau Retreat, which was newly opened in 2015, provide overall 162 different rooms and suites within a heavenly secluded location between Karwendel, Wetterstein massif and Zugspitze. The spacious rooms combine stylistically sophisticated architecture and contemporary comfort with subtle Asian influences and warm lighting. Thanks to its spectacular hillside location with a breathtaking view of Wetterstein, the suites in the 150-metre distant Schloss Elmau Retreat offer a maximum of peace and privacy for spa lovers and aesthetes. The modern interior design displays Asian ease and cosmopolitan seclusion. Recipient of a Michelin star and 17 Gault Millau points, the "Luce d'Oro" forms the centre of Schloss Elmau's culinary portfolio. The "Fidelio" enchants its guests with freshly prepared Thai haute cuisine. The "La Salle" offers breakfast in the mornings and an open live cooking experience in the evenings. In the cosy "Kaminstüberl" guests can choose from the "La Salle" menu or a variety of fondues. Additionally guests can find a broad and diverse culinary selection at the "Wintergarten", where they can enjoy a picturesque view of the Wetterstein. Furthermore a variety of bars and lounges are available for the guests' use. To make the guests' pleasure complete, there is a multiple-award-winning, extraordinary spa offering and a cultural programme for four generations. The Schloss Elmau Luxury Spa Retreat & Cultural Hideaway has been awarded with uncountable international awards and is a member of the Leading Hotels of the World.

Get your Upgrade

www.upgradetoheaven.com/schloss-elmau

SCHLOSS ELMAU LUXURY SPA RETREAT & CULTURAL HIDEAWAY . In Elmau 2, 82493 Krün, Germany . www.schloss-elmau.com

"KULTUR IST FÜR MICH DER EINZIGE GRUND, ÜBERHAUPT EIN HOTEL ZU BETREIBEN"

"To me, the only real reason
to run a hotel is culture"

– Dietmar Müller-Elmau,
Owner

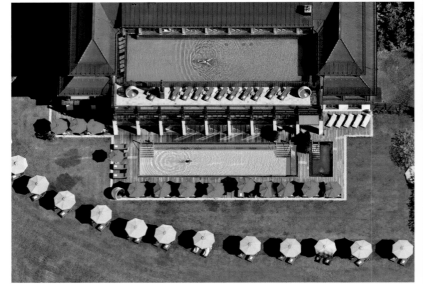

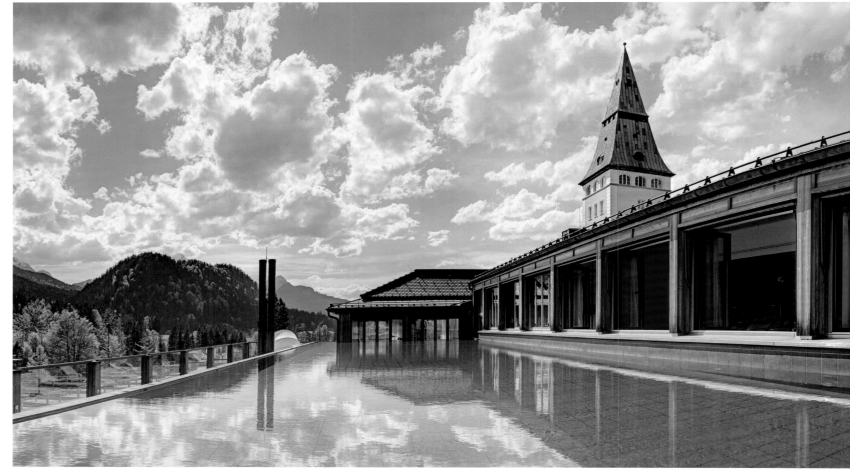

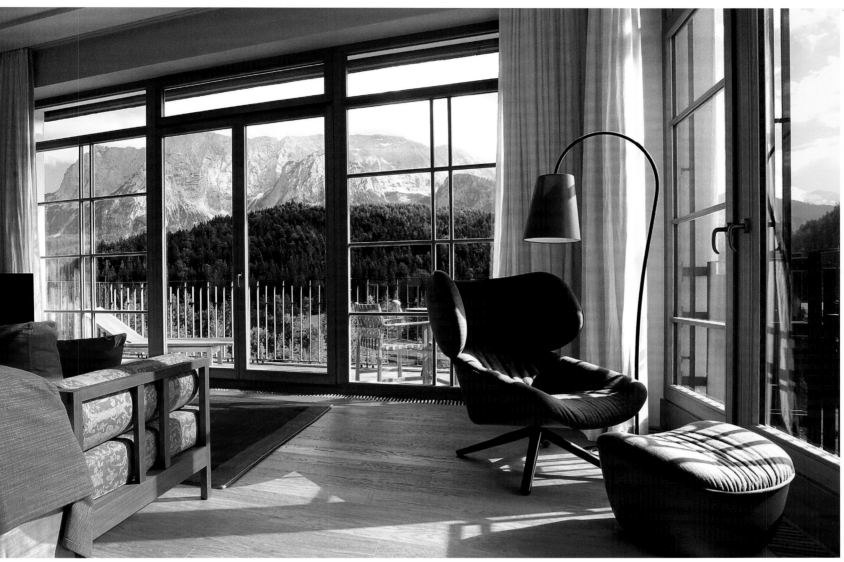

Hotel Schloss Elmau Luxury Spa Retreat & Cultural Hideaway's incomparable cultural programme offers concerts featuring top international acts and most popular jazz and pop musicians in the unique concert hall of Schloss Elmau. Another kind of pleasure is offered by the castle's four-storey, 3,000 sqm large Badehaus spa, where guests literally swim "between heaven and earth" in the rooftop pool. Further pools, saunas and brine-steam baths, as well as 15 treatment rooms and a hair studio, perfectly round off the offering and ensure the absolute well-being of the guests. The stunning oriental hammam combines religious, oriental design with ancient 200-million-year-old Solnhofer Jura limestone. Women and families are provided with a separate spa area. In the Retreat, guests can find the excellently equipped 2,000 sqm large Shantigiri Spa. Schloss Elmau Luxury Spa Retreat & Cultural Hideaway is one of the worldwide very few Jivamukti Yoga centres offering daily classes of different levels.

Zum unvergleichlichen Kulturprogramm von Schloss Elmau Luxury Spa Retreat & Cultural Hideaway gehören Konzerte mit internationalen Spitzenstars sowie angesagten Jazz- und Pop-Musikern im akustisch einmaligen Konzertsaal von Schloss Elmau. Ebenfalls größten Genuss bietet das vierstöckige, 3.000 qm große Badehaus Spa im Schloss, in dessen Rooftop-Pool die Gäste im wahrsten Sinne des Wortes "zwischen Himmel und Erde" schwimmen. Weitere Pools, Saunen und Sole-Dampfbäder sowie 15 Treatment-Räume und ein Hair Studio komplettieren das Angebot. Im Oriental Hamam wurde sakrales, orientalisches Design mit 200 Millionen Jahre altem Solnhofer Jurakalkstein kombiniert. Damen und Familien stehen separate Spa-Bereiche zur Verfügung. Im Retreat befindet sich das 2.000 qm große Shantigiri Spa, ebenfalls erstklassig ausgestattet. Schloss Elmau Luxury Spa Retreat & Cultural Hideaway ist weltweit eines der wenigen Jivamukti Yoga Center mit täglichen Klassen unterschiedlichen Levels.

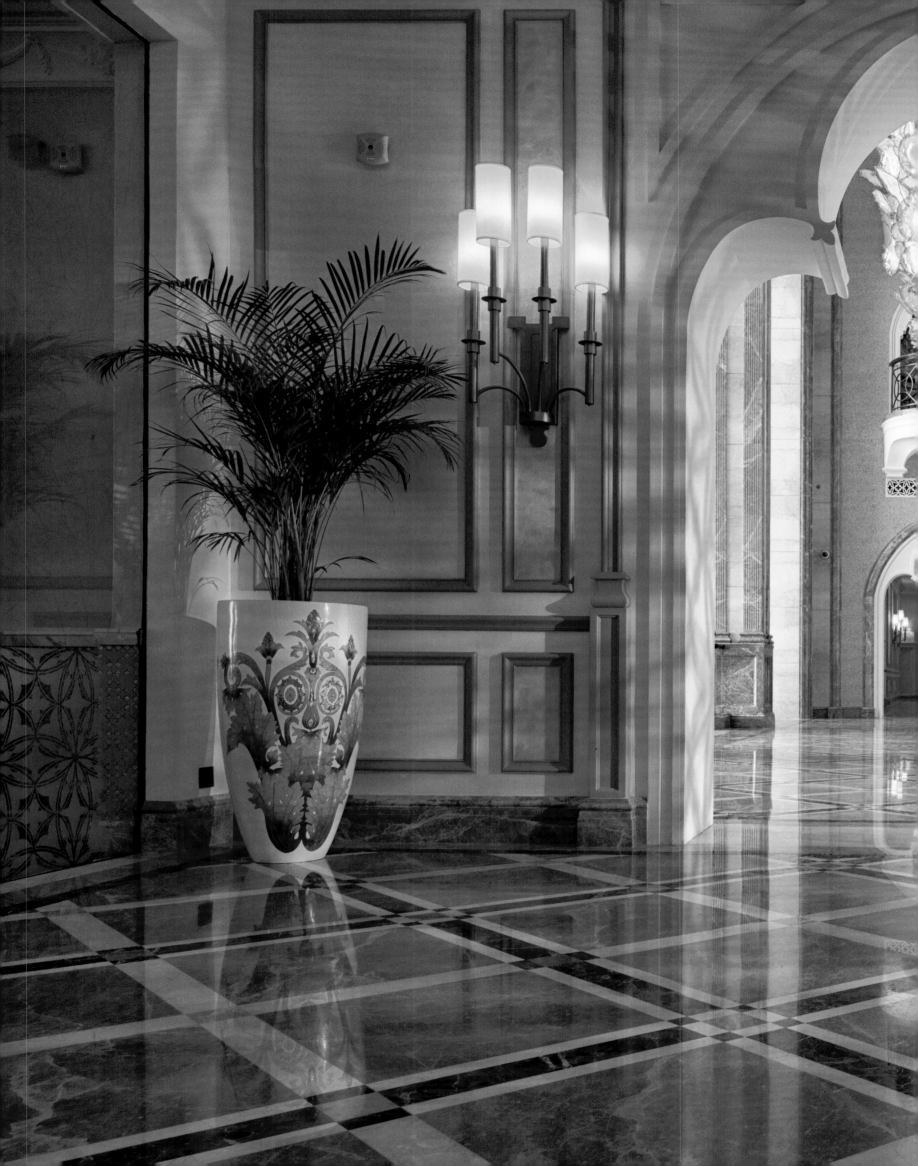

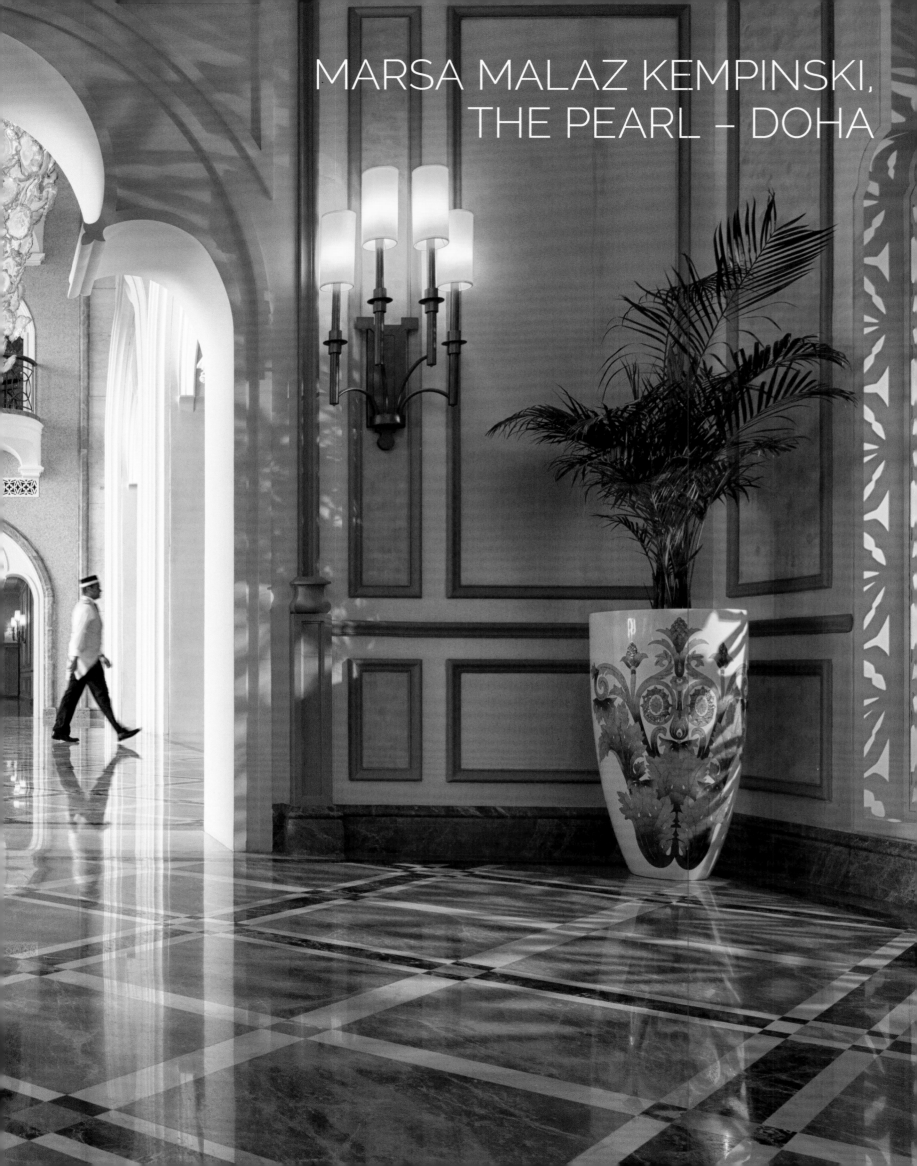

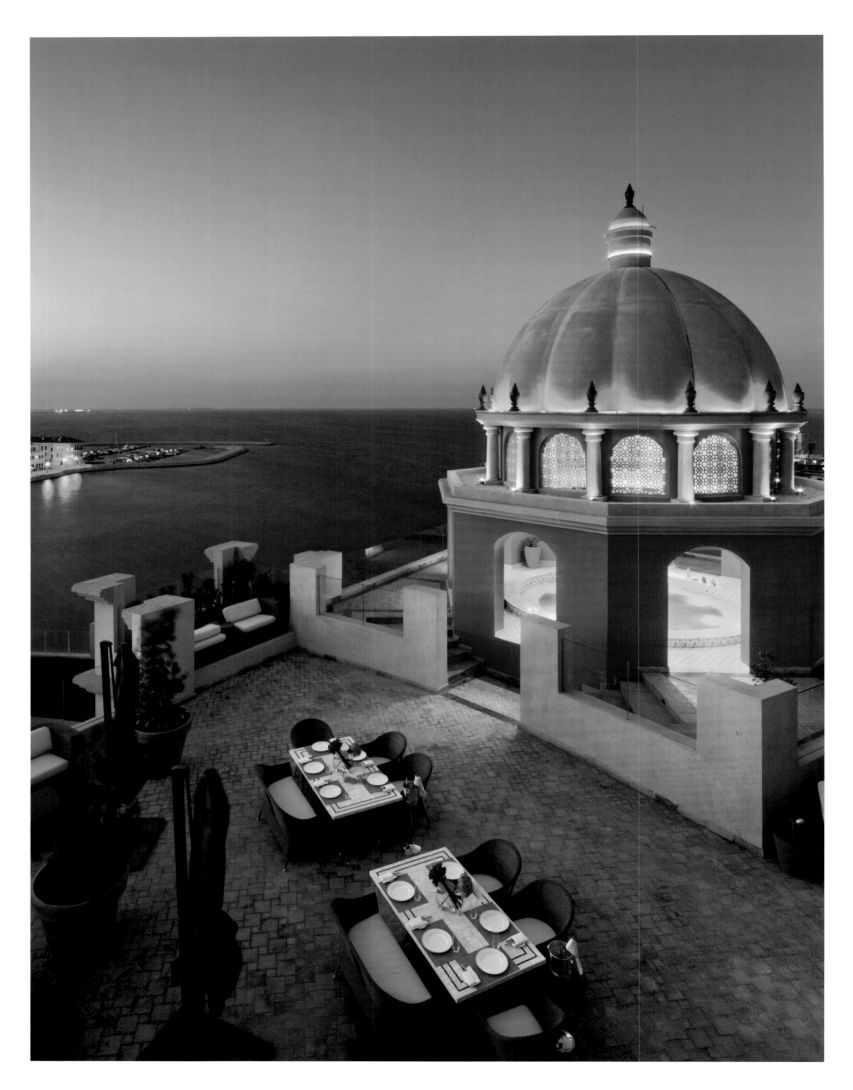

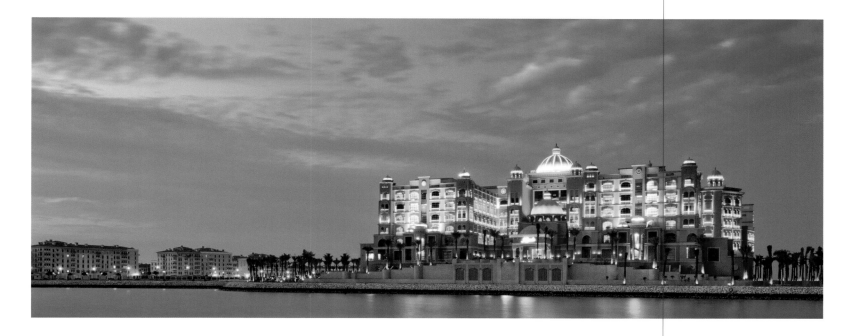

LOCATION

Das Kempinski Marsa Malaz befindet sich auf einer Privatinsel, die zu The Pearl-Quatar gehört, dem gigantischen Inselprojekt mit insgesamt 32 Kilometern neuer Küste. Doha, die Hauptstadt Katars, verbindet Tradition und Moderne auf fantastische Art und Weise und ist eine der am schnellsten wachsenden Städte der Welt. Während im Stadtteil West Bay einzigartige Hochhäuser in den Himmel emporsteigen, arbeitet man in der Innenstadt gleichzeitig an der Erhaltung traditioneller Gebäude wie dem Souq Waqif. Direkt neben dem Kempinski Marsa Malaz befindet sich das von Venedig inspirierte Quartier Qanat. Mit seinem farbenfrohen venezianischen Charakter, verschlungenen Kanälen und Fußgängerbereichen bietet es Besuchern und Bewohnern das Gefühl, mitten in Italien zu sein. Das Kempinski Marsa Malaz ist ein architektonisches Meisterwerk, in dem sich feinstes europäisches Design mit traditionellen arabischen Elementen verbinden. Umgeben vom azurblauen Wasser des Arabischen Golfs, mit den beeindruckenden Türmen von The Pear-Doha im Hintergrund, ist das erste Ultra-Luxushotel in einer der begehrtesten Lagen von Doha.

HOTEL

Opulenz und Größe, in Kombination mit dem atemberaubenden Blick über den Arabischen Golf, lassen einen Aufenthalt im Kempinski Marsa Malaz zu einem unvergesslichen Erlebnis werden. Mit der Kombination von europäischer Architektur und arabischen Elementen bleibt Kempinski seinen europäischen Wurzeln treu. Über 300 Balkone und Terrassen sowie mehr als 40 Kuppeln greifen das venezianisch-inspirierte Nachbarquartier auf.

Alle 281 luxuriösen Räume, die 69 Suiten, zwei Präsidenten und zwei Royal Suiten verfügen über Balkone oder Terrassen, von denen aus man einen prächtigen Blick über die Hotelanlage, den Arabischen Golf und The Pearl-Qatar hat. Das Interieur der Zimmer und Suiten bezeugt nicht nur Erbe und Historie der Region, sondern vermittelt durch handgearbeitete, mit Perlmutt-Elementen besetzte Möbel authentisch den Zauber Arabiens. In den Wellness- und Fitnesseinrichtungen des Kempinski Marsa Malaz finden sich neben dem ersten Clarins Spa des Mittleren Osten eine Vielzahl von Massagen, Beauty und Body Treatments, das Marsa Malaz Signature Hamam, Saunen, Dampfbäder, Kräuterbäder und Indoor-Pools. Im Health Club können Frauen und Männer separat voneinander oder auch gemeinsam trainieren. Es steht sogar ein Studio für privates Training zur Verfügung. Gäste finden zudem einen Outdoor-Tennisplatz, einen Joggingpfad oder Freizeiträder zur Nutzung auf der Insel vor.

Insgesamt elf verschiedene Restaurants stehen zur Auswahl: Vom familiären "Sawa", das Mittelmeerküche serviert, über das "Sufra" – traditionell levantisch mit modernem Twist, bis hin zur außergewöhnlichen spanischen Tapas-Location "El Faro". Der Roof Top Club wird dank High End Live Performances und Top-DJs als heißeste Partylocation Dohas gehandelt. Perfekter Ort, um sich tagsüber vom Nachtleben zu erholen oder einfach zu entspannen, ist der 150 Meter lange, abgeschiedene Privatstrand mit seinen Outdoor Pools, der wunderhübsch mit gemütlichen Liegen und Sonnenschirmen dekoriert ist.

LOCATION

The Marsa Malaz Kempinski is situated on a private island that is part of The Pearl-Qatar, Doha's man-made island with 32 kilometres of new seafront. Doha, the capital of Qatar, is one of the world's fastest growing cities and a fantastic mix of tradition and modernity. While iconic skyscrapers rise in the West Bay district, traditional buildings such as Souq Waqif in the heart of the city are restored and preserved. Next to Marsa Malaz Kempinski on The Pearl-Qatar, the Venetian-inspired Qanat Quartier is located. With its colourful Venetian character, intricate canals and pedestrian-friendly squares and plazas, Qanat offers residents and the local community the feeling of being in Italy. The Marsa Malaz Kempinski is an architectural masterpiece showing the finest European design blended with traditional Arabian elements, surrounded by the azure blue waters of the Arabian Gulf, with the impressive towers of The Pearl-Qatar in the background. It is the first ultra-luxury hotel in one of Doha's most sought-after locations.

HOTEL

The opulence and grandeur combined with breathtaking views over the azure Arabian Gulf make the Marsa Malaz Kempinski an unforgettable experience. Kempinski stays true to its European heritage, offering European architecture blended with traditional Arabian elements. Four magnificent oyster-shaped, Murano-glass chandeliers, over 300 balconies and terraces and more than 40 domes are visible Venetian influences of the neighbourhood. It's a true palace in every sense of the word.

All 281 luxury rooms, including 69 suites, two Presidential Suites and two Royal Suites have balconies or terraces, offering magnificent views over the hotel grounds, the Arabian Gulf and The Pearl-Qatar. The interior of the rooms and suites with handcrafted, mother-of-pearl elements embedded in each piece, not only reflect the region's heritage and history, but also give an authentic Arabic feel. The well-being and fitness facilities at Marsa Malaz Kempinski feature the first Spa by Clarins in the Middle East, as well as a variety of massages, beauty and body treatments, the Marsa Malaz signature hammam, saunas, steam rooms, herbal baths and indoor plunge pools. The Health Club provides a female-only fitness area and a mixed fitness area. A personal training studio for additional privacy is also available. Guests find an outdoor tennis court, a jogging trail and exercise or leisure bicycles for use on the island.

Eleven gastronomic outlets are offered to choose from. From "Sawa", where families and friends can enjoy a variety of culinary delicacies from the Mediterranean, to "Al Sufra", a traditional Levant experience with a modern twist, and "El Faro", a unique and exciting Spanish tapas destination. The rooftop club is said to be the hottest venue on Doha's night-life scene with high-end live performances and top DJs. The perfect spot to recover and relax during the daytime is the secluded 150-metre private beach and outdoor pools, which are beautifully equipped with comfortable sun loungers and umbrellas.

Get your Upgrade

www.upgradetoheaven.com/marsa-malaz-kempinski

MARSA MALAZ KEMPINSKI, THE PEARL – DOHA . LLC Costa Malaz Bay, Marsa Malaz Island, 24892 The Pearl, Qatar . www.kempinski.com/marsamalaz

"MARSA MALAZ KEMPINSKI, THE PEARL – DOHA IS RESHAPING THE CONCEPT OF LUXURY IN QATAR"

"Das Marsa Malaz Kempinski,
The Pearl - Doha setzt neue
Standards für Luxus in Katar."

– Wissam Suleiman,
General Manager

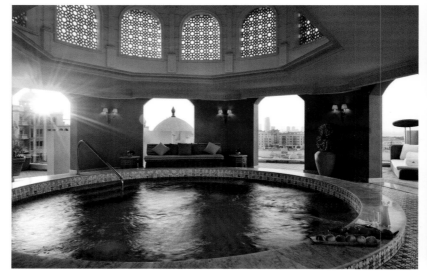

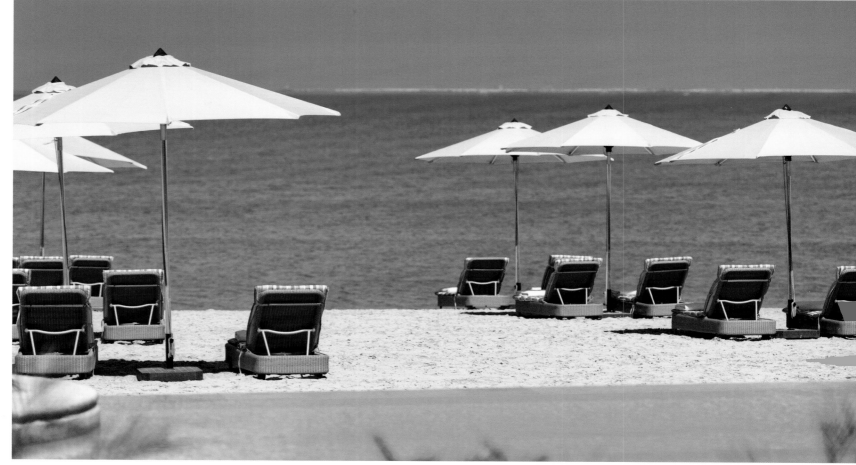

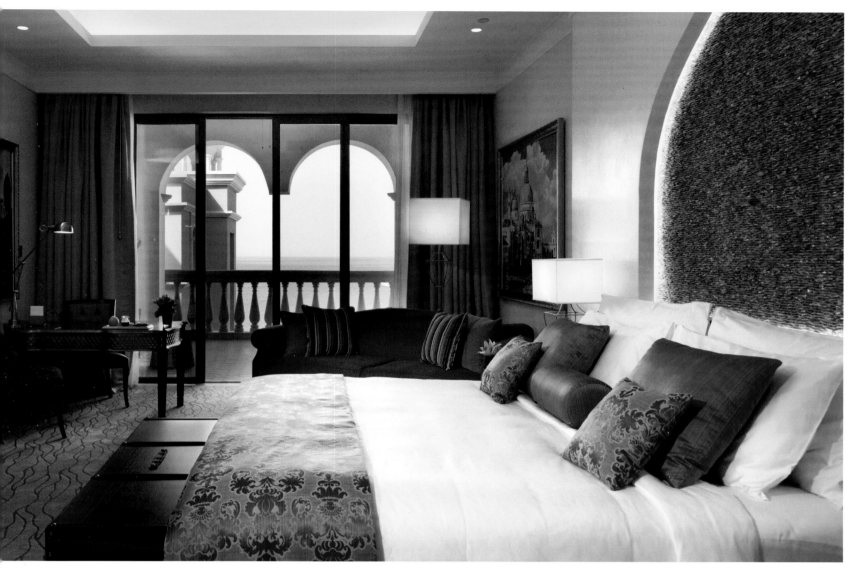

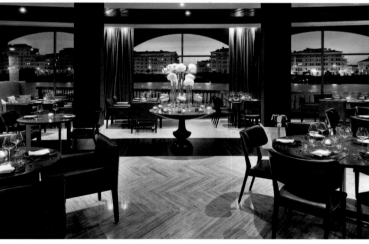

For all the rooms and suites a complimentary personal butler service is offered. Personal butlers are ready to welcome and meet guests' every need, from unpacking the luggage to anticipating guests' personal preferences. Butlers know and understand every guest and are there to provide assistance. The key to Doha is the Marsa Malaz Kempinski concierge service, which boasts in-depth knowledge of local customs, traditions and attractions. The concierges know every must-see place around town, have exclusive access to events, and understand where to acquire the perfect gift. Limousine transfers and luxurious airport transfers are available with a prestigious fleet of Jaguars, Land Rovers, BMWs and Rolls Royces. With its impeccable, traditional hospitality, the Marsa Malaz Kempinski offers a new dimension of luxury holiday in Qatar.

Bei allen Zimmern und Suiten ist ein Personal Butler Service inbegriffen. Persönliche Butler heißen ihre Gäste willkommen und sind bemüht, ihnen jeden Wunsch zu erfüllen – angefangen vom Auspacken der Koffer bis hin dazu, den persönlichen Vorlieben der Gäste zuvorzukommen. Butler kennen und verstehen jeden Gast und stehen ihnen unterstützend zur Seite. Der Schlüssel zu Doha ist der Kempinski Marsa Malaz Concierge Service, bekannt für seine tiefen Kenntnisse lokaler Gebräuche, Traditionen und Attraktionen. Die Concierges kennen alle Orte der Stadt, die man gesehen haben muss, haben exklusiven Zugang zu Events und wissen, wo sich das perfekte Geschenk finden lässt. Eine Fahrzeugflotte von Jaguar, Land Rover, BMW und Rolls Royce steht für luxuriöse Flughafentransfers und andere Fahrten zur Verfügung. Dank perfekter und traditioneller Gastfreundschaft erleben Gäste im Kempinski Marsa Malaz eine völlig neue Dimension von Luxusurlaub in Katar.

ALL-NEW JAGUAR F-PACE
PERFORMANCE ELEVATED.

Welcome to Jaguar as you've never seen it before. Now you can enjoy the dramatic drive and beauty Jaguar is renowned for, with added practicality.

Inspired by F-TYPE, its powerful, muscular looks give the All-New F-PACE a head-turning road presence. And it delivers the connected steering feel and sharp, responsive handling of a sports car too, thanks to its aluminium double wishbone front and Integral Link rear suspension.

A master of sporting performance and everyday practicality, F-PACE raises the game.

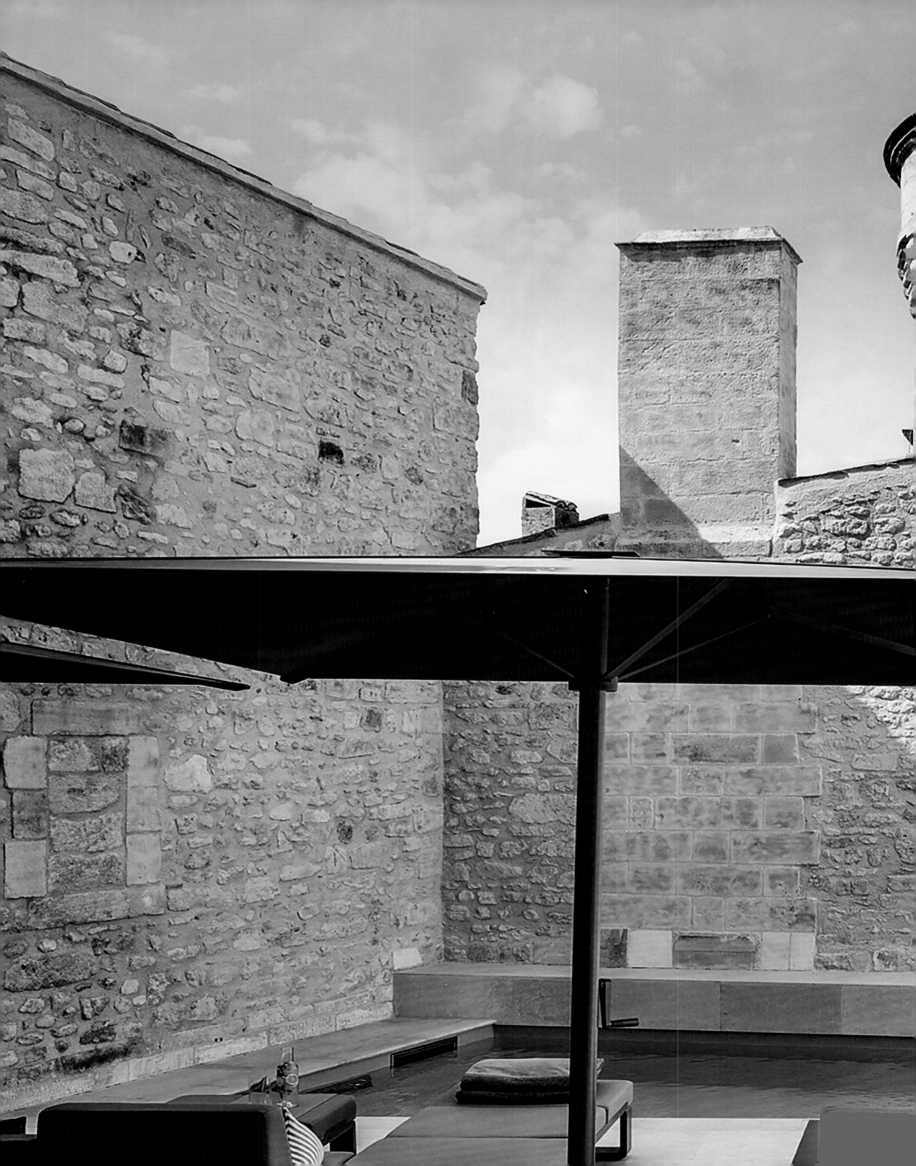

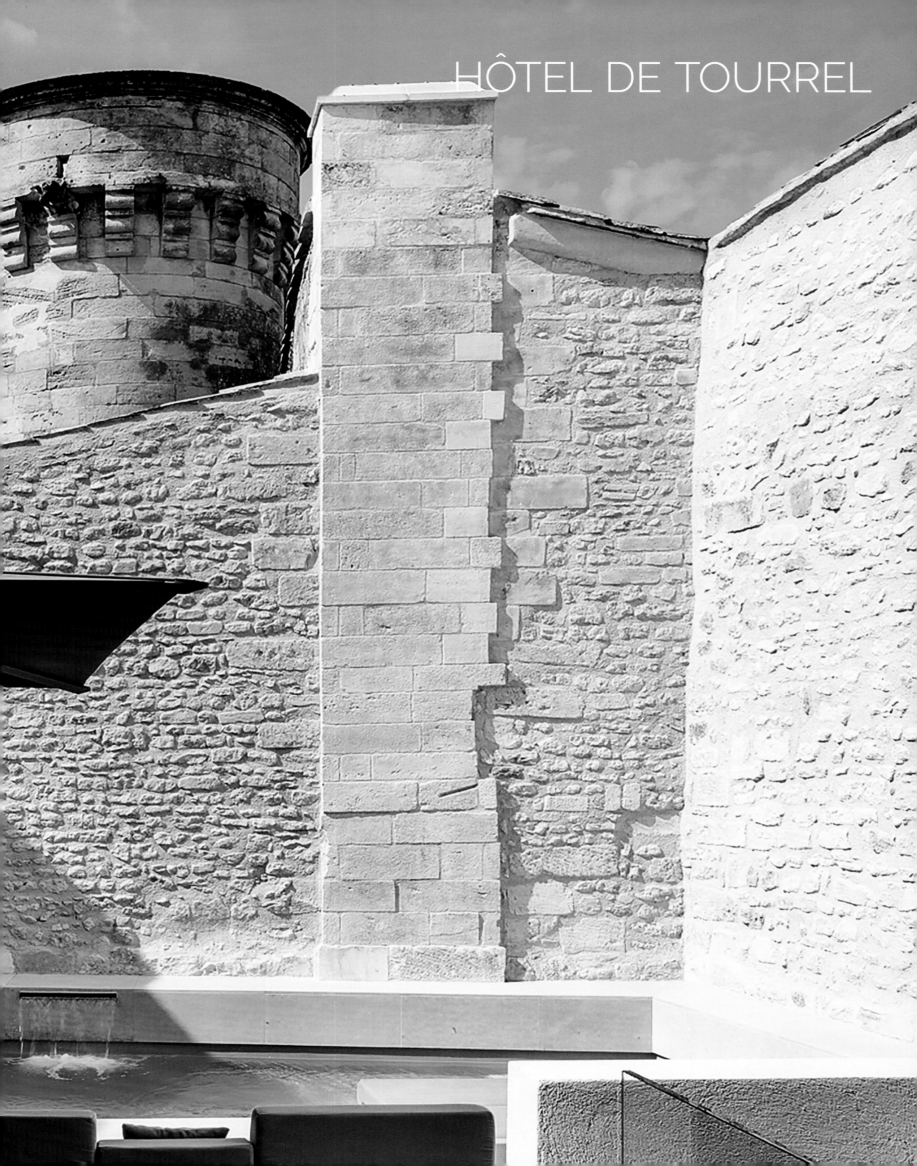

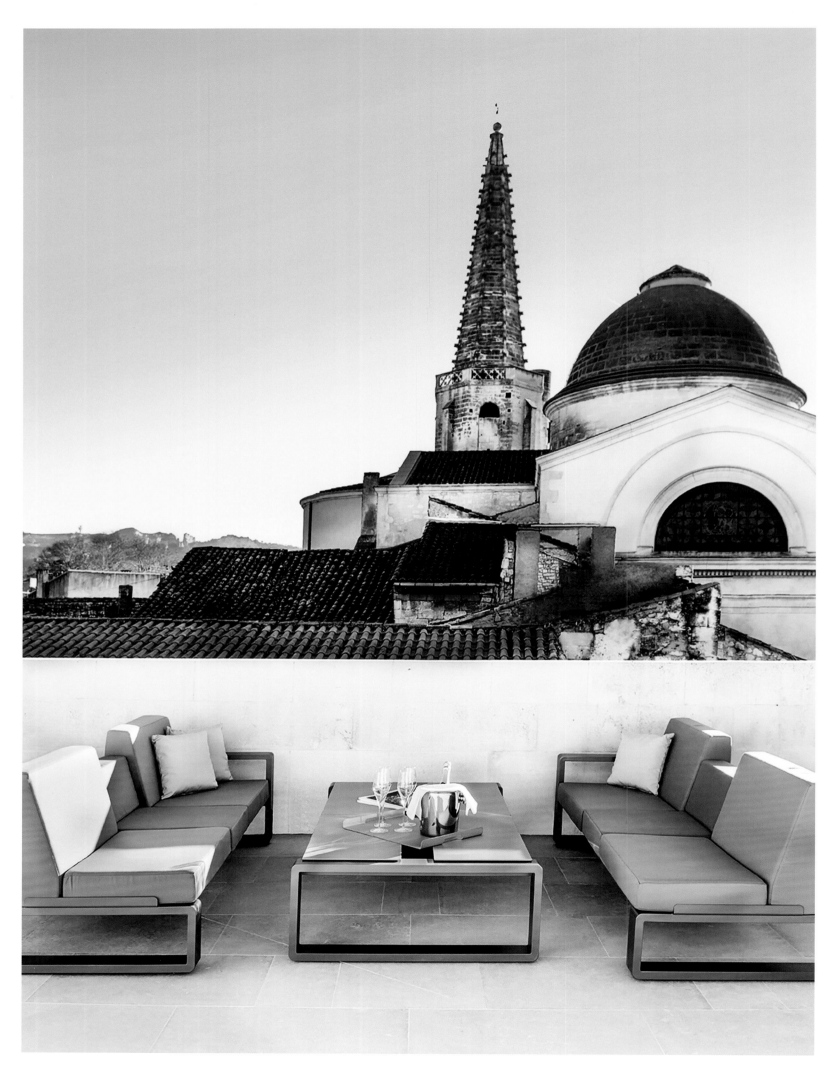

LOCATION

Das Hôtel de Tourrel von Margot Stängle und Ralph Hüsgen liegt in Südfrankreich, mitten im historischen Zentrum des kleinen Städtchens Saint-Rémy-de-Provence, das schon Van Gogh inspirierte. Mit seiner imposanten Fassade ist das aufwändig restaurierte Haus aus dem 17. Jahrhundert unübersehbar zwischen seinen historischen Nachbarn. Die nähere Umgebung bietet viele historische Sehenswürdigkeiten, wie das Dorf Baux-de-Provence, die Städte Avignon und Arles sowie ganze 34 Weinregionen. Auf Wunsch beginnt der Aufenthalt im Hôtel de Tourrel stilecht mit einer Abholung vom Flughafen Marseille mit der hoteleigenen Göttin – einem restaurierten beigen Citroen DS.

HOTEL

Der frühere Adelssitz aus dem 17. Jahrhundert wurde um einen modernen Flügel ergänzt. Heute empfängt das Hôtel de Tourrel seine Gäste in einzigartigem Ambiente. Originale Steinwände, großzügige Räume, hochwertige Materialien, ein Farbkonzept, das die Natur aufgreift, und gekonnt kombinierte Designklassiker verwöhnen das Auge. Ganze sieben Zimmer, ein jedes individuell gestaltet, stehen in dem kleinen Luxushotel zur Verfügung. Ein außergewöhnliches Vergnügen sind die beiden Dachterrassen des Hotels, eine mit wunderbarem Blick über die Ziegeldächer von Saint-Rémy und in die Berge, die andere mit einem privaten Pool. Das Hôtel de Tourrel bietet Liebhabern von Architektur und Design und auch all denen, die raffinierte Küche und guten Wein schätzen, für ihren Urlaub ein absolut außergewöhnliches Zuhause mitten in der Sehnsuchtsregion Provence.

LOCATION

Margot Stängle and Ralph Hüsgen's Hôtel de Tourrel is located in the south of France, in the historical centre of the little town Saint-Rémy-de-Provence, which already inspired Van Gogh. With its impressive façade, the complex renovated house from the 17th century stands out from its historic neighbours. The local area offers a variety of ancient sights such as the village Baux-de-Provence, the cities Avignon and Arles as well as 34 wine regions. Upon request, guests can start their stay at Hôtel de Tourrel with being picked up from Marseille's airport by the hotel's own goddess - a restored Citroen DS.

HOTEL

The private mansion of the 17th century was extended with a modern wing. Nowadays Hôtel de Tourrel welcomes its guests in an unique ambience with original stone works, spacious rooms, high-quality materials, a colour concept inspired by nature and skilfully combined classical design pieces delight the eye. Seven rooms, each individually designed, are offered by the small luxury hotel. The hotel's roof terraces are an extraordinary pleasure with one offering a picturesque view over the tiled roofs of Saint-Rémy and the mountains, the other one with a private pool. For lovers of architecture and design, as well as those who appreciate refined cooking and fine wines, Hôtel de Tourrel offers an unusual and very special "home" in the heart of Provence.

Get your Upgrade

www.upgradetoheaven.com/hotel-de-tourrel

HÔTEL DE TOURREL . 5 Rue Carnot, 13210 Saint-Rémy-de-Provence, France . www.detourrel.com

THE NEW GOURMET LUXURY DESTINATION IN FRANCE'S CULTURAL FIRMAMENT

Das neue Luxus-Gourmet-Traumziel
an Frankreichs kulturellem
Himmelszelt

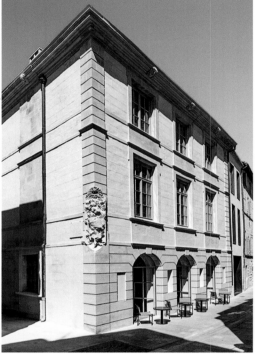

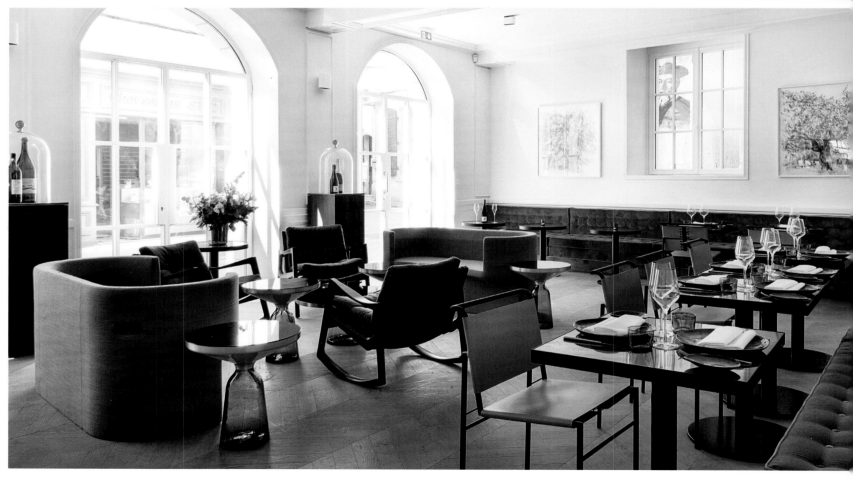

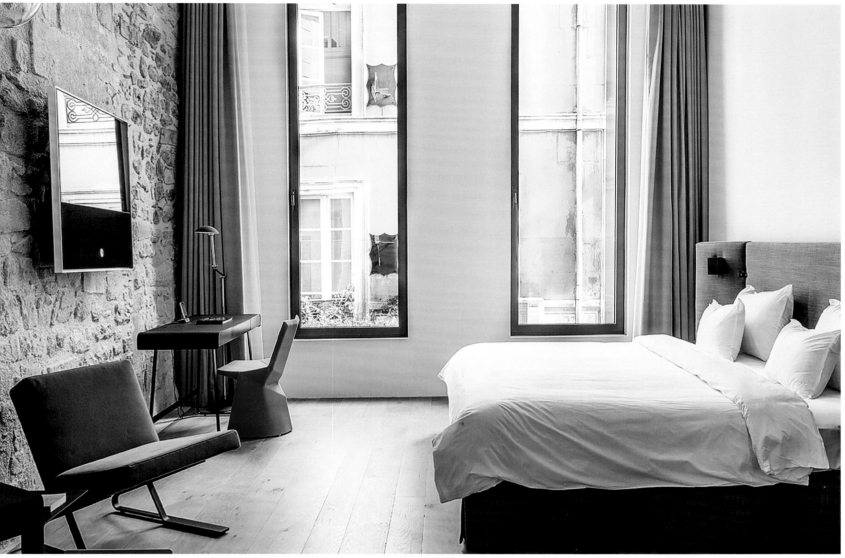

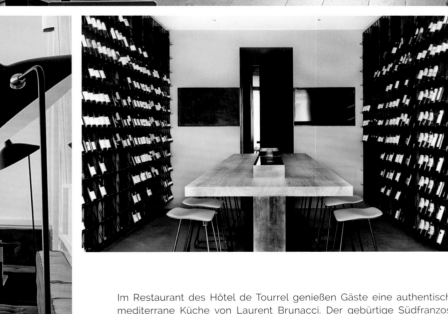

At Hôtel de Tourrel's restaurant guests enjoy the authentic Mediterranean cuisine of Laurent Brunacci. The native south French was Head Chef at various 5-star hotels in New York and Dubai over the past 20 years. Furthermore, the hotel offers a wine shop, in which Ralph Hüsgen sells 400 different wines mainly from the region and France. It is the most exciting spot to enjoy a pleasant glass of wine in Saint-Rémy-de-Provence.

Im Restaurant des Hôtel de Tourrel genießen Gäste eine authentische mediterrane Küche von Laurent Brunacci. Der gebürtige Südfranzose war in den letzten 20 Jahren gesamtverantwortlicher Küchenchef diverser 5-Sterne-Hotels in New York und Dubai. Zum Hotel gehört auch eine Vinothek, in der Ralph Hüsgen eine Weinauswahl von 400 Positionen, vor allem aus der Region aber auch aus ganz Frankreich, bietet. Sie ist längst der spannendste Platz für ein gutes Glas Wein in Saint-Rémy-de-Provence geworden.

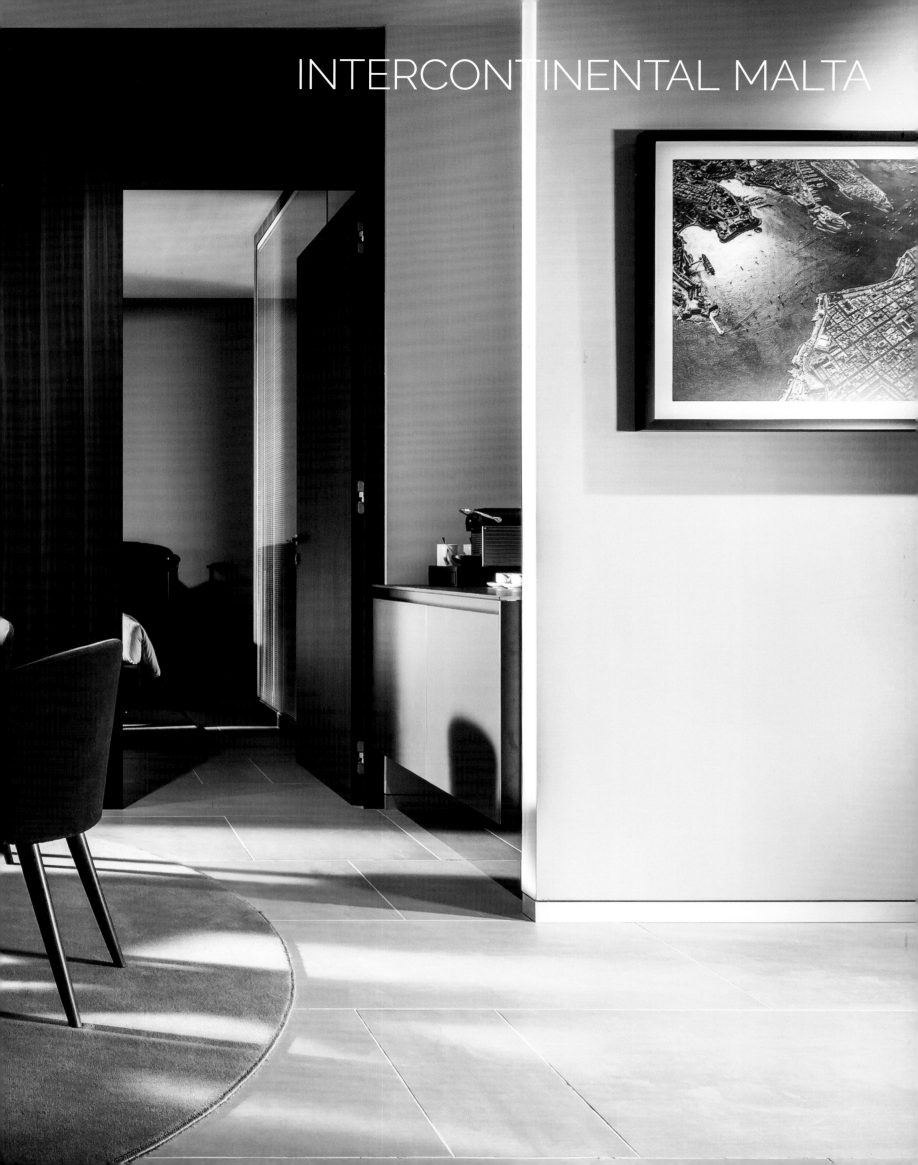

Modernes Design trifft
auf Jahrtausende alte
maltesische Geschichte.

Modern design meets
thousands of years of
Maltese history.

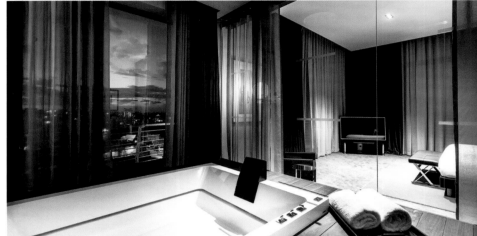

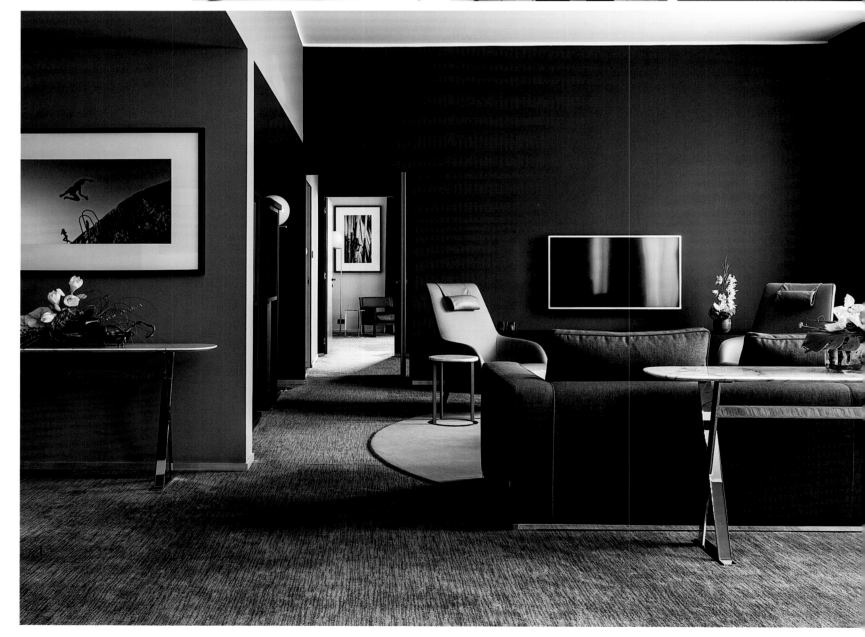

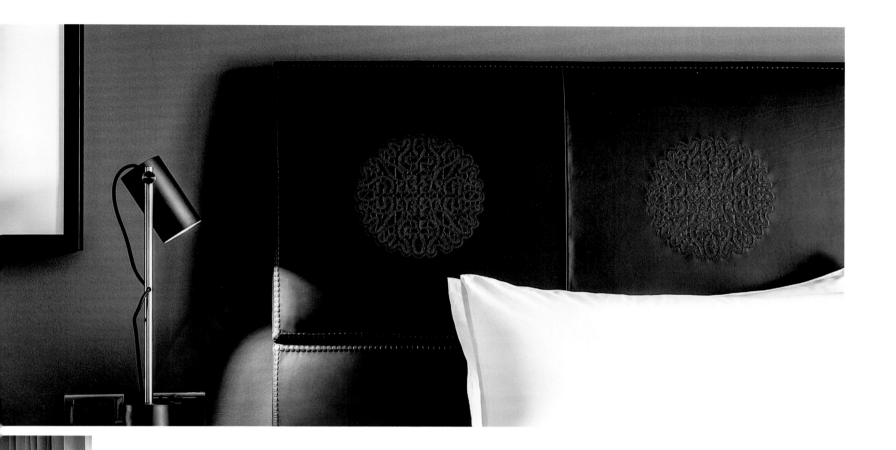

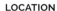

LOCATION

Die Mittelmeerinsel Malta genießt fast ganzjährig schönes Wetter und ermöglicht somit das Erkunden der über 7.000 Jahre alten Geschichte nach Herzenslust. Die Landschaft und Architektur der Insel bieten eine fantastische Urlaubskulisse. Malta verbindet Naturgenuss mit idyllischen Stränden, kristallklarem Wasser und pulsierendem Leben und bietet somit die perfekte Umgebung für jede Art von Urlaub. Hier findet sicherlich jeder etwas nach seinem Geschmack. Das InterContinental Malta liegt an der Nordküste der Insel in der St. George's Bay. Von hier aus können die Gäste Einkaufsmöglichkeiten, Entertainment und Nachtclubs gut zu Fuß erreichen. Die Inselhauptstadt Valletta, Teil des UNESCO-Weltkulturerbes, ist in nur 15 Autominuten erreichbar und bis zum Flughafen sind es lediglich 20 Minuten.

HOTEL

Alle 481 Zimmer des InterContinental Malta sind elegant möbliert und mit allem Komfort, der von einem Luxushotel erwartet wird, ausgestattet. Die luxuriösen Highline Suiten bieten ein dezent raffiniertes Interior kombiniert mit modernster Technik, betont durch die schlichte Eleganz und das individuell designte Mobiliar von Minotti. Gäste der Highline Suites haben Zugang zum Infinity-Pool auf der Dachterrasse und der Club InterContinental Lounge im 15. Stockwerk des Hauses, die beide von Hotelbutlern betreut werden und einen atemberaubenden Blick über die Insel und das Mittelmeer bieten. Die insgesamt sechs Restaurants und sechs Bars liegen an verschiedenen Orten im Resort und servieren ganztägig eine Auswahl an regionalen und internationalen Speisen, die sowohl drinnen als auch draußen oder direkt am Meer genossen werden können. Dazu gehören das kreative "Waterbiscuit" Restaurant, das "Harruba" als Hauptrestaurant des Hotels und das "Paranga" Restaurant, das direkt am Meer liegt. Die Freizeiteinrichtungen des InterContinental Malta umfassen einen Lagunen-Außenpool, einen beheizten Innenpool, den Planet Trekkers Kids Club, ein Fitnesscenter sowie das Carisma Spa & Wellness mit traditionellem türkischen Hamam sowie einem Friseur. Entspannung, Action und Spaß zugleich bietet der InterContinental Beach Club, zu dem ein exklusiver Sandstrand und eine Reihe von Bars und Restaurants gehören. Am Strand finden die Gäste zudem ein umfangreiches Angebot an Wassersport-möglichkeiten.

LOCATION

The Mediterranean island Malta benefits from almost year-round beautiful weather, enabling one to easily explore over 7,000 years of history to their heart's content. The island's landscape and architecture provides a fantastic backdrop for any vacation, with a combination of natural beauty idyllic beaches, crystal clear water and a pulsating lifestyle, all are certain to find something to suit their tastes. InterContinental Malta is located on the island's northern coast in St. George's Bay, here excellent shopping facilities, entertainment and night clubs are all within easy reach. The island's capital Valletta, a UNESCO's World Heritage Site, is just a 15 minute drive away and it is only a 20 minute drive to the airport.

HOTEL

All 481 bedrooms are elegantly furnished having all the comforts expected of a luxury property. The luxury Highline Suites offer refined sophistication blended subtlety with state of the art technology and have an emphasis on understated elegance and uniquely designed Minotti furniture. Guests may also have access to the rooftop infinity pool and Club InterContinental lounge with its breathtaking views of the island and the Mediterranean, both served by the hotel's butlers. With six restaurants and six bars, the hotel offers varied local and international cuisine at all times of day, including seaside, indoor and al fresco dining. These include the ever creative "Waterbiscuit", the hotel's main restaurant "Harruba" and its seaside restaurant "Paranga". InterContinental Malta's leisure facilities consist of a lagoon shaped outdoor pool, a heated indoor pool, the Planet Trekkers Kids Club, a gym as well as the Carisma Spa & Wellness with its traditional Turkish Hamam and a hairdresser. InterContinental Beach Club offers relaxation, action and fun at the same time with an exclusive sandy beach, bars, restaurants and water sport activities.

Get your Upgrade

www.upgradetoheaven.com/intercontinental-malta

INTERCONTINENTAL MALTA . St George's Bay, Malta STJ 3310, Malta . www.intercontinental.com

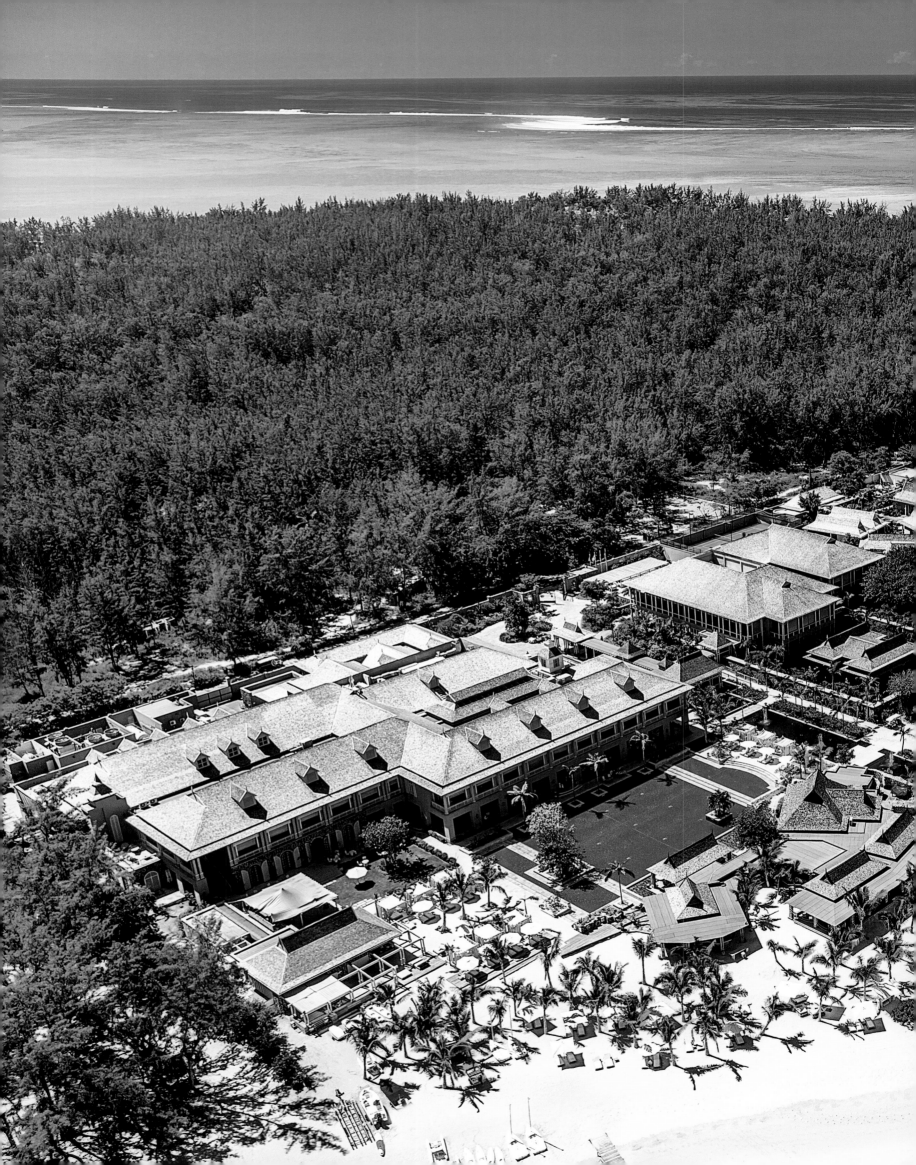

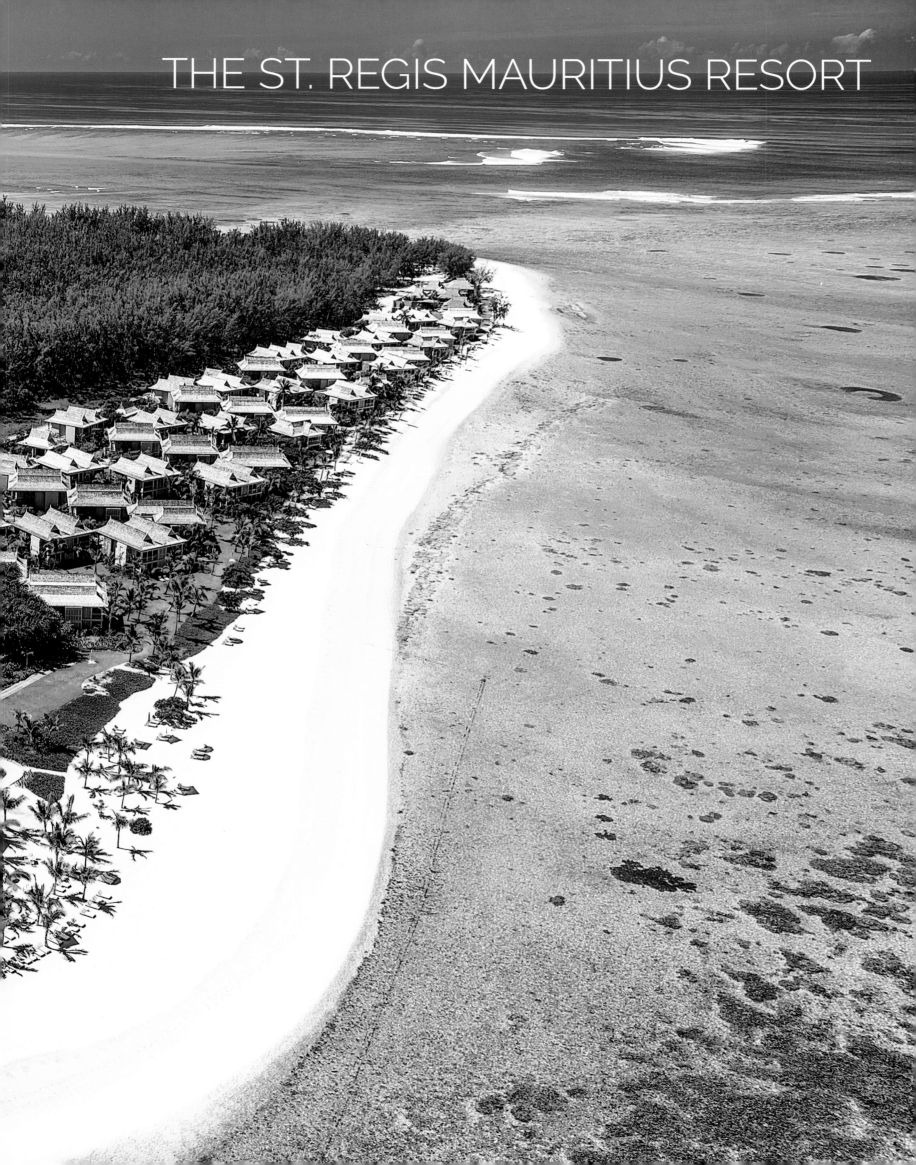

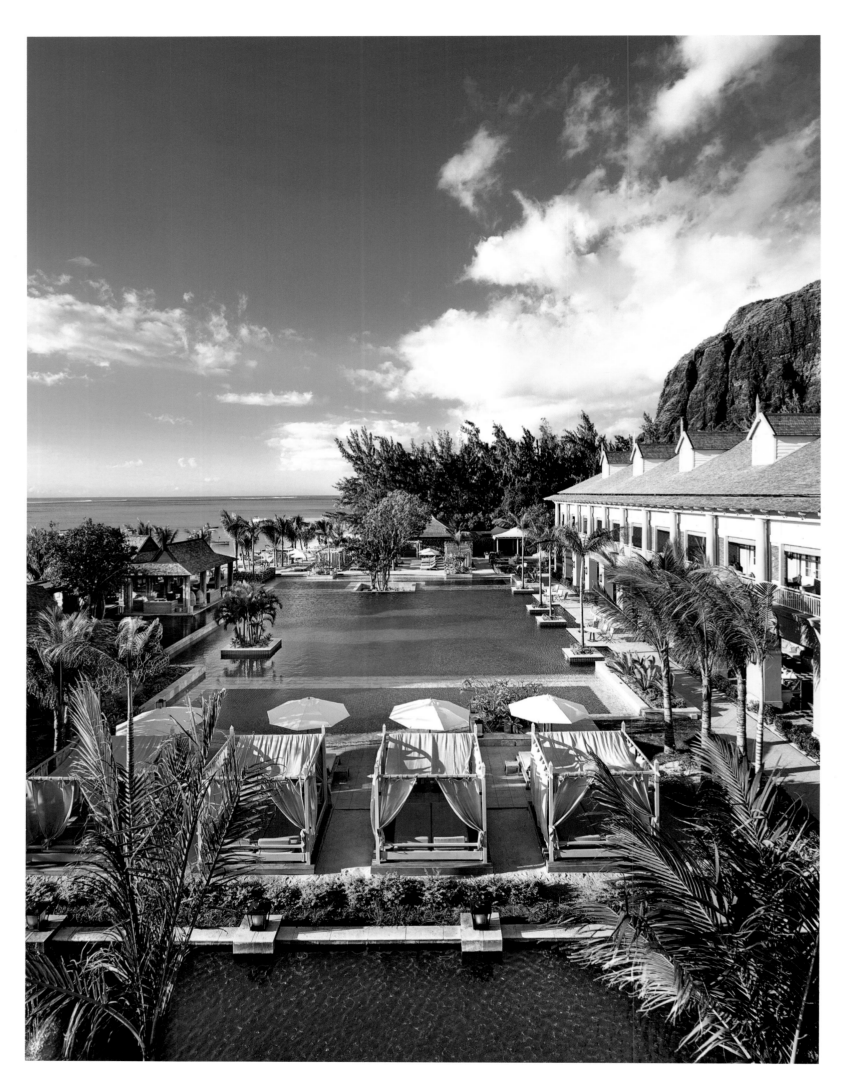

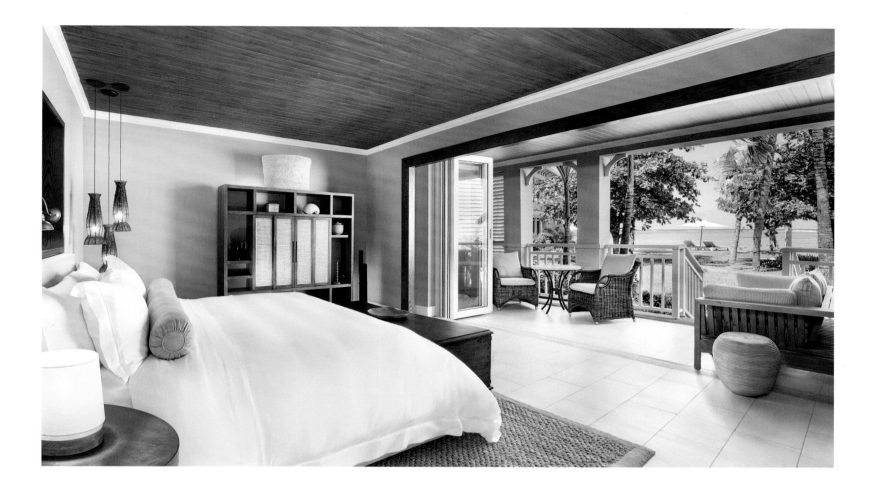

LOCATION

Mauritius, die Perle im Indischen Ozean, bietet die schönsten Landschaften, von sprudelnden Wasserfällen bis zu spektakulären Aussichten in den Bergen. Die Le Morne Halbinsel ist eine fesselnde und verlockende Adresse für die Weltelite der leidenschaftlichen Kitesurfer, aber auch für Anfänger. Der Surfspot an der südwestlichen Spitze der Insel, wo sich auch das St. Regis Mauritius Resort befindet, liegt in einer flachen türkisblauen Lagune entlang eines ein Kilometer langen Sandstrands. Mauritius bezaubert durch ihre unwiderstehliche Schönheit, Heimat zahlreicher Kulturen und Traditionen und ist zugleich eine Oase des Friedens und der Ruhe. Der große Flughafen SSR International Airport befindet sich 75 Minuten mit dem Auto vom St. Regis Mauritius Resort entfernt.

HOTEL

Das St. Regis Mauritius Resort bietet 172 exquisite Gästezimmer, Suiten und die direkt an der Küste gelegene, private St. Regis Villa im Kolonialstil. Alle Zimmer sind mit St. Regis Betten, einer großzügigen Terrasse und eleganten Badezimmern ausgestattet und bieten exklusive Annehmlichkeiten wie die berühmten St. Regis Butler und Pflegeprodukte von Remède. Dank der fünf kulinarischen Erlebniswelten bietet das Resort Feinschmeckern ein riesiges Angebot an kulinarischem Genuss. So wird beispielsweise im "Le Manoir" französisch inspirierte und traditionelle mauritische Küche serviert, und im eleganten Gourmet-Grillrestaurant "The Boathouse Grill" speisen Gäste direkt am Strand. Im Iridium Spa des Resorts können sich Gäste in zwölf Behandlungszimmern und sieben Manor House Spa Suiten verwöhnen lassen. Das St. Regis Mauritius Resort hat den weltweit ersten Prestige Kite Surf ION Club, der Kitesurfern maßgeschneiderten Service, von der Vermietung und Aufbewahrung erstklassiger Ausrüstung bis zum Privatunterricht und Insidertipps der Einheimischen, bietet. Für die Freizeitgestaltung bietet das Resort darüber hinaus zwei Pools, ein Fitnessstudio, einen Tennisplatz, eine Bibliothek mit Wintergarten sowie das private Kino La Palme d'Or. Mit seinen wunderbaren weißen Sandstränden ist Mauritius der perfekte Ort für Hochzeiten oder Flitterwochen. Dank des The Kite Flyers Club sowie zahlreicher kostenfreier Aktivitäten und Wassersportmöglichkeiten ist das St. Regis Mauritius Resort auch das perfekte Ziel für Familien.

LOCATION

Mauritius, the pearl of the Indian Ocean, provides the most beautiful landscape with sparkling waterfalls and spectacular views in the mountains. The Le Morne peninsula is a captivating and tempting destination for the world's elite of kitesurfers as well as for beginners. The surf spot is located at the south-west tip of the island, where one can also find The St. Regis Mauritius Resort, embedded along one kilometer of white sandy beach and shallow turquoise blue lagoons. Mauritius is captivating with its irresistible beauty, and is home to uncountable cultures and traditions, as well as being an oasis of peace and quiet. The SSR International Airport is situated 75 minutes away by car from The St. Regis Mauritius Resort.

HOTEL

The St. Regis Mauritius Resort offers 172 exquisite guest rooms, suites and the private St. Regis Villa, which is built in colonial style and located directly on the coast. All rooms are equipped with St. Regis beds, a spacious terrace and an elegant bathroom and offer exclusive amenities such as the famous St. Regis Butler Service and Remède beauty products. Thanks to the five worlds of culinary experience, the resort offers a huge range of culinary delights. "Le Manoir" offers French inspired and traditional Mauritian cuisine, and in the elegant gourmet barbeque restaurant "The Boathouse Grill" guests can enjoy their meals directly by the beach. At the resort's Iridium spa, guests can be spoilt in twelve treatment rooms and seven Manor House Spa Suites. The St. Regis Mauritius Resort has the world's very first Prestige Kite Surf ION Club which offers customised service to the surfers – from rental and storage of first class equipment up to private lessons and insider tips from locals. The resort offers even more leisure activities with two pools, a gym, a tennis court, a library with conservatory and the private cinema La Palme d'Or. With its wonderful white sandy beaches, Mauritius is a perfect location for weddings or honeymoons. The St. Regis also caters perfectly for families with The Kite Flyers Club, along with the variety of complimentary activities and water sports.

Get your Upgrade

www.upgradetoheaven.com/st-regis-mauritius

THE ST. REGIS MAURITIUS RESORT . Le Morne Peninsula, Mauritius . www.stregismauritius.com

BESPOKE PERSONALISED SERVICE AMIDST THE MANY CHARMS OF MAURITIUS

Einzigartiger persönlicher
Service inmitten der
vielen Reize Mauritius'

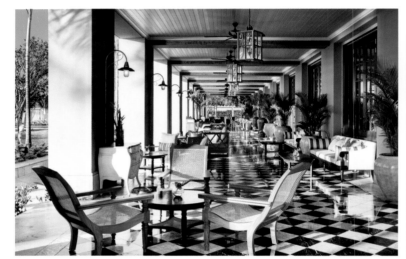

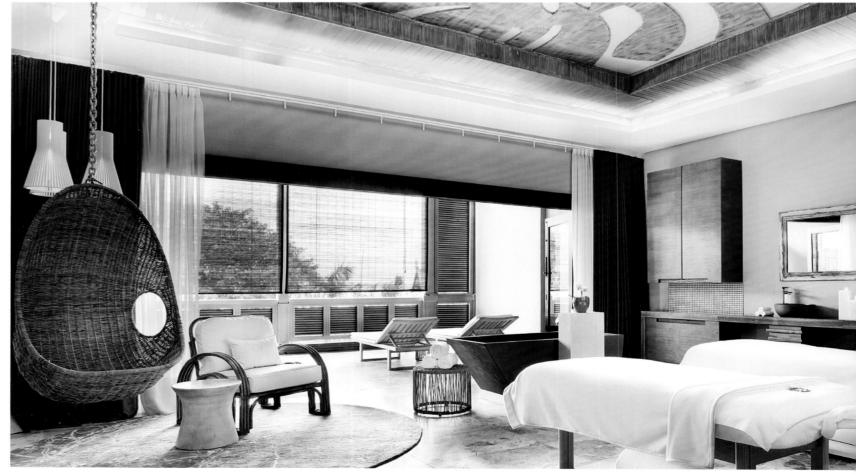

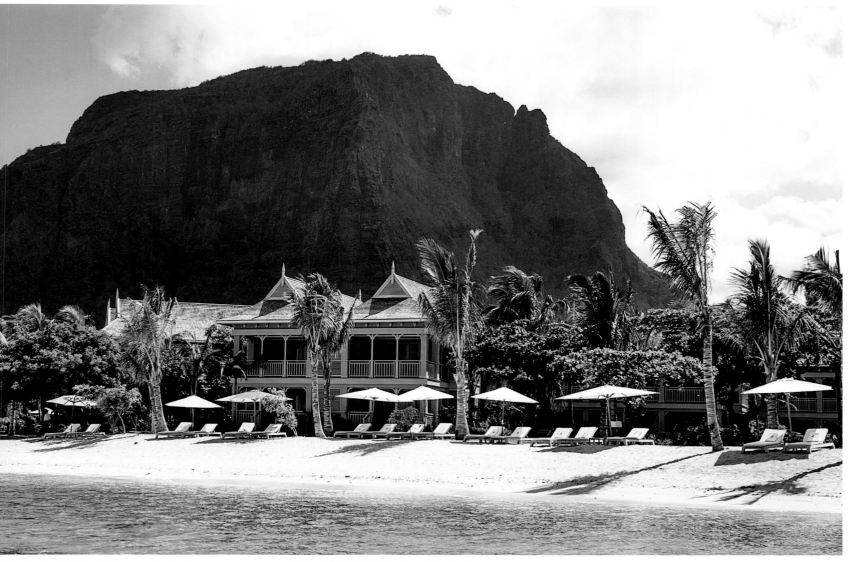

Hospitality is the island's trademark: here, every smile promises a unique encounter and unforgettable memories. The signature butler service, which has been the appreciated trademark of St. Regis for more than a hundred years, fits perfectly to the above. The St. Regis Mauritius Resort's continues traditional bespoke rituals such as Afternoon Tea, Midnight Suppers and Champagne Sabering. Extending the St. Regis legacy, The St. Regis Mauritius Resort is the island sanctuary, providing a rare blend of bespoke service set in exquisite surroundings.

Gastfreundschaft ist das Markenzeichen der Insel: Hier verspricht jedes Lächeln eine einzigartige Begegnung und unvergessliche Momente. Dazu passt der exklusive Butler-Service, seit mehr als hundert Jahren das geschätzte Markenzeichen von St. Regis, hervorragend. Auch das St. Regis Mauritius Resort bietet diesen maßgeschneiderten Service mit Afternoon Tea, Mitternachtsimbiss und das Köpfen einer Flasche Champagner mit dem Säbel. Das St. Regis Mauritius Resort ist, ganz in der Tradition von St. Regis, ein Ort mit bestem individuellen Service und exquisiter Umgebung.

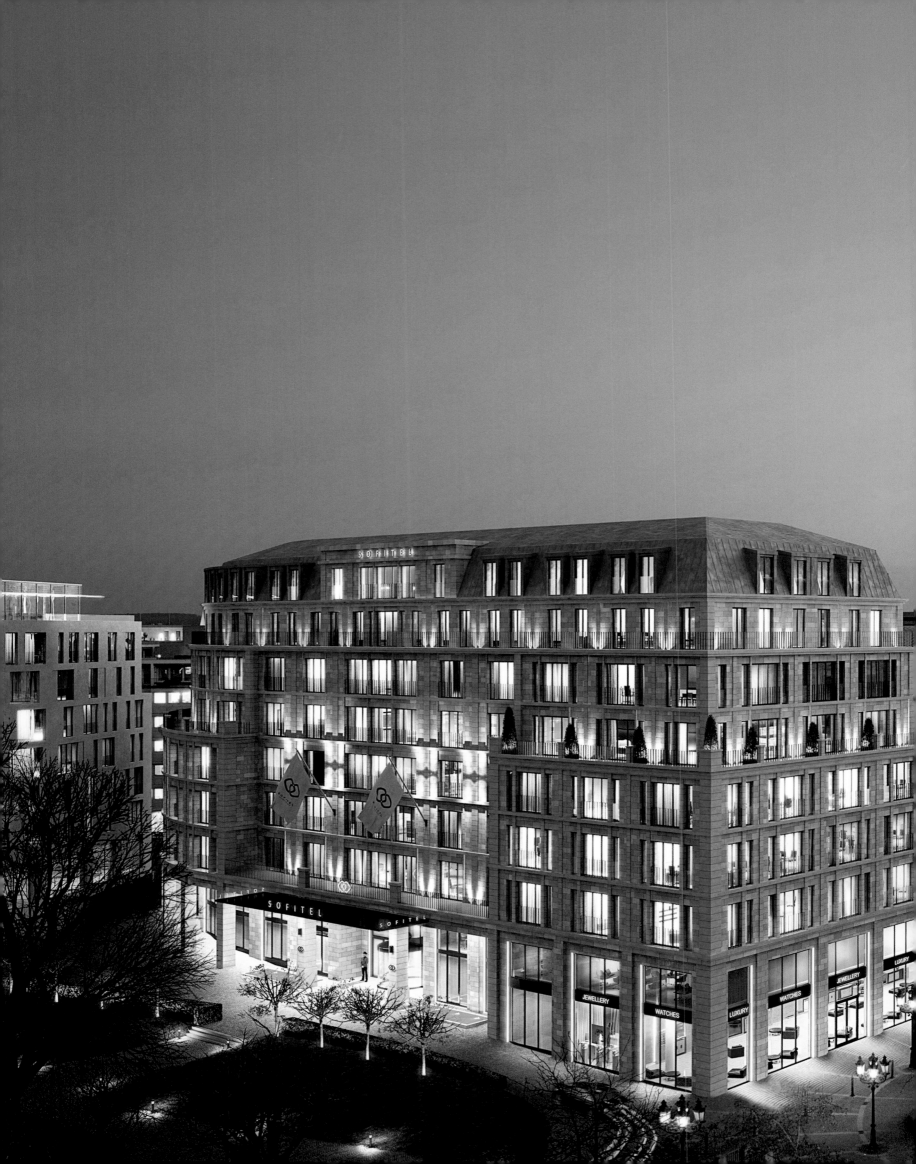

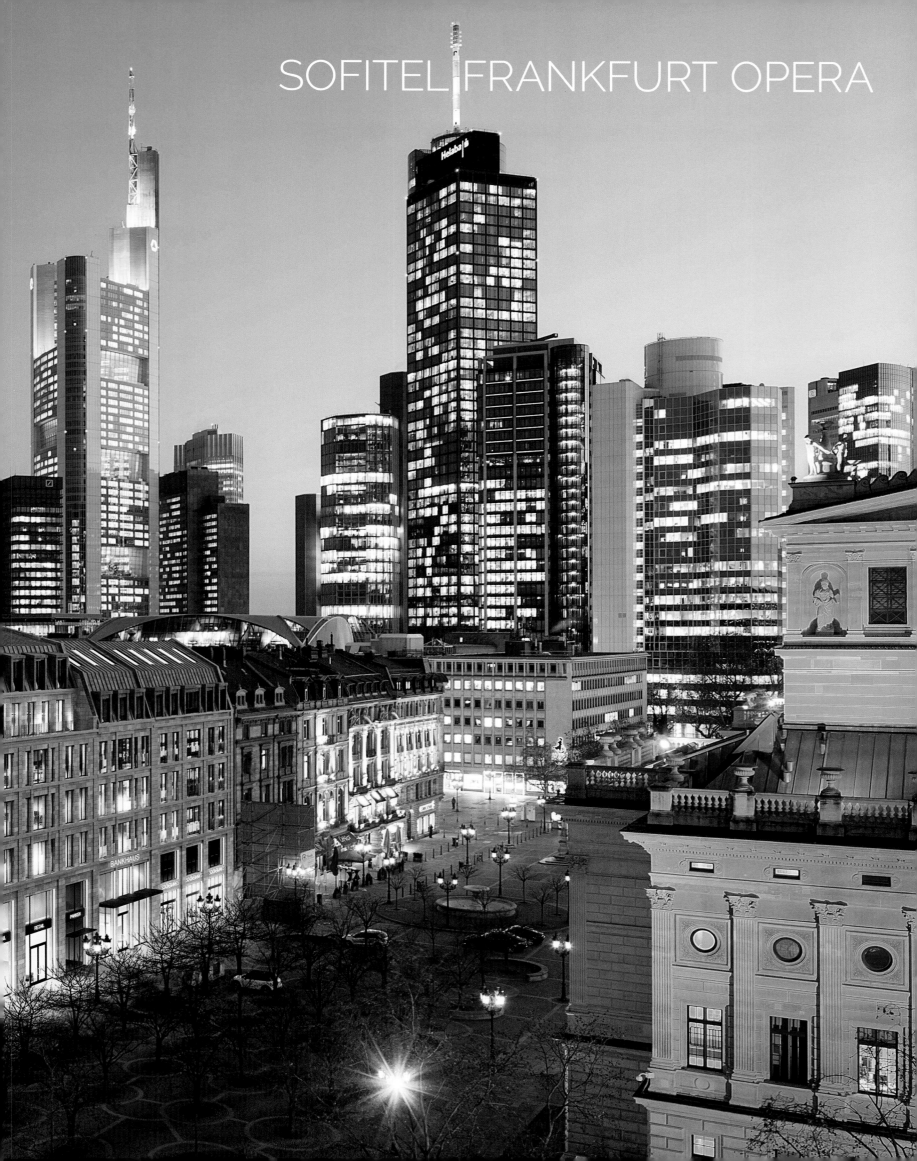

SOFITEL FRANKFURT OPERA

DIE NEUE LUXUS-ADRESSE FRANZÖSISCHER ART-DE-VIVRE MITTEN IN FRANKFURT

The new luxury French
art-de-vivre location in the
middle of Frankfurt

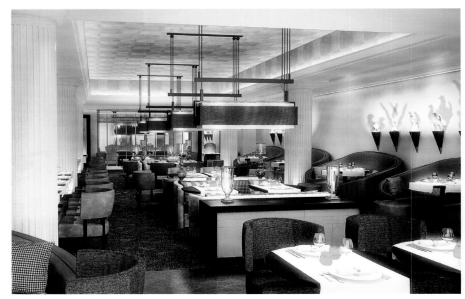

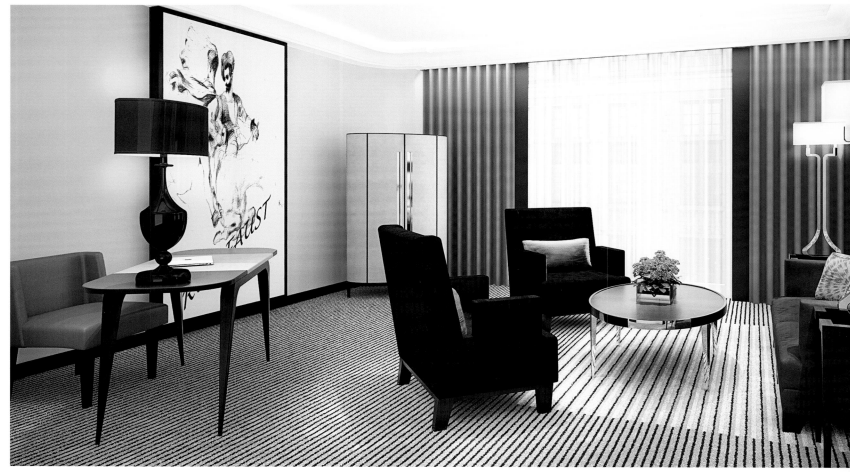

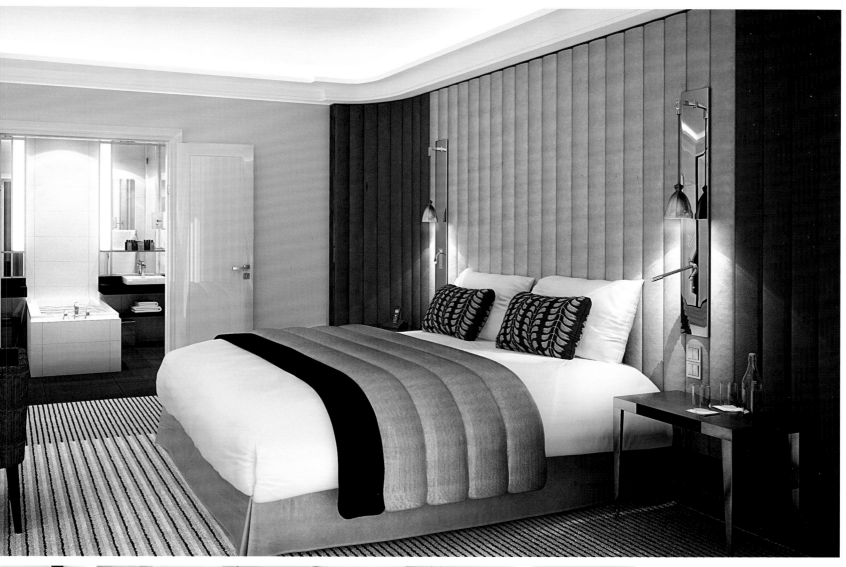

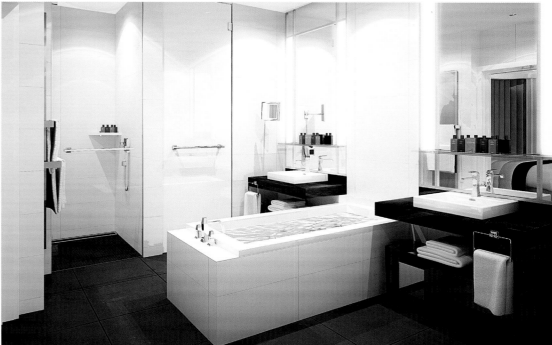

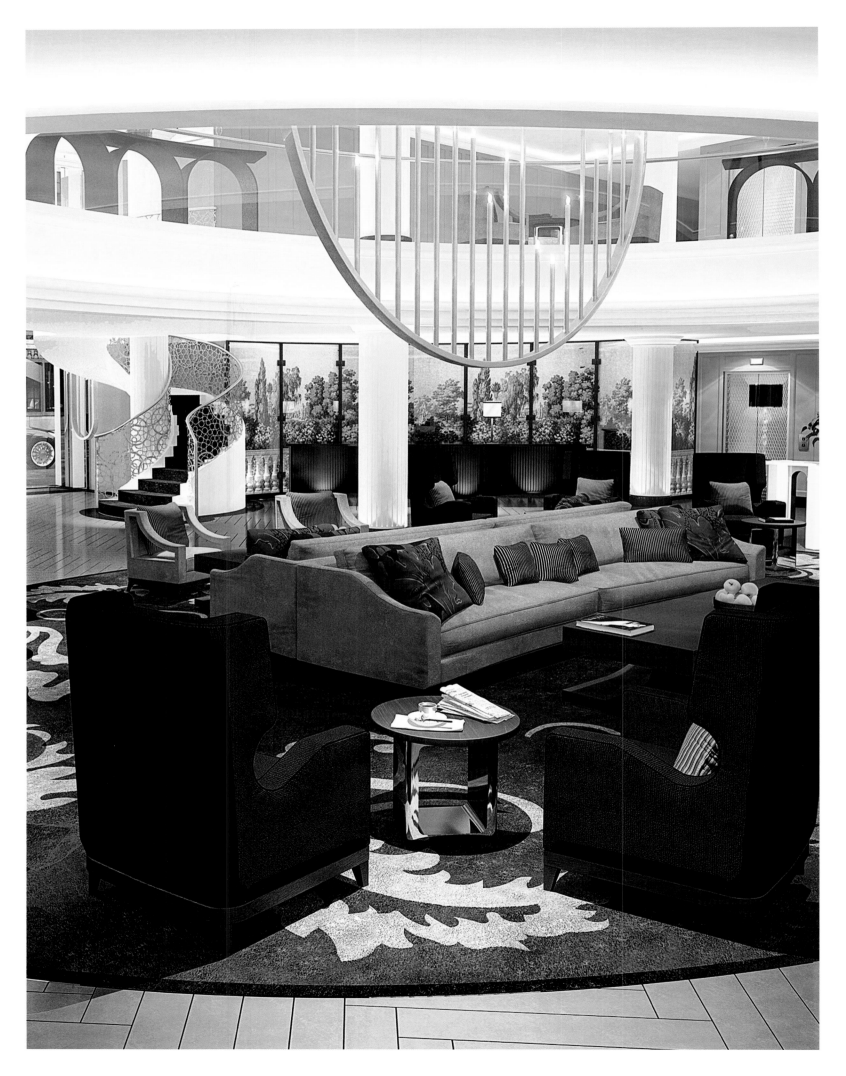

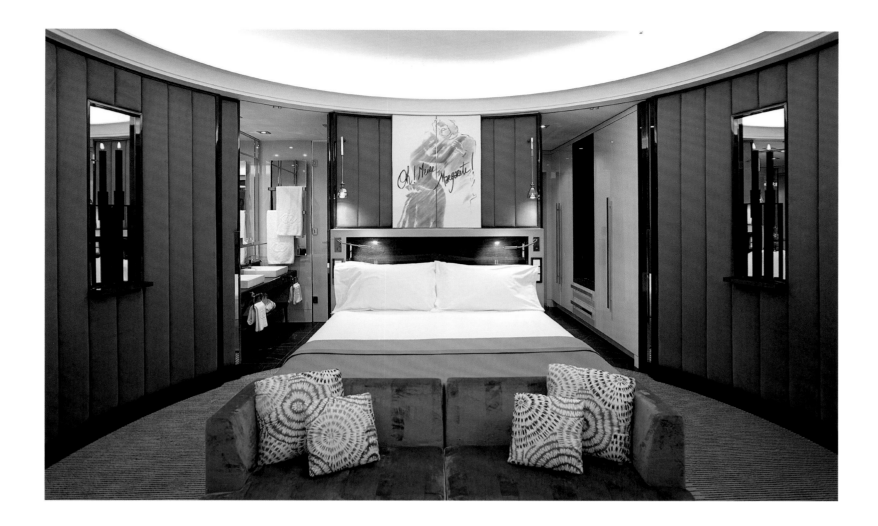

LOCATION

In Premiumlage am Opernplatz, umgeben von Stadtgrün und Gründerzeitbauten, eröffnete Sofitel im Oktober 2016 ein "Hôtel Particulier" der Neuzeit mit atemberaubender Architektur und zeitloser Gestaltung durch renommierte Designer. Die besten Shoppingadressen und bekannten Kulturangebote befinden sich direkt vor der Tür des neuen Sofitel Frankfurt Opera, ebenso die Flaniermeilen Freßgass und Goethestraße, Frankfurts erste Adressen für Haute Couture. Das Sofitel Frankfurt Opera bietet sowohl Geschäftsreisenden als auch privaten Frankfurt-Besuchern einen idealen Ausgangspunkt.

HOTEL

Das neue Sofitel Frankfurt Opera verfügt über 119 luxuriöse Zimmer und 31 Suiten, die alle einen wunderbaren Ausblick auf die Alte Oper, den angrenzenden Stadtpark oder das Atrium bieten. Das eigens für das Hotel entworfene Interieur kombiniert die dezente Sofitel-Farbwelt mit raffinierten Akzenten. Jedes Zimmer ist mit modernem Entertainmentsystem für perfekte Unterhaltung, Regendusche oder Badewanne für ein besonderes Verwöhnerlebnis sowie Hermès Pflegeprodukten ausgestattet. In ausgewählten Suiten steht sogar ein persönlicher Butler zur Verfügung. Das Restaurant "Schönemann", benannt nach Johann Wolfgang von Goethes erster Liebe, serviert Kulinarik nach Art des Pariser "Bistronomique"-Konzepts, so delikat wie unkompliziert. Auf Wunsch auch im Private Dining Room oder auf der Terrasse. Für gepflegte Getränke in angenehmer Atmosphäre bietet sich "Lili's Bar" an und erlesene Gebäckkreationen sowie Kaffeespezialitäten finden sich in der "Patisserie Boutique". Ob private Feiern oder berufliche Meetings in der Finanzmetropole Frankfurt, das Sofitel Frankfurt Opera bietet den perfekten Rahmen. Modernste Konferenztechnik, diverse Meetingräume für Konferenzen bis zu 300 Personen und ein Ballsaal lassen keine Wünsche offen. Im So Fit oder So Spa entspannen Gäste auf höchstem Niveau. Zusätzlich steht im selben Gebäudekomplex ein 3.000 qm großes kostenpflichtiges Fitnesscenter mit persönlicher Trainingsbetreuung sowie einem 25-Meter-Pool zur Verfügung. Nach dem Sport verwöhnt eine Massage oder ein Luxus-Treatment.

LOCATION

In a prime location on the Opernplatz city square, surrounded by urban green spaces and Wilhelmina style buildings, Sofitel established a "Hôtel Particulier" of the new era in October 2016, with breathtaking architecture and contemporary design brought by prestigious designers. The best shopping addresses and famous cultural offers are located directly at the new Sofitel Frankfurt Opera's front door, as well as the promenades Freßgass and Goethestrasse, Frankfurt's hot spots for haute couture. The Sofitel Frankfurt Opera offers both business people and private Frankfurt visitors an ideal starting point.

HOTEL

The new Sofitel Frankfurt Opera includes 119 luxurious rooms and 31 suites, which all have a picturesque view of the old opera, the nearby city park or the atrium. The hotel's specially designed interior combines Sofitel's subtle colour palette with refined highlights. Every room is equipped with a modern entertainment system for perfect enjoyment, rain shower or bathtub for special indulgence experiences and Hermès products. Private butlers are additionally available in selected suites. The restaurant "Schönemann", named after Johann Wolfgang von Goethe's first love, serves culinary delights after the Parisian "Bistronomique" concept, delicate and simple. Also available, in a private dining room or on the terrace upon request. For sophisticated drinks in a pleasant atmosphere "Lili's Bar" offers exquisite drink creations, while coffee specialities can be found in the "Patisserie Boutique". The Sofitel Frankfurt Opera provides the perfect setting for either private gatherings or business meetings in the financial centre Frankfurt. Modern conference technology, a variety of meeting halls for conferences for up to 300 people and a ballroom leave nothing to desire. Guests can relax to the highest standards in the So Fit or So Spa. An additional 3,000 sqm fee-based gym with personal trainer support and a 25-metre pool are offered in the same building complex. A massage or luxury treatment after a workout is the perfect delight.

Get your Upgrade

www.upgradetoheaven.com/sofitel-frankfurt-opera

SOFITEL FRANKFURT OPERA . Opernplatz 16, 60313 Frankfurt am Main, Germany . www.sofitel.com

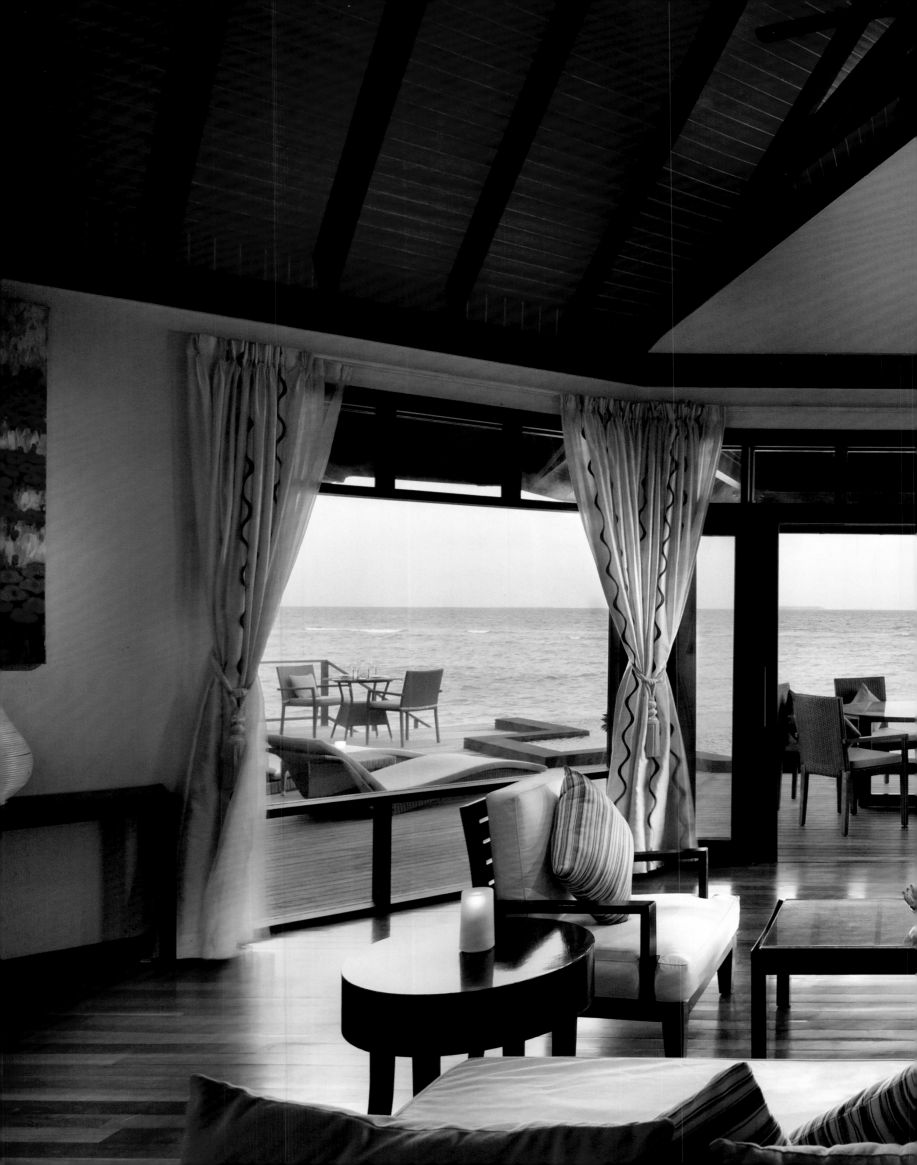

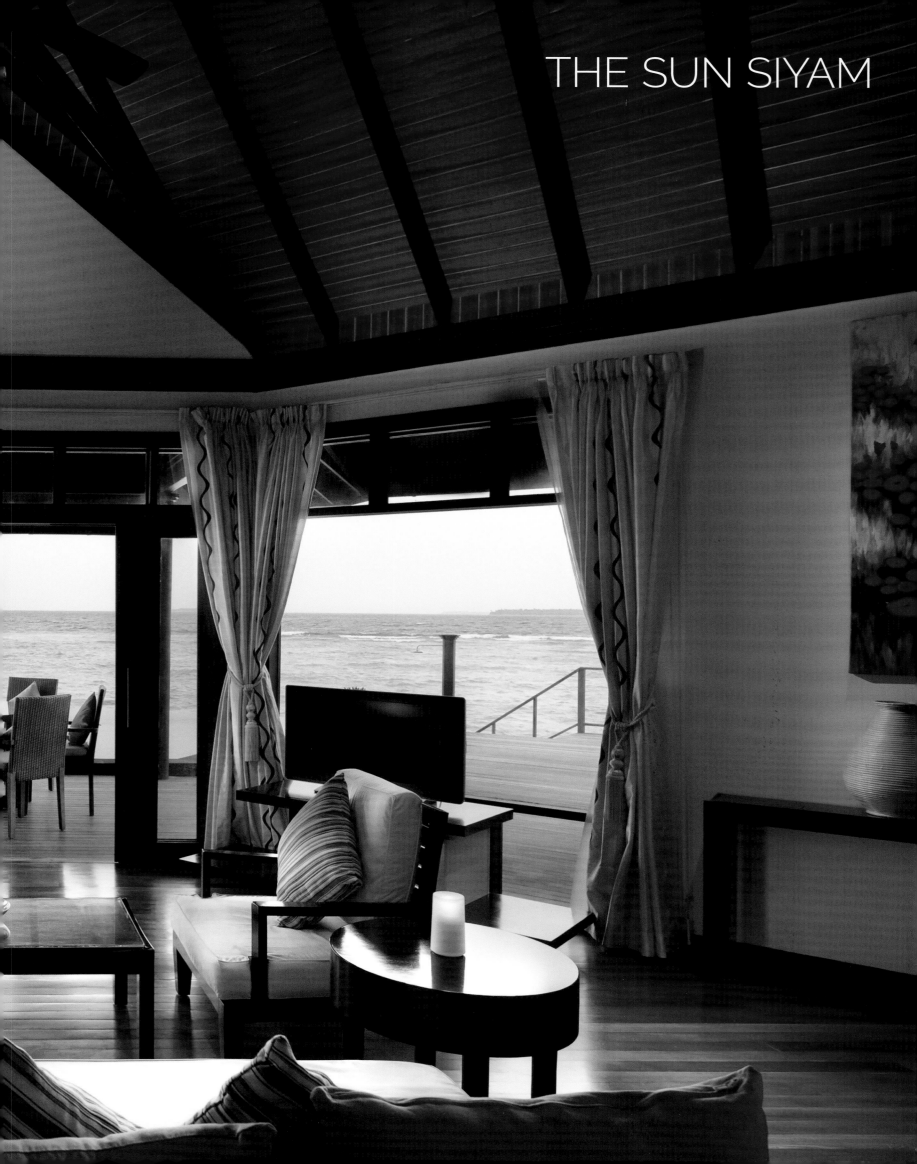

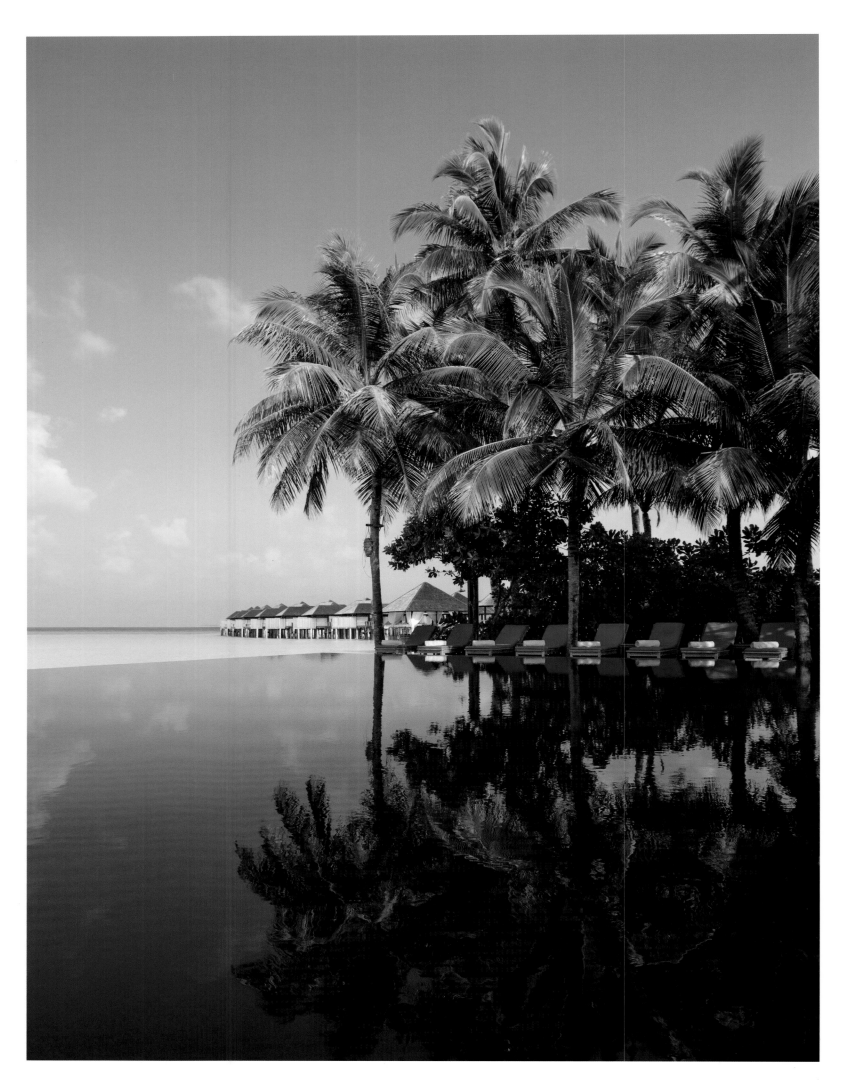

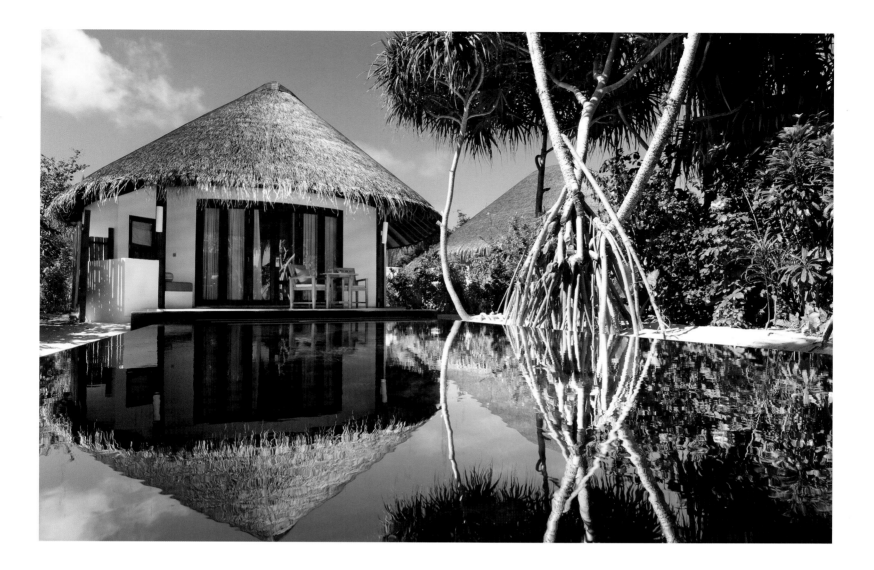

LOCATION

Im Jahr 2014 öffnete die Lifestyle-Insel Iru Fushi auf den Malediven ihre Pforten unter neuer Flagge als The Sun Siyam Iru Fushi. Das neu gestaltete Resort ist das erste Hideaway der Luxusmarke Sun Siyam Resorts. Ein 40-minütiger Flug mit dem Wasserflugzeug über die Inselwelt der Malediven bringt die Gäste von der Hauptstadt der Malediven Malé ins Resort, das im Noonu Atoll liegt.

HOTEL

The Sun Siyam Iru Fushi beherbergt seine Gäste in insgesamt 221 Villen, die alle über einen Blick auf den Indischen Ozean verfügen. Das Design der in sanften Naturtönen gehaltenen Unterkünfte spiegelt den traditionellen maledivischen Bau- und Einrichtungsstil wider. Wasserliebhaber buchen am besten eine der, direkt auf Stelzen über dem Wasser gebauten, 70 Wasservillen. Glaspaneele im Boden ermöglichen spannende Einblicke in die Unterwasserwelt. In den 44 Deluxe Beach Villas freuen sich Luxusliebhaber über einen privaten Pool. Für absolute Privatsphäre bietet The Sun Siyam Iru Fushi Insel-Retreats inmitten tropischer Pflanzenwelt. Ein Butler kümmert sich rund um die Uhr um die Bewohner der exklusiven Retreats und auch die anderen Gäste genießen maßgeschneiderten Service. Der weitläufige Spa des The Sun Siyam Iru Fushi liegt im Herzen des Resorts und verfügt über 20 Behandlungsräume. Dem Spa, das eines der größten der Malediven ist, liegt ein ganzheitlicher Ansatz zu Grunde, der westlich geprägte Praktiken mit Ayurveda vereint. The Spa by Thalgo France setzt auf einzigartige Produkte und Behandlungen, deren Basis leistungsstarke Wirkstoffe aus den Tiefen des Meeres sind. Gourmets können sich auf Gaumengenüsse in den 14 verschiedenen Bars und Restaurants an den schönsten Orten des Resorts freuen - von asiatischer Fusionsküche über mediterrane Speisen bis hin zu indischen Gerichten.

LOCATION

In 2014 the lifestyle island Iru Fushi on the Maldives opened with the new name The Sun Siyam Iru Fushi. The newly designed resort is the first hideaway of the luxury brand Sun Siyam Resorts. A 40 minute seaplane flight over Maldive's island world takes guests from Maldive's capital Malé to the resort, which is located in the Noonu Atoll.

HOTEL

The Sun Siyam Iru Fushi accomodates its guests in 221 villas, each offering a view of the Indian ocean. The design of the rooms in simple natural tones reflect on traditional Maldivian construction and interior style. Water lovers best book one of the 70 built on stilts water villas. Glass panels allow exciting insights of the underwater world. Admirers of luxury can enjoy a private pool in the 44 Deluxe Beach Villas. The Sun Siyam Iru Fushi island retreat offers absolute privacy amidst a tropical plant world. A butler takes care of residents of the exclusive retreat around the clock while other guests can also enjoy customized service. The generous spa of The Sun Siyam Iru Fushi is located in the resort's heart with 20 treatment rooms. The spa, which is one of Maldive's largest, combines shaped practices with ayurveda in a holistic approach. The Spa by Thalgo France is based on unique products and treatments, whose base are efficient ingredients from the depths of the ocean. Gourmets can enjoy culinaric delights in 14 different bars and restaurants at the most beautiful locations of the resort – from Asian fusion cuisine and Mediterranean dishes to Indian meals.

Get your Upgrade

www.upgradetoheaven.com/sun-siyam

THE SUN SIYAM . P.O. Box 2036 Malé, Noonu Atoll, Maldives . www.thesunsiyam.com

ISLANDS THAT TOUCH THE SOUL

Inseln, die die Seele
berühren

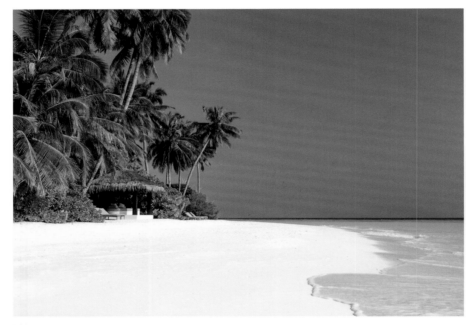

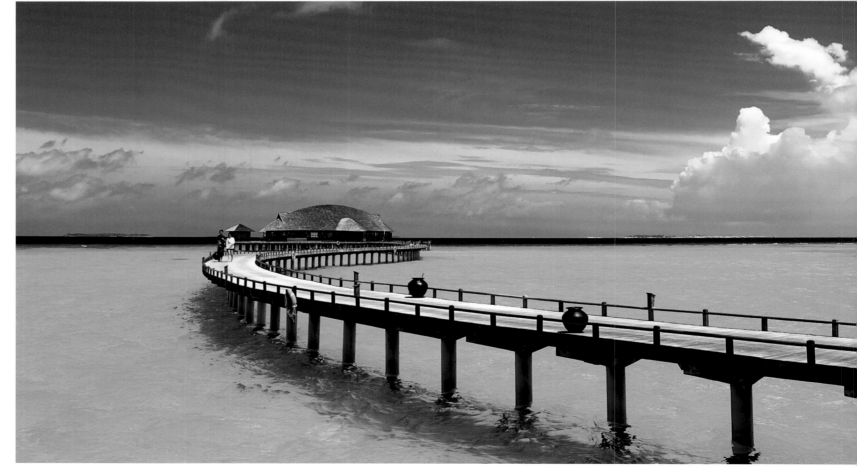

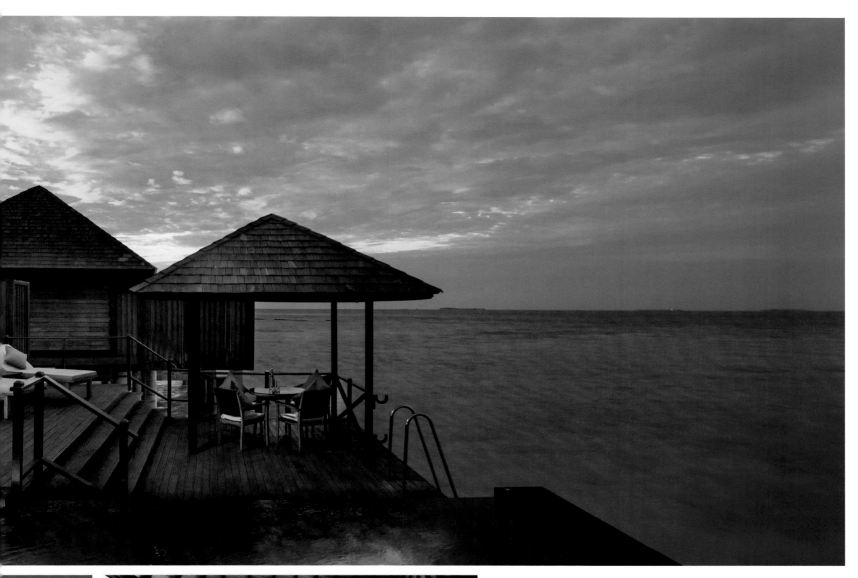

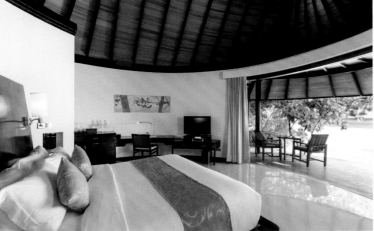

For Ahmed Siyam Mohamed, the owner of the resort, the location of The Sun Siyam Iru Fushi in his home Atoll Noonu represents his deeply rooted connection with the Maldives. Being a native entrepreneur, it is of great importance to charitably support his fellow men with social engagement. According to the motto GIVE (Get Involved, Visionary Experiences) guests can visit the community on site and experience the close connection between The Sun Siyam Iru Fushi and the community first hand. It is hard to experience the Maldives more authentically.

Für den Resort-Eigentümer Ahmed Siyam Mohamed versinnbildlicht The Sun Siyam Iru Fushi, das in seinem Heimat-Atoll Noonu liegt, seine tiefe Verwurzelung mit den Malediven. Als einheimischer Unternehmer ist es ihm ein großes Anliegen, durch soziales Engagement seine Landsleute karitativ zu unterstützen. Unter dem Motto GIVE (Get Involved, Visionary Experiences) können Hotelgäste die Community vor Ort besuchen und aus erster Hand erleben, wie eng The Sun Siyam Iru Fushi mit der Gemeinde verwoben ist. Authentischer lassen sich die Malediven kaum erleben.

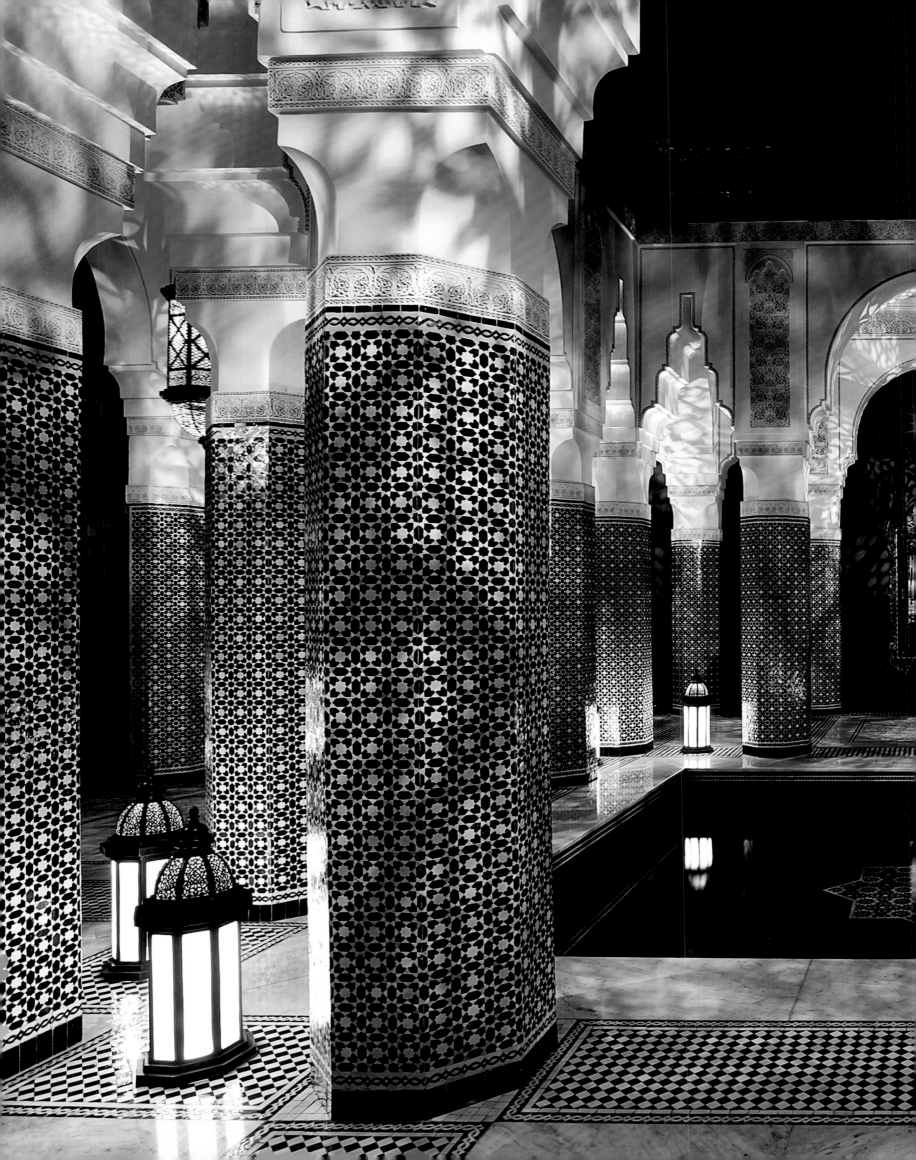

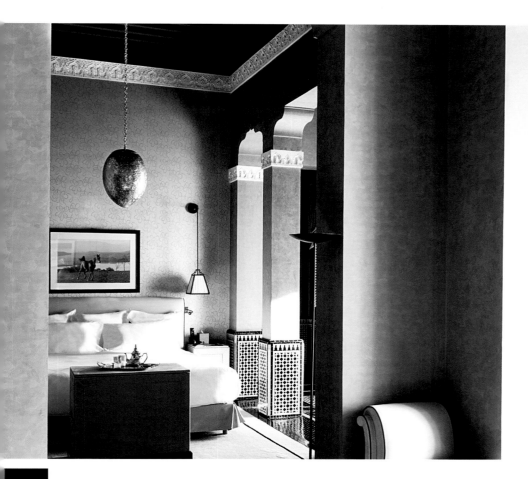

LOCATION

Am Fuße des Atllasgebirges, fernab der hektischen Medina, aber dennoch in der Nähe von Stadt und Flughafen, liegt das Luxushotel Selman Marrakech. Araber-Pferde haben eine große Bedeutung für das Hotel – es wurde sogar nach dem Vater einer Vollblüter-Linie benannt. Das Selman Marrakech Gestüt verfügt über zwei aufwändige Stallungen, die in Richtung des andalusischen Pavillon ausgerichtet sind. Vier Koppeln, die sich in den Gärten befinden, sind das Zuhause der eleganten Araber des Selman Marrakech, die eigens vom Hotel gezüchtet worden sind und sich zur Freude der Gäste auf dem Anwesen befinden. Eine wahrhaft einzigartige Erfahrung.

HOTEL

Vom berühmten Architekten Jacques Garcia entworfen und erbaut von den besten Handwerkern, verführt das Selman Marrakech mit zeitloser Harmonie. In diesem intimen und persönlichen Familienanwesen teilt jeder Gast die Freude, Liebe und Träume mit den liebenswerten Gastgebern. In dem unvergänglichen Palast, der nach den Vorstellungen des Besitzers gebaut wurde, wird die alte marokkanische Tradition wiederbelebt. Die 60 Zimmer des Selman, fünf davon sind Riads, unterscheiden sich von Allem, was Marrakesch sonst so bietet. Großzügige Räume und kleine Nischen, die zur Terrasse hin geöffnet sind, geben Gästen das besondere Gefühl, alleine im ganzen Hotel zu sein. Mit seinen zwei privaten Pools ist das Spa Espace Vitalité Chenot Marrakech eine orientalische Wohlfühl-Oase inmitten einer Oase. Es verfügt über ein Hamam, ein Dampfbad, eine Sauna, mehrere Möglichkeiten der Wassertherapie und eine große Auswahl an Behandlungen. Das "The Selman" Restaurant bietet eine internationale Fusionsküche in gehobener und zeitgleich zwangloser Atmosphäre. Neben einem großen Raum mit Feuerstelle besitzt das Restaurant außerdem ein überdachtes Außendeck. Das "Assyl" Restaurant bietet authentische marokkanische Küche in außergewöhnlichem Ambiente. Das mediterran inspirierte "The Pavilion" hat einen fantastischen Blick über die Stallungen und Koppeln, auf denen die arabischen Vollblüter des Selman Marrakech stolzieren.

LOCATION

At the foot of the Atlas Mountains, away from the hustle of the Medina but still close to city and airport, lies the luxury hotel Selman Marrakech. The Arabian horse has a huge significance. The hotel is even named after the father of a line of thoroughbreds. Facing the Andalusian pavilion, the Selman Marrakech stud has two lavish stables. In the gardens, four outdoor paddocks are home to the elegant Selman Arabian horses from the hotel's own breeding programme, roaming there for the guests' delight. This is a truly unique experience.

HOTEL

Designed by renowned architect Jacques Garcia and built by the best artisans, Selman Marrakech enticing with its timeless harmony. At this intimate, personal and family-owned property, each guest shares in the joy, love and dreams of their warm and passionate hosts. In this timeless palace, whose construction was the vision of the owner, the art of traditional Moroccan hospitality has been revived. Selman's 60 rooms, five of them are Riads, are different from anything else in Marrakech. Spacious rooms and little alcoves opening onto a terrace give the guests the special feeling of being the only one in the hotel. With its two private pools, the spa Espace Vitalité Chenot Marrakech is an oasis within an oasis and a tribute to Oriental well-being. It features a hammam, steam room, sauna, water jets, hydrotherapy and a broad variety of treatments. "The Selman" restaurant is a chic but casual dining place made up two parts: a large room with a fireplace and an extended covered patio. It offers an international fusion cuisine without being pretentious. The "Assyl" restaurant offers an authentic Moroccan cuisine in an outstanding setting. The Mediterranean-inspired "The Pavilion" has a stunning view over the stables and paddocks where the Selman's thoroughbred Arabian horses parade.

Get your Upgrade

www.upgradetoheaven.com/selman-marrakech

SELMAN MARRAKECH . Km 5, Route d'Amizmiz, Marrakech 40160, Morocco . www.selman-marrakech.com

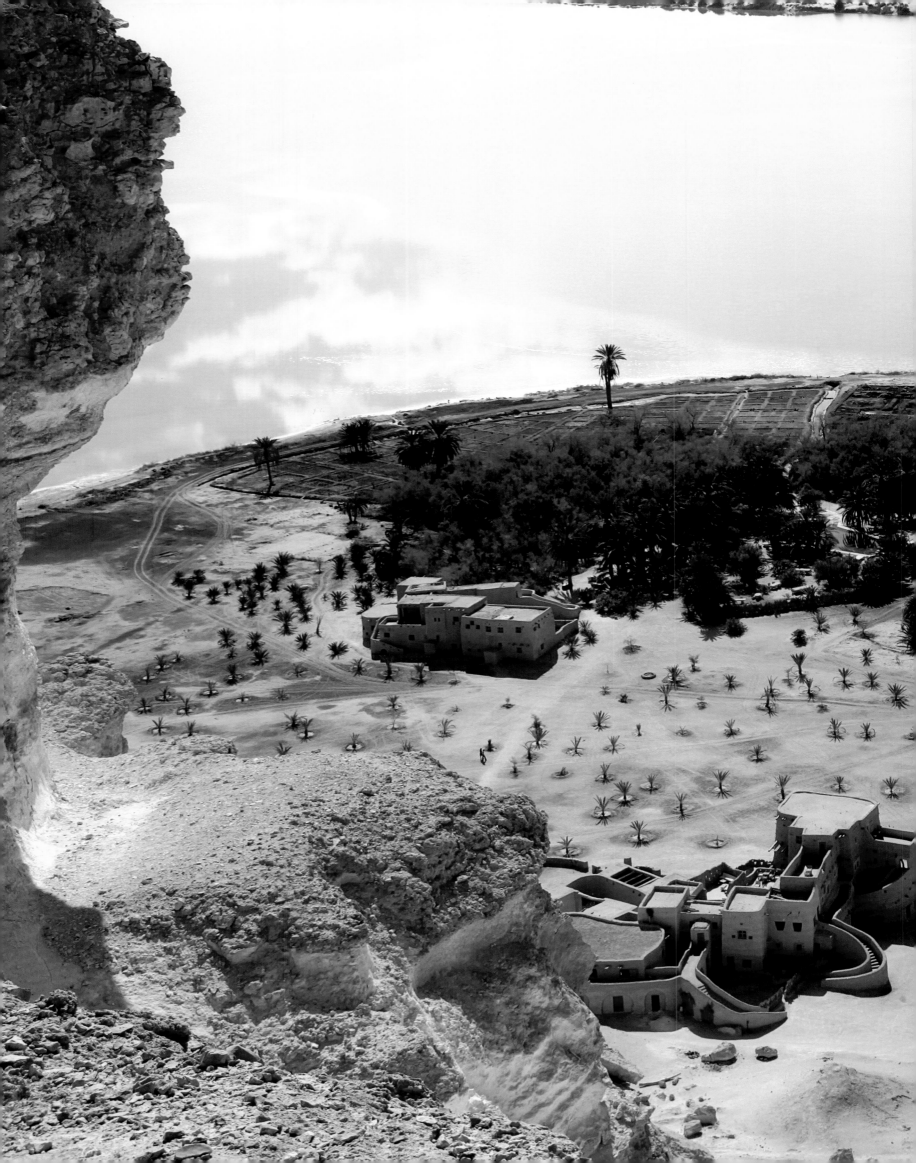

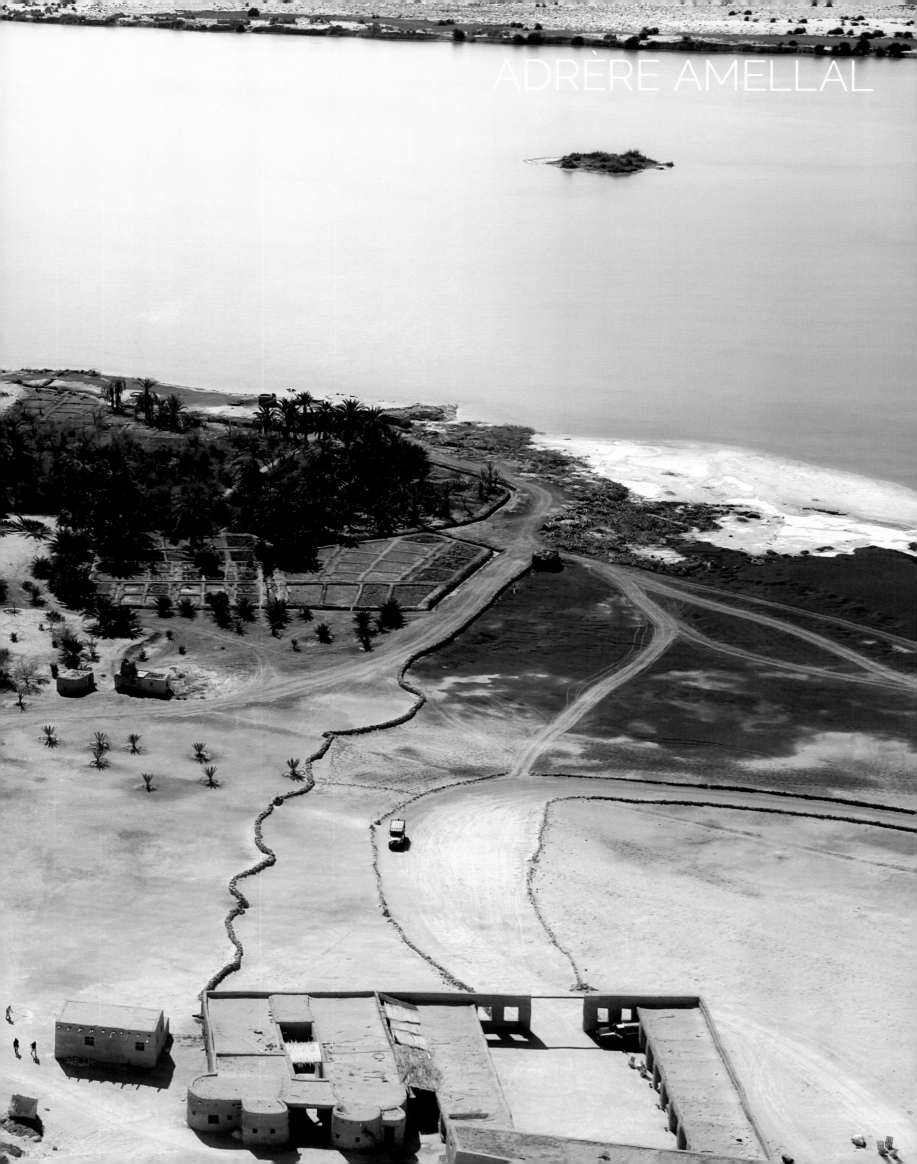

Adrère Amellal ist ein magischer Ort
jenseits von Zeit und Raum.

Adrère Amellal is a magical place
beyond time and space.

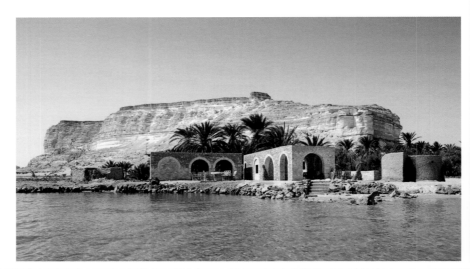

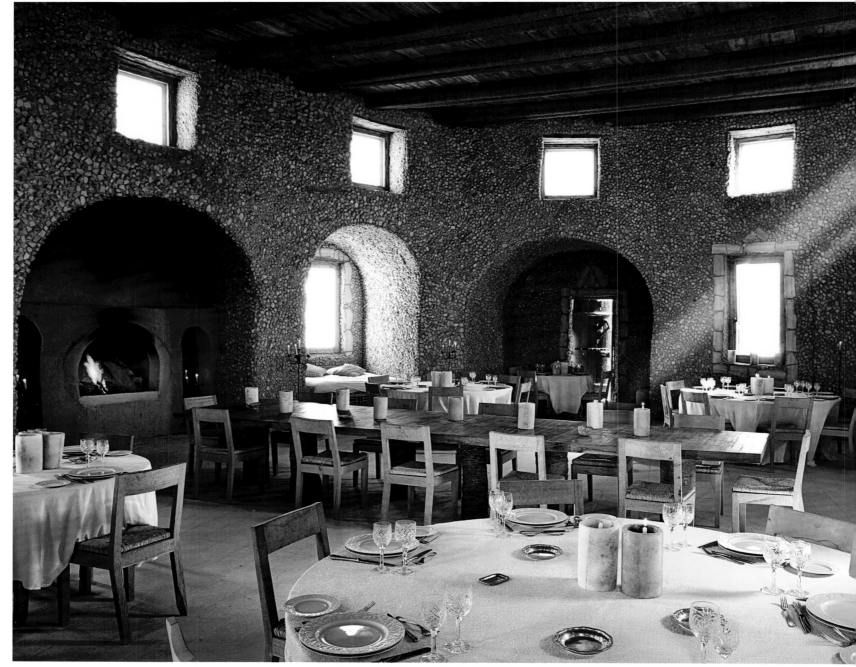

LOCATION

Die Ecolodge Adrère Amellal liegt in der Siwa Oase, der westlichsten Oasengruppe Ägyptens inmitten der libyschen Wüste, am Fuß des mystischen White Mountain. Bis ins Jahr 1.500 v. Chr. lässt sich die Geschichte der Oase verfolgen. Siwa verfügt über große Gärten, Plantagen mit Dattelpalmen und Olivenbäumen und über mehrere Salzseen. Etwa 23.000 Menschen bevölkern die Oase, die meisten davon sind Berber. Die Ecolodge Adrère Amellal ist etwa 16 Kilometer vom Hauptort, der ebenfalls den Namen Siwa trägt, entfernt. Die beeindruckende Ruine der Shali Festung, die im 13. Jahrhundert aus Lehm, Sand und sonnengetrocknetem Salz erbaut wurde, prägt das Stadtbild Siwas. Auf den Märkten finden sich in Handarbeit exquisit bestickte Stoffe und umwerfend schöner Silberschmuck. Adrère Amellal ist das Herzstück der Nachhaltigkeitsinitiative von EQI (Environmental Quality International) für die Siwa Oase. Das Projekt wurde von den Vereinten Nationen beim Weltkongress für nachhaltige Entwicklung als bestes Beispiel aufgeführt. So wurden nicht nur hunderte Jobs geschaffen, sondern auch das traditionelle Handwerk wiederbelebt und Umweltschutzmaßnahmen etabliert.

HOTEL

Adrère Amellal ist eine stilvolle umweltfreundliche Ecolodge, aus Steinsalz im traditionellen Stil der Siwan mit 2.500 Jahre alten Techniken erbaut. Das Haus bietet Gästen einen einzigartigen Aufenthalt und höchstmögliche Qualität in ursprünglicher Umgebung. Prinz Charles und die Herzogin von Cornwall gehörten bereits zu den Gästen von Adrère Amellal. Jeder der 42 Räume ist einmalig und authentisch eingerichtet, das gesamte Mobiliar zeugt vom Können des lokalen Handwerks. Weitere Besonderheiten sind alte Oliven- und Palmenhaine, gemächlich sprudelnde römische Quellen und eine hervorragende Küche mit traditionellen Gerichten. Alle verwendeten Kräuter sowie das Gemüse werden im Bio-Garten von Adrère Amellal von Hand geerntet. Fackeln, Bienenwachskerzen und die Sterne illuminieren den Ort bei Nacht, denn Strom gibt es in Adrère Amellal nicht. Nichts soll die Ruhe des ursprünglichen Ortes stören und so sind Mobiltelefone außerhalb der Zimmer verboten. Gäste können unter einer Vielzahl von Aktivitäten wählen, die lediglich von der Wüste beschränkt werden. Dazu gehören die Erkundung der Sanddünen des Ägyptischen Sandmeers, Baden im Siwa-See, eine Zeitreise zurück in die alte Shali-Festung, ein Ausritt oder Entspannung am Hotel-Pool mit natürlichem Quellwasser. Die Stille und Ursprünglichkeit dieses außergewöhnlichen Ortes sowie die Freundlichkeit der Siwa werden Gäste von Adrère Amellal tief berühren.

LOCATION

The Ecolodge Adrère Amellal lies in the oasis of Siwa, the western-most part of Egypt's oasis group in the middle of the Libyan desert, at the foot of the mystical White Mountain. The oasis's history can be traced back to the year 1,500 before Christ. Siwa offers large gardens, plantations of date palms and olive groves, and numerous salt lakes. Around 23,000 people inhabit the oasis, the majority being Berber. The Ecolodge Adrère Amellal is around 16 kilometres away from the main village, which is also named Siwa. The impressive ruin of Shali Fortress, which was built in the 13th century with a mixture of mud, sand and sun-dried salt, shapes the landscape. Exquisite embroidered hand crafted materials as well as stunning silver jewellery can be found at local markets. Adrère Amellal is the heart of the sustainable development initiative organised by EQI (Environmental Quality International) for the oasis of Siwa. The project was showcased by the United Nations at the World Summit for Sustainable Development as the best example. This has not only created hundreds of jobs, but also revitalised traditional handicrafts and environmental measures.

HOTEL

Adrère Amellal is a stylish environmentally friendly ecolodge built of rock salt in traditional Siwan style with 2,500 year old techniques. The hotel offers guests an extraordinary stay using first-class quality in an original environment. Prince Charles and the Duchess of Cornwall have already vacationed at Adrère Amellal. Each of the 42 rooms is unique and authentic, equipped with local handcrafted furniture. Further highlights are old olive and palm groves, bubbling Roman fountains and an extraordinary cuisine with traditional dishes. All ingredients such as the seasonings and vegetables are organically grown and hand-harvested in Adrère Amellal's garden. Torches, beeswax candles and the stars illuminate the village by night, as there is no electricity at Adrère Amellal. Given that nothing is meant to disturb the environment's peace, mobile phones are not allowed outside of the rooms. Guests can choose from a variety of activities, which are solely limited by the conditions in the desert. These include exploring the sand dunes of the Great Sand Sea, swimming in Lake Siwa, travelling back in time to Old Shali and its historic fortress or horse riding and relaxing by the hotel pool with natural spring water. The calm and originality of this extraordinary location as well as the kindness of Siwan will deeply touch guests at Adrère Amellal.

Get your Upgrade

www.upgradetoheaven.com/adrere-amellal

ADRÈRE AMELLAL . Al Maraqi, White Mountain, Gaafar, Egypt . www.adrereamellal.net

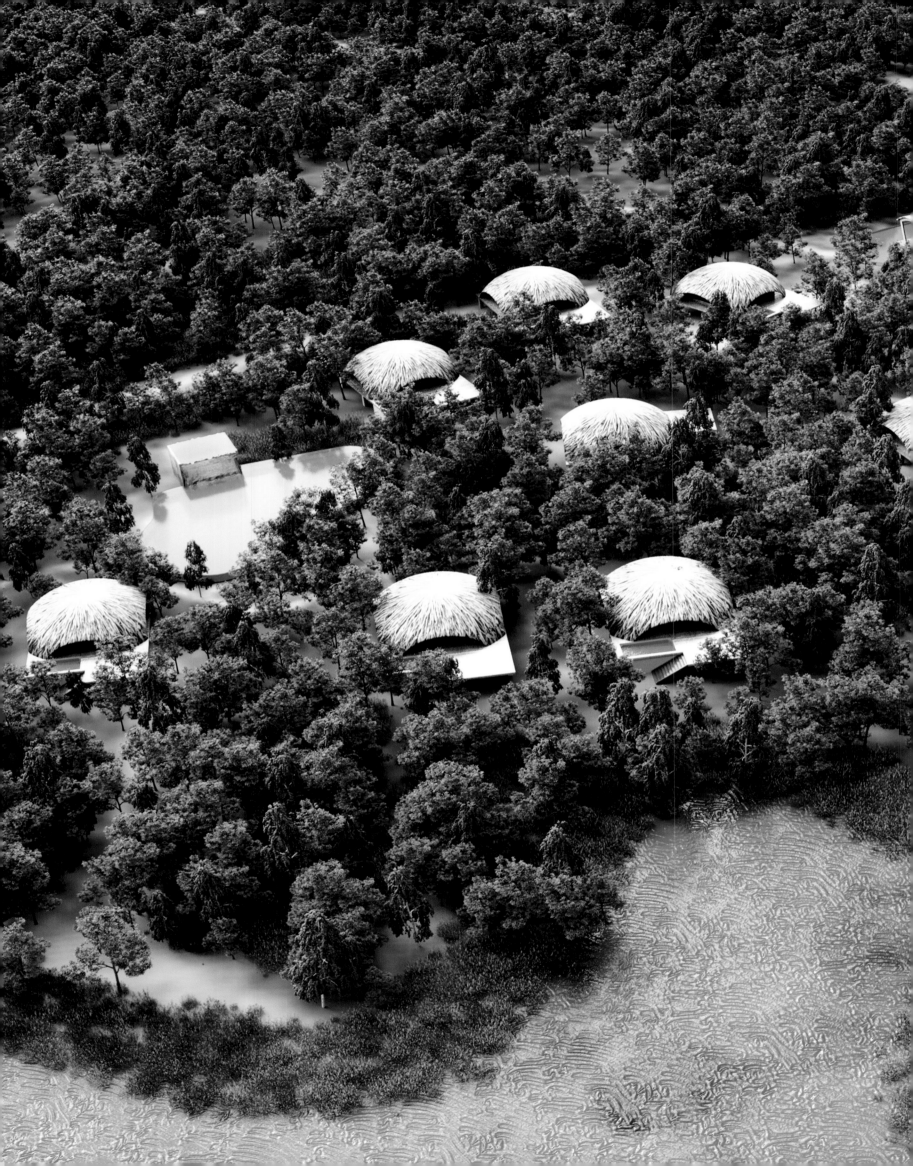

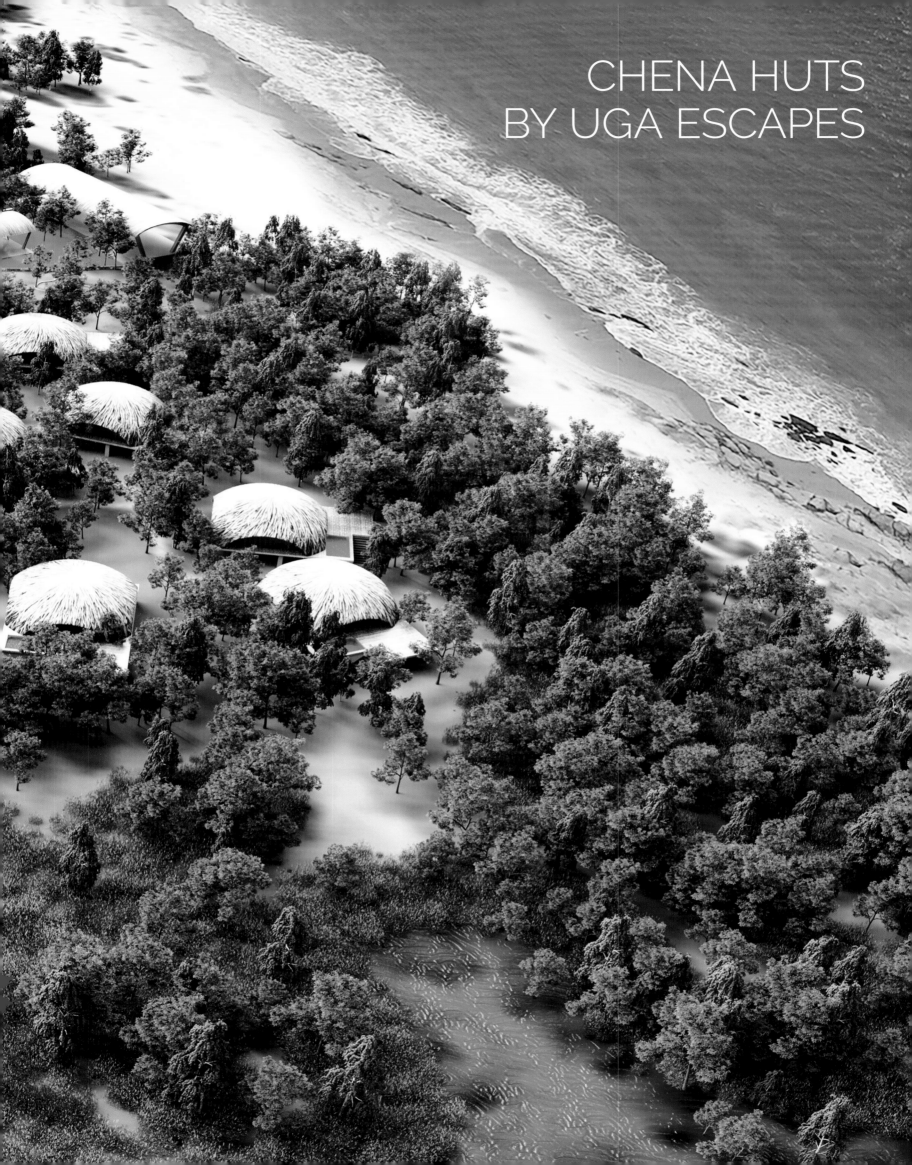

Ein magischer und ursprünglicher
Ort, umgeben von Dschungel
und Indischem Ozean.

A magical, prestine place
surrounded by jungle and
the Indian Ocean.

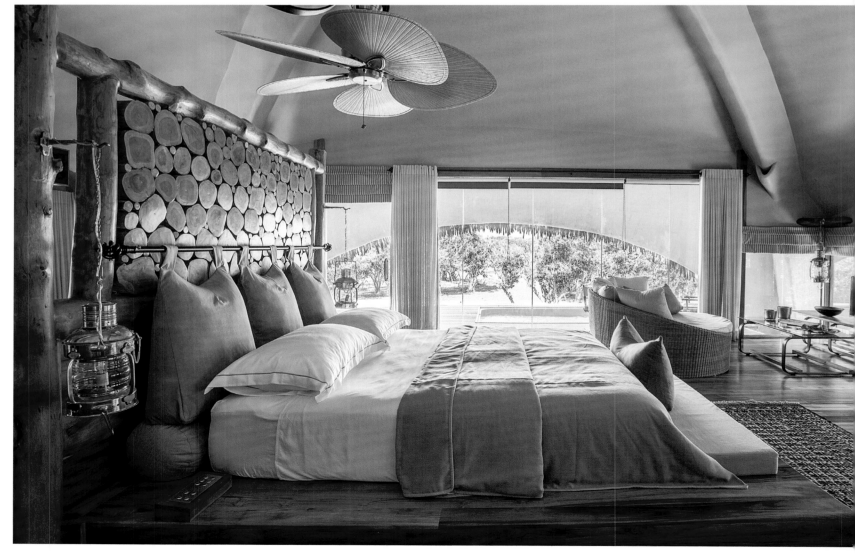

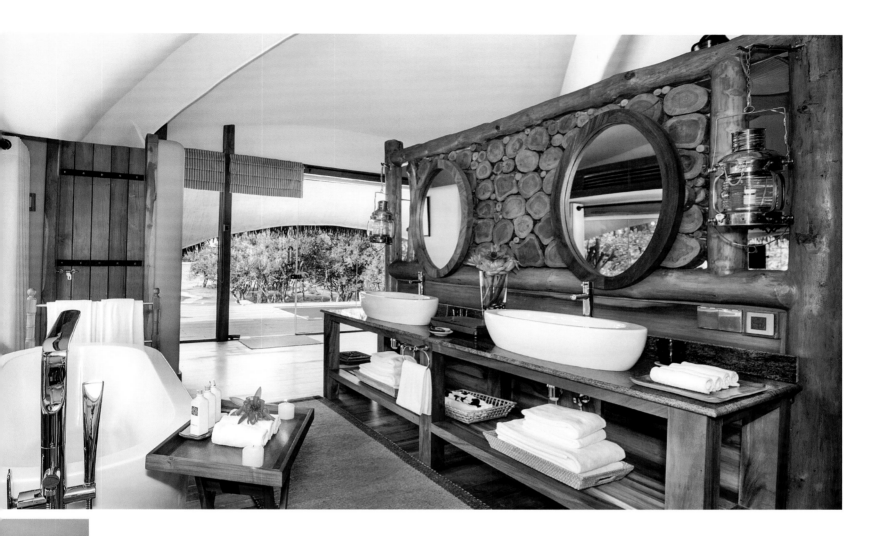

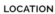

LOCATION

An der Südostküste Sri Lankas, am Ufer des Indischen Ozeans, versteckt in den Dünen, liegt das neueste Luxushotel von Uga Escapes, das Chena Huts by Uga Escapes. Das Resort ist etwa 315 Kilometer von Colombos internationalem Flughafen entfernt und etwa 26 Kilometer von Tissamaharama, der nächst gelegenen kleineren Stadt. Um dem empfindlichen Ökosystem nicht zu schaden, wird Nachhaltigkeit und Ökologie bei Uga Escapes großgeschrieben. Gäste der, sich unauffällig in die Umgebung einfügenden luxuriösen Cabins im Chena Huts, können bei Mondschein Wasserschildkröten bei der Eiablage am Strand beobachten oder Elefanten aus dem Yala National Park, dem größten Nationalpark Sri Lankas, kommend, beim Spielen in der Brandung zusehen. Maßgeschneiderte Ausflüge mit den Uga Rangers entführen die Gäste in die faszinierende Dschungel-Tierwelt, geben auf Wunsch aber auch Einblick in die Kultur und Geschichte des Landes.

HOTEL

Lediglich 14, je 105 qm große vollklimatisierte Cabins mit Pool, verteilen sich auf dem 29.000 qm großen Hotelareal. Die Außenverkleidung ist der einheimischen traditionellen Architektur nachempfunden. Im Inneren paart sich ausgewähltes Mobiliar aus Baumstämmen und rustikalen Motiven mit modernster Technik und Komfort. Die hochwertig ausgestatteten Chalets bestehen aus einem Wohn- und Schlafzimmer, einem En-suite-Badezimmer sowie einem schattigen Außendeck mit privatem Plunge Pool und einer Regenwalddusche im Freien. Für einen Safari-Apéritif trifft man sich entweder innen an der Bar oder draußen an der Poolbar, die sich versteckt hinter einem Wasserfall befindet. Anschließend wechselt man ins "Basses Restaurant", das seinen Namen dem nahegelegenen Riff und Leuchtturm verdankt. Neben den kulinarischen Highlights beeindruckt das Chena Huts by Uga Escapes mit einem abwechslungsreichen Spa-Angebot für Körper und Seele.

LOCATION

On the south-west coast of Sri Lanka, by the shore of the Indian Ocean, lies hidden in the dunes the newest luxury hotel of Uga Escapes, Chena Huts by Uga Escapes. The Resort is located around 315 kilometres away from Colombo's international airport and approximately 26 kilometres from the nearest town, Tissamaharama. Uga Escapes puts great emphasis on sustainability and ecology so as not to harm the fragile ecosystem. Guests at the luxurious cabins of Chena Huts, which unobtrusively fit into the surroundings, can watch turtles lay their eggs in the moonlight and elephants from the Yala National Park, the biggest national park in Sri Lanka, play in the surf. Tailor-made excursions with the Uga rangers take the guests into the fascinating world of the jungle wildlife as well as giving insight into the history and culture of the country.

HOTEL

Spread out over the 29,000 sqm large hotel premises are only 14 cabins with pool, each 105 sqm large and fully air-conditioned. The exterior cladding is inspired by the ancient local architecture. On the inside, state-of-the-art technology and comfort is combined with selected furniture made of tree trunks and rustic motifs. The chalets are fitted out to the highest of standards and consist of a bed and living room, an en-suite bathroom, as well as a shady outside deck with private plunge pool and a rainforest shower. To enjoy a safari apéritif one can meet at the inside restaurant bar or outside at the pool bar, which is hidden behind a waterfall. Afterwards one should visit the "Basses Restaurant", which is named after the nearby reef and lighthouse. Apart from its culinary highlights, the Chena Huts by Uga Escapes fascinate with a diverse spa programme for body and soul.

Get your Upgrade

www.upgradetoheaven.com/chena-huts

CHENA HUTS BY UGA ESCAPES . Palatupana Yala, Tissamaharama 82000, Sri Lanka . www.ugaescapes.com/chenahuts

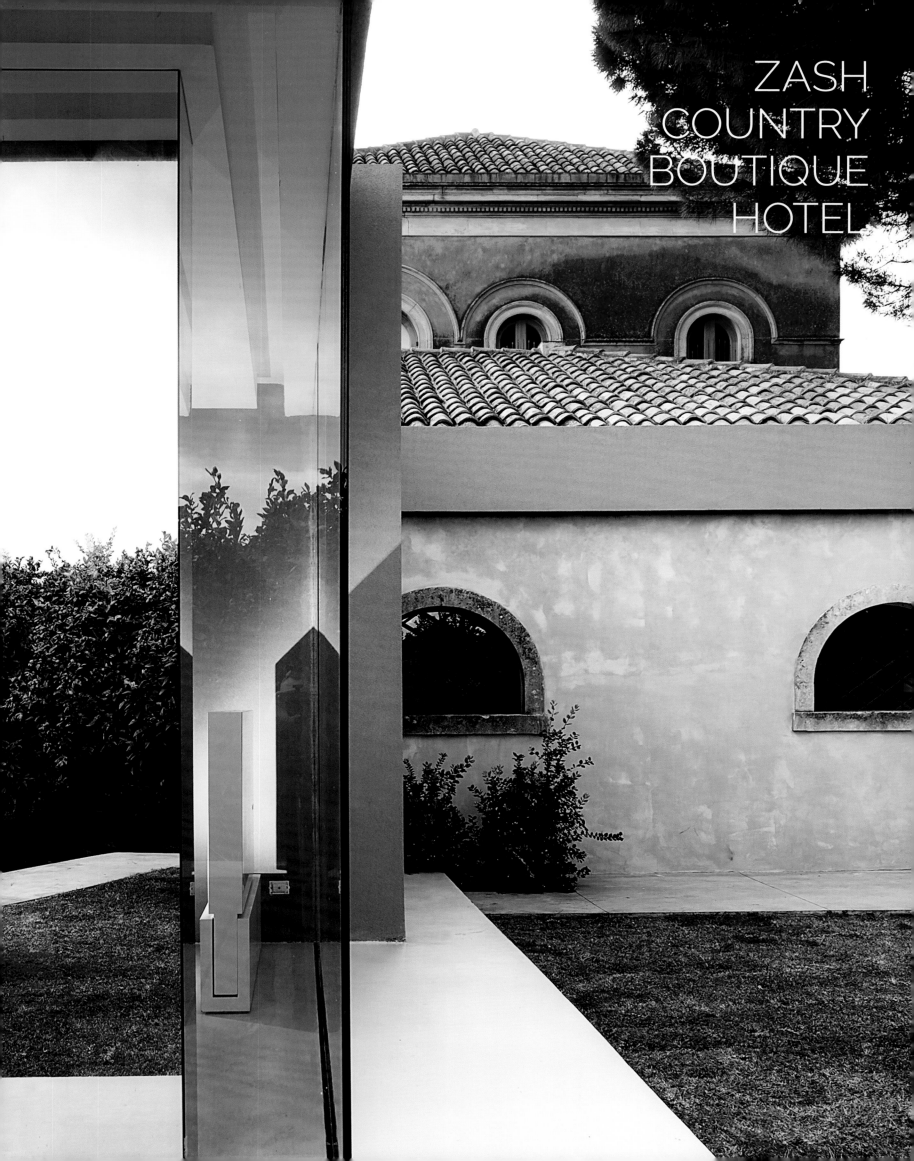

ZASH
COUNTRY
BOUTIQUE
HOTEL

Ein ländliches Boutique Hotel in dem historische Elemente
auf modernes Design und pure sizilianische Natur treffen.
Zash lässt seine Gäste in eine Welt voller positiver
Energie eintauchen, fernab der täglichen Routine.

A country boutique hotel where historical fragments meet
a contemporary taste and pure sicilian nature. Zash makes
its guests walk away from their daily routine and
dive into a dimension of positive energy.

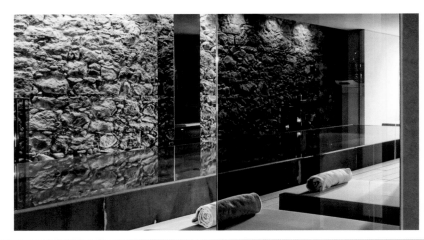

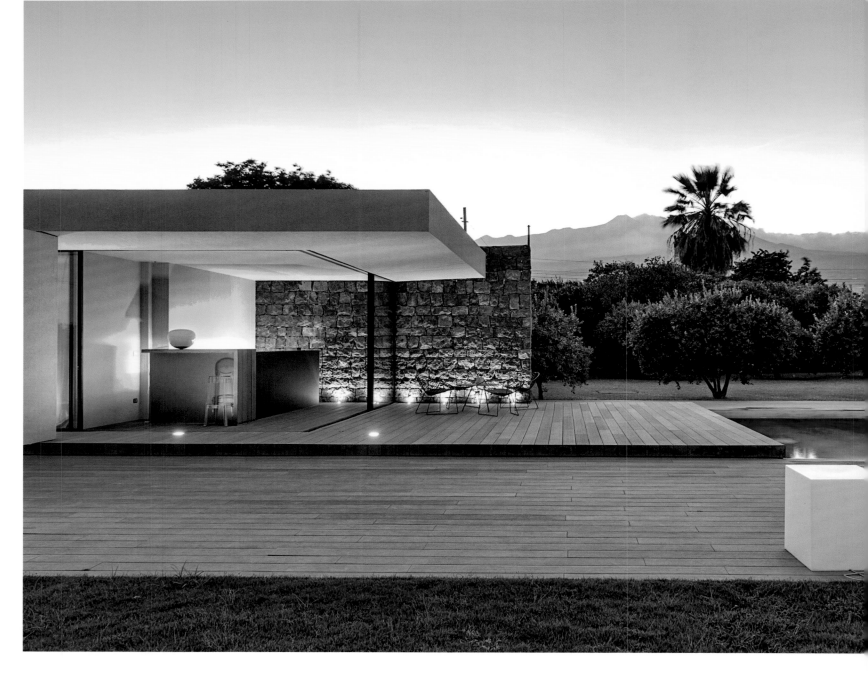

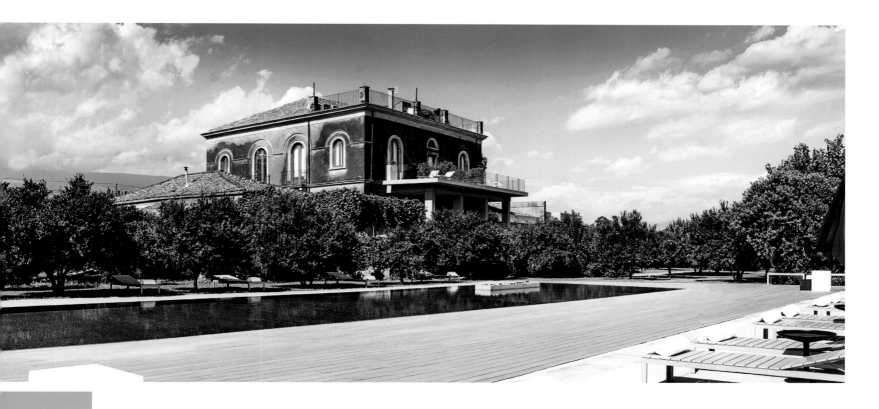

LOCATION

Im Osten Siziliens, inmitten von Zitronenhainen mit wunderbarem Blick auf den Ätna und das Ionische Meer, befindet sich ein kleines Architekturwunder – das Zash Country Boutique Hotel. Aus der einstigen Weinkellerei wurde dank der Restauration durch die Familie Maugeri ein mehrfach ausgezeichnetes Design-Hotel mit einem überwältigend schönen Garten. Die Wärme Siziliens und die Nähe zum Meer lassen gerade Zitronen und Oliven hervorragend gedeihen. Zusammen mit der schwarzen, kalten Lava des Ätnas prägen sie die raue, wunderschöne Landschaft Siziliens. Das Dorf Archi, in dem Zash liegt, ist 44 km vom nächsten Flughafen Catania entfernt. Nur ein Kilometer trennt das Hotel vom Ionischen Meer. Die Region rund um das Zash Country Boutique Hotel bietet für jeden etwas, ob vulkangeprägte Natur wie die Alcantara-Schlucht oder das Nebrodi Gebirge, sizilianisches Stadtleben in Catania und Taormina oder regionaler Weinanbau. Gäste können in nur einem Tagesausflug alle Sehenswürdigkeiten im Osten Siziliens besichtigen.

HOTEL

Im Zash Country Boutique Hotel spürt man Hingabe, Verbundenheit mit sizilianischer Tradition und Gespür für Design. Die Räume sollen durch große Fenster und Glastüren die äußere Umgebung ins Innere bringen. So werden stämmige Zitronenbäume zu einer natürlichen Tapete oder der Blick wird auf weite Landschaft freigegeben. Jeder Raum bringt Natur und Gäste durch Großzügigkeit und Verwendung von Naturmaterialien zusammen. Der Pool des Zash ist aus Lavagestein des Ätna. Im Spa gibt es keine langen Angebotslisten für Massagen, die Körper und Geist beleben, sondern nur den Gast, erfahrene Therapeuten-Hände, natürliche Produkte, Vulkangestein und die Düfte des Gartens. So sind zum Beispiel die Fronten im Zash aus Vulkangestein und durch die Fenster mit Kastanienholzrahmen schimmert das Ionische Meer. Im kleinen, feinen Restaurant des Zash kocht ein Shooting-Star der italienischen Kochszene: Giuseppe Raciti. Nach seinem Debut beim Wettbewerb "Best Emergent Italian Chef" im Jahr 2015 wurde er im Januar 2016 als einer von 12 italienischen Küchenchefs für eine Teilnahme beim berühmten "Bocuse d'Or"-Kochwettbewerb nominiert. Seine einzigartigen und unvergesslichen Kreationen basieren auf traditionellen italienischen Rezepten und allerbesten lokalen Produkten und Zutaten. Der aromatische Saft frisch gepresster Früchte aus dem hauseigenen Zitronenhain verleiht der Küche des Zash eine unverkennbar sizilianische Note. Im Jahr 2015 wählte das Geo Magazin das Zash Country Boutique Hotel unter den "100 schönsten Hotels Europas" zu einem der zehn schönsten Design-Hotels.

LOCATION

In the east of Sicily, amidst citrus groves with sublime views over Mount Etna and the Ionian Sea, one can find a small architectural miracle – the Zash Country Boutique Hotel. Thanks to the family Maugeri, who restored the former winery, it has been transformed into a multiple award-winning design hotel with an overwhelmingly beautiful garden. Sicily's warmth and its close location to the sea make it the perfect spot for lemons and olives to flourish. Together with Etna's black, cold lava, they form the rough yet beautiful landscape of Sicily. The village Archi, in which Zash is located, is 44 kilometres away from the airport Catania. There is only one kilometre between the hotel and the Ionian Sea. The region around the Zash Country Boutique Hotel offers something for everyone, from a volcanically formed landscape at the Alcantara Gorges or the natural microcosm of the Nebrodi mountain range to local viticulture and Sicilian folk traditions in the towns of Catania and Taormina. Guests can visit all of eastern Sicily's most important sites in one day trip.

HOTEL

At the Zash Country Boutique Hotel one can experience devotion, connection with Sicilian tradition and a deep sense of design. With their wide windows and large glass doors, the rooms bring the outside surroundings into the inside of the hotel. Chunky citrus trees become natural wallpaper and a view of the evocative Sicilian landscape is offered. Guests and nature are brought together through the generosity of each room and the use of natural materials. This is expressed in the volcanic stone cladding and chestnut windows through which the Ionian Sea dazzles and shines. Zash's pool is made of Etna lava stone. In the spa there is no long list of massages to revive the cult of body and mind, there is the guest at the centre, skilled hands of therapists, natural products, volcano stones and the scents of the garden. At Zash's small and evocative restaurant, a shooting star of the Italian culinary scene is on duty: Giuseppe Raciti. After his debut at the national contest "Best Emergent Italian Chef" in 2015, chef Giuseppe Raciti was selected in January 2016 among 12 Italian chefs to participate at the prestigious cooking competition "Bocuse d'or". His unique and unforgettable creations are based on traditional Italian recipes featuring the best regional products and ingredients. The aromatic juice of freshly pressed fruits from the on site lemon grove gives the Zash's kitchen an unmistakably Sicilian flavour. In 2015, Geo Magazine selected the Zash Country Boutique Hotel to be one of the ten most beautiful design hotels among the "100 Most Beautiful Hotels in Europe".

Get your Upgrade

www.upgradetoheaven.com/zash

ZASH COUNTRY BOUTIQUE HOTEL . Via strada provinciale 2/I-II n. 60, 95018 Archi, Riposto CT, Italy . www.zash.it

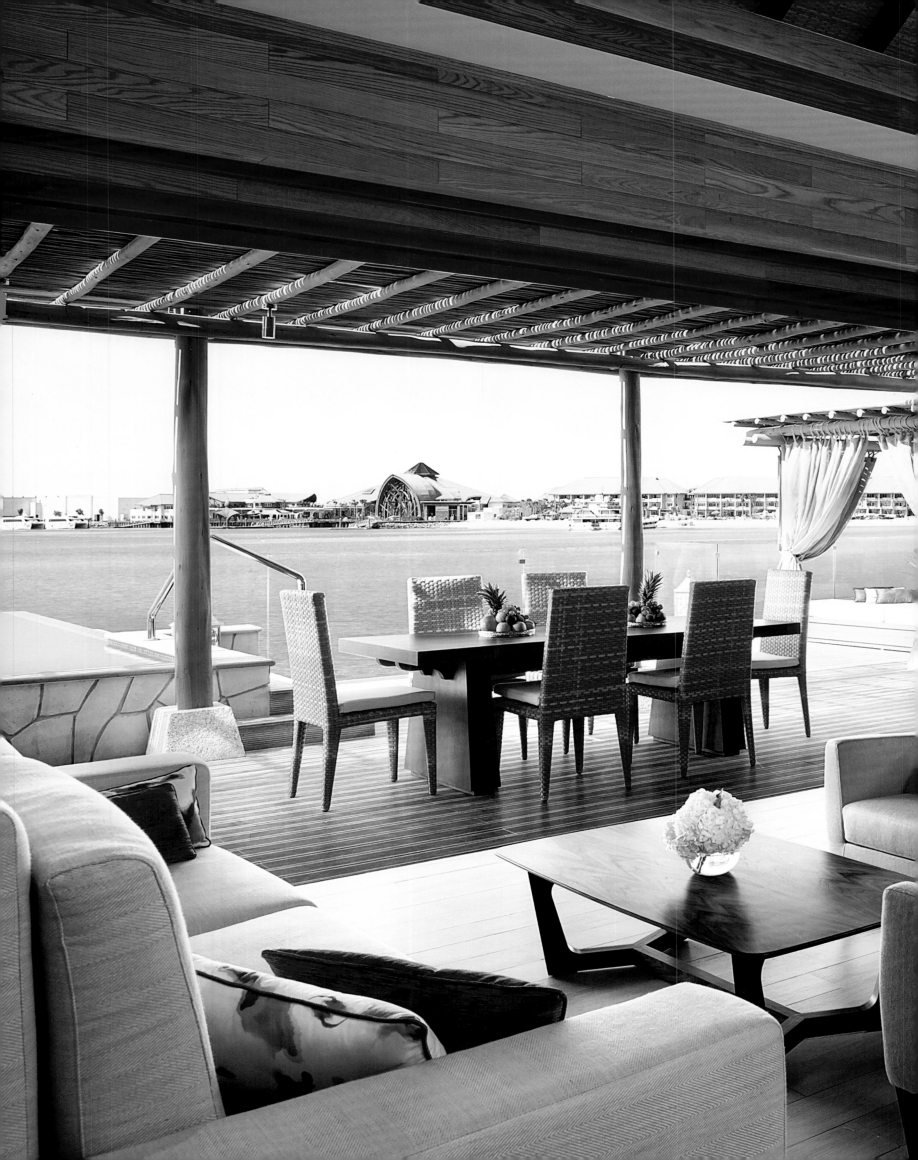

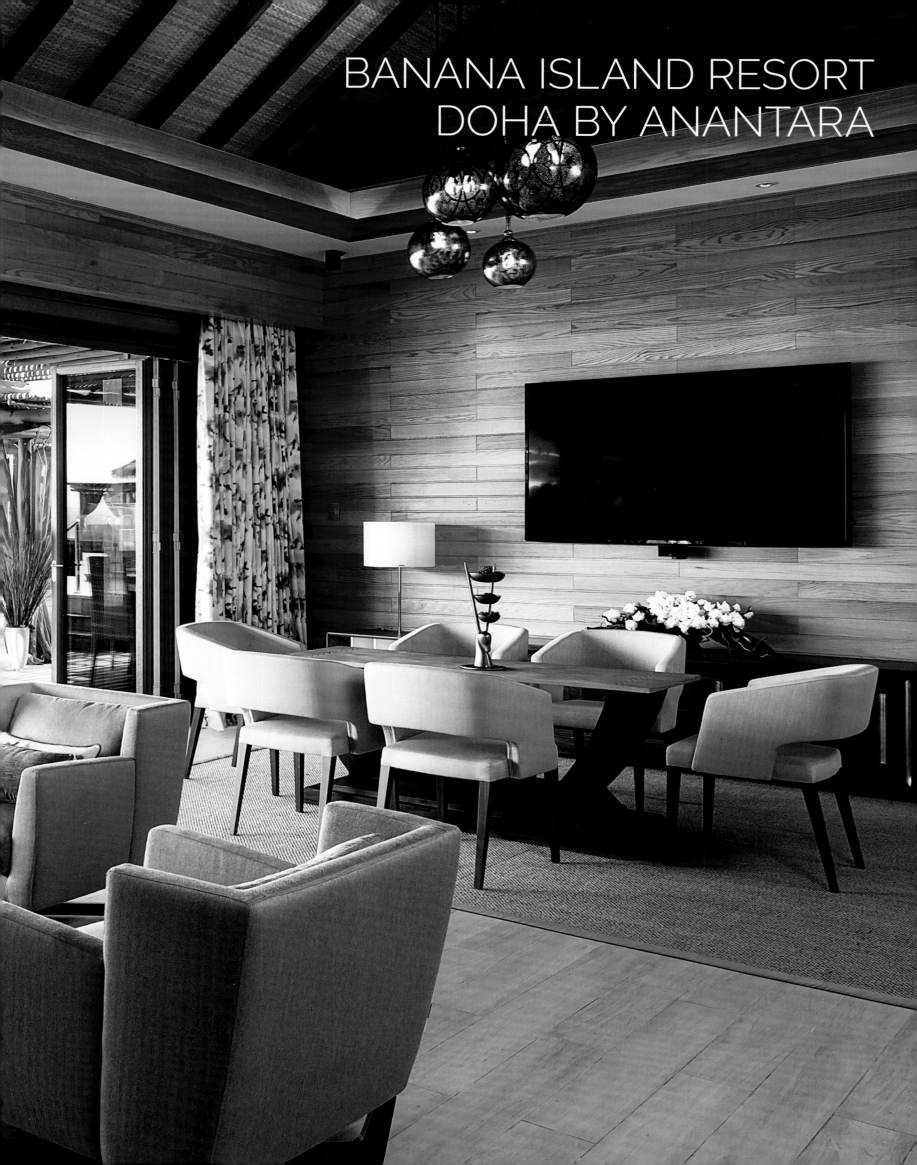

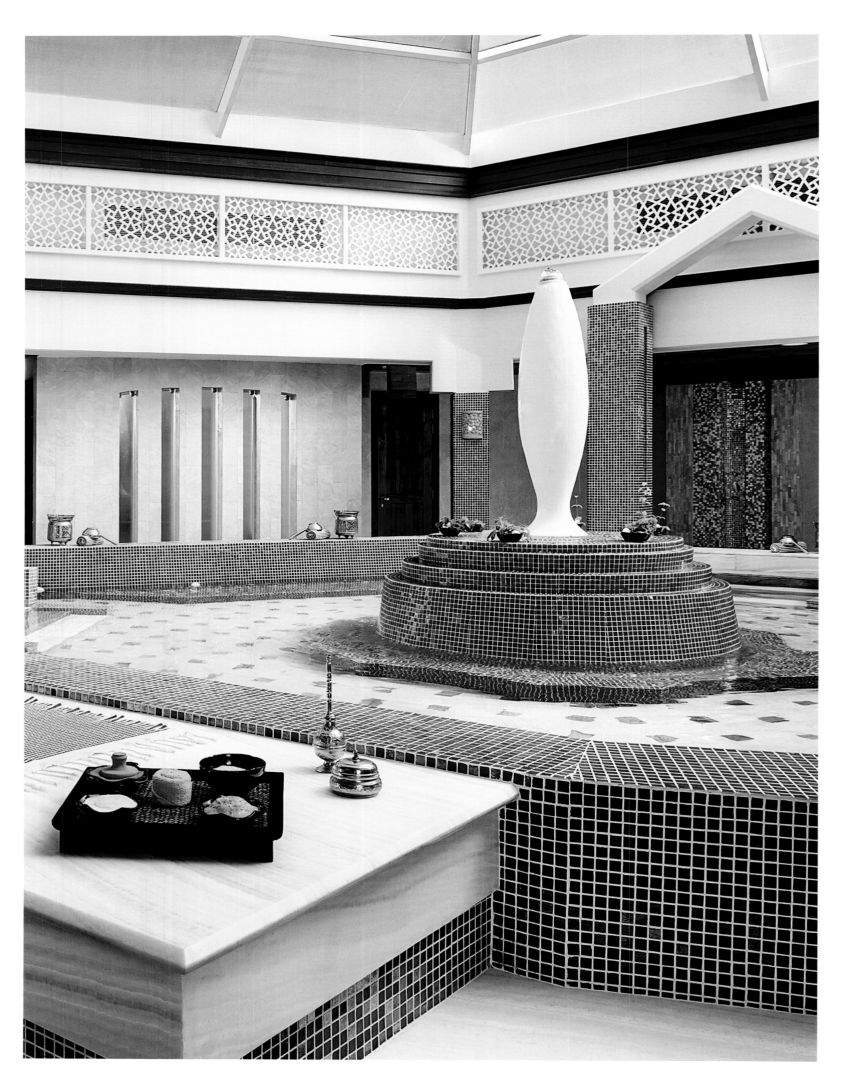

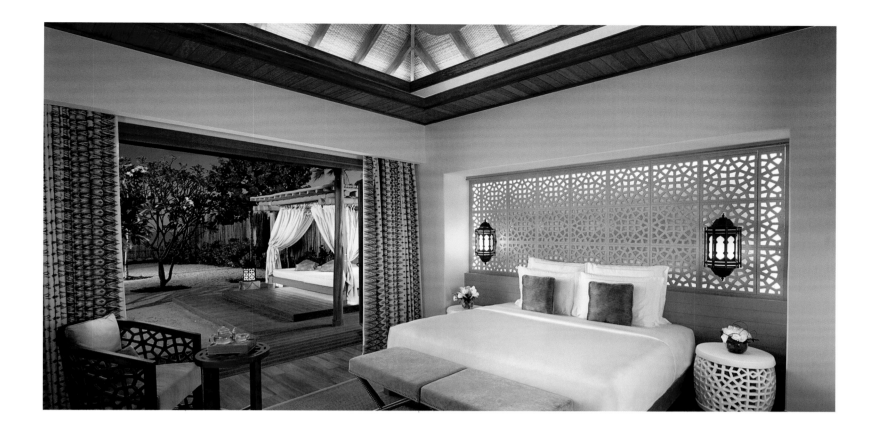

LOCATION

Das Banana Island Resort Doha by Anantara liegt in Katar auf einer halbmond-förmigen Insel im arabischen Golf und ist mit der Luxus-Fähre vom Al Shyoukh Terminal in der Stadtmitte in nur 25 Minuten erreichbar. Oder alternativ mit einem 10-minütigen Helikopterflug vom internationalen Flughafen Hamad aus. Die Insel verfügt über einen natürlichen Hafen, eingerahmt von einem 800 Meter langem Privatstrand, an dem die Gäste entspannen oder in das ruhige, sichere Wasser des türkisblauen Ozeans eintauchen können. Das Banana Island Resort Doha by Anantara bietet eine Welt fernab der pulsierenden Stadt Doha. Für Gäste, die das Land über die Insel hinaus erkunden wollen, liegt das Resort perfekt, um Katars reiche Fülle an Kultur- und Naturschätzen sowie das nur 20 Minuten entfernte Doha zu entdecken.

HOTEL

Die 141 luxuriösen Gästezimmer, Suiten und Villen des Banana Island Resort Doha by Anantara sind in arabischem Stil mit Signature Elementen von Anantara gestaltet. Dazu gehören 54 Premier Sea View Rooms, 16 Deluxe Sea View Rooms, 8 Sea View Suites, 18 Anantara Suiten und 34 großräumige Sea View Pool Suites mit privatem Pool. Die acht luxuriösen Zwei-Zimmer Over Water Villen sowie die vornehmen Drei-Bett Over Water Villen mit privatem Pool und Butler-Service sind bestens für Familien und Freunde geeignet. Im preisgekrönten Anantara Spa entspannen Gäste in himmlischer Ruhe bei außergewöhnlichen Behandlungen, in denen die ethnischen Wurzeln Dohas und der bunte kulturelle Mix von Souks, exotischen Sehenswürdigkeiten, Düften, Klängen und Berührungen zu spüren sind. Im Spa stehen zudem verschiedene Behandlungsräume, marokkanische und türkische Hamams, Pools, Saunen und Dampfbäder zur Verfügung. Das Balance Wellness Center des Hauses ist das erste und einzige seiner Art in einem Resort in Nahost und bietet ein ganzheitliches Programm für Entspannung, Detox und Stressabbau. Die einzigartigen Einrichtungen beinhalten unter anderem einen über-dachten botanischen Garten mit einer Fülle exotischer Pflanzen und eine gesunde Wellness-Küche. Acht verschiedene Restaurants bieten an spektakulären Plätzen auf der ganzen Insel eine köstliche Auswahl an internationalen und italienischen Speisen sowie dem Besten aus dem Nahen Osten – vom Yachthafen oder Pool bis hin zum Strand und auf Stegen im Wasser mit beruhigender Aussicht und leichter Meeres-brise. Das Banana Island Resort bietet auch interaktive kulinarische Erlebnisse: Ein Küchenchef zeigt den Gästen die Zubereitung von traditionellen Gerichten der Küche Katars und die Verwendung der kostbaren Gewürze und exotischen Zutaten.

LOCATION

Banana Island Resort Doha by Anantara is located on a Qatari crescent shape island in the Arabian Gulf, and is only a 25 minute journey by luxury catamarans from Al Shyoukh Terminal located in the city's downtown area or a 10 minute helicopter ride with bird's eye views of the spectacular coastline directly from the Hamad International Airport. The island provides a natural harbour framed by an 800 metre long private beach where guests can relax and swim in the calm, safe waters of the turquoise sea. Banana Island Resort Doha by Anantara feels a world away from bustling Doha. For travelers with the time and inclination to explore beyond the island, the resort is well placed for guests to discover Qatar's rich wealth of cultural and natural treasures with Doha only 20 minutes away.

HOTEL

The 141 luxury guest rooms, suites and villas of Banana Island Resort Doha by Anantara are designed in Arabian style with signature Anantara touches including 54 Premier Sea View Rooms, 16 Deluxe Sea View Rooms, eight Sea View Suites, 18 Anantara Suites and 34 spacious Sea View Pool Villas featuring a personal pool and poolside cabana. Families and groups of friends find luxurious space in the eight two-bedroom and three prestigious three-bedroom Over Water Villas with personal pool and dedicated butler service. Guests relax in heavenly peace at the awarded Anantara Spa with extraordinary treatments that capture Doha's ancient tribal roots, as well as a vibrant souk heritage of exotic sights, scents, sounds and touches. The spa offers several treatments rooms, Moroccan and Turkish hammams, pool, sauna and steam rooms. The resort's dedicated Balance Wellness Centre is the first and only facility of its kind in the Middle East within a resort, offering holistic programmes for relaxation, detox, de-stress. Unique facilities include an indoor botanical garden and nutritional wellness cuisine with menus crafted by specialist chefs. Eight dining options offer a mouthwatering choice of Middle Eastern, Italian and international cuisines at spectacular locations all around the island from the marina, poolside, by the shoreline and on over water decks with tranquil views and soft sea breezes. Offering richly interactive culinary experiences, guests can learn to recreate traditional Qatari cuisine with a master chef showcasing the Middle East's coveted spices and exotic ingredients.

Get your Upgrade

www.upgradetoheaven.com/anantara-banana-island-doha

BANANA ISLAND RESORT DOHA BY ANANTARA . P.O. Box 23919, Doha, Qatar . www.doha.anantara.com

"WE TAKE PRIDE IN OFFERING OUR GUESTS THE VERY BEST IN MODERN LUXURY"

"Wir sind stolz, unsere Gäste mit dem Allerbesten zu verwöhnen, was moderner Luxus bieten kann"

– Mr Thomas Fehlbier,
Cluster General Manager Doha

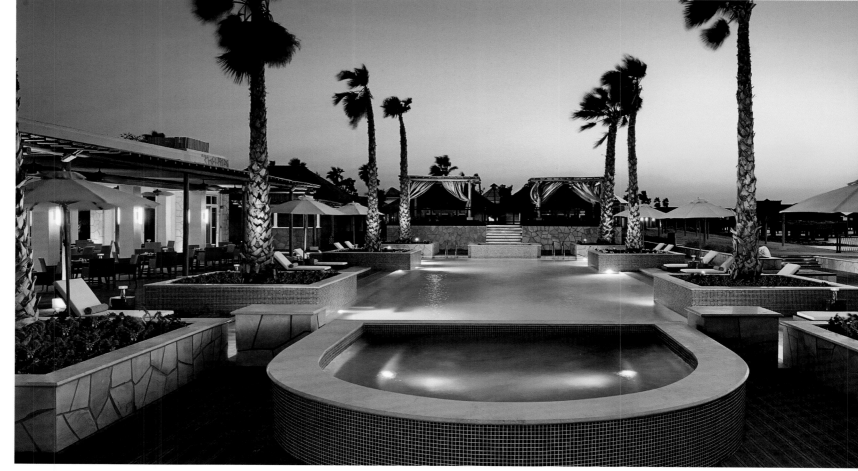

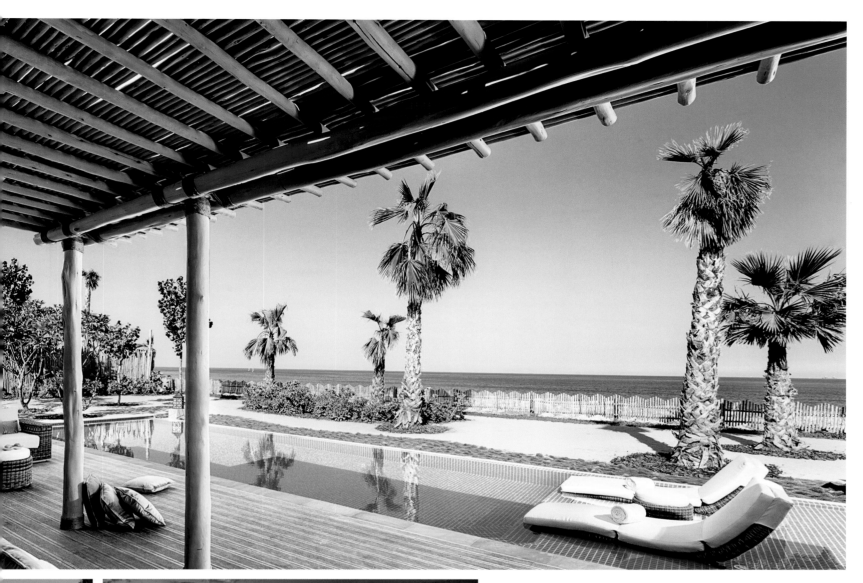

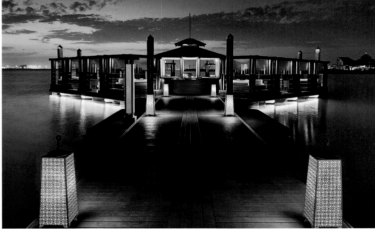

The resort boasts its own marina with 30 berths and a fully equipped dive centre with a practice pool, ideal for beginners. Water sports range from the relaxing pace of kayaking, pedalos and SUP boarding, the thrills of wakeboarding, banana boat, donut rides and water skiing to luxury floating HamacLands with picnic boxes, yacht cruises and fishing trips. In the resort's two lane surf pool the waves can be controlled to suit different skill levels, making it easier to master surfing techniques than out at sea. Guests can energise themselves with laps or a leisurely dip in the 100 metre long lagoon pool or enjoy the fun at the children's pool complete with water slides. Kids find their own program at Banana Island Resorts, offering the Coolmint kids club for the little ones and the Peppermint teens club for teenagers. Guests looking for recreation options on dry land are also spoilt for choice, from tennis, beach volleyball and a fitness centre, to an entertainment centre with a nine-hole putting golf course, eight pin bowling alley and VIP cinema theatre.

Das Resort punktet mit seiner hauseigenen Marina, die über 30 Liegeplätze und ein vollausgestattetes Tauch-Center, mit Übungspool für Anfänger, verfügt. Das Wassersportangebot reicht von entspanntem Kajak- und Tretbootfahren sowie SUP Boarding über Kicks auf Wakeboard, Banana Boot, Wasser- und Jetski bis hin zu den luxuriösen Schwimminseln mit Picknick, Segeltörns und Angelausflügen. Im Surfpool des Resorts übt sich das Surfen einfacher als auf dem Meer, da das Wellenniveau dem Können der Gäste individuell angepasst werden kann. Der 100 Meter lange Lagunen-Pool lädt Gäste ein, sich bei ein paar Runden oder entspanntem Planschen zu erfrischen. Für Kinder gibt es einen Kinder-Pool mit Wasserrutschen. Mit dem Coolmint Kids Club für die Kleinen und dem Peppermint Teens Club haben Kinder im Banana Island Resort ihr ganz eigenes Programm. Gästen, die lieber auf dem Trockenen bleiben, bietet das Banana Island Resort eine Auswahl von Tennis, Beach Volleyball und Fitnesscenter bis hin zu einem 9-Loch-Putting-Golfplatz, einer Bowling Bahn und einem VIP-Kino.

COLLECT MOMENTS,

NOT THINGS.

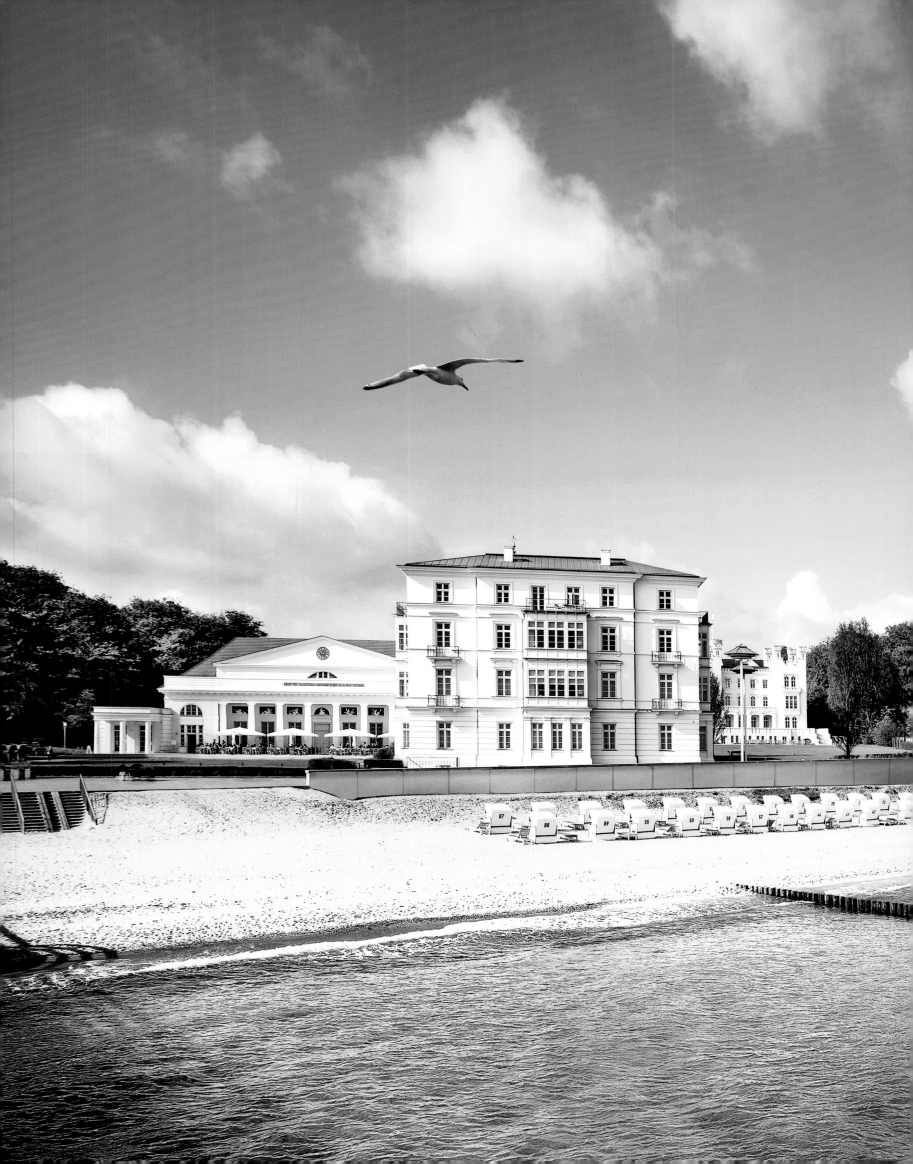

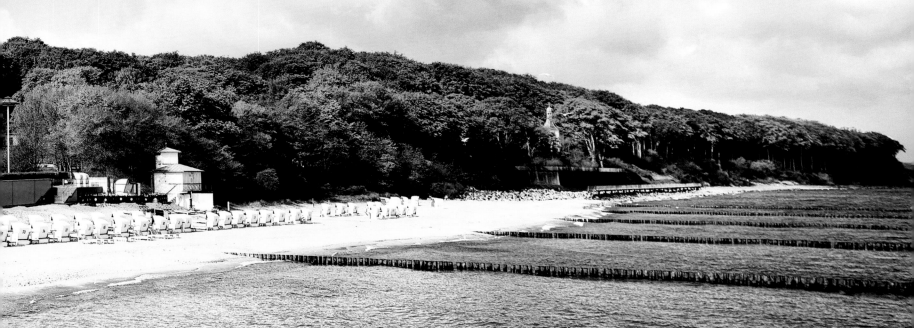

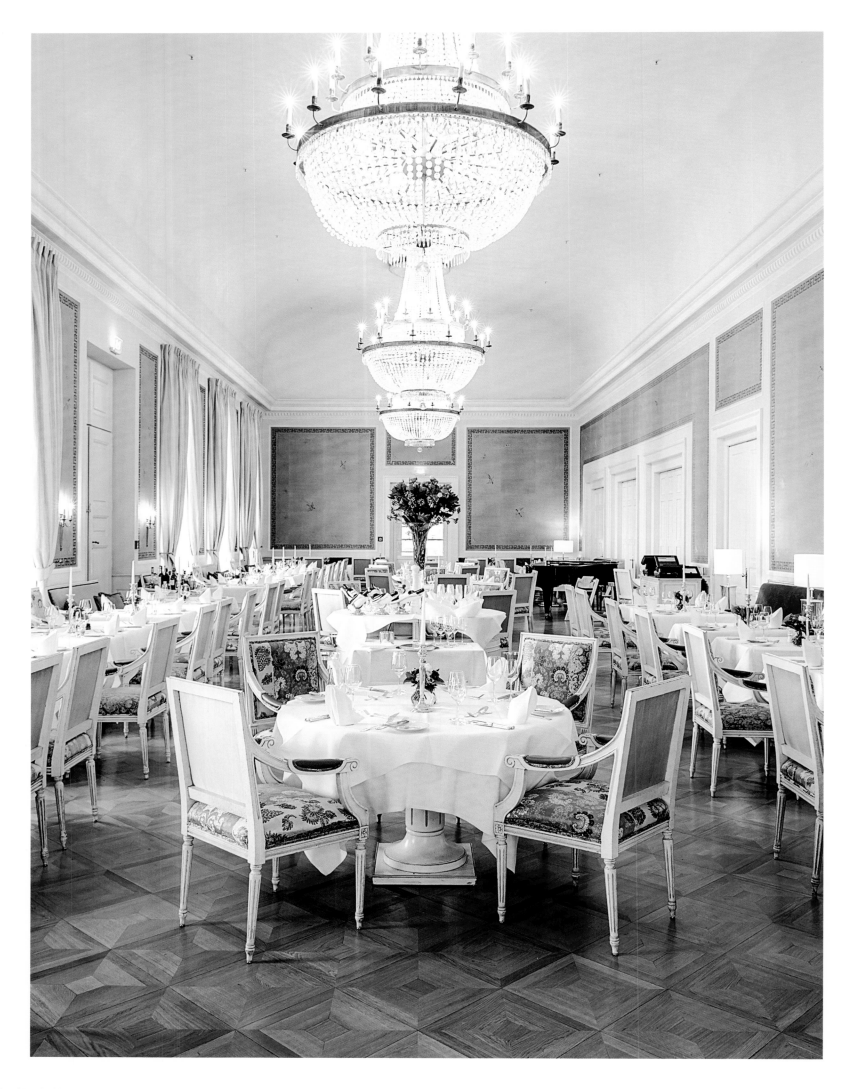

LOCATION

Heiligendamm, die "Weiße Stadt am Meer", liegt direkt an der Ostsee, etwa drei Autostunden von der Hauptstadt Berlin und zwei von Hamburg entfernt. Das erste Seebad Deutschlands blickt auf eine lange Geschichte zurück: 1793 von Herzog Friedrich Franz I. zu Mecklenburg-Schwerin gegründet, entwickelte sich Heiligendamm zu einer der besten Adressen des gesellschaftlichen Lebens in Europa. Europäischer Hochadel, inklusive der Zarenfamilie, verbrachte hier seine Sommerfrische. Das Grand Hotel Heiligendamm ist ein einzigartiges Anwesen mit großer Vergangenheit. Seine "weißen Villen" werden umrahmt vom Sandstrand auf der einen und einer parkartigen Kulisse aus Buchenwäldern und Wiesen auf der anderen Seite. Wunderbarer Ostseeblick und direkter Strandzugang machen das Grand Hotel Heiligendamm zweifellos zu einem der schönsten Ferienresorts in Europa.

HOTEL

Das klassizistische Ensemble aus sechs Gebäuden empfängt seine Gäste in vornehmer Eleganz. Zentrum der Anlage ist das Kurhaus mit Restaurant, von dessen Terrasse Gäste einen wunderbaren Meerblick genießen. Die 181 Zimmer des Grand Hotel Heiligendamm sind in verschiedenen, größtenteils denkmalgeschützten Gebäuden untergebracht, deren jeweilige Architektur sich in der Inneneinrichtung widerspiegelt. In den Häusern Grand Hotel, Haus Mecklenburg und dem Severin Palais erwartet die Gäste ein klassisch-eleganter und dennoch moderner Einrichtungsstil mit edlen Materialien in von der Natur inspirierten dezenten Farben. Strenger und massiver gibt sich dagegen die gotisch anmutende Burg Hohenzollern mit ihren Gästezimmern und exklusiven Suiten. Passend zum Tudor-Stil des Gebäudes wurden hier Samt und Seide in kräftigen Farben eingesetzt und mit dunklen Mahagoni-Möbeln kombiniert. Das luxuriöse, vielfach ausgezeichnete, Heiligendamm Spa ist eine eigene Welt für sich, die für Ursprünglichkeit, Nachhaltigkeit und Authentizität steht. Das exklusive Angebot in Sachen Wohlfühlen, Gesund- und Schönheit ist angelehnt an die Bädertradition dieses ersten deutschen Seebades und beinhaltet besondere Methoden zur Entspannung, unter anderem asiatische Massagen. Darüber hinaus bietet das Spa einen großen Indoor-Pool, verschiedene Saunen und ein Dampfbad. Die verschiedenen Restaurants des Grand Hotels bieten Gästen kulinarische Genüsse auf höchstem Niveau. Im Gourmet Restaurant "Friedrich Franz", das mit einem Michelin Stern glänzt, wird das Beste der Region mit edlen Produkten meisterhaft verfeinert. Die Sushi Bar serviert erstklassige asiatische Küche. Ein ganz besonderes kulinarisches Erlebnis ist ein romantisches Strandkorb-Dinner, das individuell vom Grand Hotel Heiligendamm arrangiert wird.

LOCATION

Heiligendamm, the white town by the sea, is located directly by the Baltic Sea, around three hours away from the capital Berlin and two hours from Hamburg by car. Germany's first seaside resort has a long history: founded in 1793 by Grand Duke Frederick Francis I of Mecklenburg-Schwerin, Heiligendamm developed into one of the best locations in Europe's social life. Europe's high nobility, including the Tsar's family, spent their summers here. The Grand Hotel Heiligendamm is a unique estate with a great past. Its white mansions are surrounded by the beach on one side and a park-like scenery with beech woods and meadows on the other side. A wonderful view of the Baltic Sea and direct access to the beach turn the Grand Hotel Heiligendamm doubtlessly into one of Europe's most beautiful vacation resorts.

HOTEL

The classicistic ensemble of six buildings welcomes guests with a noble elegance. At the centre of the complex is the Kurhaus building with its restaurant, where guests can enjoy a wonderful sea view from the terrace. The 181 rooms of the Grand Hotel Heiligendamm are situated in different, mostly heritage-protected buildings, whose architecture is reflected in the interior design. At the Grand Hotel, Haus Mecklenburg and the Severin Palais, guests can expect a classically elegant yet modern interior of fine materials combined with nature-inspired discreet colours. By contrast, the Gothic-influenced Burg Hohenzollern, with its guest rooms and exclusive suites, appears more austere and monumental. Velvet and silk in vibrant colours have been incorporated and combined with dark mahogany furniture to match the Tudor style. The luxurious multiple award-winning Heiligendamm spa is a world for itself, standing for originality, sustainability and authenticity. The exclusive offer in terms of well-being, health and beauty is inspired by the spa traditions of this first German seaside resort and includes special relaxation methods such as Asian massages. Furthermore, the spa includes a large indoor pool, various saunas and a steam bath. The Grand Hotel's different restaurants offer guests culinary delights of the highest standards. The gourmet restaurant "Friedrich Franz", awarded with a Michelin Star, uses products of the highest quality to refine regional delicacies. The Sushi Bar serves first-class Asian cuisine. A special culinary highlight is the romantic beach chair dinner, which is individually organised by the Grand Hotel Heiligendamm.

Get your Upgrade

www.upgradetoheaven.com/grand-hotel-heiligendamm

GRAND HOTEL HEILIGENDAMM . Prof.-Dr.-Vogel-Str. 6, 18209 Bad Doberan-Heiligendamm, Germany . www.grandhotel-heiligendamm.de

EIN EXKLUSIVER PLATZ AM MEER FÜR DEN WAHREN LUXUS VON HEUTE

An exclusive spot at the sea for
a true luxury experience

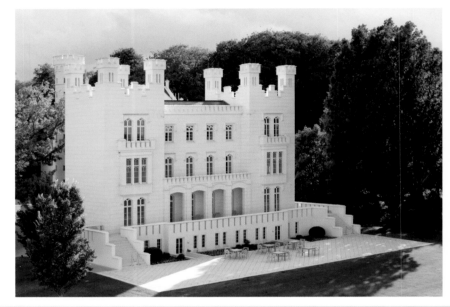

At the Grand Hotel Heiligendamm guests can enjoy peace, relaxation and time for activities. Mecklenburg-Vorpommern's Baltic Sea coast is one of Germany's most sun-kissed regions and has a lot of leisure activities to offer – from enjoying a good book in a beach chair to cycling, horse riding and hiking as to sailing, kite- and windsurfing. Sports lovers can find a 27-hole golf course, an 18-hole tournament course and two tennis courts nearby. Situated right beside the beach and offering a variety of facilities, including a kidsvilla and the "Eisbären" kids club for young guests, the Grand Hotel Heiligendamm is a perfect destination for families.

Gäste finden im Grand Hotel Heiligendamm Ruhe, Entspannung und Zeit für Aktivitäten. Die Ostseeküste Mecklenburg-Vorpommerns ist eine der sonnenreichsten Regionen Deutschlands und bietet vielseitige Freizeit-möglichkeiten - vom guten Buch im Strandkorb über Wandern, Radfahren oder Reiten bis hin zu Segeln, Kiten und Windsurfen. Sportliebhaber finden in der Nähe eine 27-Loch-Golfanlage, einen 18-Loch-Meister-schaftsplatz und zwei Tennisplätze. Die Lage direkt am Strand und das vielseitige Angebot, das für die kleinen Gäste eine eigene Kindervilla und den Eisbären Kinderclub bereithält, machen das Grand Hotel Heiligen-damm auch zum perfekten Urlaubsort für Familien.

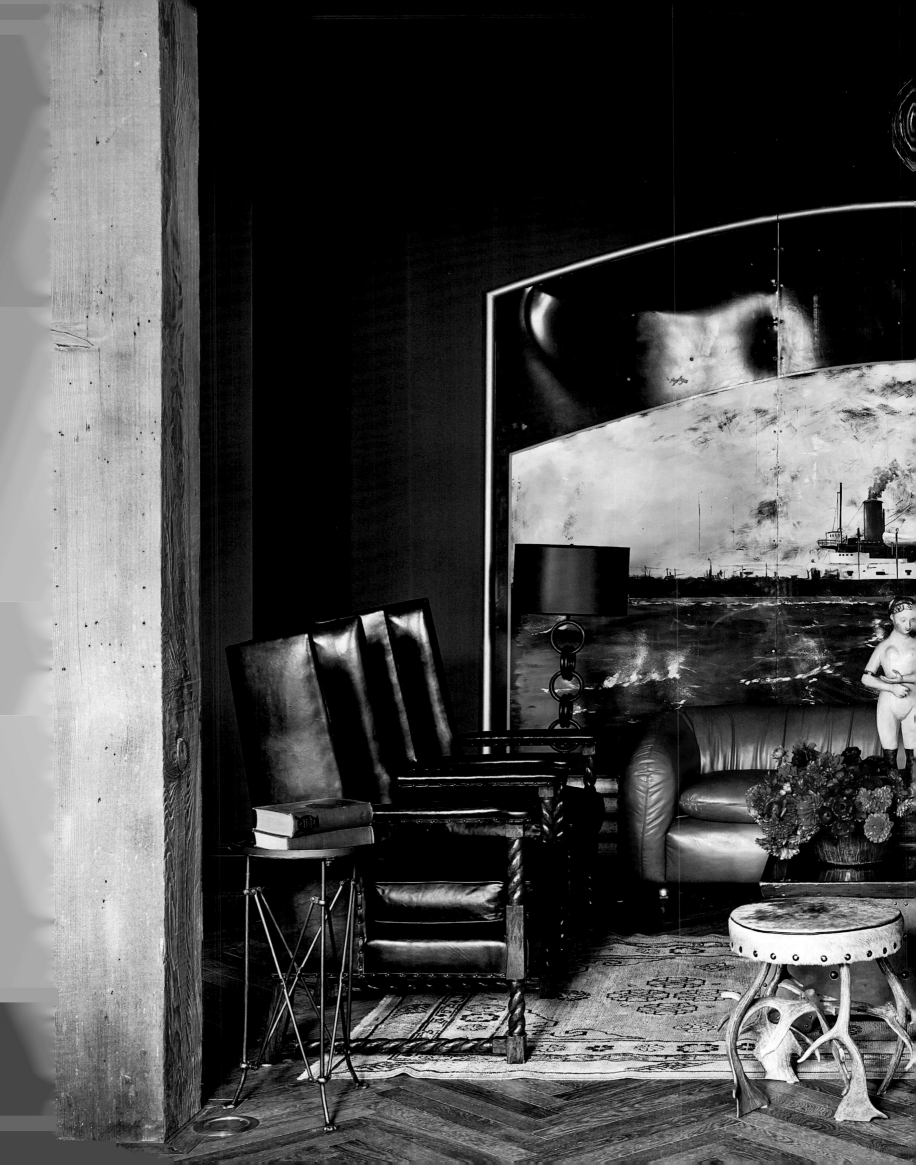

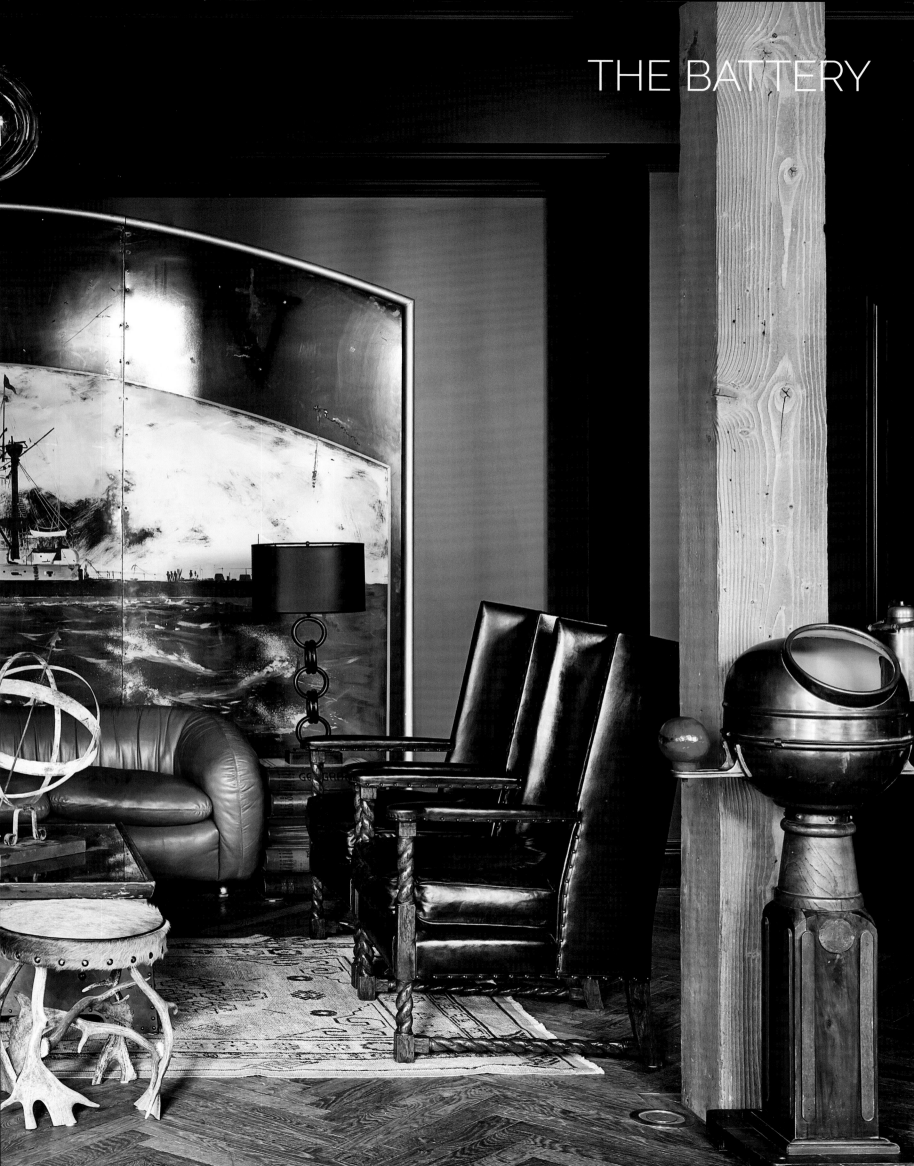

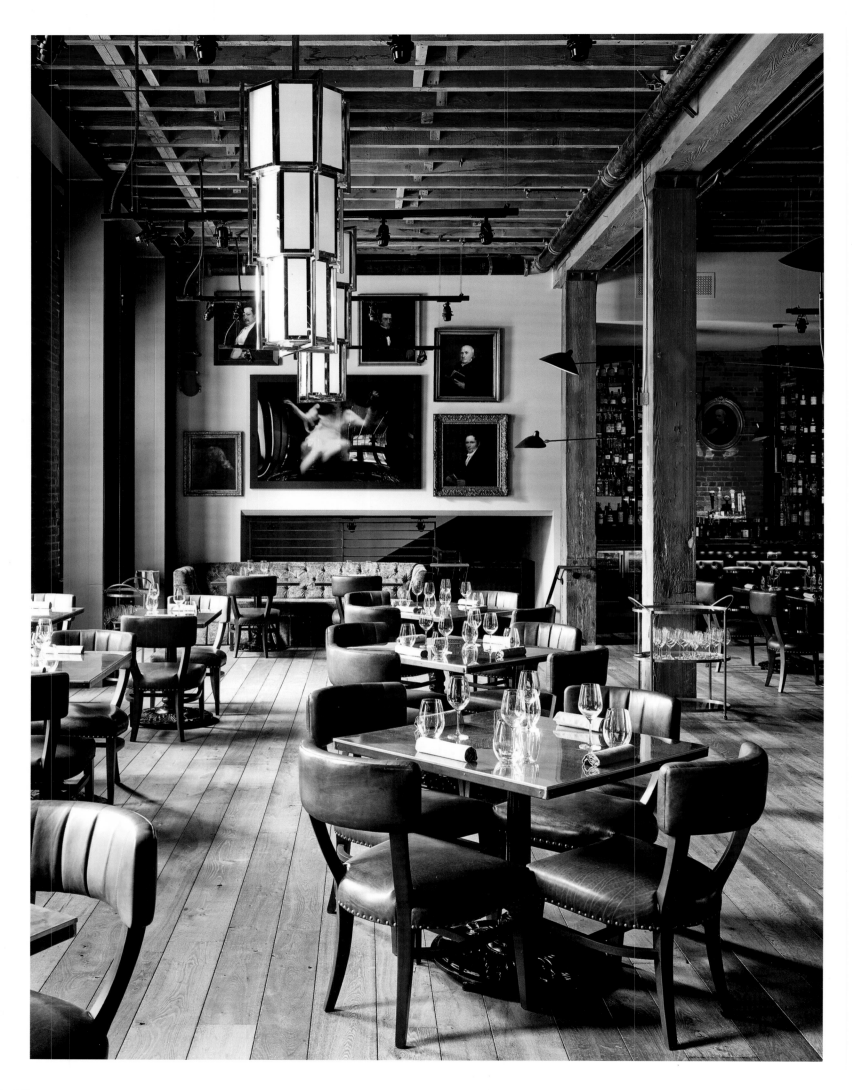

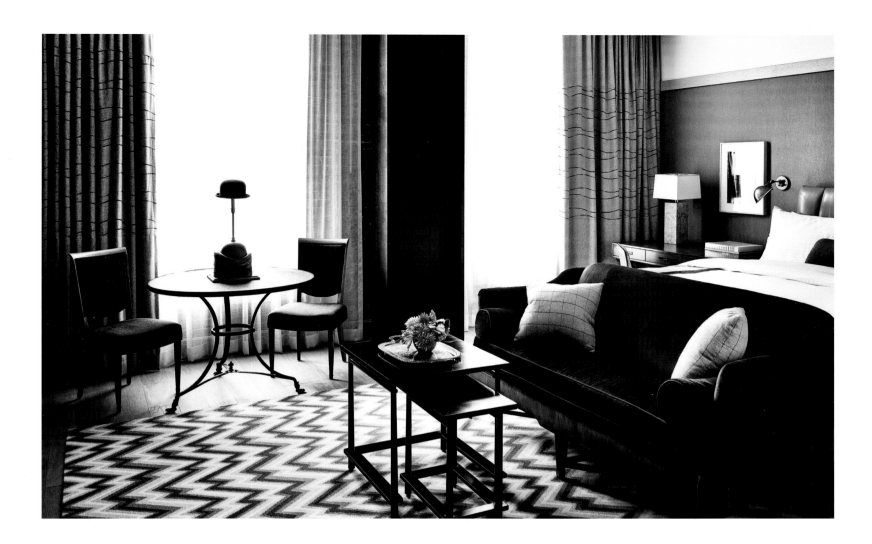

LOCATION

San Francisco liegt an der Westküste der USA, im sonnigen Kalifornien, und ist berühmt für die Golden Gate Bridge, die vielen Hügel im Stadtgebiet und die Cable Cars, mit denen man sich in der Stadt fortbewegt sowie die Häuser im viktorianischen Stil. Die Stadt ist ein absoluter Kultur-Hot-Spot und fasziniert mit ihrer völlig eigenen Mischung aus Kunst, Design und High-Tech. Im historischen Jackson-Square-Viertel findet sich zwischen Antiquitätenläden und Designer-Shops The Battery im Musto Plaza. Das Gebäude, in dem The Battery auf über 5.000 qm zu Hause ist, fällt sofort durch seinen besonderen Mix aus historischer und moderner Architektur ins Auge. The Battery ist Hotel und Member Club zugleich. Während ihres Aufenthalt werden Gäste als Clubmitglieder betrachtet und so stehen ihnen die Räumlichkeiten und Angebote des Clubs, von Ausstellungen über Lesungen renommierter Autoren bis hin zu Ausflügen, ebenfalls zur Verfügung.

HOTEL

Das luxuriöse Boutique-Hotel des The Battery bietet 14 Suiten und ein großzügiges Penthouse mit Dachterrasse. Das edle, hochwertige Interior Design des Hauses ist spektakulär und lässig zugleich. Es trägt die unverkennbare Handschrift von Ken Fulk. Der Designer aus San Francisco ist berühmt für seinen aufwändigen, oft pompösen Stil. Zu den Einrichtungen des The Battery Member Club, die auch den Hotelgästen offenstehen, gehören ein Restaurant, mehrere Bars, ein Spa, ein Weinkeller und eine Bibliothek. Der gesunde Lifestyle Nordkaliforniens lässt sich auch im Restaurant "717B" des The Battery genießen. Der Küchenchef serviert ausschließlich Kreationen auf Basis bester, nachhaltig angebauter, natürlicher Produkte. Kunst spielt eine zentrale Rolle im The Battery und so bietet das Haus Gästen und Mitgliedern ein eigenes Kunstprogramm rund um Ausstellungen in der Bay Area, das jedes Vierteljahr wechselt. Dazu gehören Galerie- und Atelierbesuche, Kunstgespräche und Museumsausflüge für Clubmitglieder und Hotelgäste. Die offene Kultur und das fantastische Ambiente machen The Battery zum perfekten Zuhause für einen Besuch San Franciscos.

LOCATION

San Francisco, located on the USA's west coast in sunny California, is famous for its Golden Gate Bridge and hills in the city area, which visitors can tour by cable car and admire for its Victorian houses. It is a cultural hotspot and is mesmerising with its individual mixture of art, design and high tech. The Battery in Musto Plaza is situated in the historic Jackson Square district, between antique and designer stores. The building, in which The Battery is spread over 5,000 sqm, is immediately striking through its special mixture of historic and modern architecture. The Battery is a hotel and members-only club at the same time. Guests are seen as club members during their stay. Therefore, the club's premises and offers, from exhibitions and lectures by prestigious authors to excursions, are available.

HOTEL

The luxurious boutique hotel of The Battery offers 14 suites and a spacious penthouse with rooftop terrace. The hotel's elegant, high-class interior design is spectacular and unpretentious at the same time. It bears the unmistakeable signature of Ken Fulk. The designer from San Francisco is famous for his complex and often grandiose style. The Battery Member Club, which is also open to hotel guests, offers a restaurant, several bars, a spa, a wine cellar and a library. Northern California's healthy lifestyle can be enjoyed in the "717B" restaurant. The chef serves creations only on the basis of the best, sustainably cultivated and natural products. Art plays a central role at The Battery, shown in the art programme around exhibitions in the Bay Area, which is provided to guests and members of the hotel and rotates every quarter. The programme includes visits to galleries and exhibitions, art talks and museum excursions for club members and hotel guests. Its open culture and phenomenal atmosphere make the Battery the perfect base for a visit to San Francisco.

Get your Upgrade

www.upgradetoheaven.com/the-battery

THE BATTERY . 717 Battery St, San Francisco, California 94111, USA . www.thebatterysf.com

SAN FRANCISCO'S MOST ELECTRIC, ECLECTIC AND ECCENTRIC PLACE

San Franciscos elektrisierendste, vielseitigste und ausgefallendste Location

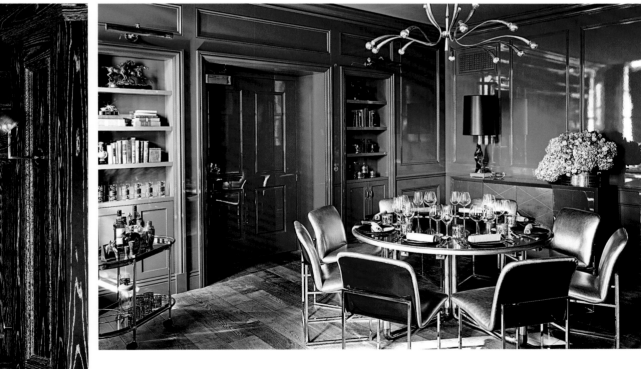

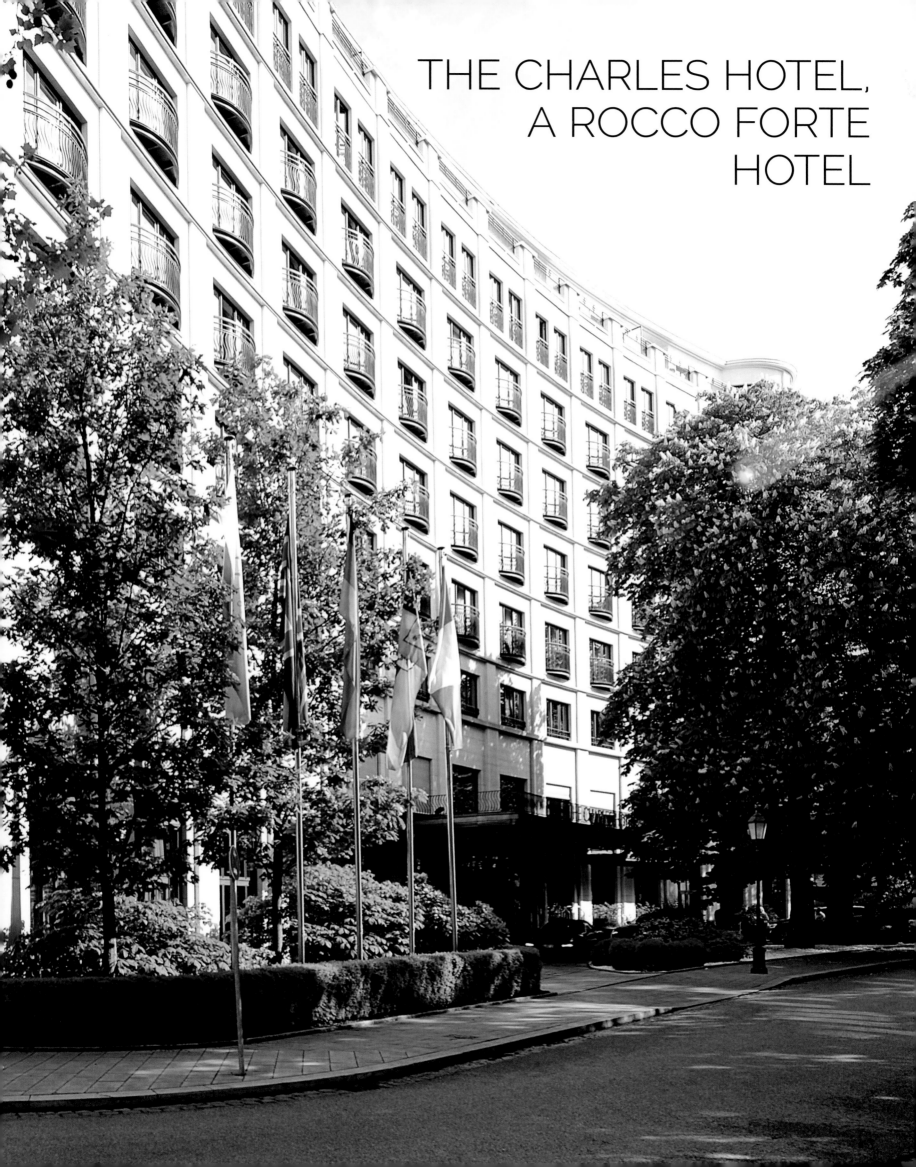

THE CHARLES HOTEL,
A ROCCO FORTE
HOTEL

MÜNCHENS HERZ SCHLÄGT RUND UM DAS THE CHARLES HOTEL

The heart of Munich beats all
around The Charles Hotel

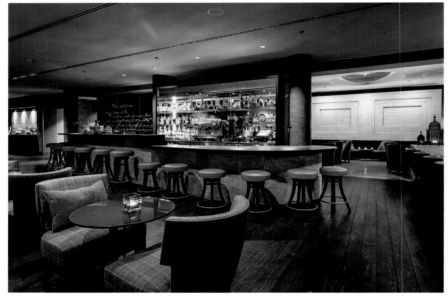

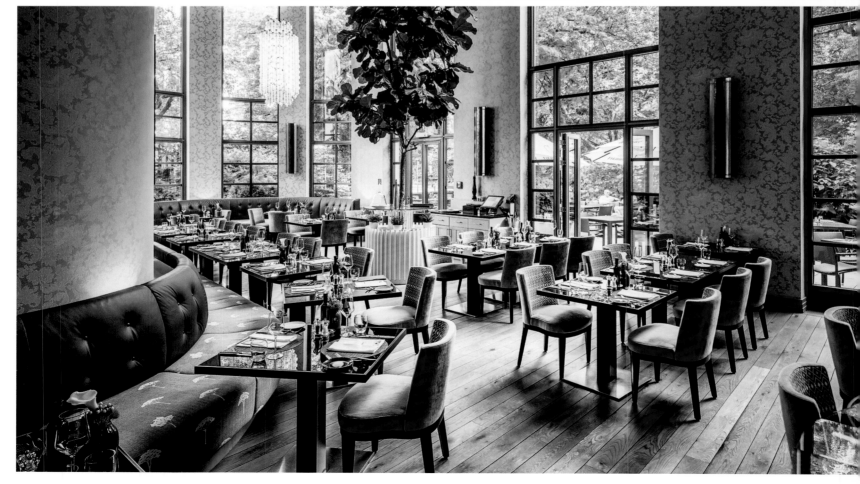

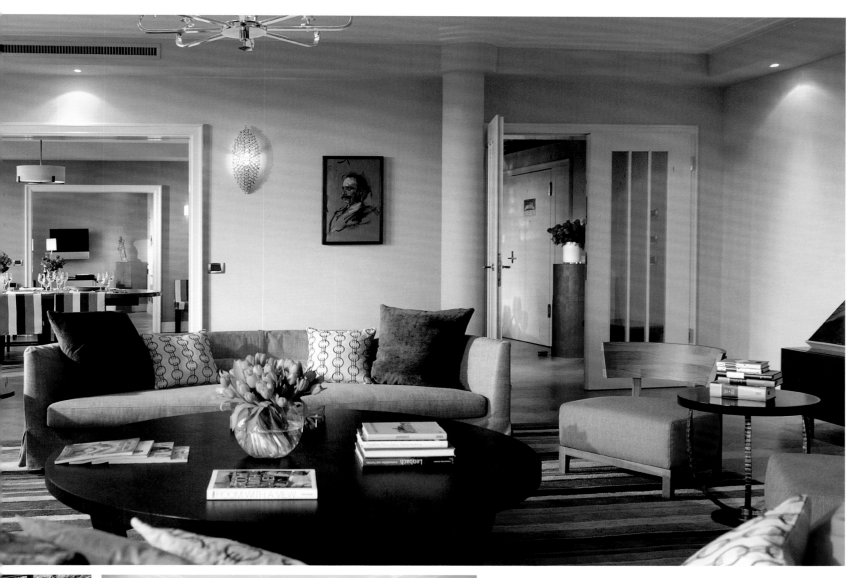

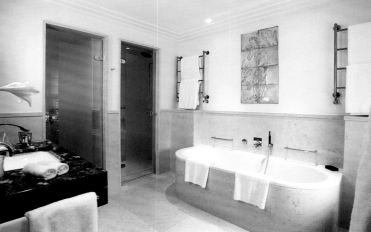

The luxurious Rocco Forte hotels originate from a family business four generations old. Every house has an individual character that matches its location. The Charles Hotel is located on the site of the former university library at the Old Botanical Garden. Inspired by this special location, Olga Polizzi, Director of design and sister of Sir Rocco Forte, used botanic and book themes for the interior design. Fine woods and traditional Bavarian natural stone, warm natural shades and high-quality crafted natural materials such as cotton and silk bear Olga's unmistakeable designer signature. Specially manufactured furniture and decoration elements as well as art pieces from Munich artists, round up the interior.

Die luxuriösen Rocco Forte Hotels entstammen einem seit vier Generationen bestehenden Familienunternehmen. Jedes Haus spiegelt einen individuellen Charakter passend zum Standort wider. Das The Charles Hotel befindet sich an der Stelle der ehemaligen Universitätsbibliothek, direkt am Alten Botanischen Garten. Die besondere Lage inspirierte Olga Polizzi, Director of Design und Schwester von Sir Rocco Forte, dazu, die Themen Botanik und Bücher für die Innengestaltung aufzugreifen. Edle Hölzer und Naturstein von traditionell bayerischer Herkunft, warme Naturfarbtöne und hochwertig verarbeitete Naturstoffe wie Baumwolle und Seide, tragen ihre unverkennbare Designhandschrift. Eigens für das Hotel hergestellte Möbelstücke und Dekorationselemente sowie Kunstobjekte von Münchner Künstlern komplementieren das Interior.

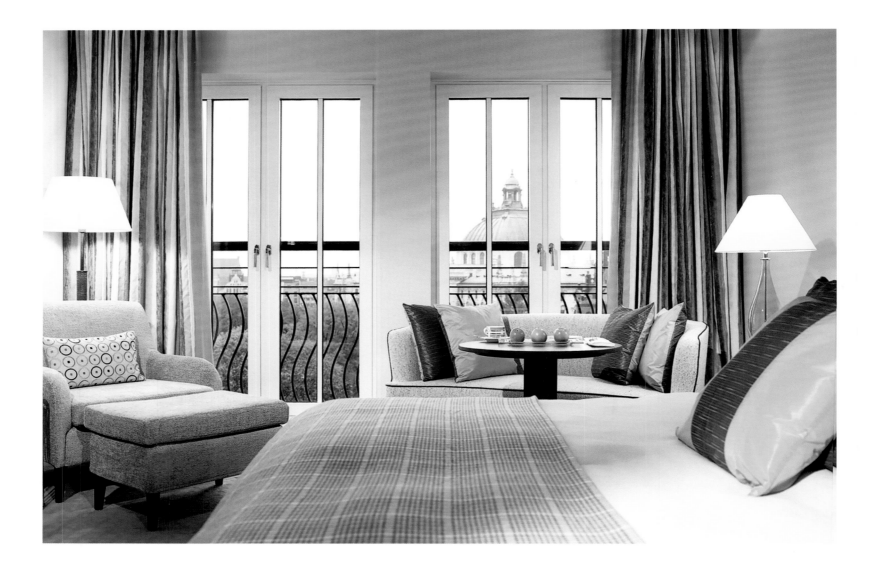

LOCATION

In dem eigens angelegten Münchner Quartier Lenbachgärten, das sich zwischen Karls- und Königsplatz sowie dem Hauptbahnhof befindet, entstand in unmittelbarer Nähe zum ehemaligen Lenbach Wohnhaus im Jahr 2007 das The Charles Hotel. Durch den Alten Botanischen Garten und diverse Grünanlagen entsteht das Gefühl, von einer großen Gartenanlage umgeben zu sein. Gäste erreichen fußläufig das Museumsquartier mit seiner lebhaften Kunstszene und dem neu eröffneten Lenbachhaus sowie den Englischen Garten, den größten Stadtpark Europas.

HOTEL

Das The Charles Hotel verfügt über 160 Zimmer, davon 24 Suiten einschließlich der Royal Suite Monforte, benannt nach dem Geburtsort des kurz vor der Eröffnung 2007 verstorbenen Vaters von Sir Rocco Forte, dem renommierten Hotelier Lord Charles Forte. Bodentiefe Fenster in den mindestens 40 qm großen Standardzimmern sorgen für lichtdurchflutete Räume und bieten gleichzeitig einen grandiosen Blick über den Alten Botanischen Garten oder die historischen Gebäude Münchens. Die individuell gestalteten Suiten verfügen über getrennte Wohn- und Schlafbereiche. Für Veranstaltungen steht ein Konferenz-Bereich auf zwei Etagen mit eigenem Eingang zur Verfügung. In Sophia's Restaurant & Bar gilt das Motto: Zwangloser Genuss mit Kompetenz und Passion. Die neue "Botanical Bistronomy" zeichnet sich durch regionale Zutaten, hohen kulinarischen Anspruch sowie gelassene Atmosphäre aus. Die außergewöhnlichen Cocktail-Kreationen zeugen von ausgeprägter Fantasie. Pure Entspannung bietet das 800 qm große Spa, das den längsten Hotel-Indoorpool Münchens besitzt. Sauna, Dampfbad, Wellnessduschen, Erholungs- und Fitnessraum lassen keine Wünsche offen. In der Lobby des The Charles Hotel inspirieren luxuriöse Marken Gäste für ihren nächsten Einkaufsbummel in der Münchner Innenstadt.

LOCATION

In 2007, The Charles Hotel was built close by the former Lenbach residential house in Munich's newly established quarter Lenbachgärten, the public squares Karlsplatz and Königsplatz and the main train station. Thanks to the Old Botanical Garden and various green parks the guests get the feeling of being surrounded by a large garden. The museum quarter, with its lively art scene, the newly opened Lenbachhaus and the English Garden, which is the largest city park in Europe, are within walking distance.

HOTEL

The Charles Hotel provides 160 rooms, 24 of which are suites and include the Royal Suite Monforte, named after the birthplace of Sir Rocco Forte's father, the renowned hotelier Lord Charles Forte, who died in 2007. Floor-to-ceiling windows in the minimum 40 sqm standard rooms provide a light-flooded atmosphere and offer a stunning view overlooking the Old Botanical Garden or the historical buildings of Munich. The individually designed suites consist of separate living and sleeping areas. Events and conferences can be held in the two-storey conference area with separate entrance. Sophia's Restaurant & Bar applies the maxim: casual enjoyment with competence and passion. The new "Botanical Bistronomy" stands out with its regional ingredients and high culinary standards in a relaxed atmosphere. Its extraordinary cocktail creations reflect a distinctive imagination. Pure relaxation is to be enjoyed in the 800 sqm spa, which boasts Munich's longest hotel indoor pool. With sauna, steam bath, wellness showers, relaxation room and gym, no wish will remain unfilled. In the lobby of The Charles Hotel, luxury brands display and inspire guests for their next shopping tour in Munich's city centre.

Get your Upgrade

www.upgradetoheaven.com/rocco-forte-the-charles-hotel

THE CHARLES HOTEL, A ROCCO FORTE HOTEL . Sophienstrasse 28, 80333 Munich, Germany . www.roccofortehotels.com/the-charles-hotel

MAKE YOURSELF
A DECLARATION OF ENDLESS LOVE.

HELIORO BY KIM

Nine endlessly interwoven strands of gold in 18 k rose gold combine to form the *Helioro* ring. Discover *Helioro* BY KIM at Wempe
at the best addresses in Germany and in London, Paris, Madrid, Vienna, New York and Beijing. www.wempe.com

WEMPE
125
YEARS
ATELIER

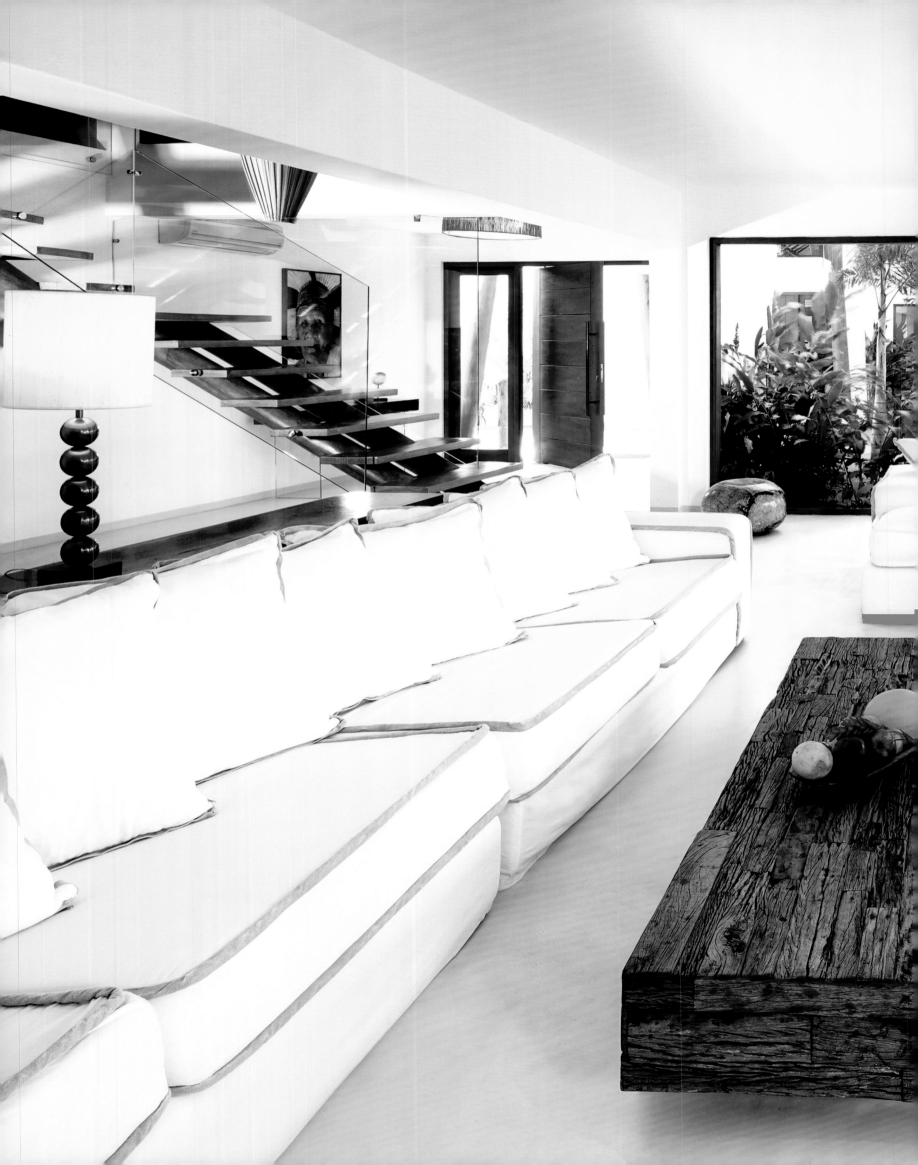

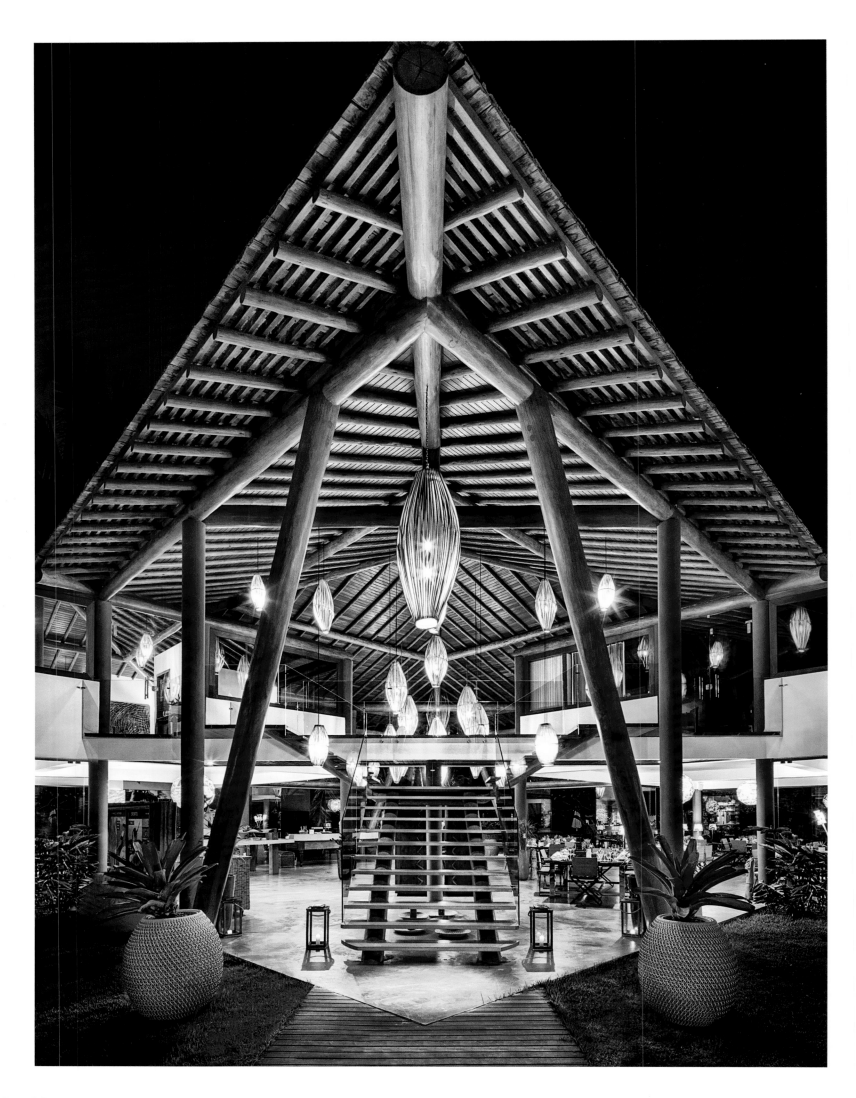

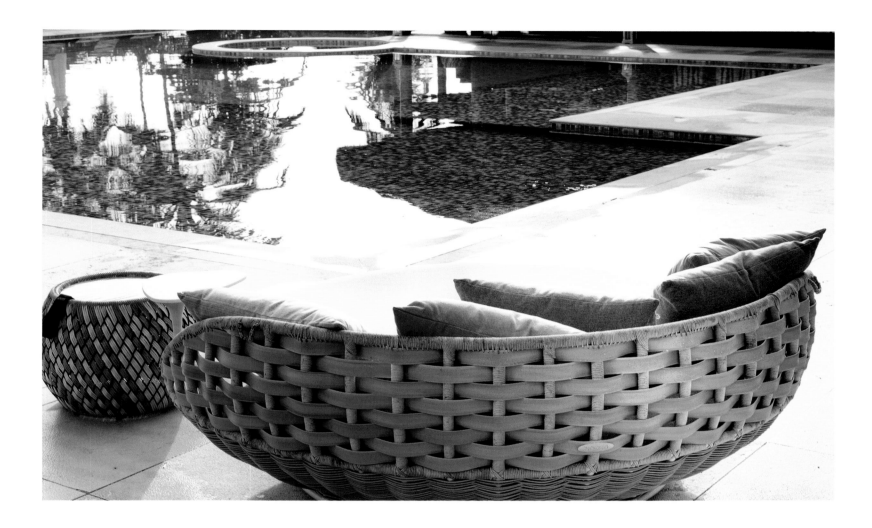

LOCATION

An der brasilianischen Atlantikküste, im Bundesstaat Bahia, erwartet das edle Campo Bahia seine Gäste. Traumhaft gelegen bei Santo André, einem mit seinen 800 Einwohnern idyllischen Fischerdörfchen direkt am Meer, an der Einmündung des "João de Tiba" Flusses. So ist Campo Bahia – mit all seinem Luxus – eingebettet in eine geschützte Gemeinschaft, in der die Zeit stehengeblieben ist. Der Transfer vom 27 km entfernten Flughafen von Porto Seguro führt über eine malerische Küstenstrasse am Atlantik bis zum Städtchen Santa Cruz Cabrália. Von dort erreicht man dann, nach einer 10-minütigen Fährenfahrt, den Zielort Santo André. Somit ist der Transfer zum Campo Bahia bereits das erste nette Urlaubserlebnis.

HOTEL

Ein fantastischer Start für eine wunderbare Geschichte: Im Sommer 2014 begann die Erfolgsstory von Campo Bahia als luxuriösem Quartier für die Fußball-Weltmeister aus Deutschland. "Jogis Jungs" schöpften in dieser harmonisch konzipierten Umgebung Kraft und Energie für ihre Matches. Brasilianische Gastfreundschaft traf auf deutsche Spielfreude, die zum langersehnten Titelgewinn führte. Aus diesem Teamspirit entwickelte sich Campo Bahia zu einem Sinnbild des Neuen Luxus, der Erholung, Entspannung sowie des Energietankens – einem luxuriösen Rückzugsort. Die Eigentümer des naturnahen Edel-Hotels haben eine traumhafte Oase mit viel Privatsphäre und vollendetem Komfort geschaffen. 14 luxuriöse und sorgfältig ausgestattete Villen in Strandlage eröffnen mit großzügigen, sonnendurchtränkten Räumen den Blick in die Weite der exotischen Landschaft. Das Restaurant "No. 1" wartet mit brasilianischen Spezialitäten auf. Der preisgekrönte Küchenchef verwöhnt die Gäste zu jeder Tageszeit mit zeitgemäßer Haute Cuisine und dem unvergleichlichen Geschmack der einheimischen Küche. Im gemütlichen "Grill Garten" verführen bei passender Live-Musik brasilianischer Churrasco und eine Caipirinha-Bar. Ein lockerer Abend am direkt am Strand liegenden "Grill Garten" ist ein unvergessliches Erlebnis für Besucher von Campo Bahia.

LOCATION

Nestled on the peaceful Brazilian Atlantic coast, in the state of Bahia, the exquisit Campo Bahia awaits its guests. Georgeously located close to Santo André, an idyllic fishing village with 800 inhabitants which sits next to the sea at the mouth of the "João de Tiba" river. Thus, Campo Bahia – with all its luxury – is embedded in a safe community in which time stands still. The transfer from the airport of Porto Seguro, which is 27 kilometers away, leads over a picturesque coastal drive by the Atlantic to the village Santa Cruz Cabrália. From there it takes another 10 minutes by ferry to reach Santo André. Therefore, the transfer to Campo Bahia is the first lovely vacation experience.

HOTEL

A wonderful story deserves a fantastic beginning. In the summer of 2014, the success story of Campo Bahia began as the luxurious accommodation for Germany's Soccer World Cup team. "Jogi's boys" drew power and energy from these harmoniously designed surroundings for their rousing match. Brazilian hospitality combined with German enthusiasm and together they led to the long-awaited title. Out of this team spirit Campo Bahia has developed into a symbol of new luxury, recreation, relaxation and rejuvenation, all at a luxurious retreat. The owners of this precious hotel have taken great care to embed in nature a wonderful oasis of privacy and total comfort. The sunny, spacious rooms of each of the fourteen luxurious, exquisitely furnished beach villas open up to views into the vast, exotic landscape. The restaurant "No. 1" dishes up Brazilian specialties. The award-winning chef will spoil guests any time of day with a blend of contemporary haute cuisine and the incomparable taste of local delicacies. At the cosy "Grill Garten" Brazilian churrasco and a caipirinha bar indulge guests with matching live music. A relaxed evening in the barbecue garden, located right on the beach is an unforgettable experience to Campo Bahia's guests.

Get your Upgrade

www.upgradetoheaven.com/campo-bahia

CAMPO BAHIA . Avenida Beira Mar No 1885, 45807000 Santo André, Brazil . www.campobahia.com

"IN THE YEAR 1500 BRAZIL WAS DISCOVERED EXACTLY AT THIS COAST. TODAY CAMPO BAHIA IS BAREFOOT-LUXURY AT ITS BEST!"

„Im Jahre 1500 wurde Brasilien genau an dieser Küste entdeckt. Heute ist Campo Bahia Barefoot-Luxury at its best!"

– Dr. Christian Hirmer, Founder and Christiane Hirmer, Founder & Interior Design

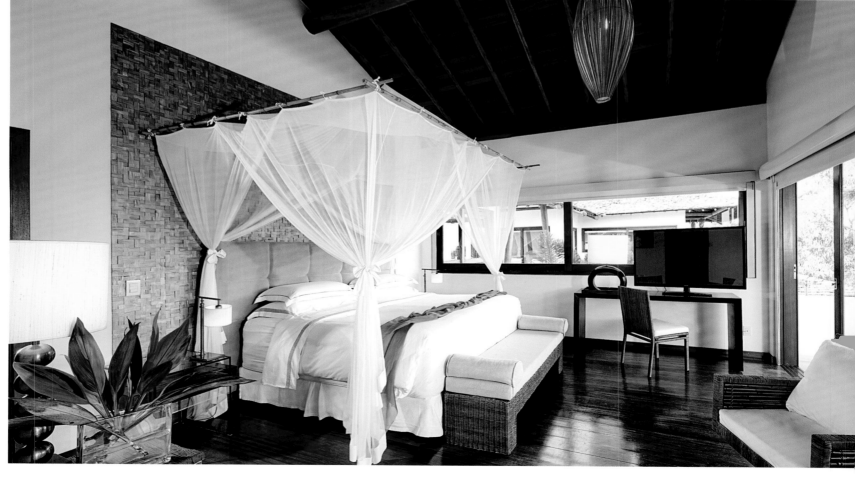

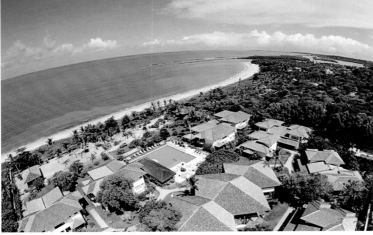

Let loose, unwind and adventure – Campo Bahia offers first-class training facilities, whether guests want to use the beach gym, play tennis or go jogging in the region of Santo André. The most beautiful golf course of South America, the "Terravista Golf Course" is located next to the resort. Furthermore, a luxury schooner is available to guests for a romantic boat trip in the sunset – of course featuring an exquisite barbecue and snacks. Campo Bahia is predestined to be a dream vacation, in which wellness, sport activites and cultural discovery excursions are combined.

Auspowern, abschalten, Abenteuer – Campo Bahia bietet erstklassige Trainingsmöglichkeiten, ob Beach Gym, Tennis oder Joggen in der Region von Santo André. Der schönste Golfplatz Südamerikas "Terravista Golf Course" befindet sich in der Nähe des Resorts. Den Gästen steht zudem ein luxuriöser Schoner für den romantischen Bootstrip in den Sonnenuntergang zur Verfügung, selbstverständlich mit hervorragender Grill- und Snack Verpflegung. Campo Bahia ist prädestiniert für einen Traumurlaub, in dem auch Wellness, sportliche Aktivitäten und kulturelle Entdeckungsreisen nicht zu kurz kommen.

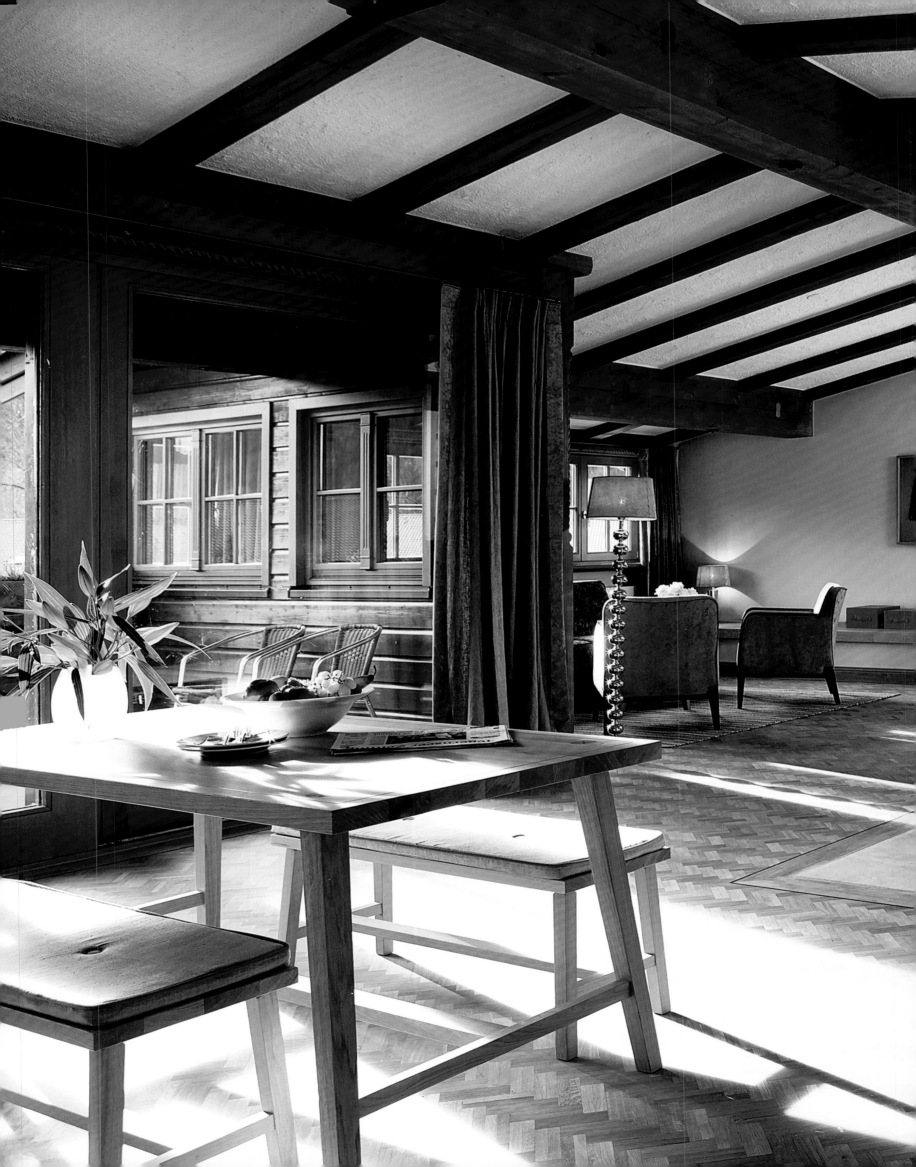

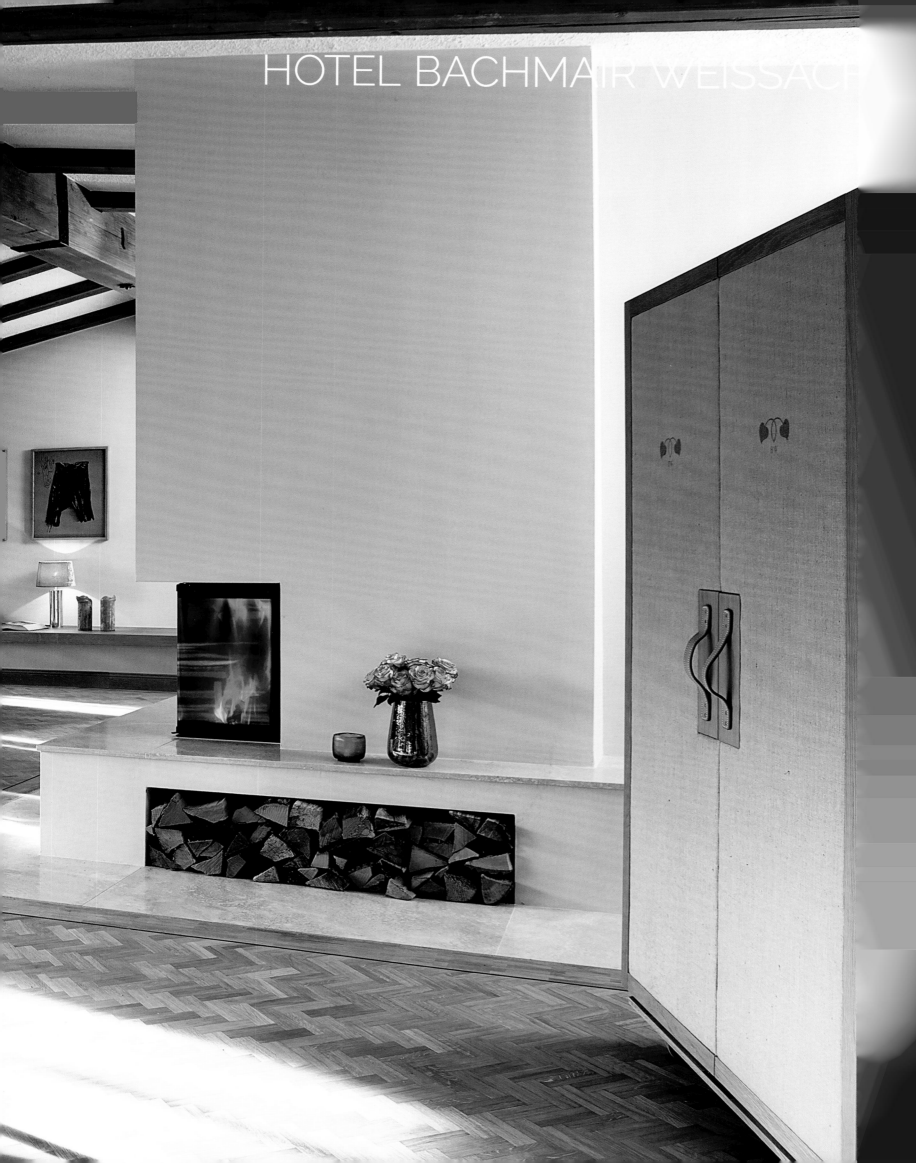

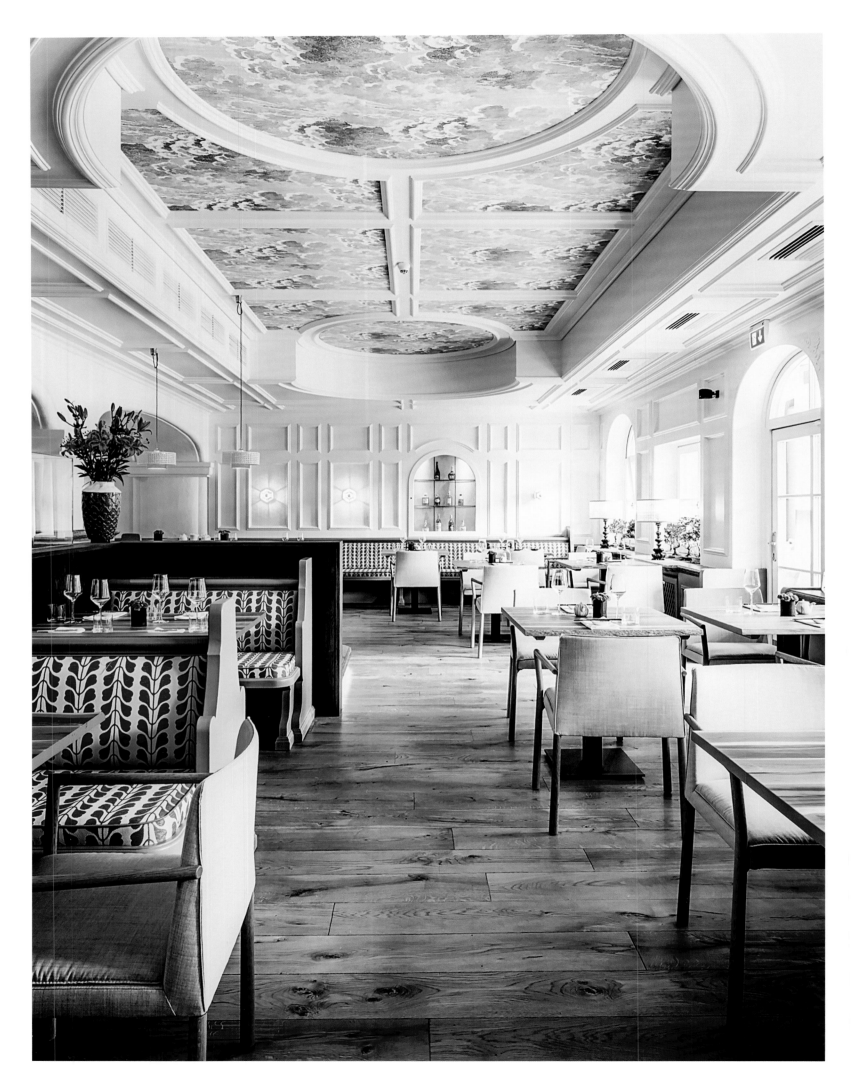

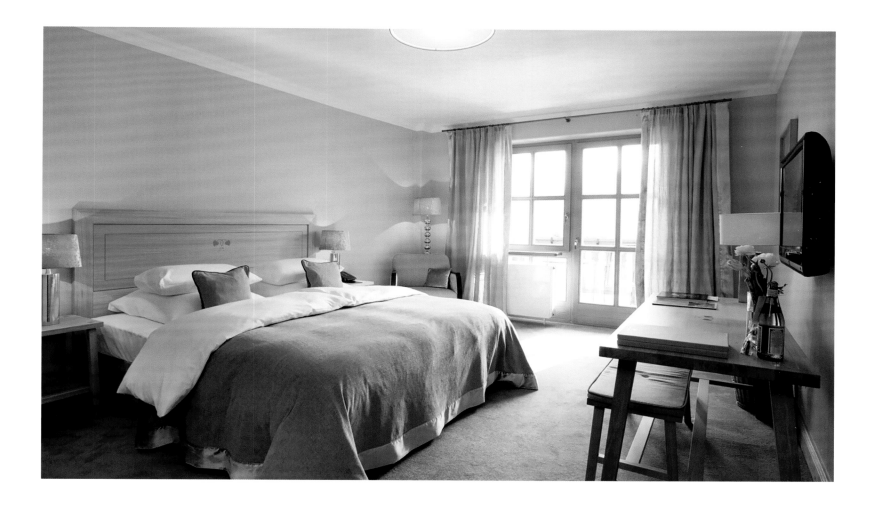

LOCATION

Das Bachmair Weissach liegt am Tegernsee in den Bayerischen Alpen, einer der schönsten Urlaubsregionen Deutschlands, etwa eine Autostunde von München entfernt. Die Kombination aus Berge und Tegernsee bietet den Gästen unzählige Möglichkeiten bei unbeschreiblich schönem Panorama, sowohl beim Wandern, Mountainbiken und Paragliding als auch bei Ski, Langlauf und Golfen, Segeln, Surfen und Stand-Up-Paddeln. Am Tegernsee kommen sowohl Genießer auf der Suche nach Entspannung, als auch sportlich Aktive auf ihre Kosten.

HOTEL

Die Geschichte des Bachmair Weissach begann im Jahre 1834 als Weissachmühle. Seit 2010 ist das Haus wieder inhabergeführt. Mit viel Liebe und Verbundenheit zur Region wurde das Grand Hotel neu gestaltet und vereint nun bayerische Tradition mit moderner Eleganz. Die 146 Zimmer bieten außergewöhnlichen Wohlfühl-Luxus und modernste Technik. Insgesamt sechs Zimmerkategorien stehen zur Wahl: Vom 25 qm großen Doppelzimmer mit Queensize-Bett über die Classic Suite mit Balkon und begehbarem Kleiderschrank bis hin zur 200 qm großen Bachmair Weissach Suite mit drei Schlafzimmern, weitläufigem Wohn- und Esszimmerbereich, einer Dachterrasse sowie einem offenen Kamin und einem privaten Spa. Alle Möbel, Stoffe und Materialien in den Zimmern wurden eigens entworfen und mit natürlichen Materialen aus der Region, beispielsweise Tegernseer Schilfleinen, gefertigt. Im Bachmair Weissach genießen Gäste, unter der Leitung des Küchendirektors Tobias Jochim, süddeutsche Gaumenfreuden auf höchstem Niveau. Der "Gasthof zur Weissach" besteht aus fünf urigen Stuben, darunter die "Kreuther Fondue Stube" mit Kaminbar. Von November bis März werden in der Kreuther Fondue Stube an rustikalen Holztischen Schweizer Klassiker wie Käse-, Fisch- und Fleischfondue serviert. Die Vielfalt moderner japanischer Küche wird live im neuen Show-Cooking Bereich der "Mizu Sushi Bar" präsentiert, wo Gästen abends auch ein DJ und Jazz geboten wird. In den 17 Eventräumen des Bachmair Weissach, darunter auch die Bachmair Weissach Arena, die größte Event-Location im oberbayrischen Voralpenland, lässt es sich hervorragend mit bis zu 1.100 Personen in besonderem Ambiente feiern – stilvoll und auf höchstem Niveau mit dem Charme des typisch Bayerischen.

LOCATION

Bachmair Weissach is located at Tegernsee in the Bavarian Alps, one of Germany's most beautiful holiday destinations, approximately one hour away from Munich by car. The combination of mountains and the lake Tegernsee offers guests countless activites, including hiking, mountainbiking, paragliding, skiing and cross country skiing, as well as golfing, sailing, surfing and stand up paddling with an indescribable panorama. Gourmets seeking relaxation, as well as sports enthusiasts can experience everything they want at Tegernsee.

HOTEL

The history of Bachmair Weissach started in 1834 with the Weissachmühle. Since 2010 the hotel has been owner-operated again. The Grand Hotel was newly designed and combines Bavarian traditions and modern elegance with love and close affinity to the region. The 146 rooms offer extraordinary feel-good luxury and modern technology. Six room categories are being offered in total: from a 25 sqm double room with queen size bed and the Classic Suite with balcony and walk-in closet all the way to the 200 sqm Bachmair Weissach Suite with three bedrooms, spacious living and dining room, a rooftop terrace as well as an open fireplace and private spa. Furniture and materials in the rooms were specially created and fabricated with natural materials from the region, such as Tegernseer reed linen. Guests enjoy South German delights at the highest level, prepared under the direction of Bachmair's kitchen chef Tobias Jochim. The "Gasthof zur Weissach" consists of five historic rooms, including the "Kreuther Fondue Stube" with fire place bar. From November until March the "Kreuther Fondue Stube" serves Swiss specialties such as cheese, fish and meat fondue at wooden tables. A variety of modern Japanese cuisine is presented at the new show cooking area of the "Mizu Sushi Bar" where guests also can enjoy a dj and jazz in the evenings. The Bachmair Weissach's 17 event spaces, including the Bachmair Weissach Arena, the biggest event space in the alpine upland of Upper Bavaria, are perfect for gatherings with up to 1,100 guests in an unique ambience – elegant and at the highest level with typical Bavarian charme.

Get your Upgrade

www.upgradetoheaven.com/hotel-bachmair-weissach

HOTEL BACHMAIR WEISSACH . Wiesseer Strasse 1, 83700 Weissach, Rottach-Egern, Germany . www.bachmair-weissach.com

"ICH WOLLTE EINEN ORT SCHAFFEN, AN DEM MENSCHEN DIE ZUFRIEDENHEIT UND GEMÜTLICHKEIT FRÜHERER ZEITEN WIEDER ERLEBEN KÖNNEN"

"I wanted to create a place where people can experience the satisfaction and relaxation of times gone by"

– Korbinian Kohler,
Owner

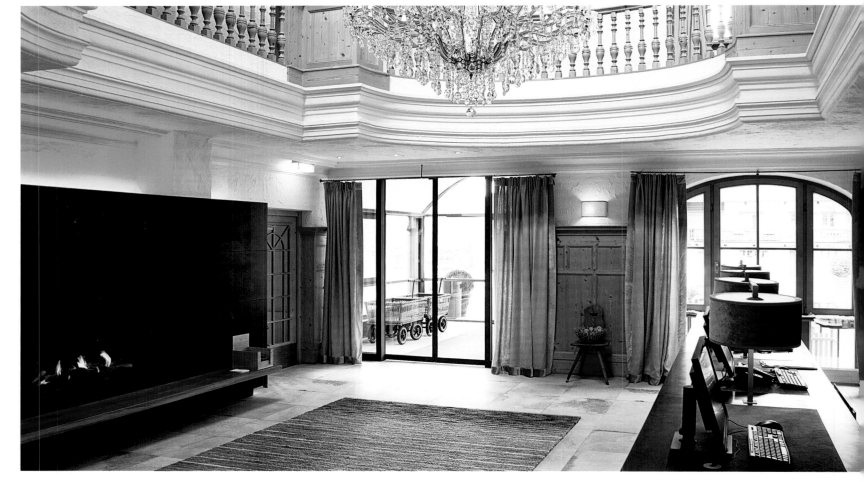

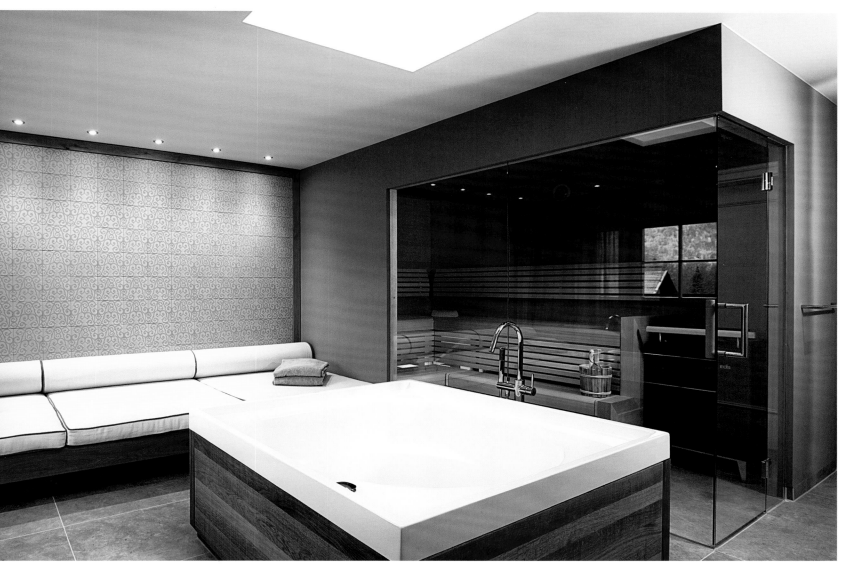

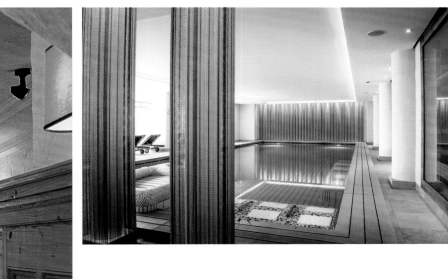

The owner Korbinian Kohler had an „urban Tegernsee Country Club" in mind, which is what guests can expect at Bachmair Weissach with a perfect mixture of nature, subtle luxury, modern elegance and Bavarian tradition. Furthermore, guests find everything the heart desires in the over 1,000 sqm large luxury spa: relaxing massages, treatments with organic beauty products of Susanne Kaufmann as well as different saunas and a spectacular 28 degrees heated pool. The spa's highlights include a blossom steam bath, a razule bath with seaweed body peeling or the "Heukraxe", a traditional heat treatment. Yoga and meditation courses are held almost daily. There is a gym with modern exercise equipment for an individual and diverse training. Nature lovers can go on jogging routes with an extraordinary view directly from the hotel.

Einen "urbanen Tegernseer Country Club" hatte der Inhaber Korbinian Kohler für sein Hotel im Sinn und tatsächlich finden Gäste im Bachmair Weissach heute eine perfekte Mischung aus Natur, dezentem Luxus, moderner Eleganz und bayerischer Tradition. Im über 1.000 qm großen Luxus-Spa finden Gäste alles, was das Herz begehrt: Entspannende Massagen, Anwendungen mit Naturkosmetikprodukten von Susanne Kaufmann sowie verschiedene Saunen und einen traumhaften 28 Grad warmen Pool. Zu den Besonderheiten des Spa-Angebots gehören ein Blütendampfbad, ein Razulbad mit Algen-Körperpeeling oder die Heukraxe, eine traditionelle Wärmeanwendung. Fast täglich werden Yoga- und Meditationsstunden angeboten. Für individuelles und abwechslungsreiches Training steht ein Fitnessstudio mit modernsten Geräten zur Verfügung. Wer lieber raus in die Natur möchte, der kann direkt ab Hotel auf Jogging Routen mit fantastischem Naturpanorama starten.

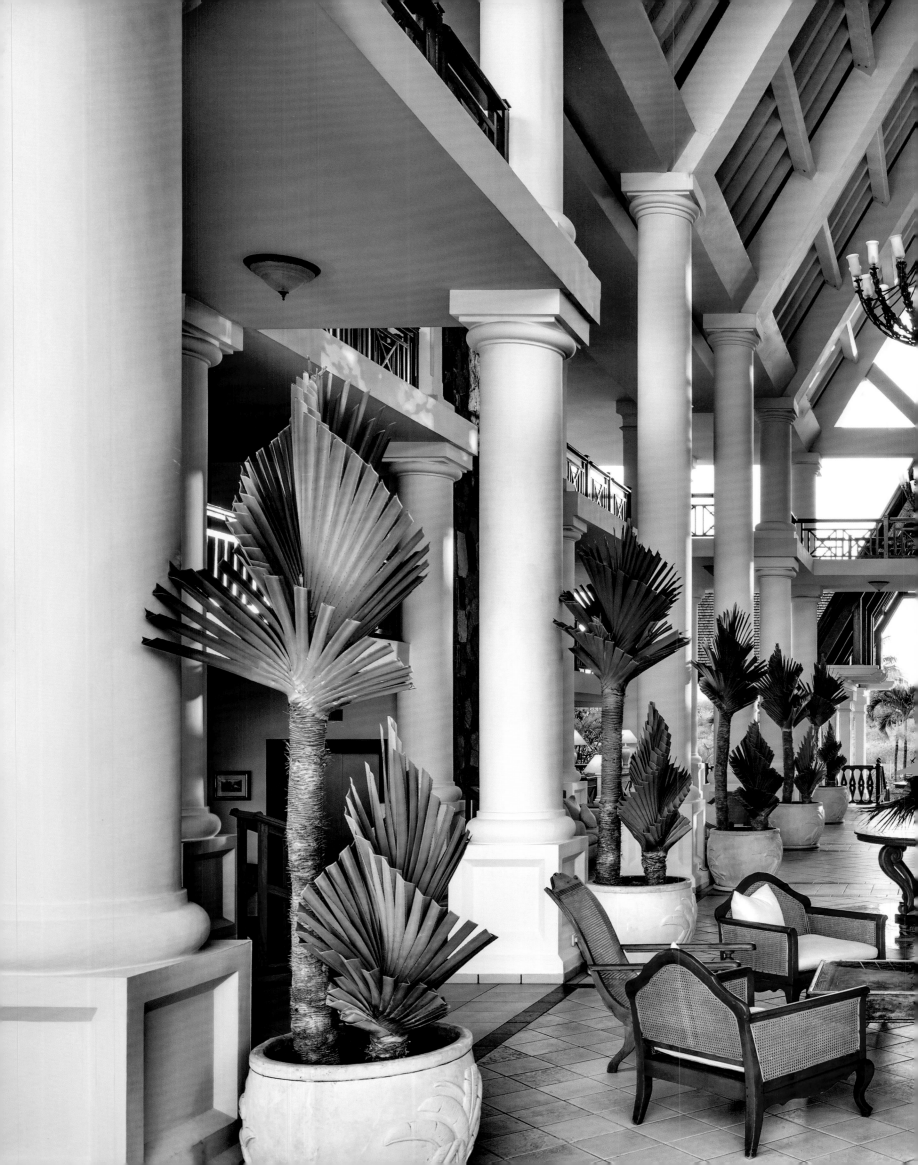

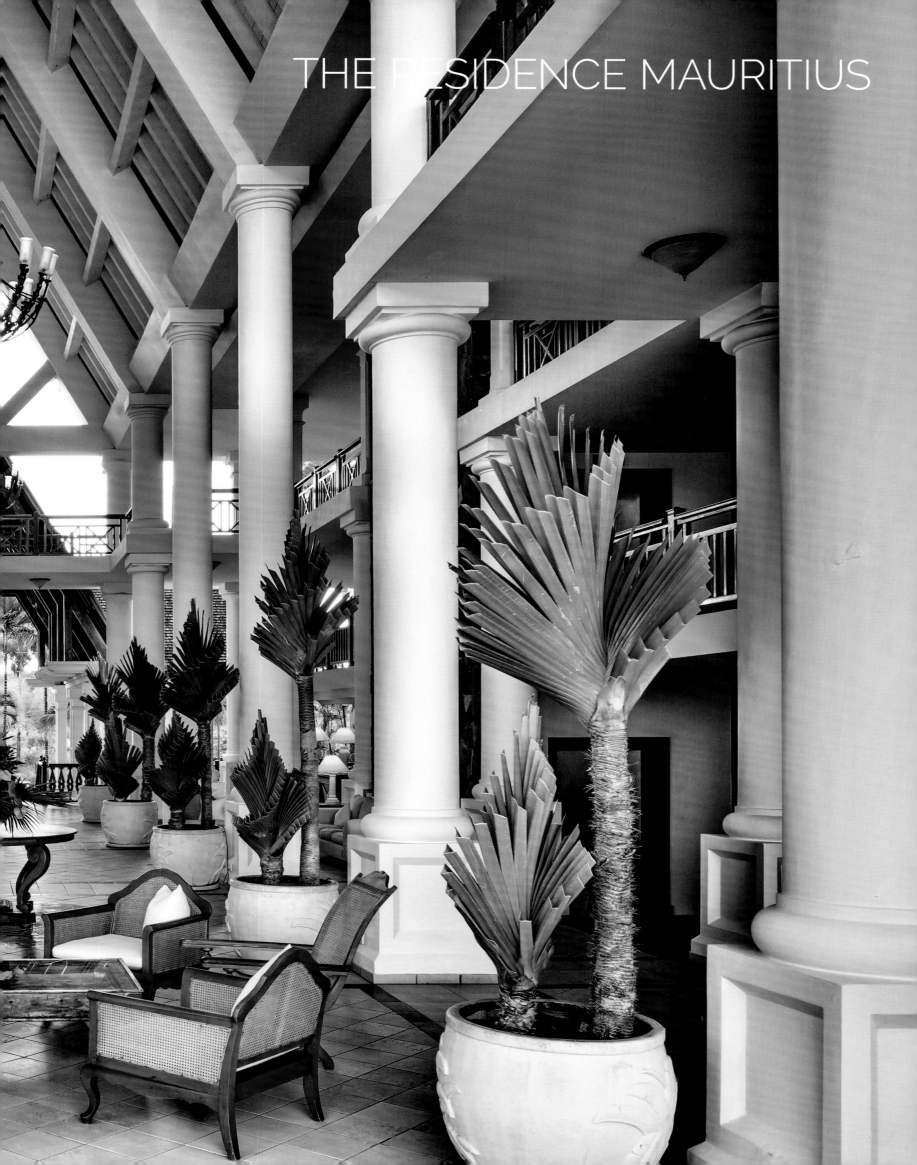

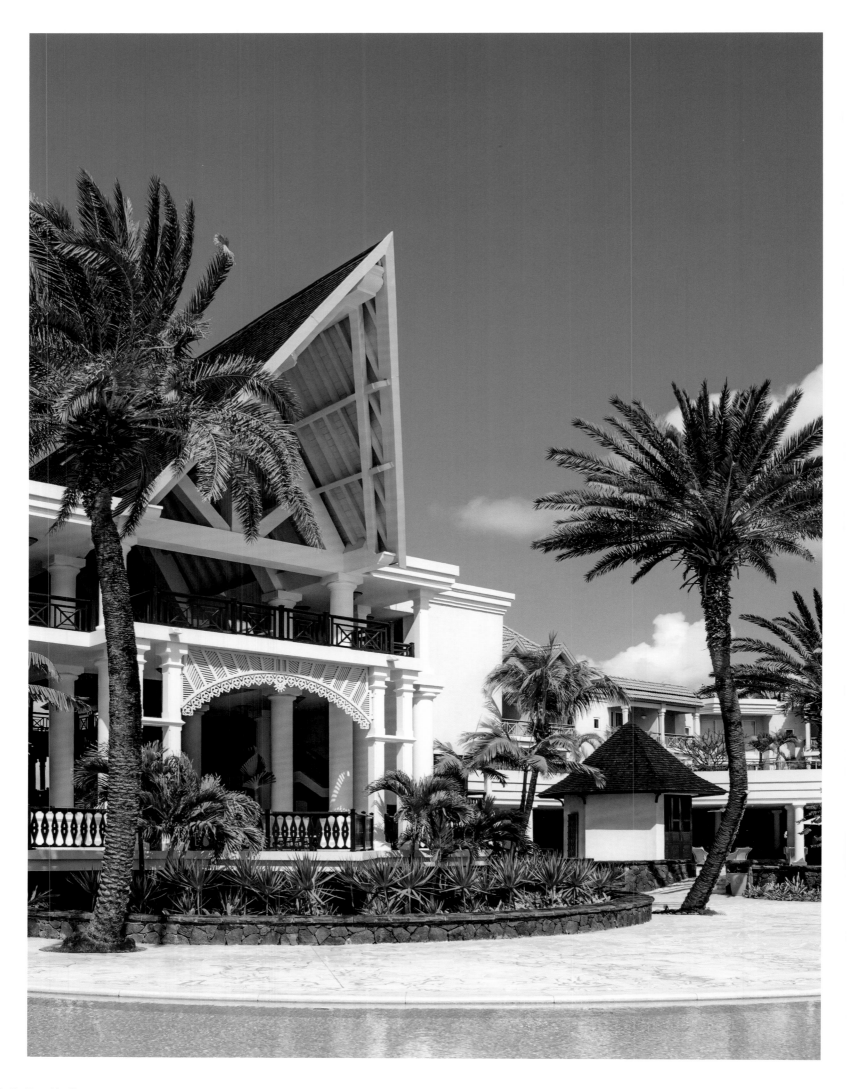

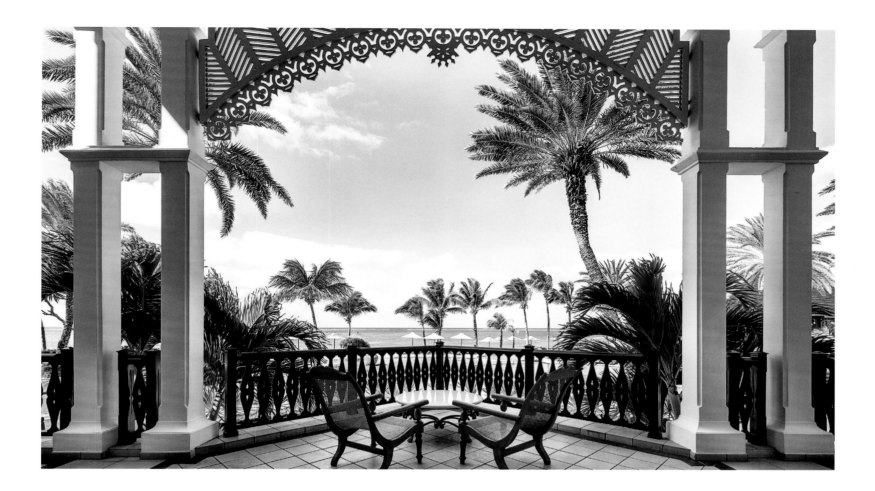

LOCATION

Die Insel Mauritius befindet sich im Indischen Ozean, 870 Kilometer östlich des afrikanischen Inselstaats Madagaskar. Mauritius ist berühmt für seine kilometer-langen weißen Sandstrände. Das Resort The Residence Mauritius liegt an der Ostküste, eingebettet in üppige tropische Gärten an einem traumhaften Strand. Landschaftlich hat Mauritius vieles zu bieten: felsige Gebirge, glitzerndes türkises Wasser und unglaubliche Naturwunder. Die ehemalige französische Kolonie, Mauritius ist seit Ende der Sechzigerjahre unabhängig, ist eine ideale Mischung aus Romantik und Abenteuer für einen fantastischen Inselurlaub.

HOTEL

The Residence Mauritius ist ein charmantes Hotel, das den Kolonialstil der Jahr-hundertwende zitiert und zugleich modern und elegant ist. Die große, lichtdurch-flutete Lobby verströmt eine exotische Atmosphäre und erinnert mit ihren hohen Decken, dem aufwändigen Holzdekor und den indischen Holzschnitzereien an das Leben auf den Plantagen. Die 135 großzügigen Zimmer und 28 Suiten sind dezent-luxuriös eingerichtet und in den Farben Weiß und Taupe gehalten. Von Balkon oder Terrasse geht der Blick entweder auf die friedliche Lagune oder private tropische Gärten. Im The Residence Mauritius steht jedem Gast ein ganz besonderer Service zur Verfügung: ein Personal Butler, der sich auf Wunsch um alles kümmert – vom Auspacken und Bügeln bis hin zum Einlassen eines ent-spannenden Bades. Kulinarisch besteht die Wahl zwischen drei Hotelrestaurants. Das "The Dining Room" ist ein elegantes Restaurant mit Strandblick mit französi-scher und einheimischer Küche. Direkt am Strand liegt "The Plantation" und bietet kreolische Küche mit fangfrischem Fisch und Meeresfrüchten. Rund um den Pool werden im "The Verandah" leichte Mittagsgerichte serviert. Kleine Gäste vergnügen sich im The Residence Mauritius im perfekt ausgestatteten "The Planter's Kids Club". Dieser ist in einem separaten Gebäude untergebracht, das einem historischen Plantagenhaus nachempfunden ist. Wassersportler freuen sich über ein vielfältiges Inklusiv-Angebot an Aktivitäten wie Segeln, Surfen, Schnorcheln, die Nutzung von Kajaks und Tretbooten sowie Exkursionen mit dem Glasboden-Boot. Das Resort verfügt außerdem über drei Flutlicht-Tennisplätze, einen Volleyballplatz, Sauna, Dampfbad, ein Fitnesszentrum und natürlich einen großzügigen Pool.

LOCATION

The island Mauritius is located in the Indian Ocean, 870 kilometres east of the African island state of Madagascar. The island is famous for its kilometre-long white, sandy beaches. The Residence Mauritius lies on the east coast, nestled in lush tropical gardens by a heavenly beach. Mauritius has scenically a lot to offer: rugged mountain peaks, sparkling turquoise water and incredible natural wonders. A former French colony, Mauritius has been independent since the end of the sixties and is an ideal mixture of romance and adventure for an amazing island vacation.

HOTEL

The Residence Mauritius is a charming hotel which reflects the colonial style of the turn of the century as well as being modern and elegant. The grand, light-flooded lobby exudes an exotic atmosphere with its high ceilings, intricate wooden screens and Indian woodcarvings reminiscent of plantation houses of the past. The 135 spacious rooms and 28 suites define tranquil luxury, bathed in the colours of white and taupe. The balconies and terraces overlook the peaceful lagoon or private tropical gardens. The Residence Mauritius provides unique, individual service to each of the guests: a personal butler who, if desired, takes care of every-thing – from unpacking and ironing to preparing a relaxing bath. For their culinary experience guests can choose from three different hotel restaurants. "The Dining Room" is an elegant restaurant with a view of the beach offering international favourites and traditional dishes. Located directly by the beach is "The Plantation", offering authentic Creole cuisine with fresh fish and seafood. "The Verandah" serves a choice of light lunch menus all around the pool area. Young guests can enjoy themselves and are taken care of in the perfectly equipped "The Planter's Kids Club", which is situated in a separate building in the style of a historical plantation house. Sports enthusiasts can choose from a variety of all-inclusive activities such as sailing, surfing, snorkelling, kayaking and excursions on a glass-bottom boat. The resort also provides their guests with three tennis courts, a volleyball court, sauna, steam bath and also a generous swimming pool.

Get your Upgrade

www.upgradetoheaven.com/the-residence-mauritius

THE RESIDENCE MAURITIUS . Coastal Road, Belle Mare, Mauritius . www.cenizaro.com/theresidence/mauritius

PEARL-WHITE SANDY BEACH AS FAR AS THE EYE CAN REACH

Weißer Sandstrand soweit
das Auge reicht

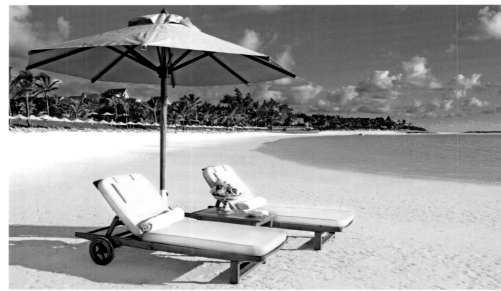

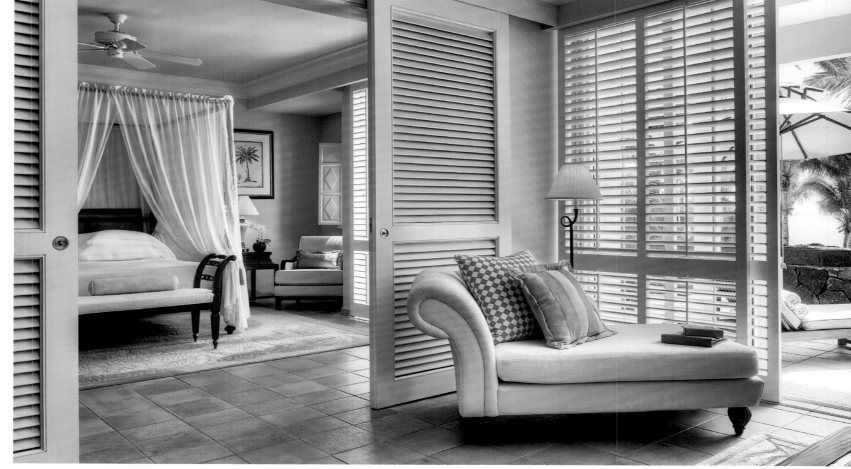

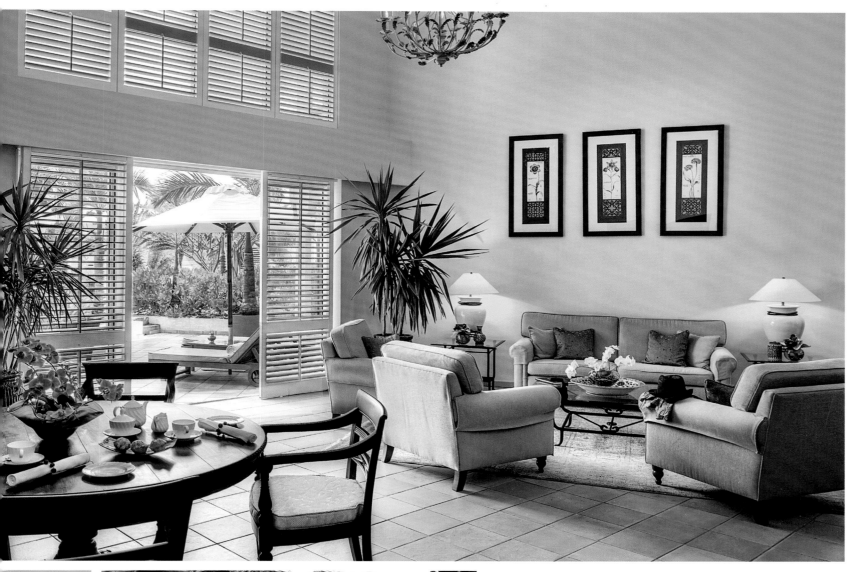

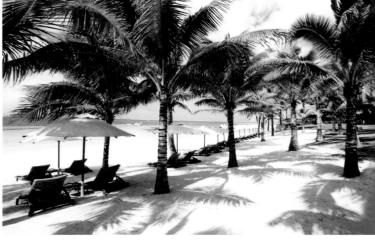

One of the most precious flowering plants in the world grows on the island in the Indian Ocean: ylang-ylang. The sensual scent of ylang-ylang is the resort's signature scent and flows through the entire hotel. In the Sanctuary Spa, guests can forget about the world with amazing treatments using products from the French luxury spa brand Carita. The spa has over ten indoor treatment areas as well as an eleventh which hides in the tropical garden with a view of the Belle Mare bay.

Auf der Insel im Indischen Ozean wächst eine der kostbarsten Blüten-pflanzen der Welt: Ylang Ylang. Der sinnliche Duft von Ylang Ylang ist der Signature-Duft des Hauses und durchströmt das gesamte Hotel. Im Sanctuary Spa vergessen die Gäste die Welt um sich herum über den herrlichen Treatments mit Produkten der luxuriösen französischen Spa-Marke Carita. Das Spa verfügt über zehn Indoor-Behandlungsräume sowie einen elften, der versteckt im tropischen Garten liegt mit Blick auf die Bucht von Belle Mare.

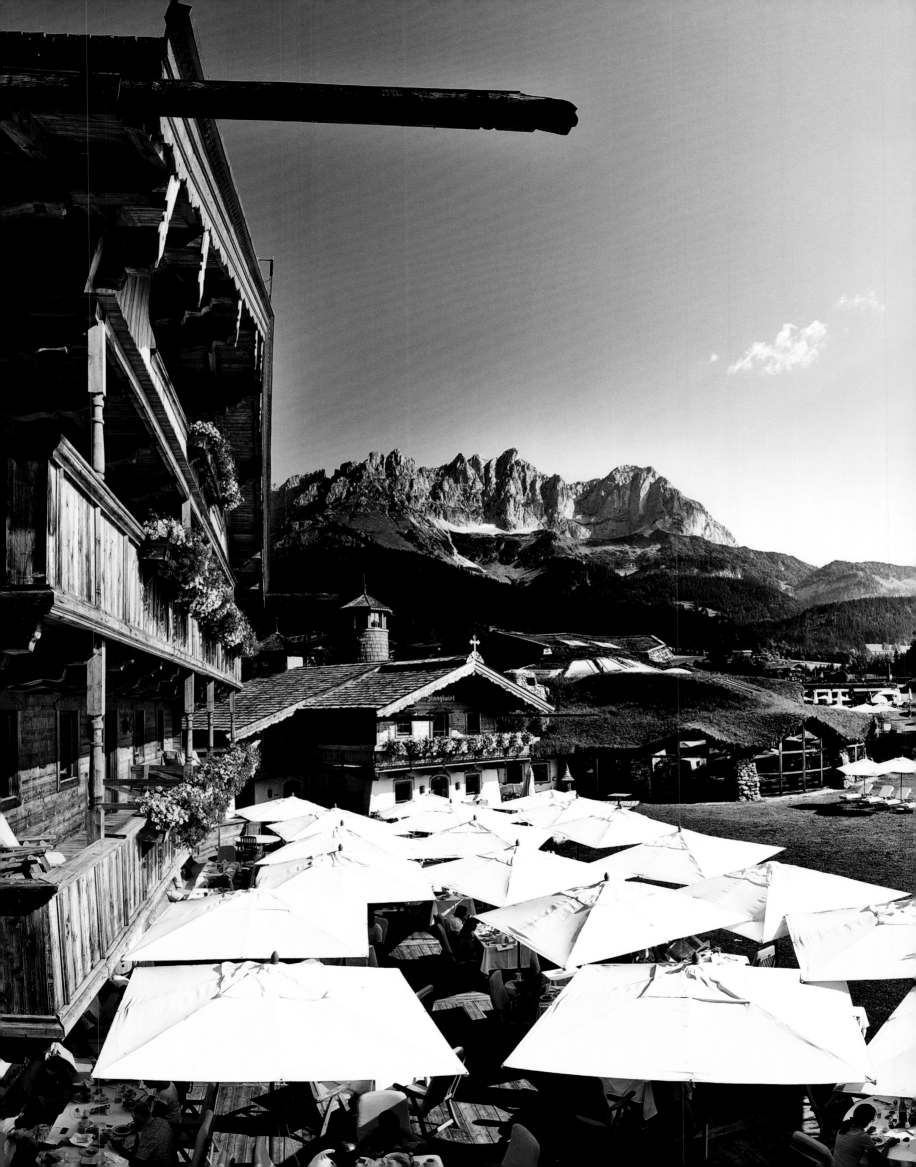

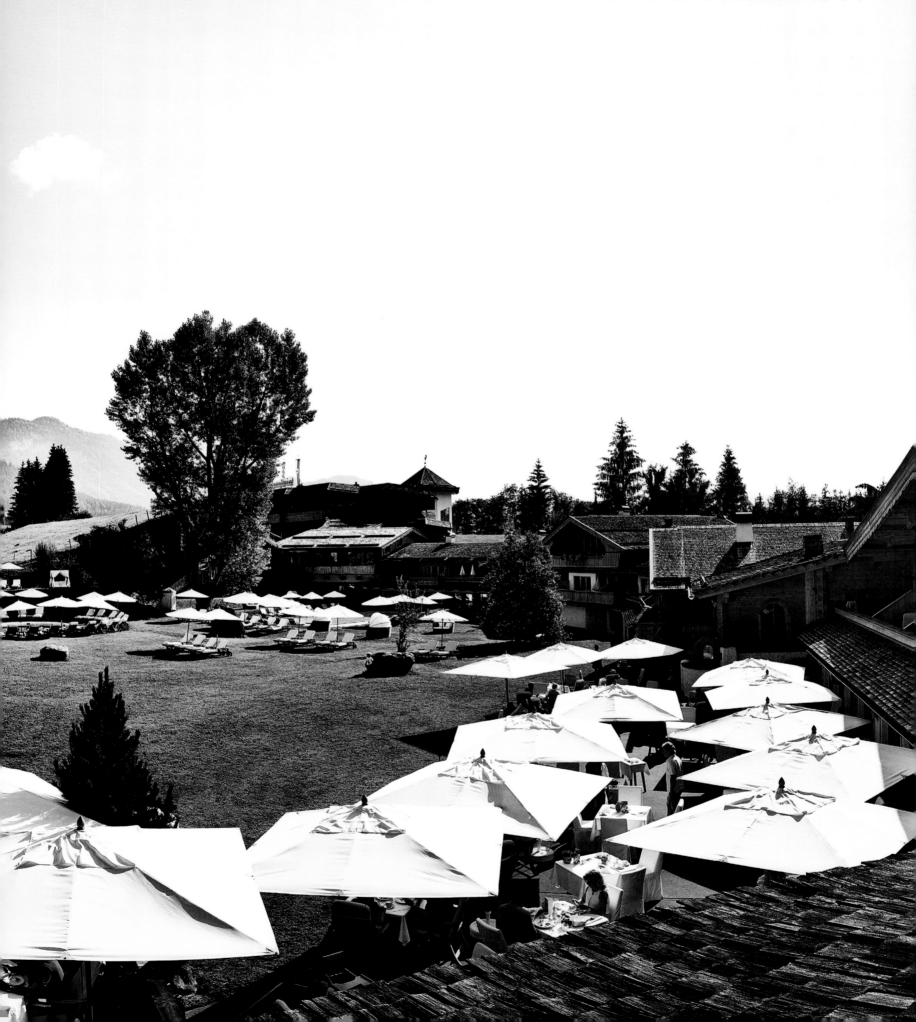

BIO- UND WELLNESSRESORT
STANGLWIRT

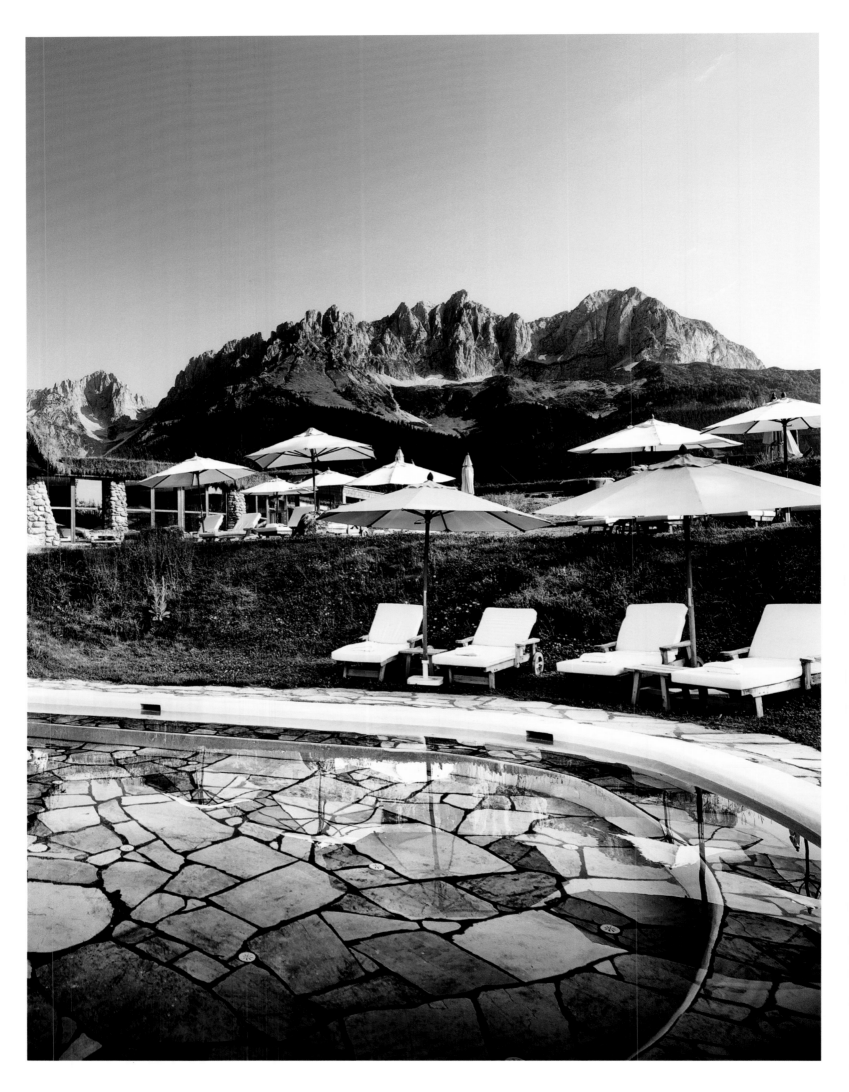

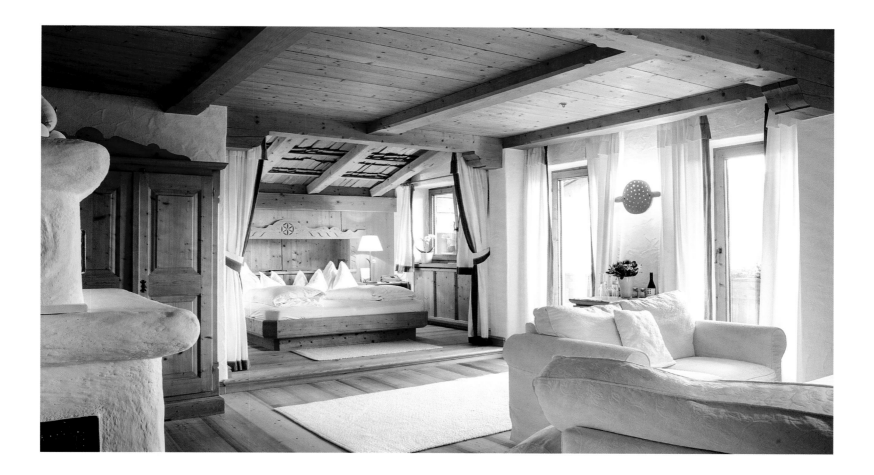

LOCATION

Nur fünf Minuten von Europas größtem zusammenhängendem Skigebiet, der Ski-Welt Wilder Kaiser, entfernt, liegt das familiengeführte 5-Sterne Bio- und Wellnessresort Stanglwirt in den Kitzbüheler Alpen. Jeden Winter trifft sich nach dem berühmten Hahnenkamm-Rennen auf der Streif die Prominenz zur legendären Weißwurstparty im Stanglwirt. Aber nicht nur im Winter lockt der Wilde Kaiser, auch im Sommer lässt es sich dort hervorragend urlauben. Ob beim Wandern, Klettern oder Mountainbiken im Kaisergebirge, beim Golfen oder Fischen oder ganz entspannt in der großzügigen und umfangreich ausgestatteten Anlage des Stanglwirts, die auch kulinarisch keinerlei Wünsche offen lässt, Genuss und Entspannung stehen im familienfreundlichen Stanglwirt an oberster Stelle.

HOTEL

In dem über 400 Jahre alten Traditionsgasthof und Hotel erwarten Gäste 171 stilvollgemütliche Zimmer und Suiten mit viel Zirbenholz, reiner Schurwolle und feinstem Leinen - eingerichtet mit viel Gespür und Wertschätzung für die Natur der Umgebung. Im historischen Gasthof "Stanglwirt" mit dem berühmten "Kuhstall-Fenster" werden Gäste mit biologischen Produkten aus eigener Landwirtschaft verwöhnt. "Stangl-Alm", "Kamin-Bistro" mit offenem Kamin und die "Kaiserstube" mit Kaiser-Blick laden ebenfalls zum Genießen und Verweilen ein. Die Wellness- und Wasser-Erlebniswelt des Stanglwirt lässt wirklich keine Wünsche offen: eine großzügige 12.000 qm große Felsen-Wellnesswelt mit Panoramablick und neuer Pool- und Saunalandschaft, größter hoteleigener Sole-Pool Europas, Leistungssportbecken mit OMEGA-Zeitmessung, Panorama-Eventsauna mit direktem Zugang zum Natur-Badesee und großzügigen Panorama-Relax-Zonen mit offenen Kaminen. Den kleinen Gästen bietet der Stanglwirt mit einer Kinderwasserwelt und 120 Meter langer Großwasserrutsche ein eigenes Paradies. Im Fitnessgarten wird an modernsten Geräten und im Rahmen eines kostenlosen Kursprogramms trainiert. Beauty- und Wellnessanwendungen mit Produkten von u.a. QMS, Maria Galland Paris, Ligne St. Barth und Dr. Barbara Sturm sind nach Wunsch buchbar. Luxus und Urigkeit, Tradition und Fortschrittlichkeit, Bio und Genuss: Diese Mischung brachte dem 5-Sterne Bio- und Wellnesshotel Stanglwirt jüngst die Auszeichnung mit dem "Traveller's Choice Award 2016" von TripAdvisor ein und der Condé Nast Traveller setzte das Haus auf die "Gold List 2016".

LOCATION

Situated only five minutes away from Europe's largest connected ski region, SkiWelt Wilder Kaiser, is the five-star family-run green spa resort Stanglwirt in the Kitzbühel Alps situated. Every winter after the famous Hahnenkamm ski race, VIPs meet up for the legendary Weißwurst Party at the Stanglwirt. The Wilder Kaiser mountain not only attracts visitors in the winter, but is also the perfect spot for excellent summer vacations – whether hiking, climbing or mountain biking in the Kaiser mountains, golfing, fishing or completely relaxing in the generous and extensively equipped Stanglwirt resort, which will fulfill the guest's culinary wish. Pleasure and relaxation are top of the list at the family-friendly Stanglwirt.

HOTEL

In the over 400-year-old traditional guest house and hotel, guests can expect 171 stylish, comfortable rooms and suites with a lot of Swiss stone pine wood, pure new wool and finest linen – furnished with instinct and appreciation for the natural surroundings. In the historic guest house "Stanglwirt" with its famous "cowshed-window", guests are spoilt with organic products from the farms own production. "Stanglalm", "Kaminbistro" with its open fireplace and "Kaiserstube" with its majestic view invite to enjoy themselves whiling away the time. The Stanglwirt's 12,000 sqm wellness and water adventure world leaves no wishes unfulfilled: a spacious rock wellness realm with panoramic views and new pool and sauna area, Europe's biggest hotel-owned brine pool, competitive sports pool with OMEGA-time measurement, panorama event sauna with direct access to the natural bathing lake and generous panoramic relaxation zones with open fireplaces. A separate paradise for young visitors at Stanglwirt is the 120-meter-long water slide in the children's water world. In the fitness garden guests may work out with latest equipment including a free course programme. Beauty and wellness treatments with products amongst others from QMS, Maria Galland Paris, Ligne St. Barth and Dr. Barbara Sturm can be booked upon request. Luxury and simplicity, tradition and progress, green and gourmet: this mixture recently led the five-star green spa resort Stanglwirt to TripAdvisor's "Traveller's Choice Award 2016" and the hotel was put on the "Gold List 2016" by Condé Nast Traveller.

Get your Upgrade

www.upgradetoheaven.com/stanglwirt

BIO- UND WELLNESSRESORT STANGLWIRT . Kaiserweg 1, 6353 Going, Austria . www.stanglwirt.com

KAISERLICHES PANORAMA UND DAS WUNDERBARE GEFÜHL VON ZUHAUSE

Majestic panorama and
the wonderful feeling
of home

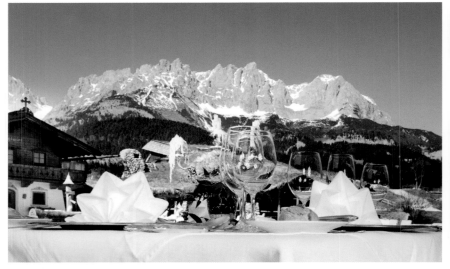

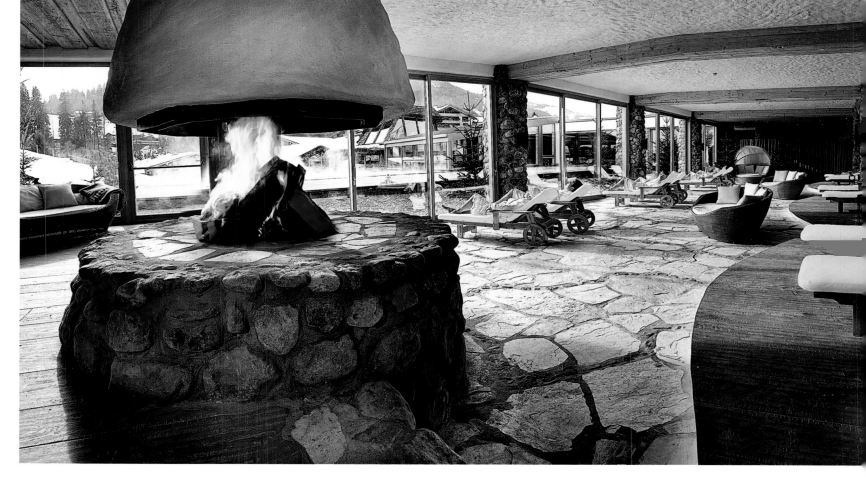

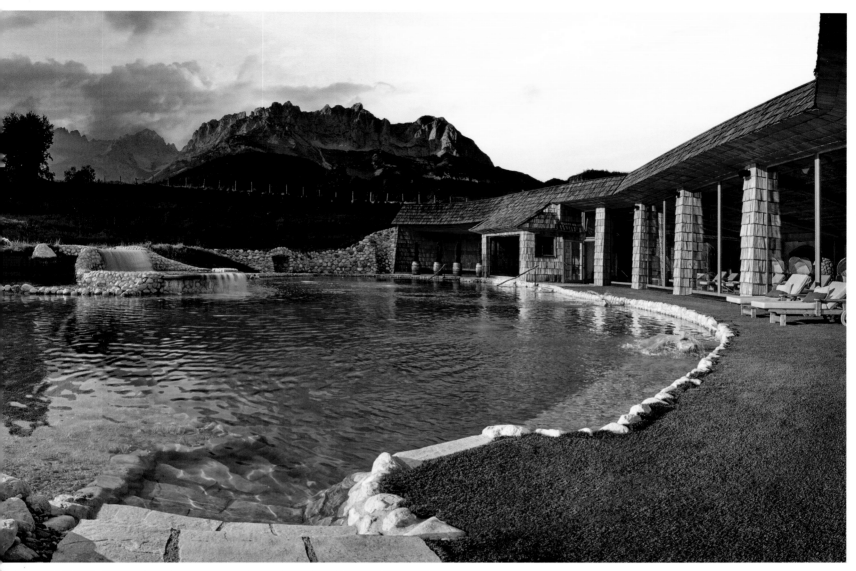

Stanglwirt offers an incredible selection of further leisure facilities, including an award-winning tennis village with tennis school, hotel-owned Golf Sport Academy with driving range, own Lipizzaner stud with riding school, carriage rides and assisted trail rides and its own elegant shopping arcade. Brand new, starting from summer 2016: "St. Angelwirt" – fishing at Stanglwirt-owned waters. A special highlight in the summer is the weekly hike with landlady Magdalena Hauser to the Stangl-Alm on the Wilder Kaiser mountain, including a cottage snack with a tasting session of the home-made Stanglalm cheese. For special private moments, Stanglwirt offers the quaint forest chalet "Hüttlingmoos" located just under the rugged rock face of the Wilder Kaiser, which can be exclusively rented with cook and butler service upon request.

Für die weitere Freizeitgestaltung bietet der Stanglwirt eine unglaubliche Auswahl, u.a. ein preisgekröntes Tennisdorf mit Tennisschule, hauseigene Golf Sport Academy inklusive Driving-Range, eigenes Lipizzanergestüt mit Reitschule, Kutschenfahrten und betreute Ausritte sowie eine edle Shopping-Arkade. Ganz neu ab Sommer 2016: "St. Angelwirt" – Fischen beim Stanglwirt in eigenen Gebietsgewässern. Besonderes Highlight im Sommer ist die wöchentliche Almwanderung mit Stanglwirtin Magdalena Hauser zur Stangl-Alm am Wilden Kaiser inklusive anschließender Hütten-jause mit Verkostung des hauseigenen Stanglalm-Käses. Für ganz private Momente bietet der Stanglwirt knapp unterhalb der schroffen Felswände des Wilden Kaiser die urige Forsthütte "Hüttlingmoos", die exklusiv auf Wunsch auch mit Koch- und Butler-Service angemietet werden kann.

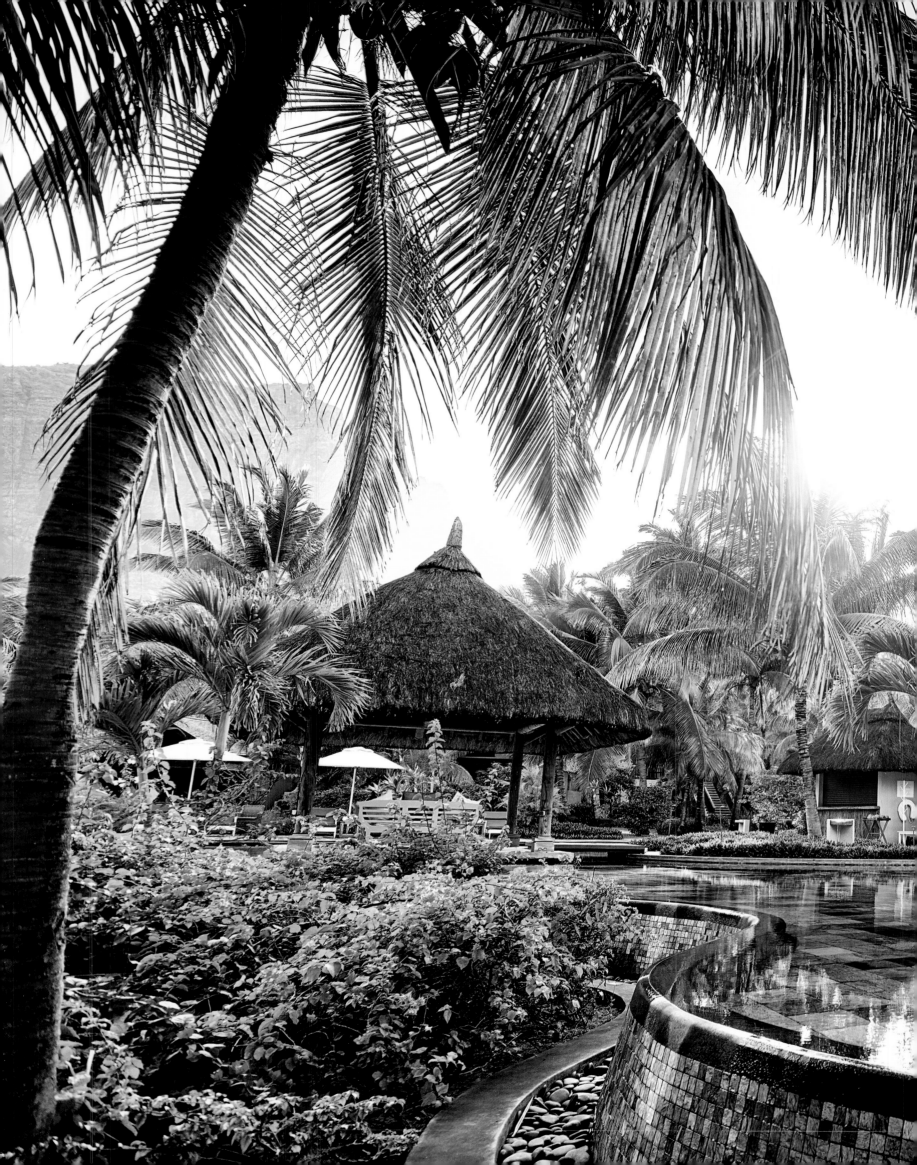

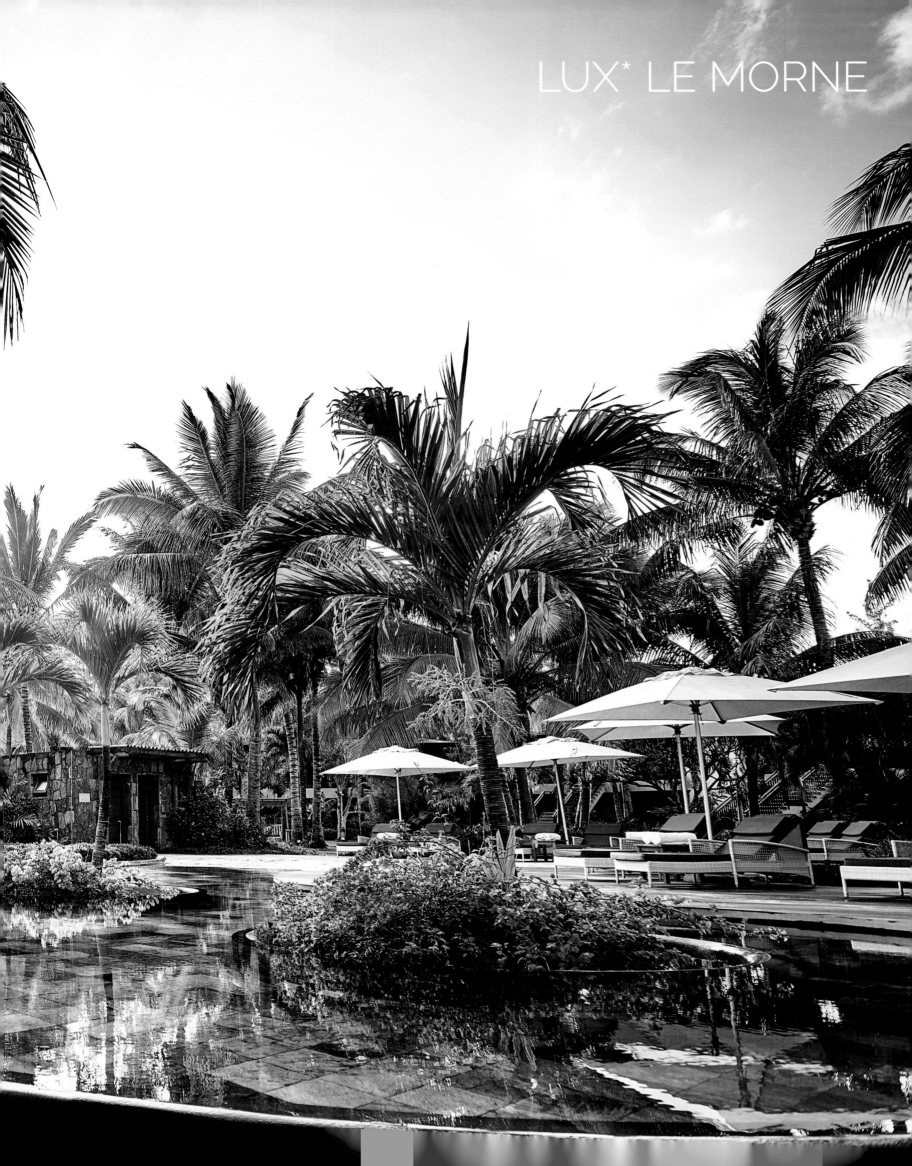

LUX* LE MORNE

Mit Delfinen schwimmen, eine einzigartige
Fauna und Flora entdecken oder sich
einfach verwöhnen lassen.

Swimming with dolphins, exploring
the unique fauna and flora or
simply being spoiled.

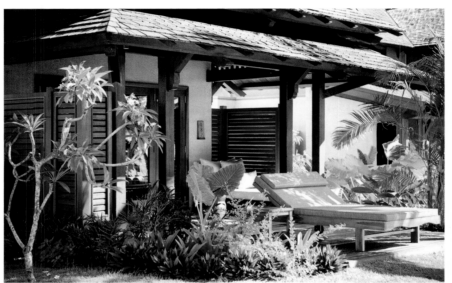

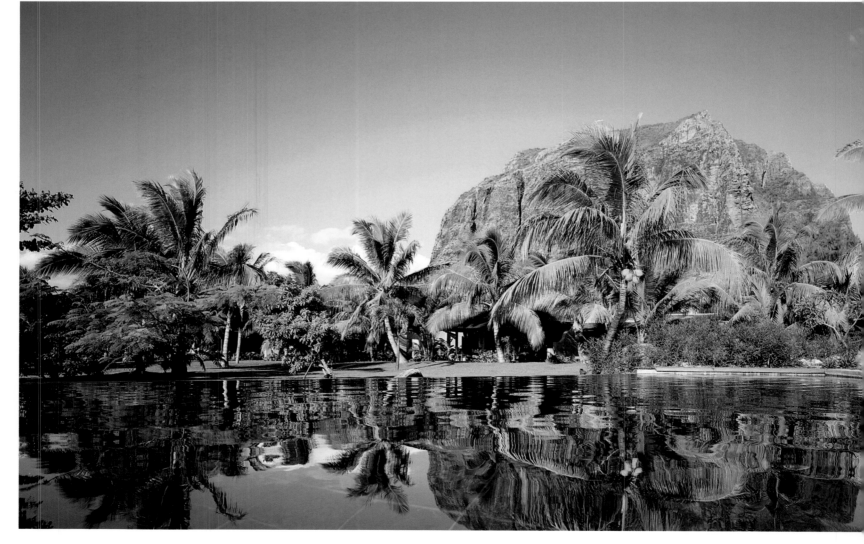

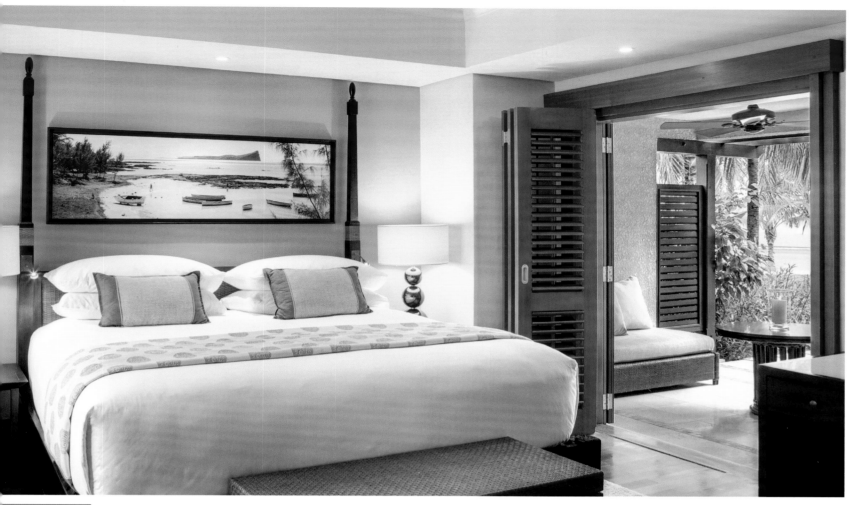

LOCATION

Am Fuße des majestätischen Gipfels von Le Morne im Südwesten von Mauritius liegt das Lux' Le Morne Resort. Die zerklüftete Halbinsel Le Morne Brabant zählt zum UNESCO-Weltkulturerbe und ist einer der schönsten Plätze der Insel. Das Resort liegt geschützt in einem herrlich gestalteten Park. Im smaragdgrünen Wasser des Indischen Ozeans können die Gäste mit Delfinen schwimmen oder, die bei Wind- und Kitesurfern weltbekannte, One-Eye-Welle entdecken. Wer noch mehr Natur möchte, fährt in den Nationalpark Black River Gorges. Eine faszinierende Pflanzen- und Tierwelt, von Orchideen über Anthurien bis hin zu Makaken und Flughunden bietet sich dem Betrachter. Nach Sonnenuntergang erstrahlt das Resort im Schein tausender Kerzen und eine einzigartige Feuer-Wasser-Installation vor der Kulisse des Meeres schafft magische Momente.

HOTEL

Das im Kolonialstil erbaute Resort Lux' Le Morne liegt an einem 500 Meter langen Privatstrand. Die 149 Zimmer sind auf Pavillons verteilt und verfügen jeweils über einen eigenen Zugang zu einem Balkon oder einer Terrasse in Richtung Meer. Die Lux'-Restaurants lassen keine Wünsche offen. In "The Kitchen", dem Hauptrestaurant, können die Gäste beim Zubereiten der Speisen zusehen. Mediterrane Aromen und italienische Zutaten bestimmen die Kochkunst im "The Beach". Direkt am Strand befindet sich eine Location, in der mittags und abends einfache und zugleich raffinierte Gerichte serviert werden. Köstliche thailändische Küche und ein atemberaubender Blick auf die wundervolle Lagune erwartet die Gäste im Restaurant "East". Das Spa bietet individuelle Wohlfühlprogramme, einen Vichy-Shower-Behandlungsraum sowie Meditationskurse und Yoga. Das Lux' Le Morne bietet Mauritius-Urlaubern den feinsten Sandstrand der Insel und durch seine geschützte Lage himmlische Ruhe, um zu entspannen.

LOCATION

Situated at the foot of Le Morne's majestic summit in the southwest of Mauritius is the Lux' Le Morne resort. The fissured peninsula Le Morne Brabant is part of the UNESCO World Heritage and is one of the island's most beautiful spots. The resort lies protected in a magnificently created park. In the emerald green water of the Indian Ocean guests can go swimming with dolphins or discover the world famous One-Eye-Wave while Wind or Kite surfing. Those who want to enjoy even more nature can visit the national park Black River Gorges. A fascinating flora and fauna, from orchids and anthuriums to macaques and flying foxes is offered to the viewer. After sunset the resort shines in the gleam of a thousand candles and a unique fire-water-installation in front of the sea creates magical moments.

HOTEL

The resort Lux' Le Morne, built in colonial style, is situated at a 500 metre long private beach. The 149 rooms are spread to pavilions with each providing their own access to a balcony or terrace with sea view. The Lux' restaurants leave no wish unfilled. In the main restaurant "The Kitchen" guests can watch their meals being cooked. Mediterranean aromas and Italian ingredients dominate the cuisine of "The Beach". Located directly at the beach one can find a spot where simple and refined dishes are served for lunch and dinner. In the restaurant "East" guests are awaited with delicious Thai cuisine and a breathtaking view of the wonderful lagoon. The spa offers individual wellness programs, a Vichy shower treatment room as well as meditation classes and yoga. The Lux' Le Morne provides Mauritian travellers with the island's finest sandy beaches and heavenly peace to relax thanks to its hidden and protected location.

Get your Upgrade

www.upgradetoheaven.com/lux-le-morne

LUX' LE MORNE . Coastal Road, Le Morne, Mauritius . www.luxresorts.com

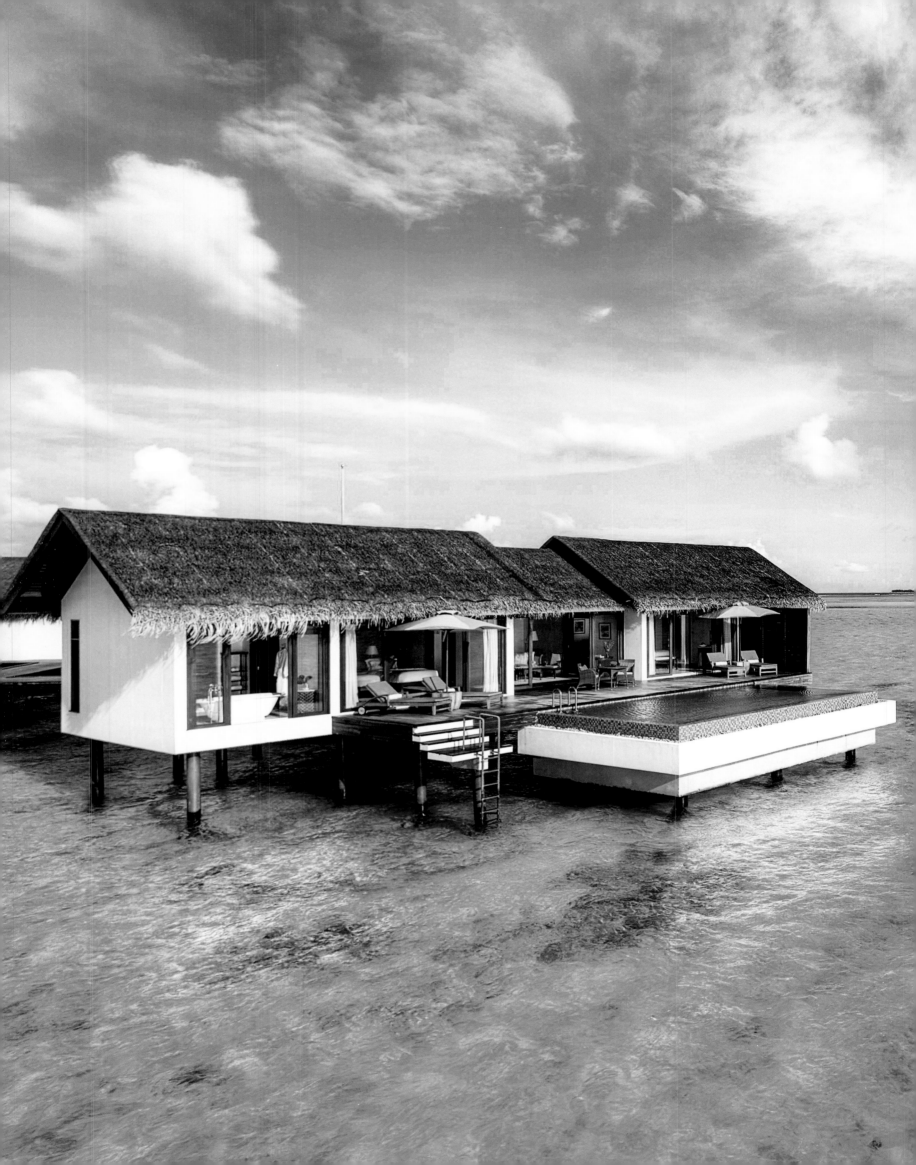

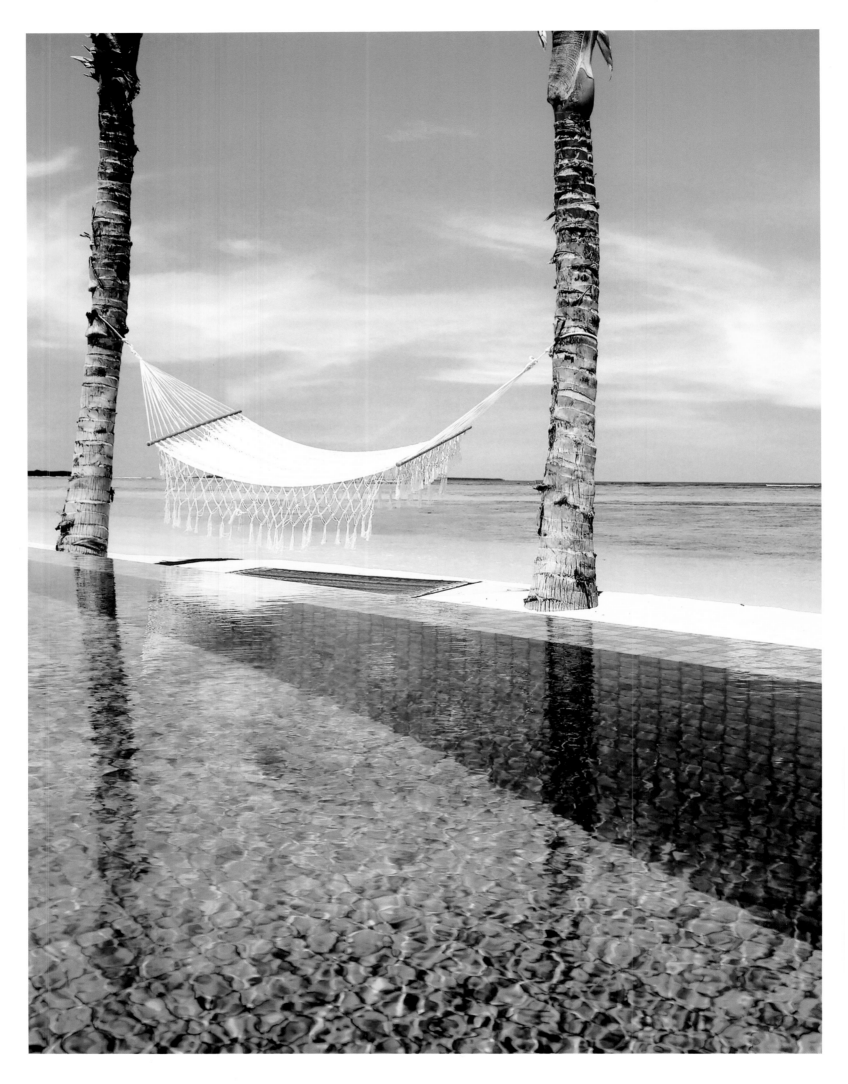

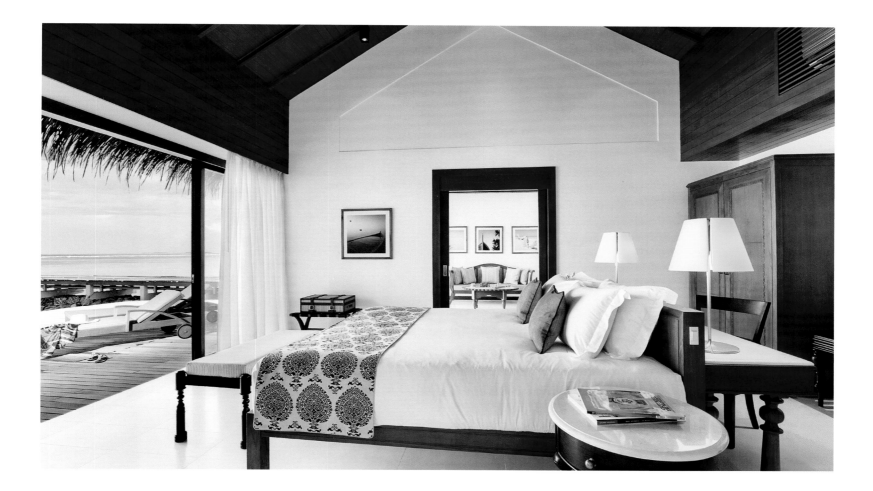

LOCATION

Das Villenresort The Residence Maldives liegt auf der Insel Falhumaafushi, das zum Gaafu-Alifu-Atoll gehört, einem der größten und tiefsten der Malediven, wo es noch weitgehend unbekannte Tauchgründe zu entdecken gibt. Durch den benachbarten Flughafen Kooddoo ist Falhumaafushi sehr gut zu erreichen. Falhumaafushi ist ein tropisches Inselparadies, umgeben von üppigem Grün und kristallklarem, türkis schimmerndem Wasser. Über 250 verschiedene Korallenarten gibt es hier und eine noch weitgehend intakte Unterwasserlandschaft. Die Wasserwelt rund um Falhumaafushi bietet mit Delfinen, Grünen Meeresschildkröten, Mantas und Adlerrochen sowie Riffhaien und Barrakudas aufregende Entdeckungen für Schnorchler und Taucher aller Könnensklassen.

HOTEL

Die 94 exquisiten Strand- und Wasservillen von The Residence Maldives bieten einen sagenhaften Blick auf den Indischen Ozean, 44 davon haben sogar einen privaten Swimmingpool. Im Innern der Räume gehen traditionelle maledivische Architektur mit individuell angefertigten Möbeln und einheimischen Kunstwerken eine gelungene Symbiose ein. Das multikulturelle Personal, das sowohl aus Europa, Asien als auch von den benachbarten maledivischen Inseln stammt, bietet einen diskreten, professionellen und sehr freundlichen Service. The Residence Maldives verfügt über das erste und einzige Spa by Clarins der Malediven. The Spa by Clarins liegt direkt über dem Wasser und besteht aus sechs Pavillons, einem großen Deck für Meditationen und Yogastunden sowie einem Friseursalon. Die Signature-Treatments tragen so wunderbare Namen wie Heaven, Peace, Waves, Pure und Relief. Darüber hinaus bietet das Villenresort ein Fitnesscenter, Sauna und Dampfbad sowie einen Infinity-Pool am Strand. Ein Candlelight Dinner bei Sonnenuntergang direkt am Strand, mit den Füßen im feinen Sand, gehört zu den ganz besonderen Erlebnissen eines Malediven-Urlaubs. The Residence Maldives bietet Private Dining sowohl am Strand als auch in der eigenen Villa – Gästen mit Halbpension sogar ohne Aufpreis. Abendessen mit der Familie oder Freunden macht beim Strand-BBQ am knisternden Feuer, das dreimal pro Woche angeboten wird, noch mehr Spaß. Weiteres kulinarisches Vergnügen finden die Gäste in den beiden Restaurants des Resorts: "The Dining Room" direkt am Strand und "The Falhumaa" am Ende des Holzstegs über dem Wasser.

LOCATION

The villa resort The Residence Maldives is located on the island of Falhumaafushi which belongs to the Gaafu Alifu Atoll, part of one of the largest and deepest in the Maldives, which still has an immense amount of unknown diving grounds to be discovered. Falhumaafushi is easily accessible via the neighbouring airport Kooddoo. Falhumaafushi is a tropical paradise surrounded by lush foliage and crystal-clear, turquoise water. There are over 250 different coral types and a virtually intact world beneath the surface of the water. The underwater world around Falhumaafushi offers exciting discoveries for snorkellers and divers with dolphins, green sea turtles, manta and eagle rays, reef sharks and barracudas.

HOTEL

The 94 exquisite beach and water villas of The Residence Maldives, 44 of which even have a private swimming pool, offer an incredible view of the Indian Ocean. Traditional Maldivian architecture combined with individually crafted furniture and local art in the rooms form a perfect symbiotic relationship. The staff, which is of multi-ethnic diversity from Europe, Asia and the neighbouring Maldivian islands, offers discreet, professional and extremely friendly service. The Residence Maldives has the first and only Spa by Clarins in the Maldives. The Spa by Clarins is located directly above the water and consists of six individual pavilions, a large deck for meditation and yoga lessons and a hair salon. The signature treatments bear such wonderful names as Heaven, Peace, Waves, Pure and Relief. Furthermore, the villa resort offers a gym, sauna and steam bath, as well as an infinity pool by the beach. A very special experience on a Maldives holiday escape is a candlelight dinner at sunset on the beach with your feet immersed in fine sand. The Residence Maldives offers private dining both by the beach and in the private villas – without surcharge even for guests on only half-board. Dining with family or friends becomes so much more fun with the beach barbecue dinners by a roaring fire, held three times weekly. Adding to the culinary enjoyment, island dining experiences include the resort's two restaurants: "The Dining Room" by the beach and "The Falhumaa" at the end of the wooden bridge over the water.

Get your Upgrade

www.upgradetoheaven.com/the-residence-maldives

THE RESIDENCE MALDIVES . Falhumaafushi, Gaafu Alifu Atoll, Maldives . www.cenizaro.com/theresidence/maldives

A WORLD AWAY FROM THE EVERYDAY

Vom Alltag unendlich
weit weg

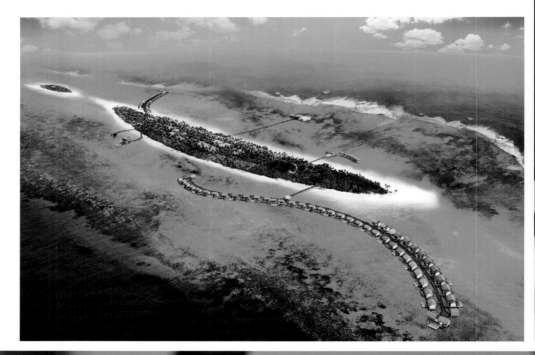

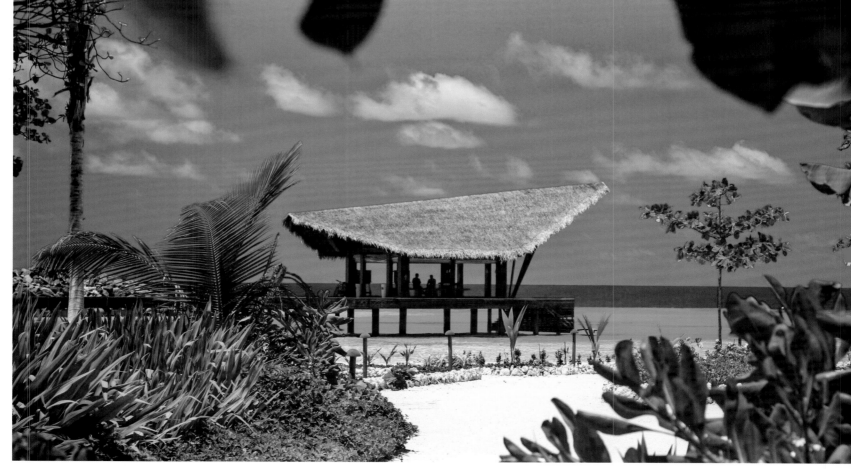

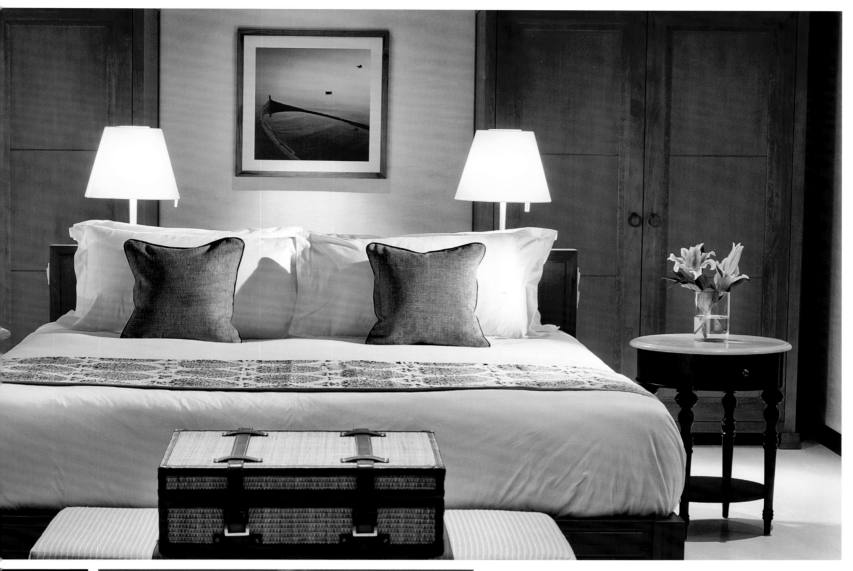

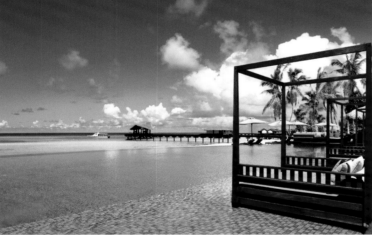

The magnificent underwater world of Gaafu Alifu can be best discovered from the resort's PADI five-star diving centre. There are also multilingual instructors for diving lessons. Numerous non-motorised water sports are offered free of charge, including catamaran sailing, kayaking, windsurfing and snorkelling. Furthermore, visits to neighbouring islands and local villages, waterskiing, jet-skiing and knee-boarding can be organized by The Residence Maldives upon request. The Residence offers coordinated packages for larger events. The island paradise is the perfect location for weddings or honeymoons – including sunsets and ceremonies by the beach or underwater.

Die grandiose Unterwasserwelt von Gaafu Alifu entdeckt man am besten vom PADI-5-Sterne-Tauchzentrum des Resorts aus. Dort stehen auch vielsprachige Lehrer für den Tauchunterricht zur Verfügung. Sämtliche nicht motorisierte Wassersportarten werden kostenfrei angeboten, darunter Katamaran-Segeln, Kajakfahren, Windsurfen und Schnorcheln. Darüber hinaus organisiert das The Residence Maldives auf Wunsch auch Ausflüge zu benachbarten Inseln und einheimischen Dörfern, zum Wasserski- und Jetski-Fahren sowie Knee-Boarding. Für größere Events bietet The Residence Maldives abgestimmte Pakete. Das Inselparadies ist der perfekte Ort für Hochzeiten oder Honeymoon – inklusive Sonnenuntergang und Zeremonien am Strand oder unter Wasser.

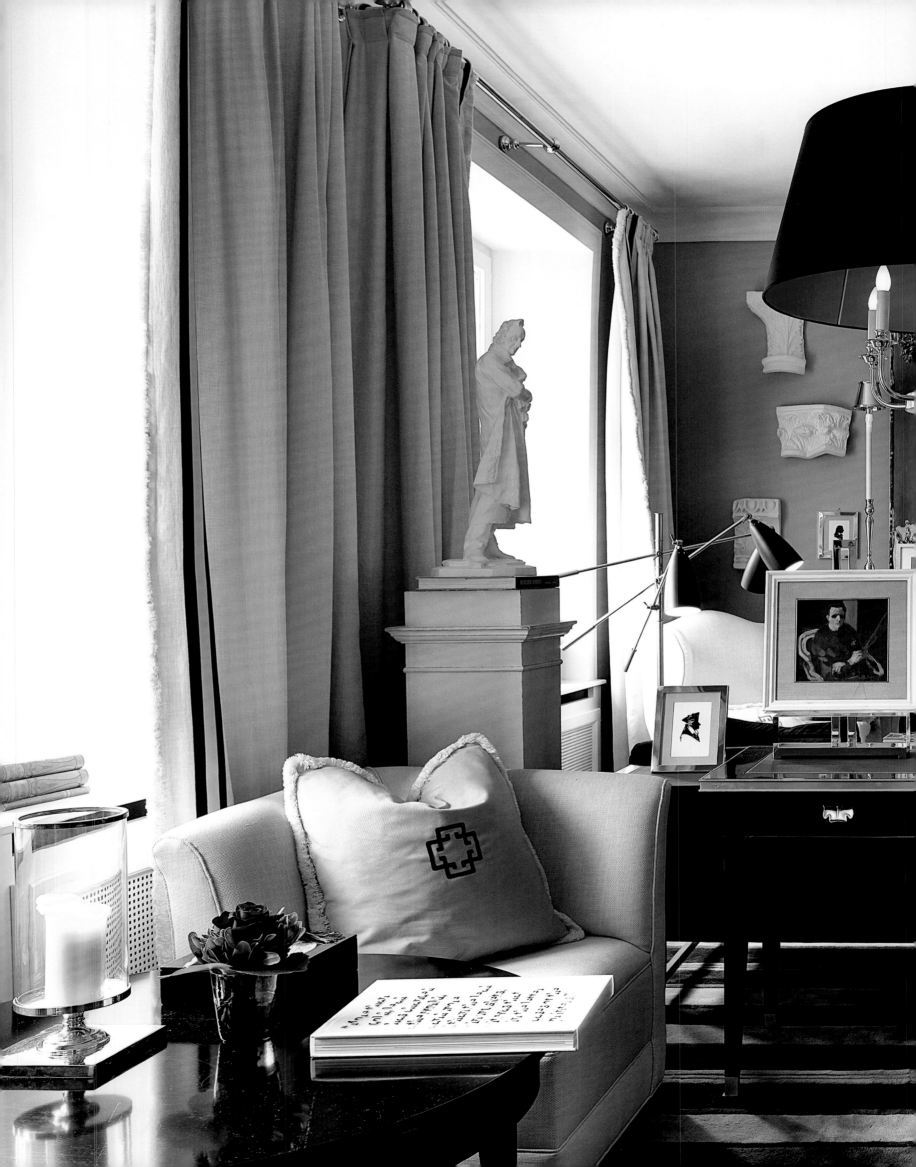

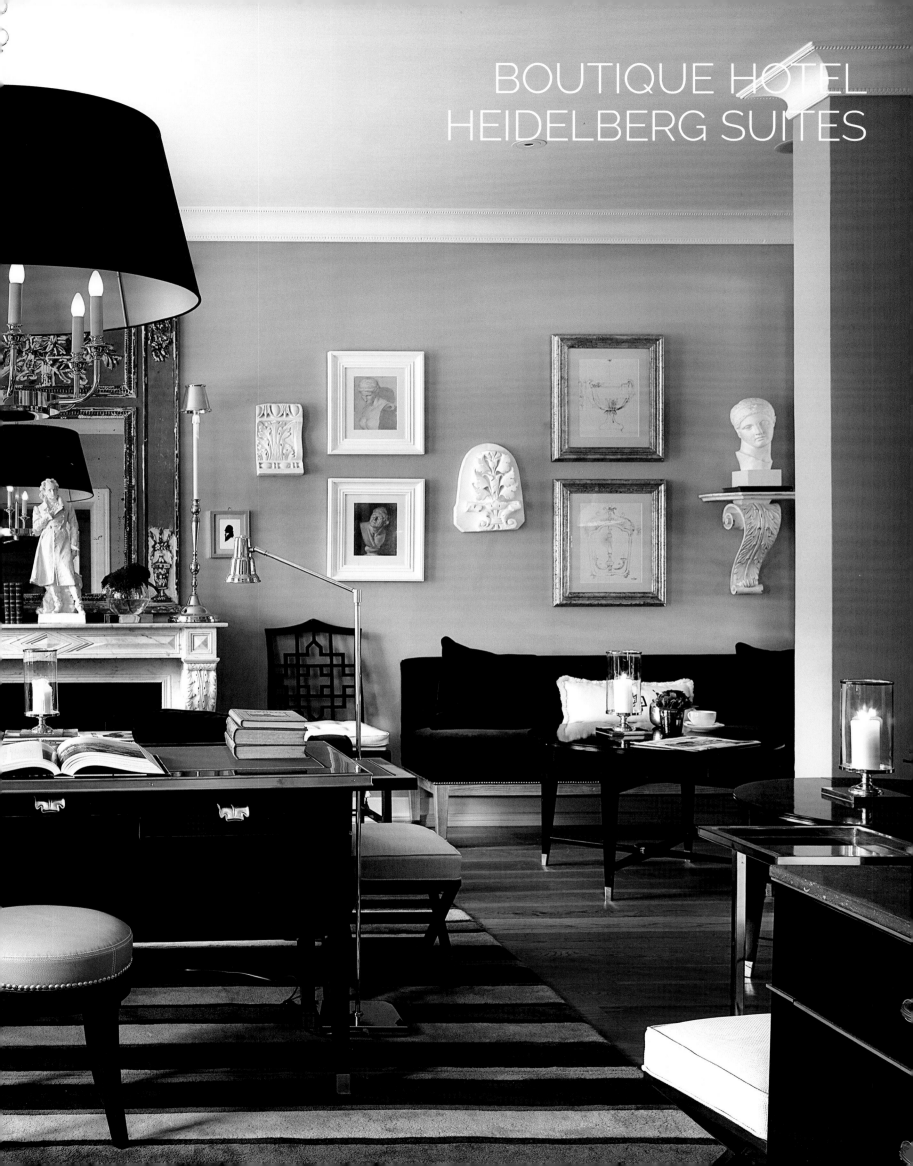

EIN ZUHAUSE IM HERZEN DER ROMANTISCHSTEN STADT DEUTSCHLANDS

A home in the very
heart of Germany's
most romantic city

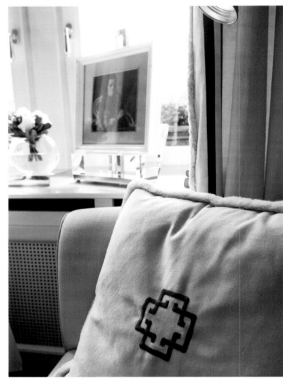

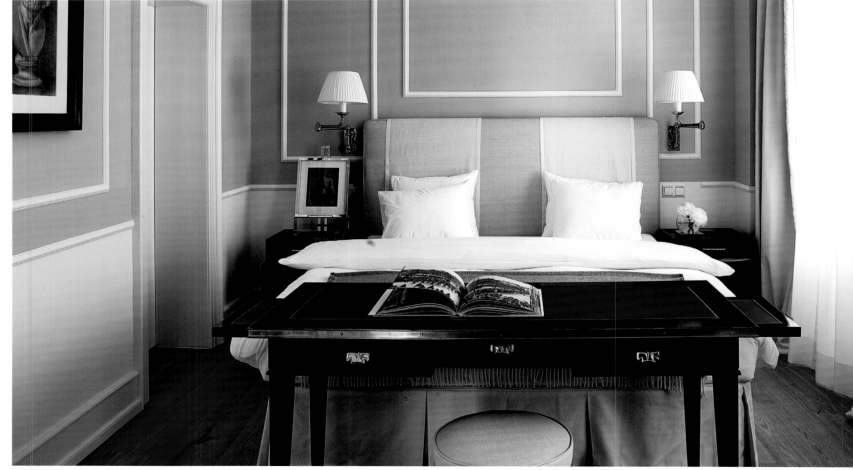

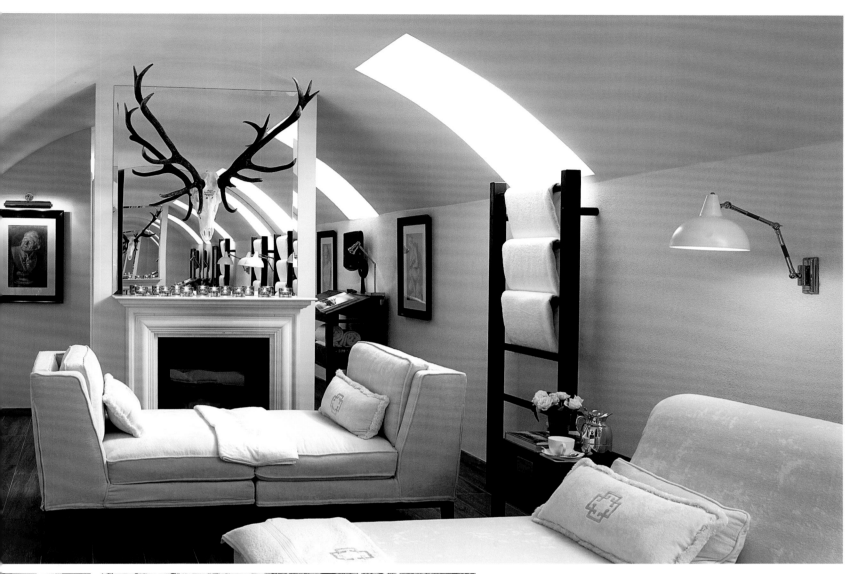

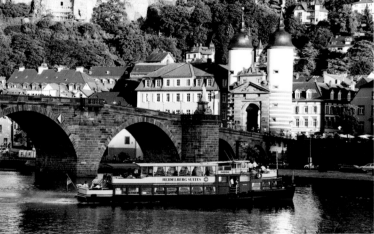

Between vineyards, Philosopher's Walk and the Neckar river, an absolutely unique domicile can be found in Heidelberg. The Boutique Hotel Heidelberg Suites was integrated into a villa estate from the 19th century and now offers an oasis of calm and beauty with modern amenities and personal service. The Heidelberg Suites Patria is the hotel's very own event ship for weddings, corporate events and other gatherings on which guests enjoy an idyllic boat ride through the Neckar valley with a beautiful view of Heidelberg castle, all in all enjoying an elegant yet still laid-back ambience.

Zwischen Weinbergen, Philosophenweg und Neckar findet sich ein exklusives Domizil, das in Heidelberg seines Gleichen sucht. Das Boutique-Hotel Heidelberg Suites, das in ein Villen-Anwesen aus dem 19. Jahrhundert integriert wurde, bietet eine Oase der Ruhe und Schönheit mit modernen Annehmlichkeiten und persönlichem Service. Mit der Heidelberg Suites Patria verfügt das Hotel sogar über ein eigenes Event-Schiff für Hochzeiten, Firmenveranstaltungen und Events. Bei einer Schifffahrt durch das idyllische Neckartal genießen Gäste in elegantem Ambiente und dennoch lässiger Atmosphäre den schönsten Blick auf das Heidelberger Schloss und seine Umgebung.

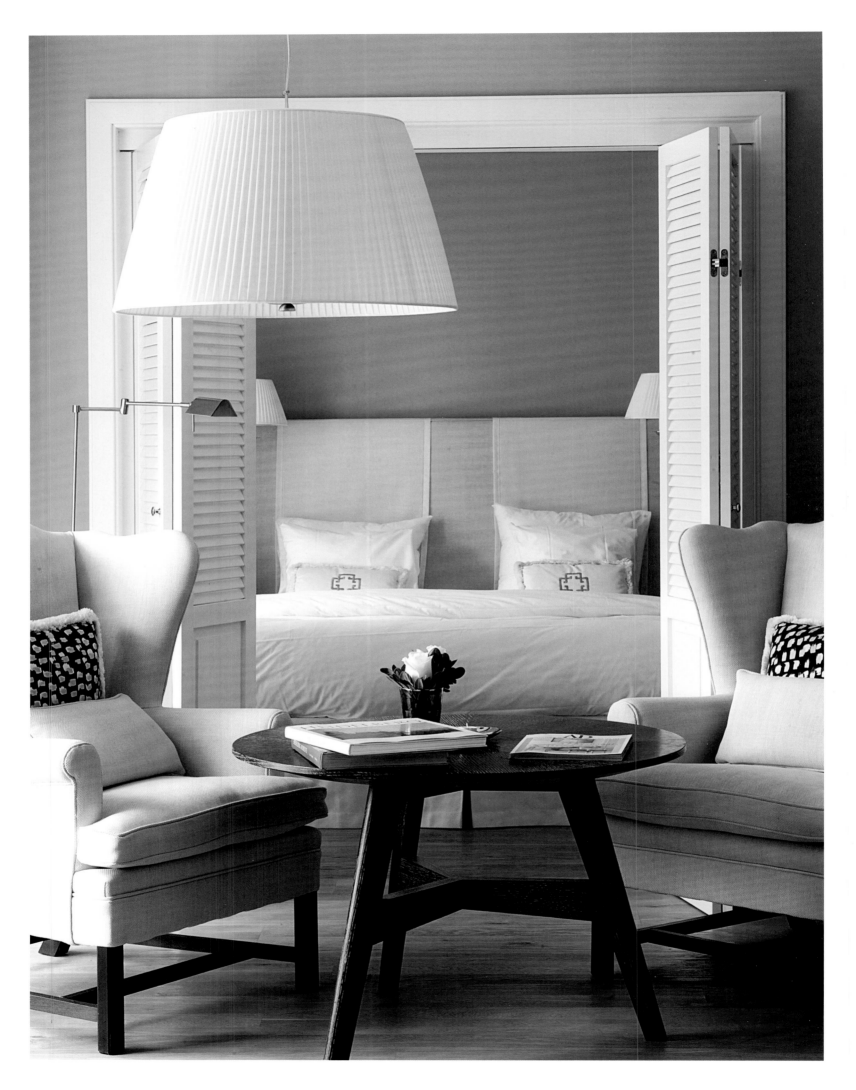

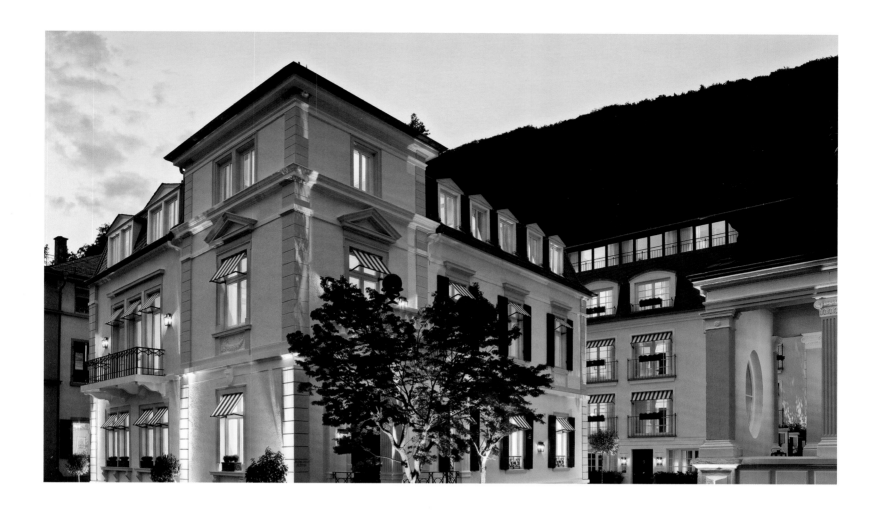

LOCATION

Heidelberg, eine der romantischsten und schönsten Städte Deutschlands, hier lässt das Boutique Hotel Heidelberg Suites die deutsche Romantik mit seinen Philosophen, Dichtern und Denkern wieder neu aufleben. Die reizvolle Lage der Stadt am Neckar sowie die imposante barocke Altstadt hat einiges an historischen Sehenswürdigkeiten zu bieten. Die exklusive Lage des Boutique Hotel Heidelberg Suites mit einmaligem Ausblick auf Schloss und Altstadt ermöglicht es, die historischen Sehenswürdigkeiten leicht zu Fuß zu erreichen. Gerne bringt der Portier Gäste mit dem hauseigenen Golfcaddy in die Altstadt.

HOTEL

Im Boutique Hotel Heidelberg Suites mit seinen 26 Suiten soll sich jeder Gast wie zu Besuch bei guten Freunden fühlen, dem Stress und der Hektik des Alltags entfliehen können und Heidelberg von seiner schönsten und elegantesten Seite erleben dürfen. Fast alle Suiten haben einen fantastischen Ausblick auf die Altstadt, zwei Zimmer und eine voll eingerichtete Pantryküche mit Espressomaschine. Sie sind mit den höchsten Standards ausgestattet. Die Penthouse Suite bietet eine große Dachterrasse mit eigenem Jacuzzi. In der Sky Suite genießen Gäste auf der eigenen Dachterrasse einen einmaligen Ausblick auf die Altstadt, die eine romantische Atmosphäre bei Tag und bei Nacht zaubert. Das Boutique Hotel mit dem unaufdringlichen Luxus eines 5-Sterne-Hotels empfängt seine Gäste in außergewöhnlichen Villen aus der Zeit der Jahrhundertwende, hochwertig restauriert vom international renommierten Architekten Michele Bönan und seiner Frau Christine Hütter Bönan. Auch das Interior und das Design der Heidelberg Suites stammt von den beiden. Als Inspiration diente ihnen die Geschichte Heidelbergs und die Epoche der Romantik. Auf persönlichen Service wird in den Heidelberg Suites ganz besonders viel Wert gelegt, die Rezeption ist gerne bei der Planung und Buchung von Aktivitäten wie Sightseeingtouren mit dem hauseigenen Golfcaddy und Reiseführer behilflich. Des Weiteren bieten die Heidelberg Suites viele Annehmlichkeiten wie einen Private Spa, einen Fitness-Pavillon mit Ausblick auf die Altstadt sowie einen Limousinen-Shuttle für seine Gäste an. Das Hotel ist zudem Mitglied der "Small Luxury Hotels of the World".

LOCATION

Heidelberg, one of Germany's most romantic and picturesque cities – where the Boutique Hotel Heidelberg Suites rekindles the spirit of German Romanticism with its philosophers and poets. The city's scenic location along the Neckar and its impressive baroque old town offer an array of historic attractions. The Boutique Hotel Heidelberg Suites' exclusive location with a unique view of the castle and old town allows guests to easily access the historical sites on foot. The concierge is happy to take guests to the old city with the hotel's very own golf caddy.

HOTEL

In the boutique hotel's 26 suites, every guest is meant to feel as if they were visiting a close friend in order to get away from the stress and hustle of their everyday life and experience Heidelberg from its most beautiful and elegant side. Almost every suite offers a view of the old town and has two rooms, a fully stocked pantry kitchen with an espresso machine, and is equipped to the highest standards. The penthouse suite includes a large roof terrace and a private jacuzzi. In the Sky Suite guests can relax on their own roof terrace with an incomparable view of the old city, which creates a romantic atmosphere by day and night. The boutique hotel with its discreet five-star luxury welcomes guests in extraordinary villas, which were built during the turn of the century and restored by the internationally renowned architect Michele Bönan and his wife Christine Hütter Bönan. The interior and design of the Heidelberg Suites also originate from the couple. The history of Heidelberg and the Romantic era served as their inspiration. The Heidelberg Suites place great importance on personal service. The reception is therefore happy to help with regard to planning and booking sightseeing tours with the hotel's own golf caddy and tour guide. Furthermore, the Heidelberg Suites offer suites with additional amenities, such as a private spa, a gym pavilion with views of the old city, as well as a limousine shuttle for its guests. The hotel is also a member of the "Small Luxury Hotels of the World".

Get your Upgrade

www.upgradetoheaven.com/heidelberg-suites

BOUTIQUE HOTEL HEIDELBERG SUITES . Neuenheimer Landstrasse 12, 69120 Heidelberg, Germany . www.heidelbergsuites.com

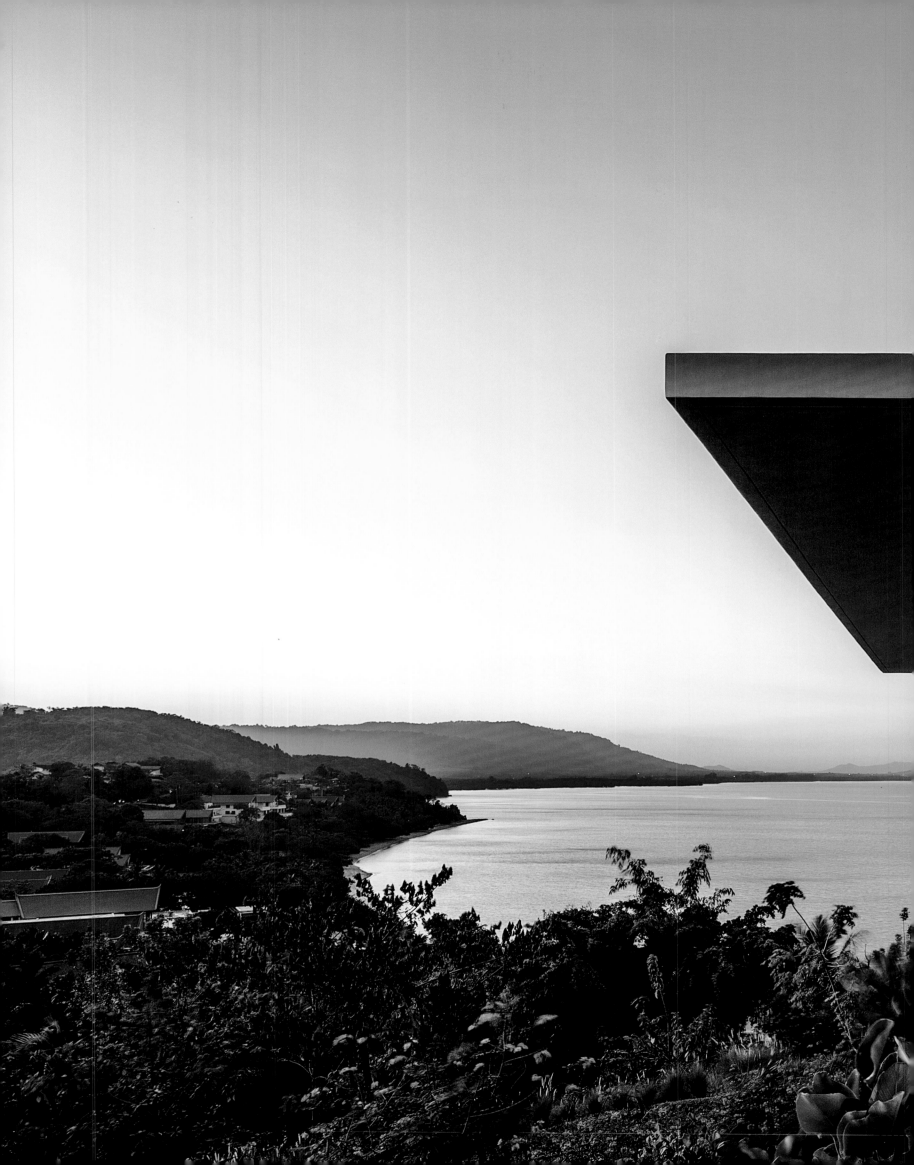

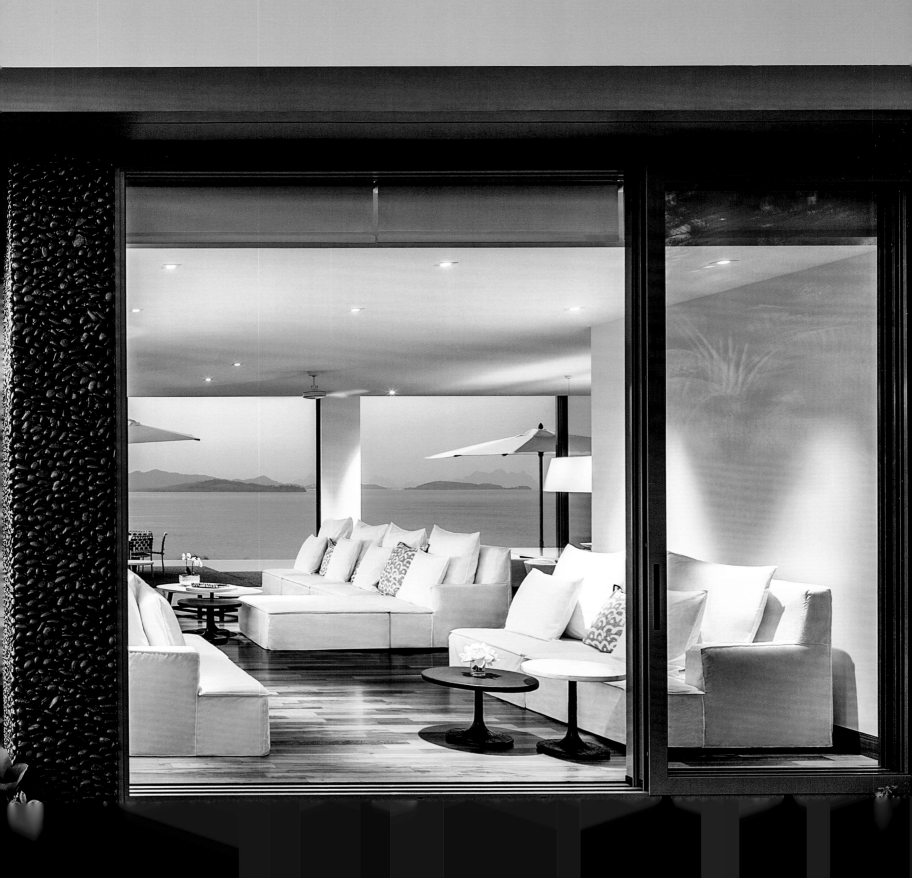

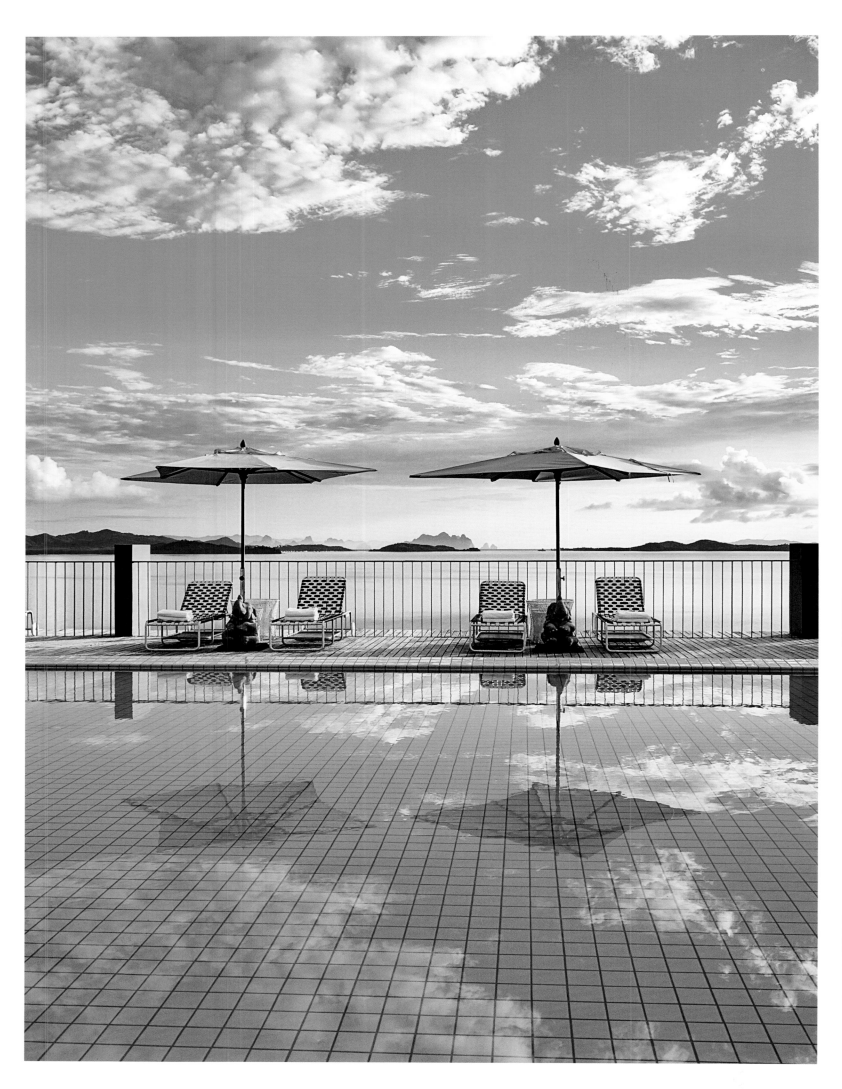

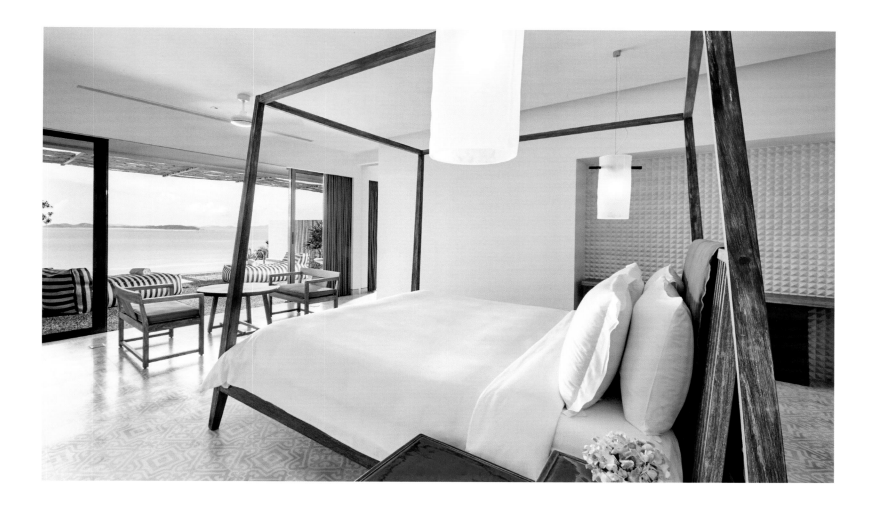

LOCATION

Point Yamu befindet sich auf einer Halbinsel an der Ostküste von Phuket, eine 25-minütige Autofahrt vom Phuket International Airport entfernt. Phuket gehört zu den Strand-Urlaubszielen Asiens, die am einfachsten zu erreichen sind. In wunderschöner, geschützter Landschaft trifft modernes Thailand auf thailändische Tradition. Die Lage des Como Point Yamu bietet Gästen die Möglichkeit, die weniger bekannte Seite der Insel kennenzulernen. Das Hotel selbst liegt an der Spitze von Cape Yamu und hat einen 360-Grad-Blick über die Andamansee und den, von der UNESCO geschützten, dramatischen Kalksteinfelsen von Phang Nga Bay. Die Bucht ist ein berühmtes Ziel für Taucher und Schnorchler. Point Yamu bietet unzählige weitere Wassersportmöglichkeiten, sowie auch private Bootstouren zu den nahen Stränden und Inseln.

HOTEL

Alle 79 Gästezimmer und Suiten und 27 private Poolvillen des Como Point Yamu überblicken das glitzernde Wasser der Phang Nga Bay, manche verfügen über einen privaten Pool oder eine eigene Terrasse sowie zusätzliche Lounge- oder Sitzbereiche. Im Como Shambhala Retreat Spa entspannen Gäste bei eigens entwickelten asiatisch inspirierten, holistischen Therapien mit Ayurveda, Massagen und Gesichtsbehandlungen. Darüber hinaus bietet Como Point Yamu ein privates Yoga-Studio, Fitnessstudio und einen atemberaubenden 100 Meter langen Infinity-Pool. In den beiden hoteleigenen Spitzen-Restaurants werden thailändische und italienische Küche serviert. "Nahmyaa" bietet neben Thai Food auch gesunde Como Shambhala-Gerichte und das italienische Restaurant "La Sirena" bedient seine Gäste ganztägig auf einer Terrasse mit umwerfender Aussicht auf die Bucht. Neben vielen sportlichen Aktivitäten wie Schorcheln, Radfahren und Golf bietet das Como Point Yamu auch Bootsausflüge und kulturelle Aktivitäten wie Thai-Koch-kurse, den Besuch der für Thailand typischen Märkte oder der Altstadt von Phuket.

LOCATION

Point Yamu is located on a peninsula east of Phuket, a 25-minute drive from Phuket International Airport. Phuket is one of the most easily accessible main beach vacation spots in Asia. Modern Thailand meets Thai traditions in a beautiful and secluded area. Como Point Yamu's location furthermore offers guests the opportunity to visit the less known region of the island. The hotel is situated at the top of Cape Yamu and has a 360-degree view over the Andaman Sea and of the UNESCO-protected, ancient limestone karsts of Phang Nga Bay. The bay is a popular destination for divers and snorkellers. Point Yamu offers many further water sport activities, as well as private boat tours to the closest beaches and islands from the marina.

HOTEL

All of the 79 guest rooms and suites and the 27 private pool villas of Como Point Yamu have a view of the shimmering water of Phang Nga Bay; some have their own private pool or terrace, as well as additional lounge and seating areas. Guests relax at Como Shambhala Retreat Spa with specially designed Asian-inspired, holistic therapies with Ayurveda, massages and face treatments. Furthermore, Como Point Yamu offers a private yoga studio, gym and a breathtaking 100-metre infinity pool. The hotel's excellent restaurants serve Thai and Italian dishes. As well as Thai food "Nahmyaa" also offers healthy Como Shambhala dishes, and the Italian restaurant "La Sirena" serves guests all day on a terrace with a stunning view of the bay. In addition to sport activities including snorkelling, biking and golfing, Como Point Yamu furthermore offers boat trips and cultural activities such as Thai cooking courses, a visit to Thailand's famous markets or a trip to the historical city of Phuket.

Get your Upgrade

www.upgradetoheaven.com/como-point-yamu

COMO POINT YAMU . 225 Moo 7, Pa Klok, Talang, Phuket, 83110 Thailand . www.comohotels.com/pointyamu

A WORLD OF PRIVATE, OCEANFRONT LUXURY

Privater Luxus direkt
am Wasser

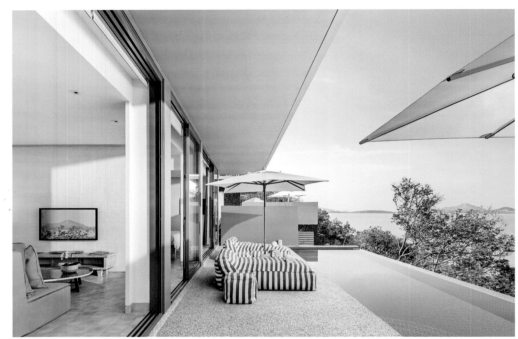

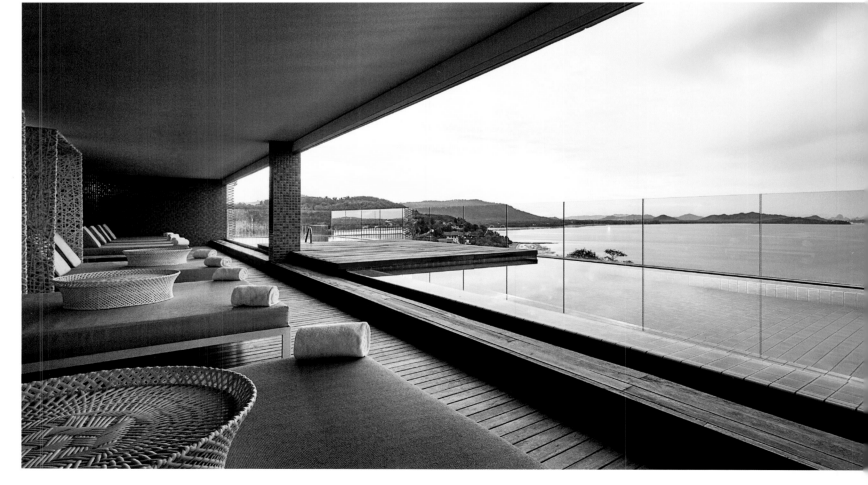

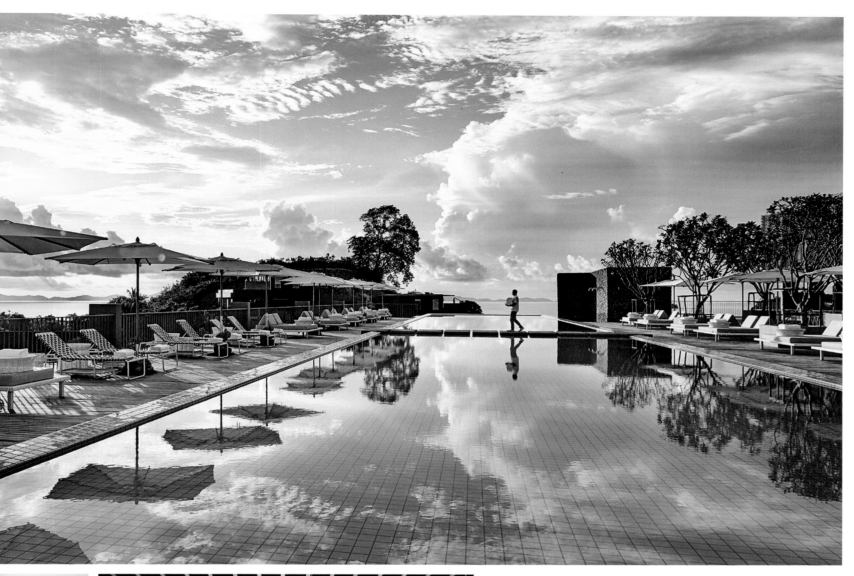

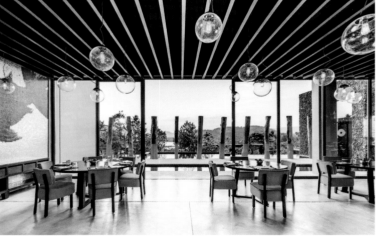

The interior design of Como Point Yamu originates from the prestigious Italian designer Paola Navone, who already designed Armani Casa, Poliform and Driade. Her goal was to create a feel-good atmosphere. She combines local design elements, regional craftmanship, natural tones and colourful highlights with contemporary Thai luxury. Some of the luxurious pool villas can also be acquired by purchase. The Como Beach Club, which is 40 minutes away by speedboat, is exclusively for villa owners and hotel guests. The Beach Club consists of a 15-metre saltwater pool, treatment rooms, restaurants and a water sport centre.

Das Interior Design des Como Point Yamu stammt von der renommierten italienischen Designerin Paola Navone, die unter anderem auch bereits für Armani Casa, Poliform und Driade entworfen hat. Ihr Ziel war es, eine Wohlfühlatmosphäre zu schaffen. Sie vereint lokale Designelemente, regionale Handwerkskunst, natürliche Töne und farbige Akzente zu zeitgenössischem Thai Luxus. Einige der luxuriösen Pool Villen können auch als Privatresidenzen käuflich erworben werden. Exklusiv für Villen-Eigentümer und Hotelgäste gibt es den Como Beach Club, der 40 Minuten mit dem Speedboot entfernt ist. Zur Ausstattung des Beach Club gehören unter anderem ein 15 Meter langer Salzwasser-Pool, Behandlungsräume, Restaurants und ein Wassersportzentrum.

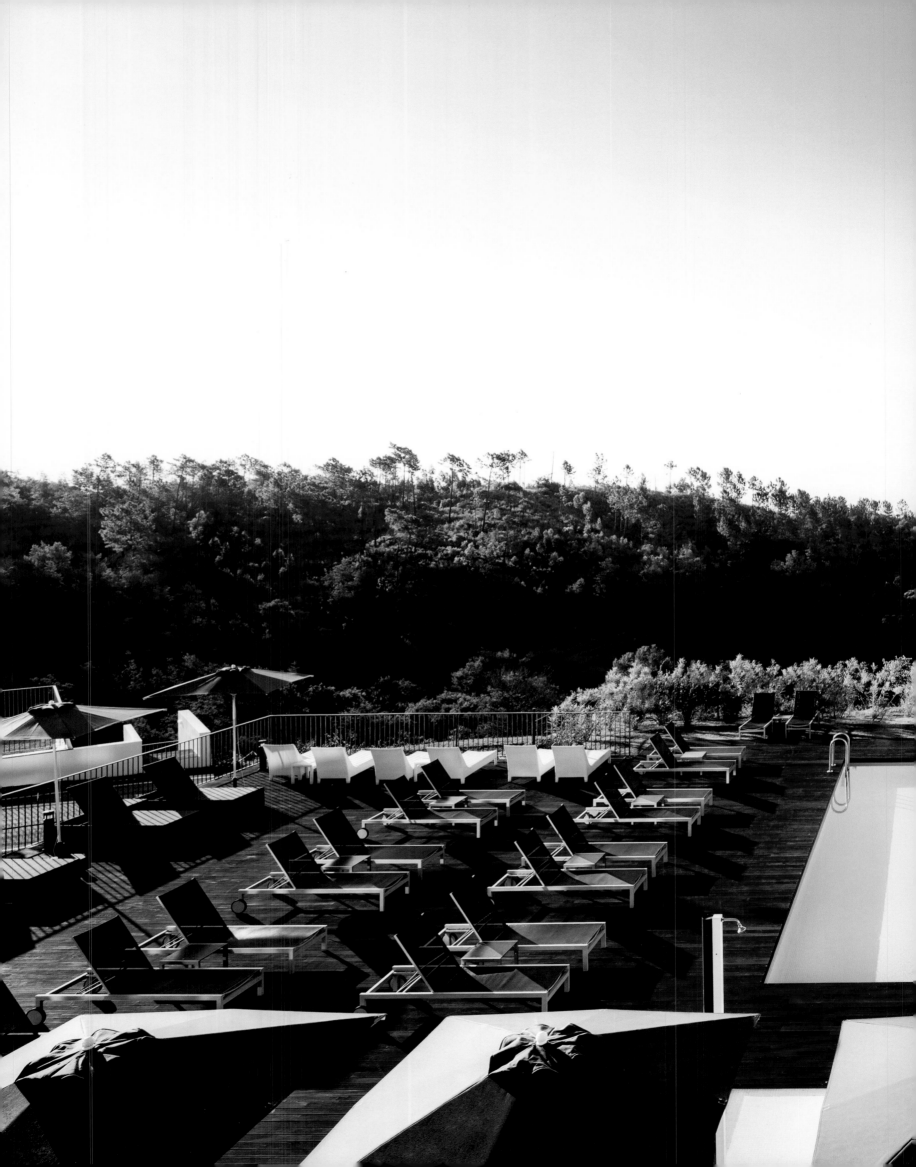

MACDONALD MONCHIQUE
RESORT & SPA

Das im Juni 2016 neu eröffnete 5-Sterne-Haus
Macdonald Monchique Resort & Spa ist der
neue exklusive Hotspot der Algarve.

The newly opened five-star hotel Macdonald
Monchique Resort & Spa is the new and
exclusive hotspot of the Algarve.

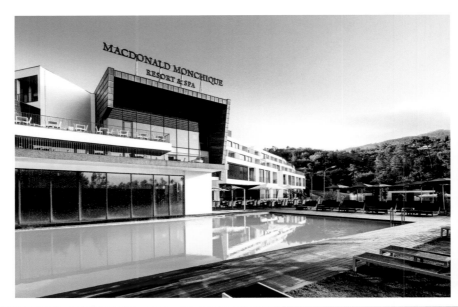

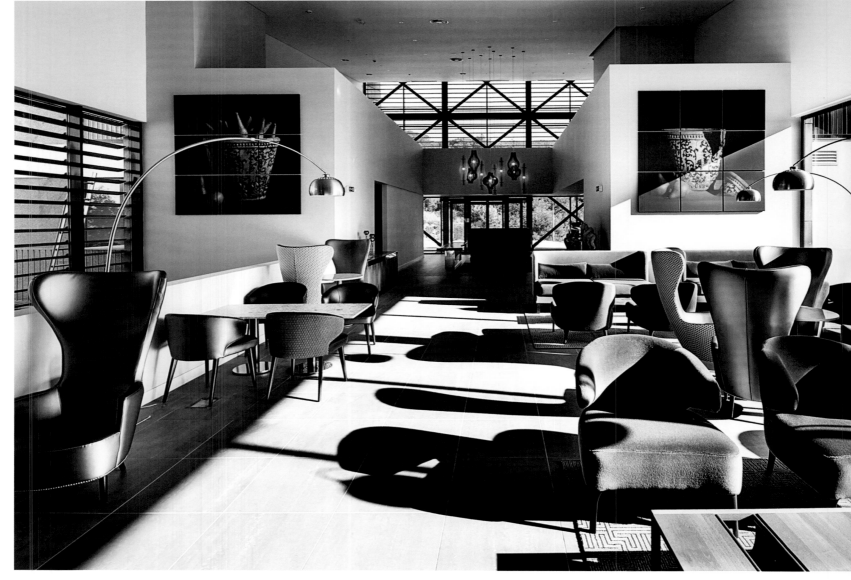

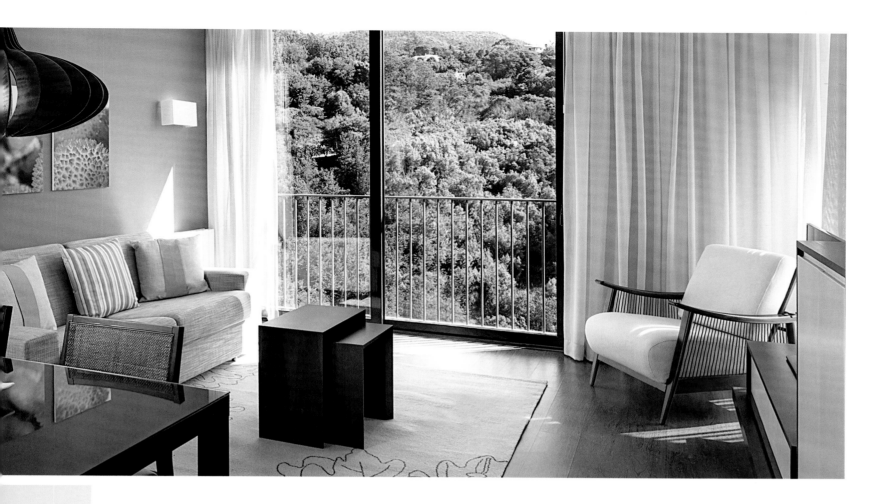

LOCATION

Umgeben von alten Korkeichen und Eukalyptusbäumen liegt das 5-Sterne-Hotel Macdonald Monchique Resort & Spa in der Serra de Monchique im Herzen der Algarve. Die Atlantikküste mit langen Sandstränden und spektakulären Klippen ist in etwa einer halben Autostunde zu erreichen. Bereits in der Antike war die Serra de Monchique für ihre Thermalquellen bekannt, die sich im zu Fuß 15 Minuten entfernten malerischen Dorf Caldas de Monchique befinden. Ob Wandern, Radfahren, Wassersport, Delfine beobachten oder eine Runde Golf auf nahegelegenen Plätzen, die zu den schönsten der Welt gehören – die Region bietet so vieles für einen abwechslungsreichen Aufenthalt an Portugals Algarve.

HOTEL

Das neue 5-Sterne-Haus Macdonald Monchique Resort & Spa in den Bergen der Algarve begeistert mit modernem Design und hervorragender Ausstattung. Alle 185 Suiten in sechs Kategorien verfügen auf mindestens 40 qm über Terrasse oder Balkon, Schlafzimmer, zwei Bäder, Wohn- und Essbereich sowie eine Fensterfront, die ein atemberaubendes Panorama über die sanfte Bergwelt der Serra de Monchique bis hin zum Atlantik bietet. Das luxuriöse Sensorial Spa, ein türkisches Bad, eine Aromagrotte, verschiedene Ruheräume sowie eine pinkfarbene Himalayasalzwand-Sauna machen das Hideaway zu einem ganz besonderen Ort, um die Akkus wieder aufzuladen. Zudem werden Kurse in Yoga, Meditation und Pilates angeboten. Vier Restaurants, drei Bars und ein kleiner Gourmetsupermarkt sorgen für lukullische Freuden bei den Gästen. Das Hauptrestaurant "Mon-Chic" ist eine High Class Fine Dining-Location mit saisonalen und À-la-carte Gerichten. Die für Portugal typischen Tapas petiscos sind zusammen mit einem Glas Bier oder Wein das kulinarische Highlight im "A Petisqueira". Jeden morgen finden die Gäste eine große Frühstücksauswahl im "O Mercado Culinario". Einen Hauch von Italien an der Algarve bieten knusprige Pizzen und frische Pasta in der "Pizzaria da Serra". Im Macdonald Monchique Resort & Spa lässt es sich das ganze Jahr über entspannen und genießen.

LOCATION

Surrounded by old cork oaks and eucalyptus trees is the five-star hotel Macdonald Monchique Resort & Spa in the heart of the Algarve's Serra de Monchique. The Atlantic coast with extensive sandy beaches and spectacular cliffs is within easy reach in thirty minutes by car. In ancient times Serra de Monchique was famous for its thermal springs, which are 15 minutes away on foot in the beautiful village Caldas de Monchique. Whether guests are hiking, biking, doing water sports, dolphin watching or playing golf on nearby courses, which are among the most beautiful in the world, the region offers so much for a diverse stay in Portugal's Algarve.

HOTEL

The new five-star hotel Macdonald Monchique Resort & Spa in the Algarve mountains excites with modern design and excellent facilities. All 185 suites of six categories have at least 40 sqm, and provide a terrace or balcony, bedrooms, two bathrooms, living and dining area, as well as a window front, offering a breathtaking panorama over the undulating mountain world of Serra de Monchique all the way to the Atlantic. The luxurious Sensorial Spa, a Turkish bath, an aroma grotto, different relaxation areas and a pink Himalayan salt wall sauna make the hideaway a very special spot to recharge one's batteries. Furthermore, yoga, meditation and Pilates courses are offered. Four restaurants, three bars and a small gourmet supermarket create epicurean excitement among guests. The resort's main restaurant "Mon-Chic" is a top-class fine dining destination with seasonal and à la carte menus. Typical Portuguese tapas petiscos combined with a glass of beer or wine are the highlight at "A Petisqueira". Every morning, guests find a large breakfast selection at "O Mercado Culinario". The "Pizzaria da Serra" offers a hint of Italian in the Algarve with crispy pizzas and fresh pasta. At Macdonald Monchique Resort & Spa guests can relax and enjoy themselves all-year-round.

Get your Upgrade

www.upgradetoheaven.com/macdonald-monchique

MACDONALD MONCHIQUE RESORT & SPA . Lugar do Montinho, 8550-232, Monchique, Algarve, Portugal . www.macdonaldmonchique.com

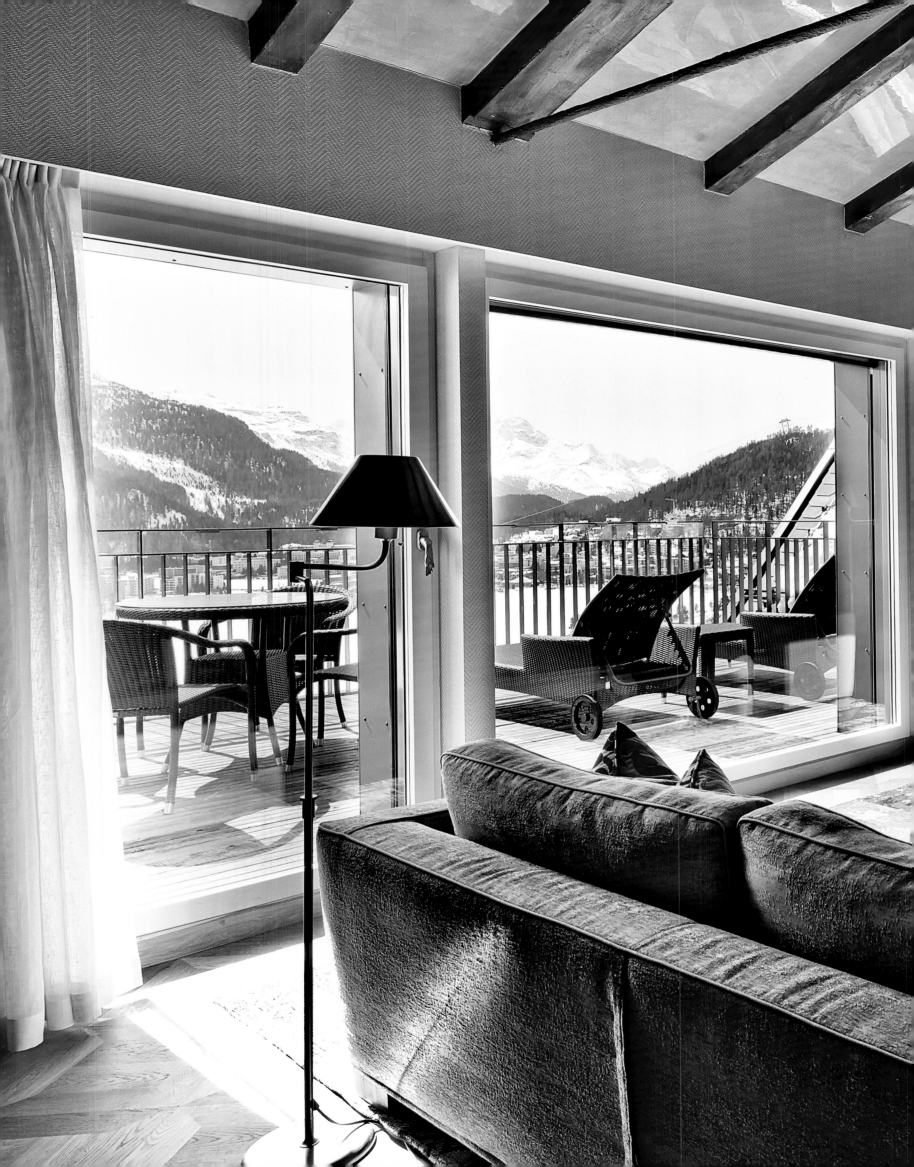

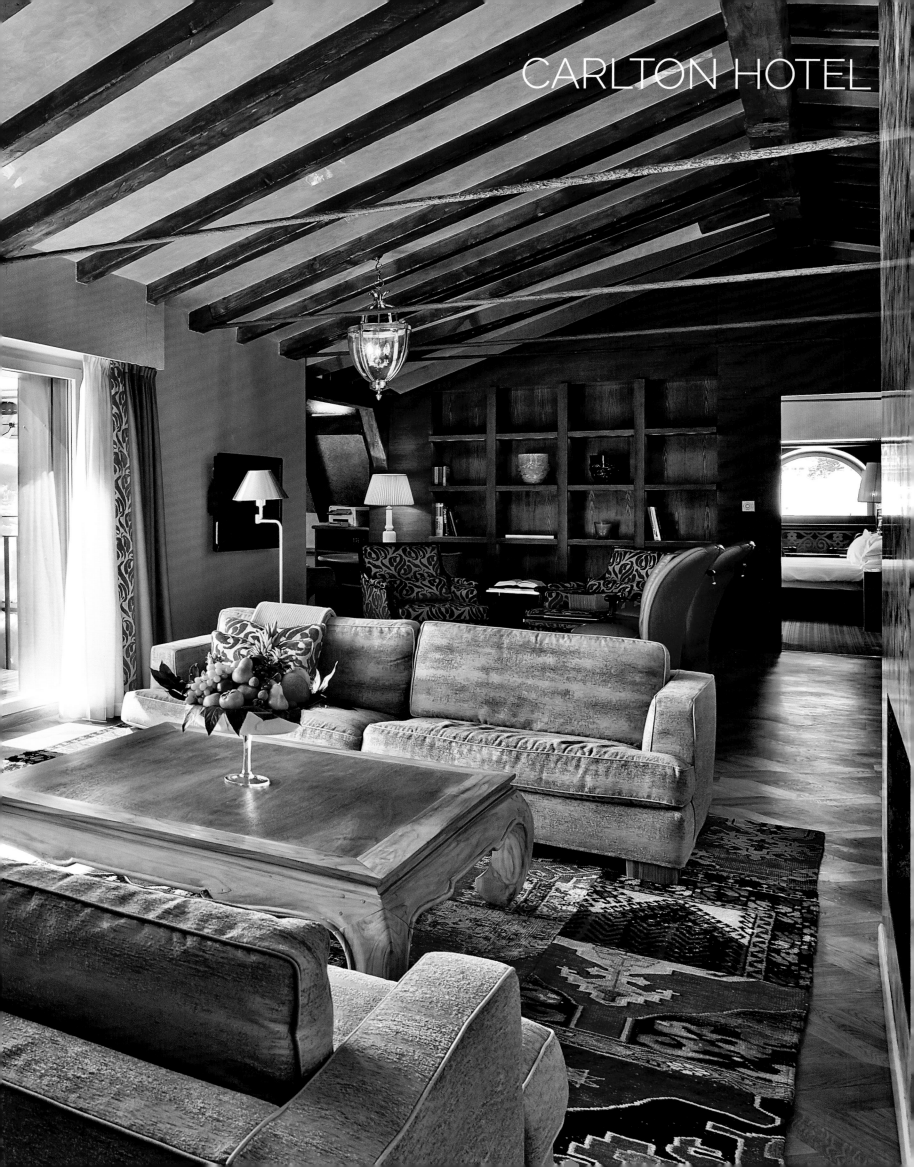

Das luxuriöse 5-Sterne-Superior
Hotel verzaubert die Sinne mit
außergewöhnlicher Farbenwelt.

The luxurious five-star superior hotel
bewitches the senses with an
extravagant world of colour.

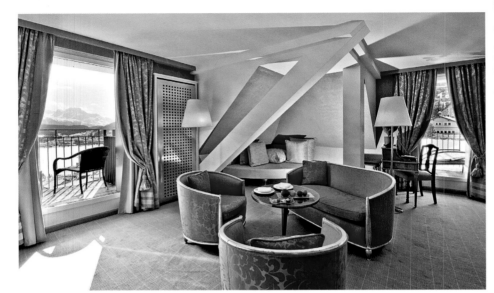

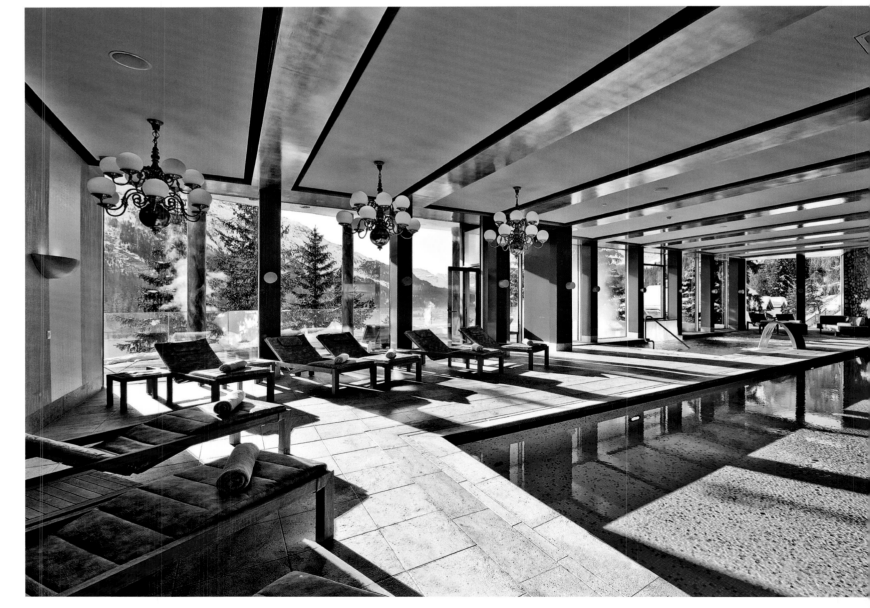

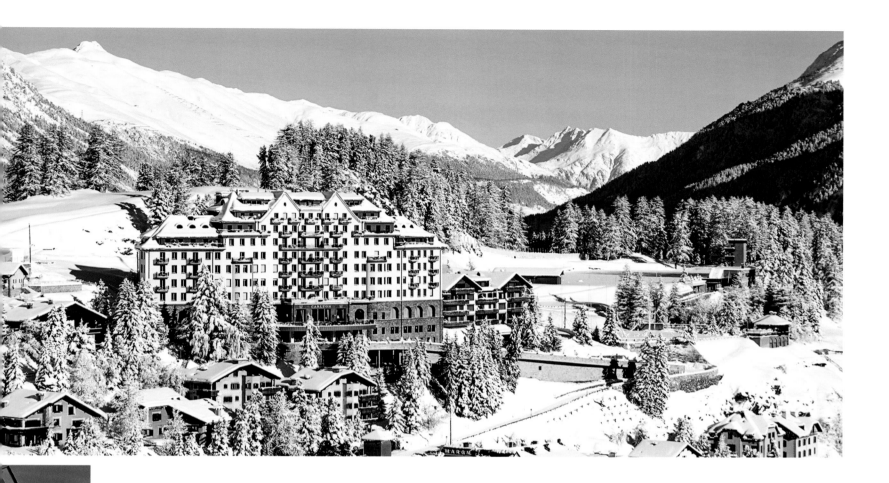

LOCATION

Das Carlton Hotel liegt in St. Moritz, einem der bekanntesten Skigebiete der Welt, auf 1.856 Höhenmetern gelegen. Diese international beliebte Destination ist bekannt für ihre elegante und exklusive Atmosphäre und bietet Gästen die perfekte Umgebung für ihren Winterurlaub.

HOTEL

Das Interior des Carlton Hotel wurde vom Schweizer Designer Carlo Rampazzi eingerichtet, dessen Kombination aus antiken Möbeln und einem modernen und lebendigen Farbkonzept, dem Hotel seinen unverwechselbaren Charakter verleiht. Alle 60 Suiten und Junior Suiten des Carlton Hotel wurden mit edlen Materialien ausgestattet. Der Fokus lag auf lichtdurchfluteten, großzügigen Räumen. Sie alle sind nach Süden ausgerichtet und bieten Blick über den St. Moritz See und die Alpen, 45 davon verfügen über einen Balkon oder eine Terrasse. Auf der obersten Etage des Hauses befindet sich St. Moritz' größte Suite, das Carlton Penthouse. Es erstreckt sich auf 386 qm und verfügt über drei große Schlafzimmer, wobei jedes einzelne mit einem eigenen Badezimmer ausgestattet ist, ein Wohnzimmer mit offenem Kamin, eine voll ausgestattete Küche und fünf Terrassen, die einen atemberaubenden Panoramablick auf das Tal freigeben. In den Restaurants "Romanoff" und dem, mit einem Michelin Stern ausgezeichneten, "Da Vittorio – St. Moritz", können die Gäste erstklassige Küche genießen. Die großzügige Sonnenterrasse des Hotels eignet sich perfekt für ein leichtes Mittagessen oder Nachmittagstee. Im 1.200 qm großen Carlton Spa finden die Gäste eine Vielzahl von Entspannungsmöglichkeiten. Das Spa ist auf drei Etagen verteilt und bietet sechs Behandlungsräume, eine private Spa Suite, einige Pools, einen Fitnessraum, verschiedene Saunen und Dampfbäder sowie einen separaten Bereich nur für Frauen und einen Friseur. Das gesamte Team des Carlton Hotel bietet perfekten Service und sorgt mit größter Mühe dafür, jeden noch so ausgefallenen Wunsch der Gäste zu erfüllen. Das Carlton Hotel gehört zu den Leading Hotels of the World. Es öffnet jedes Jahr zur Wintersaison, von Mitte Dezember bis Anfang April (exakte Öffnungsdaten finden sich auf der Hotel-Website).

LOCATION

The Carlton Hotel is situated in St Moritz, one of the most famous ski resorts in the world, at an altitude of 1,856 metres above sea level. This favourite international destination is renowned for its elegant and exclusive atmosphere and offers its guests the perfect environment for their winter holidays.

HOTEL

For the interiors of the Carlton Hotel, Swiss designer Carlo Rampazzi has combined antique furniture with vibrant modern colour schemes, which gives the hotel its distinctive unconventional character. All 60 suites and junior suites of the Carlton Hotel were created with elegant materials and an emphasis on light and space. They are all south facing and overlooking Lake St Moritz and the Alps. Fourty-five units have a balcony or terrace. The Carlton Penthouse on the top floor, the largest suite in St Moritz, extends to 386 sqm with three large bedrooms, each of which has its own separate bathroom, a living and dining area with open fire place, a fully equipped kitchen and five terraces boasting panoramic views over the valley. Guests can enjoy world-class cuisine in both restaurants, the "Romanoff" and the Michelin Star-awarded "Da Vittorio - St. Moritz". For a light lunch or afternoon tea, the hotel's spacious sun terrace is absolutely perfect. In addition, the 1,200 sqm of the Carlton spa offer numerous possibilities to relax. On three floors with six treatment rooms, private spa suite, pools, fitness room, various saunas and steam baths, as well as a separate ladies' area and hairstylist. The entire team of the Carlton Hotel provide perfect service and will make every effort to satisfy even the most extravagant wishes. The Carlton Hotel belongs to The Leading Hotels of the World. It opens every year for the winter season from mid December to the beginning of April (exact opening dates can be found on the hotel website).

Get your Upgrade

www.upgradetoheaven.com/carlton-st-moritz

CARLTON HOTEL . Via Johannes Badrutt 11, 7500 St Moritz, Switzerland . www.carlton-stmoritz.ch

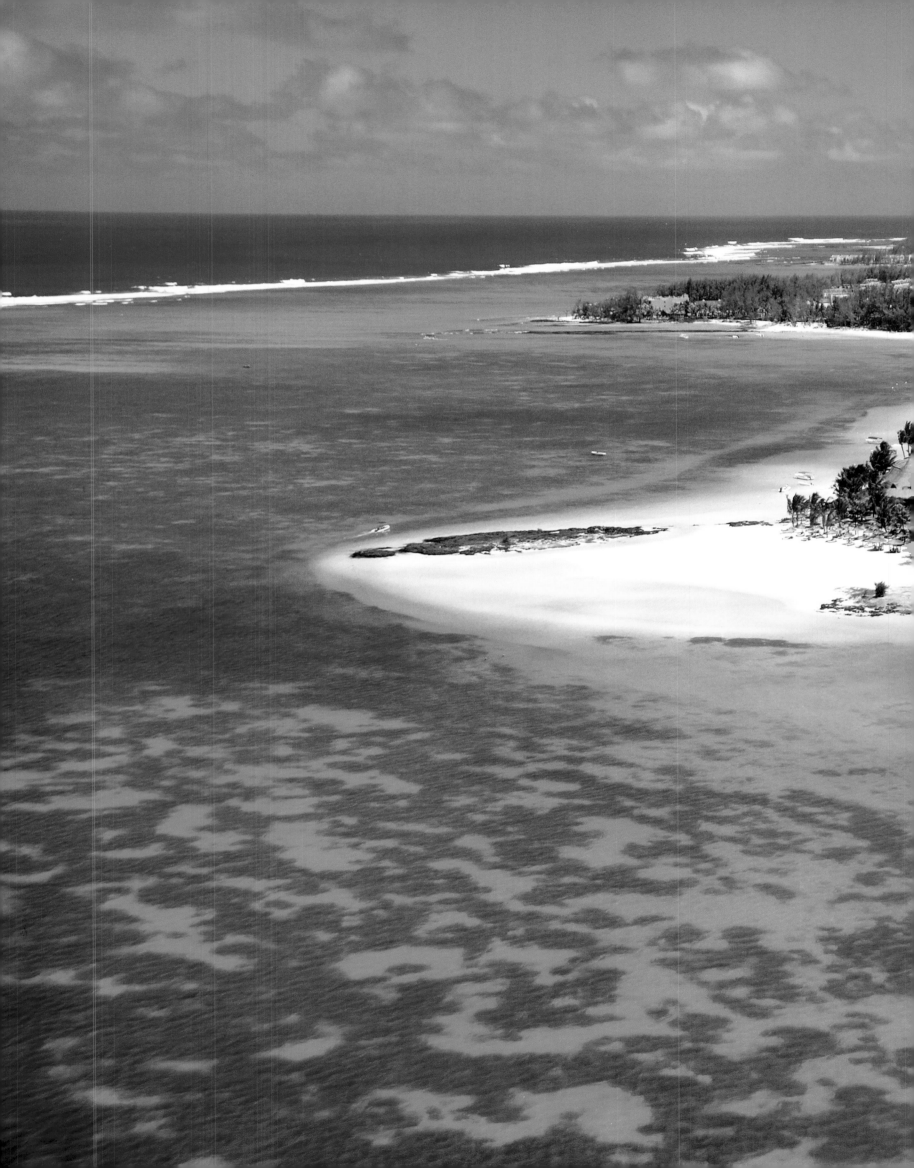

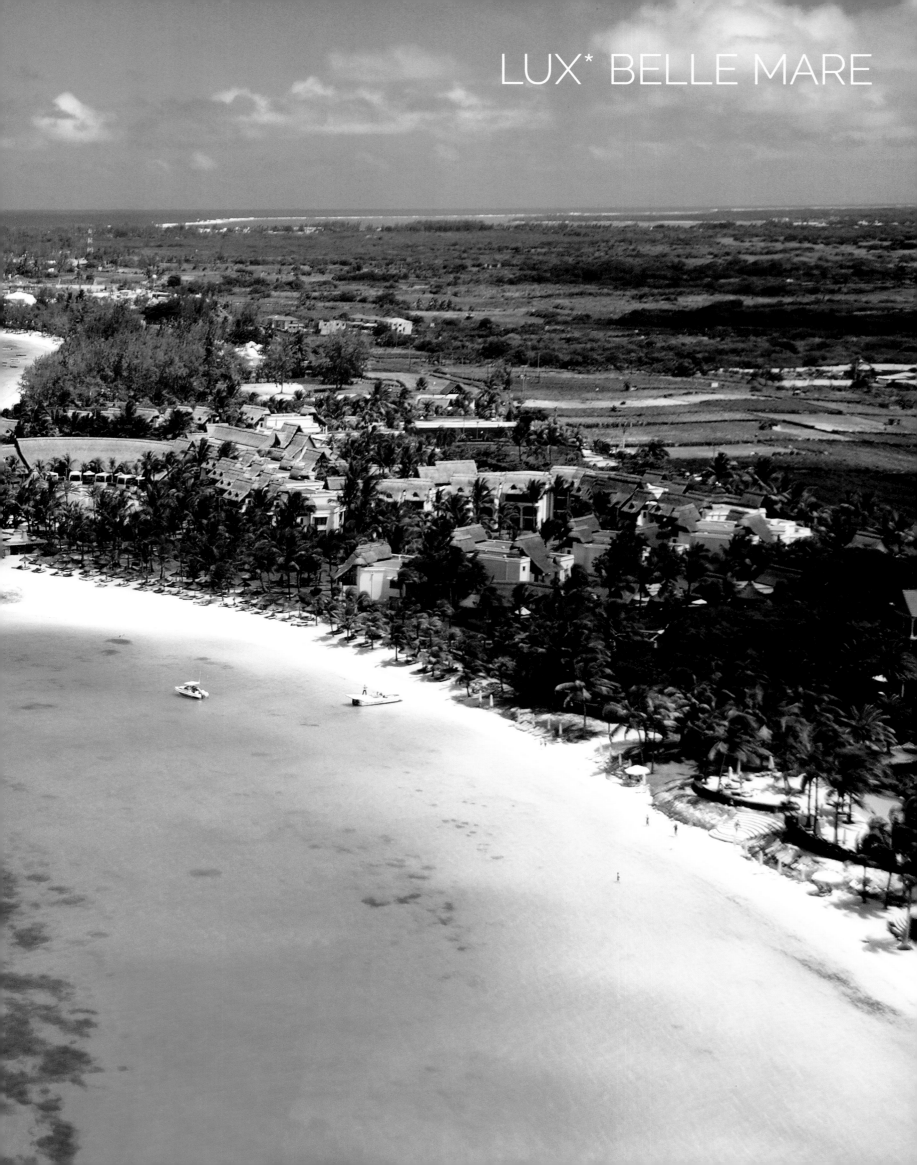

"THE RESORT IS A TRUE BEAUTY AND A CREDIT TO ITS ISLAND HOME OF MAURITIUS"

"Das Resort ist eine echte Schönheit und ein Aushängeschild für seine Heimat Mauritius"

– Paul Jones,
CEO Lux* Resorts & Hotels

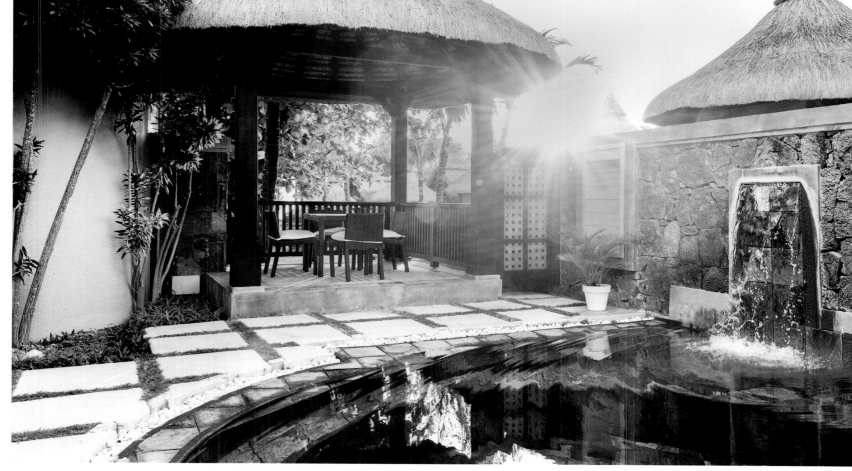

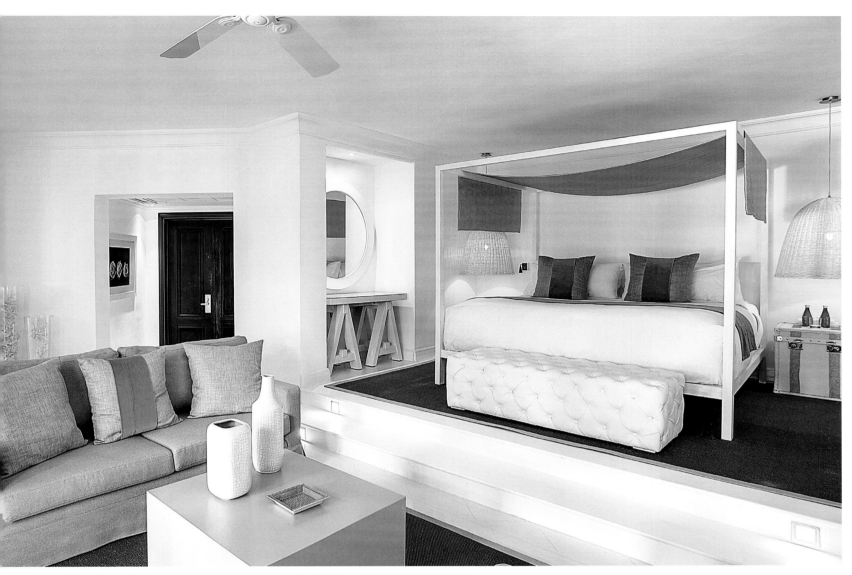

British design queen Kelly Hoppen has breathed new life into Lux˙ Belle Mare by giving it a complete makeover. True to the hotel group's motto "Lighter. Brighter.", the grande dame of Mauritius is now shining in new splendour thanks to the star interior designer. Light, inviting colours characterise the design concept. Among these soft hues Kelly Hoppen has mixed splashes of turquoise, cheerful apple green and vibrant orange to add bold and fresh highlights. Interiors with natural fabrics and maritime design elements are combined with plenty of light, designed by British lighting designer Rob Clift, and convey a wonderfully carefree holiday feeling.

Die britische „Queen of Design", Kelly Hoppen, verpasste dem Lux˙ Belle Mare ein komplettes Make-Over. Getreu des Hotelgruppen-Mottos „Lighter. Brighter." ließ die Star-Innenarchitektin Mauritius' Grande Dame in neuem Glanz erstrahlen. Helle, einladenden Farben dominieren das Design-Konzept. In diese weichen Farben mischte Kelly Hoppen einen Hauch Türkis, fröhliches Apfelgrün oder ein kräftiges Orange, um frische Akzente zu setzen. Ein Interieur aus natürlichen Stoffen sowie maritimen Design-elementen kombiniert mit viel Licht, das der britische Lichtdesigner Rob Clift gestaltete, vermittelt ein wunderbar leichtes Urlaubsfeeling.

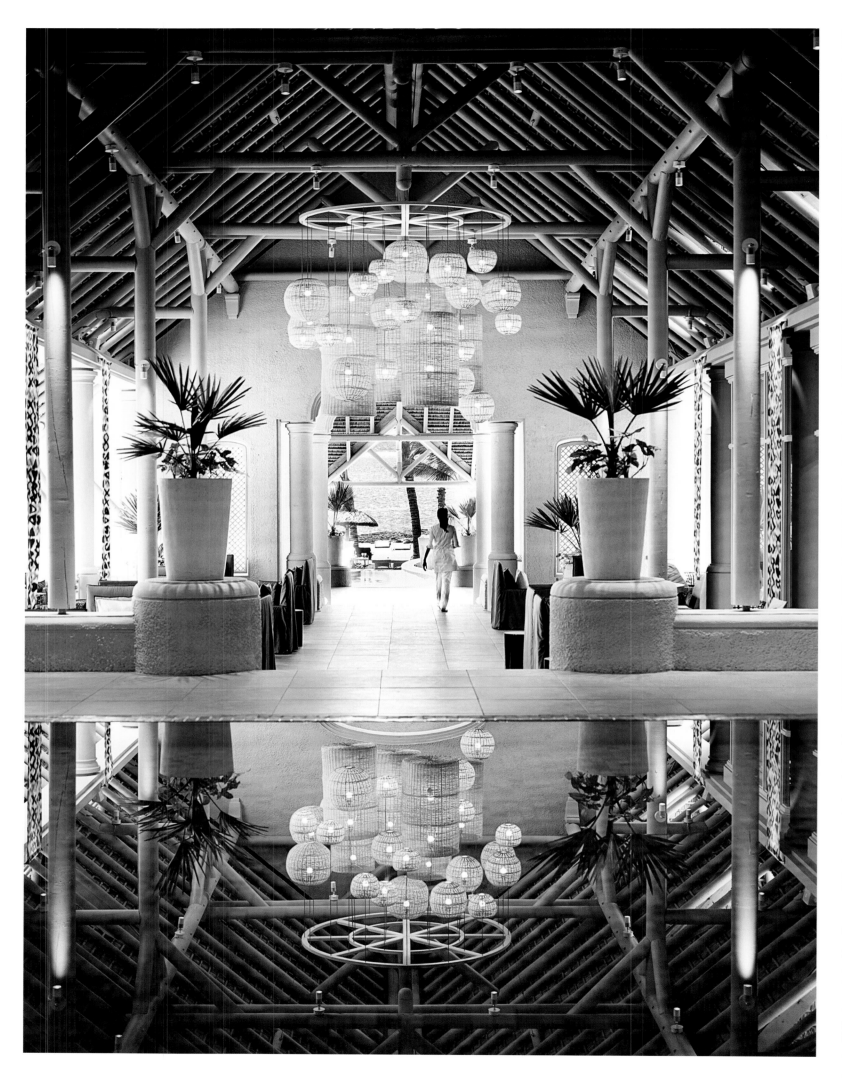

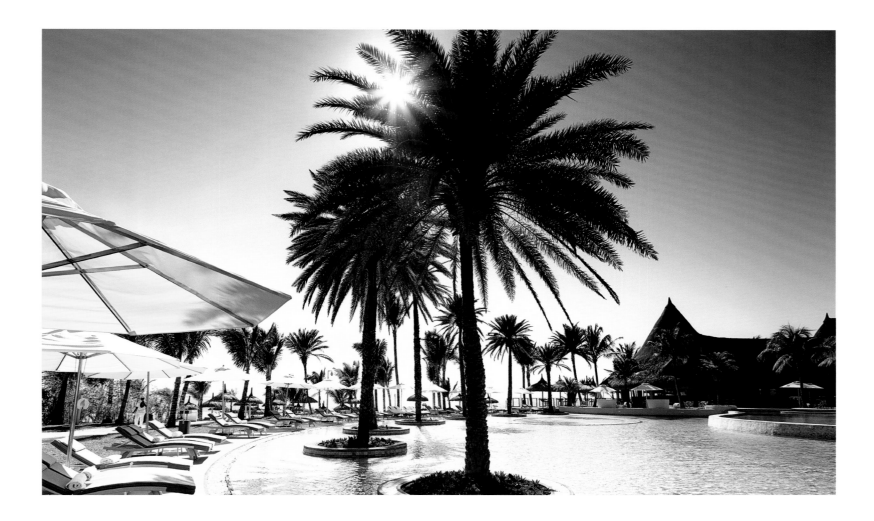

LOCATION

Weißer feiner Sandstrand, türkisblaues Meer und üppige tropische Vegetation – das Lux* Belle Mare liegt an einem paradiesischen Ort im Nordosten der Insel Mauritius. Fernab vom touristischen Trubel, in nächster Nähe zu kleinen Fischerdörfern, bietet das Flaggschiff von Reasons To Go Lux* Entspannung pur ohne auf Komfort verzichten zu müssen. Ausgedehnte Strandspaziergänge in überwiegend unberührter Natur, ein faszinierendes Korallenparadies mit bunten Fischen, als wären sie gemalt, und atemberaubende Sonnenuntergänge lassen jedes Urlauberherz höher schlagen. Die Lagune ist durch das vorgelagerte Korallenriff geschützt und ideal zum Baden. Auf den Wanderwegen des elf Kilometer entfernten Nationalparks Bras d'Eau begegnet man schillernd bunten Schmetterlingen und farbenprächtigen seltenen Vogelarten. Der Inselflughafen ist nur 45 Kilometer entfernt.

HOTEL

Das luxuriöse Resort besteht aus 174 Zimmern sowie 12 privaten Villen. Die modernen, in hellen Erdfarbtönen gestalteten Zimmer sind geräumig und bestechen durch ihre schlichte Eleganz. Wer nicht in der azurfarbenen Lagune schwimmen möchte, findet gewiss ein erfrischendes Plätzchen in der 2.000 Quadratmeter großen Poollandschaft. Das Hotel verfügt über Haupt- und Strandrestaurants. Zwei À-la-carte-Restaurants, zum einen das "Amari" des indischen Sternekochs Vineet Bhatia und zum anderen das "Duck Laundry" mit chinesischen Spezialitäten, laden zum gepflegten Dinner ein. Wer es etwas lebendiger mag, geht ins "M.I.X.E." mit seinen offenen Showküchen. Für den Sundowner trifft man sich gern im "Beach Rouge". Livemusik, wechselnde DJs und der überwältigende Panoramablick über die Lagune bilden den perfekten Abschluss eines perfekten Strandtages. Die "K-Bar", eine Hommage an die Designerin Kelly Hoppen, ist mit einer Mikrobrauerei ausgestattet. Dort kann jeder Biersorten kreieren, die sogar personalisiert in die eigene Minibar geliefert werden. Wer es auch im Urlaub sportlich mag, ist im 200 qm großen modernen Fitnessstudio, das mit neuesten Geräten ausgestattet ist, richtig. Dank eines Teams aus Sport- und Ernährungswissenschaftlern lässt sich das Aktivprogramm noch um entsprechende Ernährungstipps ergänzen.

LOCATION

A fine, white sandy beach, the azure ocean and lush tropical vegetation – Lux* Belle Mare is located in a little corner of paradise in the north-east of the island of Mauritius. Off the beaten tourist track, close to small fishing villages, the flagship of Reasons To Go Lux* offers the ultimate relaxation and all the comforts you could dream of. Long walks along the beach amidst largely untouched nature, a fascinating coral paradise with brightly coloured, picture-perfect fish and breathtaking sunsets are the dream of every holidaymaker. The lagoon is protected by the coral reef in front of it and is ideal for swimming. On the hiking trails of the Bras d'Eau National Park, located just 11 kilometres away, you will encounter dazzling butterflies and flamboyantly coloured, rare species of birds. The island's airport is just 45 kilometres away.

HOTEL

This luxurious resort consists of 174 rooms and 12 private villas. Decorated in light earthy tones, the modern rooms are spacious and impress with their sleek elegance. You can choose to swim in the azure lagoon or take a refreshing dip in the resort's huge 2,000 sqm pool. The hotel has a number of restaurants, including on the beachfront. Guests can indulge their culinary desires at the two à la carte restaurants: Amari by Indian Michelin-starred chef Vineet Bhatia, and Duck Laundry which serves Chinese specialities. If you prefer a livelier setting, you can dine at "M.I.X.E." with its open show kitchens. And "Beach Rouge" is the perfect spot to meet for a sundowner. Live music, a varied DJ line-up and awe-inspiring panoramic views of the lagoon are the perfect way to round off a day on the beach. The "K-Bar", an homage to the hotel's designer Kelly Hoppen, has its own microbrewery. Here every guest can create their own craft beer and even have it personalised and delivered to their own minibar afterwards. Those who like to keep fit on holiday will enjoy the state-of-the-art gym covering an area of 200 sqm which provides the latest in exercise equipment. Thanks to a team of sport experts and nutritionists, the active offer can be complemented by personalised dietary advice.

Get your Upgrade

www.upgradetoheaven.com/lux-belle-mare

LUX* BELLE MARE . Coastal Road, 742CU001, Mauritius . www.luxresorts.com/luxbellemare

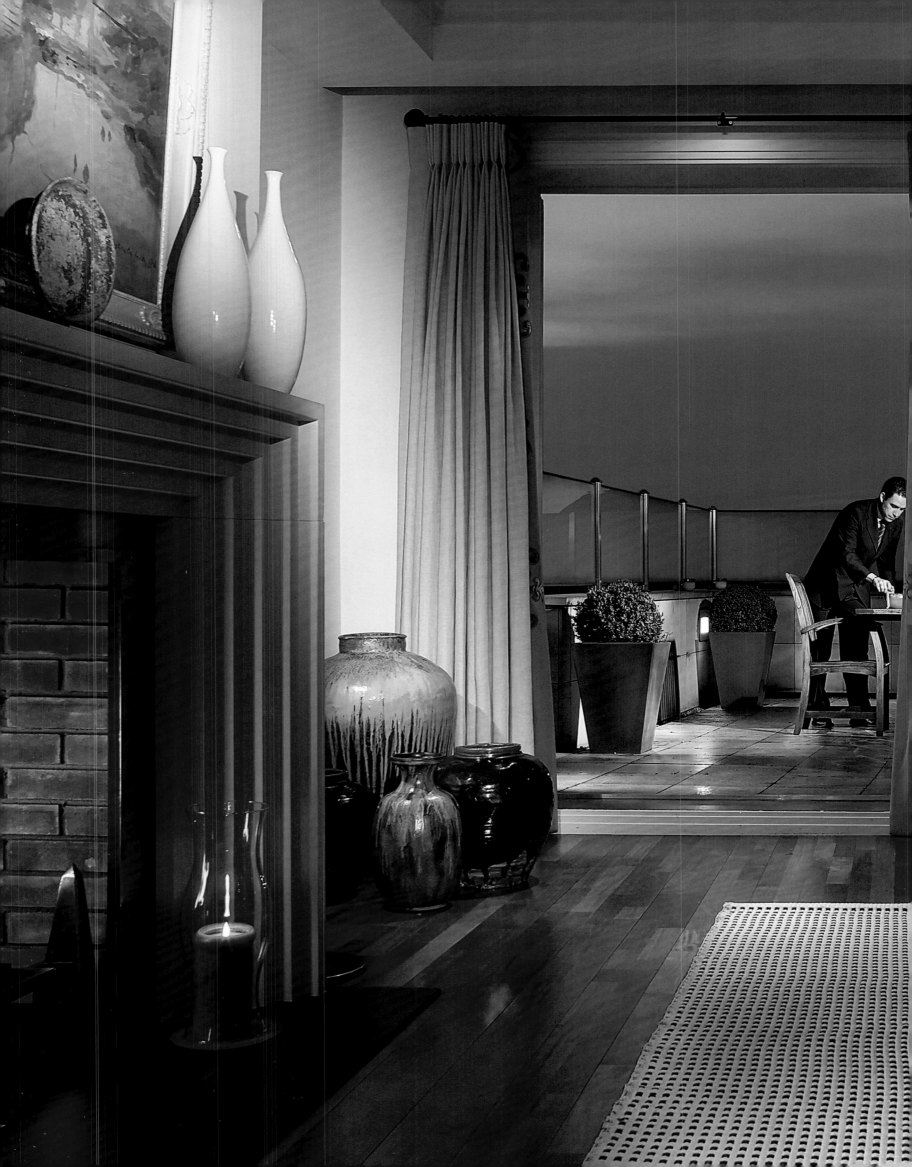

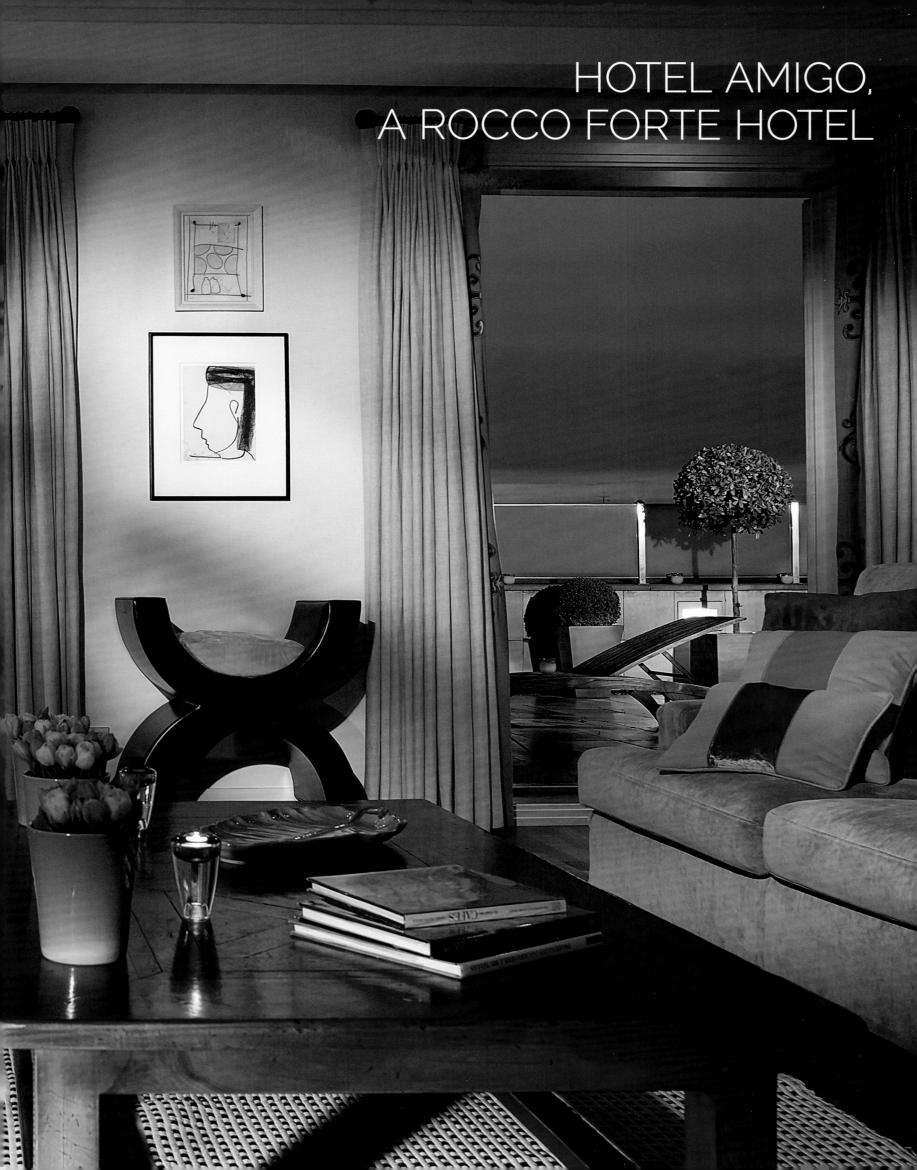

Kunstliebhaber dürfen sich auf einen besonderen Aufenthalt in einem der luxuriösesten Häuser Brüssels freuen.

Art enthusiasts can look forward to a special break in one of Brussels' most luxurious hotels.

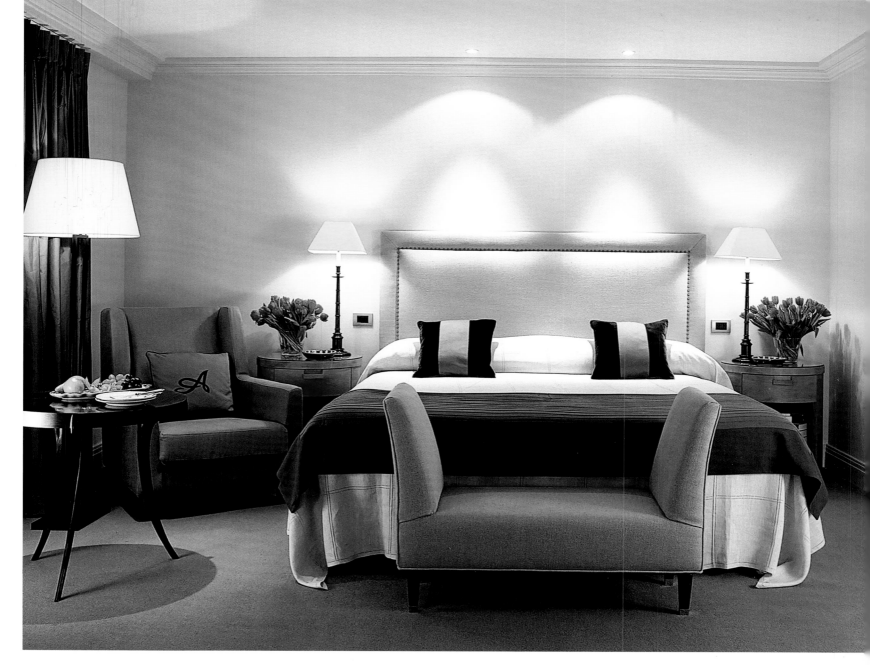

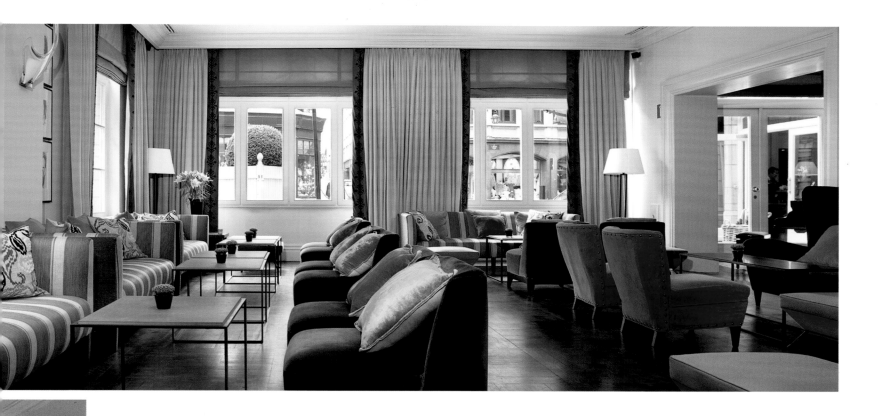

LOCATION

Das Hotel Amigo liegt im Herzen der belgischen Hauptstadt Brüssel, nur wenige Schritte vom Grand Place entfernt. Jugendstil, Kunstmuseen und Comic-Szene prägen das Stadtbild von Brüssel. Die Sehenswürdigkeiten der Stadt liegen alle nahe beieinander. Im historischen Zentrum wartet Brüssels Marktplatz mit seinen stolzen Barock- und Zunfthäusern sowie dem imposanten Rathaus, während sich die großen Museen auf dem Kunstberg, der Brüsseler Museumsmeile, konzentrieren. Mit seinen experimentellen Kunstgalerien, Museen und Kunstevents avancierte Brüssel zu einem der führenden Kunst-Hot-Spots Europas. Das luxuriöse Rocco Forte Hotel Amigo ist Partner der wichtigsten Kunst-Events, was es, neben seiner zentralen Lage, gerade für Kunst-Fans besonders attraktiv macht.

HOTEL

Rocco Forte gab dem 1957 erbauten Hotel Amigo nach der Übernahme mit der großangelegten Renovierung den Glanz vergangener Zeiten zurück und brachte es wieder an die Spitze der Brüsseler Luxushotels. Das Hotel Amigo verfügt über 173 Zimmer und Suiten mit einer Kombination aus modernem Design, traditionellen Möbeln und Kunst. Reproduktionen der Surrealisten Marcel Broodthaers und René Magritte schmücken alle Schlafzimmer. An den Wänden der großzügigen Bäder tummeln sich Tim und Struppi-Figuren des berühmten Comiczeichners Hergé. Die größte Suite "Royal Suite Blaton" hat auf 220 qm ein Wohnzimmer, eine Küche und eine private Dachterrasse mit Blick auf den Turm des Rathauses, der zum UNESCO-Weltkulturerbe gehört. Der Stil des Hotels ist eine Verbindung der modernen Interiors der Marke Rocco Forte Hotels, mit dem ursprünglichen Charakter und Charme des Hauses. Zum kunstvollen, von Rocco Forte erhaltenen, Erbe des Hotels gehören flämische Gobelins aus dem 18. und der originale Lobby-Boden aus dem 17. Jahrhundert. Das preisgekrönte Restaurant "Bocconi" serviert exquisite italienische Küche, die von Einheimischen, Besuchern und Prominenten gleichermaßen geschätzt wird. Gäste speisen dort authentische italienische Küche in gemütlichem, zeitgenössischem Ambiente. Im großzügigen und lichtdurchfluteten Inneren des Restaurants herrscht zeitlose Eleganz mit einem Hauch Moderne. Wände mit Porzellantellern von Piero Fornasetti schaffen eine heimelige Atmosphäre, während man von der Terrasse aus die Welt beim Vorbeiziehen beobachten kann. Die Bar Amigo ist der perfekte Ort für einen Apéritif, einen der beeindruckend vielen Whiskies oder Cognacs oder einen der vielen berühmten Drinks des Hauses.

LOCATION

Hotel Amigo is perfectly located in the heart of Belgium's capital Brussels, just a few steps from the famous Grand Place. Art Nouveau, museums of art and the comic scene characterise the picture of Brussels. The city's sights are all located closely to one another. In Brussels' historic center one can find the marketplace with its impressive baroc and guild houses as well as an imposing town hall. The big museums are all gathered at the Kunstberg, Brussels' museum mile. With its cutting-edge galleries, museums and art events, Brussels has become one of Europe's leading art world hotspots. The luxurious Rocco Forte Hotel Amigo is partner of the key art events which makes it, together with its perfect location, an attractive destination especially for art enthusiasts.

HOTEL

When taking over the Hotel Amigo out of 1957, Rocco Forte gave the hotel a complete refurbishment to restore it to its former glory and to claim its rightful status as the best luxury hotel in the city of Brussels. Hotel Amigo offers 173 rooms and suites combining contemporary design with traditional furniture and artworks. Reproductions of the surrealist artists Marcel Broodthaers and René Magritte decorate each bedroom and figures of Hergé's Tintin comic characters enliven the walls of the good-sized bathrooms. Being the largest suite with 220 sqm of living space, the "Royal Suite Blaton" provides a living room, a kitchen and a private roof terrace, which offers a privileged view of the tower of the City Hall, part of the UNESCO World Heritage. The hotel's style reflects the contemporary and modern interiors now synonymous with the Rocco Forte hotels' brand, whilst retaining the hotel's original character and charm. The artistic heritage of the hotel preserved by Rocco Forte contains Flemish tapestries of the 18th and the authentic pavement of the 17th century in the lobby. Award-winning "Bocconi" restaurant serves exquisite Italian cuisine prized by locals, visitors and celebrities alike. Guests indulge in authentic Italian cuisine in a comfortable and contemporary atmosphere. Inside the light flooded and spacious restaurant there is an atmosphere of timeless elegance with a touch of modernity. Porcelain plates made by Piero Fornasetti decorate the walls creating a cosy feel, whilst guests can sit on the terrace watching the world go by. The Bar Amigo is the perfect spot to enjoy an apéritif, choose from the impressive list of whiskies and cognacs or try one of the many signature cocktails.

Get your Upgrade

www.upgradetoheaven.com/rocco-forte-amigo-hotel

HOTEL AMIGO, A ROCCO FORTE HOTEL . Rue de l'Amigo 1-3, Brussels 1000, Belgium . www.roccofortehotels.com/hotel-amigo

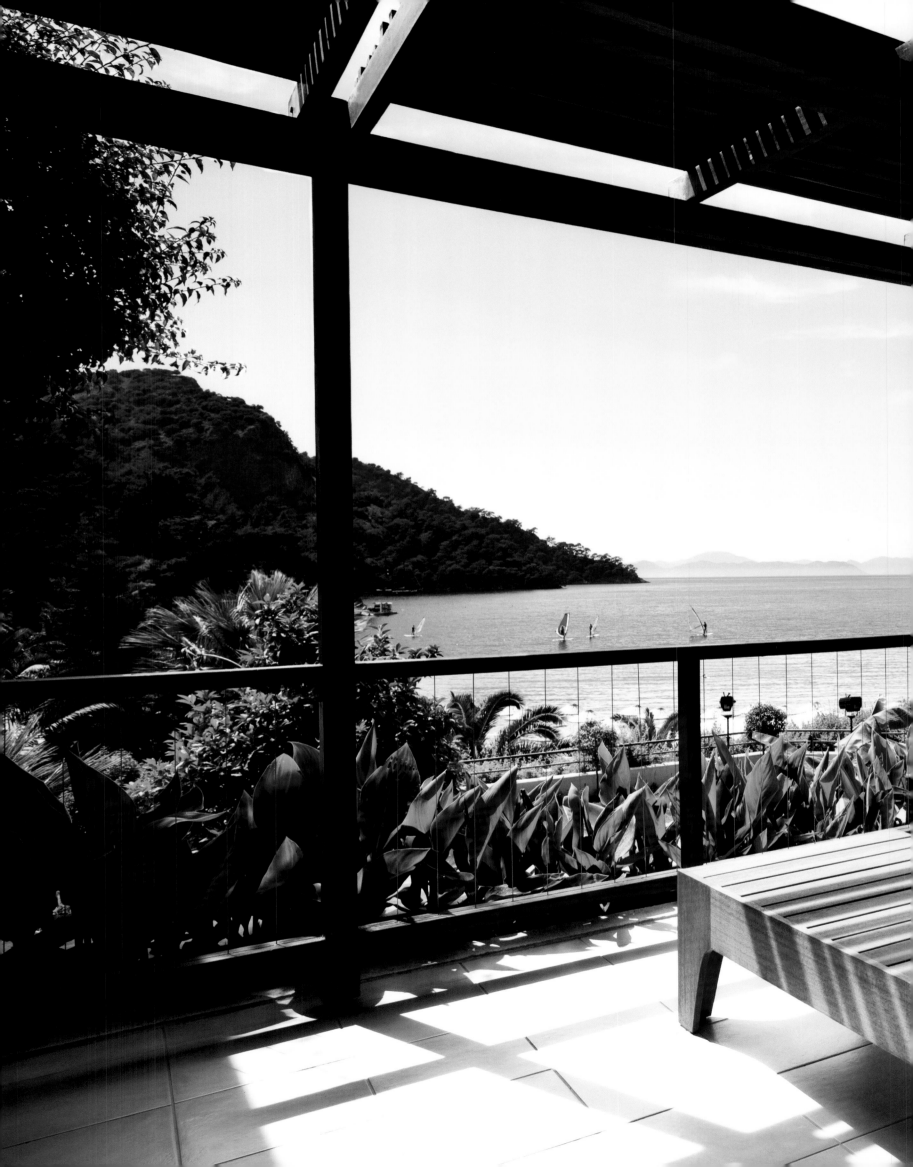

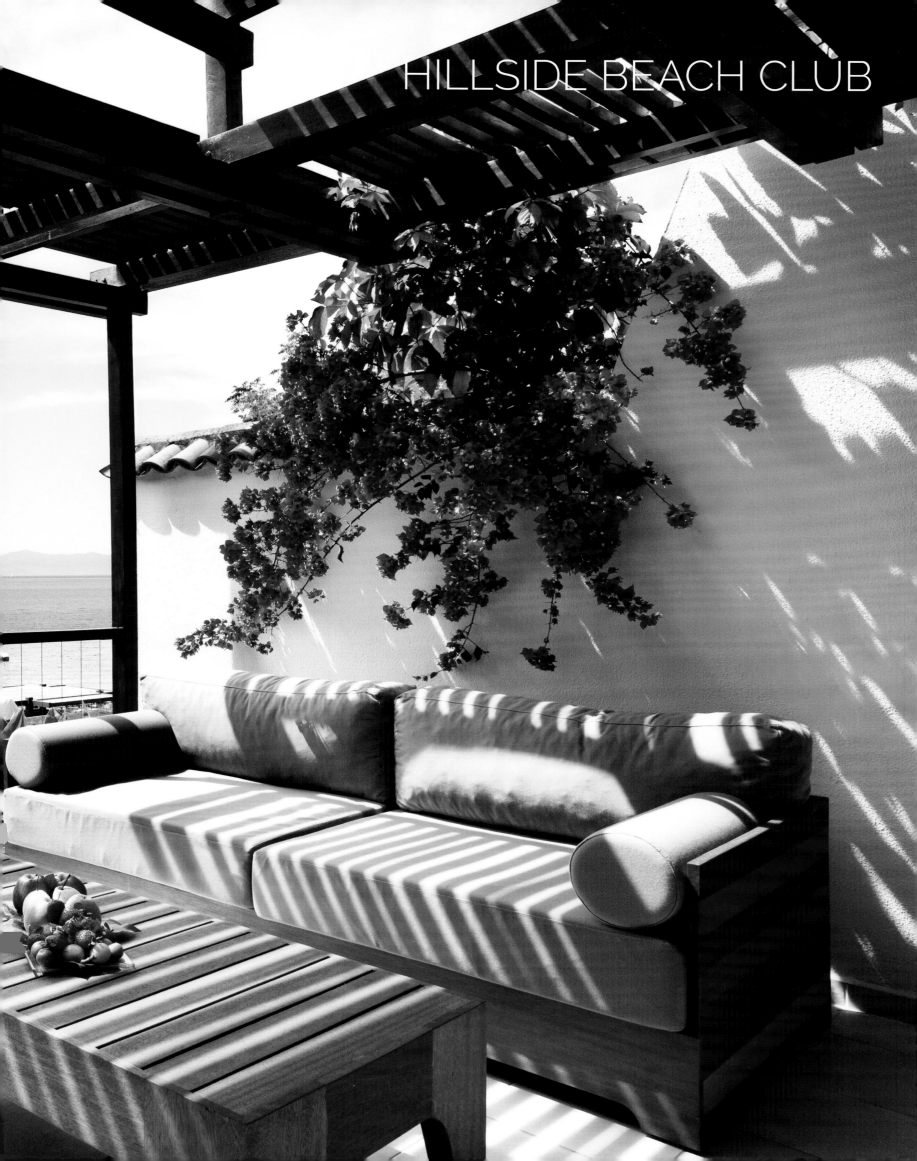

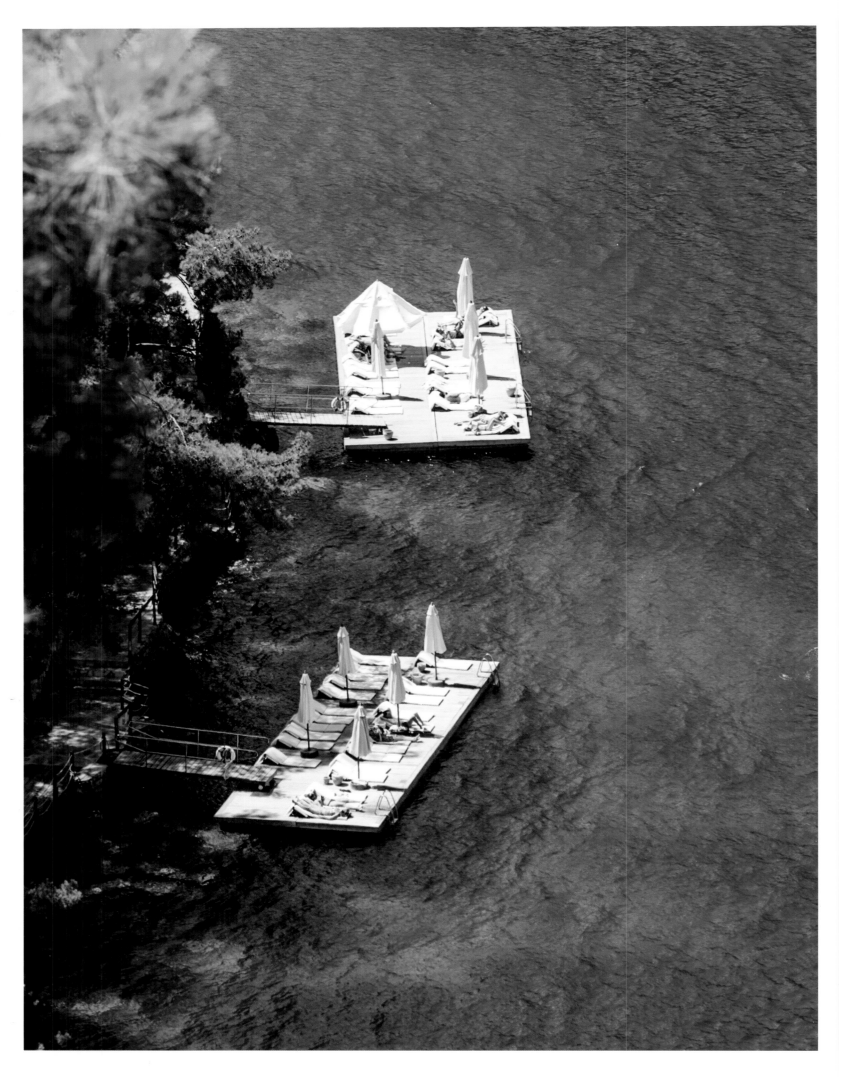

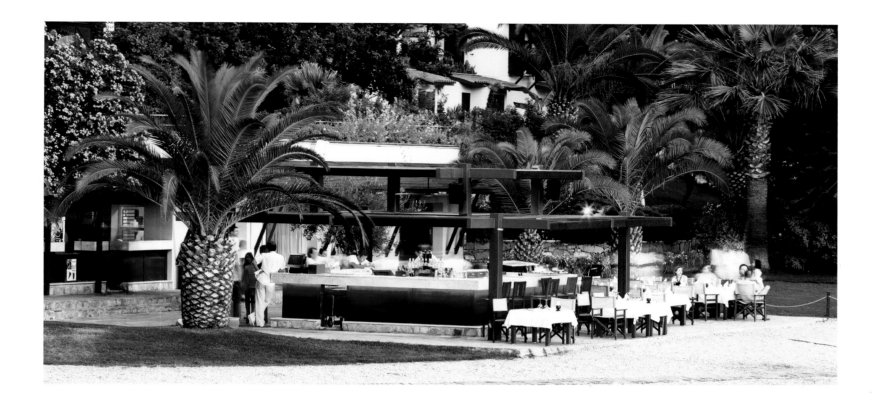

LOCATION

Die Lykische Küste im Südwesten der Türkei zieht mit ihrer landschaftlichen Schönheit, Sehenswürdigkeiten und vielfältigen Sportmöglichkeiten Wassersportler und Outdoor-Fans ebenso wie kulturell Interessierte an. Ursprüngliche Strände, kristallklares Wasser, dicht bewaldete Hügel und steile Schluchten, der Canyon von Saklikent, freuen Naturliebhaber besonders. Der Hillside Beach Club liegt eingebettet in üppige Pinienwälder, direkt an der hauseigenen, tiefblauen Kalemya-Bucht. Rund vier Kilometer sind es zum Ferienort Fethiye und etwa eine Autostunde ist der internationale Flughafen Dalaman entfernt. Nicht weit vom Hillside Beach Club liegen zahlreiche antike Städte. Das UNESCO-Weltkulturerbe Xanthos mit seinen Ausgrabungsstätten gehört ebenso zum Ausflugsprogramm wie Patara, der legendäre Geburtsort des Gottes Apollon.

HOTEL

Zur Auswahl stehen im Hillside Beach Club 330 Zimmer in vier Kategorien, darunter viele Familienzimmer. Die Räumlichkeiten verteilen sich über mehrere Gebäudekomplexe, die sich terrassenförmig an die bewaldeten Hänge über dem Meer schmiegen. Von fast jedem Zimmer aus genießt man auf Balkon oder Terrasse die Aussicht über die türkisblaue Kalemya-Bucht. Das vielseitige Sport- und Freizeitprogramm macht den Hillside Beach Club zum idealen Ferienziel. Tauchgänge zum größten Schiffswrack der Türkei oder zu gewaltigen Unterwasserhöhlen, geführt von der hoteleigenen Tauchschule, Segelkurse oder Wakeboarden und Wasserskifahren sind nur ein paar der Wassersportangebote des Hillside Beach Clubs. Entspannung und Pflege bieten den Gästen gleich zwei Spas: Das Sanda Nature Spa schmiegt sich an einen bewaldeten Hang oberhalb der Kalemya-Bucht. Dank baumhausähnlicher Architektur und natürlichen Materialien scheint es, in den Baumkronen schwebend, mit seiner Umgebung zu verschmelzen. Die Behandlungen orientieren sich an fernöstlicher Gesundheitsphilosophie. Das Sanda Spa im Hauptgebäude des Resorts besinnt sich auf die traditionelle osmanische Badekultur rund um den Hamam. Kulinarischen Hochgenuss versprechen das edle "Pasha on The Bay" mit mediterraner Küche, das Sea Food und türkische Meze serviert, oder die "Beach Bar & Restaurant", die abends mit italienischen Köstlichkeiten aufwartet. Im Hauptrestaurant gibt es ein reichhaltiges, frisches Buffet mit lokalen und internationalen Speisen sowie einen Koch, der ausschließlich für die kleinen Gäste zuständig ist. 2015 wurde der Hillside Beach Club zum zweiten Mal in Folge mit dem World Luxury Hotel Award ausgezeichnet, dieses Mal in der Kategorie "Luxury Coastal Resort". Der Hillside Beach Club ist zur besten Reisezeit von April bis Oktober geöffnet (exakte Öffnungsdaten finden sich auf der Hotel-Website).

LOCATION

The Lycian coast in the south-west of Turkey attracts outdoor fans, water sports enthusiasts and those culturally interested with its variety of sports activities, landmarks and natural beauty. Nature lovers can enjoy discovering crystal clear waters, densely forested hills and steep canyons such as the Saklikent Canyon. The Hillside Beach Club, embedded in lush pine forests, is located directly at the resort's own deep blue Kalemya bay. The holiday spot Fethiye is approximately four kilometres away, and guests can reach the international airport Dalaman within an hour by car. Guests can find several historic cities not far from Hillside Beach Club. The UNESCO World Heritage Site Xanthos, with its archaeological excavation, is part of the sightseeing programme as well as Patara, the legendary birthplace of the god Apollo.

HOTEL

There is a selection of 330 rooms in four categories, including many family rooms, at Hillside Beach Club. The premises spread over several terraced building complexes, which nestle on the wooded slopes above the sea. The view to the turquoise Kalemya bay can be admired from almost every room's balcony and terrace. The variety of sport and leisure activities make Hillside Beach Club the ideal vacation spot. Dives to Turkey's largest shipwreck or to the enormous submarine caves, led by the hotel-owned diving school, sailing courses or wakeboarding and waterskiing are only a few of the many water sport activities the Hillside Beach Club has to offer. Two spas offer guests relaxation and pampering: the Sanda Nature Spa hugs the forested hill above the Kalemya bay. Thanks to its tree house-like architecture and the use of natural materials, it not only appears to be floating in the tree tops, it also merges with the surrounding area. The treatments are orientated on Far Eastern health philosophy. The Sanda Spa is located in the resort's main building and focuses on the traditional Ottoman bathing culture with the hammam being the centre. Culinary pleasures are promised by the noble "Pasha on the Bay" with Mediterranean cuisine, offering mainly seafood with Turkish mezes, or the "Beach Bar & Restaurant", which offers Italian delights in the evening. There is a nutritious, fresh buffet with local and international dishes in the main restaurant, as well as a chef, who is exclusively allocated to young visitors. In 2015 Hillside Beach Club was again awarded with the World Luxury Hotel Award, this time in the category "Luxury Coastal Resort". The Hillside Beach Club is open for the best travel period from April until October (exact opening times can be found on the hotel website).

Get your Upgrade

www.upgradetoheaven.com/hillside-beach-club

HILLSIDE BEACH CLUB . Belen Mah. Belen Cad. No: 132 48300 Kayaköy Fethiye, Muğla, Turkey . www.hillsidebeachclub.com

PERFECT HOLIDAYS FOR TWO OR THE WHOLE FAMILY

Perfekte Ferien für
zwei oder mit der
ganzen Familie

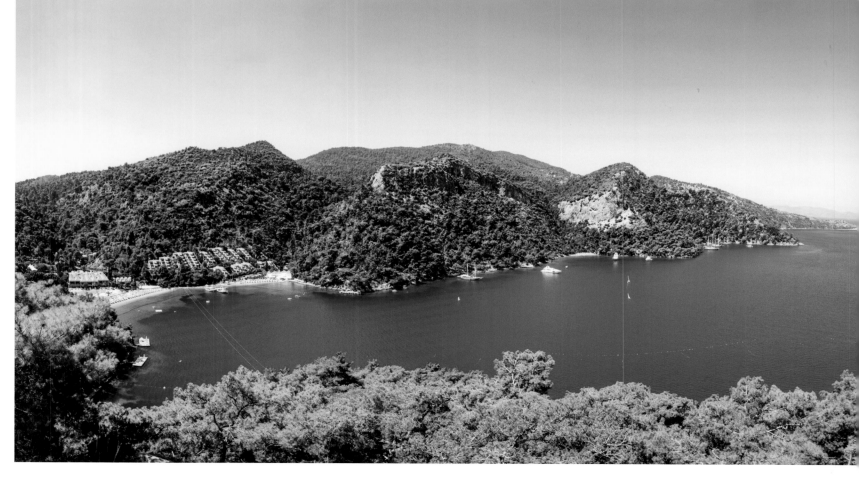

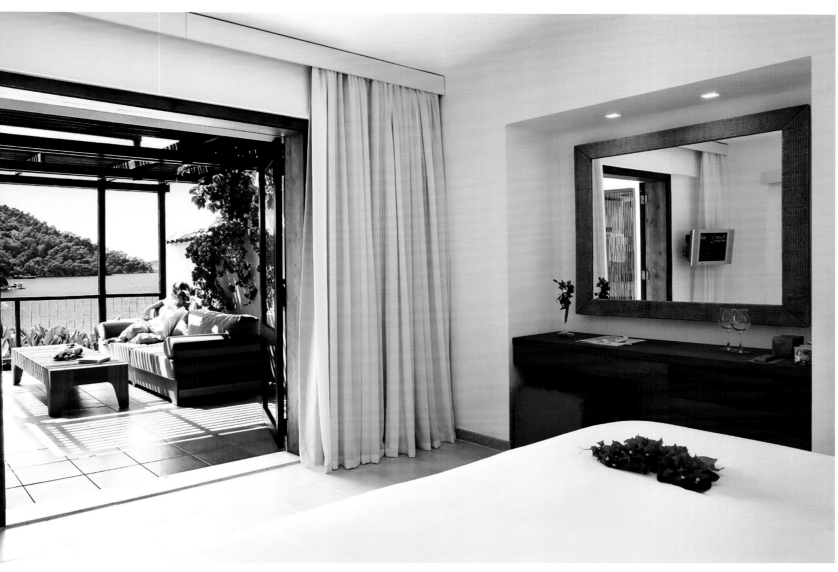

Families love the gently sloping gravel beaches of the hotel with professional lifeguards on site. The 315-metre-long swimming lane in the bay is perfect and secure for every water enthusiast to enjoy. Guests can read, relax, and enjoy their morning yoga in peace on the phone-free Silent Beach. On the main beach, guests are able to use the beach order app to order drinks and snacks directly to their sunbeds.

Familien lieben den weitläufigen, flach abfallenden Kiesstrand des Hillside Beach Clubs mit professioneller Badeaufsicht. Dank einer 315 Meter langen Schwimmbahn können Wasserratten sicher durch die Bucht schwimmen. Am handyfreien Silent Beach können Gäste ungestört lesen, relaxen und sich zum Morgen-Yoga zurückziehen. Am Hauptstrand können sich die Gäste über die Beach Order App des Hotels ihre Getränke und Snacks direkt an die Liege bringen lassen.

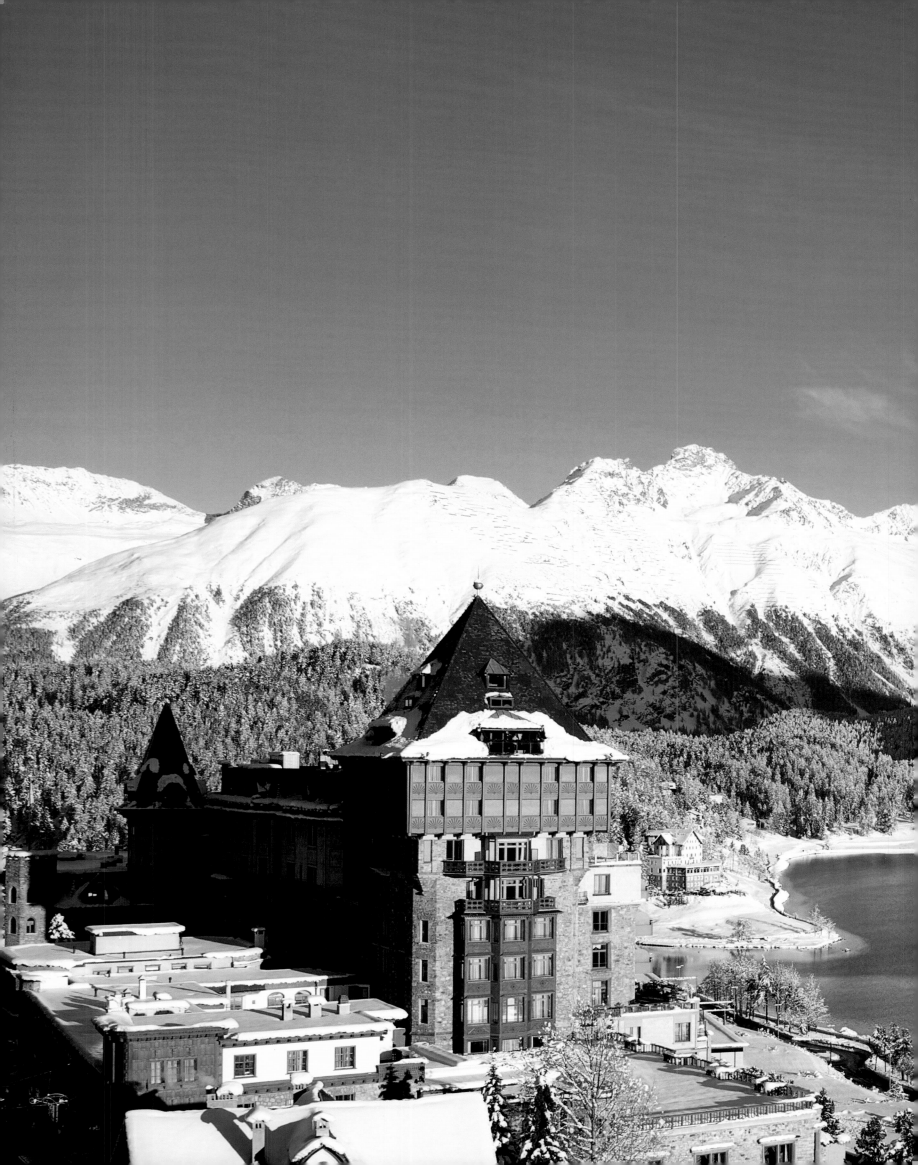

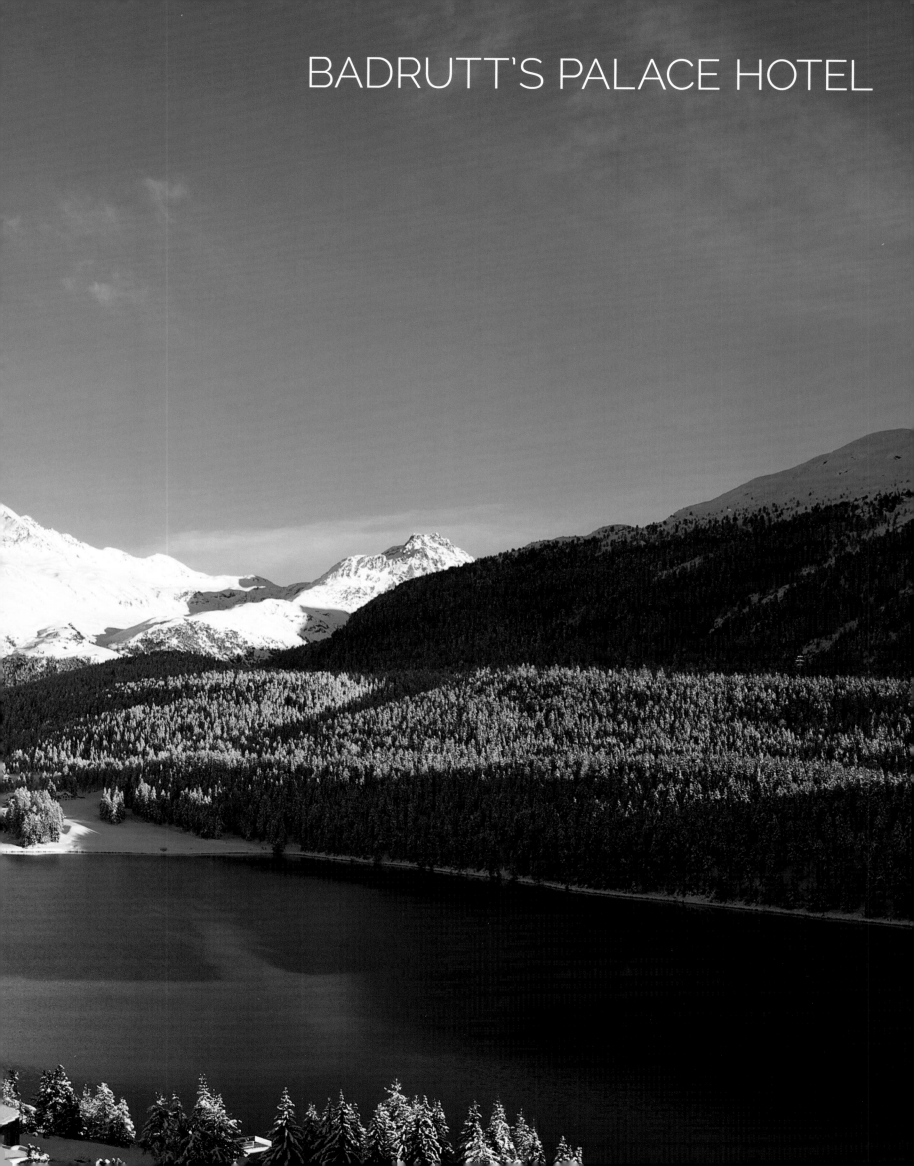

BADRUTT'S PALACE HOTEL

Das Badrutt's Palace Hotel gehört zu den
Luxushotels dieser Welt, die man erlebt haben
muss! Seit 120 Jahren begrüßt man dort
die internationale High Society.

Badrutt's Palace Hotel belongs to the luxury
hotels of the world, which you simply have to
experience. International high society has
been welcomed there for the past 120 years.

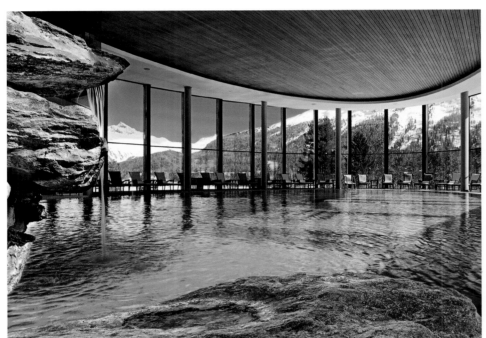

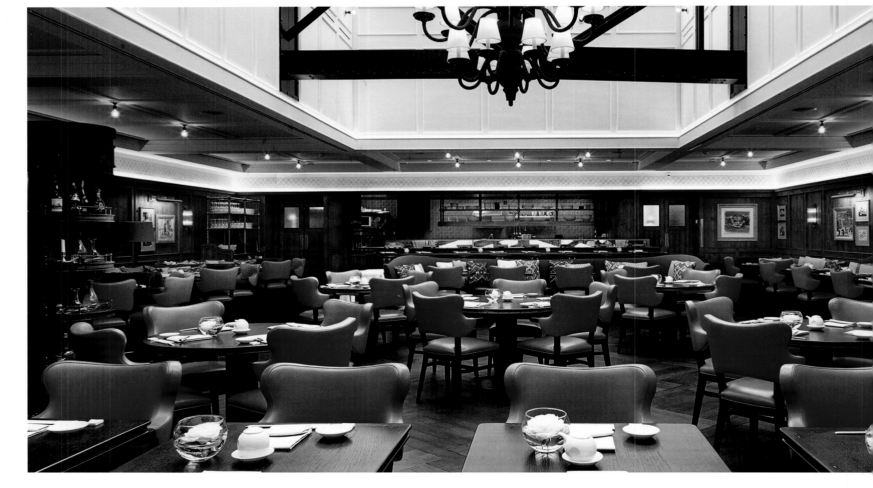

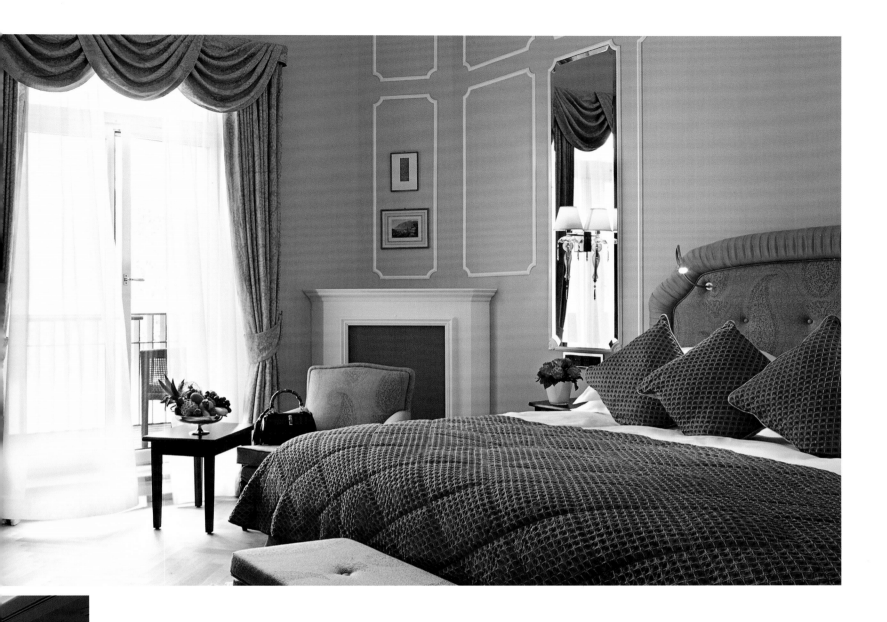

LOCATION

Weltbekannt und wie ein Märchenschloss liegt das Badrutt's Palace Hotel im Herzen von St. Moritz, umgeben von atemberaubender, unberührter Landschaft und Blick auf den St. Moritzersee. Seit jeher ist St. Moritz Hotspot des internationalen Jetsets: Im Winter locken der Snow Polo World Cup St. Moritz und eines der interessantesten Skigebiete der Welt, im Sommer lässt sich die Natur beim Wandern oder Segeln genießen.

HOTEL

Das 5-Sterne-Domizil Badrutt's Palace Hotel gehört zu den besten Hotels weltweit und vereint Historie mit modernem Zeitgeist. Seit über 120 Jahren verwöhnt das legendäre Traditionshaus seine Gäste in luxuriöser Atmosphäre. Für kulinarische Genüsse besteht die Wahl zwischen verschiedenen hervorragenden Angeboten: das "Le Restaurant", das japanisch-peruanische "Matsuhisa@Badrutt's Palace" und die Restaurants der "Chesa Veglia", einem alten Bauernhaus. In den drei rustikalen Restaurants der "Chesa Veglia" werden italienische und schweizerische Küche sowie feine Grillspezialitäten angeboten. Das Badrutt's Palace Hotel bietet 157 Gästezimmer, davon 37 Suiten, mit außergewöhnlichem Schweizer Alpen-Panorama sowie den aufwändig gestalteten Palace Wellnessbereich. Das Hotel ist Mitglied der The Leading Hotels of the World, Swiss Deluxe Hotels und Swiss Historic Hotels.

LOCATION

World renowned and reminiscent of a fairy-tale castle, Badrutt's Palace Hotel, in the heart of St Moritz, is perfectly located in breathtaking scenery with an unobstructed view of Lake St Moritz. The town of St Moritz has always been the hot spot of the international jet set: winter brings with it the Snow Polo World Cup St Moritz and one of the world's leading ski areas. The summer is ideal for hiking and sailing.

HOTEL

The five-star-domicile Badrutt's Palace Hotel is one of the best hotels worldwide and combines history with a modern mentality. For over 120 years the legendary tradition-steeped hotel has been spoiling its guests in a luxurious atmosphere. For culinary pleasure, there is a choice between different excellent offers: the "Le Restaurant", the Japanese-Peruvian "Matsuhisa@Badrutt's Palace" and the restaurants of "Chesa Veglia", an old farm house. In the three rustic restaurants of "Chesa Veglia", there is a choice of Italian, Swiss or delicious specialities directly from the grill. Badrutt's Palace Hotel provides 157 guest rooms, 37 of which are suites, with an exceptional panorama of the Swiss Alps, as well as the extravagant Palaces wellness-area. The hotel is a member of The Leading Hotels of the World, Swiss Deluxe Hotels and Swiss Historic Hotels.

Get your Upgrade

www.upgradetoheaven.com/badrutts-palace-hotel

BADRUTT'S PALACE HOTEL . Via Serlas 27, 7500 St Moritz, Switzerland . www.badruttspalace.com

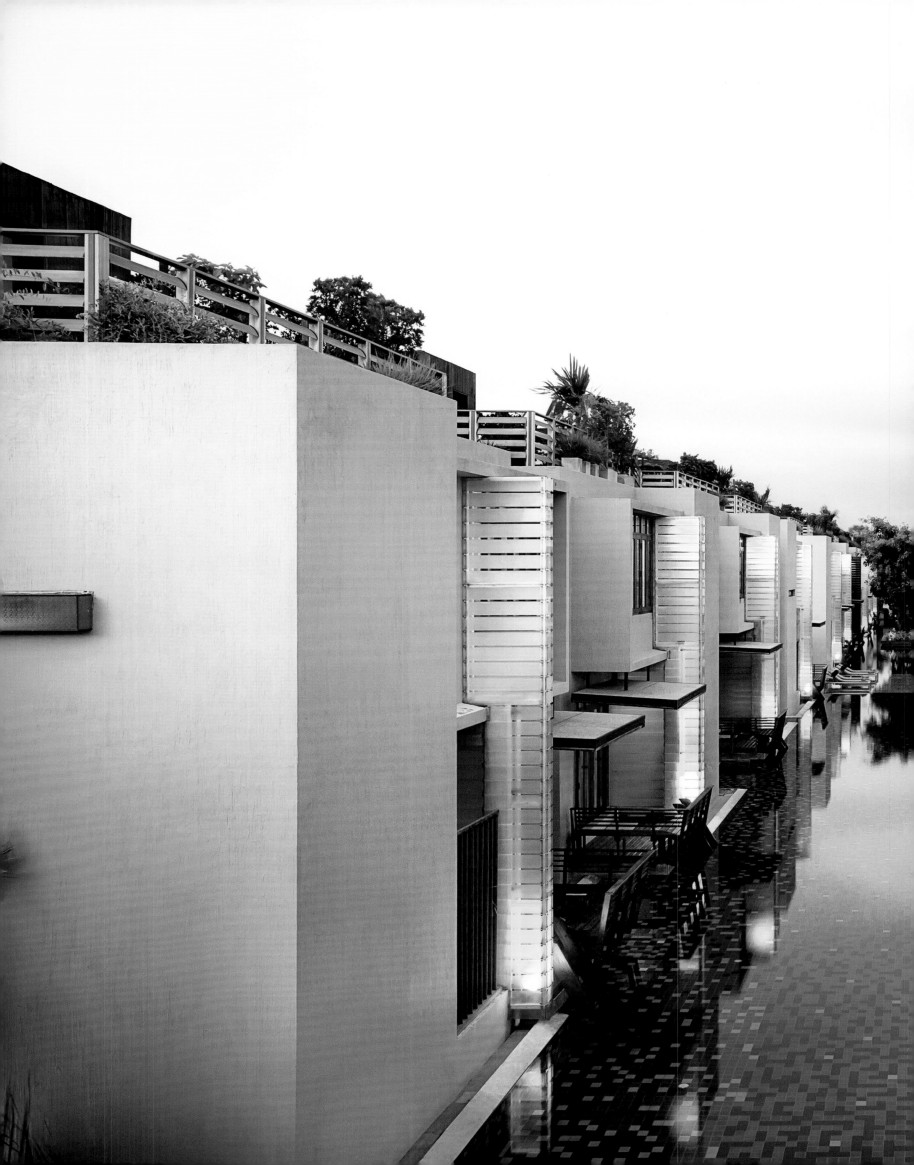

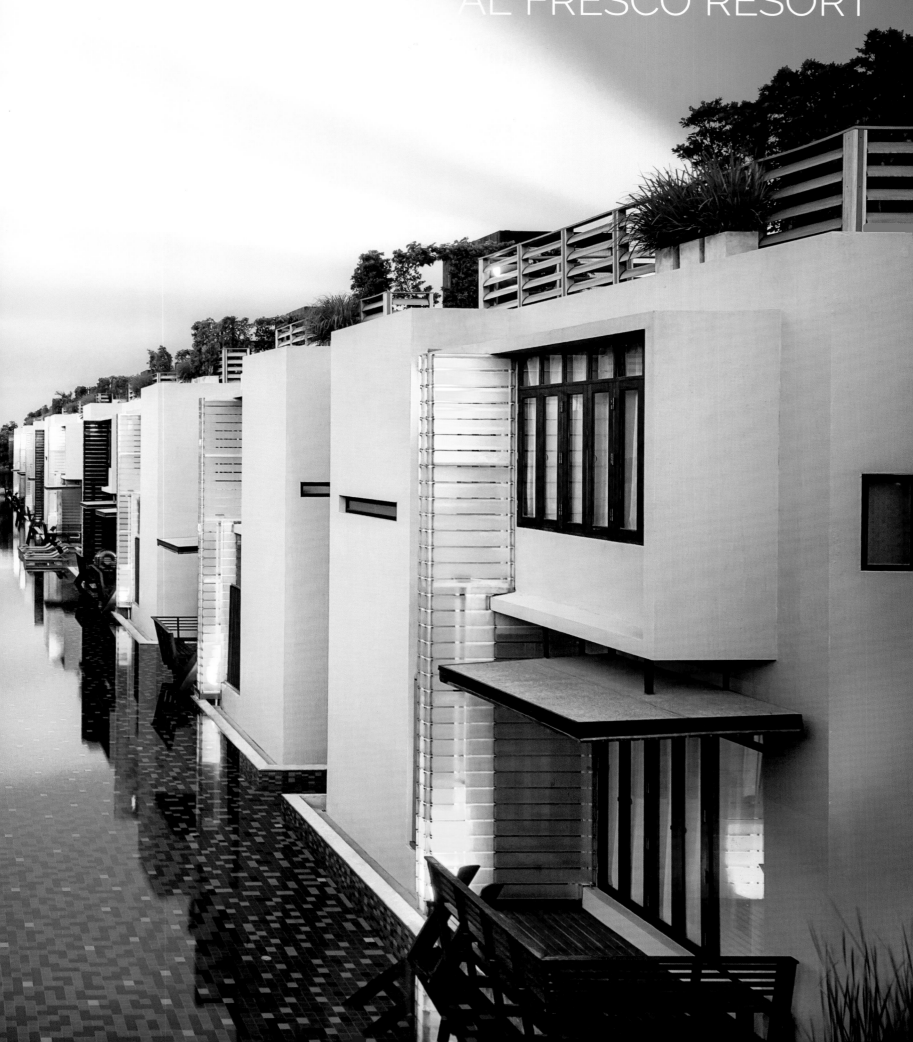

Das Let's Sea Hua Hin Al Fresco Resort
vermittelt den ruhigen Charme Hua Hins.
Ein Ort modernen Designs, an dem
Gäste wahre Entspannung finden.

The Let's Sea Hua Hin Al Fresco Resort
captures the quiet charm of Hua Hin.
A place of modern design where
people find true relaxation.

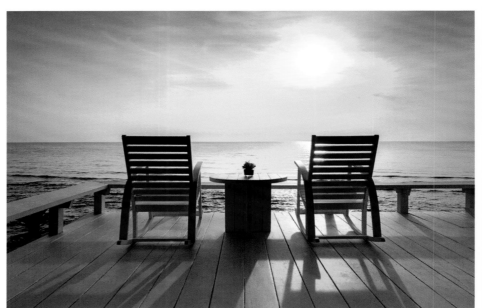

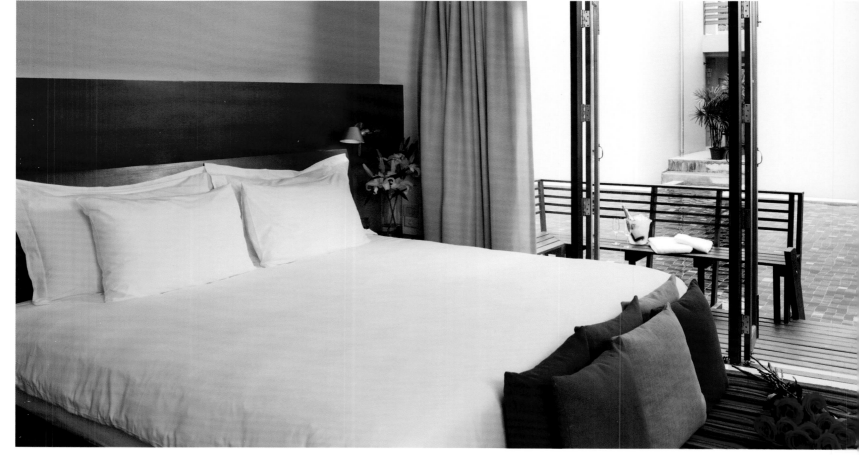

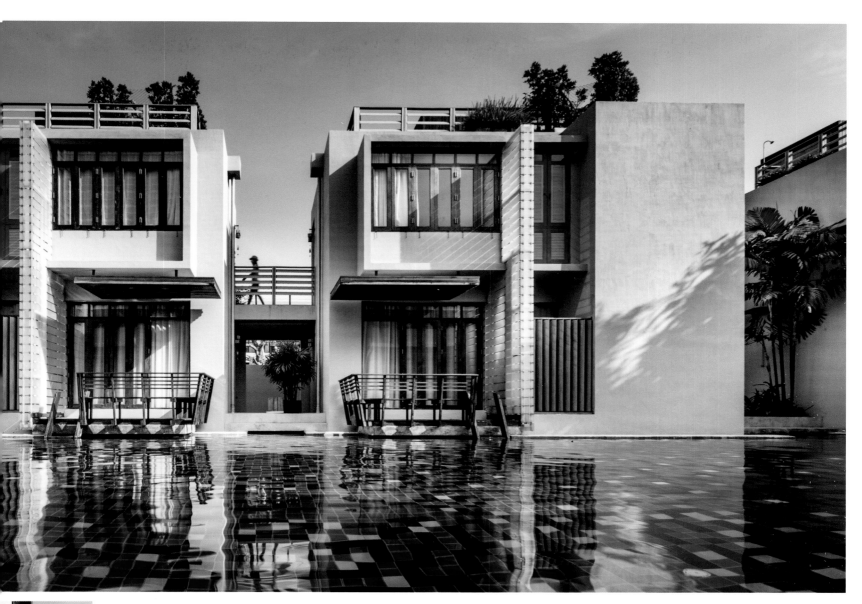

LOCATION

Hua Hin ist nicht nur der exklusivste Badeort an der Thailändischen Küste, sondern auch königliche Residenz. Eine zweite derartig pittoreske Innenstadt, wie Hua Hin mit seinen engen Gassen, wird in Thailand schwer zu finden sein. Der etwa fünf Kilometer lange Moonrise Strand ist ideal für romantische Spaziergänge oder Jogging. Hua Hin ist ein ganzjähriges Reiseziel mit tropischem Klima, durchzogen von angenehm kühlenden Meeresbrisen.

HOTEL

Das direkt am Strand gelegene Let's Sea Hua Hin Al Fresco Resort bietet 40 Gästezimmer in modernster Architektur. Durch den eindrucksvollen Lagunen-Pool, der sich 120 Meter durch das Resort zieht, hat jedes Zimmer eine Wasserfront. Der entspannte Lifestyle der Gegend ist in der Kombination von individuellem Service und durchdachtem Design spürbar. Mit Luxus voller Flair und gleichzeitigem rücksichtsvollen Umgang mit den Ressourcen hilft das Let's Sea Hua Hin Al Fresco Resort, die Schönheit Hua Hins zu erhalten. Das Strandrestaurant des Hotels gehört zu den bekannten Adressen der Stadt. Im Gaia Spa genießen Gäste Treatments in Zelten auf dem Dach - hoch über der Küste Hua Hins mit wunderbarem Blick auf den Golf von Thailand. Bei Zubuchung des Z-Luxe-Club Programms genießen Sie besondere Dienstleistungen wie das professionelle Auftragen von Sonnencreme oder den Shuttle Service in die Innenstadt.

LOCATION

Hua Hin is the most exclusive bathing destination of Thailand, as well as being the royal residence. You will hardly find another Thai town centre as picturesque as that like the one of Hua Hin, with its narrow streets. Moonrise beach is about five kilometres long and ideal for romantic walks or jogging. Hua Hin is a year-round destination with a tropical climate cooled by ocean breezes.

HOTEL

Let's Sea Hua Hin Al Fresco Resort offers 40 guest rooms on a beachfront property. Cutting-edge architecture ensures no two rooms share a wall. The striking lagoon pool stretches 120 metres through the resort, creating a unique water frontage for each of the guest rooms – no guest ever has to reserve a spot by the pool. The spirit of the low-key Hua Hin coastal lifestyle is captured by intuitive service and thoughtfully designed facilities. With luxury high on ambiance but low on local impact and respectful of the surrounding culture, Let's Sea Hua Hin Al Fresco Resort helps to ensure the natural beauty of Hua Hin. The hotel's beach restaurant is a famed dining destination. At Gaia spa guests enjoy treatments under rooftop tents high above the shores of Hua Hin overlooking the Gulf of Thailand. For additional services like expert application of suntan cream or free scheduled shuttle transfer to the town centre you may add the Z-Luxe-Club programme to your booking.

Get your Upgrade

www.upgradetoheaven.com/lets-sea-hua-hin

LET'S SEA HUA HIN AL FRESCO RESORT . 83/188 Soi Huathanon 23, Khaotakieb–Hua Hin Road, Hua Hin, Prachuap Khirikhan 77110 Thailand . www.letussea.com

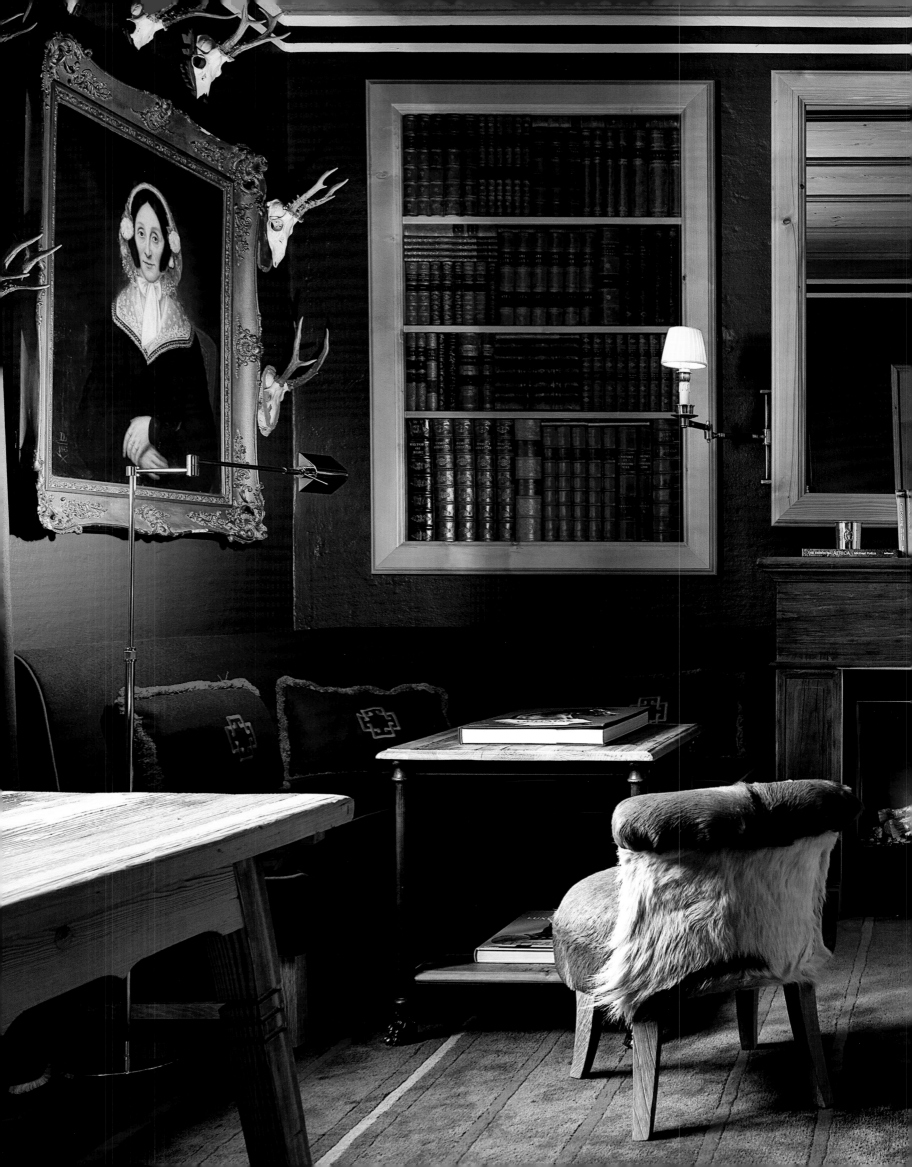

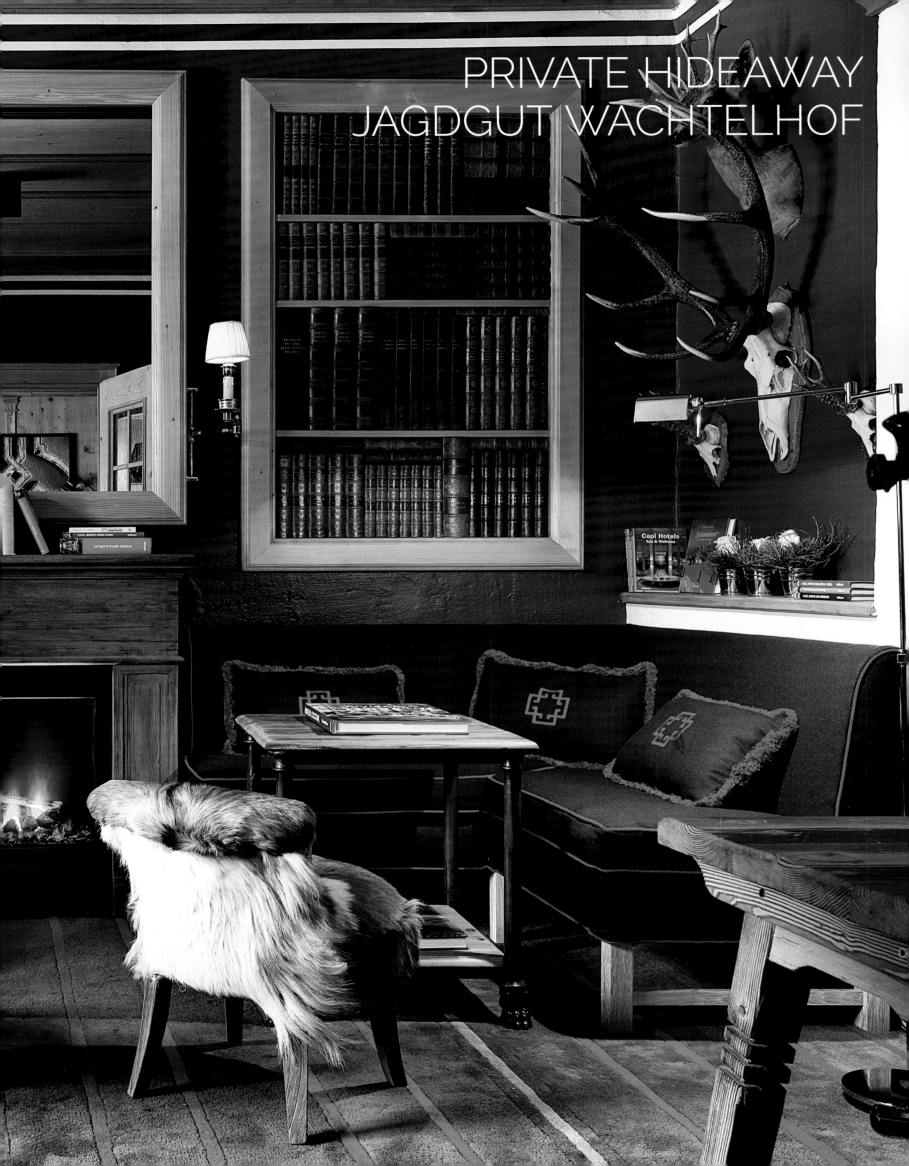

Das perfekte Hideaway für Menschen,
die auf der Suche nach dem
wahren Bergleben sind.

The perfect hideway for
people searching for
true alpine life.

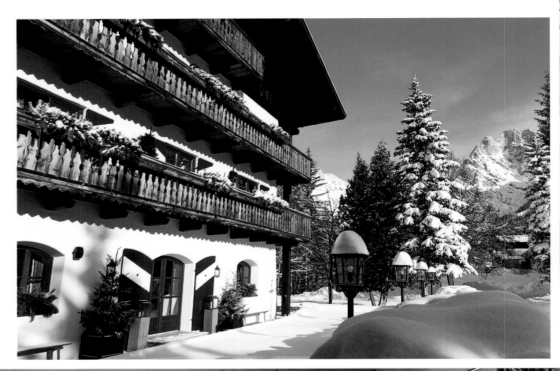

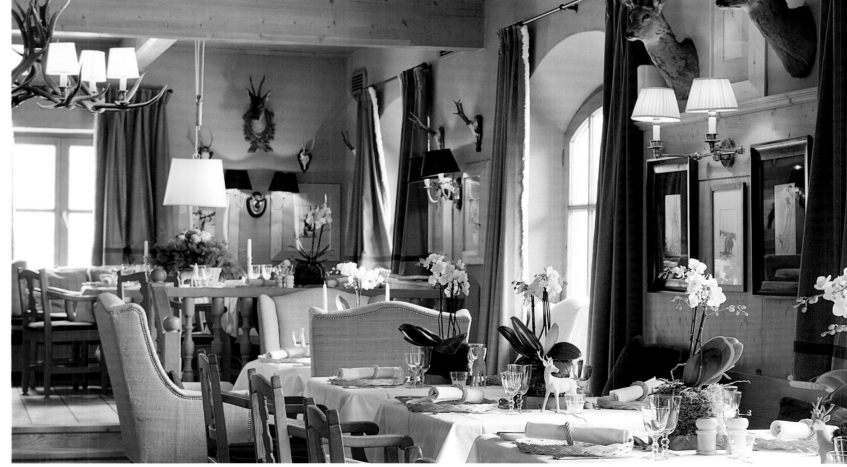

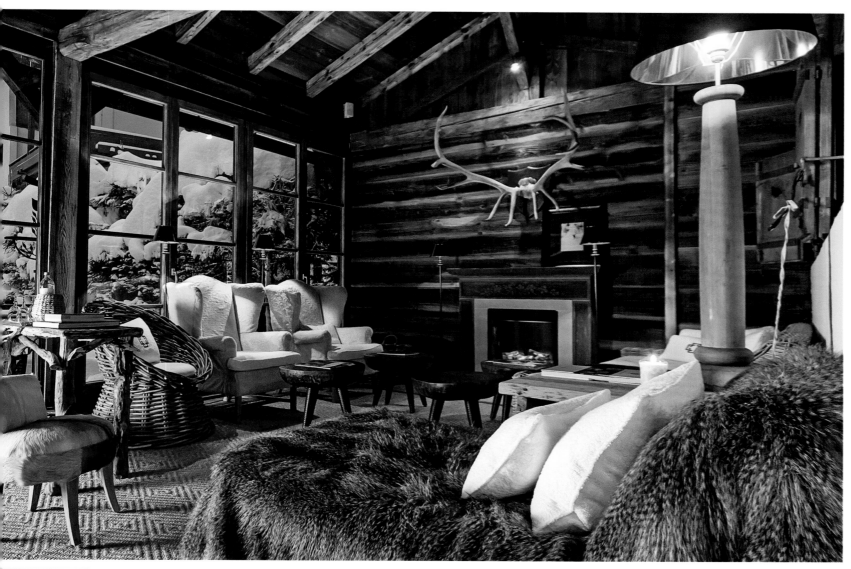

LOCATION

Das österreichische Private Hideaway Jagdgut Wachtelhof liegt in unmittelbarer Nähe von Salzburg und Kitzbühel, im idyllischen Pinzgau im wunderschönen Salzburger Land. Perfekt für alle Natur- und Sport-begeisterte: mit den Skiern kann man bis vor die Haustüre fahren! Hier erleben Gäste einen wunderbaren Mix aus Kultur und Natur und können dabei die vielen Freuden des Sommers und Winters genießen.

HOTEL

Das Private Hideaway Jagdgut Wachtelhof ist ein Ort der Stille und Ursprünglichkeit. Ein atemberaubender Wellnessbereich, hervorragende österreichische Küche, aufmerksamer und herzlicher Service, Nostalgie und alpines Design des Stararchitekten Michele Bönan und seiner Frau Christine Hütter Bönan warten auf die Gäste. Für das unverwechselbare Interior der 17 Zimmer und Suiten wurden edles Holz und traditionelle Stoffe, Fell sowie Cashmere von höchster Qualität verwendet. An oberster Stelle steht im Private Hideaway Jagdgut Wachtelhof das Wohl der Gäste. Auf Wunsch lässt es sich auch als privates Chalet komplett für Hochzeiten, Firmen- oder Familienfeiern buchen. Gault Millau zeichnete das Private Hideaway Jagdgut Wachtelhof als "Hotel des Jahres 2016" aus, zudem ist es Mitglied der "Small Luxury Hotels of the World". Zur kommenden Wintersaison 2017 wird das Private Hideaway Jagdgut Wachtelhof auf insgesamt 34 komfortable und luxuriöse Alpine Suiten mit gehobener Ausstattung erweitert.

LOCATION

The Austrian Private Hideaway Jagdgut Wachtelhof is located in close proximity to Salzburg and Kitzbühel, in the idyllic Pinzgau in the beautiful Salzburger area. Perfect for all nature and sport enthusiasts – visitors may ski directly to the front door! Guests experience a wonderful mix of culture and nature and can enjoy the joys of summer and winter in doing so.

HOTEL

The Private Hideaway Jagdgut Wachtelhof is a place of silence and originality. A breathtaking wellness area, an exceptional Austrian kitchen, attentive and sincere service, nostalgia and alpine design of the star architect Michele Bönan and his wife Christine Hütter Bönan await their guests. For the unmistakable interior of the 17 rooms and suites, finest wood and traditional fabrics, fur and cashmere of highest quality were used. The primary focus of Private Hideaway Jagdgut Wachtelhof is the well-being of their guests. Upon request it can also be booked completely as a private chalet for, weddings, business or family celebrations. Gault Millau awarded Private Hideaway Jagdgut Wachtelhof as "Hotel of the Year 2016" and it is a member of "Small Luxury Hotels of the World". During winter season 2017 Private Hideaway Jagdgut Wachtelhof will be extended to 34 luxury and distinguished Alpine Suites with upscale equipment.

Get your Upgrade

www.upgradetoheaven.com/jagdgut-wachtelhof

PRIVATE HIDEAWAY JAGDGUT WACHTELHOF . Urslaustrasse 7, 5761 Maria Alm, Hinterthal, Austria . www.hotelwachtelhof.at

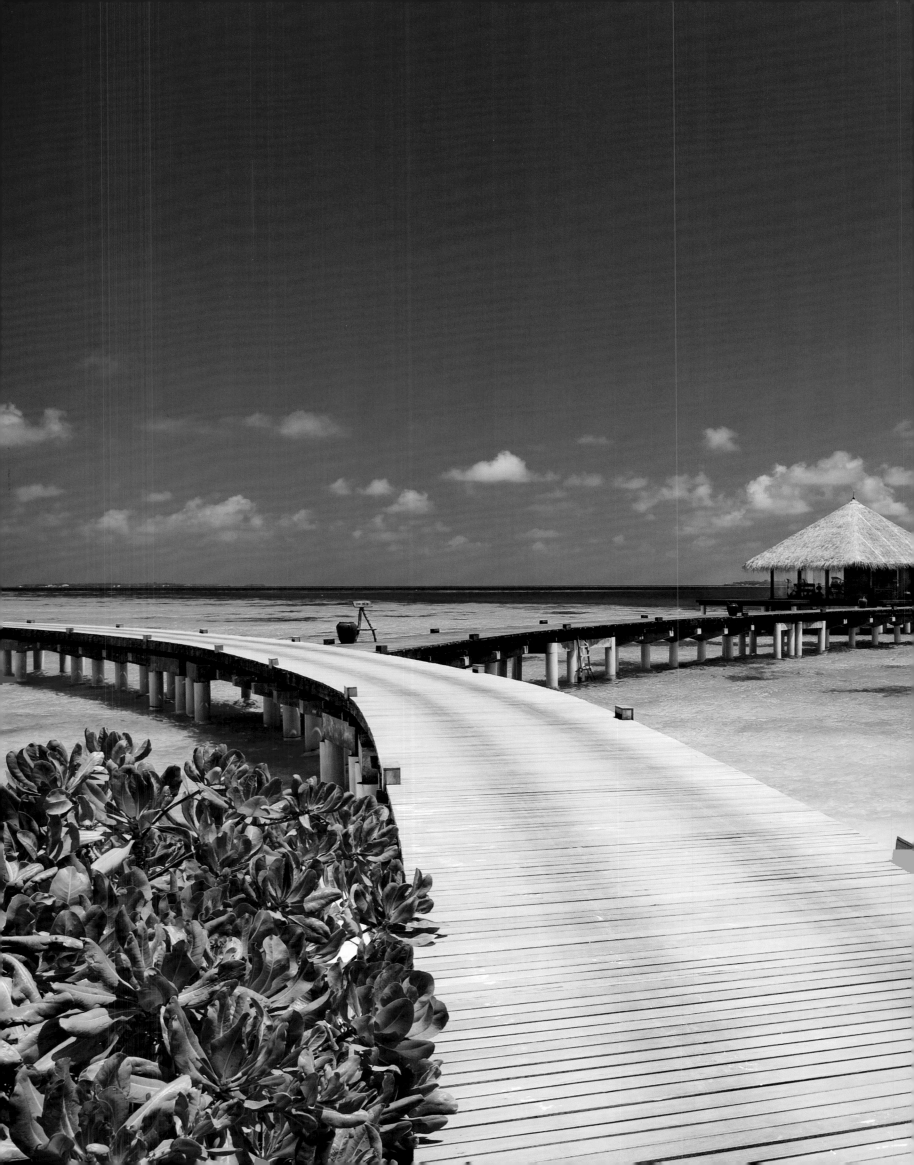

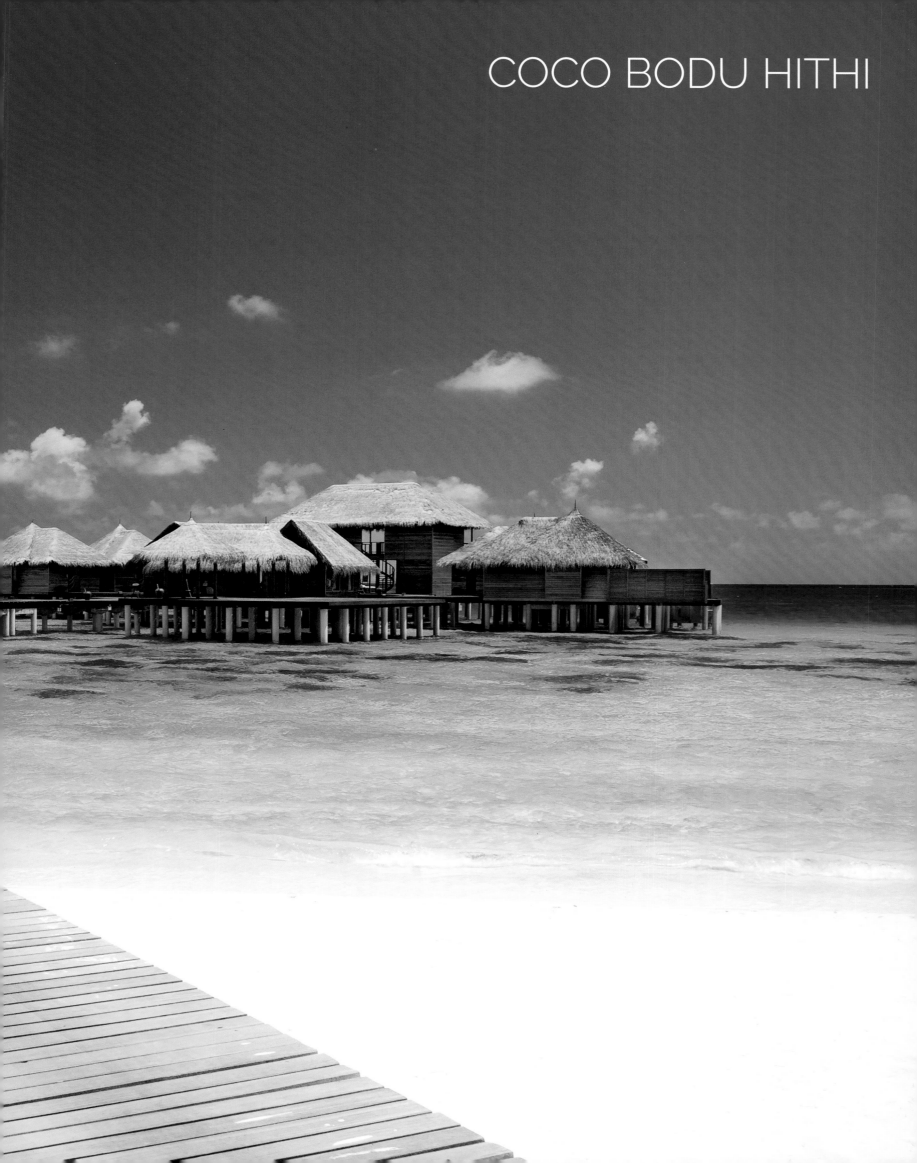

COCO BODU HITHI

Relaxen im Sand oder über dem Ozean schweben –
Coco Bodu Hithi ist der perfekte Ort für Gourmets
und Entspannungssuchende.

Lazing on the sand or floating above the ocean –
Coco Bodu Hithi is the perfect location for
gourmets and for those seeking relaxation.

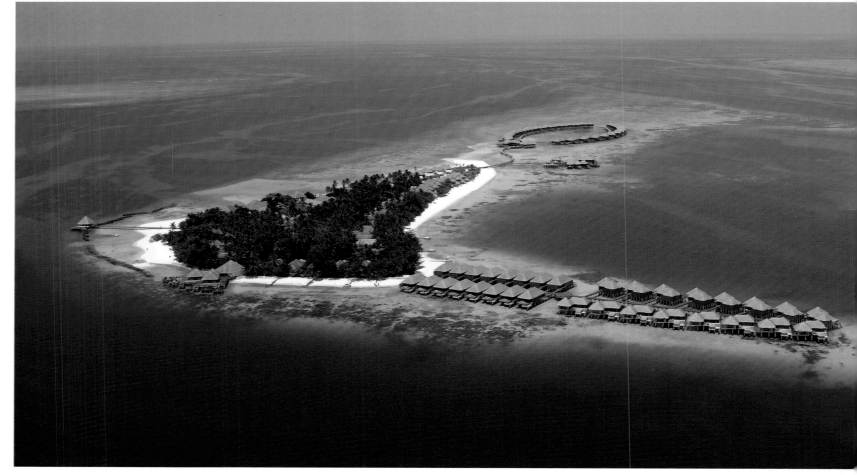

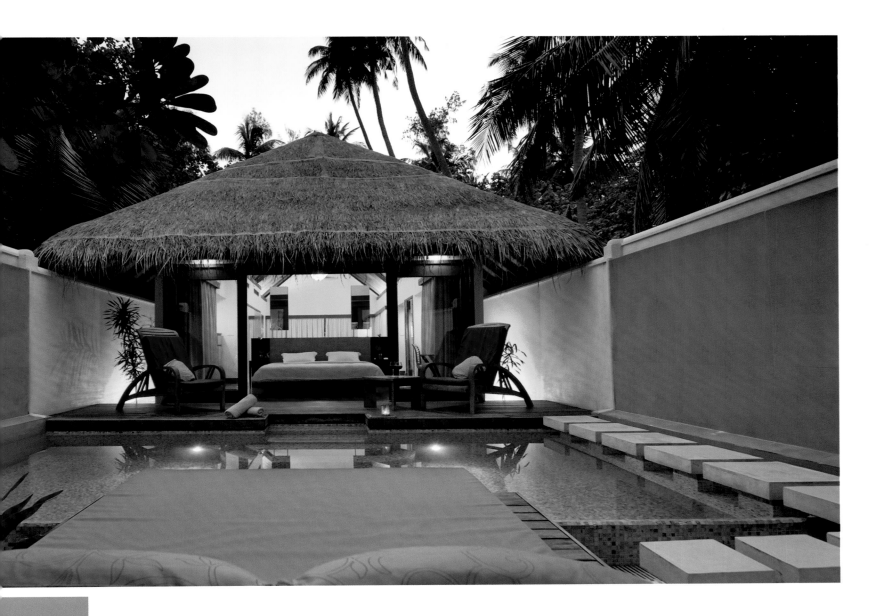

LOCATION

Das Resort der Coco Collection befindet sich auf Bodu Hithi, einer traumhaften Malediven-Insel im Nord-Malé-Atoll, nur 40 Bootsminuten vom Flughafen entfernt. Der Indische Ozean bietet eine spektakuläre Unterwasserwelt, die sich auf vielfältige Art und Weise entdecken lässt. Das prachtvolle Korallenriff und die heimischen Schildkröten lassen sich am besten bei einem Tauch- oder Schnorchelausflug bewundern. Der Erhalt dieser faszinierenden Natur liegt dem Coco Bodu Hithi besonders am Herzen und so kümmert sich eine ansässige Meeresbiologin um die Pflege der Meeresbewohner.

HOTEL

Auf Coco Bodu Hithi vereinen sich Elemente traditioneller maledivischer Architektur, wie die mit Palmblätter gedeckten Strohdächer, mit zeitgemäßem Design zu einer wundervollen Mischung. Jede der insgesamt 100 Villen verfügt über einen eigenen Pool. Während man in den auf Pfeilern direkt ins Wasser gebauten Villen über der Meeresoberfläche zu schweben scheint, hat man in den geräumigen Island Villas die Wahl zwischen Sonnenterrasse mit Meerblick oder separatem Garten mit Pool. Puren Luxus und exklusiven Service bieten die Coco Residences. Im spektakulären Coco Spa können Gäste während der Behandlung die Unterwasserwelt des Indischen Ozeans beobachten. Nicht nur die sieben verschiedenen Restaurants zeugen von der erstklassigen Gastronomiekultur. Immer wieder gastieren international renommierte Sterneköche auf Coco Bodu Hithi. Ein kulinarisches Highlight, das Sie keinesfalls verpassen dürfen, ist das Meeresfrüchte-Barbecue am Strand.

LOCATION

This Coco Collection resort is located on Bodu Hithi, a wonderful Maldivian island in North Malé Atoll, just 40 minutes by boat from the airport. The Indian Ocean offers a spectacular underwater world, which can be explored through many diverse ways. The magnificent coral reef and the local turtles can be best admired during a dive or snorkel excursion. The preservation of this fascinating natural environment is very important to Coco Bodu Hithi and a local marine biologist takes care of the marine life.

HOTEL

In Coco Bodu Hithi, traditional Maldivian architecture, such as coconut palm leaves thatched roofs, and contemporary design, result in a wonderful mix. Each of the 100 villas is equipped with a private pool. The villas, built on abutments, seem to magically float on the sea. Guests living in the spacious Island Villas may choose between the sun terrace with ocean view or a separate garden with pool. Coco Residences offer pure luxury and exclusive services. In the spectacular Coco Spa, guests can observe the underwater world of the Indian Ocean during their treatment. It is not only the seven different restaurants that bear witness to the first-class gastronomic culture, but also the fact that Coco Bodu Hithi regularly hosts internationally reknowned chefs. A culinary highlight, which should not be missed, is the seafood barbecue on the beach.

Get your Upgrade

www.upgradetoheaven.com/coco-bodu-hithi

COCO BODU HITHI . North Malé Atoll, Maldives . www.cocoboduhithi.com

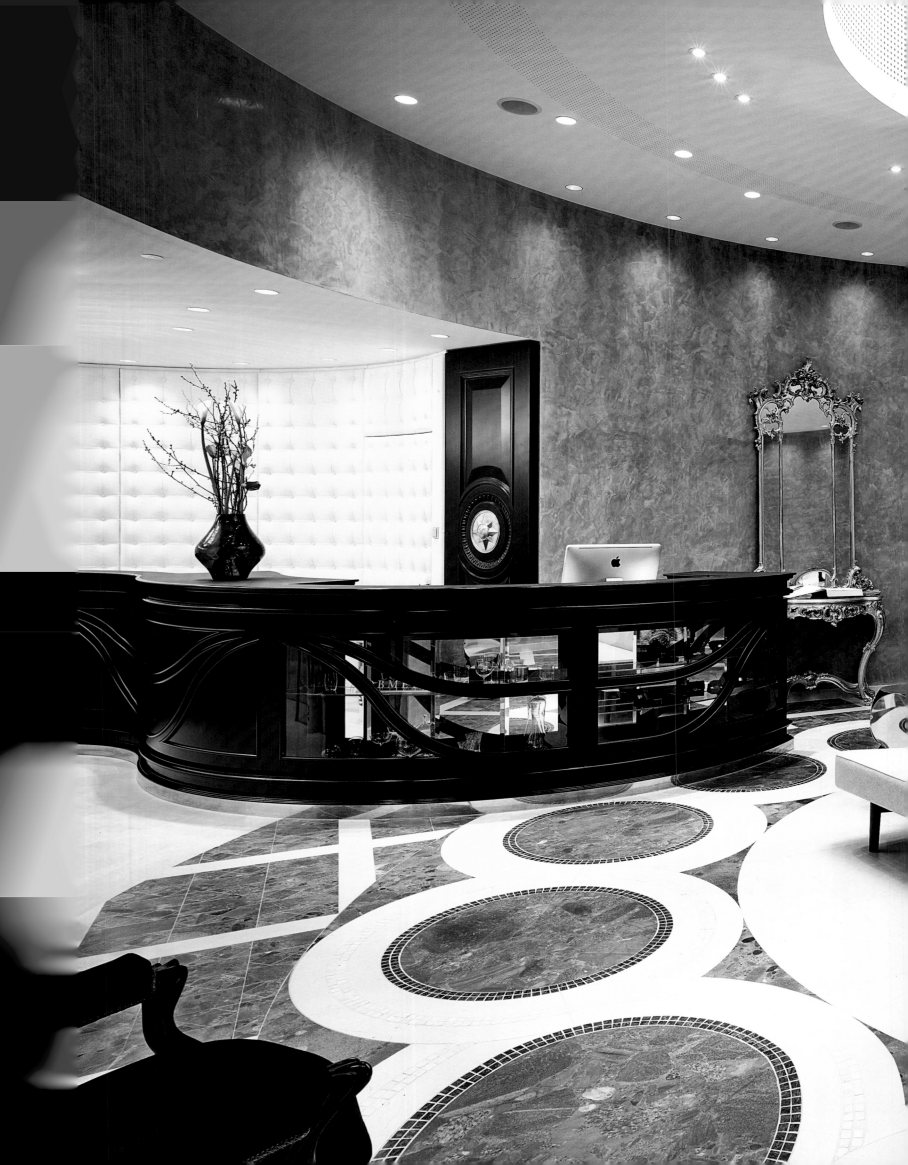

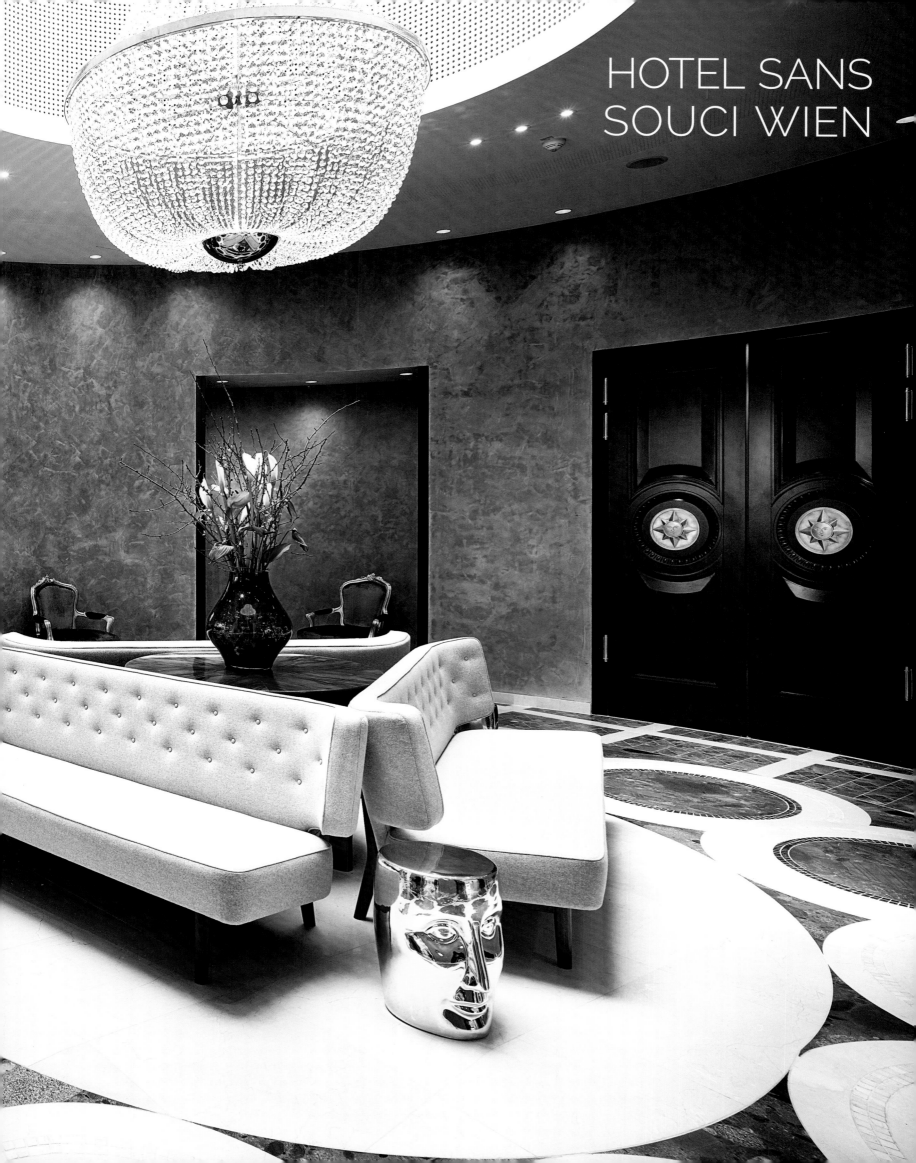

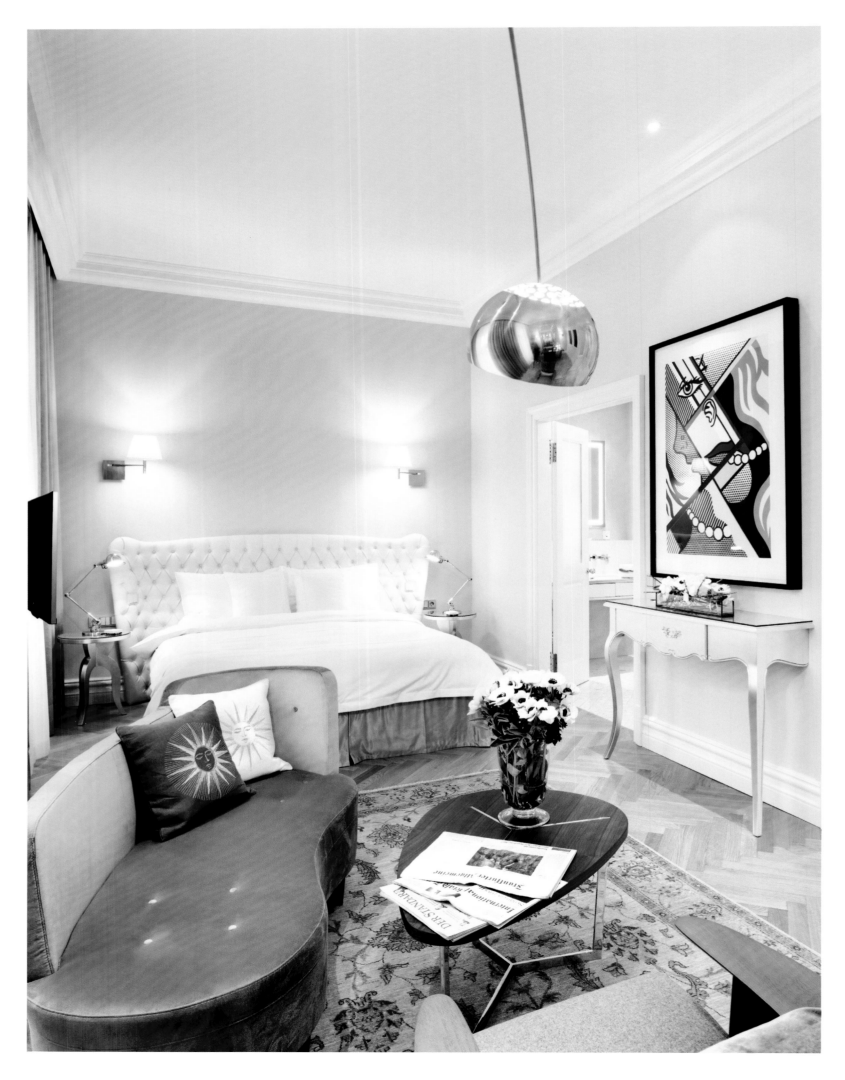

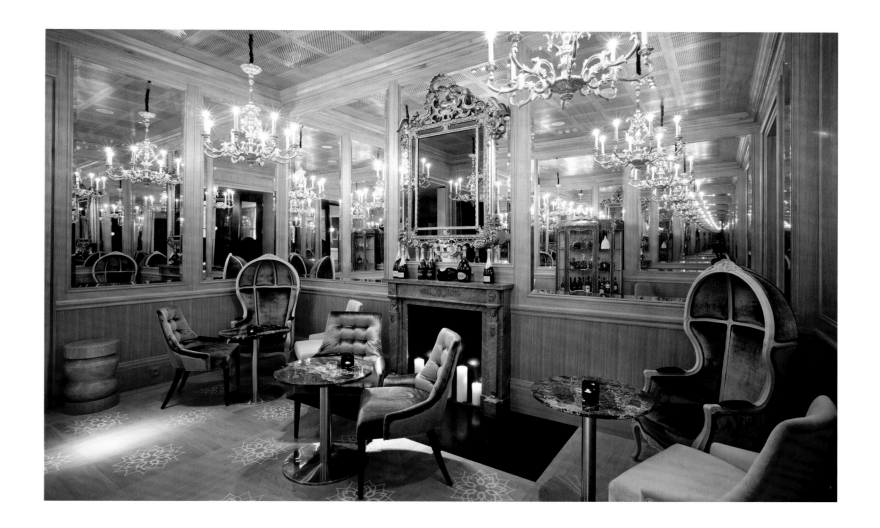

LOCATION

Mitten im kulturellen Herzen der Stadt Wien, zwischen dem historischen ersten Bezirk und dem Künstlerviertel Spittelberg, befindet sich das exklusive luxuriöse Hotel Sans Souci Wien. Die österreichische Hauptstadt lockt mit Prachtbauten, einem szenigen Donauufer und einer Kunst- und Kulturvielfalt, die ihresgleichen sucht. Auch ist Wien für seine Kaffeehauskultur mit den dazugehörigen kulinarischen Spezialitäten bekannt. Das Hotel Sans Souci Wien befindet sich in einem 1872 erbauten Gebäude, das Geschichte erzählt. Hier stand das Gasthaus "Zum großen Zeisig", in dem Johann Strauß 1858 seine "Tritsch-Tratsch-Polka" uraufführte. Das Hotel Sans Souci Wien ist der ideale Ausgangspunkt für einen Besuch des MuseumsQuartier oder für ausgedehntes Shopping. Sowohl die trendigen kleinen Design-Stores im 7. Bezirk, als auch Wiens größte Shoppingmeile, die Mariahilfer Straße, und die noblen Luxus-Boutiquen im 1. Bezirk sind bequem zu Fuß erreichbar.

HOTEL

Das luxuriöse Hotel Sans Souci Wien besitzt 65 individuell gestaltete Zimmer und Suiten mit entspannter Atmosphäre von unaufdringlichem Luxus. Diesen charakteristischen Sans Souci-Charme spürt man auch im Restaurant "La Véranda", in der hoteleigenen Cocktailbar, im Salon und auch im großzügigen Spa. Ein 20 Meter langer Indoor-Pool, Saunen, ein Fitnessbereich, Personal Trainer und Therapeuten sowie eine Vielzahl von traditionellen und exotischen Beauty- und Massage-Treatments runden das Angebot des Spa ab. Es werden ausschließlich exklusive Pflegeprodukte der österreichischen Naturkosmetiklinie "Vinoble" verwendet. Highlight des Hotel Sans Souci Wien ist die Sammlung moderner Kunst, die Originale von Roy Lichtenstein, Allen Jones und Steve Kaufman umfasst und in den öffentlichen Bereichen und Zimmern zu sehen ist. Kunst und Kultur dominieren nicht nur das Innenleben des Hotel Sans Souci Wien, sondern auch die unmittelbare Umgebung: das MuseumsQuartier, eines der weltweit größten Areale moderner Kunst, ist nur zwei Gehminuten vom Hotel entfernt.

LOCATION

In the middle of the cultural heart of Vienna, between the historical first district and the bohemian Spittelberg quarter, is the exclusive luxury Hotel Sans Souci Wien. The Austrian capital attracts visitors with its monumental structures, its trendy Danube shoreline and a tremendous variety of art and culture. Moreover, Vienna is known for its Kaffeehaus culture its accompanying culinary specialities. The Hotel Sans Souci Wien is in a historic building which was built in 1872. The guest house "Zum großen Zeisig", in which Johann Strauß premiered in the year 1858 his "Tritsch-Tratsch Polka" was located here. The Hotel Sans Souci Wien is the ideal starting point for a visit to the MuseumsQuartier or for extended winded shopping trips in Vienna: the trendy, small design stores in the seventh district, Vienna's largest shopping mile, Mariahilfer Strasse, and the noble luxury boutiques of the first district are easily reachable on foot.

HOTEL

The exclusive luxury Hotel Sans Souci Wien owns 65 individually designed rooms and suites with subtle luxury in a relaxed atmosphere. The same characteristic Sans Souci charm can be found in the restaurant "La Véranda", in the hotel's own cocktail bar, in the lounge and in the generously designed spa. A 20-metre indoor pool. saunas, a fitness area, personal trainers and therapists, as well as a number of traditional and exotic beauty and massage treatments complete the spa's offer. Only exclusive care products from the Austrian organic cosmetic line "Vinoble" are used. The collection of modern art, originals by Roy Lichtenstein, Allen Jones and Steve Kaufman, which can be seen in the public areas and rooms, is the highlight of the Hotel Sans Souci Wien. Art and culture do not only dominate the inside of Hotel Sans Souci Wien, but also the immediate surroundings: the MuseumsQuartier, one of the world's largest areas of modern art, is only two minutes on foot from the hotel.

Get your Upgrade

www.upgradetoheaven.com/hotel-sans-souci-wien

HOTEL SANS SOUCI WIEN . Burggasse 2, 1070 Vienna, Austria . www.sanssouci-wien.com

THE CHARISMATIC HIDEAWAY IN VIENNA

Ein außergewöhnlicher
Rückzugsort mitten
in Wien

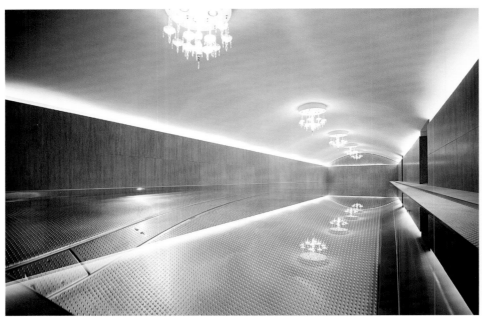

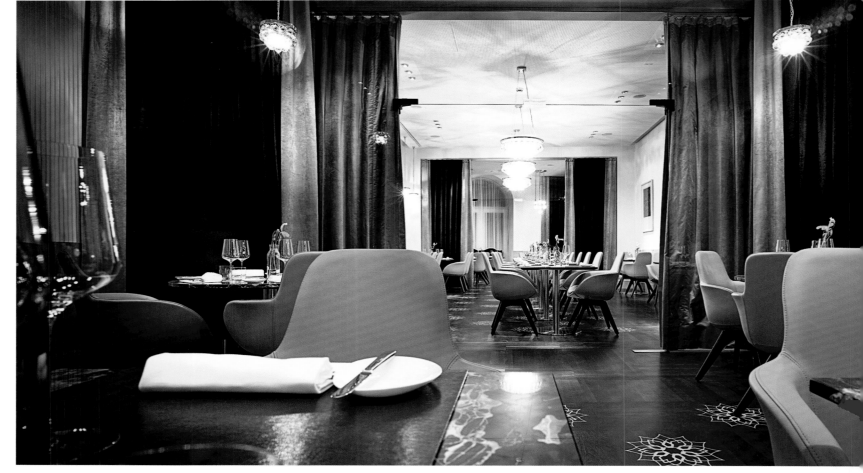

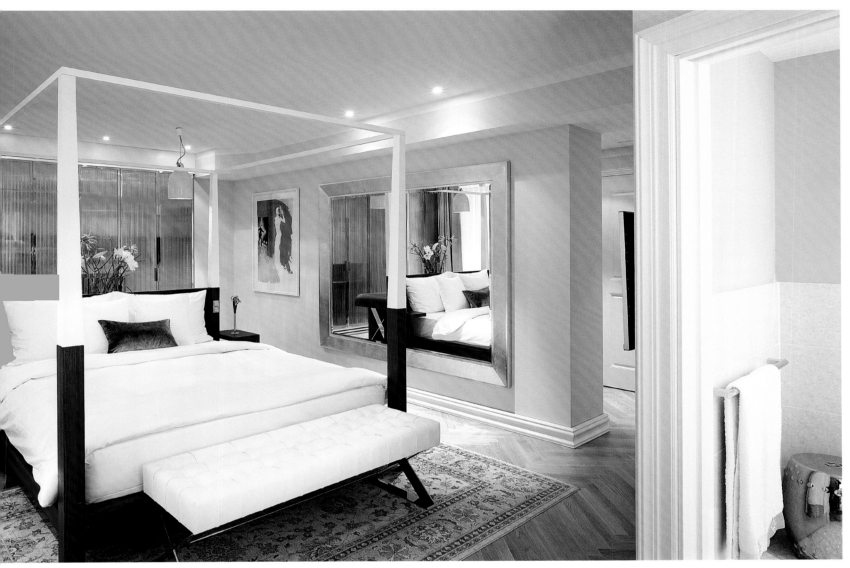

Hotel Sans Souci Wien is the only hotel in Vienna which was designed and realised by London's design group yoo. yoo is the creative team around the world famous designer Philippe Starck. The characteristic yoo design immediately shows when entering the lobby, which is flooded with light and continues in the individual designed and spacious rooms and suites painted in light colors.

Das Hotel Sans Souci Wien ist das einzige Hotel in der Stadt, das vom Londoner Designkollektiv yoo geplant und realisiert wurde. yoo ist das kreative Team rund um den weltbekannten Designer Philippe Starck. Das charakteristische yoo-Design zeigt sich bereits beim Betreten der licht-durchfluteten Lobby und setzt sich in den, in hellen Farben individuell gestalteten, großzügig angelegten Zimmern und Suiten fort.

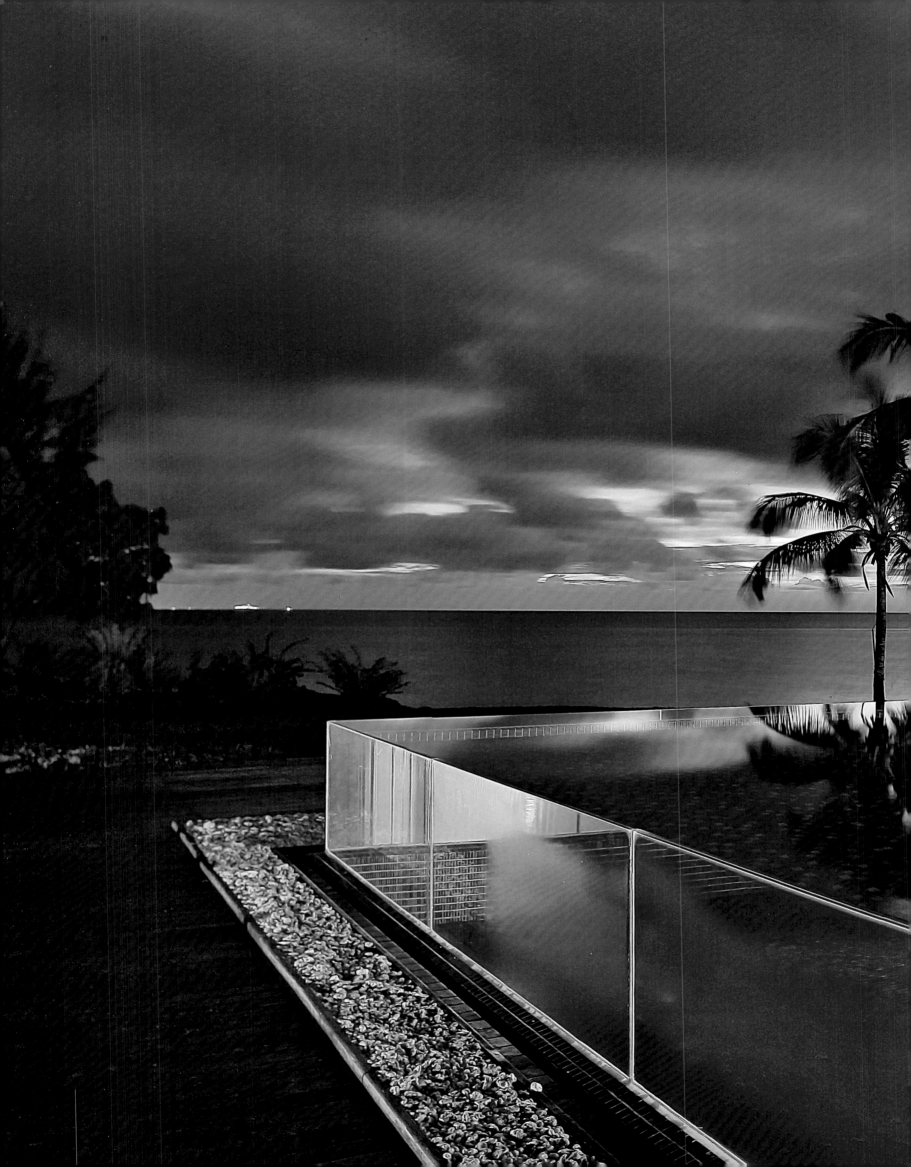

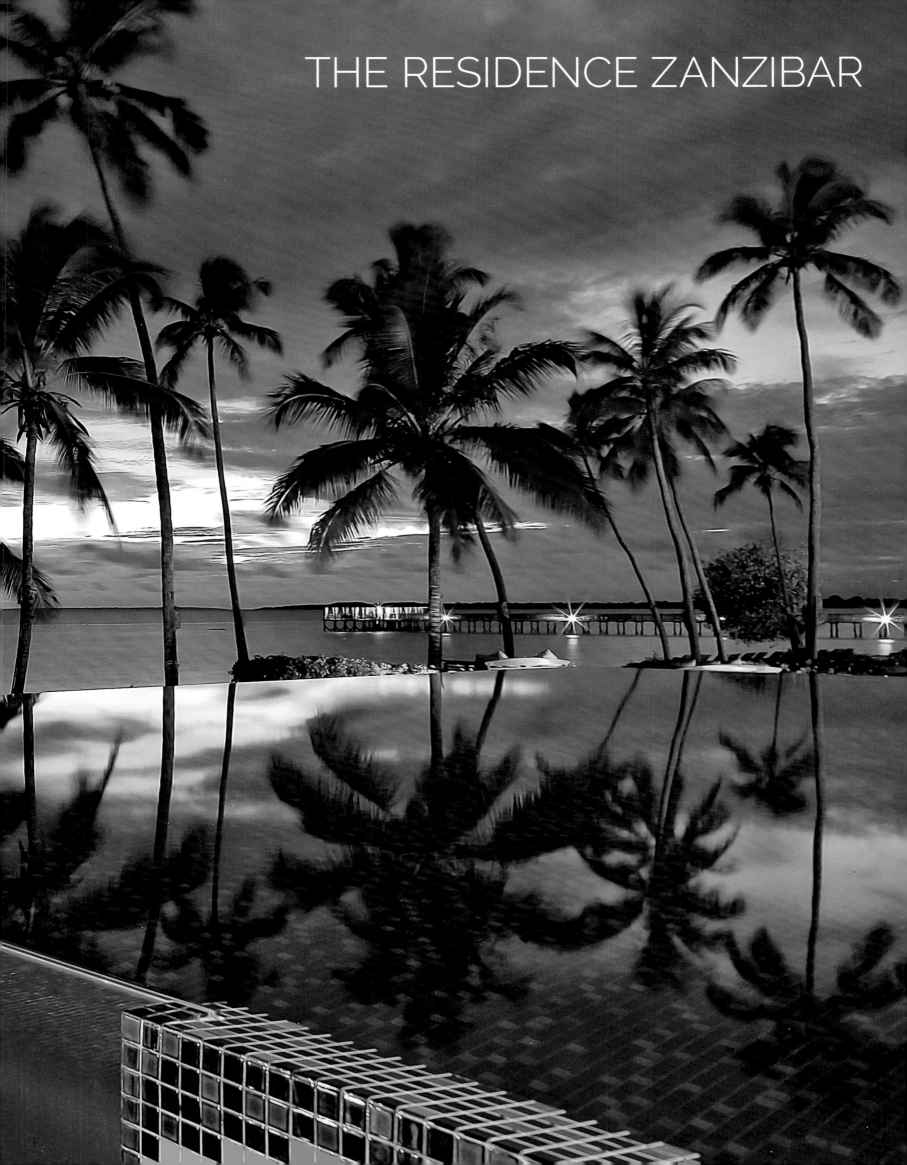

THE RESIDENCE ZANZIBAR

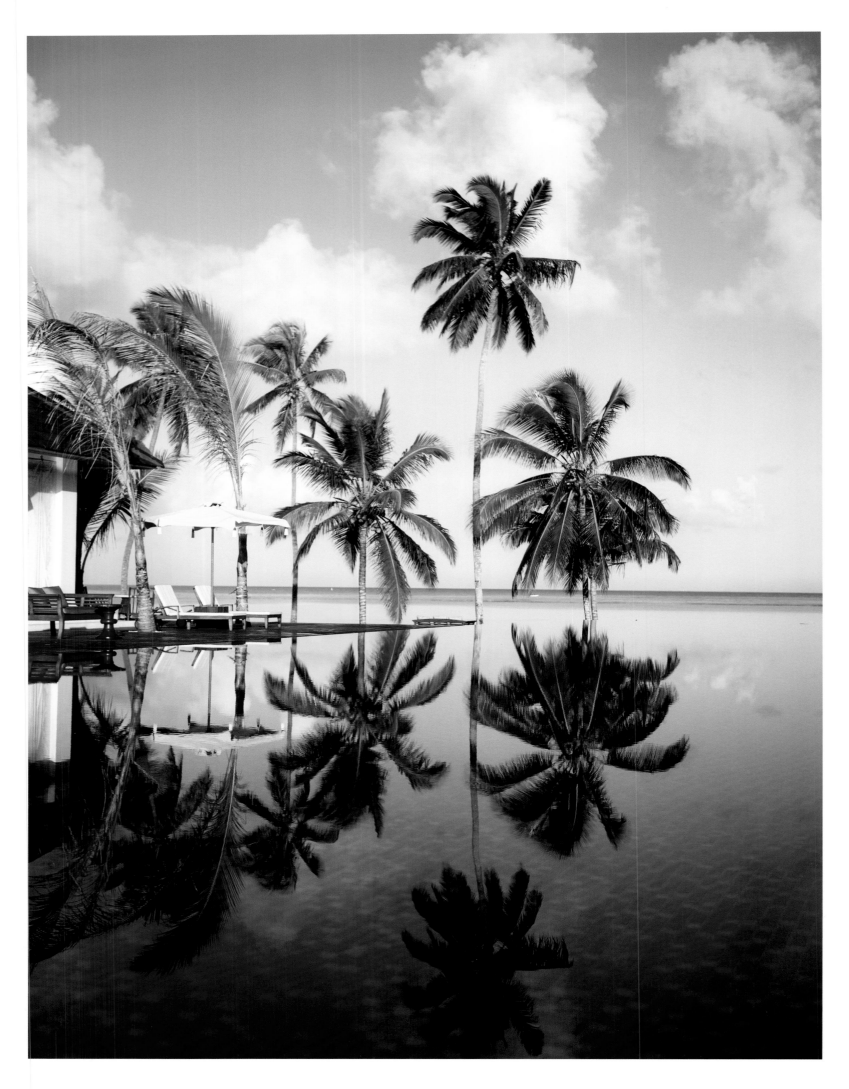

LOCATION

Allein der Name Sansibar lässt schon träumen von Urlaub, palmenbesetzten paradiesischen Stränden und exotischen Gewürzen. Die Trauminsel liegt im Indischen Ozean. Auf ihr vereinen sich afrikanische, indische und arabische Einflüsse. Sansibar ist eine Schatztruhe; Insel-Exkursionen sind demnach ein Muss. Besonders reizvoll ist eine Küstentour mit einem traditionellen Dhow Boot, ein Besuch des Jozani Forest, wo man den nur hier lebenden Roten Stummelaffen zu Gesicht bekommen kann, Delfinbeobachtungen und nicht zu vergessen ein Besuch von Stone Town, das als Weltkulturerbe unter dem Schutz der UNESCO steht. The Residence Zanzibar ist im Südwesten der Insel, an einem kilometerlangen Sandstrand, inmitten eines 32 Hektar großen Gartens, gelegen. Das Resort ist ein idealer Ausgangspunkt, um die Schönheit der Insel und die Gastfreundschaft der einheimischen Swahili kennenzulernen.

HOTEL

The Residence Zanzibar ist ein spannender Mix von dezentem Luxus und Insel-Charme. Das Resort verfügt über 66 exquisite Villen mit eigenem Swimmingpool. Das Interior Design ist inspiriert von den vielen Kulturen, die auf Sansibar aufeinandertreffen. Ob in den exotischen Gärten oder am feinen weißen Sandstrand, im The Residence Zanzibar finden Gäste Inspiration und Entspannung gleichermaßen. Für Aktive bietet das Resort unzählige Wassersport- und Ausflugsmöglichkeiten. Das Privat-Boot des Resorts bringt Gäste in wenigen Minuten direkt in die abgeschiedene Menai Bucht, in der Korallenriffe locken und Delfine gesichtet werden können. Die Zubereitung von Speisen wird in The Residence Zanzibar wie eine Kunst zelebriert; hier zu speisen, ist ein unvergessliches Erlebnis. Im Hauptrestaurant "The Dining Room" erleben Gäste, neben köstlichen internationalen Klassikern, die kulinarische Welt Ostafrikas mit all den Gewürznoten, für die Sansibar so berühmt ist. Das Signature-Restaurant "The Pavilion" bietet ein bezauberndes Ambiente mit Holzschnitzereien auf den Türen und Messinglaternen und serviert einen exotischen Mix aus mediterraner Küche und der des Mittleren Osten. Wer in absoluter Privatheit dinieren möchte, bekommt das Essen an seinem Lieblingsplatz unter dem Sternenhimmel, am Strand, auf dem Anlegesteg oder in der eigenen Villa serviert. Seit der Eröffnung im Jahr 2011 wurde The Residence Zanzibar jährlich von TripAdvisor zertifiziert und findet oft Erwähnung in internationalen Reisemagazinen wie beispielsweise dem Condé Nast Traveller Spanien.

LOCATION

The name Zanzibar alone already has you dreaming of holiday, tropical beaches covered in palm trees and perfumed with the scent of exotic spices. The dream island lies in the Indian Ocean and combines African, Indian and Arabic influences. Zanzibar is a treasure chest which makes island excursions a must. Especially delightful is a coastal tour on a traditional Dhow boat, a visit to Jozani forest, in which you may encounter Red Colobus monkeys, do dolphin watching and last but not least visit Stone Town, which has been placed under the protection of UNESCO as a World Heritage Site. The Residence Zanzibar is located in the southwest of the island on a beautiful sandy beach that goes on for miles and miles, in the middle of a 32-hectare-large garden. The resort is the ideal starting point to get to know the beauty of the island and hospitality of the native Swahili.

HOTEL

The Residence Zanzibar is an exciting mix of quiet luxury and island charm. The luxurious resort features over 66 exquisite villas with private swimming pools. The interior design is inspired by various cultures that come together in Zanzibar. Either in the exotic garden or on the fine white sandy beaches, guests will equally find pure inspiration and relaxation. The resort also offers countless water sports and excursion opportunities for action lovers. The resort's private boat brings guests in only a couple of minutes directly to the secluded Menai cove, where coral reefs await and dolphins are spotted regularly. Preparing a meal in The Residence Zanzibar is celebrated as a form of art, enjoying a meal here is an unforgettable experience. In the main restaurant, "The Dining Room", apart from savouring international favourites, guests uncover the culinary world of East Africa and all its spice nuances Zanzibar is so well known for. The resort's signature restaurant, "The Pavilion" delights within an intricate, intimate setting with wooden carved doors and hanging brass lanterns, as it features an exotic mix of Middle Eastern and Mediterranean cuisine. For those who prefer to dine in privacy, they can choose to have food served at their favourite spots, under the stars, at the beach, on the private jetty or in their own villa. The Residence Zanzibar has been annually awarded by TripAdvisor since its opening in 2011, and is frequently recognised by international travel publications such as the Condé Nast Traveller Spain.

Get your Upgrade

www.upgradetoheaven.com/the-residence-zanzibar

THE RESIDENCE ZANZIBAR . Mchamgamle, Kizimkazi, PO Box 2404 Zanzibar, Tanzania . www.cenizaro.com/theresidence/zanzibar

ZANZIBAR MEANS RUSTLING PALMS, POWDER-SOFT WHITE SAND AND CHRYSTAL-CLEAR WATER

Sansibar bedeutet Palmenrascheln,
puderzarter weißer Sand und
kristallklares Wasser

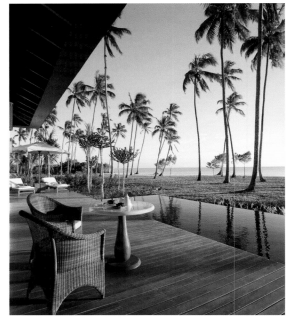

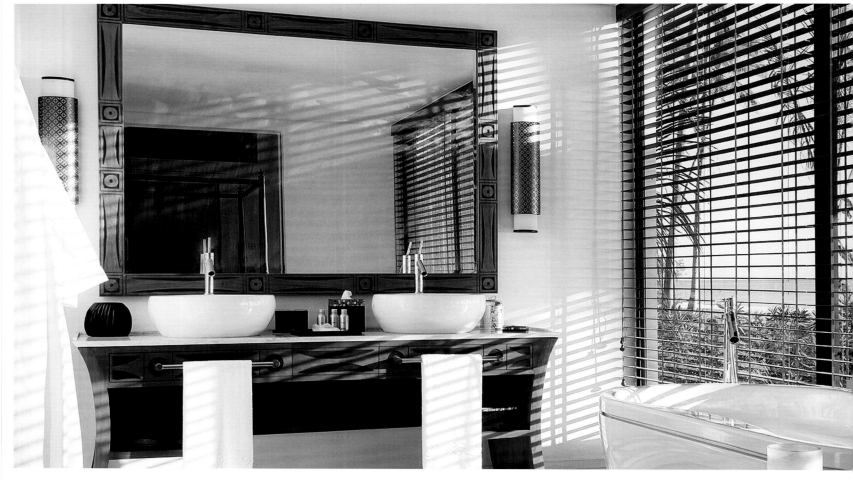

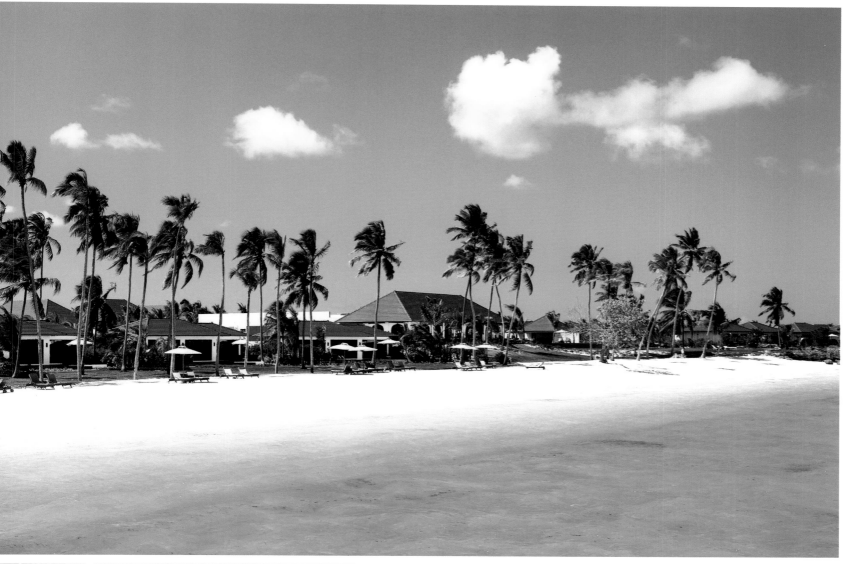

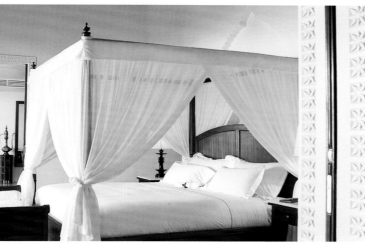

In The Residence Zanzibar's spa, beauty treatments are offered using products by the British brand "ila", which are made of plants and herbs local to Zanzibar. Honey from of the local bees as well as coconut, cinnamon, lemon grass and garlic all find use in current treatments with ila products. At the end of the relaxing and pampering treatments, the indescribably joyful lifestyle of the Swahili awaits you.

Im The Spa at The Residence Zanzibar werden Beauty-Treatments mit Produkten der britischen Marke "ila" angeboten, die auf Sansibar wachsende Pflanzen und Kräuter beinhalten. Bei den exklusiven ila-Treatments finden u.a. Honig von einheimischen Bienenvölkern sowie Kokosnuss, Zimt, Zitronengras und Knoblauch Verwendung. Am Ende der entspannenden und verwöhnenden Treatments wartet das unbeschreiblich fröhliche Lebensgefühl der einheimischen Swahili.

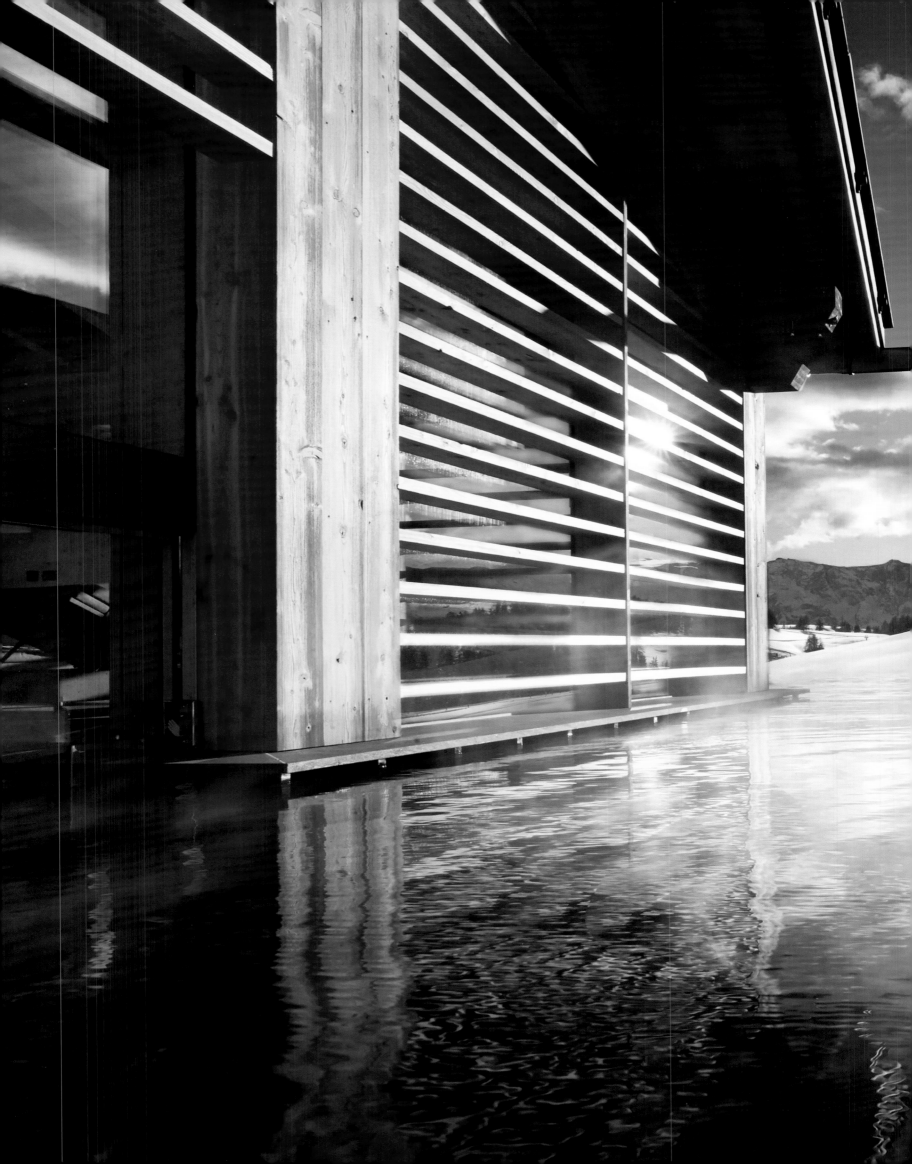

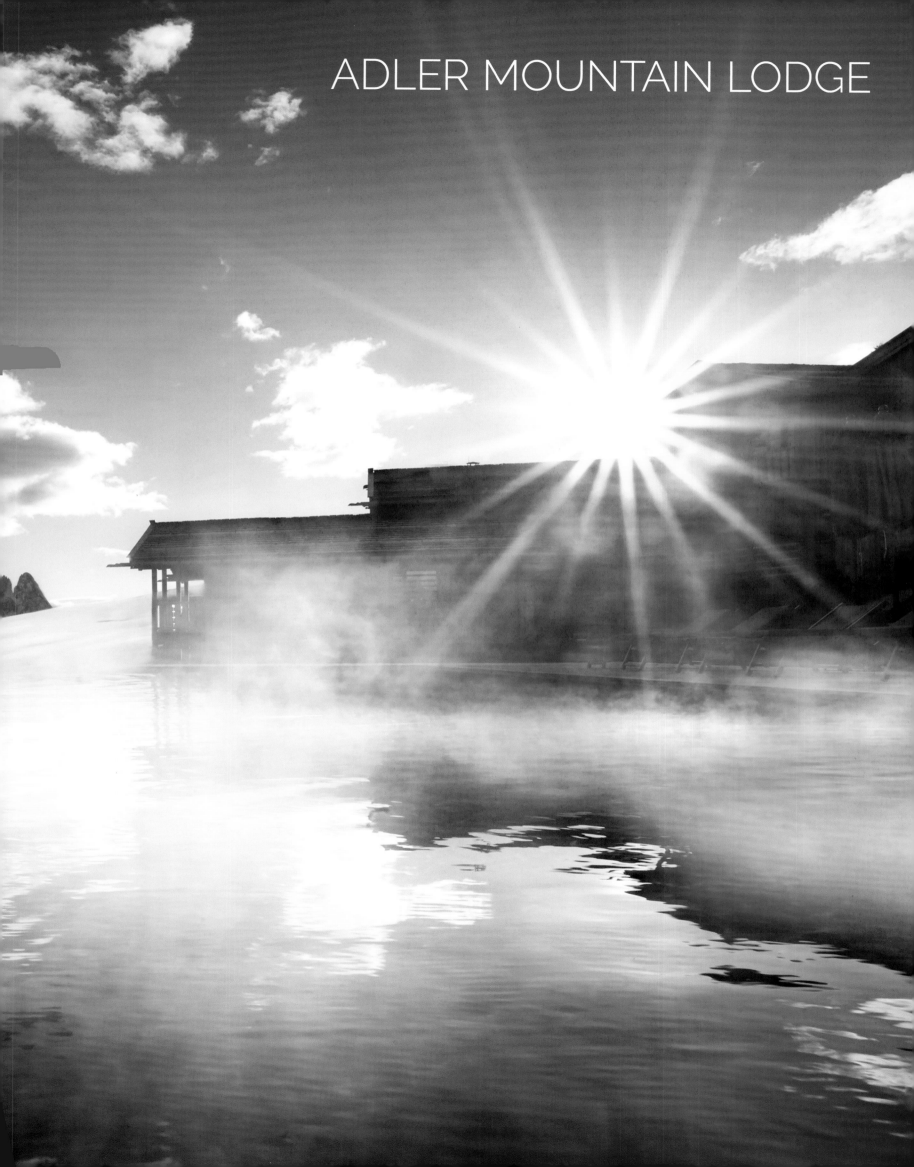

EIN TRAUM WURDE ENDLICH WAHR

A dream finally came true

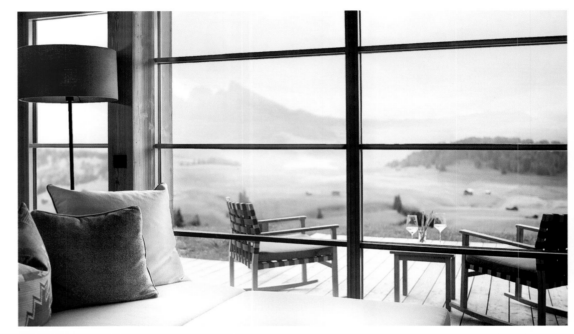

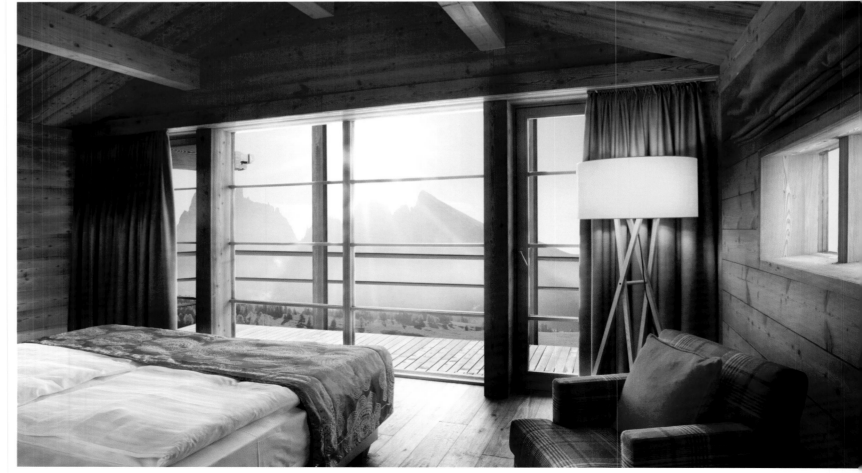

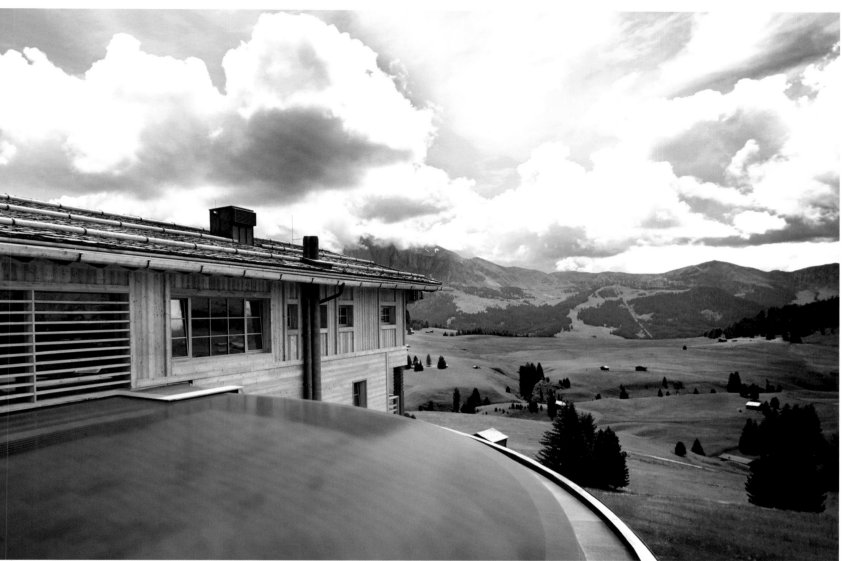

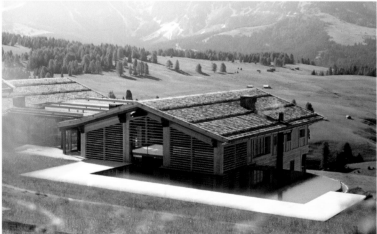

The Adler Mountain Lodge is embedded in the mountain world of the South Tyrolean Dolomites on the Alpe di Siusi at an altitude of 1,800 metres. More than ten years passed before the Sanoner family could realise their dream of a hotel on the largest Alpine pasture of Europe. It was not meant to be a traditional hotel, but rather a lodge. The Sanoner family found inspiration for the concept on their travels to Namibia. Untreated natural materials, native woods, finest South Tyrolean wood carving and a sustainable construction are very important to the architects and developers. The Adler Mountain Lodge is already the fourth Adler Spa Resorts hotel.

Die Adler Mountain Lodge liegt eingebettet in die Bergwelt der Südtiroler Dolomiten, auf 1.800 Höhenmetern, auf der Seiser Alm. Mehr als zehn Jahre vergingen, bis die Hoteliersfamilie Sanoner ihren Traum von einem Hotel auf der größten Hochalm Europas verwirklichen konnte. Kein klassisches Hotel sollte es werden, sondern eine Lodge. Anregungen für das Konzept holte sich Familie Sanoner unter anderem auf Reisen nach Namibia. Unbehandelte Naturmaterialen, heimische Hölzer, feinste südtiroler Schnitzkunst und eine nachhaltige Bauweise liegen den Architekten und Bauherren besonders am Herzen. Die Adler Mountain Lodge ist bereits das vierte Hotel der Adler Spa Resorts.

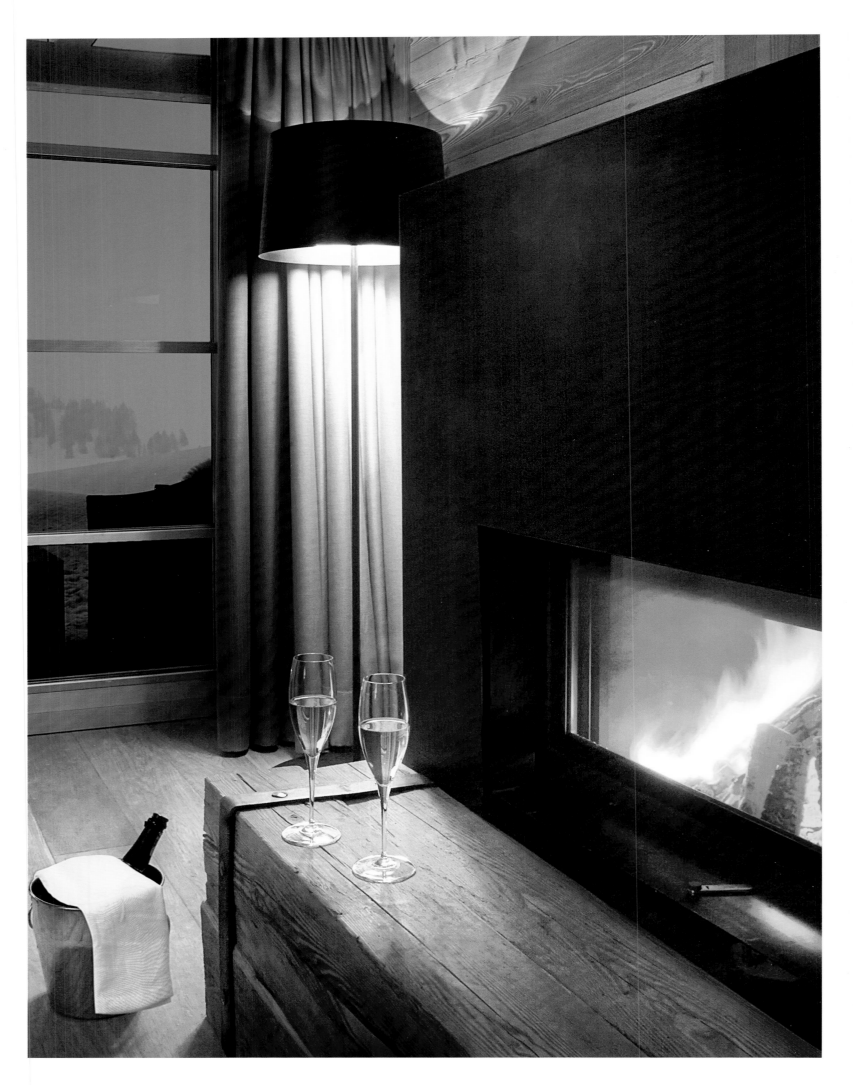

LOCATION

Die Seiser Alm befindet sich rund 40 Kilometer östlich von Bozen und liegt auf einem Hochplateau. Im Sommer ist die Hochalm ein Eldorado für Wanderer und Mountainbiker, in den Wintermonaten für Skifahrer und Langläufer. Die beeindruckenden Gipfel des UNESCO-Weltnaturerbes Dolomiten dominieren neben dem grünen Teppich der Seiser Alm das Landschaftsbild. Das Landschaftsschutzgebiet bietet eine einzigartige alpine Flora und Fauna. Der Umwelt zuliebe ist der motorisierte Verkehr auf der Seiser Alm seit Jahren eingeschränkt. Gästen der Lodge ist die Zufahrt zur Hotelgarage mit einer Fahrgenehmigung für die An- und Abreise jedoch gestattet. Nicht nur die Schönheit der Dolomitengipfel, sondern auch Südtiroler Kultur, Genüsse und weltbekannte Schnitzkunst locken die Gäste auf die Seiser Alm.

HOTEL

Zwölf private Chalets aus natürlichem Gebirgsholz innen wie außen gruppieren sich um das Hauptgebäude, die Main Lodge, mit 18 weiteren Suiten, einem Restaurant mit regional-mediterranem Fokus sowie einem Wellness- und Fitnessbereich mit spektakulärem beheizten Infinity-Außenpool.

Panoramafenster und große Holzbalkone eröffnen den Gästen der Suiten beste Aussichten auf die Dolomiten. Die Suiten sind in natürlichem Fichtenholz aus den Wäldern der Seiser Alm gehalten und verfügen über ein großzügiges Bad mit Infrarot-Wellnessstrahl. In den großen, hellen Chalets erwartet die Gäste im Erdgeschoss ein gemütlich eingerichtetes Wohnzimmer mit verglastem Kamin. Auf der ersten Etage befinden sich ein heimeliger Schlafbereich, das Badezimmer und eine eigene Sauna. Eine Terrasse und ein Balkon verteilen sich auf die zwei Ebenen. Der Fitness- und Wellnessbereich mit Saunalandschaft, einem Ruhe- und drei Behandlungsräumen befindet sich in der Main Lodge. Gäste ziehen im beheizten Außenpool, beim Blick auf die majestätischen Bergformationen, ihre Bahnen und genießen von der umgebenden Natur inspirierte Massagen und Schönheitsbehandlungen. Entschleunigung und Besinnung auf das Wesentliche lautet die Philosophie der Adler Mountain Lodge. Das ganzheitliche Verwöhnangebot beinhaltet ein à la carte wählbares betreutes Outdoor-Programm sowie ein Inklusiv-Arrangement, beginnend mit einem Frühstücksbuffet am Morgen, gefolgt von vitalen Mittagsgerichten, einer südtiroler Marende am Nachmittag und einem Gourmetdinner am Abend. Quellwasser und lokale Softdrinks sind ganztägig inklusive. Am Abend reicht das Hotel eine hochqualitative Auswahl an typischen Weinen und Likören. Die Küche der Adler Mountain Lodge ist geprägt von Aufgeschlossenheit für Neues, Rückbesinnung auf die Tradition Südtirols und dem Wunsch nach gutem, echtem Geschmack. Die Verwendung lokaler Produkte und Unterstützung der regionalen Anbieter gehört ebenso zum Selbstverständnis der Adler Mountain Lodge, wie umweltbewusstes und nachhaltiges Verhalten und herzliche Südtiroler Gastfreundschaft in einzigartigem Ambiente.

LOCATION

The Alpe di Siusi is located around 40 kilometres east of Bolzano on a high plateau. In summer the Alpine pasture is an eldorado for hikers and mountain bikers, in winter months for skiers and cross-country skiers. The impressing summits of the UNESCO Natural World Heritage Site the Dolomites combined with the green carpet of the Alpe di Siusi dominate the landscape. The conservation area offers unique Alpine flora and fauna. Nature's sake the motorised traffic on the Alpe di Siusi has been limited for years. Lodge guests have access to the hotel's garage with a permission for arrival and departure. Not only does the beauty of the Dolomites' summits attract people to the Alpe di Siusi, but also the South Tyrolean culture and world famous wood carving.

HOTEL

The main building is enclosed by further twelve private chalets made of natural timber, outside as well as inside. It contains 18 suites and a restaurant with focus on regional and Mediterranean food as well as a wellness and fitness area with a spectacular heated outside infinity pool.

Panoramic windows and grand wooden balconies give suite guests the splendid mountain view of the Dolomites. The suites are held in natural spruce from the forests of the Alpe di Siusi and include a large bathroom with infrared wellness sensors. In the large, luminous chalets, a cosily decorated living room and glazed fireplace await the guests on the ground floor. On the first floor, guests will find a homely sleeping area, the bathroom and their very own private sauna, with the terrace and balcony overstitching both floors. The fitness and wellness area with sauna facilities, a relaxation area and three treatment rooms are placed in the main lodge. Guests can swim laps in the heated outside pool with a view to the majestic mountains, enjoy massages and beauty treatments inspired by the surrounding natural environment and much more. The Adler Mountain Lodge's philosophy is based on relaxing and reflecting on the essentials. The pamper programme in its entirety is filled with an outdoor à la carte programme, as well as an all-inclusive arrangement that starts with a breakfast buffet in the morning, followed up by energising lunch meals, a South Tyrolean Marende in the afternoon and a gourmet dinner in the evening. Spring water and local soft drinks are offered all-inclusive throughout the entire day. In the evening the hotel provides a high-quality and unique selection of traditional wines and liquors. The Adler Mountain Lodge's cuisine is shaped by openness for the new, recollection of the traditions of South Tyrolean cuisine and the wish for genuine and authentic taste. A use of local products to support regional vendors, as well as eco-friendly behaviour is as self-evident to the Adler Mountain Lodge as sincere South Tyrolean hospitality, which all in all guarantees an unparalleled ambience.

Get your Upgrade

www.upgradetoheaven.com/adler-mountain-lodge

ADLER MOUNTAIN LODGE . Pizstrasse 11, 39040 Alpe di Siusi, South Tyrol, Italy . www.adler-lodge.com

Hotels in Heaven

@hotelsinheaven.official
facebook.com/hotelsinheaven
hotelsinheaven.com

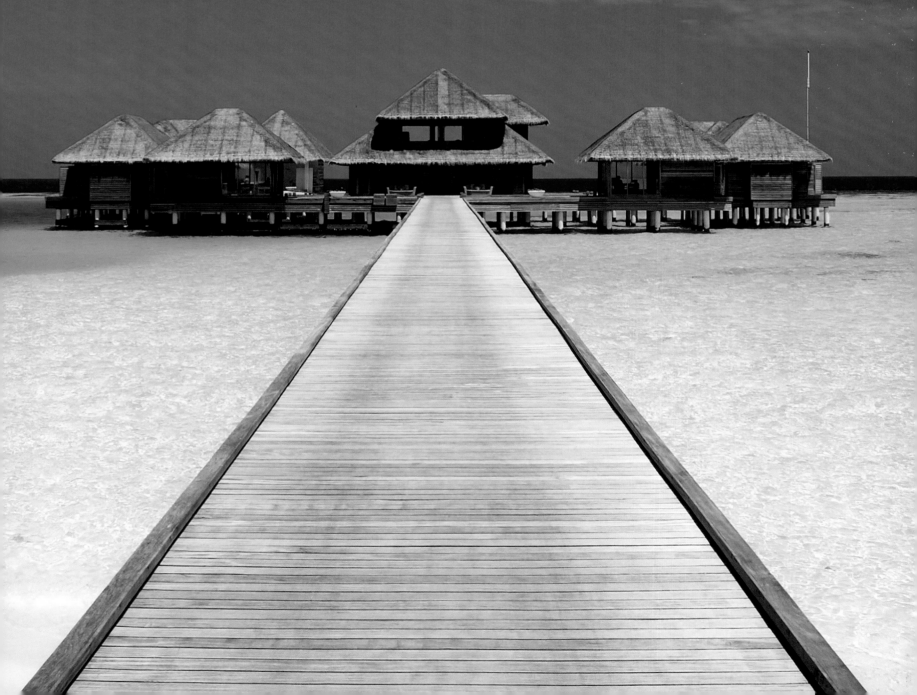

THE MOST AMAZING, UNIQUE AND BEAUTIFUL HOTELS IN THE WORLD

Hotels In Heaven® is for affluent hedonists in search of effortless extravagance and comfort in top of the line locations and unites the most amazing, unique and beautiful design hotels across the globe. Readers from around the world turn to hotelsinheaven.com for its unique selection of luxury hotels and to find what they cannot find elsewhere.

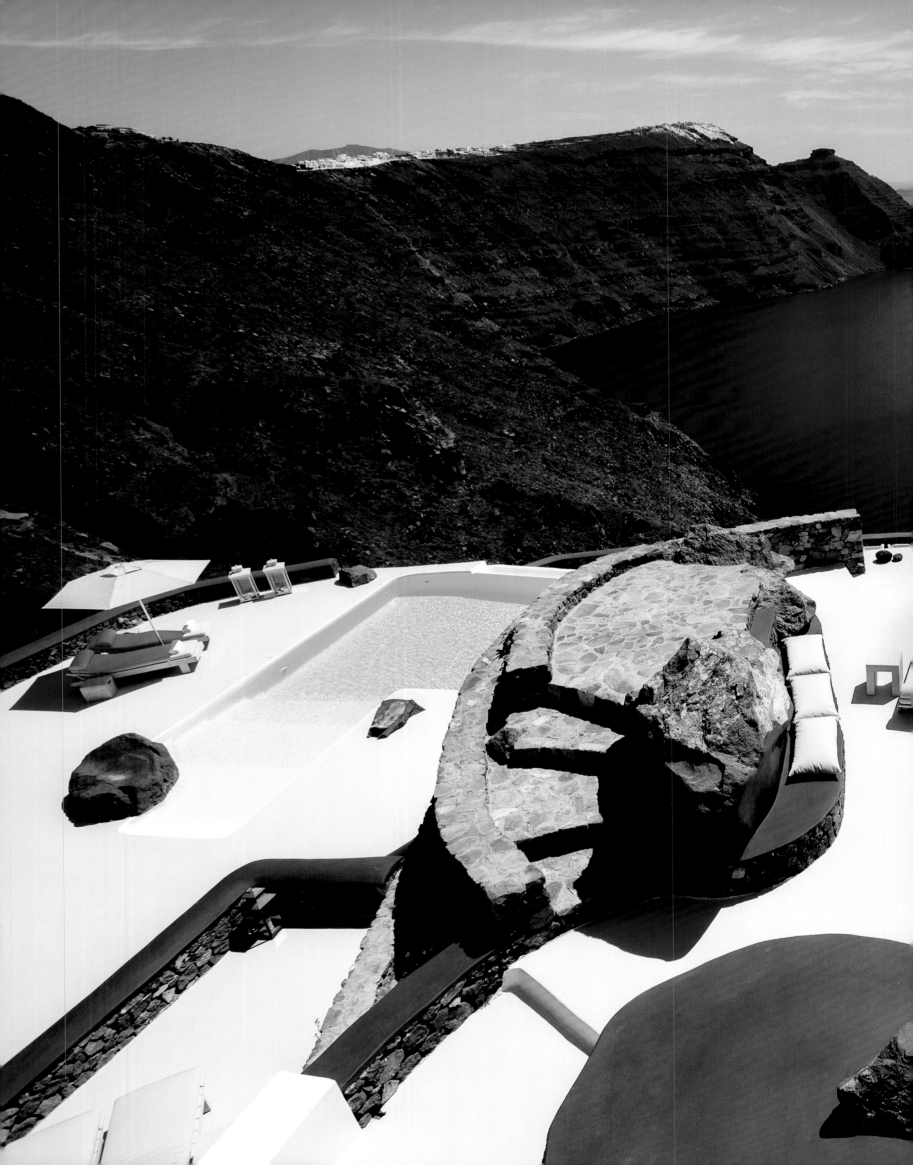

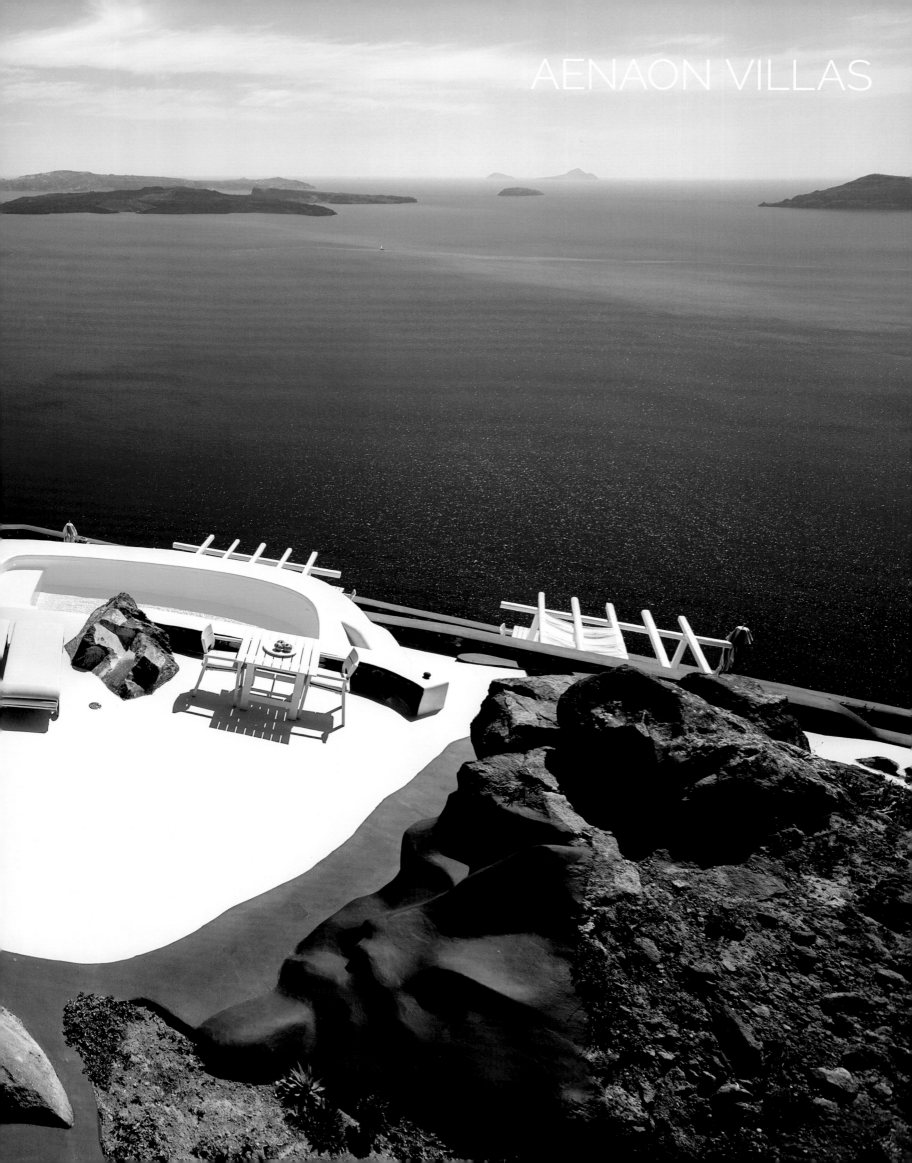

Sie werden den schlichten, eleganten Stil der luxuriösen Aenaon Villas lieben, die auf der wunderschönen Insel Santorini erbaut wurden.

You will love the simple yet elegant style of the luxurious Aenaon Villas set on the beautiful island of Santorini.

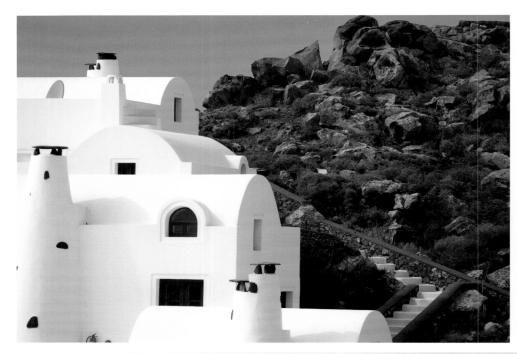

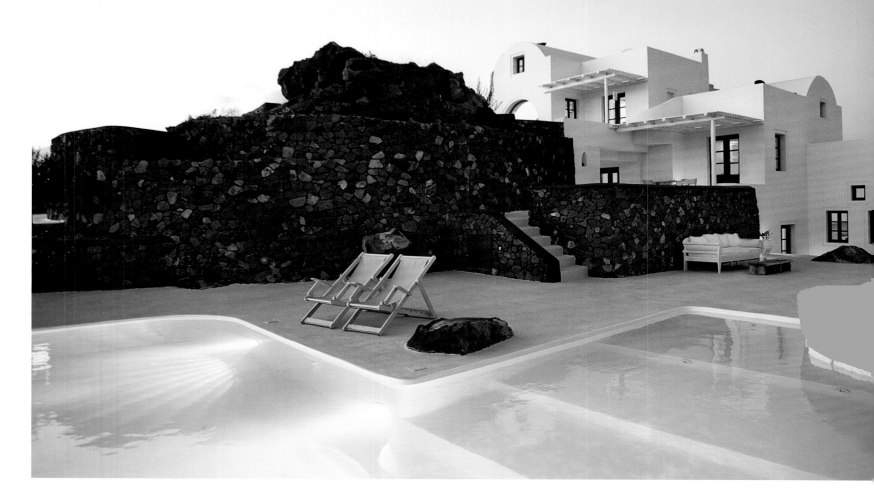

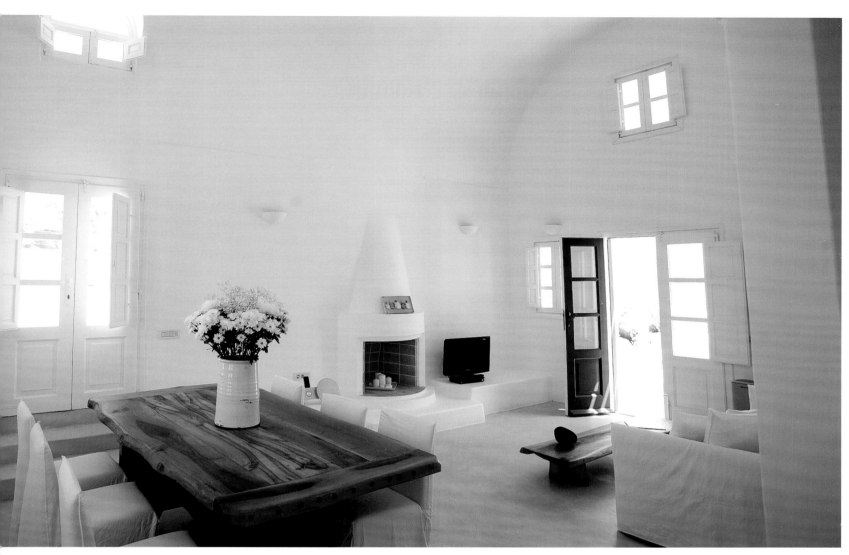

LOCATION

Santorini gehört zu der Inselgruppe der Kykladen in der Südlichen Ägäis. Die kleine felsige Insel ist einer der wenigen besiedelten Vulkane dieser Welt und berühmt für die steilen Felswände der Caldera. Auf dem höchsten und engsten Punkt Santorinis, direkt auf der Caldera, befinden sich die Aenaon Villas auf dem alten Weg, der die Städte Oia, Imerovigli und Fira verbindet. Von dort aus genießt man einen fantastischen Rundumblick und besonders wichtig: absolut atemberaubende Sonnenuntergänge.

HOTEL

Die Besitzer Alexandra und George begrüßen ihre Gäste in einem wirklich idyllischen und einzigartigen Retreat. Sie bauten Aenaon Villas mit dem größten Respekt für die traditionelle kykladische Architektur. Die sieben luxuriösen Villen sind herrlich großzügig, geschmackvoll eingerichtet und mit moderner Ausstattung versehen. Private Verandas führen direkt zum auf der Caldera liegenden Infinity-Pool, der einen spektakulären Blick auf die Ägäis freigibt. Die am höchsten gelegene Villa verfügt über einen eigenen Pool auf der privaten Veranda. Sie werden auf Santorini nur schwer einen besseren Platz für den Sonnenuntergang finden. Aenaon Villas bieten einen authentischen Ort voller Privatheit für einen perfekten Entspannungsurlaub. Die kleine Anlage gewann kürzlich bei den "2016 TripAdvisor Travellers' Choice Awards" als bestes BnB Griechenlands. Bei den Smith Hotel Awards 2015 wurden die Aenaon Villas als "Einsteiger" unter den besten Boutique- und Luxushotels in der Kategorie "Above & Beyond" ausgezeichnet und 2012 wählte Fodor's sie unter die "100 besten Hotels der Welt".

LOCATION

Santorini is one of the Cyclades Islands, which are situated in the South Aegean Sea. The small rocky island is one of the few populated volcanoes on earth and famous for the steep cliffs of the Caldera. At the highest and narrowest part of Santorini, right on the edge of the Caldera, Aenaon Villas are situated on the ancient path that connects the towns Oia, Imerovigli and Fira. The property offers views of all points on the horizon and most important: absolutely breathtaking sunsets.

HOTEL

The owners Alexandra and George welcome their guests in a truly idyllic and unique retreat. They built Aenaon Villas with the utmost respect for the traditional Cycladic architecture. The seven luxurious villas are wonderfully spacious, tastefully decorated and equipped with all modern amenities. Private verandas provide access to the infinity pool built on the Caldera's edge, featuring a spectacular view on the Aegean Sea. The villa that is situated on the highest level of the property provides a private plunge pool on its secluded veranda. You will hardly find a better spot to watch the sunset in Santorini. Aenaon Villas offer an authentic place full of tranquil privacy for a perfect, relaxed stay. The small property won the "2016 TripAdvisor Travellers' Choice Awards" as one of the best 25 BnBs in Greece, was a "Runner Up" of the best 10 boutique and luxury hotels in the "Above and Beyond" category of the 2015 Smith Hotel Awards and was a Fodor's winner as one of the best 100 hotels in the world of the 2012 Awards.

Get your Upgrade

www.upgradetoheaven.com/aenaon-villas

AENAON VILLAS . Imerovigli, Santorini 84700, Cyclades Islands, Greece . www.aenaonvillas.gr

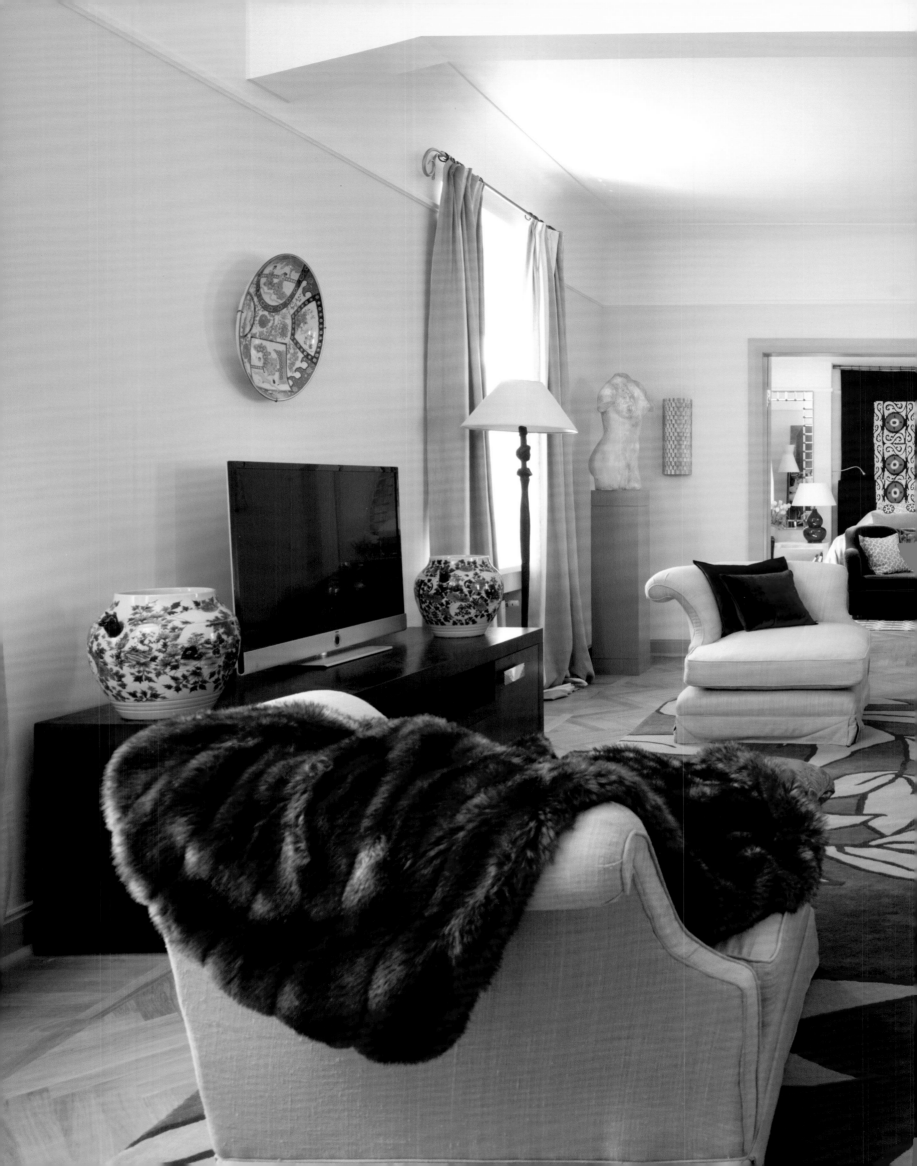

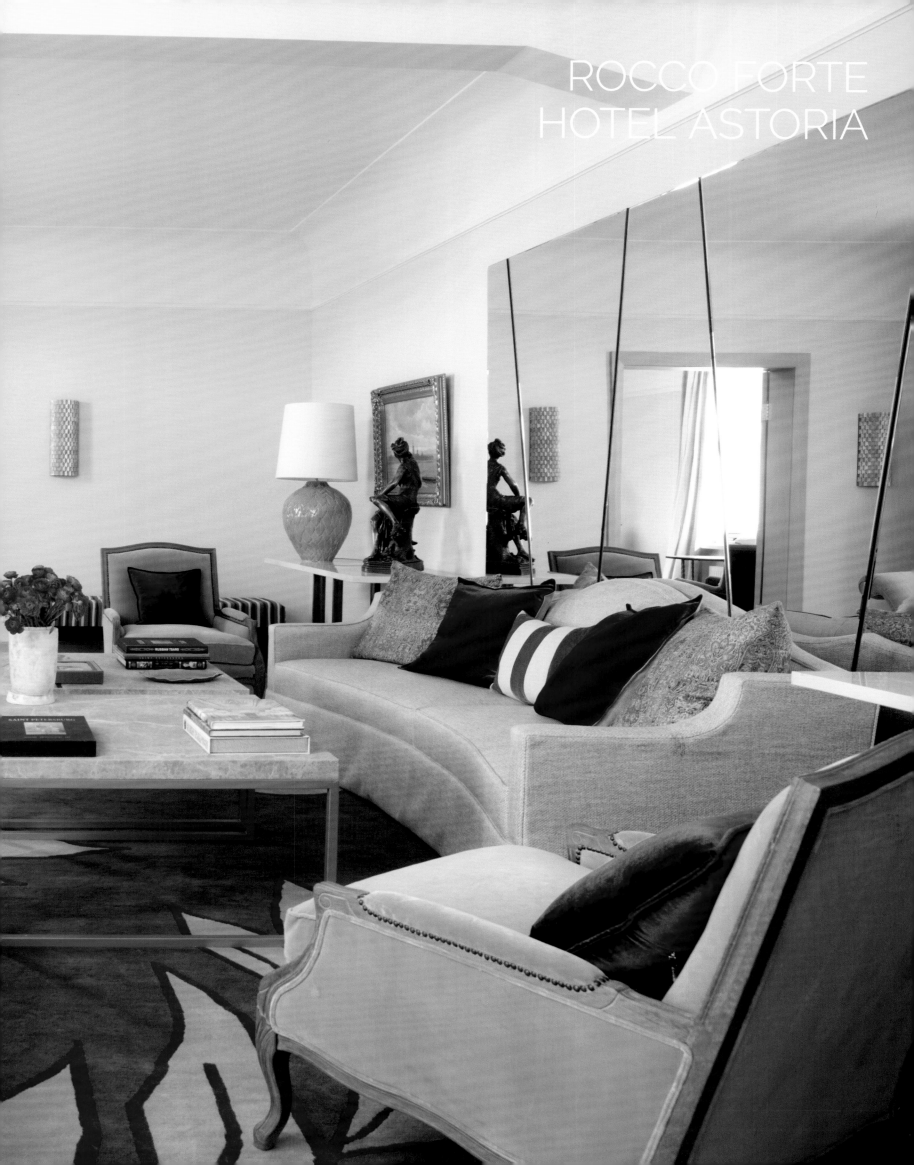

Rocco Fortes Schlüssel
zu Sankt Petersburg.

Rocco Forte's key
to St Petersburg.

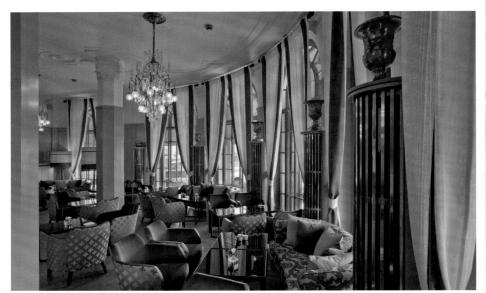

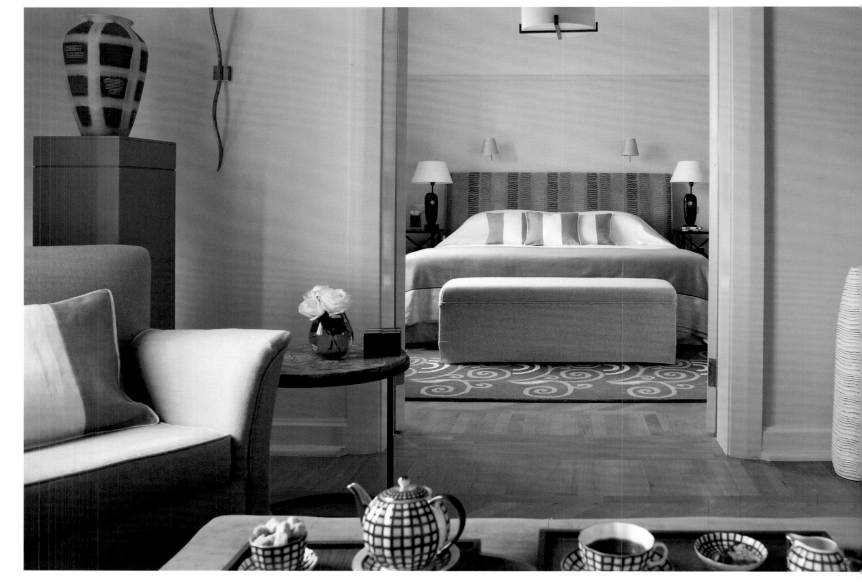

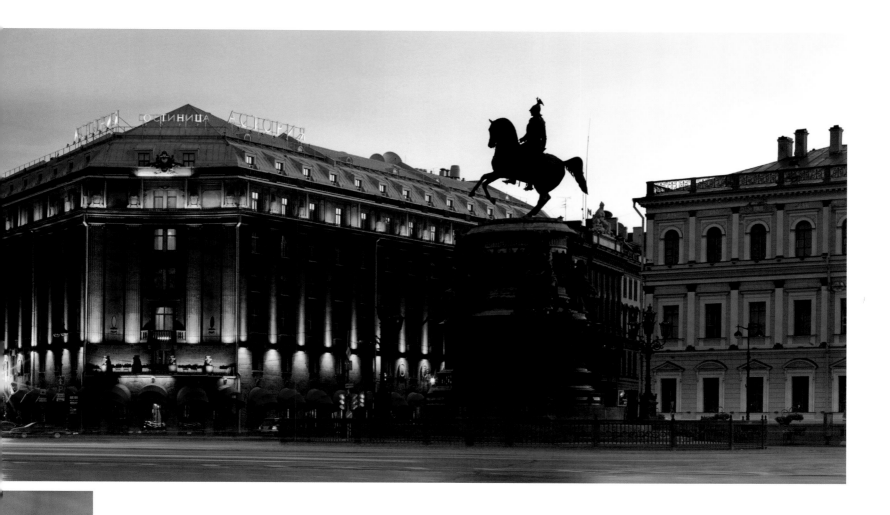

LOCATION

Mit seinem weltberühmten Ballet, seinem prunkvollen Opernhaus und den einzigartigen Weißen Nächten im Sommer ist Sankt Petersburg, das "Venedig des Nordens", das ganze Jahr über ein wundervolles Reiseziel. Mitten im Herzen der Stadt liegt ihr elegantestes Hotel – das Astoria, seit 1997 ein Rocco Forte Hotel. Das denkmalgeschützte Haus ist bereits seit 1912 ein Wahrzeichen Sankt Petersburgs und beherbergte in dieser Zeit die berühmtesten Gäste aus aller Welt. Das Hotel ist der ideale Ausgangspunkt für die Erkundung dieser geschichtsträchtigen Metropole. Das weltbekannnte Eremitage Museum, das Mariinski-Theater und die Isaakskathedrale befinden sich nur wenige Schritte vom Hotel entfernt. Auf der Haupteinkaufsstraße, dem Newski-Prospekt, befinden sich die besten Boutiquen und Designergeschäfte. Das Concierge-Team des Hauses hilft den Gästen gerne dabei, einen perfekten Plan zu erstellen, um die vielen Geheimnisse Sankt Petersburgs zu entdecken.

HOTEL

Die 83 Zimmer und 86 großzügigen Suiten des Hotel Astoria unterstreichen die Schönheit und Tradition der Stadt Sankt Petersburg. Alle Zimmer und Suiten wurden individuell von Olga Polizzi gestaltet. Zeitgenössische Eleganz trifft auf klassischen Charme. Die Betten sind mit feinstem Volga-Leinen bezogen, russische Kunstwerke sowie Antiquitäten und Drucke des Mariinski-Theaters schmücken das Hotel. Gäste können sich zudem aus einer Auswahl von russischen Literaturklassikern, von Tolstoi und Puschkin bis hin zu Dostojewski und Tschechow, bedienen. Das Restaurant "Astoria Café" serviert edle russische Küche mit französischen Highlights. Der eleganteste Afternoon Tea der Stadt wird in der historischen "Rotonda Lounge" des Hotel Astoria serviert. Die "Lichfield Bar" bietet eiskalten Vodka in einem verführerischen Ambiente. Das 24h-Fitnessstudio des Astoria Spa ist rund um die Uhr geöffnet, darüber hinaus gibt es eine Sauna und ein türkisches Dampfbad. Das Rocco Forte Hotel Astoria ist ein Ort echter russischer Gastfreundschaft, an dem Gäste persönlichen Service freundlichster Art und mit lokaler Note erleben.

LOCATION

St Petersburg, the "Venice of the North", is a wonderful vacation spot all year round with its world famous ballet, prestigious opera and extraordinary White Nights in the summer. In the heart lies the city's most legendary hotel – Astoria, a Rocco Forte hotel since 1997. The listed venue has been St Petersburg's landmark since 1912 and hosted many eminent guests from all over the world. Hotel Astoria is the ideal spot to start exploring St Petersburg. The world famous Hermitage Museum, the Mariinsky Theatre and St. Isaac's Cathedral are only a few steps away from the hotel. City's best boutiques and designer stores are located on the main shopping street - Nevsky Prospect. The hotel's concierge team will be happy to arrange a perfect itinerary for the guests to unlock every city secret.

HOTEL

The Hotel Astoria's 83 rooms and 86 spacious suites highlight the beauty and traditions of St Petersburg. All rooms and suites have been individually designed by Olga Polizzi. Contemporary elegance is blended with classic charm. Beds are draped in finest Volga Linen, Russian artworks, antiques and prints from the Mariinsky Theatre decorate the hotel. Guest can also enjoy a selection of Russian classical literature from Tolstoy and Pushkin to Dostoevsky and Chekhov. The restaurant "Astoria Café" offers fine Russian cuisine with a French twist. The city's most elegant Afternoon Tea is served in the Hotel Astoria's historic interiors of "Rotonda Lounge". The "Lichfield Bar" is the perfect spot for an ice cold vodka in seductive surroundings. Astoria spa offers round-the-clock gym, sauna and Turkish steam bath for the guests' pleasure. Rocco Forte Hotel Astoria is a place with true Russian hospitality, where personal service is delivered with gracious ease and a local touch.

Get your Upgrade

www.upgradetoheaven.com/rocco-forte-hotel-astoria

ROCCO FORTE HOTEL ASTORIA . 39 Bolshaya Morskaya, St Petersburg, 190000, Russia . www.roccofortehotels.com/hotel-astoria

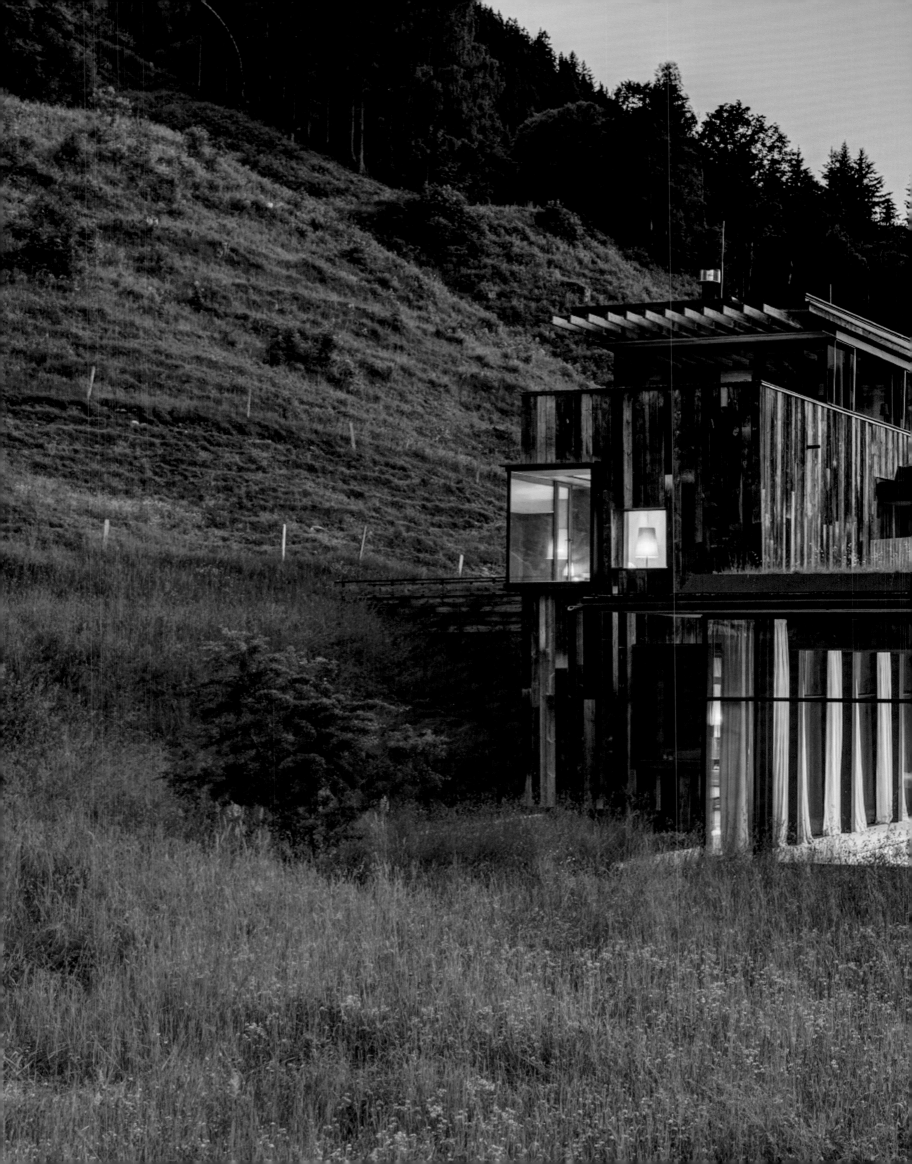

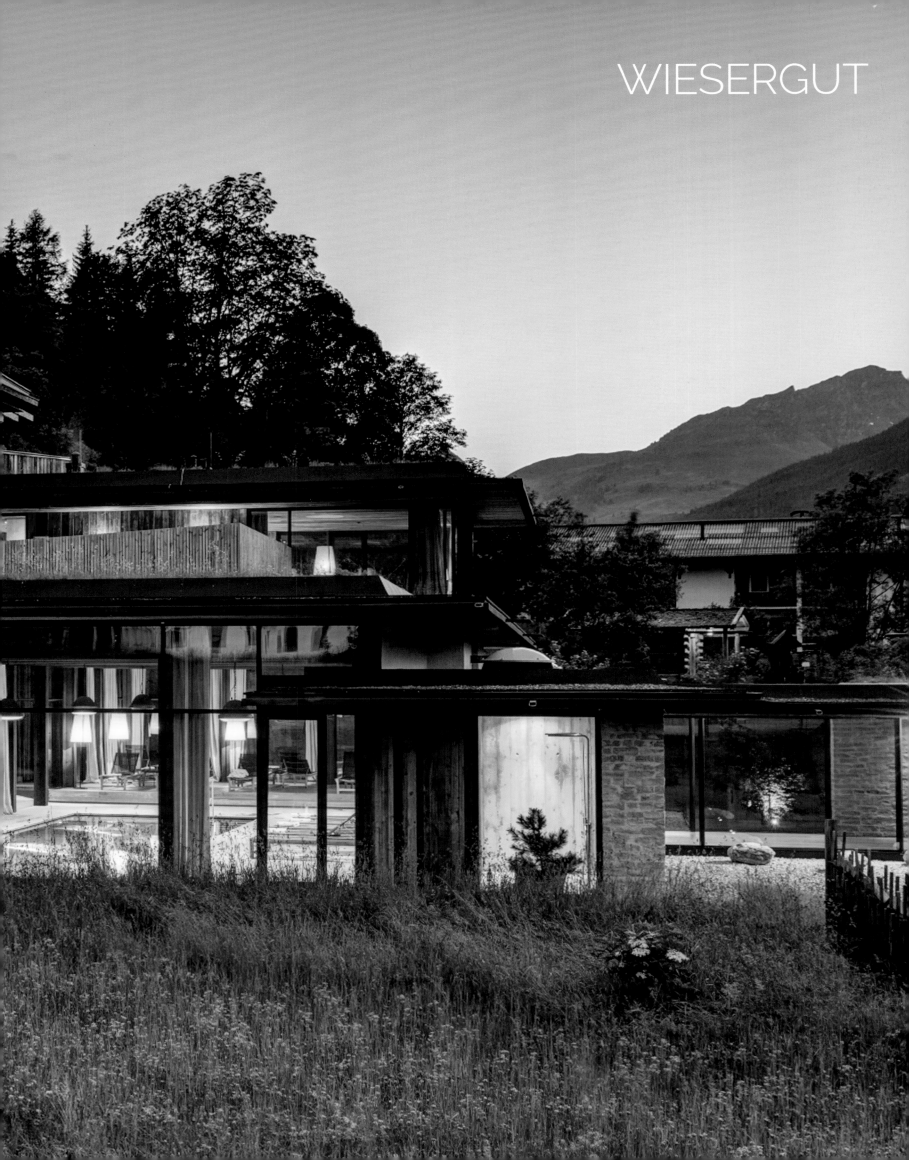

WIESERGUT

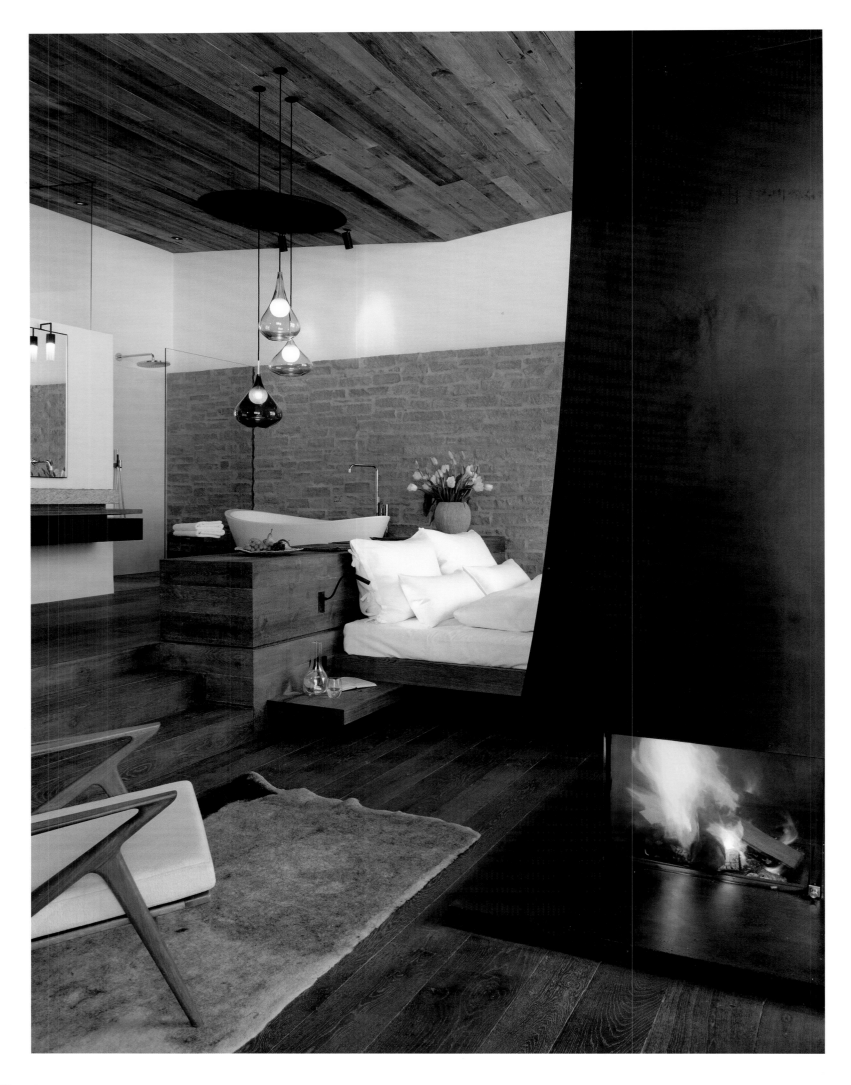

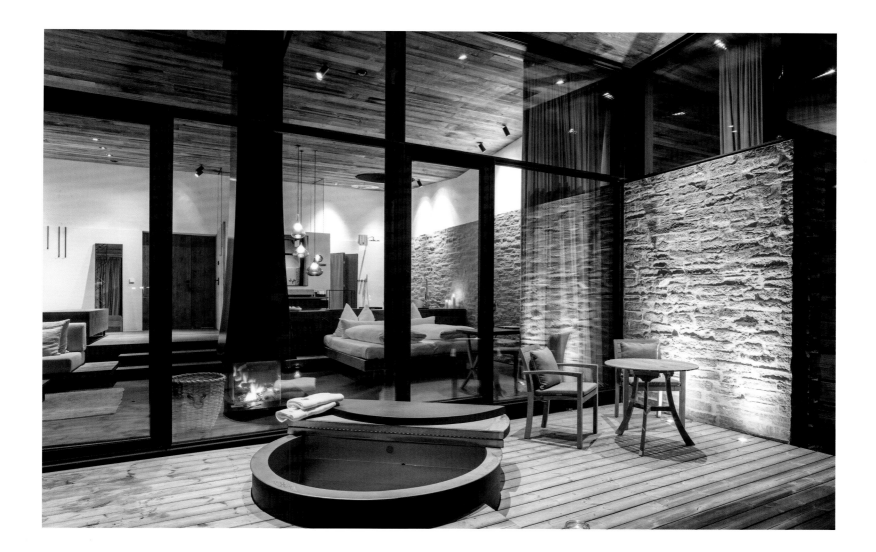

LOCATION

Eingerahmt von Bergen liegen Wiesergut und Wieseralm der Familie Kröll im Glemmtal, mit direktem Zugang zum Ski- und Wandergebiet Saalbach Hinterglemm Leogang, einem der größten und modernsten Skigebiete der Alpen. Mit 270 Kilometer bestens präparierter Pisten mit garantierter Schneesicherheit sowie je 400 Kilometer Wanderwegen und Mountainbike-Strecken, vorbei an Bergseen, schroffen Gipfelfelsen und wunderschönen Almlandschaften, bietet das Glemmtal zu jeder Jahreszeit Aktivitäten für Freizeitsportler und Sportbegeisterte. Ski-Touren-Gehen, Schneeschuhwandern und Langlauf sind nur ein paar Aktivitäten, die sich im Winter anbieten. Im Sommer stehen u.a. Klettertouren, Wandern, Rafting, Pilates und Yoga auf dem Programm. Die Geschichte des heutigen Wieserguts beginnt mit einem Gutshof, genannt Wiesern, im Jahre 1350. Martina und Josef Kröll planten viele Jahre ein Hotel mit moderner Identität, puristischer Architektur und edlen Materialien. Ziel war es, den Ort, den sie lieben zu bewahren.

HOTEL

Das Wiesergut besteht aus dem Gutshof mit 17 Suiten, Restaurant und Piazza sowie einem Eingangsbereich mit Remise, sieben separaten GartenSuiten und dem Wiesergut Spa. Die vier Meter hohen Glasfassaden der lichtdurchfluteten GartenSuiten geben die Sicht auf die umliegenden Berge frei. Ein Kamin aus unbehandeltem Stahl, eine freistehende Badewanne mit Blick in den Sternenhimmel sowie ein mit warmem Quellwasser gefüllter Hot Tub auf der eigenen Sonnenterrasse laden zum Träumen ein. Eine ebenso hochwertige Ausstattung und ein ähnliches Design finden sich in den GutshofSuiten wieder. In einem separaten Gebäude wartet das Wiesergut Spa mit einem besonderen Highlight – dem Private Spa auf dem Dach mit Kamin, Badewanne im Freien und atemberaubendem Ausblick.

LOCATION

Framed with mountains, the Wiesergut manor and Wieseralm estate owned by the Kröll family in the valley of Glemmtal are located with direct access to the ski and hiking area Saalbach Hinterglemm Leogang, one of the biggest and most modern ski areas of the Alps. With 270 kilometres of perfectly primed slopes with guaranteed safety, as well as 400 kilometres hiking trails and mountain bike routes passing mountain lakes, rugged summit rocks and beautiful Alpine landscapes, Glemmtal offers activities for hobby sportsmen and sports enthusiasts all year round. Ski touring, snowshoeing and cross-country skiing are just a few of the possible winter activities. In the summer, climbing tours, hiking, rafting, Pilates and yoga are on the agenda. The history of today's Wiesergut starts with a manor farm called Wiesern, in 1350. Martina and Josef Kröll spent many years planning a hotel with a modern identity, puristic architecture and premium materials with the goal of preserving the place they love.

HOTEL

The Wiesergut consists of the Gutshof manor with 17 suites, restaurant and piazza as well as a reception with remise, seven separate GardenSuites and the Wiesergut spa. The four-metre-high glass facades of the GardenSuites flooded with light allow a beautiful view of the surrounding mountains. A fireplace made out of untreated steel, a detached bathtub with a view of the starry sky and a hot tub with warm spring water on the private sun terrace invite guests to start dreaming. Furthermore, furnishings of a similiar high quality and design can be found in the Gutshof-Suites. In a separate building the Wiesergut spa with a special highlight – the private spa on the roof with a fireplace, an outdoor bathtub and the breathtaking view – is waiting.

Get your Upgrade

www.upgradetoheaven.com/wiesergut

WIESERGUT . Wiesern 48, 5754 Hinterglemm, Austria . www.wiesergut.com

"WIR EMPFINDEN EIN GLÜCKSGEFÜHL AN DIESEM ORT, DEM ORT UNSERER AHNEN, AN DEM WIR UNSERE GÄSTE AUF INDIVIDUELLE ART UMSORGEN DÜRFEN"

"We feel blessed and happy to serve
our guests at this very special place
our ancestors once founded"

– Martina und Josef Kröll,
Owners

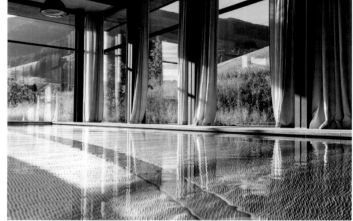

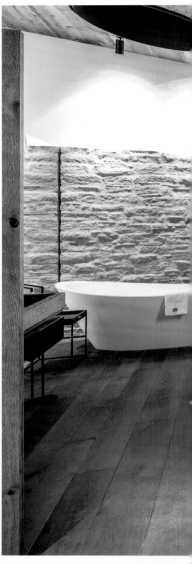

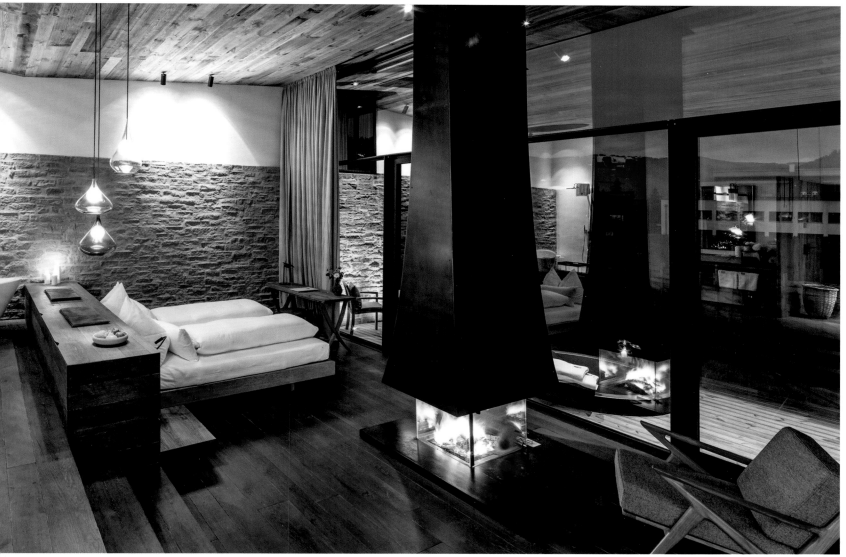

"Back to the roots" is the philosophy of the kitchen team. To achieve this, traditional, high-quality ingredients are newly interpreted. On the menu you can find Pinzgauer beef and game dishes, as well as local fish such as Alpen salmon. The Wiesergut preferably uses products from the family-owned farm, such as the beef and veal, eggs, homemade butter and cottage cheese and home-smoked bacon from the farm's own pigs. The Wiesern bread is still kneaded by hand, formed and directly baked in the piazza's wood-fired oven. The natural focus at Wiesergut is the ring of fire, made by the Swiss artist Andreas Reichlin. It contributes warmth in the winter, creates romantic summer nights and is the perfect grill for cosy barbecues in the inner courtyard.

"Back to the roots" lautet die Philosophie des Küchenteams, das traditionelle, qualitativ hochwertige Zutaten neu interpretiert. Auf der Speisekarte stehen Pinzgauer Rind und Wildgerichte, aber auch heimische Fische wie der Alpenlachs. Im Wiesergut kommen überwiegend Produkte aus der familiengeführten Landwirtschaft zum Einsatz, so zum Beispiel das Rind- und Kalbfleisch, Eier, hausgemachte Bauernbutter und Frischkäse sowie hausgeräucherter Speck der eigenen Schweine. Auch das Wiesernbrot wird noch immer von Hand geknetet, geformt und direkt im Holzbackofen an der Piazza gebacken. Den natürlichen Mittelpunkt im Wiesergut bildet ein Ring aus Feuer, geschmiedet vom Schweizer Künstler Andreas Reichlin. Er spendet Wärme im Winter, schafft romantische Sommerabende und ist der perfekte Grill für lauschige Barbecues im Innenhof.

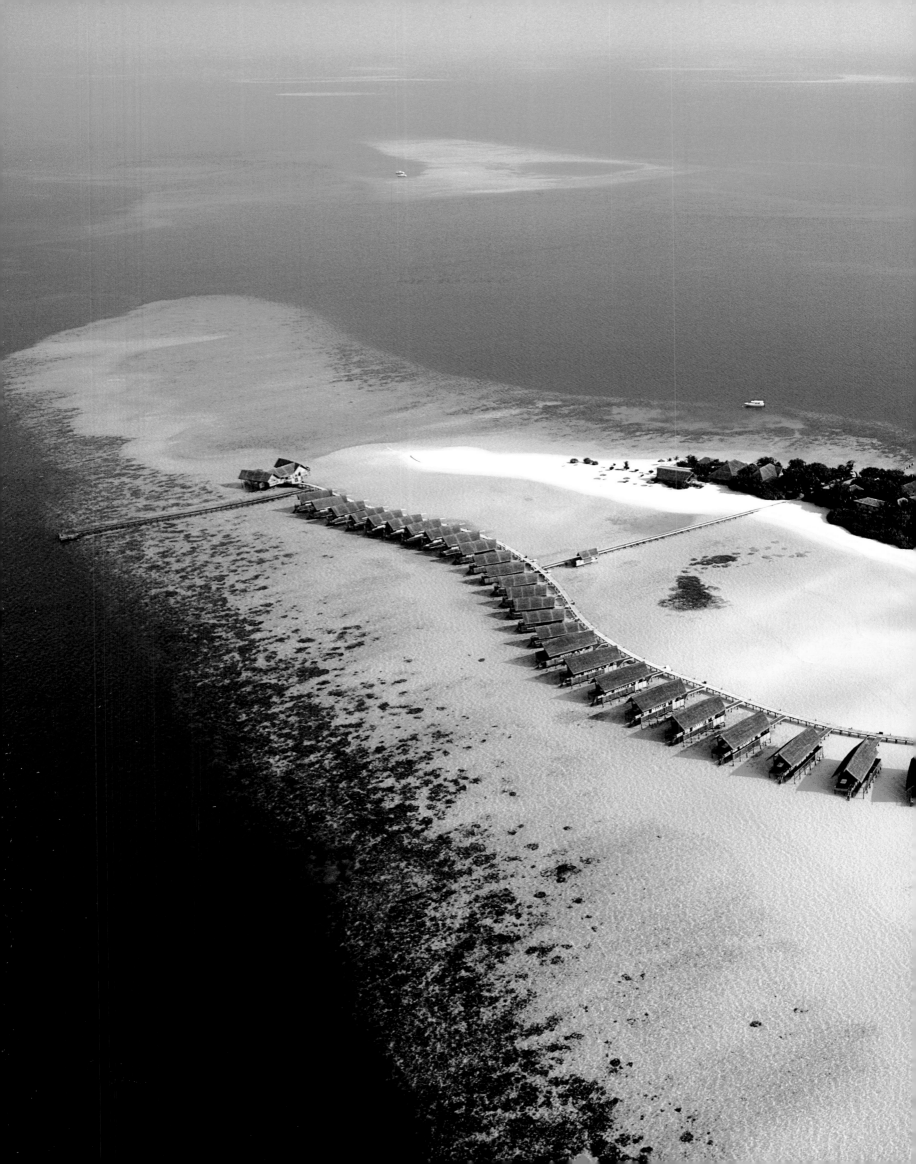

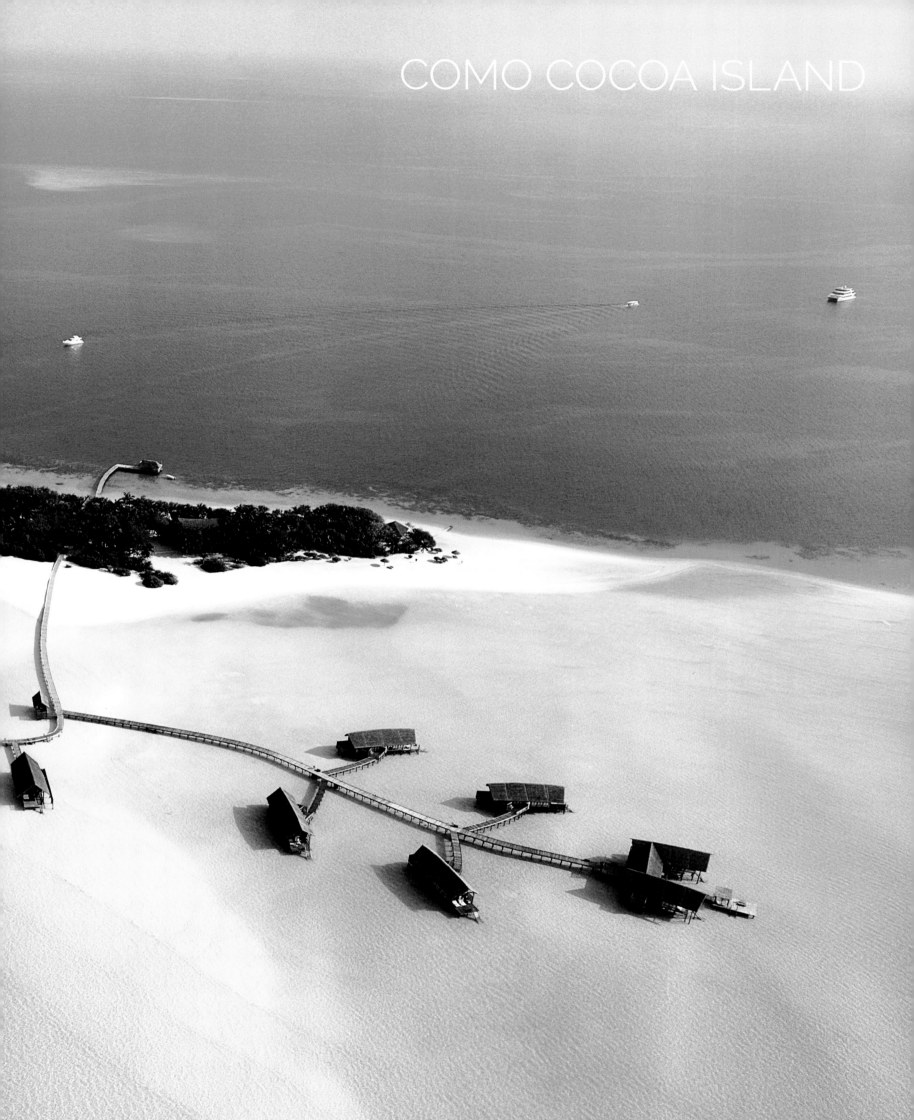

Im maledivischen Luxushotel Como
Cocoa Island ist die Unbeschwertheit
des Archipels spürbar.

Como Cocoa Island is a Maldives
luxury hotel that reflects the
archipelago's serene soul.

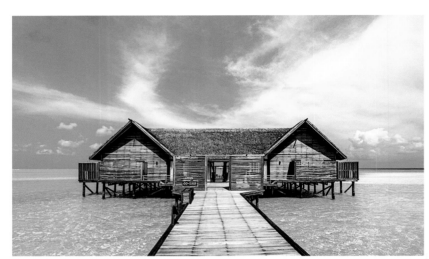

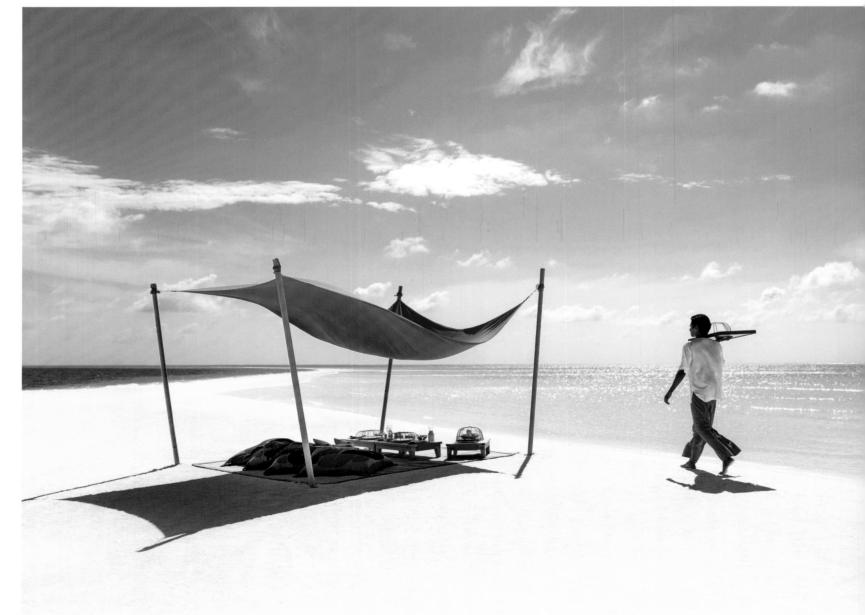

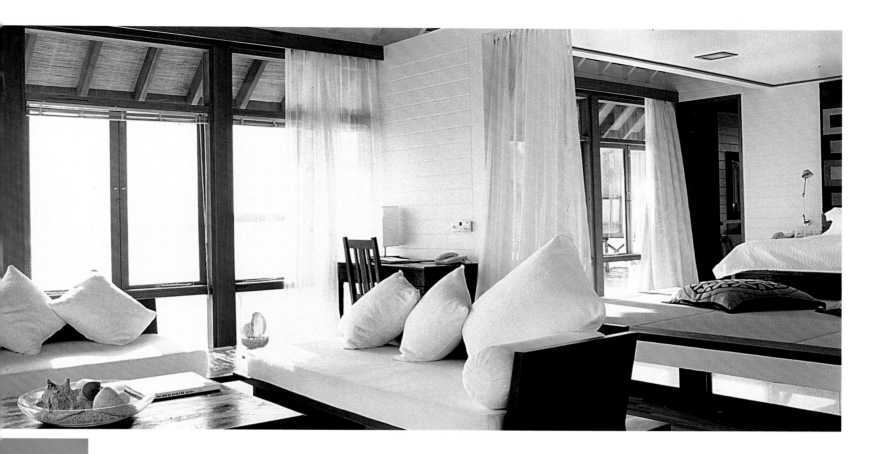

LOCATION

Cocoa Island liegt im Süd Malé Atoll der Malediven, einem unberührten Archipel, wo die Gezeiten über Jahrhunderte den feinen, puderzucker-weißen Sand geformt haben. Die Privatinsel ist bei den Einheimischen unter dem Namen "Makunufushi" bekannt. Etwa 40 Minuten dauert es mit dem Speedboot zum internationalen Flughafen Malé. An den Küsten von Cocoa Island wachsen wilde Meertraubenbäume, bunte Hibiskussträucher und sattgrüne Palmen. Mit zwei privaten Hausriffs ist Cocoa Island weltweit einer der besten Orte zum Tauchen.

HOTEL

Die Ausstattung der 33 Overwater Suiten des Como Cocoa Island ist inspiriert von den örtlichen Dhoni-Booten aus naturbelassenem Holz mit "Kajan"-Dächern. Man erreicht sie über Holzstege, die sich über dem warmen Wasser der Lagune erstrecken. Auf den privaten Sonnendecks mit Loungemöbeln und Esstisch lässt es sich wunderbar entspannen. Die Suiten haben direkten Zugang zur Lagune, für Schwimmvergnügen steht darüber hinaus auch ein 25 Meter langer Infinity-Pool zur Verfügung. Das Como Shambhala Retreat auf Cocoa Island hat sich der Erneuerung von Körper und Seele verschrieben. Das Konzept basiert auf einem holistischen Ansatz, der durch Yoga zusätzlich unterstützt wird, und kombiniert Heiltraditionen aus Asien mit natürlichen Therapiemethoden, inspiriert aus Meer und Erde. Angeboten werden Ayurveda, Massagen und Gesichtsbehandlungen sowie einmal wöchentlich je eine kostenlose Yoga- oder Pranayama-Meditationsstunde. Sportliche Gäste haben die Wahl zwischen Tauchen, Schnorcheln, Katamaran- oder Kajak fahren und Windsurfen. Im Restaurant "Ufaa" wird die Natur mit Meeresfrüchten, fangfrischem Fisch und organischem Gemüse in aufregenden und gesunden Kreationen zelebriert. Die Küche ist ein außergewöhnlicher Mix aus europäischen Gerichten und dem Besten der indischen und srilankischen Traditionen. Como Cocoa Island wurde 2012 bei den "Condé Nast Traveller Readers' Spa Awards" in der Kategorie "Best Hotel Spas in Africa, Middle East and the Indian Ocean" ausgezeichnet. Zudem gilt es laut den "TripAdvisor Traveller's Choice Awards" als eines der "Top 25 Hotels in the World", ebenso als eines der "Top 25 Relaxation/Spa Hotels in Asia".

LOCATION

Cocoa Island is on the South Malé Atoll, an untouched archipelago, which was formed to fine, powdered, sugar-white sand through centuries of tides. The private island is known to locals as "Makunufushi". It takes around 40 minutes to get to the international airport Malé by speedboat. Wild sea grape trees, colourful hibiscus bushes and vibrant green palm trees grow by the coasts of Cocoa Island. With two private house reefs, Cocoa Island is one of the best places for diving.

HOTEL

The design of the 33 Overwater Suites of Como Cocoa Island is inspired by local dhoni boats made out of natural wood with "Kajan" roofs. They can be reached over wooden bridges, which stretch over warm water of the lagoon. Relaxing is wonderful on the private sun decks with lounge furniture and dining table. Suites have direct access to the lagoon, above that a 25-metre infinity pool is provided for any kind of swimming pleasure. The Como Shambhala Retreat on Cocoa Island focuses on renewing body and soul. It is set on a holistic concept, which is supported by yoga and combined with healing traditions from Asia, with natural therapy methods inspired by the sea and earth. Ayurveda, massages and face treatments are on offer as well as a weekly free yoga or Pranayama meditation lesson. Guests with more sporting interests have the choice between diving, snorkelling, catamaran sailing, kayaking or windsurfing. The restaurant "Ufaa" celebrates nature and seafood, freshly caught fish and organic vegetables in exciting, healthy creations. The cuisine is an extraordinary mixture of European dishes and the best of Indian and Sri Lankan traditions. Como Cocoa Island was distinguished with a "Condé Nast Traveller Readers' Spa Award" in the category "Best Hotel Spas in Africa, Middle East and the Indian Ocean". Furthermore, according to "TripAdvisor Traveller's Choice Awards", it is one of the "Top 25 Hotels in the World" and one of the "Top 25 Relaxation/Spa Hotels in Asia".

Get your Upgrade

www.upgradetoheaven.com/como-cocoa-island

COMO COCOA ISLAND . Makunufushi, South Malé Atoll, Maldives . www.comohotels.com/cocoaisland

BON VOYAGE.

IMPRINT

© 2016 teNeues Media GmbH & Co. KG, Kempen

Concept & Art Direction	David Löwe
Text	Marina Bauernfeind
Production	Dieter Haberzettl
Imaging	Jens Grundei

UPGRADE TO HEAVEN
is edited by
Marina Bauernfeind & David Löwe

PUBLISHED BY TENEUES PUBLISHING GROUP

teNeues Media GmbH & Co. KG
Am Selder 37, 47906 Kempen, Germany
Phone: +49-(0)2152-916-0
Fax: +49-(0)2152-916-111
e-mail: books@teneues.com

Press department: Andrea Rehn
Phone: +49-(0)2152-916-202
e-mail: arehn@teneues.com

teNeues Publishing Company
7 West 18th Street, New York, NY 10011, USA
Phone: +1-212-627-9090
Fax: +1-212-627-9511

teNeues Publishing UK Ltd.
12 Ferndene Road, London SE24 0AQ, UK
Phone: +44-(0)20-3542-8997

teNeues France S.A.R.L.
39, rue des Billets, 18250 Henrichemont, France
Phone: +33-(0)2-4826-9348
Fax: +33-(0)1-7072-3482

www.teneues.com

ISBN 978-3-8327-3415-2
Library of Congress Number: 2016942246
Printed in Italy

Bibliographic information published by the Deutsche Nationalbibliothek
The Deutsche Nationalbibliothek lists this publication in the Deutsche Nationalbibliografie;
detailed bibliographic data are available on the Internet at http://dnb.dnb.de.

www.upgradetoheaven.com is an offer of Upgrade To Heaven GmbH,
Baaderstrasse 19, 80469 Munich, Germany

teNeues Publishing Group

Kempen
Berlin
London
Munich
New York
Paris

teNeues